DIMENSIONS OF THE AMERICAS

DIMENSIONS OF THE AMERICAS

ART AND SOCIAL CHANGE IN LATIN AMERICA AND THE UNITED STATES

SHIFRA M. GOLDMAN

The University of Chicago Press *Chicago and London*

Shifra M. Goldman has been a research associate with the
Latin American Center, UCLA, for more than a decade and
an educator for over twenty years. She is the author
of *Contemporary Mexican Painting in a Time of Change*
(1981) and coauthor of *Arte Chicano: A Comprehensive
Annotated Bibliography of Chicano Art, 1965–1981*
(1988).

The University of Chicago Press, Chicago 60637
The University of Chicago Press, Ltd., London
© 1994 by Shifra M. Goldman
All rights reserved. Published 1994
Printed in the United States of America

03 02 01 00 99 98 97 96 95 94 1 2 3 4 5

ISBN: 0-226-30123-0 (cloth)
 0-226-30124-9 (paper)

29.95 PB

Library of Congress Cataloging-in-Publication Data

Goldman, Shifra M., 1926–
 Dimensions of the Americas : art and social change
in Latin America and the United States / Shifra M.
Goldman.
 p. cm.
 Includes bibliographical references (p.) and index.
 1. Art, Modern—20th century—America. 2. Art
and society—America—History—20th century.
I. Title.
N6501.G64 1994
701'.03'097—dc20 94-7458
 CIP

This book is printed on acid-free paper.

To the memory of my mother and father

A tentative glossary of art historical and related terms,

CONTENTS

Women Speaking

Facing Big Business and the State

Latin American Art in the United States

Nationalism and Ethnic Identity

ILLUSTRATIONS

PREFACE

The Essays

Looking back over almost twenty years of my writing, the reader can observe broad strands of thought and analysis, including the very choice of subjects, that bind these thirty-three pieces together into a coherent and cohesive whole. Many textures are involved: that of the researched essay in which history was slowly disinterred from old newspapers, magazines, books, and archival material; that of the catalogues and art criticisms which depended on travel, gallery, museum and studio visits, contemporary reports of work by journalists, interviews with artists and friends of artists; and that of theoretical pieces which resulted from meditation over particular problems of the moment. Very little research could be done in local libraries in the States, no matter how well-equipped they were in other subjects.

To know anything about modern Latin American art in the 1960s and 1970s when it was almost a totally ignored field of study in the United States—not offered in academe, not supported by grant monies to scholars—meant travel and more travel, as far and as often as one's personal budget and limited time taken from earning a living and raising a family could be sustained. It meant carting back books generally not available in the United States, catalogues, clippings, tape cassettes, and thousands of slides made on the spot (since almost none could be purchased). With few general histories, or the kind of extensive periodical literature that characterizes European, U.S., and other studies, the very comprehension of a modern Latin American art history, except in fragments, was (and is) difficult. To further attempt the construction of a *social* history of art about modern Latin America has been even more difficult. Its fragmentary nature is best illustrated by the writings that make up this book, which do

not pretend to be a history, nor even an adequate coverage of the topic, but simply an introduction to the problems.

Pursuing the details of Chicano art, which appeared modestly on the scene in the late 1960s and was ignored by almost all professionals in the art world, similarly required constant travel and collecting to try to cobble a national overview of something so new and so disparaged that no body of art literature was even visible. It had to be painstakingly unearthed from local publications in the Southwest and Midwest, from alternative publications and galleries, from Chicano Studies Libraries, and from the personal archives of the artists. Slowly, those of us who wrote about Chicano art stumbled across each other, or sought each other out. Unlike Latin America, there were no art dictionaries or histories, and few illustrated catalogues, to bring home. There were no slides to be purchased. All this had to be carpentered, as did a theory for this new phenomenon. And the task is still in process, with new voices joining the discourse.

The most wonderful aspect of this labor is that similar structures were being built for women artists, for Native Americans, for Asian Americans, and for the contemporary generation of African Americans, whose past experience and history, fortunately, provided a corps of already trained writers and documentarians.

The adhesive which binds these writings together is my own politics, and something more should be said about that. It has been my experience that converging art and politics, or even art and a social conscience, was disparaged in the United States from the late 1940s on (for excellent historical reasons, including the cold war and the McCarthyite attack on free speech). However, over the years I have found greater reception and approval for these interests in Latin America than I have in the U.S., and this has encouraged me to continue. In Latin America, even a geometric abstractionist (and I have interviewed or chatted with many) can have a social point of view and an interest in politics. Not that I always agree, or have my own views accepted, but functioning as a political being is a "given" in nations where survival itself is closely linked to historical and political knowledge and, often, action. The U.S. dichotomy that assigns politics to "hardheaded businessmen" and politicians and considers intellectuals to be "eggheads" (as Adlai Stevenson was called in his presidential bid) does not hold in Latin America, any more than it does in Europe. Artists of all kinds can aspire to be presidents (as Peruvian writer Mario Vargas Llosa did in the late 1980s), serve as ambassadors (as did Chilean Pablo Neruda and Mexican Octavio Paz), and occupy other posts of importance in government. On a more modest level, Mexican artist Felipe Ehrenberg even ran for public office, viewing his campaign as a political "performance." However, other artists have actually served in legislative capacities.

In impoverished and destabilized countries like many in Latin America, politics addressed to social change is the lubricant that makes life possible. And that lubricant is often provided by culture and the arts, though never by them alone.

A brief word should be said about the organization of this book. In the Introduction, I have attempted not only to periodize Latin American and U.S. social art history, but also to project the changing intellectual environments within which both artists and writers functioned within the second half of the twentieth century. The essays and articles themselves, despite their thematic grouping, retain a certain chronological order which positions them within the time they were written. I did a minimum amount of editing designed primarily for better readability, but resisted the temptation to change any ideas. They must stand or fall within their own time frame. Information has been updated with new endnotes, and repetitive or overlapping references have been removed.

In the Public Eye

This section concerns public and popular art; public art, like the mural, is intended to be public simply by virtue of its location and availability; while popular art is carried out in the streets or in places of public assembly and is intended for a popular audience, though its means and media may be, like the mural, categorized as "high," or "fine" art. "Siqueiros and Three Early Murals in Los Angeles" relates the history of three major murals painted during a brief visit in 1932, two of which were painted over or destroyed. Of considerable consequence is the fact that the Mexican muralist initiated his theories of outdoor murals for the passing public in Los Angeles, and began the search for adequate artistic technology toward that end. "Mexican Muralism" analyzes the differing treatment of key themes by José Clemente Orozco, Diego Rivera, Siqueiros, and Tamayo, and traces the course of Mexican influence on murals and easel painting in Latin America and in the United States. "Resistance and Identity: The Street Murals of Occupied Aztlán" documents the renewed influence of the Mexicans thirty years after the New Deal ended and the social and technical concerns among Chicano artists of the 1970s who were an important part of the national street mural movement. "Elite Artists and Popular Audiences" connects the 1968 massacre of protesters at Tlatelolco, Mexico City, with the emergence of socially conscious young artists who employed the new language of Conceptual Art in their multiple activities addressed to broad audiences in the streets.

Multiples

"Multiples" is a term that defines handmade graphics and photo-offset prints, works of art that are made to be reproduced in many copies rather

than as a unique single piece. A print has the virtues of being available for circulation (unlike a stationary mural), less expensive for the public to purchase, and—in its poster form—having the capability of including explanatory or didactic text. In fact, the poster invites an imaginative use of calligraphy. The focus of all the prints discussed here lies in their function as public announcements or public education. Even the techniques (silk screen in Cuba and among Chicanos; linoleum and woodcuts by Mexicans and Puerto Ricans) are those which do not require a press for printing and therefore are available to artists with limited funding or without high technology. The facts that printmaking assumed the role of a major art form in two Caribbean countries in the 1950s and 1960s, and among Chicano artists in the 1970s, and that in all three cases it was linked to progressive or radical social innovations have particular significance. The pioneering role of Mexico's Taller de Gráfica Popular (Popular Graphics Art Workshop) of the 1930s (with its recognized debt to José Guadalupe Posada) is clearly indicated in the Chicano and the Puerto Rican cases.

Women Speaking

These five articles engage the female and feminist voice and its social role in very different contexts. "Six Women Artists of Mexico" raises questions about the greater public exposure of women artists in major Mexican museums than of their equals in the United States, and tracks the history of six such women from two generations. "'Portraying Ourselves': Contemporary Chicana Artists" and "Mujeres de California" continue with Chicana and Latin American women artists living in the U.S. Included are women from Chile, Cuba, Mexico, Argentina, Puerto Rico, Costa Rica, and El Salvador, as well as Chicanas. "Ana Mendieta" is the review of an exhibition by this Cuban-born feminist artist, while "The Mythopoetics of Anguish" derives from a catalogue written for Guatemalan painter Isabel Ruiz. That Latin American and Latina women have made an impressive showing in the arts since the late 1970s is apparent throughout the continent. They are no longer the "exception," but part of the rule.

Facing Big Business and the State

If the 1960s was an era of challenge to established institutions and political systems, of uprisings and revolutions for independence in many parts of the Third World, the 1980s can be seen as a period of the reversal of democratic aspirations as neoconservative governments moved to power in the late capitalist world and tightened their grip on both the Third World and their own populations. For Latin America, reactionary forces

were in power from the 1960s to the 1990s; some still remain so. Lest this
be seen as cyclical, it should be clear that neither the circumstances nor
the forces involved remain fixed; there is constant change and reconfigu-
ration. If the 1960s were marked by cultural dependency and nationalist
resistance, the 1980s and 1990s are multinational in character. The most
powerful corporations are multinational and no longer conduct business
from a purely nationalist view but contend with other multinationals for
world economic spheres; the same must be seen as true for the cultural
sphere. The developed capitalist nations of the West are in cultural col-
lusion for domination of the art market, and for the cooptation of the
cultural production of the Third World. Political states have their own
cultural agendas, often in tandem with the multinational corporations
which they represent, or on whose patronage they often depend. The art
market itself has become multinational, both the auction houses and the
"chain store" type of art dealers. As one critic pointed out in the 1980s,
"Only recently has the cultural separatism of the late 1970s started to
yield, largely thanks to a lively group of internationally inclined dealers.
The art market contributes importantly to international exchange in pe-
riods when the new is hot—i.e. readily saleable." All the essays in this
section were written in the 1980s and 1990s in response to one or another
of the above concerns.

 "Art and Politics in the 1980s" is a summary piece examining the re-
emergence of politically oriented art in new and dazzling ways. It is a
reprise of the pressing issues of nuclear war and Central America in terms
of U.S. foreign policy and how artists encountered these themes in their
art and their organizations. "Dissidence and Resistance" looks at the art
of Chile's younger generation (after Chilean art was decapitated by the
exile of their teachers and models), and at the means by which the new
artists confronted the serious problems of producing meaningful art un-
der a savage dictatorship. "Rewriting the History of Mexican Art" exam-
ines the year of Mexican/U.S. cultural exchange in 1978 (the "Mexico
Today" activities) in light of the discovery of petroleum in Mexico in the
early 1970s. It also deals with Latin American art and the international
art market. "Mexican and Chicano Workers in the Visual Arts" contrasts
working class images made by non-Latinos during the New Deal period
with similar material by Mexican and Chicano artists in later periods.
"La casa de cambio/The Money Exchange" reviews a Border Art Work-
shop exhibition on the San Diego/Tijuana frontier which addressed
the contradictions of that border through installation and performance.
"Looking a Gift Horse in the Mouth" undertakes an examination of the
extra-artistic reasons behind the Latin American "art boom" in the U.S.
during the 1980s. Both "Metropolitan Splendors" and "Three Thousand
Years of Mexican Art" examine, respectively, the history of cultural re-
lationships between Mexico and the United States (as a prelude to the

North American Free Trade Agreement) surrounding the exhibition "Mexico: Splendors of Thirty Centuries," and a critique of the exhibition itself as an examination of what has been called the "ideology of museography" or "the politics of display."

Latin American Art in the United States

All these articles (from magazines, newspapers, and catalogues) deal with exhibits of Latin American and Latino art in the U.S. "Latin American Visions and Revisions" covers the large traveling exhibit "Art of the Fantastic: Latin America, 1920–1987," one of the earliest and most comprehensive of the Latin American exhibitions that marked the "art boom." It was followed by a major exhibition, "The Latin American Spirit: Art and Artists in the United States, 1920–1970," which took a giant step—within the circumstances of the "boom"—to more accurately define the diversity and defy the stereotypes of Latin American and Latino art. It was an exhibit in which Latin Americans were involved at the critical junctures: from curation to catalogue essays. "Un punto en común/ Common Ground" compares the work by a Salvadoran popular sculptor with that of a North American artist working with Latin American themes; eventually the two exhibited together. "Clima Natal" comes from the catalogue of a traveling exhibition of three young Costa Rican artists; the exhibition was intended to support the plan for Central American peace proposed by Costa Rican President Oscar Arias, and was organized by Artists Call Against U.S. Intervention in Central America. "Social Illuminations: The Art of Guillermo Bert" explores in some detail an ambitious and imaginative installation piece by an immigrant Chilean artist responding to the realities of his Los Angeles environment, while "How Latin American Artists in the U.S. View Art, Politics, and Ethnicity in a Supposedly Multicultural World" highlights the critique made by Latin Americans of North American and Euro-centrisms, particularly in the work of Chilean Alfredo Jaar and Argentinian Leandro Katz (both of New York).

Nationalism and Ethnic Identity

Both of these topics are complex and explosive and have taken on new and difficult significations in the postmodern world, especially with the breakup of the Soviet Union and the enmities thereby exposed between "ethnic groups" who formerly coexisted. However, the fact that hybrid social situations exist throughout the modern world is no secret: tribal groups and clans are powerful impediments to national unities—particularly when their situations are exacerbated by the postcolonial designs of the developed world, or by the elite rulers of developing nations

who wish to retain power. Most modern nations have been formed at the expense of conquered tribal or potentially national groups who are then transformed into ethnic minorities—or racial or religious minorities, when "race" and religion are employed among the bases of suppression. Thus questions of nationalism and ethnicity become one of the symptoms of colonialism.

"Response" opens a dialogue on the hotly debated role of Chicano artists as they started to enter the art market in the early 1980s and were tempted to relinquish their earlier social idealism and engagement in order to sell their work. "Inside/Outside Mainstream" argues these points from the view of Latin American artists. The common issues raised in this section include U.S. reception of modern Latin American art, the themes and styles of such artists being accepted as valid on their own terms, the culture shock of the artist who comes to live in the U.S., and the impact of military or political conflict on art production. Two of the essays deal with Chicano racial, ethnic, and class identity as expressed in visual images. "Homogenizing Hispanic Art" is a highly critical review of the "Latino melting pot" premise under which the traveling exhibition "Hispanic Art in the United States" was organized. "Under the Sign of the *pava*" researches the national and international contexts for the development of Puerto Rican art before and during the governorship of Luis Muñoz Marín. "Living on the Fifth Floor of the Four-Floor Country" was a catalogue essay for the work of New York-born Puerto Rican artist Juan Sánchez, in which motifs from the Island and those of New York mingle in a paean to independence and cultural literacy for Puerto Ricans. Finally, the separate histories—parallel and convergent—of artists from the three largest Spanish-speaking groups of the United States are explored in "The Manifested Destinies of Chicano, Puerto Rican, and Cuban Artists in the United States."

Selected General Bibliography on Latin American Art

Until a coherent, detailed, and socially framed history of modern Latin American, Brazilian, and Caribbean art becomes available in English, collections of writings—such as this one, and some of the extensive catalogues complementing large-scale exhibitions of Latin American art that have appeared in the United States and Europe during the decade of the 1980s—are, at the best, stopgap measures. For the general reader, they offer an overview of some history and of selected problems which have concerned exhibit organizers, or (as in my case) the elaboration of research, the production of catalogue texts, and the critical commentary around topics of interest over an extended period of time. To a certain degree, they exist without a frame of reference—artistic, if not historical.

Within the field of Latin American studies, a vast body of literature,

both historical and theoretical, is available in English to the person interested in the social sciences and literature. It is sufficiently extensive so that a range of opinions are available for comparison; so that multidisciplinary anthologies on given themes can be encountered; and so that an ongoing debate about existing theories can be perused. However, the performing and visual arts share the same lacuna: their wide desert of information is dotted, like an abstract surrealist landscape, with biomorphic or geometric shapes that undertake to define certain prescribed territories and the presences that inhabit them. Encountering the "territory" or the "presence," one is hard put to acquire more substantial information about either, lacking histories, biographies, encyclopedias, and a literature of criticism and discourse.

Even outside the English-language field there exists no definitive modern art history of the Spanish- and Portuguese-speaking countries of the Americas. Many nations have produced their own histories, dictionaries, encyclopedias, and theoretical studies, as well as numerous biographies of artists beyond the catalogue variety. Unfortunately, much of this literature is not readily available.

The list of publications in English, Spanish, and Portuguese that appears in this bibliography makes no pretension to be complete or even sufficient. It is intended merely as an introduction that can certainly be extended. No periodical literature is included; however, it is recommended that the reader search out the excellent publication *Arte en Colombia* in its International Edition, which is entitled *Art Nexus* and which provides English translation for articles and reviews about Latin American art globally. The present compilation provides a minimal guide for the reader interested in further exploration—though that exploration would, of necessity, have to be conducted in a number of libraries, since the neglect of modern Latin American art in the United States (including in the academies) has resulted in the above-mentioned scarcity of printed material. Possibly the best location for Latin American materials is the Nettie Lee Benson Latin American Library at the University of Texas, Austin, which also includes the holdings accumulated by the Mexican American Studies department there. Finally, the selections here represent a spectrum of philosophies and approaches to the study of art.

ACKNOWLEDGMENTS

This book is the product of a long period of growth to which a great many colleagues and friends have contributed. With few exceptions, the essays and articles themselves were not read before original publication except by the respective editors of the publications where they appeared, and to these editors I am grateful for polishing my language and refining occasional ideas that were somewhat undercooked as I labored against a deadline over a hot typewriter or computer. I have acknowledged the intellectual influence of a number of writers and theoreticians in the Introduction. To that I must add the influence of hundreds of spirited conversations held in numerous cities of Latin America, Europe, and the United States with artists, researchers, critics, curators, educators, historians, and/or political activists too numerous to name. The ideas we debated are imbedded in many of the writings that appear here, and in a great many more that do not. Despite the myth of inarticulateness cherished by some artists, many others are highly articulate in both verbal and written form, and I have benefited from this articulation.

I owe special thanks in the shaping of this book, and its Introduction—which became a separate project when I was challenged to provide a theoretical underpinning for the essays and articles accumulated over so long a period of time—to Mari Carmen Ramírez, Dawn Ades, Luis Camnitzer, Carol Wells, Albert Boime, and John Weber.

I am grateful to Rancho Santiago College for two travel/research grants that permitted me to spend time in Cuba, Brazil, Uruguay, Argentina, and Chile in 1989 and 1990. I also wish to thank faculty member Carol Miura and librarian Susan Luévano for research support, their friendship, and numerous discussions that advanced my knowledge. From other institutions, Evy Horigan, Art Librarian at the California Institute of the

Arts, Ruth V. Robert from the Indianapolis Museum of Art, and Gwynne Barney of the Los Angeles County Museum of Art have been especially helpful in locating materials and obtaining permissions.

I thank Lenny and Cricket Potash for their unfailing understanding, also Betty Kano, Cecelia Klein, Tim Drescher, the late Arnold Belkin, Arline and James Prigoff, Juan Sánchez and Alma Villegas, and, finally, my son, Eric García, for his loving support and friendship.

Finally, no acknowledgment would be complete without recognizing the vision and patience of the Press's senior editor Karen Wilson as well as the thoughtful and careful manuscript editing of Jo Ann Kiser.

INTRODUCTION

I

> The artistic work is a form of social communication in which elements of the dominant culture coexist with a democratic culture that generates cultural projects. The commercial circuit by which a painting, statue or book is converted into merchandise does not exhaust or block its potential for mediating reality through the imaginary.[1]

> Latin American cultures are not embalmed traditions; they are the conflictual result of relations between highly diverse groups with common or convergent histories.[2]

As film historian Julianne Burton has noted, "More, perhaps, than in other regions of the world, culture in Latin America inhabits a politicized zone, for Latin American artists and intellectuals acknowledge how profoundly history and politics inflect creativity."[3] What has been true for film in the twenty-five years which Burton considers has been equally true for the visual arts, as this collection of essays and criticism demonstrates.

What knits together the seemingly disparate essays and critiques that comprise the present volume is, admittedly, the social and political interests of the author. My obvious partisanship is more understandable when placed in the context of U.S. history during the last thirty years and the context of my own participation in political activities throughout those years. The critical stance I assumed in 1973 when I wrote my first art historical essay on Siqueiros for publication and the one which I took in

1

the last piece on Mexican art written in 1992 are embedded—to place it very broadly—in the decision to involve myself directly in redressing social inequities in the immediate world in which I live. In other words, I feel that my art historical research and my political convictions are in conjunction with each other, and are framed by what was known in the late 1960s, when I began my doctoral studies, as the "social history of art," that is, the insertion of cultural practices within their social and historical context, ideally with the two acting in praxis.

My proposal for these introductory remarks is twofold: on the one hand to survey the terrain and thus to provide an overview, as a frame of reference for my written material, of those currents in modern Latin American art which have taken a critical posture toward social issues and concerns; on the other hand, to position myself as a North American observer, commentator, interpreter, and intervener within the narrative fabric of U.S. and Latin American art history. By carrying forth the latter, I hope to avoid what an astute commentator has referred to as the temptation to dress one's own knowledge in garb at once "universal" and "culturally invisible to itself."[4]

Surveying the Terrain

What I have tried to do in the historical overview of Latin American art that follows is to construct a type of periodization in which artistic production and activity can be conjoined with historical facts, social formations, movements of peoples, economic and political realities, mythologies, and philosophical and aesthetic propositions, both local and international. The periodization is not refined here because of the necessity for brevity; it therefore operates with a decade-by-decade exposition from the 1920s (the birth of the Latin American vanguard) to the 1980s. However, the reader should understand that the summary form abbreviates, or by necessity ignores, the tremendous variations between nations and regions, as well as art production (such as abstraction) that cannot be considered "engaged" art on its own authority without extra-artistic factors (titles, manifestos, etc.). It should also be clear that modern Latin American art was always part of the international panorama, whether or not recognized by the Euro-American discourse.

Unlike the United States, which has indulged itself with the ideologies of isolationism and nativism while practicing imperial expansionism abroad, Latin American countries have never had the luxury of entertaining a perfected and unimpeachable sense of nationhood and selfhood. For its intellectuals and artists, therefore, the search for a national culture and the affirmation of the existence of such a culture has represented a special battlefield—especially during the third decade of the twentieth century, which marked the revolt against European-influenced academic

art and the emergence of a modernist avant-garde. As Martinican Frantz Fanon pointed out, the passion with which native intellectuals defended the existence of their native culture may have amazed Europeans, who were apt to forget that their own selves were conveniently sheltered behind a French or German culture which had full proof of its existence and which was uncontested.[5] Fanon, of course, was writing in 1961 and referring to modernist attitudes of the first half of the century. In our own, postmodern time, this clean division between the colonizers' and colonized's cultures is no longer possible. For one, the modernist verities and paradigms are under attack. For another, the colonized are often *within* the body of the countries and cities of the colonizers, jostling them for their own space and identity. The globalization of manufacture, trade, finance, communications, and culture no longer permits identity and subjectivity to be articulated only on a national, or continental, basis. The discursive factors have changed. The current "integration" of Latin American economies into the "new world order" has provoked new thinking in Latin America as elsewhere on questions of modernization, modernism, and postmodernism as well as the pluralism which camouflages itself behind an egalitarian mask while it neutralizes class conflict (which has not abated) and the claims of new social movements.[6]

The questions of universalism versus nationalism, of the domination of world history and tradition by the European models of civilization and rationality, of progress, are being vacated. Nevertheless, as Latin Americans were always aware (by force, if not by inclination) and as many Europeans and Euroamericans are becoming aware, the world since the fifteenth century and the birth of capitalism has functioned as a whole, a totality, a system, instead of as a sum of self-contained societies and cultures. Human aggregates have been "inextricably involved with other aggregates, near and far, in weblike, netlike connections."[7] Furthermore, these involvements have been class-determined. "The history of Latin America's underdevelopment," says Uruguayan writer Eduardo Galeano, "is . . . an integral part of the history of world capitalism's development. Our wealth has always generated our poverty by nourishing the prosperity of others—the empires and the native overseers."[8] Paradoxically, in the postmodern period, while foundational constructs of all types are splintering, the economic grid and the class divides are even more determinatively global, in intricate ways that even economists cannot always unravel.

The concept of "culture" came to the fore in a specific historical context, when European nations were contending for dominance while others were striving for separate identities and independence. A distinctive culture legitimated the aspiration of each struggling society to form a separate state of its own. This occurred in the United States in the eighteenth century, and in Latin America in the nineteenth century; while

subethnicities everywhere, whether or not state-oriented, whether or not using the term "culture," understood (and understand today) the necessity of maintaining their cultures as a key to survival as a group. The notion of separate and integral cultures, therefore, responded to this political project.[9] Equally, no society or cultural project is fixed, unitary, and bounded. It must give way to the sense of fluidity and permeability of cultural sets. A culture, therefore, is better seen as a series of processes that construct, reconstruct, and dismantle cultural materials in response to identifiable elements.[10]

The Latin American search for identity that preoccupied the modernist vanguard of the 1920s was one based on a unitary "ontological" concept containing an essential element: a specifically defined community with a presentiment of its own uniqueness. In later years, this definition was amended; it then depended on an identity defined by its opposition to the dictates of the "universal" canons imposed by the metropolitan centers. In the postmodern period, it has been argued that identity can be most fruitfully understood as a plurality of variable positions rather than as the binary order that had prevailed in mid-century. Thus "the position of each one of many cultural (id)entities proliferating in Latin America [and the United States] is not established once and for all. . . . [Rather] it takes shape in relation to other cultural forces with which it clashes, joins or crosses, trading metaphors and concepts, establishing ambiguous boundaries and sharing hybrid territories."[11]

1920s to 1940s

The conjunction of art and politics in Latin America took a new direction in the 1920s with the emergence of the Mexican School, which followed on the heels of two major revolutions that changed the politics of Latin America and the world: the Mexican Revolution of 1910, which profoundly affected consciousness throughout Latin America; and the Russian Revolution of 1917, which had global repercussions among artists, intellectuals, and working people. The first two decades of the twentieth century marked a stage of social and political struggles throughout the continent: labor and social reforms in Uruguay (1911–15) under President Batlle y Ordoñez, the rise of the nationalist and Indian-oriented Aprista party in Peru, a protracted period of social struggle in Brazil until the installation of the nationalist regime of Getulio Vargas (1930–45), the movement for university reform begun in Córdoba, Argentina (1918), which branched out continentally, the resistance of Sandino in Nicaragua, and the formation in various countries of communist parties.[12] In addition to internal conflict, the United States between 1898 and 1932 intervened militarily and politically in over thirty nations; for long periods of time it ran the governments of the Dominican Republic,

Cuba, Puerto Rico, Nicaragua, Haiti, and Panama; and for shorter times those of Honduras, Mexico, Guatemala, and Costa Rica, to protect or advance its investments. Thus a powerful anti–North American sentiment simmered in many countries and contributed to their nationalist postures.

The end of World War I, which called into question the very validity of western civilization, ushered in two decades of self-discovery in Latin America. During this period, there arose a growing interest in the autochthonous and African peoples, an interest spurred to some degree by Europe's fascination with Africa, "primitivism," and a prevalent glorification of antirationalism but owing its genesis to the more important search for each nation's own past and present and the hope of integrating subaltern groups (primarily as laborers) into the national identity.[13] It was also the perceived closeness of Indians and blacks to natural life and the land that attracted artists and intellectuals in search of their roots.[14] This interest was particularly pronounced in (if by no means limited to) areas with large indigenous populations such as Mexico, Central America, and the Andean nations of Ecuador, Colombia, Bolivia, and Peru where the new wave of indigenism was tied to social reform. For the countries like those in the Southern Cone (which itself includes Brazil, Uruguay, Paraguay, Chile, and Argentina), whose aboriginal populations had been largely decimated, indigenism took on a utopian cast. In places with a considerable African presence, such as Brazil and the Caribbean countries (though from the eighteenth century forward there was hardly a country in Latin America without an African-descent population), identity was sought through the acknowledgment of the previously ignored African elements of their culture, sometimes with the suggestion that Africans exercised a moral superiority by reason of their suffering.[15]

At the same time, the decades of the twenties and thirties saw a late assimilation of European avant-garde tendencies, from impressionism and postimpressionism to German expressionism, fauvism, cubism, futurism, constructivism, and surrealism. It was an era of declarations and manifestos embodying vanguard artistic and social positions, particularly in Mexico, Brazil, Argentina, Peru, and Cuba. Mexico pioneered the public art forms of muralism and graphics in 1921 and 1937 respectively. I recall asking Argentine painter Antonio Berni in 1979 why—in light of Siqueiros's presence in Buenos Aires in 1933 and the subsequent murals painted by Berni himself and other prominent artists in the city—there had been no mural movement in Argentina. His response was simply, "We never had a revolution and there was no interest in public art."

Nevertheless, other countries *sans* revolution did turn to social realist muralism (mostly under the influence of the Mexicans) in the 1930s and 1940s—among them Peru, where historical and political muralism flour-

ished in the 1940s and 1950s by painters Juan Manuel Ugarte Eléspuru, Sabino Springett, José Sabogal (whose visit to Mexico in 1922 inspired a variation of social realism and indigenism in his work and those of colleagues), Enrique Camino Brent, Carlos Quizpez Asin, Teodoro Nuñez Ureta, and Francisco Izquierdo; Colombia, by Pedro Nel Gómez (who considered himself primarily a muralist, and produced major works from the 1930s until the 1970s), as well as Ignacio Gómez Jaramillo and Alipio Jaramillo; Brazil, by Cândido Portinari; Bolivia, by Walter Solón Romero, David Crespo Gastelú, Jorge and Gil Imaná, Lorgio Vaca, Miguel Alandía Pantoja; Costa Rica, by Francisco Amighetti; Chile, by José Venturelli, Gregorio de la Fuente, Carlos Hermosilla, Julio Escamez; Ecuador, by Oswaldo Guayasamín and Eduardo Kingman; Venezuela, by César Rengifo.

Though there were muralists in Uruguay after Siqueiros's visit in 1933, the Mexican influence was probably deflected by the return to Montevideo in 1934 of utopian constructivist Joaquín Torres García, who redirected Uruguayan idealism. Siqueiros likewise visited Cuba in 1943, where he painted two murals, without much consequence in terms of Cuban muralism. Not until after the Cuban Revolution of 1959 did some muralists emerge in Cuba, notably Orlando S. Suárez, who compiled the *Inventario del muralismo mexicano,*[16] which appeared in 1972, and who was therefore very conversant and involved with the Mexican School. (Muralism as a primary public art form was generally rejected in post-revolutionary Cuba in favor of billboards, and of silkscreen and offset posters which became internationally recognized in the 1970s.)

Despite Berni's disclaimer about public art, political art and art of social criticism or comment were much more evident in Latin America after World War I than the abbreviated list above suggests. Graphics, which had a long history in Mexico and was revitalized with the 1937 formation of the Taller de Gráfica Popular , also had (and has) a vigorous following throughout Latin America, even before the twentieth century. Particularly important are the graphics of Puerto Rico (from the 1950s on), Uruguay, and, as already mentioned, Cuba—not only for silkscreens, but for the magnificent woodcuts of Carmelo González, considered the "father" of Cuban relief printmaking in this century. Social commentators during roughly the first half of the twentieth century include Berni, Mauricio Lasansky, José C. Arcidiácono, Alfredo Guido, Demetrio Urruchúa, Lino Eneas Spilimbergo (Argentina); Lasar Segall (Brazil); Carlos Hermosilla and Julio Sierralta (Chile); Carlos Correa (Colombia); Amighetti (Costa Rica); Lorenzo Homar, Rafael Tufiño, Carlos Raquel Rivera (Puerto Rico); Guayasamín, Kingman, Galo Galecio (Ecuador); Sabogal, Julia Codesia, Camilo Blas (Peru); Carlos González, Antonio Frasconi, Luis Solari (Uruguay); and Héctor Poleo (Venezuela). While many of the above are also painters, some like Lasansky, Amighetti, Homar, Carlos González, Frasconi, and Solari are best known as printmakers.

1940s to 1960s

In the late forties, Latin American art changed radically. World War II, which ended in 1945, had provided a stimulus for the industrialization of Latin American countries while the United States was occupied abroad and needed their manufactures and their good will in the face of German and Italian enticements. With the Allies' march to victory in the mid-forties signaling a democratic victory over dictatorships, Latin Americans moved to replace their own dictatorships. Between 1944 and 1945, Fulgencio Batista fell in Cuba, Maximiliano Hernández Martínez abandoned office in El Salvador, Jorge Ubico fled Guatemala, and strongmen Alfonso López Pumaréjo of Colombia, Manuel Prado of Peru, Isaías Medina of Venezuela, and Getulio Vargas of Brazil were forced from office. These were not long-lasting changes, however. The United States emerged from World War II as a global power, and reestablished its hegemony over Latin American economics and politics. By the 1950s, Batista had returned to power in Cuba, until he was finally dislodged by the Cuban Revolution; and the Guatemalan democratic revolution was overturned in 1954 by the CIA.

Between 1945 and 1965, different forms of patronage for the arts arose in the form of new museums, art galleries, international competitions, and corporate sponsors (both local and international) whose activities eventually rivaled and even took over the patronage role from national and provincial governments. A younger generation of artists in the 1950s abandoned the idea that artists could, or should, help to change society. The social and political action of the previous decades had either been frustrated or neutralized, and artists felt that the possibilities for national affirmation were exhausted. They turned to the international art movement, which was dedicated to abstraction in its geometric and lyrical aspects. Figuration was rejected in the cosmopolitanism of the abstract mode, a mode generally embraced by artists, critics, and the art market.

1960s to 1980s

For Latin America, the Cuban Revolution of 1959, soon transformed into a socialist revolution, had enormous repercussions; it opened a new era of social and political changes, and renewed aspirations for self-determination. The thoroughgoing agrarian reform, nationalization of foreign enterprises, and successes in raising the living standards of the people offered Latin America a radical alternative to development along capitalist lines. Carried out in spite of a constant U.S. blockade, Cuba's support to the arts of the Third World—particularly to its film festivals and visual arts biennials (1984, 1986, 1989, 1991)—caused a number of artists to consider Havana the "Paris" of Latin America. This period was marked

by the ongoing resistance of Vietnam to foreign colonialism (which changed from French to U.S. in the 1950s); the rising tide of African independence movements; the perceived heroism of Ernesto "Ché" Guevara (who became a cultural, as well as a political icon in the 1960s) and who was assassinated in Bolivia in 1967; the increased militancy of African Americans in the United States as Martin Luther King, Jr., Malcolm X, and the Black Panthers made their presences felt in the sixties and seventies; the insurgency of student movements in many parts of the world (including the one that was decimated through massacres and arrests in Mexico in 1968); and the widespread activities in the United States and France. In Latin America the pattern of democratic revolution had been reversed in certain areas by a pattern of counterrevolution begun in the 1950s. Determined by its own economic and strategic needs and by the exigencies of the cold war, the U.S. invaded the Dominican Republic in 1965 to dislodge a reformist president; and from 1964 to 1976 supported or induced right-wing takeovers in Brazil, Chile, Argentina, and Uruguay with aid to police and military forces. The 1980s saw the United States involved in new patterns of repression (low-intensity warfare and the support of mercenaries) in Central America, and quick-strike tactics in Grenada and later in Panama. Thus many of the artistic activities described below occurred under military regimes of a fascistic nature, while others were in response to the more repressive actions of democratic governments.

The most important tendency of the early 1960s was neofiguration, still influential in many parts of Latin America. Neofiguration (or neo-humanism, as some called it), as practised in its major centers of Mexico and Argentina, was an art of existential anguish combined with contemporary social criticism which found adherents in many parts of the world,[17] and offered an alternative to social realism and abstraction. Among the neofigurative artists, a number were certainly interested in making critical statements, including Arnold Belkin and Francisco Icaza of Mexico; Leonel Góngora, Fernando Botero, and Pedro Alcántara of Colombia; Jacobo Borges of Venezuela; Rómulo Macció, Luis Felipe Noé, and Antonio Seguí of Argentina; Rubens Gerchman, Antonio Dias, and Roberto Magalhães of Brazil; Nelson Ramos of Uruguay; Antonia Eirez of Cuba; José Balmes of Chile; and (in the seventies and eighties) Fernando Carballo and Fernando Castro of Costa Rica; and Roberto Cabrera and Isabel Ruiz of Guatemala, to mention but a few.

The end of the 1960s saw a resurgence of muralism, now sited in the United States, where street muralism became a national movement for progressive artists of all ethnicities and races. It became a major form of public communication for Chicanos[18] in the Midwest and the Southwest, for Puerto Ricans in the Midwest and on the East Coast, and for some Latin Americans. The Mexicans had been a vital influence for muralists

in the United States during the 1930s and 1940s under the aegis of the New Deal arts programs; now once again U.S. artists sought their work in reproduction, traveled to Mexico to see the originals, learned directly from the last surviving member of the *tres grandes* (Big Three), David Alfaro Siqueiros, or studied, after his death in 1974, at the Cuernavaca Workshop he had established. In addition, muralists Pablo O'Higgins and Arnold Belkin (of different generations, but both English-speakers by birth[19]) were particularly important to Chicano muralists who could afford to go to Mexico. The influence of Siqueiros, and secondarily that of Orozco and Rivera, was pervasive on Chicanos and non-Chicanos alike, particularly after Siqueiros's 1932 Los Angeles mural *Tropical America,* whitewashed in 1934, was widely publicized by Chicano filmmaker Jesús Salvador Treviño's fledgling documentary *América tropical,* produced for public television in 1971 and shown nationally. Muralists additionally applied styles and techniques derived from their European/U.S-oriented art studies which, in the sixties and seventies, did not include the work of the Mexicans or the New Deal social realists.

Partly inspired by the U.S. model, public muralism, frequently in the streets (made possible by the advanced technology pioneered by Siqueiros, who adapted synthetic paints to artistic use), flowered in many parts of the western world, including some Latin American areas. Both Mexico and Puerto Rico had direct access to information about the U.S. movement and, as a result, street murals appeared in several Mexican cities as well as in the streets of San Juan.[20] Murals also blossomed on the walls of Chile during the Allende presidency, and in Nicaragua after the 1979 Revolution. The Chilean murals were a departure from the Mexican model in style and conception; the Nicaraguan, executed by an international array of visiting muralists as well as by the Nicaraguans themselves, were very eclectic. They shared only the concern with public communication on the issues of their time.[21] Muralism as a phenomenon has either been eliminated (as in Chile and Nicaragua), or has tapered off elsewhere.[22] Though murals continue to be painted in the United States (and in Mexico, until his death in 1992, by Arnold Belkin, and by José Hernández Delgadillo), they have been replaced or augmented, with the advent of postmodernism, by other forms of outdoor social communication, from moving computer-generated electrical signs in New York to the "corrections" made to commercial billboards and the renting of billboard space for artists' statements; and by public performance and masking in political demonstrations; as well as by outdoor installations.

Latin American graphics also had a renaissance in the 1970s, taking as a partial model the Cuban silkscreen experience, which was known throughout Latin America as well as in other parts of the world.[23] In the United States, where lithography was revived as a fine art form by June Wayne's Tamarind Workshop in 1960, the massive resurgence of silk-

screen posters and prints was the first such popular manifestation since the pioneer silkscreen posters of the New Deal era. As has been pointed out in reference to the poster (in all media):

> The decade of the 1960s was the most innovative and diverse in the history of the poster in this country . . . It was also a time of social and political change; reaction against the war in Southeast Asia, a growing assertiveness on the part of ethnic minorities, a self-consciousness of youth as a subculture, and a new women's movement. All of these social and political factors are reflected in posters of the period.[24]

Psychedelic silkscreen posters of the sixties' hippie movement, and an awareness of Cuban posters in the seventies, inspired artists in the San Francisco Bay area, especially those Chicanos and Latin Americans who formed La Raza Silkscreen Workshop. Puerto Ricans in New York and Chicago also became knowledgeable about the graphics history of their island, where silkscreen had been borrowed from New Deal sources in the late forties, and after 1950 had reached heights as a national expression far beyond the U.S. example. In fact, the Taller Alma Boricua of New York's Puerto Rican arts community brought together New York and Island printmakers to promote print production on the mainland.

Relief prints (linoleum and woodcuts) of social content were also revived, finding their expression in the Bay area and in Chicago. Island Puerto Ricans, building on influences from the Mexican Taller de Gráfica Popular, raised relief printing to a very high level that was uniquely Puerto Rican. In 1970, Puerto Rico initiated its graphics biennial, which permits an excellent overview of the best in Latin America. The poster is especially suited to political statements, both through the multiplicity which makes it available at many sites simultaneously and through its combination of text and image. For Lorenzo Homar of Puerto Rico, who might be called the "father" of relief and silkscreen techniques, images were masterfully combined with a most incredible calligraphy that has since become one of the hallmarks of Puerto Rican posters.

Remarkably, in 1988 the Museum of Modern Art in New York, recognizing the validity, for once, of political graphics in the U.S., installed a show called *Committed to Print*.[25] Coming as it did on the heels of the Latin American art "boom" in the United States, and a necessary awareness of the Third World amd feminist presence within its borders, this amazing show included a good representation of women, African Americans, Asians, Native Americans, and Latin Americans. Among the latter were Puerto Ricans Luis Alonso, Marina Gutiérrez, Carlos Irizarry, and Juan Sánchez; Cuban Luis Cruz Azaceta; Chicanos Carlos Cortez, Rupert García, Dolores Guerrero-Cruz, Luis Jiménez, and Elizabeth Rodríguez; Luis Camnitzer (Uruguay), Josely Carvalho (Brazil), Elizabeth Catlett

(Mexico), Antonio Frasconi (Uruguay), Alfredo Jaar (Chile), and Marisol (Marisol Escobar; U.S.-Venezuela). All but Alonso, Irizarry, and Catlett reside in the U.S.

The late 1960s—with 1968 as a signalizing date when large youth and student demonstrations occurred in many world capitals—was a period of great politicization in Latin America, particuarly among, but not limited to, younger artists. New Left politics and ideas spread throughout Latin America and common cause was sometimes made with the older social realists. The sixties was also the era of avant-garde exploration in the areas of pop, conceptual, performance, and mail art. The Southern Cone countries—particularly Argentina—were in the forefront of this wave. Argentina played a strong role owing to the presence of cultural promoter and critic Jorge Romero Brest, who, as director of the Center of Visual Arts of the Torcuato di Tella Institute, brought the latest avant-garde developments to the attention of Argentine artists. By the mid-sixties, Argentine artists had received recognition in the art capitals of Paris and New York, and had won prizes throughout Latin America, especially for an Argentine synthesis of pop art.[26] In later years, Romero Brest's promotional place was filled by Jorge Glusberg, a wealthy businessman (and former disciple of Romero Brest) who established the Centro de Arte y Comunicación (Center for Art and Communication). CAYC, as it is called for short, provided for exhibitions and promotion abroad, very sophisticated exhibition space, and numerous publications. So powerful has Glusberg become, in light of CAYC services and its strong financial base, that he functions almost like a "czar" of Argentine art, with few challengers or critics. Romero Brest's protégé, Marta Traba, became the most important critic promoting modern art in South America from the 1960s until her premature death in 1983. Traba lived for a long period of time in Colombia—where she was instrumental in establishing the Museum of Modern Art—as well as in Venezuela and Puerto Rico. She vehemently attacked social realism, and opted to support a uniquely Latin American art which would not mimic that of U.S. materialism and false values.[27] On the whole, however, her criticism, while of high caliber and much respected in Latin America, was definitely idiosyncratic.

Pop, conceptual, performance, and mail art also opened up avenues for political expression, particularly in the countries dominated from the 1960s to the 1980s by military dictatorships. Conceptual art, for one, offered the possibility of hidden or coded messages understood by an art audience but not necessarily by the critics or the censors, and was adopted in the mid-seventies in Chile by a group of younger artists seeking a language that could be employed under the Pinochet dictatorship. It also played a central role in Mexico among the younger generation of artists who had been affected by the 1968 massacre at Tlatelolco and who formed the Mexican Front of Cultural Workers in the 1970s, a period now

known as the "decade of the groups." A host of conceptual artists from the Southern Cone countries have developed a distinctive and highly sophisticated Latin American voice that is currently being acknowledged and analyzed by critics and historians.[28] Furthermore, the 1980s and 1990s have seen a revival of conceptual art in many areas of the world, including Latin America and the United States, as artists seek more flexible languages and materials to explore scores of new issues in the expanded terrain of global and regional politics.

Performance art with social and critical content has been practiced extensively in Latin America. Included have been Puerto Rican graphic artist Antonio Martorell (collaborating with filmmaker Rosa Luisa Márquez); Carlos Zerpa of Venezuela; and Cuban artist Manuel Mendive, in a type of dance/art-performance that evokes the Afro-Cuban experience with a troup of body-painted dancers. Performance combined with a multimedia installation called *Sal-Si-Puedes* appeared in Montevideo in 1983 during the military dictatorship. Coordinated by printmaker and painter Nelbia Romero, the group of dancers, photographers, writers, musicians, and visual artists embedded its protest against contemporary tortures and killings of political prisoners in history by referring to the (unmentioned) 1831 massacre of the indigenous Charrúa peoples by government forces.[29] Thus they produced a double critique, of the past and the present. The Los Angeles Chicano group ASCO, composed of Gluglio "Gronk" Nicandro, Willie Herrón, Patssi Valdez, and Harry Gamboa, Jr., worked with tableaux and performances in the street from the early 1970s until their demise as a group in the mid-1980s.[30] Mexican poet Guillermo Gómez-Peña—active in Mexico with the group that now calls itself Poesía Visual y Alternativa and whose major theoretician, César Espinosa, carried this activity forward into the 1980s from its genesis in the Mexican Front of Cultural Workers—brought his form of performance (visual poetry) to the San Diego/Tijuana group Border Art Workshop/Taller de Arte Fronterizo (BAW/TAF), which challenges and explores the political and social implications of the Mexico-U.S. border. Evolving from the BAW/TAF was the multinational women's group of performance and installation artists known as Las Comadres (now defunct), also centered at the Tijuana/San Diego border. The 1990s has seen an explosion of performance art among Chicano artists inspired by Gómez-Peña, and by the theatrical group Culture Clash, which itself works with short skits and funky political humor in the tradition of Luis Valdez and the Teatro Campesino of the 1960s and 1970s.

Closely linked to the activities of the Mexican Front of Cultural Workers and the Visual and Alternative Poetry group is the whole field of mail (or correspondence) art, which was generated by the Fluxus movement in Europe and the United States in the early sixties, arrived in Chile with the presence of German artist Wolf Vostell in the mid-1970s, and in Mex-

ico through Felipe Ehrenberg when he returned from England in the early seventies. A whole language of artists' books, alternative publishing, collage, rubber stamps, copy machine art, mimeography, assemblages, postcards, and concrete poetry was translated to Latin America, and politicized.[31] "South American correspondence art has always been typified by socio-political content and graphic visual presentation," says Michael Crane, coeditor of the book *Correspondence Art*.[32] As defined in South American terms in 1977 by Walter Zanini, then director of the Museum of Modern Art of São Paulo:

> Mail art belongs to a class of systems that breaks down barriers separating the levels of art from those of life . . . Communication through postal correspondence will become an important element for the conciliation and expansion of this autonomous behavior . . . It means a step forward in the democratization of activities, in the direction of an effective questioning of bureaucratic demands, and . . . a contributing factor in the formation of a new culture.[33]

Zanini expressed these sentiments during the time when the most active participants came from countries under the domination of military dictatorships: Brazil, Argentina, and Uruguay. In fact, Uruguayan Clemente Padín, fomenter, active participant and theoretician in the events of mail art, was arrested with mail artist Jorge Caraballo in August 1977, convicted by a military court, and forced to spend two dangerous years as a political prisoner. Padín was guilty of creating what he called "'the language of action,' that is, art that offered direct social/political action."[34] Mail art, owing to the freedoms offered by postal systems for direct communication, was always an international enterprise, though not all participants saw it as a form of political and social communication.

What has been called "auto-destructive art" or "destruction art" had in the 1960s as one of its major practitioners Brooklyn-born Rafael Montañez-Ortiz (Ralph Ortiz), who gave this practice an ethnocultural as well as a political dimension. Developing in the era of pop, happenings, and Fluxus, Ortiz (who is part Puerto Rican, part Mexican) directed his works of destruction (of a mattress, pianos, and white chickens) toward the articulation of sacrifice as an Afro-Caribbean, Mexican, and Asian Indian ritual. With an axe, with water, with fire, he evoked Caribbean *santería*; Aztec ritual sacrifice to Huitzilopochtli (god of the sun) and the Aztec *Nuevo Fuego* ritual for the reincarnation of the world; Indian cremation and suttee; Prometheus (and Mexican muralist Orozco's "Man of Fire"); the Phoenix and Quetzalcoatl metaphors of resurrection; the destruction of the Arawak Indians of Puerto Rico and Cuba by the Spaniards; and a protest against atomic bombings and the napalming of Vietnam. He equated sacrifice to liberation; to the freedom sought for their countries by Puerto Ricans and Mexicans.[35] The later activities of Cuban-born Ana

Mendieta, when she smeared herself with blood and rolled in white chicken feathers, when she burned the shape of her body into the earth with gunpowder, are related to a similar concept of sacrifice (of herself) as liberation. The auto-destruction of art by Europeans like Gustav Metzger and Jean Tinguely[36] was contained *within* the arena of the art world, directed—like the self-referentiality of some of the practitioners of early conceptual art—toward the destruction of the artwork itself as a precious object, toward the destruction of the exploitive aspect of the capitalist art world. Those of Latin America aimed for something more comprehensive: an outward-directed affirmation of identity and an invocation of spiritual practices on behalf of, as surrogates for, actions directed toward personal and political liberation.

Owing to changes in U.S. immigration law,[37] a great influx of Latin American artists began in the 1960s and continued through the 1980s. Though located throughout the United States, the greatest number congregated in or near New York (since the end of World War II considered the international art capital), where they have added immeasurably (though often without record or recognition) to the richness and complexity of the New York art scene[38] as well as of their nations of origin. San Francisco has also benefited by the presence of Latin American artists who emigrated to the West Coast.

These three decades of massive exodus from Latin America were partially due to what I have referred to in my article titled "Dissidence and Resistance" as "the long night of the generals": the military dictators who took power in Brazil, Argentina, Chile, and Uruguay. Other dictators were already in place by those dates in Guatemala, Nicaragua, and Paraguay (the longest dictatorship in the Americas by one man, finally over in 1989). The displacement of one dictatorship by revolution—that of Cuba—also caused a large exodus of middle- and upper-class Cubans in the 1960s, who settled primarily in Florida. The Nicaraguan Revolution of 1979, along with the revolt of the poor and disenfranchised in El Salvador and Guatemala, caused the United States to intervene with economic support of unpopular governments and their armed forces, and with the *contra* mercenaries pitted against the Sandinistas who led the revolution of Nicaragua. As a result, refugees from these countries—particularly El Salvador, from which, it is estimated, a million people fled in fear for their lives—also came to the United States, to say nothing of other American nations. Among these largely undocumented persons, whom the United States refused to recognize as political refugees, only a handful were, or became, visual artists.

In many cases the rise in the U.S. of the numbers of Latin American artists was caused not by the dangers and the exile of dictatorships, but by the impoverishment of their nations, in which the hand of the United States can also be traced. I refer here to the question of foreign debt, an

indirect, several-step neoimperialist technique of extracting profits from debtor nations of the Third World. Thus the influx of Mexican artists, which began in the early 1980s with an economic crisis and a ferocious inflation that continues to grow, and was exacerbated by the disastrous Mexico City earthquake of 1985, is in response to the need for Mexican artists to survive. And Mexico is certainly not the only nation with serious debt and inflationary problems leading to the impoverishment of its people, artists included.

Still other artists arrived to study and create amid the intellectual excitement of a multinational city like New York, or in other locations conducive to their growth. Like Paris, long considered the most desirable location to study and exhibit, enterprises aided by the scholarships tendered by the French government to promising young artists or mature achievers, the U.S. now beckons artists (and intellectuals) of Latin America, sometimes with fellowships. Many stay on, as they earlier did in Paris, adding luster to their adopted country while depriving their countries of origin of the talent needed to maintain a high level of artistic continuity. This might be considered the "brain drain" usually associated with the scientific field.

Among the Latin American artists born or raised in the U.S. who suffered the injustices of racial, social, economic, and cultural oppression (Chicanos, Puerto Ricans), political commentary of the type propagated in the 1970s has changed considerably but has by no means been abandoned. Instead of being visible in the streets and in community centers, it is now generally encountered in galleries, alternative cultural spaces, and, increasingly, in museums. More subtle and complex in content and rendition, more varied in style as its makers achieve sophistication, it is concerned with new issues correspondent to changed historical conditions.[39]

Rightfully, a comparison should be made between these artists who have been able to surmount the most stupendous obstacles placed in the way of poor and oppressed people of color to achieve intellectuality and artistic expertise and the immigrant and visiting Latin American artists with whom they are inevitably compared by the establishment and, if the truth must be told, by the immigrant artists themselves. The newer arrivals (including the Cuban emigrés of the 1960s) did not generally come from a working-class background, nor did they confront systematic discrimination based on race and ethnicity (unless they were black)—though they did face xenophobia. On the whole, they were well educated and artistically trained, had traveled and been in touch with the most contemporary artistic currents of the Americas and Europe. In their native countries, their matrix was the intellectual and artistic world to be found in every Latin American country. They fluently commanded Spanish or Portuguese languages and therefore were often well read in

literature and theory. The problem for them, after they learned English, was to translate their experience of what many consider a more materialistic, less humane, politically illiterate country than their own, at least in terms of the critical intelligentsia; a country where artists earlier in the century assumed (and allowed) the myth of inarticulateness and "illiteracy" to cloud or obstruct their use of the written and spoken word. (This mythology was forced to change with the advent of conceptual art). They also encountered a country where a knowledge of history (even one's own, and certainly that of other parts of the world) is not considered essential, or even desirable. Many arrived after the Nixon era, when the expression "Let's put this behind us" became a popular slogan, one that symbolized the discouragement and subsequent abandonment of political knowledge and, therefore, of history itself. In this TV-nourished (or malnourished) nation, where only a small fraction read newspapers for the news, the sophisticated Latin Americans suffered an acute sense of culture shock and displacement.

The resident Chicanos and Puerto Ricans, on the other hand, are part of this ambience; they were raised with it and understand it at a gut level—in fact, they have internalized and accepted a good many of its behavior patterns, though at the same time they criticize its injustices. This is most clearly demonstrated when they visit the country of their parents and feel alien and unaccepted, especially by middle-class intellectuals with whom they now identify. Having lost the working-class camaraderie which can cross borders more easily, they coexist, somewhat uneasily at times, with middle-class, cultured Latin Americans, whom some feel are condescending. Having been raised in the xenophobic monolingualism of the United States—where "English Only" laws were passed during the 1980s in a number of states with large populations of foreign language speakers, sometimes violating legal treaties—many Chicanos and Puerto Ricans have lost their Spanish, creating another rift with the more recent Latin Americans arrivals. At the same time, whether or not their art demonstrates any overt social or political consciousness, the Latin Americans share with the Chicanos and Puerto Ricans a history of European/U.S. colonialism and neocolonialism, and the marginalization which is part of every Latin American experience. Even the Cuban emigrés, whose politics as a group formed, until recently, a polarity to the progressive and even radical postures of the others, find common cause with them on these grounds. They may not like Fidel Castro, but they also rejected the U.S.-supported Batista dictatorship and, like the Island Cubans, they respect and honor the revolutionary teachings of José Martí.

We have seen that the postmodern directions, pop and the various modes of conceptual art, opened up new methodologies and liberated the

languages that artists could apply to their work. Humor, irony, satire, sarcasm, fantasy, exaggeration, believable impossibilities, symbolism, metaphor, allegory, and mixed messages have long been employed by Latin American artists and writers to very good effect, at the same time that photorealism and rational and scientific modes like op and kinetic art have functioned. By the late 1960s, when these new visual ideas and technologies became available, it was demonstrated that such forms could as easily be crafted for social and political statements as for purely aesthetic ones. As such, they have been widely employed by Latin Americans as interventions in their own realities. One Mexican performance artist has even argued that "the streets of Latin American cities and Chicano barrios have always operated as 'free stages' for the . . . para-artistic events of [an] interdisciplinary nature, which strongly resemble what we now call 'performance' art." He also points out that:

> The leap from modernism to postmodernism was also that from the concept of the artist as a bohemian to the artist as a social thinker; from the microcosm of the studio to society; from art as unigeneric to interdisciplinary; and most important, from culture as a static self-contained system to a dynamic one encompassing multiple territories of thought and action (semiotics, politics, social anthropology, media, education, etc.).

When New York and European art worlds were making this leap, "Chicano and Latino artists didn't participate formally in this historic breakthrough. Why? Either it wasn't a culturally relevant leap to make (we had other intellectual needs at the time), or it simply wasn't available to us."[40] The point is that the political language of the last three decades (labeled with hindsight as "postmodernist") has been very different than that employed in earlier eras, but is no less political for that. The complexity of late capitalism, which has been been called postindustrial and postideological, requires a more complex artistic language to fathom, comment on, and offer alternatives to its involuted but widely disseminated (and still existing) ideologies.

To return to the example of film for a moment, we no longer find the social realist films of the forties or the great epics of Sergei Eisenstein useful for present social interventions; they have moved into historical space. What is needed in the second half of the twentieth century are the surreal critiques of a Fellini or a Buñuel, or, for example, the layered sociopsychological, cultural, and political explorations of a Fernando Solanas in his evocation of the Argentine dictatorship, *Tangos: The Exile of Gardel* (1986). The pain, displacement, and longing of two generations of exiles separated from home, family, and friends are presented with an innovative filmic language. Consistent with today's realities, both the

plot of the film (a theatrical revue) and the fate of the exiles, even after the fall of the dictatorship, are left open for resolution—thus universalizing the experience for all exiles, everywhere.

II

A Personal Odyssey: The Search for a Social History of Art

> When we speak . . . of the social bases of art we do not mean to reduce art to economics or sociology or politics. Art has its own conditions which distinguish it from other activities. It operates with its own special materials and according to general psychological laws. . . . There is an overwhelming evidence which binds art to the conditions of its own time and place.[41]

> [It is] my conviction that the sociological method [is] indispensable in the history of art as in the history of other spiritual creations . . . [however] everything in history is the achievement of individuals; individuals always find themselves in time and place; their behavior is the product both of their inborn capacities and of the situation. That is in truth the kernel of the doctrine of the dialectical character of historical events.[42]

> The separation between history and sociology is [not] epistemologically justified: a history which is not social and a sociology which ignores the formative processes of structures are inacceptable. We admit that the difference between history and sociology is the result of a traditional academic compartmentalization and of styles of work, but we understand that historical and sociological studies, correctly formulated, must converge in a single social science.[43]

I consider myself a social art historian. In examining my development in this role, I have undertaken to review my own history, which is the history of my generation and that of subsequent generations traversing a similar landscape. While in the past the art historian was seen as an objective (or neutral) player—a transparent presence through which the "truth" might be filtered and recorded—the intellectual revisions of the last three decades make this ideological position no longer pertinent or relevant. Feminist, ethnographic, literary, and cultural theoreticians have effectively dismantled the claim to objectivity; in fact, to the degree that scholars provide information and attitudinal assumptions to the power structures of a society, to the degree that these attitudes are promoted (in our day through educational institutions and mass media) to their publics, the commentator on cultural phenomena is also an interpreter, car-

rying out an intervention in public consciousness, which is a social as well as a theoretical act.

If the sixties were a symbolic arena in which the past met the future in open conflict, the changing nature of the discourse was already apparent in the early seventies when Henry A. Millon and Linda Nochlin organized a two-stage colloquium on art and politics at the Massachusetts Institute of Technology. Approaches and methodology varied significantly, they said, ranging from what might be called "traditional-empirical" to "Marxist-critical," with many shades between.[44] With the exception of the "Marxist-critical," however, such variety could be discovered in any ambitious historiography of the time. However a good deal of the discussion time of the colloquium was given over to "examination of the ideological assumptions, overt or hidden, controlling the ways various participants dealt with their particular subjects."[45] This was a new approach for the time. Twenty years later, in the full complexity and variety of postmodernism within which political art—to say nothing of the relation between art and politics—is an accepted part of the spectrum, the question itself seems antiquated.

In the intellectual autobiography bracketed as a "personal odyssey" which follows, the contextualizer is contextualized. It is one person's narrative of an era of change. Nevertheless, with the sixties as a springboard, and the seventies as a period of expansion and diversification (as well as the beginning of a reversal), it is clear that I was by no means unique.[46] My major idiosyncrasy in the 1960s, when I wrote a Master's thesis on modern Mexico, was the choice of modern Latin America rather than Europe or the United States as a locus for art history. Although I was probably the first (not without opposition) to receive a Ph.D. in this area at UCLA (1977), I was certainly not the last. In fact, the suspicion remains that my dissertation opened a door that could no longer be kept shut. However, the choice of social art history as a methodology, in a period of formalist hegemony, certainly narrowed the range.

There are many ways in which social art historians define their methodologies. Albert Boime, for example, delineates basic propositions without which one cannot even approach the field:

A work of art is the result of thousands of decisions made by the artist under the pressure of a community in which he or she participates, and this involves the mediating network of art patrons, critics, dealers and art historians. These decisions are reached in the context of a cherished value system based on the economic and political interests of privileged social groups. Clarification of the social role of art is therefore vital if we are to understand the historical meaning . . . of art [and] the formalist and stylistic assumptions imposed on this art by art historians.[47]

The social history of art has also been defined by what it is *not:*[48] works of art do not "reflect" ideologies, social relations, or history;[49] history is not a "background" to the work of art—as something that is essentially absent from the work of art and its production but that occasionally puts in an appearance. The artist's point of reference as a social being is not, a priori, the artistic community. Nor should the social history of art depend on intuitive analogies between form and ideological content—the strength of social art history is that it makes its analogies specific and overt. However crude these equations, they represent an advance on the language of formal analysis, just because they make their prejudices clear. If the social history of art has a specific field of study, it is to discover what concrete transactions are hidden behind the mechanical image of "reflection," to know *how* "background" becomes "foreground"; to discover the network of real, complex relations between form and content rather than making vague analogies; finally, in a departure from older theories of social art history, to acknowledge that art is autonomous in relation to other historical events and processes, though the grounds of that autonomy alter.

My approach, which incorporates much of what is said by the several authors quoted above (though not all, and not exclusively) has been to construct the type of art history and art criticism in which a meaningful and defined synthesis between art, history, sociology, anthropology/ethnography, philosophy, psychology, and semiotics can take place: no one aspect backgrounding the others, but rather explaining them; none "reflecting" the others, but functioning interactively. As an ideal, I do not achieve this synthesis frequently enough to satisfy myself (and perhaps others), and often there is not enough publication space allocated to attempt such a study in depth.

I feel I came closest to some of these goals in my 1981 book *Contemporary Mexican Painting in a Time of Change* (Austin: University of Texas Press). Laying out the broadest dimensions of a given period in Mexican art history, that of the 1960s, the book went backward to sketch in the previous dynamics of avant-garde Mexican art in its social context; examined the new sociopolitical and economic position of Mexico in the post-World War II period; looked at the changing social and class makeup of Mexican society in the prosperous fifties and the subsequent growth of a middle class of collectors and private galleries to accommodate this class as revolutionary muralism waned. It also considered the ties between Mexican and Latin American governments, their cultural elites and cultural bureaucracies; United States cultural policies during the cold war; and the cultural activities of transnational corporations (both U.S. and Latin American), who had their own agendas. The supra-state role of the Organization of American States and its cultural arm, the Pan-American Union (its Visual Arts Department augmented at a later

date by the addition of the Art Museum of the Americas—formerly the Museum of Modern Art of Latin America) was also considered. My analytical focus in the early and mid 1970s, when *Contemporary Mexican Painting* was written, was that of "dependency theory,"[50] then prominent—though hotly debated—among social scientists in Latin American studies. I developed this theory under the rubric of "cultural imperialism," a concept I still subscribe to for the period of time in question.[51]

I also went into great detail about the individual artists who formed the group Nueva Presencia (or Los Interioristas) in Mexico (1961–63), who were the focus of my study. Their biographies as individuals trained in a particular artistic and social structure, their personal idiosyncrasies and ideologies, their class background, their varied politics, their stylistic characteristics, their psychological profiles—as related to their art—their cohesion as a group, their polemical exchanges, the literature and other art forms (including film) that informed their ideas, their relationships with museums and galleries (the art market), and their intracompetiveness, etc., were minutely considered. Finally, the works of art themselves, in which this complex mix was embedded, were the witnesses to a sequence of ideas. I have been both criticized and lauded for this section, depending on what one or another reader was looking for. However, I felt that both the general and the specific were necessary components of my version of the social history of art.

Having established the social and historical framework, I looked at the personal integration and posture of the individual artists. There was a shared "style" and ideology (however vague) during the existence of the group Nueva Presencia—in fact these helped to bring its members together as a short-lived collective. When they separated, each went in a different direction: all their directions determined by what was culturally and socially current in the succeeding decade. Of great importance was the fact that the style and meaning known as neofiguration (which has recognizable features) were connected to the confluences of the late fifties and early sixties. As mentioned above, neofiguration was international in scope; appeared throughout Latin America as a recognizable phenomenon; and is still utilized by some artists in the smaller, more marginalized nations in which a personalized social critique is not only effective but sometimes necessary.

Another, even more "bare bones" model of social art history is the 1985 essay "Revelando la imagen/Revealing the Image," coauthored by myself and Tomás Ybarra-Frausto as the introduction to a bibliography on Chicano art.[52] For a cultural production so little known (and of so little interest to mainstream art institutions and academics when we began in 1978 to compile the bibliographic entries), it was necessary to define the territory. Thus, sections on bibliographies, resources, and methodologies of research; on a Chicano time frame; and on pioneering publications

were considered essential. The main body of the essay, "Outline of a Theoretical Model for the Study of Chicano Art," was intended to serve as a template for a social history of Chicano art—which, to date, has not been written. When it is, elements of the theoretical model will need to be updated.

The body of the introductory essay, divided into appropriate time frames, began with the Juan de Oñate expedition into the territory now known as New Mexico, which established in the 1598–1821 period the major institutional forms of conquest: the *entrada*, or military expedition, the *presidio*, or military outpost, the missions which combined religion and ideological dissemination, and the *pueblos*, or civilian settlements. The remnants of these sociopolitical structures are part of the tourist route throughout the Southwest United States, and are being deconstructed in works by Chicano artists and their collaborators, as the residue of the colonial mentality is recognized as still alive in modern history and mythology. Explored is the period from Mexican Independence until the Mexican American War when the United States acquired its western territories and began the assimilation and proletarianization of their Mexican residents. Analysis continues with the post–Independence War period (1821–1910), and the Mexican American period (1910–65) which saw the largest migration of the Americas during the revolutionary era, the rise of nativist sentiment, the "revolving door" of Mexican labor with temporary importation and deportation as cycles of prosperity and depression alternated. Then follows consideration of the "Spanish" mythologies infecting the Anglo culture, which found it hard to accept Mexicans as fully civilized; and of the Mexican Americans and their persistent retention of Mexican culture in spite of discrimination and prohibition. The essay concludes with the Chicano period (1965–81) whose cultural flowering was coeval with the rise of the Chicano political and economic movements. Civil rights, the Cuban Revolution of 1959, the farmworkers' movement, the student and youth movements of the 1960s, the anti-Vietnam war movement, the alliances reflecting Chicano indigenism and the American Indian movement, the special adaptation of feminism by women artists, the culture developing in jails where Chicanos and blacks were incarcerated at levels far in excess of their proportions in the population, the challenging of Hollywood stereotypes by Chicano filmmakers, and the concept of a Chicano architecture: these are all developed with examples of cultural manifestations in the visual and other arts.

As a guide to a viable methodology, it is worth repeating the advice to Anglo ethnographers given by the highly respected Mexican American anthropologist Américo Paredes. He suggested that they needed to hone their grasp of the Spanish language, arrive at a finer understanding of social relations, develop a richer sense of social context, and consider their

own ethnicity and class affiliation (the dominant ones) when dealing with a subordinate culture. Paredes's theory of culture eschewed crude idealist and materialist theories which, on one hand, remove cultural formations from the political and economic factors that condition them, or, on the other hand, reduce all interests to socioeconomic factors. In Paredes's analysis, culture neither determines all human behavior nor dissolves into the economic base.[53]

As an *estadounidense* (or U.S. American), born of European working-class Jewish immigrants and trained in the Eurocentric and racist school system of the United States, I take Paredes's injunctions very seriously when considering Latin American and Latino art. As I recently wrote, it has taken years of travel, research, and self-retraining (since the university offered me no models) to reconfigure my understanding so that I might be able to contribute to the discourse (a process that will never be complete); to come face-to-face with my presumption in seeking to present the history, iconography, and interpretation of Latin American culture from without. This is done with the full consciousness that I speak in intellectual alliance with, not instead of, the voices from Latin America, many of whom are my friends and colleagues.[54]

As a theoretical model for Chicano art history, "Revelando" is, obviously, highly schematic. In a field with hardly any art histories, with little critical analysis of works of art, with few trained art historians and critics, the first process was one of "mapping" and "naming" (as Lucy Lippard calls it[55]). It was crucial to include a great deal of (generally unknown) information and to establish a periodization that might differ from that of traditional U.S. histories, but was pertinent to that of Mexican and Chicano people in the area now known as the United States of America. We drew heavily not only from Chicano (and other) historians, but also from anthropologists and sociologists, as well as from existing art and cultural books and articles. The methodology—which lacks the in-depth presentation of works of art, artists, and the circumstances of arts production that an art history would require—is one I have attempted to follow in my own writing. Within the Chicano/Mexican paradigm, the essay that comes closest is "Mexican and Chicano Workers in the Visual Arts," the longest included in this collection. In the Latin American area, "Under the Sign of the *pava*: Puerto Rican Art and Populism in International Context," is another.

III

A Personal Odyssey: View from the United States

Like any living concept, that of the "social history of art" has, over a period of time, been in a state of flux. The definition of "social history"

and what it encompasses as a methodology for the interpretation and analysis of cultural production has undergone numerous changes during the last thirty years. My intention here is to highlight certain thinkers and their publications and the degree to which they shaped my own voyage as an art historian functioning in the United States. There have been many modifications and revisions since I first began to research and write about modern Latin American art in the 1960s, to concern myself with the state of art history and criticism as disciplines and with the theories that informed their practices.

The last three decades have seen a growing interest, on the part of art historians and art critics, in the intersection between art, sociology, and politics, subjects which did not preoccupy the majority of art historians during the triumphant years of Greenbergian formalism. The cessation, if not the actual abjuration, of research and publication about the conjunction between art and the ideas and ideologies of the sociopolitical arena can be dated approximately between 1950 and 1970, give or take a few years. In other words, between the accelerating first phase of the cold war that started in the United States under the Truman presidency in the late 1940s after World War II and its continuation during the Eisenhower and subsequent presidencies. The pursuance of the Korean and Vietnam Wars that accompanied the growth of U.S. empire abroad; the censorship and fear unleashed by McCarthyism in its several manifestations domestically; and the rising opposition to war and thought control (which peaked by the end of the 1960s) mark this period.[56]

Without remotely intending to establish a historiography of social art history (a very worthwhile project in its own right), I believe it important to review some of the major texts and the periods in which they appeared (since each period was accompanied by its own historical and ideological environment to which both the art historian as an individual and the choice and direction of texts for publication were subject) in order to formulate a background for my own choice of subjects and methodologies. The extension of that project into the arena of an attempted social art history addressed to the modern art of Latin America and that of Latinos living in the United States becomes a separate problematic—one which I have been trying to formulate since the early 1970s when I began to write, almost simultaneously, about contemporary Mexico and the newly generated art movement of Chicanos in the U.S. This is the odyssey I hope to explore in what follows.

Social Art History: 1950–70

The era of (un)American activities, investigations, jailings, and blacklists of political and cultural figures (among them the directors and screenwriters known as the "Hollywood 10") compelled a whole generation of

intellectuals and academics to steer clear of socially oriented theory and art history, at least publicly. In the field of culture, however, the most prestigious and influential art historical publication was *The Social History of Art* (which first appeared in English in 1951) by Hungarian-born Arnold Hauser, who pioneered the field with Frederich Antal. Wide demand for the comprehensive two-volume multidisciplinary survey resulted in numerous reprints.[57] Even today, it is hard to imagine anyone developing a methodology for social art history, or a critique of its failings, without having read Hauser. It remains the definitive compilation, though many of its arguments and approaches have been challenged and partially disassembled and a new survey from the eighteenth century on is now being published in increments.[58]

I cut my art historical teeth on Hauser's densely written volumes, using them as a frame of reference for art historical research along with the traditional fare of the times, while a graduate student at the University of California, Los Angeles. This was in the late 1960s, when I returned to academic and artistic life after years of political activism on behalf of civil rights and social justice. (I had been trained as a studio artist in New York's High School of Music and Art, and at UCLA—training that later stood me in good stead when writing about the specificities of artworks.) Not that Hauser's writings were considered acceptable in my conservative university; at least one professor warned me against Hauser because he was a Marxist. The notion of a dialogue between different opinions, so basic an academic concept, seems to have been lost from sight during the anticommunist paranoia of the cold war. It is also a sign of the time that Hauser's social history was viewed suspiciously in the United States while Janson's *History of Art* (first published in 1962) was one of the two major texts adopted for classroom use.[59] In Janson's first editions, Africans and Native Americans do not emerge from antiquity into the modern world, women artists do not appear in history until the twentieth century (in later editions, they are tokenized), while Asia and pre-Columbian America were banished to a "Postscript." In the fourth edition, this last category vanished altogether. All that remains of the nonwestern world is contained in the first chapter, which conflates the Old and New (Neolithic) Stone Ages with modern peoples (originally and apologetically subtitled "primitive") renamed "ethnographic." The same erroneous reasoning remains:

> The term "ethnographic" will serve us better [than "primitive"]. It stands for a way of life that has passed through the Neolithic Revolution but shows no signs of evolving in the direction of the "historic" civilizations. . . . The entire pattern of ethnographic life is static rather than dynamic, without the inner drive for change and expansion that we take for granted in ours. Ethnographic soci-

eties . . . represent a stable but precarious balance of human beings
and their environment, ill-equipped to survive contact with urban
civilizations. Most of them have proved tragically helpless against
encroachment by "civilized" societies. Yet at the same time the cul-
tural heritage of ethnographic societies has enriched our own: their
customs and beliefs, their folklore, and their music have been re-
corded by ethnologists, and ethnographic art is being avidly col-
lected and admired throughout the western world.[60]

This apologetic for western colonialism based on the ineptitude and
static quality of "tribal" and "village" cultures, incapable (according to
the author) of establishing cities and states, has long been discredited.
The inclusion of pre-Columbian America and precolonial Asian peoples
would make this argument even more wildly inaccurate, since cities,
states, and empires characterized both these areas. The argument is
equally inaccurate for the African arts that remain in this chapter: ac-
cording to Janson, the "native kingdoms" that arose along the coast of
Equatorial Africa were the result of contact with the historic civilizations
of the Mediterranean, but none of them proved very enduring. The deci-
sive factor, he argues, may have been their failure to develop a system of
writing. "They existed, as it were, along the outer edge of the historic
civilizations, and their rise and fall, therefore, are known to us only in
fragmentary fashion."[61] The deliberate ignorance of western scholarship
vis-à-vis "Darkest Africa" and its history is here clearly set forth, along
with the predatory attitudes of Europeans and Euro-Americans about the
cultural properties of nonwestern societies. Understandable, perhaps, in
the 1950s when Dr. Janson was compiling his "world" history (for how
else are we to react to a title like the *History of Art?*), but reprehensible
when continued unchanged into the 1991 edition. It almost goes without
saying that the modern and contemporary sections refer to all of Latin
America with two newly added brief paragraphs (p. 736) on Orozco and
the muralists who shared a common source in the Symbolists and
Gauguin!

I have dwelt on a standard text like Janson because its attitudes, with
few correctives by the educational system, served (and serves) as the ini-
tial nourishment for generations of art historians who imbibe its inaccu-
racies and Eurocentric attitudes, probably without thinking, and who
proceed to staff our schools, libraries, museums, and other professional
locations with these attitudes on a subliminal level, ready to teach new
generations and curate new exhibitions in a rapidly changing art world.

In all the truthfulness of hindsight, however, it must be said that Hau-
ser's history suffers from the same Eurocentrism as that of Janson.
Though complex questions of class and gender are introduced, the same
linear progression of cultural history from the Ancient Near East, to

Greece and Rome, to western Europe, is the established paradigm. Although Hauser recognized that the influx of American precious metals coincided with a new stage of capitalism in the Spain of Charles V and Phillip II (which laid the basis for the European Industrial Revolution), the construction of this wealth upon the profits extracted from the colonies of Africa, the Near and Far East, Latin America, and the South Pacific—as well as the infusion of cultural forms into the West from these sources—is not mentioned.

Hauser's social history—while amplifying my cultural perceptions through time and space and providing a methodology for a sharpened critical and analytical approach—was, for me, a link back to a more enlightened and less frightened pre–cold war past. In fact, my library in the 1960s also contained the 1964 revised edition of Oliver Larkin's 1949 synthetic survey, *Art and Life in America,* which was intended for "students of American civilization who wished to know what part the visual-plastic arts have played in our society [and] for students of American art who may find some profit in seeing the subject as a developing whole."[62] I valued it for its lucid style and as a type of U.S. art history which had almost vanished by the time of its last reprint. By no means a Marxist, but rather a traditional humanist and liberal devoted to North American values, Larkin included the American Scene and social-realist artists, as well as sections on war and fascism, the pre- and postwar attack on New Deal art, and the cold war—none of which he hesitated to criticize.

Important for my development as a art historian (already more aware of Latin America because of a move to California) was the fact that one could encounter, in Larkin's pages, references to artists whose names and imagery were wiped out of histories written during the cold war era, or were referred to only pejoratively: black artists like Henry O. Tanner, Richmond Barthé, Horace Pippin, Hale Woodruff, Charles Alston, Jacob Lawrence, Charles White, and Romare Bearden; women artists and photographers like Berenice Abbott, Peggy Bacon, Isabel Bishop, Margaret Bourke-White, Bernarda Bryson, Alice T. Mason, Sue Fuller, and Emma Lou Davis; Asian American artists like Yasuo Kuniyoshi, Seong Moy, and Isamu Noguchi; and, of greatest moment for the theme of this present volume, the activities of the Mexican muralists Diego Rivera, José Clemente Orozco, David Alfaro Siqueiros, and their impact on U.S. artists in the 1930s. "When Rivera built his Detroit murals on the industries of that city in 1932," said Larkin, "and Orozco at Dartmouth exposed the modern barbarities of American civilization in menacing shapes and strident color, the pale classical amenities of academic mural painting, its literary evasions, and its inert symmetries received a blow from which they could never recover."[63]

A few years after the arrival of the Mexicans, says Larkin, their example bore fruit in murals of genuine monumentality, many of them

executed in true fresco. He lists New Deal muralists like Edgar Britton, Karl Kelpe, William C. Palmer, Charles Alston, and James Michael Newell—though many more would qualify as well. Larkin further noted the political repercussions of the Mexican presence for their North American admirers when he said, "It was the Mexicans who taught their would-be emulators the dangers of the enterprise, as outraged Dartmouth graduates protested the brutality of Orozco's work, and the patriots of Detroit charged the museum director with selling out its walls to an 'outside, half-breed Mexican Bolshevist'."[64] The owners of Rockefeller Center in New York, upon discovering that the same Diego Rivera had painted a portrait of Lenin on their walls, paid off the artist, covered—and subsequently destroyed—*Man at the Crossroads.*[65]

By the 1950s, the intellectual blackout that had descended upon the United States as a result of the witch-hunting had also negatively affected interest in the works of the Mexicans. Abstraction, particularly abstract expressionism and its variants, dominated the arts. A sufficient body of literature is available to the reader on the interaction between thought control and the arts during the cold war period to obviate the need for a recapitulation here.[66] What is of moment in the present context is that Mexican murals and works of art were once more attacked: in one case, Diego Rivera's 1931 mural *Construction of a Fresco* at the then California School of Fine Arts (now the San Francisco Art Institute) was covered by the director, supposedly for aesthetic reasons as incompatible with the new vanguardism of abstract expressionist teaching which dominated the school between 1946 and 1950. As a result, those pioneer Chicano artists who attended the school in the 1950s were deprived of a work that would have come closer to matching their search for identity, and for a corresponding aesthetics, than the formalist concerns of their teachers. With the advent of a new director, and a return to the figure in the 1950s, the mural was uncovered in the mid-1950s and restored in 1988.[67] Rivera's 1939–40 portable mural *Marriage of the Artistic Expression of the North and South of this Continent,* also known as *Pan American Unity* (which was painted for San Francisco City College and had been in storage after the Golden Gate International Exhibition closed), was finally installed at the college in 1961 but not opened to the public until 1983, when Chicano art student Emmanuel Montoya helped organize a campaign toward that end.[68]

Orozco's five fresco murals of 1931–32 at New York's New School for Social Research had a yellow curtain hung over the panel *Struggle in the Occident* in 1953; this was the wall on which Orozco painted his only tribute to Lenin and Stalin, as well as to Felipe Carrillo Puerto, the socialist governor of Yucatan who was assassinated in the 1920s for bringing reform to the peasants of his state. The curtain was later removed, but the murals were allowed to deteriorate so badly that when I saw them

in 1986 they were on the verge of disappearing. Fortunately, they were restored in 1988 and are still in place.[69]

Within the cradle of the cold war fifties, the era of the "gray flannel suit," new winds were blowing. The black civil rights movement was already under way; feminism was broadcast as early as 1952, when French philosopher and author Simone de Beauvoir was translated into English, and in 1963, when Betty Friedan's *The Feminine Mystique* alerted a whole generation of (primarily white) women that patriarchal mythologies required a fresh look.[70] The decades of the 1950s and 1960s also signaled liberation struggles in colonized Africa, and the translated writings and speeches of African leaders, some of whom also addressed cultural issues, became available. Chief among these, and highly influential in the Americas, were the works by Frantz Fanon from Martinique, especially *The Wretched of the Earth*. Fanon was a doctor of neuropsychiatry radicalized by his participation in the Algerian (and, later, the pan-African) liberation movements. His chapter "On National Culture" analyzed the cultural estrangement of the colonial epoch and the necessity for colonized peoples and their intellectuals to resurrect their precolonial history and culture as an antidote to the colonizers' claims that if the settlers left, the native peoples would at once fall back into barbarism, degradation, and bestiality. Neither Fanon's analysis nor his prescriptions were simple, however; he understood that "racializing" claims, and creating narrow nationalisms, would tend to lead up a blind alley. Within the pan-African world, he understood the historically based differences between entities: the problems and solutions of African Americans from the United States were not the same as the ones for those from Africa, nor were the cultures of African Arabs the same as those of African blacks. Nor could contemporary intellectuals and artists immerse themselves in the past, and away from actual events, seeking "authenticity." This, he cautioned, could become a banal search for exoticism. The artists who turn their backs on foreign culture (which they have studied) and who set out to look for a "true" national culture, forget that the forms of thought and what it feeds on, together with modern techniques of information, language, and dress, dialectically reorganized the people's intelligences. The constant principles which acted as safeguards during the colonial period were undergoing extremely radical changes. Artists can not turn to the past and embrace the castoffs of thought, its shells, and corpses; rather they must go on until they have found "the seething pot out of which the learning of the future will emerge."[71] Other cultural references appear in the speeches of Amilcar Cabral, revolutionary leader of Guinea (Bissau).[72] From Latin America came the influential text *Pedagogy of the Oppressed*, by Brazilian educational reformer Paulo Freire,[73] and the cultural pronouncements over several decades of Ernesto "Ché" Guevara and Fidel Castro from revolutionary Cuba.

While many of these thinkers and their theories no longer occupy the stage, since the politics of the present world has decentered their arguments, they made valuable contributions to the realities of their time and have left an important conceptual legacy which forms the fertile soil in which contemporary theoreticians can ground themselves.

Social Art History: 1970–90

The changing climate of the late 1960s and the decade of the seventies also produced a new spectrum of publications. I read many books on anthropology and archaeology (a long-standing interest); on history of all periods; on psychology amd psychiatry of various kinds, including such writers as Erich Fromm; on African and African American art and history (having followed the latter for many years), which entered academic consciousness as a subject to be taught in the early 1970s;[74] and on feminism. The WomanSpace Gallery and the Woman's Building made Los Angeles a central site for feminist artmaking, with Miriam Schapiro, Judy Chicago, Ruth Iskin, Arlene Raven, and Sheila de Bretteville providing leadership, and June Wayne setting an example. In mid-decade, the Woman's Building provided a link between the Chicano arts movement and feminism by exhibiting Chicana artists. By 1975, nevertheless, it was evident that the U.S. feminist movement was primarily white and middle class and had difficulty making any lasting bridges with women of color in the United States, and with Latin American women at international events.[75]

Also appearing in the 1970s was the foray into aesthetics by German-born, California-based Herbert Marcuse who cofounded the Frankfurt Institute of Social Research with Theodor Adorno and Max Horkheimer. Though Marcuse's ideas, particularly those of his book *One Dimensional Man*,[76] impacted most strongly on the thinking of the *political* New Left (considered revisionist by official Marxists-Leninists), two of his important publications directly addressed the arts. The essay "Art as a Form of Reality" argued that the aesthetic dimension of a work of art allows it to both mediate and heighten reality in ways that direct encounters with that reality would not. He admonished the very real impatience of the young radicals of the New Left who adopted the slogan that art had come to an end, suspending it along with other manifestations of bourgeois culture as incapable of sparking action and practice to change the world. However, he pointed out, the New Left had a valid position when it militated against exhausted formal languages that could not convey the present reality, and against the "Commodity Form" of art.[77] Marcuse was operating at that juncture between the genesis of new formal languages (pop, conceptual, minimal) and the ethical and political norms being challenged in the sixties.

Marcuse's book *The Aesthetic Dimension*[78] is linked to similar no-

tions. In it, he criticized the deterministic Marxist position that social relations of production must be represented in the work of art—an aesthetic imperative that followed from the base-superstructure conception and one that Marcuse felt violated the dialectic formulations of Marx and Engels. These concepts, he argued, had become a rigid schematization with devastating consequences for aesthetics. Consistent with his earlier writings, he did not demand an abandonment of the theoretical relationship between social existence and consciousness, but a liberation of subjectivity which allowed for the inner resources of the individual— passion, imagination, conscience—to be realized as a force against alienation and a force for liberation through the subversive aspect of art and through its transcendental qualities. In a 1955 work, *Eros and Civilization,*[79] Marcuse expanded the debate advanced by Christopher Caudwell in the 1930s for a reconciliation between Marx and Freud. His argument for a nonrepressive mode of human existence through the liberation of instinctual needs and satisfactions, specifically those of sexuality and the "Pleasure Principle," had implications for the coming feminist movement of the late 1960s. Two concepts lie at the root of these new formulations: Freud's theories on sublimation and the early Hegelian writings of Marx in *The Economic and Philosophical Manuscripts* of 1927 (whose relatively subjective emphasis on the self did not appear in the "scientific socialism" of Marx's maturity).[80]

I have spent so much time on Marcuse because many of his positions broadening and revising the tenets of vulgar or mechanistic Marxist interpretations prefigure the later revisions made not only by feminists but by younger practitioners of the social history of art. We have lost sight of his contributions owing to the tremendous interest in French poststructural philosophy that has engulfed previous thinking—though postmodernism itself, in its non-nihilist applications, is returning to many of these considerations in newer contexts.

It is impossible to understand the florescence of social art history and criticism that began in the 1970s without reference to the earlier florescence of social and political art in the 1960s. Or more precisely, the power of sixties' political protest internationally to change ideas and even climates (which have never been adequately measured in terms of the development of artists, art critics, and art historians) must be very seriously considered despite subsequent disillusionments.

The context of sixties' protest art and actions must be sought in the conjunction of a number of issues: the black civil rights movement which began in 1955 and reached massive proportions in the 1960s and 1970s with the ethical appeal of Dr. Martin Luther King, Jr.; the separatism of Malcolm X, and the militant appeal of the Black Panthers; the growing alienation of young people (expressed in such Hollywood films as *The Wild One* and *Rebel without a Cause*); the alternative (and psychedelic)

countercultural life styles suggested by the "beatniks," and later by the "hippies"; the power struggle between the United States and the Soviet Union, with its ominous nuclear threat that came to a crescendo in October 1962 with the confrontation in Cuba; the Free Speech movement and sit-ins on college and university campuses; and, from 1968 on, the growing anti-Vietnam war movement. Observers agree that it was the greatest antiwar movement in the history of the nation, extraordinary for its size, duration, and capacity to disrupt and divide U.S. society.[81] Draft resistance, the My Lai massacre, the torture and killings in Vietnam shown nightly on television, the death of thousands of U.S. soldiers (the deaths of Vietnamese seemed less important to U.S. audiences), the bombing of Laos and, in 1970, of Cambodia aroused acts of public conscience that on one day in 1969 involved close to two million people nationally. The African American and Chicano movements both protested Vietnam, considering it, as Muhammed Ali proclaimed, "a white man's war"—one in which he refused to serve, a move which cost him his championship boxing title. Of great importance for arousing a critical attitude toward a supposedly democratic and fair government was the discovery that the government itself had been lying to the people that elected it, as attested to by the dramatic release in 1971 of the Pentagon Papers on the history of Vietnam. The misinformation about bombing in Laos and then in Cambodia infuriated the nation, and cost Lyndon Johnson his election, while Richard Nixon was curbed by Congress. It was felt by many, including artists, that if the government lied, everything could be called into question, including national icons of all sorts (the U.S. flag was one such), and the entire art structure.

In her interesting study *Aspects of Social Protest in American Art, 1963–1973*,[82] Geraldine Obler lists the issues to which artists responded during the period in question and explores the way in which organizations of artists and critics challenged the cultural traditions of the art establishment. For example, she quotes a series of polemical questions directed to the art community and posed on radio by the Guerrilla Art Action Group in 1971 in the form of one-line statements by a collective of four artists:

I accuse; You say you are an artist; I say you're just a businessman. The galleries are the business of art; the magazines are the business of art; You, the critics, are the whip hand in the business of art; Art has become the supreme instrument through which our repressive society idealizes its image; Art is used today to distract people to accept more easily the repression of big business; Museums and cultural institutions are the instruments of sanctification for the artists who collaborate in such manipulations and cultivate such idealization; no wonder art has become irrelevant, trivial and sterile.[83]

The association of art with big business in an era when a former president not too many years earlier had warned the U.S. people about the dangers of the military-industrial complex is an important signifier of changing consciousness in the art world. By the mid-sixties, U.S. corporations were spending about $22 million on the arts; by the mid-eighties, the figure rose to $600 million, an increase which coincided with the expansion of multinational or global corporations. This pattern developed during the ten-year reign of Thomas Hoving (1966–77) as director of the Metropolitan Museum of Art, one of whose innovations was hanging large banners on the facade of the museum. According to Brian Wallis, these banners signaled the beginning of a new era for museums: the age of corporate sponsorship and a general alliance of the museum with mass spectacle, entertainment, and consumerism.[84] The commodification of art (or its corporate sponsorship as a means of providing luster for the companies of corporate capitalism[85]) was not the only issue agitating artists in the sixties, obviously, but it was certainly a central one. Another issue was one that pinpointed the gap between the artists' desire to participate in social action and the abstract language dominant in the sixties which precluded such a possibility. This contradiction was made evident during the erection of the 1966 Artists Protest Tower (or California Peace Tower) in Los Angeles. The three hundred international artists who hung small works on the outdoor installation—constructed by Mark Di Suvero—considered their participation as a social action. The works themselves were nondescript. "American artists haven't done this sort of thing for twenty years," said painter and co-organizer Irving Petlin. "They don't know quite how to respond to it."[86]

Incomplete as it is, focused mostly on occurrences in New York, Obler's study still offers an idea of the scope of artistic ferment during this crucial decade. Her bibliography, with some exceptions, is derived from newspaper and magazine sources of the late 1960s and early 1970s, and reflects, in the titles of the chapters, the explosive confrontation that was taking place on the intellectual and political level: 1) the crisis in American art, 2) the art critic as social reformer, 3) the need for a new criticism, 4) the resolution of a museum sex-bias case, 5) the Supreme Court and the flag (shades of more recent controversies during the Reagan/Bush administrations), 6) the end of the cult of the unique, 7) "the old gray museum, she ain't what she used to be," 8) the politicalization of the avant-garde, 9) a call to artists for social action, 10) pickets on Parnassus, and 11) on understanding black art. These are only some of the issues addressed. The social arena was changing, and the cultural one with it.

Actually, as the above list verifies, the writers who engaged the role that art plays in society were not only the art critics but the artists themselves as writers, functioning on the cutting edge of a radical realignment of artistic consciousness. This trickle swelled to a stream by 1970 and

into a river by mid-decade. In 1971, Therese Schwartz coined the phrase "the politicalization of the avant-garde," and dated its beginning to 1965 when many artists took their first public political action by signing a full-page *New York Times* advertisement against the war in Southeast Asia headlined "End Your Silence." Five hundred artists donated ten dollars each toward the cost. Schwartz reported that South America had its protests too, citing censorship and subsequent artists' protests in connection with a small but important exhibition at Buenos Aires' Instituto Torcuato di Tella in May 1968. Though the artists' action might seem mild, said Schwartz, in Argentina it seemed almost revolutionary. "It was part of the new self-awareness that artists were experiencing everywhere."[87]

The sea change effected in her own development by the tumultuous sixties is most lucidly and forthrightly put forward by critic Lucy Lippard who reveals that any social consciousness she was equipped with "was buried when I immersed myself in the New York art world in 1959. It surfaced again," she relates, "on a jurying trip to Argentina in 1968, when I was forced to confront and reject corporate control and met for the first time artists who had committed themselves to militant social change, feeling that isolated art for art's sake had no place in a world so full of misery and injustice."[88]

Lippard's own entry into a new consciousness began with antiwar activities and continued when she "fell into the arms of feminism in the summer of 1970."[89] Her association with Latin America is attested to in her pioneering book *Mixed Blessings: New Art in a Multicultural America*, where she writes "I owe much that is buried in this book to the U.S. Solidarity movement with Central America, to the cultural vitality of the Nicaraguan Revolution and the FMLN in El Salvador, and to the vital young artists of Cuba."[90] Her book, over seven years of research and writing, began in Central America, spread to the Caribbean and all of Latin America, coming to rest (more reasonably, she says) in North America.[91] Lippard, in fact, was the national coordinator of the organization Artists Call Against U.S. Intervention in Central America, which was founded in New York in 1983 and spread to twenty-six cities in the United States, and to Mexico, Canada, and France. It ended in 1989 in Los Angeles, where the chapter in which I was active circulated a Costa Rican art exhibit throughout California for a year on behalf of Central American peace. One tremendous consequence of Artists Call—in addition to its important support for embattled Central American peoples, their artists, and their intellectuals—was the alliance built across the United States between hitherto separated North American and Latin American artists, whether these artists lived in their countries of origin, in Europe, or in the U.S. Artists began to exhibit together, carry on street performances and manifestations, organize exhibitions, and so forth. The organization

also engendered greater communication. Thus an important conjunction was achieved.

New York, as the cultural capital of the United States, was the crucial pivot. As already mentioned, more Latin Americans made their home in New York, or visited for longer or shorter stays, than any other location in the nation. Since they were considered marginal by the dominant institutions of the art world, the news or reviews of their exhibitions, activities, or art production rarely appeared in the mainstream art press. Many maintained their ties with their native countries, were given exhibitions in Latin America—including the prestigious São Paulo Biennial from 1951 on and the important Havana biennials in 1984, 1986, 1989, and 1991—and represented their countries at large European events. Nevertheless, in the U.S. they were marginalized stepchildren, beset with all the stereotypes ladled on Latin America over the century. The Latin Americans carried on an active aesthetic, social, and political life among themselves, generally not included in or supported by the New York arts communities. Two nonprofit institutions were crucial to Latin Americans and Latinos—both the result of the militant Puerto Rican presence in New York during the 1960s and 1970s: the Cayman Gallery directed for many years by Nilda Peraza (later MOCHA, the Museum of Contemporary Hispanic Art, which is now defunct), and El Museo del Barrio, headed until 1993 by Petra Barreras del Río. Chief curator Susana Torruella Leval served both institutions and has been equally responsible for their creative agendas. The Intar Latin American Gallery, a tiny space energetically run by Inverna Lockpez as part of a larger Cuban cultural complex, entered the alternative gallery system in 1979. Among the three, hundreds of publications were produced, which if catalogued and listed in a bibliography would give a clearer idea of Latin American arts activities in New York and nationally.[92]

Within the great diversity of New York, it could be foreseen that many alternative spaces would be established to represent and advance cultural programs for underrepresented artists. By the late 1980s, dialogues ensued between artists and alternative institutions and the stage was set for the New York "Decade Show";[93] Lippard's antiofficial brand of "multiculturalism"; and the enormous changes that occurred as alert and sensitive artists in the United States began to prepare their response in 1992 to the proclaimed "celebrations" of the Columbus Quincentenary.[94]

As a social art historian and critic looking back at the decade of the eighties, I find that it was a crucial period that signaled new alignments, new intellectual and artistic experiments, and new interchanges. It seemed to me at the time that a new history of modern art was in the making, one that was inclusive rather than exclusive, and one within which my social historical approach—always more acceptable in Latin

American circles than in the United States—could play a role. In fact, it was a forerunner of the progressive possibilities contained within the new postmodern paradigm. Unknown to us, however, the decade of the Latin American "art boom" was to begin the international institutionalization and commercialization of modern Latin American art, spurred by the exigencies of the international art market and by global politics, and the terms of the discourse were to be considerably altered.

My own contribution to the discourse, which began in the 1970s with publications and numerous lectures on Mexican and Chicano art, was scarcely known in the United States, since most of my articles appeared in Mexico, Europe, or in the Spanish-language and the alternative presses of the U.S. With the 1981 publication of my book *Contemporary Mexican Painting*, and the 1985 appearance of *Arte Chicano*, however, my location within the sparse field of modern Latin American scholarship in the United States was established. The network of progressive artists and art historians in the United States and Mexico (including those of us recording and participating in the dialogue about the national mural movement of the seventies and eighties) was expanded, as a result of extensive travels, by the addition of new friends and colleagues throughout Latin America. Further conjunctions occurred as the result of the numerous campaigns in the art arena in which I was involved: the actions taken in the early 1960s to induce the Mexican government to free Siqueiros from jail; the California Peace Tower of 1966; the attempt to restore the 1932 Siqueiros mural in Los Angeles, which enlisted large segments of the Chicano community and participation by the arts community, beginning in 1968 and continued into the 1990s; the huge 1969 "Fiesta de los Barrios" in Los Angeles, the largest cultural endeavor organized by the newly emerging Chicano student and youth communities at the time, and one that attracted ten thousand people in one weekend; the numerous efforts on behalf of the United Farm Workers throughout the seventies; the organization of Los Angeles's Artists Call; the activities with Art Against Apartheid; my active involvement from 1983 on with the 1990 groundbreaking exhibition at UCLA of "Chicano Art: Resistance and Affirmation"; and my participation on many panels which opened up new territory on Latin American and Latino art. Thus the two facets of my life—the art historical and the activist; the theoretical and the empirical—were in constant conjunction, feeding from each other and enriching each other, forming that praxis which I consider essential to a social art historian and educator who is dealing with contemporary art.

My charge, as an art historian, was twofold: to do the research on modern and contemporary Latin American and Latino artists that would permit me to consider their personal production in the context of the sociohistory of their countries and of the art world; and, second, to attempt to deflect and correct the stereotypes, distortions, and Eurocentric

misunderstandings that have plagued all serious approaches to that art since the 1950s. This last was a particularly important task for a North American, coming from one of the countries whose transgressions in this direction have been legion—as well as from one of the countries closest to Latin America and most indebted to Latin American influences in everything from food to the imagery of high art.[95] In fact, the United States "devoured" portions of Latin America (Mexico, Puerto Rico) in the course of its imperial expansion. I am not alone in that task, and can count on the concurrent scholarship and theoretical elaboration of a growing number of colleagues in Latin America, the United States, and Europe, some of whom are mentioned in these pages.

To list all, or even a sizable portion, of the publications that began to appear in the 1970–90 period is beyond the scope of this introduction. Beacons of the passage from ahistorical and apolitical formalism to social criticism and history (not all from the Left by any means, or even consciously considered social art history) include, as examples, books by British critic John Berger, Donald Drew Egbert, Linda Nochlin, Ralph E. Shikes, and Lee Baxandall.[96] (The comprehensive list available in the anthology by Millon and Nochlin, *Art and Architecture in the Service of Politics*, has already been mentioned. The latter is also forward-looking for its time in that it includes three essays on Latin American art.)

The work that also triggered a revision in the art history of the United States—with side consequences for the history of the Mexican muralists in the United States—was the New Deal research of Francis V. O'Connor. In O'Connor's case, it was his subject matter and research rather than his own conscious sense of reviving the conjunction between art and politics that mattered. Between 1969 and 1973, O'Connor authored or edited three important books that laid the groundwork for a series of later publications on the New Deal—reinserting this period into the history of modern U.S. art.[97] An extensive and still growing literature on the art and artists of the 1930s and 1940s (erased from cold war art histories for their politics and for their representationalism) marks not only the importance of O'Connor's initial contribution, but the changing climate of the time. If there is a certain historical symmetry between the establishment of the New Deal government-sponsored arts programs in the 1930s and the formation of the National Endowments in the 1960s, it would be remiss not to mention the corresponding symmetries of right-wing attacks on these programs in the late 1930s and the 1940s and, once again, in the late 1980s, continuing into the 1990s, within different historical contexts.

Finally, two books specifically acknowledging and tracking the artistic presence of hitherto ignored resident Latinos in the United States must be part of the record: Jacinto Quirarte's pioneering book *Mexican American Artists*, which opened the door to this topic and, in a final chapter, introduced the newly emerging Chicano art movement; and Peter Bloch's

Painting and Sculpture of the Puerto Ricans, which is a survey of Island art from the pre-Columbian period forward, with one final chapter dedicated to New York Puerto Rican artists. Neither is a *social* history of art; however, Quirarte is a trained art historian who provided a firm base of documentation, aesthetic analysis, and information for later researchers. Bloch's book is more opinionated, the work of an enthusiastic amateur. Nevertheless, as the earliest and only texts until recent years, both excavated the unknown cultural histories of the two major Spanish-speaking groups in the United States.[98] More of this history (as well as the history of many Latin American artists living in the U.S.) is embedded in the catalogues of a number of U.S. exhibitions that included Chicanos and Puerto Ricans during the Latin American "art boom" of the 1980s and 1990s.[99]

Social art history texts of all sorts continued to proliferate throughout the 1970s and 1980s, which brings us up to this writing. These texts are authored by both Marxists and non-Marxists, as criticism and history (national and global) are reevaluated and revised—not without strong, sometimes acrimonious debate between the "traditionalists" and the "revisionists."[100] By 1973, there were a sufficient number of Marxist-oriented art historians (and artists) who embraced the "revisionist" position to form the Caucus of Marxism and Art within the College Art Association. By 1976, *Praxis: A Journal of Radical Perspectives on the Arts*—irregularly published until 1981 with international contributions and distribution—appeared in California; while the same year on the East Coast, the journal *October: Art/Theory/Criticism/ Politics*, dedicated to "artistic practice joined with critical theory in the project of social construction"[101] and focused on a postmodern view of cultural production, made its first appearance with a very different cast of actors and topics. *Praxis*, in its scant five issues, was distinguished by the inclusion of Latin American theoretical and literary writings, including those of Argentinian/Cuban Ernesto "Ché" Guevara, Mexicans Adolfo Sánchez Vázquez and Enrique González Rojo, Chileans Ariel Dorfman and Teresa de Jesús, Nicaraguan Ernesto Cardenal, Puerto Ricans Ricardo Morales and Ricardo Alonso, Cuban Vicente Gómez Kemp, and by the inclusion of art portfolios by Chicano Rupert García and Chilean René Castro.

The 1980s were dominated by poststructuralism adopted by the visual arts from philosophy, literary critics, and anthropology, and by the debate on postmodernism. Amid the torrent of publications that appeared, three anthologies published by New York's New Museum of Contemporary Art provide a broad spectrum of argumentation by some of the most important theoreticians from the First and Third Worlds: *Art After Modernism: Rethinking Representation*, including commentators on cultural and gender politics such as Walter Benjamin (whose writings were revived in the 1970s), Martha Rosler, Lucy Lippard, and Laura Mulvey, and postmod-

ernist commentators like Frederic Jameson, Hal Foster, and Craig Owens; *Out There: Marginalization and Contemporary Cultures*, in which influential Third World critics such as Homi Bhabha, Edward Said, Gayatri Chakravorty Spivak, Trinh T. Minh-ha, and Cornel West and literary figures such as Audre Lorde and bell hooks are anthologized; and *Discourses: Conversations in Postmodern Art and Culture*, which took the form of "conversations" of various types from interviews, symposia, and panels, as well as monologues.[102]

Latin American theoreticians, writing in Spanish, Portuguese, and English, are certainly part of the discourse, but, unfortunately, most are barely known in the United States. In tracing the social history of art in Latin America in what follows, some of these critical writings will be summarized, albeit briefly.

IV

A Personal Odyssey: View From Latin America, History and Theory

History

Since I am tracing my own intellectual history, I am bound to say that the two writers who most influenced my "social," as well as my methodological, approach to Latin American art in the 1960s and 1970s were Argentine-born art critic Raquel Tibol of Mexico City, and British-born literary critic Jean Franco, who lived in California for many years and now makes her home in New York.

Tibol's most comprehensive study is the last volume of the monumental *Historia general del arte mexicano*.[103] Part of a trilogy in which other authors dealt with the pre-Hispanic and colonial periods, Tibol set forth the history of nineteenth- and twentieth-century architecture, sculpture, painting, and printmaking, considering not only the Mexican academics but the presence of foreign and of nonacademic artists. In four chapters, she covers neoclassicism and independence; the academy and national organization; modernism and the *porfiriato;* and ends with contemporary art and the cultural revolution. Her prolific production as critic and historian since she arrived in Mexico in 1953 as Diego Rivera's secretary has included extensive writings and collected documents on Orozco, Rivera, Siqueiros, Frida Kahlo, Rufino Tamayo, and many others. Several months spent in Mexico City's Hemeroteca Nacional (periodicals library) reading systematically through Mexican art criticism from 1959 to 1965 convinced me that Tibol's critical methodology was unique. In fact, almost single-handedly, she established standards for a new type of Latin American art criticism and art history. She is concise, informative, rigorous, accurate—correcting dates, facts, and biographical information from

primary sources. In contrast to the poetic, "literary" type of criticism which Latin Americans inherited from Europe, Tibol records technical information (materials, sizes, properties, and handling of works of art) as well as compositional, thematic, and social analysis. The *materiality* of the visual arts—and therefore the language of form and technique, which are such crucial carriers of meanings in their own right is recognized and recorded, as is the symbolic aspect. She early saw the necessity of establishing a documentary base for artistic analysis, and therefore compiled many books of writings by and about artists, carefully dated and located. Taken together, these books form a formidable library which no serious researcher on Mexican art can bypass.[104] Finally, Tibol has trained many young researchers during the course of organizing large exhibitions. She is solicited as a juror throughout Latin America, and as to her work as a journalist, her regular critical columns examine art from many parts of the world with the same attention to detail.

Franco's classic book *The Modern Culture of Latin America: Society and the Artist*,[105] as well as subsequent books and articles, provided as firm a basis for ideas and information in English as Tibol's numerous books, catalogues, and articles did in Spanish. Franco's invaluable book is not only a social history, but includes both literature and the visual arts chronologically arranged yet thematically organized. The introduction to her book clarifies her perspective and identifies issues that characterize Latin American culture:

> Literature—and even painting and music—have played a social role, with the artist acting as guide, teacher and conscience of his[her] country. The idea of moral neutrality or the purity of art has had relatively little impact. In countries like those of Latin America, where national identity is still in the process of definition and where social and political problems are both huge and inescapable, the artist's sense of responsibility towards society needs no justification. Generally, movements in the arts [unlike those of Europe] have not grown out of a previous [stylistic] movement, but have arisen in response to factors external to art.[106]

The Modern Culture of Latin America examines that culture from the days of the positivist ideology that dominated the latter nineteenth century through the "New Cinema" or "Third Cinema"—which developed in Latin America during the 1960s and was finally dismantled when its makers were "disappeared," jailed or sent into exile by the repressive dictatorships of the 1970s—and the internationalist poster movement of socialist Cuba. Between those chronological markers, she engages the symbolic revolt of the modernist movement; the search for identity, and the differentiation from the Anglo-Saxon traditions of the United States; the intensified return to "roots" (cultural nationalism, the Indian, the

Negro, the land) in the post–World War I period that rejected the European standard of civilization so brutally exposed by the slaughter of the war; the political struggles between opposing ideologies ushered in by the 1920s; and the cosmopolitan/universalist versus the national/regionalist debate.

In later publications, Franco examines such urgent social questions as "dependency theory," which preoccupied social scientists in the 1960s and 1970s, as it related to Latin American culture;[107] while a more recent and highly original study is Franco's *Plotting Women: Gender and Representation in Mexico*,[108] in which the chapter "Body and Soul: Women and Postrevolutionary Messianism," examines Frida Kahlo and Antonieta Rivas Mercado in relation to the men in their lives (Diego Rivera and José Vasconcelos) and to patriarchal ideologies (pp. 102–28).

Franco's entry into the postmodern debate is evidenced by her participation in the Tabloid Collective of 1980. Postmodernism has brought to the fore the intersection of "high" art with popular culture and mass media—an intersection that probably began in the 1960s with pop art, and is a full-blown phenomenon today. The publication *Tabloid: A Review of Mass Culture and Everyday Life* was issued from Stanford, California (where Franco was a professor at Stanford University), and its first position paper articulated its critique of mass culture theory and the institutions of everyday life "which turned us all into automata: passive reflectors of a conspiracy of media owners, commodity manufacturers, and purveyors of junk food." The collective, nevertheless, insisted on locating the practices of resistance which subvert, unhinge, and radically modify the pre-packaged world of everyday cultural life,[109] which remains a key argument in the writings of Latin Americanist theoreticians.

From Cuba, an excellent social analysis of Cuban art from the nineteenth century to the mid-1970s is Adelaida de Juan's *Pintura cubana: Temas y variaciones*.[110] This publication does not pretend to be a historical resumé of Cuban painting; rather it is a collection of separate studies which, brought together in the absence of a developed and sequential history of Cuban art, serves to present an ample panorama of Cuban painting, graphics, and caricature set into their respective time frames. A review of the themes across time includes those of portraits and figures, the landscape and the city, still lifes and flowers, historical subjects, allegories, symbols, the use of the imagination, and the history and politics of abstraction. Adelaida de Juan's book was my first introduction to a social analysis of modern Cuban art—a project I have been refining on my own behalf since my first trip (with subsequent visits) to Cuba in 1982, which laid the groundwork for several articles dealing with Cuban and Cuban American art. The work of other Cuban scholars, such as Elena Serrano, Ramón Vázquez Díaz, and especially critic and theoretician Gerardo Mosquera in the field of contemporary art, has been crucial.

Social art history in Brazil can be found in Aracy Amaral's book *Arte para quê? A preocupação social na arte brasileira 1930–1970.* [111] Amaral, one of Brazil's most prolific art historians, undertakes in her volume to summarize the various movements and philosophies concerning socially committed art in the twentieth century, before proceeding to outline the trajectory of such consciousness among artists, architects, and critics of Brazil in the time period indicated. With this book, Amaral and I began functioning on parallel ground. Drawing on my research concerning U.S. manipulation of art and artists in Latin American during the cold war, and extensively quoting my findings, Amaral used this base (and that of other North Americans, including Max Kozloff and Eva Cockcroft) to set forth the Brazilian case, as I had the Mexican. Amaral was one of the persons I sought out in my first trip to São Paulo in 1978, and one who personally began my education about modern Brazilian art. Since that time, we have periodically exchanged our written materials—a process I have continued over the years with many Latin American historians, critics, and curators.

In *Arte para quê?*, Amaral charts the emergence of a political consciousness in the 1930s, impacted by the Mexican and Russian revolutions, concurrent with the early administration of populist nationalist president Getulio Vargas (which later degenerated into a dictatorship). The influence of Mexican muralism affected Brazilian artists (as it did many nations of the Americas) while German expressionism offered a dramatic language to social works of art. Two publications, *O Homem Livre* of São Paulo and the *Movimento* of Rio de Janeiro, were antifascist in nature, uniting left-wing radicals of various stripes.

With the end of World War II and the apparent victory of democracy over fascism, followed by the escalation of the cold war, the growing nuclear capabilities of the United States, and the launching of the Korean War, Brazilian artists promoted peace activities, turning to printmaking as a viable medium for wide dissemination. With the strong influence of Kathe Kollwitz's social prints, and Mexico's Taller de Gráfica Popular as a model, Clubes de Gravura (Printmaking Clubs) were established in the early 1950s in Porto Alegre, São Paulo, Rio de Janeiro, Santos, and Recife. Employing the popular linoleum blocks of the Mexicans as well as woodcuts, they engaged a multitude of social themes.

In 1951, the inauguration of the São Paulo Biennial at the Museu de Arte Moderna brought new international tendencies to São Paulo, and a rupture took place between the earlier realism and the new abstraction influenced by European models—particularly those of Mondrian and Max Bill. Promoted by the biennials and the governmental and cultural elites of Brazil and other Southern Cone countries in the period of prosperity and industrialization following the war, the new directions were confirmed by the I National Exhibition of Concrete Art in São Paulo and Rio,

paralleled by the initiation of the construction of Brasilia (begun in 1956), the new capital of Brazil, intended by President Juscelino Kusbitschek e Goulart to open up the closed regions of the country to development. In 1959, a neoconcrete manifesto and exhibition set new directions for geometricism and rationality until informalism (abstract expressionism) became the next international tendency.

The last chapter of Amaral's history, and one which particularly interests me, concerns the growing polemic about the social responsibility of architecture and the architect to the Brazilian people. Triggered by the construction of Brasilia, and by the rationalist (internationalist) tendencies of Le Corbusier—which found expression in Rio's Ministry of Education and Public Health, built in 1936–43 by Lúcio Costa and Oscar Niemeyer (among others), the same architects responsible for Brasilia—the argument raged between the defenders of contemporary architecture and those who felt that architecture was serving the dominant classes and ignoring popular needs.[112] In mapping the itinerary of my first trip to Brazil in 1978, I included Brasilia, which proved to be aesthetically marvelous but psychologically devastating as an example of the failure of a modernist utopian vision. Unlike Rio, no *favelas* (slums) were visible amid the perfections of the planned housing areas. Neither, however, was there evidence of low-cost housing, such as that which had interested the architects of the Bauhaus. Instead, workers' housing (unlike those of governmental administrators, bureaucrats, and foreign ambassadorial staffs) was banished into invisibility beyond the perimeters of the city where it could not intrude on the symbolic and patriarchal perfections of the governmental and official religious zones, or the overwhelming alienation of the internally contained and fragmented residential zones. Every big city is sectioned by class divisions; this one, however (advertently or not), built class divisions into its city *planning*. Brasilia in 1978 was also devoid of urban cultural centers, which arise simultaneously in any city that develops organically—that is, over time and with the needs of different populations to service. Except for the meager resources of the university, no citywide museums or art galleries were available, no central library; movie theaters and schools were contained within, and pertained to, each residential complex. Streets and complexes were numbered, instead of named. At the time, Brasilia seemed retrofuturistic to me, like a colony established on the moon, and I could understand the rumors that diplomats and government officials escaped by plane to Rio every weekend. Thus the critique about whom architecture in Brazil was serving was, it seems to me, a legitimate concern.

The chapter "A crise da vanguarda no Brasil" in *Artes plásticas: A crise da hora atual*,[113] written at the height of the Brazilian military dictatorship by art critic Frederico Morais, tracks the Brazilian avant-garde within the social, political, and conceptual context of two decades, begin-

ning with the 1950s, which were noted for vigorous activity in concrete and neoconcrete art), and going through the 1960s, during which Argentinian neofiguration and pop art influences from Europe established a rupture within the vanguard symbolized by two Rio de Janeiro exhibitions: "Opinião 65" and "Opinião 66." A number of artists (among them, Hélio Oiticica) abandoned neoconcretism in order to enter into alliance with a new generation exploring what was called in Brazil "narrative figuration," as well another direction, known as "anti-art"(p. 84), in which Lygia Clark figured. Since I had begun my own research of Mexican and Argentinian neofiguration in the 1960s, I was very interested in the specificities of the Brazilian movement as given by both Amaral and Morais.[114] Added to the evidence that neofiguration existed in a number of Latin American countries, in some briefly and in others extending to the present, percolating south from Mexico and northern South America and north from Argentina, it appears to me that a hemispheric examination of this phenomenon and its implications could detail and further enrich our knowledge of Latin American cultural formations. Neofiguration seems to suggest itself as an existential and critical bridge between the hegemony of apolitical abstraction and the new politicized currents of the 1960s and 1970s, not simply a return to figuration, as art historians immersed in narrow arguments of stylistic change have suggested.

By the 1970s, when the attacks of the military government had taken their toll in the forms of fear, censorship, and self-censorship (though the 1960s saw some of the most innovative art forms, such as the "environments" of Oiticica, and the rise of the critical tropicalism movement in music and the arts), the avant-garde was marginalized or went into exile. Those who participated in Brazilian exhibitions did so with paintings and conceptual art pieces utilizing double-entendre.

In his important chapter, Morais also comments on the role of art criticism, including his own, in a period which shares certain characteristics with Chilean art under the Pinochet dictatorship. The huge size of Brazil, and the simultaneous existence (up to and including the present) of regional movements outside the major centers of Rio de Janeiro and São Paulo, make the critical landscape extremely rich, varied, and complex. It should also be mentioned that Brazil's isolation from the rest of Latin America, owing to language differences (which present real barriers) and a different historical rhythm based on Portugal's relationship to her colony, is apparent when one reads its art criticism and art history. "Brazil and Latin America are beginning to know each other," wrote Morais in 1979. "There is a growing consciousness that we must walk together and think together about our reality."[115] Increasingly, he points out, this has been occurring through interchanges between critics, historians, artists, cultural organisms, museums, and even galleries, as well as continental exhibitions, symposia, specialized magazines, and books. In 1977, the

Grand Prize of the São Paulo Biennial, for the first time in its history, was awarded to an avant-garde group from Argentina, while in 1978 the entire Biennial was dedicated to Latin American art.[116]

In Peru, Mirko Lauer is one of the foremost social art critics and historians, though, like a number of Latin Americans functioning in the camp of visual arts, he is trained in other fields. Of great importance is his slim and highly complex analytical volume *Introducción a la pintura peruana del siglo XX.* [117] Bypassing the Incan and Spanish colonial periods as imperial, he claims the three great autonomous periods of visual art in Peruvian culture are those of the pre-Inca, of popular artisanship, and of the republican pictorial tradition. The first two have been largely ignored until recently (the 1970s); the latter has been treated exclusively with an aesthetic focus, and with few considerations of the social and cultural nature of pictorial production. This he undertakes to remedy, from the nineteenth century until the end of the 1960s.

Insisting firmly on an approach to modern Peruvian art that considers the interaction of dominant/subdominant cultures as they function in relation to dominated/subdominated cultures, Lauer follows a methodology that structures cultural phenomena in a system parallel to the social and economic systems of the dominant class. The cultural plurality of Peru (the division between the rulers and the ruled, who are indigenous and working peoples) is contained, he argues, within a single great system, national and global, of domination. Cultural domination results in the fact that vast numbers of human groups find it impossible to participate fully in the functioning culture, or to obtain control of the cognitive instruments that can formalize and objectify their own lived experiences. It is the dominating subculture that controls these instruments and determines the features of the dominant culture, which maintains hegemony over the dominated.[118] After detailing the customary migration of nineteenth- and twentieth-century Peruvian painters to Europe (often for many years), where they adopted not only European styles but also European themes—thus isolating themselves from Peruvian concerns, though not from national adulation—he points out that the artistic debate (one that marked not only Peru, but most of Latin America) was between the camps of localism (or regionalism) and universalism. The localist tendency corresponded to moments of internal power struggles which required redefinitions of national reality, while universalism seemed to prevail when a local bourgeois group was at the end of a period of hegemonic domination. Thus, when Peru was tied to European investment, universalism held sway in the social and aesthetic realms. When there were local changes and social upheavals, the regional model replaced the universal.

Lauer further argues that the earliest vanguard manifestations—which corresponded to the 1919 establishment of the first Escuela Nacional de

Bellas Artes during a period in which an antioligarchic revolution placed a new president in a position of power—arose in the 1920s under the leadership of painter José Sabogal. This vanguard embraced the ideology of indigenism, which was tied to regionalism and to cultural nationalism and was reflective of the Mexican movement. However, this was not the first time that Indians were subjects for painters. In four crucial chapters on the Indian in the visual arts, Lauer points out that paintings of Indians during the nineteenth century were produced for the dominant culture that tried to integrate the images of the dominated in a process that was not one of discovery or revelation, but one of (involuntary) mystification on the part of the artist. Indians were rarely individualized; rather, the anonymous and idealized or romanticized Indian (the "good savage" of the eighteenth century) filled the gap of a deliberately forgotten history.

Nor was this eradicated in the twentieth century; it remained as a form of thinking and of picturing that formed a contradiction even within the work of Sabogal. The record indicates, according to Lauer, that Sabogal protested against the lack of knowledge and the invidious characterizations of the Andean Indians; nevertheless, his own work was not sufficiently advanced to overcome the contradictions within which he worked. Unlike Mexico, where the aboriginal (and *mestizo*) peoples participated in the revolution, where their bodies and faces were known, where (for a time) they imposed their military and social presence on those around them, the Peruvian artists either did not know or could not change their inherited "mind-sets," or else could not market paintings in which the exploited Indian was shown with realism. Rather, the fiction of the proud and grand Inca was perpetuated, instead of a depiction of the actual misery within which the Indians lived.

By the 1940s, the indigenous movement had effectively ended, losing its aggressive and subversive edge. It became officialized by the dominant culture and the art market. Younger generations attacked indigenism, and once more turned to various European versions of universalism—both figurative and abstract. Abstraction—or nonfiguration—argues Lauer, was the child of post–World War II industrialization and urbanization, when Peru was, more completely than before, penetrated by U.S. capital investment. The growing class of businessmen and professionals supported the nonfigurative mode, and was the base from which was launched a local art market.

In the socioeconomic crises of the 1960s, the clash of forces made it necessary to again reconfigure the profile of national culture, this time based on a sixties' populism and a neoindigenism that took the dominated culture into account. With the intervention of the Peace Corps, emphasis was placed on Indian artisanship: its regulation, promotion, commercialization, and the stylization of its forms (to suit a tourist and export market). In the fine arts, there was a galvanization of abstract

painters toward expressionism and the creation of a system of symbols that could transmit the cultural "essences" in a scheme that has been called the "Theory of National Races," of the search for "Peruvianism." Thus there was a new conjunction which assimilated the Indian into the national mythology, but with the same requisites of depersonalization and dehistoricization. This process, says Lauer, had its microcosm in the abstract work of Fernando de Szyszlo.

Turning to Uruguay, art historian Gabriel Peluffo provides his view of the relationship between a marginalized national state in crisis and the production of symbolic materials by artists, art critics, art historians, and intellectuals in his article "Crisis de un inventario."[119] It is generally represented by historians that Uruguay, a small nation that came into being in 1830 after serving as a buffer zone between Argentina and Brazil, remained throughout much of the twentieth century a country more faithful to democratic practices than any other in Latin America. This was presumably achieved during the era of reformist president José Batlle y Ordoñez (1903–29), who instituted such a number of social reforms and quasi-socialist economic policies (though not in the rural sector for a highly urbanized population) that some historians refer to Uruguay as the "Switzerland of Latin America."[120] This seeming utopia ended in the 1950s, but the nationalist aura continued, according to Peluffo, until 1973 when a military coup installed one of the least publicized and most severe dictatorships in Latin America. Its doctrine of "national security," of an "internal enemy," instituted such a reign of terror that it canceled out whatever remained of the mythology of the Uruguayan family (that is, a family encompassing the nation, or at least the nation's intellectuals[121]) that had been the seemingly inexpungible condition for Uruguayan identity for seventy years. On the other hand, the consciousness of marginality and the phantom of guilt that transnational economic power had introduced into the "debtor" nations of Latin America in the 1970s had multiple repercussions in the cultural arena. "It is difficult to think of defending or of reconstructing an imaginative life of one's own," says Peluffo, "when an external debt operates in such a manner on the real and symbolic levels that it promotes a state of passivity and collective depatrimonialization as the price of being modern." This weakening of the national self, of national identity, which always functions in the first person, comments Peluffo, produces a crisis in one's cultural "inventory"—understanding the term inventory "phonetically" as the cumulative registry of a long history as well as a collective project which can be considered an "invention," an imaginary social construct projected toward the future. Both are components of the concept of identity—of the crisis of a cultural hegemony developed over a long period of time, from the emergence of *batllismo* (the programs and modernizations of Batlle) to the consolidation of the military dictatorship.

If the "content and symbolic forms with which the ideals of the State had been represented for the national collective," continues Peluffo, were made obsolescent during the dictatorship [1973–84], the long-awaited recomposition of the cultural camp after the fall of the dictatorship found itself in unknown terrain. Not only had the old signposts disappeared, but privatization of the cultural sphere (as well as the economic) seemed to be the culmination of strategies developed by transnational capital since the decade of the 1970s. The loss of state control in national cultural initiatives—made almost planetary—was paralleled by the reinforcement of the market as a legitimating agent of certain ethical and aesthetic guidelines. If the culture industry has democratized and intersected diverse symbolic languages—previously compartmentalized from the social point of view—it has not been able to change the operation of cultural norms that hierarchize certain views in relation to others, forcing entire spectrums of values to conform to rigorous mechanisms of social difference.

In addition, since the decade of the 1970s, says the author, the massive phenomenon of political and economic exile [during the dictatorship] accentuated a need for reflection on the collective imagination of "Uruguayanism" which could be invoked regardless of the physical and geographical situation of its interpellators. Obviously the traditional emphasis on the origins of the nation and its ethnocultural composition—based on its waves of immigration—is now subjected to renewed doubts concerning its viability and credibility as a nation-state: there is a tension created between the deterioration of the local imagination and the foreign fascination exercised by the fantastic cultural scenery of the wealthy nations which beckon young Uruguayans.[122]

However one views Peluffo's vision of nationalism, the issues he raises are profound for Latin America and for our analysis of its art, not just for nations in the postdictatorial phase, such as Argentina, Chile, Paraguay, and Brazil, which are suffering similar phenomena (each reflecting its own national history) within the context of global postmodernism, but for those still in the throes of trying to free themselves from dictatorial regimes, such as El Salvador and Guatemala. In my opinion, the fragmentation of consciousness and national solidarity, once the need and habit of resistance is no longer necessary—the resistance that was translated into powerful symbolic languages for the visual arts, film, and literature by those who remained in the country during the dictatorship, and those who returned from exile—left yawning lacunae which many artists were (temporarily) unsure how to fill. Though it must again be reiterated that each country has its own history and cultural profile, and that Peluffo has presented very clearly that of Uruguay, there exist certain symmetries on the psychological, temporal, and artistic-conceptual levels between Uruguay and—for example—Chile (explored in this book in "Dissidence and

Resistance"). The years of fear leave their lesions on a personal level; artists returning from exile and seeking to reinsert themselves in the artistic space are distanced from those who remained throughout the brutal years. All artists have to readjust to the difficult realities of a postdictatorial period in countries that have been irrevocably damaged by the experience, and need to seek new forms of artistic language to meet these new realities—including working through the human cost of the repression by exploring the tortures, the disappearances, the mass graves that have been found, and the loss of compatriots who will never return to live "at home" after long absences and the building of new lives abroad. How does one restructure a sense of place, of national belonging, of identity, when the metaphysical profile of nationhood upon which identity has been formed, ambiguous as it might have been, is politically damaged and destroyed, and furthermore, called into permanent question by the very dissolution (nationally and globally) of all such parameters in the contemporary world? The double marginalities, those of being kept peripheral to the metropolis in the realms of ideology and artistic communication, and in the economic arenas through manipulated import dependency and impoverishing debt,[123] affect (as Peluffo points out) the psyche, causing painful wounds which may heal but will always leave scars.

Among the younger scholars who have emerged in recent years, and who are plowing up and replanting the existent histories of Latin American art, must be included Puerto Rican art historian Mari Carmen Ramírez. Her study *The Ideology and Politics of the Mexican Mural Movement: 1920–1925*[124] promises to open new terrain that will revise long-held and imprecise views of the most influential school of Mexican art in the twentieth century. Her thesis is to unravel and isolate the complex and often contradictory series of political, ideological, and aesthetic factors that converged in the consolidation of the mural movement as a banner of prestige and legitimation for the postrevolutionary government, in an attempt to establish the bases for a radical socioartistic movement. The microcosmic view to which this study is limited concerns the period from 1920 to 1925—the germinal years that generated the shifting but core concepts of the mural movement and that endorsed, in its earliest phase, a "symbolic mysticism" (p. 11). This was later transformed to a more pragmatic version of nationalist populism induced by the politics of the Alvaro Obregón presidency. It finally resulted in a militant radicalization of the Mexican painters through their involvement with the Mexican Communist party and the publication of the radical newspaper *El Machete*, which led to their estrangement from the State.

Ramírez also undertakes to change the marginalized focus of most histories on Mexican muralism in order to consider the movement as an important product of the wave of radicalization that shook the European avant-garde in the years following World War I and the Russian Revolu-

tion, one that developed in constant dialogue with these traditions. The key to the muralists' success, in light of failed German and Russian revolutionary avant-garde movements, she claims, lay "precisely in their relationship to the State and their willingness to engage in the political battles of the period (p. 17). Her central argument is that the mural movement responded to the needs of a new state to secure cultural vehicles that would express a new model of Mexican culture elaborated in opposition to the Porfirian model, and grounded in the collective identity of the people: the peasant, Indian, and working-class population that constituted the political basis of Obregón's power. She also takes an original tack in arguing that the radical politicization of the Mexican painters was not only linked to the project of the formation of a Mexican avant-garde, but that, "given the muralists' complete unfamiliarity with the politics of the Mexican left, their entrance into the Mexican Communist Party derived more from their avant-garde stance than from any clear understanding of Mexican political reality" (p. 5). This is certainly an inversion of existing thinking.

British art critic Guy Brett has tackled, as his major focus, the avant-garde art of the Southern Cone, particularly artists from Brazil, Chile, and Argentina, but also including Venezuela. His interest, however, extends beyond these nations into the whole realm of the experimental—that realm of Latin America which is most often scorned as being imitative of the European avant-garde, or is ignored for lacking "authenticity."[125] I felt the presence of a kindred mentality when I first read Brett's catalogue essay "A Radical Leap,"[126] to the effect that the concrete-optical-kinetic art movements of the 1950s and 1960s were based not only on the fact that artists were interested in and knowledgeable about science and the relation of science to philosophy, but also in the argument that these interests were not derivative but stemmed from genuinely international movements.

In setting out the field of discourse for Latin American art, then, Guy Brett argues for the existence of a set of tensions and complex relationships which upset the customary categories and labels—i.e., the stereotypes—in order to engage a group of works which must be considered simultaneously "international" and Latin American (that is, not the same as European or North American art). In summary, in order to accomplish this new understanding, Brett argues that:

1. one must consider the movements of the artists themselves, who traveled and often spent extended periods of time abroad,

2. it is necessary to posit that the grouping of artists by "isms" misses what was really innovative. Artists touched various movements of the European avant-garde without belonging to any of them in more than a sense of seeking a "new space,"

3. the relationship of Latin American artists to the metropolitan art centers cannot be dismissed as a provincial imitation of the latest fashions; the artists often sought out the works of artists no longer "fashionable" (Mondrian, Vantongerloo, Brancusi) in order to construct their own languages and concepts as they chose, and

4. the work must be located within Latin American history and space. The term "Latin American" is a gigantic simplification that doesn't consider differences of nation, class, cultural tradition, and levels of (national) wealth and poverty—despite the commonality between Latin American "subjects" caught in cycles between economic booms and busts, civilian and military rule, socialist experiments and right-wing tyrannies. Into this must be factored the foreign elements continually engaged in robbing the continent since the time it became "America."

The "radical leap" into science- and technology-ordered forms like concrete, optical, and kinetic art occurred at a time of high optimism and a desire for the modern engendered by the booming Latin American economies of World War II and its aftermath. It appeared earliest in the wealthier industrializing countries like Argentina, Brazil, Venezuela, and to some degree, Mexico.[127]

Before leaving art history and criticism to discuss theory, it behooves me to mention one crucial catalogue that has served many Latin Americanists (like myself) in English-speaking countries: the one by Stanton Catlin and Terence Grieder entitled *Art of Latin America since Independence*.[128] Divided into five time slots from 1785 to 1965, each with a brief historical overview, it also contains biographies of the artists, a bibliography, a checklist of 395 works, and 116 black-and-white and color plates. Listed are academic and nonacademic artists from Argentina, Bolivia, Brazil, Chile, Colombia, Cuba, Ecuador, Guatemala, Haiti, Mexico, Nicaragua, Panama, Peru, Uruguay, and Venezuela, and an extensive list of non-Latin Americans who were associated with Latin America or with Latin Americans abroad. As such, though schematic, it offered, at the time of its publication in 1966, one of the most extensive presentations of modern Latin American art available, not just in quantity, but in conceptual terms. It came as no surprise to realize, almost twenty-five years later, that the ambitious project "Art in Latin America: The Modern Era, 1820 to 1980"[129] modeled itself on the 1966 exhibition, updated correspondingly.

Theory

Since the early part of the twentieth century, Latin American theoreticians have been wrestling with the concept of modernism as it was integrated into literature and the arts in this hemisphere. Actually, three

terms are in question: "modernity," which has been defined as a histori-
cal stage; "modernization," seen as a socioeconomic process that under-
takes to construct modernity; and "modernisms," which are the cultural
projects that renew symbolic practices with an experimental or critical
point of view.[130]

The social context of modernism as it affected literature has been de-
fined by Mexican critic Françoise Perus, and summarized by Chicago lit-
erary critic Marc Zimmerman, as an aesthetic posture that corresponds
to the integration of Latin America's economy in a worldwide capitalist
system. Consolidated around 1880 and enduring until 1920, modernism
developed as Latin American oligarchs achieved local hegemony. It then
lost ground to the "social novel," which expressed the "crisis of the local
oligarchic road to capitalist development" and the irruption of the middle
and popular sectors into the political scene. The "new narrative" of the
1960s is a manifestation of the crucial turn toward industrialization and
urbanization, entailing a resurgence of modernist tendencies, now greatly
modified in form and function because of the complex and conflicting
modalities of a more comprehensive, yet more vulnerable, imperialism.
Modernism is therefore to be understood in terms of its ties to "the re-
sidual but ever-present antirealist tendencies of avant-garde Latin Ameri-
can literature" rather than simply as a formal change in discursive
language and structure generated by a Latin American realization of
"man's [sic] inherent existential anguish."[131]

Debate over the relationship between modernization (socioeconomic
and technological) and modernism/modernity occupies Latin American
cultural theoreticians as part of the discourse over postmodernism.
Locked into this paradigm are the reevaluations also taking place in re-
gard to the avant-garde of the 1920s. Chilean critic Nelly Richard places
the problem succinctly: Latin America's "peripheral modernity"—which
she conceives of as a copy of the metropolitan center's self-image as
a universal foundation for its dominant western rationality—was the
source of Latin America's long search for identity. Today's postmodern
displacements and interdependencies have made it possible for cultural
power to flow through heterogeneous and dispersed microcircuitry, thus
shattering the category of the center.[132] For social scientist Renato Ortiz,
Brazilian modernism of the 1920s and 1930s was achieved without mod-
ernization, which didn't arrive in Brazil until its radical tranformation in
the 1960s by the "second industrial revolution" (computers, television)
of a late global capitalism into which Brazil inserted itself. Modernists of
the 1920s and 1930s, says Ortiz, might poetically invest the highways of
the Milky Way with automobiles careening vertiginously in a country
without automobiles (all were imported) and with highways which were
few and unpassable. Modernity, however, was in actuality, a political pro-
posal for the future modernization of Brazilian society.[133]

Néstor García Canclini argues that if, in continental Europe, modernism was the result of "the intersection of different historical temporalities," in Latin America, modernism resulted from the sedimentation, juxtaposition, and intersection of indigenous traditions (especially in Mesoamerican and Andean areas); Spanish colonial Catholicism; and modern political, educational, and communicational policies. Desirous of giving elite culture a modern profile, while recruiting what was indigenous and colonial in the popular sectors, an interclass *mestizaje* (mingling) generated hybrid formations in all the social strata. The secularizing and innovative impulses of modernism were most efficacious, he believes, for the groups of "high culture."[134]

In the arenas of the indigenous and popular arts, three interesting examples culled in Latin America that illustrate the postmodern process and the interface between modernity, modernization, and modernism include the case of the Chamacoco Indians of Paraguay, whose chiefs traditionally needed to demonstrate skilled hunting, courage in war, wisdom in negotiation, and convincing oratory. Today's chief, however, speaks five languages in addition to his own and has been baptised as a Catholic, a Protestant, and a Mennonite, while maintaining his own rituals—as do his people, who use radios, telephones, tape recorders, and motorcycles as well as masks, paint, and feathers in jungle rites.[135] Another instance concerns a humorous retrofuturistic Indian metropolis, Tupinicópolis, which was the second finalist in the 1987 competition for best "samba" during the Rio de Janeiro carnival. Its theme was the "Tupí" Indians (Tupinambá of the Brazilian Amazon) of this cosmopolis who rode supersonic Japanese motorcycles, played rock and roll, and dressed in sneakers, phosphorescent feathers, and blenders as headgear. Thus the participants carnivalized the perception of Latin America as "primitive," but also recycled postcolonial pop and the glamor of high tech.[136] A final example is that of *Superbarrio*, a popular hero dressed like a cross between Superman and the masked anonymity of Mexican wrestlers, who emerged in Mexico City after the 1985 earthquake to act on behalf of the homeless displaced by the quake, the poor, and the exploited. Superbarrio made the transition into postmodernism when he was invited by Chicano artists to visit their spaces in California. "El Santo," a famous Mexican wrestler, was early incorporated into the performance work of Chicano René Yáñez and Superbarrio into the later work of Mexican border artist Guillermo Gómez-Peña.

As can be seen, the advent of postmodernist theory has had as profound an impact on intellectuals from Latin America as on those from Europe and the United States—though with important distinctions.

The editor of a scholarly journal devoted to Latin American subjects has noted that certain major themes of past significance appear to have lost contemporary relevance. Those "isms" of the past—nationalism,

imperialism, populism, Catholicism, corporatism, authoritarianism, indigenism, developmentalism, and militarism—each referring to a theoretical core concept (not unlike an ideal or an essence in the Hegelian sense), apparently have lost their currency, he says. While the old problems and issues have not necessarily disappeared, they are increasingly being addressed through an effort to disaggregate phenomena, to take things apart to see how they work. In other words, a concern with essences has been superseded by an interest in the processes.[137] As examples, the editor claims, subnational, international, and transnational phenomena are now seen as intersecting, and are analyzed in ways that focus on process and diversity. The older diachronic or time-series approach is now being enriched by an infusion of synchronic or cross-sectional research strategies in such areas as gender, ecology, ethnicity, religion, class, public opionion, and public policy.[138] While I certainly cannot argue that such a shift is not occurring, and is as much in evidence among cultural theoreticians as among social scientists as indicators that the realities of the world we knew just a few decades ago are in a profound state of change, the danger lies in pushing the dismantlement so far that intellectuals lose sight of the real problems mentioned above which remain systemic, while they dissect the processes with new insights, often using the tools provided by our romance with, first, structuralism and then poststructuralism. To recognize both the globalism of our time and its subnationalist and transnationalist tendencies, as countries fragment into their component ethnicities; as corporations begin to function like metastates; or as "common markets" are created between formerly competitive nations, is to recognize the realities of the end of the century as well as the end of the millennium.

Nevertheless, the economic and power discrepancies between the former "First" and "Third" Worlds (what is referred to as the "Center" and the "Periphery") remain in place as a new kind of cannibalism (the "North American Free Trade Agreement" between the United States, Canada, and Mexico—but with a vision directed at all of Latin America) seems perched to supplant the U.S. Monroe Doctrine in the Americas. This local version of the "new world order" articulated by then president George Bush was being put into place just as the former colonizing nations of Europe attempted to unite their economic destinies to the exclusion of the "have not" nations and peoples of the world—which possibly will include those of the former Soviet Union. The lines are drawn not simply on national or on the North/South divisions that replaced the East/West competitions with the collapse of the USSR and the cold war, but in terms of a consolidating yet competitive international elite and an international yet fragmented working class.

Latin Americans and Latin Americanists engaged in the postmodern discourse have responded to these challenges in the cultural arena. One

of the most prolific and analytical writers on this and other issues is Néstor García Canclini, Argentine-born philosopher who has been based in Mexico City since the early 1970s and whose work has been important to my own development. Long interested in the interface between "fine" art (*arte culto*) and "popular" art (understood in Latin America as art of the people, rather than that of mass culture), García Canclini has adapted the tools of anthropology and sociology to carry on research in both arenas. His research has led to the publication of two books on popular culture: *Arte popular y sociedad in América Latina* (1978), and *Las culturas populares en el capitalismo* (1982),[139] which opened up fresh vistas from which to view the contemporary production of indigenous peoples. García Canclini "takes a many-sided view of these phenomena: the economic, political and cultural domination of capital [which] is served by the incorporation and symbolic refunctionalization of indigenous craft products and fiestas, while at the same time the indigenous population utilizes them as material and symbolic responses to their changing socioeconomic reality."[140]

It was a natural step for García Canclini, in subsequent publications in which he analyzed the methodology of the sociology of art and advanced his suggestions for revisions, to direct his attention to the "fine" arts, and finally to combine popular, fine, and mass cultural forms as the basis for his discourse on the Latin American aspects of modernism and postmodernism. The problematic is first set forth in *La producción simbólica: Teoría y método en sociología del arte.*[141] A follower of Antonio Gramsci[142] and Pierre Bourdieu (with whom he studied), García Canclini began with this book his interrogation of existing theory as it pertained to the decade of the 1970s. After reviewing the contemporary relationship between art and sociology, its theoretical and methological premises, the concept of structure and superstructure, and making an analysis of the artistic process (art as an ideological process, the use of new materials), he examined the theories as they applied to avant-garde art in Argentina in the tumultuous and experimental sixties. He considered the rupture with traditional nineteenth-century bourgeois artistic tastes that began with the 1920s and 1930s, the various movements that nationalized and socialized global artistic inventions toward the needs of Argentina, and the industrial modernization of the fifties (called *desarrollismo*, or developmentalism, in Latin America), which by the sixties brought a host of new industrial materials to the attention of Argentine artists in a period of social and cultural radicalism. Simultaneously the new industrial and commercial bourgeoisie (as well as foreign investors) provided patronage and access to exhibition spaces, scholarships, and the new materials, including video and television. One cannot understand, says García Canclini, the aesthetic innovations of the sixties in Argentina (nor in Latin America) if one doesn't consider—in addition to the changes in soci-

ety—that the transformations were sparked by the introduction of new materials provided by business establishments whose names also underwrote the exhibitions, competitions, prizes, scholarships, and catalogues. In other words, new technology impacted aesthetic choices as powerfully as did new ideas within the autonomous realm of art production; while the sixties also signaled a definitive penetration of cultural activity by private enterprise which was to permanently impact the cultural role of the state.[143]

Viewed from the United States, the 1950s also began the "massification" of the media and its advertising component. If radio began in the U.S. in 1921 and television in 1945, by the 1960s CBS, NBC, and ABC had become worldwide communications enterprises: CBS with television distribution in 100 countries; NBC in 83; and ABC's Worldvision—the most active in the international field—reaching 60 percent of all the world's TV homes outside the U.S. In addition, ABC had some financial involvement in telecasting in Guatemala, Honduras, Costa Rica, Panama, Colombia, Venezuela, Ecuador, Argentina, Chile, and Mexico (to mention only the Latin American countries). By 1966, a fourth group, Time-Life Broadcast Stations, provided television programming for fifty-six stations in Latin America, including those in Venezuela, Argentina, and Brazil. The Brazilian tie-in created concern in that country because the Brazilian constitution prohibited foreign ownership of the nation's communications media; therefore, Brazil's TV Globo attempted the acquisition of radio and TV stations in all the nation's major cities.[144] To leave the impression, however, that U.S. comunications firms continued to dominate the market would give a false impression. By 1972, Televisa, the Mexican audiovisual conglomerate, exported 1,300 hours of television programs, while by 1980 it reached 25 million households in the United States. Ninety percent of the films circulating on the Spanish-speaking circuit in the U.S. come from Mexico, to say nothing of those from other Latin American countries, and those from Spain. By 1982, Brazil's Rede Globo (TV) exported to the value of seven million dollars, mainly to Latin America, but including Spanish- and English-dubbed programs to the U.S. At the same time, there are imbalances: while Mexico and Argentina have plunged since 1980 into an under-production crisis, Brazil moved toward being the biggest cinema producer of the continent.[145] These statistics refer to audiovisual mass media; if that is extended to the print media, particularly to the highly popular comic books and *fotonovelas* (photonovels)[146] that circulate in Latin America and the United States, the impact of (visual) mass media on Latin Americans is enormous. With the great expansion into new artistic materials and techniques of the 1960s and 1970s, mass media imagery formed an important part of the collages, assemblages, and installations of Latin American artists in many

countries. It is for this reason that Néstor García Canclini argues for a new understanding of culture in his book *Culturas híbridas.*

The "cultural hybridism" of the title derives from an idea that gained an increasing popularity in the late eighties, an idea very inadequately expressed in the United States by terms such as "pluralism" and "multiculturalism," terms that are very much in question in Latin America. García Canclini opened the discourse with an apt rephrasing (conscious or not), of a famous encounter much admired by the surrealists, and invented by the Uruguayan-born French poet the Comte de Lautréamont: "the unexpected meeting, on a dissecting table, of a sewing machine and an umbrella."[147] "How can one understand," says García Canclini in the introduction to his book, "the encounter between indigenous artifacts and vanguard art catalogues on the table of a television set? What are painters seeking when they quote in the same painting pre-Columbian and Colonial images with those of the culture industry, which they then reconfigure using computers and lasers?" (p. 14). The media of electronic communications, which seem designed to replace those of fine art and of folklore, are broadcasting the latter on a massive scale. Even in the developed countries rock and classical music are being renewed through fusion with popular Asian and African American melodies, while many people have records and cassettes which combine classical music with jazz, folk songs, tango or salsa, including composers like Piazzola, Caetano Veloso, and Rubén Blades. Just as there is no abrupt break between the traditional and the modern, there is also none between the fine, popular, and mass media arts. It is this process which García Canclini denominates as "hybridization," a term which he prefers to others such as syncretism or *mestizaje* because it can connote diverse intercultural mixes (not just the racial one of *mestizaje*) and is more flexible than syncretism, which is usually a reference to religious fusions or traditional symbolic movements. Furthermore, it can include modern forms (pp. 14–15, n. 1).

Considering the above, García Canclini sets forth three hypotheses for consideration. The first suggests that since no strict division exists between the traditional and the modern, or between fine, popular, and mass culture, it is necessary to ascertain if their hybridization can be best understood through the disciplines that customarily study them (art and literary history for fine art; folklore and anthropology for the popular; and communications studies for mass media), or whether what is required are "nomadic" social sciences that can circulate among them and consider them on a horizontal plane rather than at three vertical levels. The second hypothesis is that by working with these disciplines it is possible to conceive of Latin American modernization in a different manner. Rather than being a foreign and dominant force that would act as a substitute for the traditional and the regional, it would act as a form of renovation in

which diverse sectors would be in charge of their own multitemporal heterogeneity. A third direction would argue that such a transdisciplinary look at the hybrid circuits might break the boundaries of cultural research altogether. An explanation of why there is a coexistence of ethnic cultures and new technologies, of crafts and industrial production, might make clear various political processes. The study of cultural heterogeneity might help explain how both popular and elite groups combine modern democracy and archaic power relationships, how liberal institutions and authoritarian habits can intermingle, and how they carry on transactions between themselves.

Finally, García Canclini engages the question of the concurrent existence of modernity and postmodernity, which latter is understood as a break with the former. Above all, he engages the thesis that the conflicts between cultural modernism and social modernization (which are being debated in Latin America) lead either to a deficient version of modernity as canonized by the metropolis, or to its inverse: that Latin America, by being the home of pastiche and *bricolage* in various epochs and aesthetic systems, has been postmodern in its own way for many centuries. Neither the paradigm of imitation, nor that of originality, nor the theory that attributes everything to dependency, nor the dangerous concept that explains Latin America through "marvelous realism" or Latin American surrealism have taken note of the existence of hybrid cultures.

To conclude the present exploration of theory, I would like to consider the debate concerning "multiculturalism"—a proposition that is completely current in the U.S. as of this writing; has not been, and may never be, fully defined; and remains conflictive. That the problem is a complex one is indicated by Chicano anthropologist Renato Rosaldo:

> Although the official [doctrine] holds that all cultures are equal, an informal filing system more often found in corridor talk than in published writings classifies cultures in quantitative terms, from a lot to a little, from rich to poor, from thick to thin, and from elaborate to simple. Variables . . . define greater and lesser "degrees" of culture in a manner that tacitly derives from notions of "high culture" as measured in opera houses, art museums, and canonical lists of great works [in contrast to] cultural minorities who are cultural, not "rational."[148]

The multicultural discourse is, by its very nature, linked with postmodernism. It began (unnamed) by the 1970s when the new immigration policies of the U.S. government had changed the demographic patterns of the nation by allowing the entry of hitherto inadmissible numbers of (among others) Latin Americans and Asians, many coming here as a result of North American imperial policies. By the 1980s, people from these groups—becoming aware of endemic U.S. racism and nativism, es-

pecially during times of economic stress—were also alerted to the civil rights struggles of long-resident minorities such as African Americans, Latinos, and Native Americans on issues of race, ethnicity, and political and economic opportunity. Within this historical conjuncture, the political and cultural boundaries that had long determined the meaning of race, ethnicity, and cultural politics began to shift. First, the legacies of anti-colonial and postcolonial struggles ruptured the ability of Eurocentric discourses to marginalize and erase the many-faceted voices of those "Others" who fought the yoke of colonial oppression. Second, the population of North America's (now swelling) subordinated groups was changing the cultural landscapes of U.S. urban centers. Those defined by postmodernism as "Other" started to move from the margin to the center, challenging the view that "people of color" could be relegated to the periphery of everyday life. Third, while people of color were redrawing the cultural boundaries of the urban centers, the boundaries of power appeared to be solidifying in favor of the rich, white middle and upper classes.[149]

Under the Reagan administration's "politics of greed," class and ethnic divisions grew deeper as even the white working class was persuaded that its security was eroded and imperiled by the implementation of affirmative action and other social programs, and undertook to blame its own ills upon the more open immigration policies, the entry of undocumented workers, and the changing nature of national and cultural identity. Thus the legacy of institutional and ideological racism and nativism once again reached a dangerous threshold ("hate crimes" for example), threatening the maintenance of a democratic community.[150]

Simultaneously, the legacy of the 1970s marked the formation of numerous groups during the 1980s and 1990s around issues of racism, ethnicity, gender, sexual preference, ecology, homelessness, immigration policy, imperialist incursions into Third World countries (Central America, Grenada, Panama), the support of racist governments (South Africa), and many other issues. Like the 1960s, the 1980s saw a politicization of cultural workers, now along the lines of the liberating aspects of postmodern theory—what can be called a critique of postmodernism, or a postmodern discourse of resistance.[151]

An example of multiculturalism *avant la lettre* is the case of Costa Rican artist Rolando Castellón, who, in 1974, curated the first Third World show at the San Francisco Museum of Modern Art—an activity he continued for a number of years—mounting the strongest and most effective works of Bay area artists from many races and nationalities. In 1976, the year of the U.S. Bicentennial, Carlos Villa—an art professor of Filipino descent at the San Francisco Art Institute—guest-curated an exhibition titled "Other Sources," which included, according to the catalogue, the work of artists whose heritage was rooted in China, Japan,

Oceania, Central and South America, and Africa.[152] By 1979, photographer Sheila Pinkel of Los Angeles proposed an across-the-board show, "Multicultural Focus: A Photography Exhibition for the Los Angeles Bicentennial," which opened in 1981.[153] New York City took the largest step toward articulating the multicultural paradigm when "The Decade Show: Frameworks of Identity in the 1980s" opened in 1990 as a collaborative project curated and exhibited by the Museum of Contemporary Hispanic Art, the Studio Museum in Harlem, and the New Museum of Contemporary Art. Thus, unlike other badly managed multicultural endeavors, conceptual, financial, and museographic decisions were controlled by the cultural populations concerned.

Finally, Lucy Lippard's book *Mixed Blessings: New Art in a Multicultural America* made a major contribution by focusing on many Third World artists in the United States with a three-track text featuring the author's voice, those of artists, writers, and spokespersons for the various groups, and the captions for the numerous illustrations. Lippard's purpose was not to, per se, identify multiculturalism, or to write a book about the "Other." Rather she chose to demonstrate the ways in which cultures see themselves and others; the ways in which cross-cultural activity is reflected in the visual arts. Additionally, she wished to explore what traces are left by movements into and out of the so-called centers and margins. To offset the concept of the "melting pot" (an ideology which has never really worked, and the U.S. equivalent of "whitening" theory in certain South American countries with Indian and African presences), Lippard undertook to write about "our common 'anotherness.'"[154] She felt that the time was not ripe (if it ever would be) for a nice, seamless narrative about multiculturalism, and warned against sometimes untrustworthy enthusiasms.

By the late 1980s, terms like "multicultural diversity" had begun to appear at mainstream educational and art institutions—though often not understood by administrators as a cultural expansion of the 1970s concept of affirmative action that had been intended originally, on a social plane, to bring discriminated populations and professionals into employment areas previously closed to them.[155] In its time, affirmative action (which coincided with the establishment in academe of Latino, African, Native American, Asian, and women's studies departments) came under attack, and was vitiated and turned back on itself ("reverse discrimination") through legal and ideological modifications. The mainstreaming of multiculturalism similarly marked the start of the bureaucratization and institutionalization of the multicultural concept with a corresponding sequence of practices "marked by appeasement and co-option on the part of the white Western world."[156] Appeasers were those who felt that multiculturalism would make for good politics, and "keep the natives quiet"; while co-opters were those institutions who, after receiving funding for

multicultural projects, felt that white artists, using a process of appropriation, could now do the job.[157]

Three Latin American cultural critics, all residing in the United States, have entered the discourse. They are: Mexican Guillermo Gómez-Peña, U.S.-born literary and cultural critic George Yúdice, of El Salvadoran descent, and Puerto Rican Mari Carmen Ramírez. They represent variants of recent multicultural theory, developed over a period of time and responsive to the permutations taking place as positions along a wide spectrum of pro-and-con multiculturalist opinion become more clearly defined.[158]

The person who made multiculturalism a central motif in his writing has been visual poet Guillermo Gómez-Peña. Best known on the performance art circuit as a "border" artist, he was one of the cofounders of the collaborative Border Art Workshop/Taller de Arte Fronterizo on the San Diego/Tijuana international frontier that captured international attention for the work of a number of artists. For the purposes of this discussion, however, I would like to separate, momentarily, two concepts that are fundamentally linked in Gómez-Peña's writing: that of border propositions; and that of multiculturalism, for which he is a major proponent and critic. In fact, the prefix "multi" is integral to his concepts, as its frequent employment in his writing attests: multicultural, multilingual, multiracial, multiethnic, multimedia, multilayer, multifocal, multiple repertoires, multiple occasions, and so on. "Inter" is another such prefix: interdisciplinary, interchangeable, intercultural, intersection, intermediary, intervene, and so forth. Posited against the "multis" and the "inters" are the negative "monos": monocultural, monolingual, monolithic, monoreality. The cultural fluidity, cultural syncretism, deterritorialization, and transterritorialization implicit in this use of language indicates the separation of ways between modernism and postmodernism.[159] There are no longer fixed boundaries to human experiences and cultural identification. In their own way, Gómez-Peña's prefixes are the equivalent of García Canclini's "hybridism," each within its special construct. The major differences are contained in the fact that Gómez-Peña has lived in the United States since 1978 and accepted into his parameters the border experiences, biliguality, and biculturalism of Southwest Chicanos as a one base of reference, while García Canclini remains based in Mexico and projects his theoretical construct from that location. The latter faces south, toward Latin America, and articulates a theory pertinent to that reality; while Gómez-Peña, though personally tied to Mexico, has rejected it as his primary base of operation and now, as a citizen of the Third World, living, coping, and creating in one of the major centers of the First World, looks outward to Canada and Europe as well as to Latin America. His view of multiculturalism (now changing) has been utopian, beyond that of Chicano artists and intellectuals. The latter emerged

from their early separatist ethos toward a Latino (and Native American) amalgamation, seeing it as a means of empowerment by joining forces within the borders of the United States. They remain skeptical, however, of multiculturalism as a *modus operandi*, and of modern Mexico itself, which has a recent history of rejection toward the culture of its estranged, working-class-cum-artists "children," although ancient and traditional Mexican culture forms a fulcrum of identity reclamation for Chicanos. Knowing and being secure in his own unchallenged identity, though rejecting Mexico's present political and social malaise, Gómez-Peña can afford a postmodern expansionism. Chicanos and Latinos still feel the need to defend their hard-won rights to self-identification and self-articulation in the eyes of the hegemonic powers. These rights are still under question, and under attack. Having barely become symbolic "citizens" of the United States, they are not prepared to become citizens of what they view (often correctly) as a hostile or indifferent world, though they gladly take advantage of offers to exhibit their culture in far-flung corners of the world, from Latin America and Europe to the Middle East. Indeed, they are not even prepared to immerse themselves in the pan-latinamerican-ization that Gómez-Peña advocated in his utopian phase as a connective to the international avant-garde. Their need, as expressed in various recent statements, is to identify themselves as a recognized, valid, and important strand of [North] American life and culture and, as such, to enter the domains of the mainstream, hopefully on their own terms.

George Yúdice presents a different view of multiculturalism. New York-born, and situating himself as "an early actor in the U.S. multicultural movement," he began to develop a "persistent bifocality" when, as an unappointed representative of progressive U.S. cultural politics, he attempted to translate U.S. multiculturalism for his counterparts (progressive intellectuals and activitists) in some Latin American countries.[160] Though he remains an enthusiastic advocate of greater recognition for U.S. cultural diversity in educational and artistic institutions, the media, and other public spheres, his advocacy, correctly, is not simply for *recognition*, but for *access* to all the rights and services that accompany citizenship. He feels that the United States overshot its mark and self-servedly celebrated "American" multiculturalism as isomorphic with the world. He questions the authority of U.S. institutional intellectuals and activists to represent other peoples based on an injunction which stems from U.S. internal identity problems.

At the same time, Yúdice remains critical of total Latin American rejection of multicultural sensitivities. Latin American suspicions, he says, beyond a justified repugnance to U.S. imperialism, often stem from their own unease at undervaluing the cultural diversity of their own societies—especially when that diversity is defined in terms of race, ethnicity, sexual preference, and (I would add) gender.

Yúdice points out that multiculturalism has many varieties, ranging from the "liberal touchy-feely, 'I'm okay; you're okay,' variety to the radical program of seeking justice for those groups who are oppressed in U.S. society" (p. 205). There is also the confusion of feeling that one group can speak knowledgeably for another though separated by time, experience, and geography. "It is not adequate, in my opinion," he says, "to have a U.S. Latino speak for, say, Ecuadorians or an African American for Ghanians" (p. 206). On this point he is in accord with Frantz Fanon (see above), who argued that there are historically based political and cultural differences between entities: between those in the original homeland and those of a diaspora. Multiculturalism must extend its reach to include knowledge of countries of origin quite independently of U.S. identity politics, argues Yúdice.

Yúdice's final cautionary note is directed to the possible global implications of buying into the notion that the U.S. can reconstitute the whole world through multiculturalism. There is no guarantee, he says,

> that multiculturalism will have only progressive effects. Not only is there the problem of a U.S.-based multiculturalism enveloping the cultural production of other countries; worse still, it may unwittingly, despite its resistance to conservative attacks, become a "front" for our own integration into a global market in which the image—the politics of representation—supplants resources and services shrinking at an ever faster pace. (p. 213)

Before engaging the last in the string of argumentations, I should state that providing some information on each of the three writers about their site of origin, background, and their length of stay in the United States fits into the strategy of pinpointing theoretical formulations with a consideration for who is doing the theorizing. It is the same strategy I try to use when considering the artworks of Latin American/Latino artists, and is meant to be resistant to homogenizing of all sorts.

In the case of Mari Carmen Ramírez, her quite extraordinary administration as an energetic and respected director of a Puerto Rican university museum for a number of years, the fact that she was in that position as a very young woman (although middle-class professional women in Latin America generally have encountered far less career resistance than their U.S. counterparts), and the fact that she was university-educated as an art historian in the United States are coupled with the fact that, when she wrote the paper now to be discussed,[161] she had been living and working in the United States for a relatively short period of time. In addition, as a Puerto Rican whose country exists in a colonial relationship vis-à-vis the United States and has never achieved a postcolonial status, passing directly from Spanish to U.S. domination, she (like most Puerto Rican intellectuals) has a strong nationalist suspicion of that which is U.S.-

engendered. In that regard, she shares the traditional Mexican view, which has always been stronger than that of other Latin American nations because of its contiguity to the "giant of the North," tempered by the fact that Mexico has long been a sovereign nation while Puerto Rico is located in limbo, accepted in full partnership by neither Latin nor North America.

Ramírez premises her position on the fact that, with the second highest growth rate in the United States, the Latin American community is destined to assume a protagonist role in the process of multicultural reconfiguration of U.S. society. The importance of this emerging dynamic of cultural exchange is that it promises to redefine the image of Latin American/Latino art and culture from *inside* the dominant center. In this sense, multiculturalism (and the market, I should add) has caused a considerable opening up of educational and cultural organizations to these marginal groups, though principal institutions still resist acceptance within *their* established canon.

Nevertheless, serious problems exist, according to Ramírez, problems originating in the ambivalence and contradictions of the multicultural model itself, especially when it is approached indiscriminately. Among the problems is the blurring, or homogenization, of the distinctive traits that constitute Latino/Latin American identity in the United States context; another is the lack of recognition that a significant difference exists between U.S. minority artists and those of the peripheral nations of Latin America—the former developed on the margins of North American culture (the Center) while the latter found their identity as citizens of the Periphery itself. Within the definitions of multiculturalism, Ramírez argues, it is difficult to explain the phenomenon of Central, South American, and Caribbean artists whose identities are grounded in the traditions of their countries of origin but whose artistic development has benefited from the expanded opportunities provided by their life in metropolitan centers.[162] Among the South or Central American artists with extended residence in the United States, for example, the majority resist integration into North American culture. Instead they take on a double identity: that of their countries of origin and that of their country of permanent residence. As such, they can participate in national and international exhibitions as representatives of one or the other. At the same time, they function as part of the art history and museum collections of their nation of origin, and traffic back and forth—living an identity suspended between two waters. In other words, if multiculturalism has, as one of its functions, the integration of diverse populations into an egalitarian fabric with many more strands than the earlier melting pot ideology but still ordered by a central homogenizing canon, then its efficacy will be no more viable than the latter as a key to the representation of diversity.

Finally, Ramírez dissects the problematic of *difference* as elaborated by

multicultural theory. In general terms, she says, multiculturalism fore-grounds the racial, ethnic, and cultural difference of marginal groups as a value in itself, irrespective of whether in practice it is true or not. This premise has, at times, led these artists to express themselves in terms of difference alone, which, in itself, legitimizes their inclusion and egali-tarian acceptance in the new "center." The devolution of this argument depends on the fact that the directors and curators of mainstream insti-tutions make the selections from the broadened field of artistic possibili-ties based on their existent standards and canons. In order to underline the fact that multicultural policy mandates diversity, curators tend to choose works that illuminate the differences of that diversity while art-ists, opting for mainstream acceptance, express themselves in terms of that difference. In both cases, there exist the dangers of stereotyping and encouraging the self-stereotyping of entire *groups*. Or as Ramírez puts it:

> The problems associated with the celebration of *difference* are ulti-mately related to the mainstream's function as interlocutor and le-gitimizer of the *difference* that marks marginality. In other words, this dynamic can only function if there exists an "other" who will authorize this *difference*, a situation that continues to perpetuate both the division between "us" and "them" and the inequality through which *difference* can function autonomously.[163]

As Renato Rosaldo has commented, although the notion of "difference" has the advantage of making culture particularly visible to outside ob-servers, it poses a problem because such differences are not absolute. They are relative to the cultural practices of ethnographers (substitute museum directors, art curators, and critics). Such studies highlight cultural forms that diverge from (tacitly normative) North American middle-class professional ones." The temptation to dress one's own 'local knowledge' of either the folk or professional variety in garb at once 'uni-versal' and 'culturally invisible' to itself seems to be overwhelming."[164]

My position on multiculturalism (as on the other topics raised above) has been injected in and around the summations of history and theory as they were presented. Speaking independently, my own opinion on multi-culturalism appears in an article reprinted in this collection, however it bears repeating in this specific context:

> The true hybridization and cross-culturalism that can rally different viewpoints amd aesthetic configurations around common issues and that can realistically define a multicultural American continent with comprehension of the confrontation which is taking place (and must take place) between the forces of power and the disempowered has not yet occurred. As a result, the hegemonic power is able to confuse and disorient this new inclusive democratic urge repre-

sented by the term multiculturalism. The symbolic and *Realpolitik* social meanings of multiculturalism are obscured. . . . The idealists don't always understand that inclusion is not sufficient—that access to power, decision making, and funds must be included. A retranscription of past cultural history is simply not sufficient.[165]

There has been a careful sifting of these issues, raised in various ways, throughout this Introduction. It has focused more precisely on the Latin American section within which modernity and postmodernity find their commentators and critics The contradictions that exist between the Center(s) and the Periphery(ies) are spelled out in different historical periods, and those between Eurocentrism and nonwesternism are posed. It also has presented a tentative and schematic outline of the issues and concepts that continue to preoccupy Latin Americans and Latinos during the last two decades of the twentieth century and of the millennium. Of equal importance is the fact that these are not sterile, abstract questions safely left to ivory-towerists. They concern real situations, social problems, and issues of power that need to be articulated in the arts, as well as in the realms of politics and the social sciences. These are decades fraught with unanticipated changes, with the rise and the fall of egalitarian and democratic hopes for the majority of the world's population, which is non-European and non-white, with the building of new configurations on grassroots levels, and with new inclusionary precepts necessary to human survival.

Notes

1. Naín Nómez, "On Culture as Democratic Culture in Latin America," *Studies in Latin American Popular Culture*, no. 2 (1983): 175.

2. Néstor García Canclini, "Culture and Power: The State of Research," *Media, Culture and Society* 10 (1988): 478.

3. Julianne Burton (ed.), *Cinema and Social Change in Latin America: Conversations with Filmmakers* (Austin: University of Texas Press), ix.

4. Renato Rosaldo, *Culture and Truth: The Remaking of Social Analysis* (Boston: Beacon Press, 1989), 202.

5. Frantz Fanon, *The Wretched of the Earth*, trans. by Constance Farrington (New York: Grove Press, 1968), 209.

6. George Yúdice, Jean Franco, and Juan Flores (eds.), *On Edge: The Crisis of Contemporary Latin American Culture* (Minneapolis: University of Minnesota Press, 1992), ix.

7. Eric R. Wolf, *Europe and the People without History* (Berkeley: University of California Press, 1982), 385.

8. Eduardo Galeano, *Open Veins of Latin America: Five Centuries of the Pillage of a Continent*, trans. by Cedric Belfrage (New York: Monthly Review Press, 1973), 12.

9. Wolf, *Europe and the People without History*, 387.

10. Wolf, *Europe and the People without History*, 387.

11. Ticio Escobar, "Identity and Myth Today/Identidad, mito: Hoy," *Third Text*, no. 20 (Autumn 1992): 26 passim.

12. See Adelaida de Juan, "Actitudes y reacciones," in Damián Bayón (ed.), *América Latina en sus artes* (Mexico City: Siglo Veintiuno Editores, 1974), 34–44.

13. Not to put too idealistic a gloss on this concern, the seemingly benign plans to integrate Indian peoples meant their absorption into the "national culture" and into its working class, at the cost of losing their own cultural identities, communal independence, and, possibly, whatever lands they still owned. Indigenous groups did not accept this process any more passively in the twentieth century than they did during the Spanish Conquest. See Guillermo Bonfil Batalla (ed.), *Utopía y revolución: El pensamiento político contemporáneo de los indios en América Latina* (Mexico City: Editorial Nueva Imagen, 1981).

14. Jean Franco, *The Modern Culture of Latin America: Society and the Artist*, rev. ed. (Harmondsworth: Penguin Books, 1970), 140.

15. Franco, *The Modern Culture of Latin America*, 139–40.

16. Orlando S. Suárez, *Inventario del muralismo mexicano (Siglo VII a. de C.)* (Mexico, D.F.: Universidad Autónoma de México, 1972).

17. See Shifra M. Goldman, *Contemporary Mexican Painting in a Time of Change* (Austin: University of Texas Press, 1981); Peter Selz (ed.), *New Images of Man* (New York: Museum of Modern Art, 1959); Barry Schwartz, *The New Humanism: Art in a Time of Change* (New York: Praeger Publishers, 1974); Félix Angel, "The Latin American Presence," subsection on "The Argentine New Figuration Painters: Ernesto Deira, Romulo Macció, Luis Felipe Noé, and Jorge de la Vega," in *The Latin American Spirit: Art and Artists in the United States, 1920–1970* (New York: Harry N. Abrams), 258–63; Laura Linares and Keneth Kemble, "El movimiento artístico que marcó una época: Otra Figuración 20 años después," *La Nación* (Buenos Aires), March 1, 1981: 12–15; Jorge López Anaya, "Teoría y práctica de la neofiguración," *Revista de Estética* (CAYC, Buenos Aires), no. 3 (1984): 51–60; and Daisy Valle Machado Peccinini de Alvarado, *Novas figurações, novo realismo e nova objetividade. Brasil anos '60*, unpublished Ph.D. dissertation, São Paulo, 1987.

18. The term Chicano began to be used in the 1960s as a special self-designation for young Mexican Americans (born or largely raised in the United States) who wished to separate themselves from what they viewed as the assimilationist tendencies of their forebears. Stressing their Indo-American roots was the designation of the Southwest United States (territory taken from Mexico and home to the greatest concentration of Mexican Americans) as Aztlán, the mythical site of origin of the Aztecs, while the term *raza* (or "our people") was commonly used for Latinos in general. For further definition in the field of art, see "Revelando la imagen/Revealing the Image," in Shifra M. Goldman and Tomás Ybarra-Frausto, *Arte Chicano: A Comprehensive Annotated Bibliography of Chicano Art, 1965–1981* (Berkeley: Chicano Studies Library Publications Unit, University of California, Berkeley, 1985), 3–55; and the catalogue *Chicano Art: Resistance and Affirmation: 1965–1985* (Los Angeles: Wight Art Gallery, University of California, Los Angeles, 1991).

19. O'Higgins (1904–83) was born in Salt Lake City, Utah; Belkin (1930–92) was born in Calgary, Canada.

20. The most complete information about the new muralism of the 1970s and 1980s is contained in *Community Murals Magazine*, published under various names from 1978 to 1987, edited by Tim Drescher; Eva Cockcroft, John Weber, and James Cockcroft, *Toward a People's Art: The Contemporary Mural Movement* (New York: E.P. Dutton & Co., 1977); and Alan W. Barnett, *Community Murals: The People's Art* (Philadelphia: The Art Alliance Press, 1984).

21. For Nicaragua, see Eva Cockcroft and David Kunzle, "Report From Nicaragua," *Art in America* 70, no. 5 (May 1982): 51–59; David Craven and John Ryder, *Art of the New Nicaragua*, privately printed, 1983; and David Craven, *The New Concept of Art and Popular Culture in Nicaragua since the Revolution in 1979* (Lewiston, New York: The Edwin Mellen Press, 1989). For Chile, see David Kunzle, "Art in Chile's Revolutionary Process: Guerilla Muralist Brigades, *New World Review* 61, no. 3 (1973), and "Art of the New Chile: Mural Poster and Comic Book in the 'Revolutionary Process'," in Henry A. Millon and Linda Nochlin (eds.), *Art and Architecture in the Service of Politics* (Cambridge: MIT Press, 1978), 356–81. Since the Sandinista government was voted out of office, new bureaucrats have had some murals destroyed. See David Kunzle's book-in-preparation, *Murals of Revolutionary Nicaragua, 1979–1991/92*.

22. A controversial twenty-three-panel mural, painted by Ecuadorean Oswaldo Guayasamín on the front wall of the Plenary Hall of the National Congress in Quito, penetrated U.S. news. Trouble with the 1600-square-foot mural began in August 1988, when the mural was unveiled, revealing a Nazi-style helmet inscribed "CIA" and enclosing a skeletal face. Despite U.S. insistence that the section be removed, the artist (and the government of Ecuador) have refused. See Frank Fitzgerald and Ana Rodríguez, "Guayasamín: Artless Power vs. Powerful Art," *Report on the Americas* 23, no. 2 (July 1989): 4–6; James F. Smith, "The Painter and the Yanquis," *Los Angeles Times*, November 29, 1989, Calendar Section: 1ff.

23. See Susan Sontag, "Posters," in Dugald Stirmer (ed.), *The Art of Revolution* (New York: McGraw Hill Book Co., 1970), xii–xxiii; David Kunzle, "Uses of the Portrait: The Che Poster," *Art in America* 63, no. 5 (September-October 1975): 63–73; David Kunzle, "Nationalist, Internationalist and Anti-Imperialist Themes in the Public Revolutionary Art of Cuba, Chile and Nicaragua," *Studies in Latin American Popular Culture* 2 (1983): 141–57; Damián Bayón, "La mejor plástica de una nueva cultura: El afichismo cubano," *Sin Nombre* (San Juan, Puerto Rico), 68–71; Felix Beltrán, "The Poster and National Consciousness," *Art and Artists*, (February 1983): 10–11.

24. John Garrigan, "Introduction," *Images of an Era: The American Poster 1945–75* (Washington, D.C., Smithsonian Institute, 1975), 10.

25. Deborah Wye, *Committed to Print: Social and Political Themes in Recent American Printed Art* (New York: The Museum of Modern Art, 1988).

26. Jorge Romero Brest, *El arte en la Argentina: Ultimas décadas* (Buenos Aires: Paidós, S.A., 1969), 108–10.

27. Marta Traba, *Dos décadas vulnerables en las artes plásticas Latinoamericanas 1950–1970* (Mexico City: Siglo Veintiuno editores, 1973).

28. Nelly Richard, "Margins and Institutions: Art in Chile Since 1973, *Art &*

Text 21 [n.d., 1986]; Guy Brett, "Hélio Oiticica: Reverie and Revolt," *Art in America* 77, no. 1 (January 1989): 110–120+; Brett, *Transcontinental: An Investigation of Reality, Nine Latin American Artists*, Ikon Gallery (London: Verso, 1990); Mari Carmen Ramírez, "Re-Installing the Echo Chamber of the Past," in *Encounters/Displacements: Luis Camnitzer, Alfredo Jaar, Cildo Meireles*, Archer M. Huntington Art Gallery (Austin, Tex.: University of Texas, 1992), 9–23.

29. See "Recent Latin American Art" in *Art Journal* 51, no. 4 (Winter 1992): 12.

30. See S. Zaneta Kosiba-Vargas, *Harry Gamboa and ASCO: The Emergence and Development of a Chicano Art Group, 1971–1987*, unpublished Ph.D. dissertation, University of Michigan, 1988.

31. Mail art took advantage of the expanded field of graphics. For the Mexican aspect, see Raquel Tibol, *Gráficas y neográficas en México*, (SEP and Universidad Nacional Autónoma de México, 1987), 265–73.

32. Michael Crane, "The Spread of Correspondence Art," in Michael Crane and Mary Stofflet (eds.), *Correspondence Art: Source Book for the Network of International Postal Art Activity* (San Francisco: Contemporary Arts Press, 1984), 148. Mexican usages of graphics and mail art can be seen in the publications accompanying two large exhibitions: "América en la mira: Muestra de gráfica internacional" (see catalogue of same name—Mexico City: Frente Mexicano de Trabajadores de la Cultura, 1978), which, as the title suggests, offers international views of the Americas, and "Testimonios de Latinoamérica: Comunicaciónes visuales alternativas," which is featured in *La Semana de Bellas Artes*, Instituto Nacional de Bellas Artes, no. 43, (September 27, 1978), and which exhibited artists from Mexico, Brazil, Colombia, Argentina, Chile, Uruguay, Venezuela, and Guatemala.

33. Quoted by Edgardo-Antonio Vigo, "The State of Mail Art in South America," in Crane and Stofflet, *Correspondence Art*, 350.

34. Geoffrey Cook, "The Padín/Caraballo Project," in Crane and Stofflet, *Correspondence Art*, 369. Cook, a North American, despite the criticism of what he calls "the academic sections of the mail art community," was one of two prime organizers who attempted to channel the mail art network's protest and rage into constructive action by addressing their respective governments and that of Uruguay. As a result of U.S. and French government intervention, Padín and Caraballo were both paroled, though prohibited from continuing their mail art activities for a period. Undaunted, Padín has continued to be a visual poet in a political vein, and after the fall of the dictatorship, has taken to the streets with visual commentary and actions.

35. Telephone conversation with the artist, January 22, 1991. See the catalogue *Rafael Montañez Ortiz: Years of the Warrior 1960; Years of the Psyche 1988*, El Museo del Barrio, 1988. Ortiz was the first director of the Museo, which is housed in and serves the New York Puerto Rican community.

36. See Stewart Home in "Gustav Metzger and Auto-Destructive Art," in Home's *The Assault on Culture: Utopian Currents From Lettrisme to Class War* (Stirling, Scotland: AK Press, 1991), 60–64. There are also chapters on Fluxus and mail art providing the political programs of these movements usually omitted in U.S. publications.

37. In 1965 the nationalist and racist biases of the 1952 McCarran-Walter Immi-

gration and Nationality Act were amended to allow immigration by hemisphere rather than by national quota. This change permitted the influx of Asians, Latin Americans, and Africans, previously excluded in favor of immigrants from northern and western Europe. According to the 1990 Census, Latinos form 24 percent of New York City's population (almost two million of the over seven million residents), making New York the largest Latino city in the country after Los Angeles. Puerto Ricans, the oldest and largest community in New York, represent more than half the city's Latinos. See Annette Fuentes, "New York: Elusive Unity in La Gran Manzana," *NACLA Report on the Americas* 26, no. 2 (Sept. 1992): 27–28.

38. See Carla Stellweg, "'Magnet—New York': Conceptual, Performance, Environmental, and Installation Art by Latin American Artists in New York," *The Latin American Spirit: Art and Artists in the United States, 1920–1970* (New York: The Bronx Museum of the Arts, 1988), 284–311. For a detailed account of political art by Latin Americans in the same period, see Eva Cockcroft's "The United States and Socially Concerned Latin American Art," in the same publication, 184–221.

39. For a report on the changing roles of Chicanos, see Shifra M. Goldman, "Updating Chicano Art: The 'CARA' Show in Retrospect," *New Art Examiner* 20, no. 2 (October 1992): 17–20.

40. Guillermo Gómez-Peña, "A New Artistic Continent," in Philip Brookman and Guillermo Gómez-Peña (eds.), *Made in Aztlan* (San Diego: Central Cultural de la Raza, 1986), 86.

41. Meyer Schapiro, "The Social Bases of Art" (1936), in David Shapiro (ed.), *Social Realism: Art as a Weapon* (New York: Frederick Ungar Publishing Co., 1973), 118–19.

42. Arnold Hauser, *The Philosophy of Art History* (Cleveland: Meridian Books, [1958] 1961), vi.

43. Néstor García Canclini: *La producción simbólica: Teoría y método en sociología del arte* (Mexico City: Siglo XXI Editores, S.A., 1979), 54, n. 27 (translation mine). Nicos Hadjinicolaou, writing prior to 1973, argued that the (structural-functionalist and/or Weberian) sociology of art, which came into being at the beginning of the twentieth century as part of general sociology but with no connection to art history, did not yet exist as an independent discipline because it had no distinct subject matter. Until it established a material historical base, it did not qualify as an accurate sociology of art. *Art History and Class Struggle*, trans. by Louise Asmal (London: Pluto Press, [1973],1978), 54. On the sociological distinctions made by Hadjinicolaou, see Janet Wolff, *The Social Production of Art* (New York: New York University Press, [1981], 1984), 6.

44. Millon and Nochlin, "Introduction," *Art and Architecture in the Service of Politics*, viii.

45. Millon and Nochlin, "Introduction," *Art and Architecture in the Service of Politics*, viii.

46. See the extensive bibliography of books and articles on art and politics, written primarily in the 1970s, listed in Millon and Nochlin, note 2, p. x.

47. Albert Boime, *Art in an Age of Revolution, 1750–1800* (Chicago: University of Chicago Press, 1987), xx.

48. T. J. Clark, *Image of the People: Gustave Courbet and the Second French*

Republic 1848–1851 (Greenwich: New York Graphic Society Ltd., 1973), 10–11 passim.

49. Sociology has developed beyond what is called "reflection theory." The ideological character of works of art and cultural products is recognized to be extremely complex, mediated by the existence and composition of social groups and by the nature of their ideologies and consciousness. Wolff, *The Social Production of Art*, 60.

50. Dependency theory is based on the assumption that underdevelopment is structurally linked to development in the dominant nation and that the specific forms of dependency in Latin America at any given historical period are shaped by the characteristics of the international system and of Latin America's function within it. This argument looks at economics as a world system; any inherent psychological defects or lack of capital on the part of underdeveloped countries is not in question. Dependency theory considers the colonial period as one which falls into the mercantilist phase of the international system; the colonial period as a financial-industrial phase of the nineteenth century; and the technical-industrial phase after World War II, when multinational corporations developed satellite industries in the underdeveloped world using cheap labor—a period in which marginalized Latin American populations were brought into a consumer culture. Jean Franco, "Dependency Theory and Literary History: The Case of Latin America," *Minnesota Review*, no. 5 (Fall 1975): 67–68.

51. In a book published well after mine was written, Chilean mass communications theoretician Armand Mattelart (and his collaborators), commenting on dependency theory, say the following, with which I concur: "The notion of cultural imperialism and its corollary 'cultural dependence' is clearly no longer adequate. Historically, these two notions were an essential step in creating an awareness of cultural domination." Armand Mattelart, Xavier Delcourt, and Michele Mattelart, *International Image Markets: In Search of an Alternative Perspective* (London: Comedia Publishing Group, 1984), 25.

52. Goldman and Ybarra-Frausto, *Arte Chicano*, 3–59.

53. Goldman and Ybarra-Frausto, *Arte Chicano*, 10.

54. Introduction by Shifra M. Goldman and Luis Camnitzer to the *Art Journal* issue *The Columbus Quincentenary and the Art of Latin America* 51, no. 4 (Winter 1992): 18. I share the feelings articulated by Lucy Lippard when she mentions the "uneasy situation of First World critics" writing about the Third World: white critics who, if they talk too much, are seen as taking over, or if they shut up, are seen as condescending onlookers. *Mixed Blessings: New Art in a Multicultural America* (New York: Pantheon Books, 1990), 9–10. In my experience, this arises among the embattled "minorities" of the United States whose historical and well-founded distrust of the dominant white society permits the conquerors to divide them from potential allies of all colors and ethnicities. I have rarely encountered this attitude among artists and intellectuals raised in Latin America. There, disagreements or animosities are more often based on class and ideological differences, or openly self-serving postures, rather than on race or ethnicity.

55. Lippard, *Mixed Blessings*, 3.

56. One of the most absorbing accounts of the process of intellectual realignment in the United States is Serge Guilbaut's book *How New York Stole the Idea*

of Modern Art: Abstract Expressionism, Freedom and the Cold War, trans. by Arthur Goldhammer (Chicago: University of Chicago Press, 1983).

57. Arnold Hauser, *The Social History of Art*, trans. by Stanley Godman, first published in England in 1951 through the intercession of Herbert Read, then an editorial adviser to Routledge and Kegan Paul, was printed in the United States by Alfred A. Knopf. The first paperback edition in four volumes appeared in 1957 by Random House's Vintage Books (New York), and it was last issued in 1985.

In the 1960s, I came across John Howard Lawson (one of the "Hollywood Ten") and his book *Film: The Creative Process: The Search for an Audio Visual Language and Structure* (New York: Hill and Wang, 1964), which included a brief history of film (the last art form discussed by Hauser), as well as aesthetic and theoretical sections. The plays of Bertolt Brecht appeared in reprints; and by 1968, essays by Walter Benjamin, including his influential "The Work of Art in the Age of Mechanical Reproduction," made their appearance in English translations. Ernst Fischer's *The Necessity of Art: A Marxist Approach*, trans. Anna Bostock (Harmondsworth: Penguin Books, 1963) and (at the time I was reading Sartre, Camus, and Heidegger) Sidney Finkelstein's *Existentialism and Alienation in American Literature* (New York: International Publishers, 1965) were also available. Through an interest in the history of philosophy, I came across Harry K. Wells, *Pragmatism: Philosophy of Imperialism* (New York, International Publishers, 1954); the same publisher in 1971 issued *Selections From the Prison Notebooks of Antonio Gramsci*, translated and edited by Quintin Hoare and Geoffrey Nowell Smith, where I found the important essay on the formation of intellectuals.

These readings provided the "seasoning," so to speak, for standard art histories and theoretical texts on the history of aesthetics from Aristotle to Worringer. On the major topic in which I was interested, modern Mexico, there was little in English that could be purchased except for Bernard S. Myers's admirable book *Mexican Painting in Our Time* (New York: Oxford University Press, 1956). All the rest had to be located in libraries outside of UCLA, or outside the United States.

58. UCLA art historian Albert Boime has projected a five-volume series known as *A Social History of Modern Art*, of which two volumes, *Art in an Age of Revolution, 1750–1800* (1987) and *Art in an Age of Bonapartism, 1800–1815* (1990), have been published by the University of Chicago Press.

59. H. W. Janson, *History of Art: A Survey of the Major Visual Arts from the Dawn of History to the Present Day* (Englewood Cliffs, N.J.: Prentice-Hall, reissued by Anthony F. Janson in the 4th rev. ed., 1991). It is significant that Helen Gardner's *Art through the Ages: An Introduction to Its History and Significance*, which first appeared in 1926, included Asian, Islamic, Native America, African, and Oceanic art, though not beyond antiquity in some cases and not beyond the eighteenth century in others. Art of the United States was also included through the twentieth century by the 1936 edition. (New York: Harcourt, Brace and Co., 1936). It is noteworthy that the preface to the 1936 edition emphasizes that the artworks are organized chronologically, and are analyzed for the "more important geographic, social, political and religious conditions which determine the kind and character of art produced"(p. iv). With the publication of the fifth (1970) and sixth (1975) editions by Horst de la Croix and Richard G. Tansey (Gardner died in

1946), "style" had become the major focus, with iconography, artist biographies, and historical context as appendages. (See sixth edition, pp. 2–19). Correspondingly, the book's title was changed to *Gardner's Art through the Ages*, and the concern with history and significance was dropped. Janson's and Gardner's histories—both revised posthumously—are the major competitors as survey textbooks in the United States.

60. Janson, *History of Art*, 4th ed., 86.

61. Janson, *History of Art*, 89–90.

62. Oliver W. Larkin, *Art and Life in America*, rev. ed. (New York: Holt, Rinehart and Winston, 1964), v.

63. Larkin, *Art and Life in America*, 409.

64. Larkin, *Art and Life in America*, 409.

65. In 1986, the one hundredth birthday of Diego Rivera was celebrated in both Mexico and the United States. In addition to the retrospective organized by the Detroit Institute of Arts with a handsome, well-researched catalogue, two publications dealt specifically with the destroyed Rockefeller Center mural. One was a personal memoir by Rivera's New York assistant, Lucienne Bloch, "On Location with Diego Rivera," *Art in America* 74, no. 2 (February 1986): 102–23; the other a valuable book containing bilingual newspaper clippings surrounding the event: Irene Herner de Larrea et al., *Diego Rivera: Paraíso perdido en Rockefeller Center* (Mexico City: Edicupes, S.A., 1986). See also Laurance P. Hurlburt, *The Mexican Muralists in the United States* (Albuquerque: University of New Mexico Press, 1989), 159–74. Rivera's destroyed mural could not be reclaimed; the artist's solution was to paint a similar version on the top floor of Mexico's Palacio de Bellas Artes, where it can be seen to this day.

66. Among the publications are Max Kozloff, "American Painting during the Cold War," *Artforum* 11, no. 9 (May 1973): 43–54; William Hauptman, "The Suppression of Art in the McCarthy Decade," *Artforum* 12, no. 2 (October 1973): 48–52; Eva Cockcroft, "Abstract Expressionism: Weapon of the Cold War," *Artforum* 12, no. 10 (June 1974): 39–41; Jane de Hart Mathews, "Art and Politics in Cold War America," *American Historical Review* 81, no. 4 (October 1976): 762–87; Goldman, *Contemporary Mexican Painting in a Time of Change*, 29–35; Frances Pohl, "An American in Venice: Ben Shahn and United States Foreign Policy at the 1954 Venice Biennale, or Portrait of the Artist as an American Liberal," *Art History* 4, no. 1 (March 1981): pp. 80–113. Kohl eventually incorporated this article into her monograph *Ben Shahn: New Deal Artist in a Cold War Climate, 1947–1954* (Austin: University of Texas Press, 1989). Shahn was not only a muralist in his own right, but knew Rivera, Orozco, and Siqueiros during the periods these artists were in New York. Cockcroft and Goldman direct their attention to the cold war and Latin American art.

As in all fields, a new generation of thinkers are reassessing and updating our understanding of cold war culture in broader and more sweeping terms. *Recasting America: Culture and Politics in the Age of the Cold War*, edited by Lary May (Chicago: University of Chicago Press, 1989), is such an anthology.

67. Interview with Carlos Villa, first a student and then an instructor at the San Francisco Art Institute, July 1989. For details on the return of the figurative mode in California—which eventually connected with the Mexican neofigurative movement in the 1960s—see Peter Plagens, *Sunshine Muse: Contemporary Art*

on the West Coast (New York: Praeger Publishers, 1974), 56–66. Plagens graphi-
cally details the anticommunist cultural atmosphere in southern California from
the time of the Siqueiros mural whitewash until the end of the 1950s: pages
21–23.

68. Letter to author from Emmanuel Montoya, January 8, 1983, flyer announc-
ing the opening of the restored mural to the public in 1983, and a 1983 brochure
reproducing the mural with numbers identifying the scenes and the persons
painted taken from a 1941 *Life* magazine reproduction used by Emmy Lou Pack-
ard to restore the mural in 1962.

69. The fresco restoration was funded by Equitable Life Assurance Society in
1988, though the New School had been seeking monies for restoration since the
early 1970s. In 1984, Equitable had purchased, restored, and hung in their New
York corporate headquarters the murals painted for the New School in 1930 and
1931 by Thomas Hart Benton. See "Orozco Unveiled," *Art in America* 76, no. 11
(November 1988): 216. Like a beacon in time, 1953 marked the covering of the
Orozco mural in New York and the cancellation of an Orozco exhibition at the
new art gallery of the University of California, Los Angeles, the latter owing to
the protest of a political science professor. The Pasadena Art Institute thereupon
sponsored the 200-work exhibition. "Orozco Show Banned in L.A.," *Art Digest*
(August 1953).

70. Simone de Beauvoir, *The Second Sex*, trans. H. M. Parshley (New York:
Alfred A. Knopf, 1952); Betty Friedan, *The Feminine Mystique* (W. W. Norton,
1963). By 1966, Friedan organized NOW, the National Organization for Women,
which took feminism out of the realm of theory into political and social action.

71. Fanon, *The Wretched of the Earth*, 224–25.

72. Africa Information Service, *Return to the Source: Selected Speeches of
Amilcar Cabral* (New York: Monthly Review Press, 1973).

73. Paulo Freire, *Pedagogy of the Oppressed*, trans. Myra Bergman Ramos
(New York: Herder and Herder, 1970).

74. In fact, I first taught survey classes on Mexican art in 1966, and on African
and African American art beginning in 1970. The latter was an expanded view
which included art in the Caribbean and Latin America as well as in the United
States. My only publication on African American art is a recent one: *John Out-
terbridge: Sculptor of Oppositions*, catalogue for an exhibition I curated, Rancho
Santiago College Art Gallery, Santa Ana, California, 1992. Part of my critique of
the catalogue *Art in Latin America: The Modern Era, 1820–1980* concerns the
almost casual way in which the presence of Africans in Latin America is treated.
See Shifra M. Goldman, "Identifying Latin American Art: Are the Lines Accu-
rately Drawn?" *Art History* (U.K.) 13, no. 4 (December 1990): 592.

75. The case of Domitilia Barrios de Chungara is one in point. The courageous
wife of a Bolivian tin miner, she was officially invited by the United Nations to
speak at the International Women's Year Tribunal held in Mexico City in 1975.
Mother of seven children, speaker of Spanish and Quechua, she came as a repre-
sentative of the "Housewives Committee of Siglo XX"—the only working-class
woman participating actively as a representative from Bolivia. The goals of U.S.
feminists and those of Latin American women (who saw their liberation in con-
junction with that of their class and nation, men included) were neither com-
patible nor mutually understandable. See Domitilia Barrios de Chungara with

Moema Viezzer, *Let Me Speak! Testimony of Domitilia, a Woman of the Bolivian Mines,* trans. Victoria Ortiz (New York: Monthly Review Press, 1978). As women's voices from Latin America became more frequently heard in the late 1970s and the 1980s, that of Rigoberta Menchú, a speaker of Quiché Maya who acquired Spanish in her role as a leader of Guatemala's besieged Indian communities, also reached publication. Menchú, in exile since 1981, was awarded a Nobel Peace Prize in 1992. See Elisabeth Burgos-Debray (ed.), *I, Rigoberta Menchú: An Indian Woman in Guatemala,* trans. Ann Wright (London: Verso, 1984).

76. Herbert Marcuse, *One Dimensional Man: Studies in the Ideology of Advanced Industrial Society* (Boston: Beacon Press, 1964).

77. Herbert Marcuse. "Art as a Form of Reality," in Edward F. Fry (ed.), *On the Future of Art* (New York: Viking Press, 1970), 123–34.

78. Herbert Marcuse. *The Aesthetic Dimension: Toward a Critique of Marxist Aesthetics* (Boston: Beacon Press, 1978).

79. Herbert Marcuse. *Eros and Civilization: A Philosophical Inquiry into Freud* (Boston: Beacon Press, 1955).

80. Donald Drew Egbert, *Social Radicalism and the Arts: Western Europe. A Cultural History from the French Revolution to 1968* (New York: Alfred A. Knopf, 1970), 73–74.

81. Judith Calvir Albert and Stewart Edward Albert, *The Sixties Papers: Documents of a Rebellious Decade* (New York: Praeger, 1984), 15.

82. Geraldine Obler, *Aspects of Social Protest in American Art: 1963–73.* Unpublished doctoral dissertation, Columbia University Teachers College, 1974.

83. The artists were Poppy Johnson, Jon Hendricks, Laurin Raiken, and Jean Toche, each posing a question. *Kunst und Politik,* "Action Interview of the Guerrilla Art Group on Radio WBAI" (Basel: Kunsthalle, January 24–February 21, 1971), n.p. Reprinted by Obler, *Aspects of Social Protest in American Art,* 45–46. Hendricks and Toche formed a full-time political art group in the United States.

84. Brian Wallis, "Institutions Trust Institutions," in Brian Wallis (ed.), *Hans Haacke: Unfinished Business* (New York: New Museum of Contemporary Art, 1986–1987), 51.

85. See Richard Eells' book, *The Corporation and the Arts* (New York: Macmillan Co., 1967). Addressed to the corporate community, it urges that corporations seek a vital relationship between the contemporary institutions of the corporation and the arts. The ideology engendered in this new approach to "corporate ecology" is typically that of the cold war—that is, that the freedom to create and to innovate in the U.S. are values common to the spheres of art and corporate enterprise.

86. "Potpourri of Protest," *Newsweek,* March 14, 1966: 101.

87. Therese Schwartz, "The Politicalization of the Avant-Garde," *Art in America* 59, no. 6 (November/December 1971): 96–105.

88. Lucy Lippard, *Get the Message? A Decade of Art for Social Change* (New York: E. P. Dutton, 1984), pp 2–3. Lippard's baptism and conversion has continued to the present. Of importance for the present context was the meeting set up in New York with Lippard and others, including a representative of INALSE (the Institute of the Arts and Letters of El Salvador in Exile), which led to the formation of Artists Call Against U.S. Intervention in Central America.

89. Lippard, *Get the Message?*

90. Lippard, *Mixed Blessings*, vii. Her use of the word "America," she explains, refers to the whole continent though it concentrates on art made in the United States.

91. Lippard, *Mixed Blessings*, 3.

92. Long overdue is an accounting of the entire alternative structure established by Latino and Latin American artists and their supporters across the nation, including those run by Chicanos throughout the Southwest and Midwest, and the Cuban Museum of Art and Culture, established in 1982 in Miami, but torn apart by political dissension. An attempt to set up a network of Latino arts organizations funded by the National Endowment for the Arts began in 1978 and foundered in 1981 when the National Endowment withdrew its support. The Task Force on Hispanic American Arts, chaired by Jacinto Quirarte, had representatives from primarily the Chicano and Puerto Rican communities across the nation. For a list of Chicano organizations, spaces, and research facilities, see Goldman and Ybarra-Frausto, *Arte Chicano*, v.

93. See *The Decade Show: Frameworks of Identity in the 1980s*, catalogue (New York: Museum of Contemporary Hispanic Art, The New Museum, The Studio Museum of Harlem, 1990).

94. See Goldman and Camnitzer (eds.), "The Columbus Quincentenary and Latin American Art," *Art Journal* 51, no. 4 (Winter 1992).

95. The Latinamericanization (or Latinization) of the United States has been a subject for cultural critics for at least ten years. The most recent, from a postmodernist viewpoint, can be found in Celeste Olalquiaga's *Megalopolis: Contemporary Cultural Sensibilities* (Minneapolis: University of Minnesota Press, 1992), 76–80.

96. Two books of the 1960s are included here as important signifiers of Berger's innovative criticism which anticipated some of the new analytical currents of the 1970s and 1980s: John Berger, *The Success and Failure of Picasso* (Hammondsworth, Eng.: Penguin Books, 1965); and *Art and Revolution: Ernst Neizvestny and the Role of the Artist in the U.S.S.R.* (New York: Pantheon Books, 1969). Perhaps the most influential use of this type of criticism by Berger is *Ways of Seeing*, based on the BBC television series (New York: Viking Press, 1973). See also Donald Drew Egbert, *Social Radicalism and the Arts, Western Europe: A Cultural History From the French Revolution to 1968* (New York: Alfred A. Knopf, 1970). In 1952, Egbert coedited *Socialism and American Life*, from which his essay *Socialism and American Art in the Light of European Utopianism, Marxism and Anarchism* was published as a book by Princeton in 1967. Other books to be consulted are Ralph E. Shikes, *The Indignant Eye: The Artist as Social Critic in Prints and Drawings From the Fifteenth Century* (Boston: Beacon Press, 1969); Lee Baxandall, *Marxism and Aesthetics: A selective Annotated Bibliography, Books and Articles in the English Language* (New York: Humanities Press, 1973); and Linda Nochlin, *Realism* (Hammondsworth, Eng.: Penguin Books, 1972).

97. Francis V. O'Connor, *Federal Support for the Visual Arts: The New Deal and Now*, 2d ed.(Greenwich, Conn.: New York Graphic Society, 1971; based on a research project commissioned by the National Endowment for the Arts several years after its establishment by Congress, to compare "then" and "now."); Francis V. O'Connor (ed.), *The New Deal Projects: An Anthology of Memoirs* (Washing-

ton, D.C.: Smithsonian Institution Press, 1972); and Francis V. O'Connor (ed.), *Art for the Millions: Essays from the 1930s by Artists and Administrators of the WPA Federal Art Project* (Boston: New York Graphic Society, [1973] 1975).

98. Jacinto Quirarte, *Mexican American Artists* (Austin: University of Texas Press, 1973); Peter Bloch, *Painting and Sculpture of the Puerto Ricans* (New York: Plus Ultra Educational Publishers, 1978). Patricia L. Wilson Cryer's unpublished doctoral dissertation, *Puerto Rican Art in New York: The Aesthetic Analysis of Eleven Painters and Their Work*, New York University, 1984, is also of interest, though more limited in scope.

99. Most notable are *Hispanic Art in the United States: Thirty Contemporary Painters and Sculptors*, catalogue (New York: Abbeville Press, 1987); *The Latin American Spirit: Art and Artists in the United States, 1920–1970*, catalogue (New York: Harry N. Abrams, 1988); *The Decade Show*, 1990; *Chicano Art: Resistance and Affirmation, 1965–1985*, catalogue (Los Angeles: Wight Art Gallery, University of California, Los Angeles, 1991).

100. See reviews of Donald Preziosi's *Rethinking Art History: Meditations on a Coy Science* (New Haven: Yale University Press, 1989): David Whitney in *Art Bulletin* 72 (March 1990): 156–66; and Thomas Crow, "Art History as Tertiary Text," *Art in America* 78, no. 4 (April 1990): 43, 45.

101. Annette Michelson, Rosalind Krauss, Douglas Crimp, Joan Copjec (eds.), *October: The First Decade, 1976–1986* (Cambridge, Mass.: MIT Press, 1987), ix.

102. Brian Wallis (ed.), *Art After Modernism: Rethinking Representation* (New York: New Museum of Contemporary Art, 1984); Russell Ferguson et al. (eds.), *Out There: Marginalization and Contemporary Culture* (New York: New Museum of Contemporary Art, 1990); Russell Ferguson et al. (eds.), *Discourses: Conversations in Postmodern Art and Culture* (New York: New Museum of Contemporary Art, 1990).

103. Raquel Tibol, *Historia general del arte mexicano: Epoca moderna y contemporánea* (Mexico City: Editorial Hermes, S.A., 1964). Unless otherwise indicated, all translations from Spanish- and Portuguese-language titles are mine.

104. Just a few titles from Tibol's vast production include the books *Siqueiros: Introductor de realidades* (Mexico City: Empresas Editoriales, 1969); *David Alfaro Siqueiros: Der neue mexikanische Realismus. Reden und Schriften zur Kunst* (Dresden: VEB Verlag der Kunst, 1975); *Pedro Cervantes* (Mexico City: Secretaría de Educación Pública, 1974); *Diego Rivera: Arte y política* (Mexico City: Editorial Grijalbo, 1979); *Hermenegildo Bustos: Pintor de pueblo* (Guanajuato: Gobierno del Estado de Guanajuato, 1981); *José Clemente Orozco: Cuadernos* (Secretaría de Educación Pública, 1983); *Frida Kahlo: Una vida abierta* (new edition of a 1977 publication, reprinted in English as *Frida Kahlo: An Open Life*, trans. by Elinor Randall, Albuquerque: University of New Mexico Press, 1993). Tibol's writing also appears in hundreds of anthologies and catalogues.

105. Franco, *The Modern Culture of Latin America*.

106. Franco, *The Modern Culture of Latin America*, 11.

107. Dependency theory is very complex and still under debate. Franco's article recommends the reader to K. T. Fann and Donald C. Hodges, *Readings in U.S. Imperialism* (Boston: Sargent, 1971); and issues of the journal *Latin American Perspectives*. Franco, "Dependency Theory and Literary History," pp. 65–80. Its cultural application was even more complex. I employed this theory for the third

chapter in my book *Contemporary Mexican Painting in a Time of Change* (Austin: University of Texas Press, 1981), insofar as it described "cultural imperialism" through penetration of Latin American artistic formations via the export of U.S. art exhibitions, corporate sponsorship of art activities in Latin American countries, and the process of awarding scholarships, prizes, and so forth.

108. Franco, *Plotting Women: Gender and Representation in Mexico* (New York: Columbia University Press, 1989).

109. "On/Against Mass Culture, III: Opening Up the Debate," *Tabloid: A Review of Mass Culture and Everyday Life*, no. 5 (Winter 1982): 1.

110. Adelaida de Juan, *Pintura cubana: Temas y variaciones* (Mexico City: Universidad Nacional Autónoma de México, 1980).

111. Aracy A. Amaral, *Arte para quê? A preoçupacāo na arte brasileira, 1930–1970*, 2d ed. São Paulo: Livraria Nobel, 1987).

112. Regional variations of the functionalist international style in architecture, with input from Le Corbusier and Bauhaus architects, can be traced from the 1920s through the 1960s throughout Latin America in Francisco Bullrich, *New Directions in Latin American Architecture* (New York: George Braziller, 1969). The social context and issues are set forth by Latin American architects and theoreticians in Roberto Segre (ed.), *Latin America in its Architecture*, trans. Edith Grossman (with an illuminating introduction to the English edition by Fernando Kusnetzoff, see especially pages 12 and 13; New York: Holmes nad Meier, 1981).

113. Frederico Morais, *Artes plásticas: A crise da hora atual* (Rio de Janeiro: Editora Paz e Terra, 1975), 69–117.

114. In 1990, I again explored this terrain in Rio, with the help of artist Rubens Gerchman, who had been part of it, and whose work I knew from my earlier visit. In addition, I met younger critical artists, such as conceptualists Cildo Meireles and Tunga, who are receiving international attention as a result of the new attitudes adopted toward Latin American art in the 1980s in Europe and the U.S.

115. Frederico Morais, *Artes plásticas na América Latina: Do transe au transitório* (Rio de Janeiro: Editora Civilização Brasileira, 1979), 13.

116. The 1977 prize was awarded to a group of artists under the banner of CAYC, the Argentine organization funded and promoted by Jorge Glusberg. (See page 11 of Introduction.) In 1978, some of the most prominent Latin American artists (such as Rufino Tamayo of Mexico and Fernando de Szyszlo of Peru) allegedly refused to participate in the "First Latin American Biennial" because of its theme, "Myths and Magic in Latin American Art"—with subthemes of the "indigenous," the "African," the "Euro-Asiatic" and "*Mestizaje*" (mixtures of peoples and cultures). Nevertheless, this motif did not prevent the participation of the well-known CAYC-sponsored Grupo de Los Trece (the Group of Thirteen), which included some of the most interesting conceptual artists of Argentina.

117. Mirko Lauer, *Introducción a la pintura peruana del siglo XX* (Lima: Mosca Azul Editores, 1976).

118. This theoretical methodology by Lauer is taken almost directly from Aníbal Quijano, "Cultura y dominación," *Revista Latinoamericana de Ciencias Sociales*, Santiago de Chile (June-December 1971): 39–56. (See Lauer, *Introducción a la pintura peruana del siglo XX*, n. 5, p. 23.)

119. Gabriel Peluffo, "Crisis de un inventario," in Hugo Achugar and Gerardo

Caetano (eds.), *Identidad uruguayo: ¿Mito, crisis or afirmación?* (Montevideo: Ediciones Trilce, 1992), 1–11.

120. Hubert Herring, *History of Latin America from the Beginnings to the Present*, 3d ed. (New York: Alfred Knopf, 1972), 786.

121. Telephone conversation by the author with Uruguayan artist and critic Luis Camnitzer, April 1993.

122. Concerning deterritorialization, Luis Camnitzer has written that during the period of the dictatorship a parallel Uruguayan culture was created outside the country's borders, a separate, uprooted culture to be distinguished from that created by Uruguayan-educated artists living abroad who made themselves known in Uruguay. He also affirms that time in Uruguay "passes at a markedly slower rate than in neighboring countries," thus suggesting a reason for the long survival of a traditional nationalism. Camnitzer, "Carlos Capelán," in *Carlos Capelán: Kartor och landskap*, catalogue (Lund, Sweden: Lunds Konsthall, 1992–93), 58.

123. The so-called "development decades" of the 1960s and the 1970s were marked by the growth of an assertive, confident "South" (Latin America, and the emerging states of Africa and Asia) through vigorous state leadership, domestic market protection, strong controls on western (Euroamerican) investment, and concerted efforts to bring about a global redistibution of wealth. Disciplining the South became a priority of Reaganite/Bush conservatives in the 1980s, when all these activities were targeted by military interventions and/or economic warfare through the "structural adjustment" loans of the World Bank, where Washington's influence was paramount—or, as Cherokee artist Jimmie Durham succinctly and sardonically phrased it, "Third World countries . . . change their societies to fit World Bank guidelines so that they can get World Bank loans to pay off previous loans" (Durham, "Legal Aliens," *The Hybrid State*, catalogue [New York: Exit Art, 1992], 74.)

The debt crisis came in the early 1980s, at a staggering human and social cost, which is still increasing. By 1990, nearly 100 debtor countries in Latin America (Mexico is a prime example), Asia, and Africa had been forced into line, relinquishing important sovereign rights in the process. See Walden Bello, "South Gets 'Discipline,' Not Development," *Guardian*, June 17, 1992: 12.

124. Mari Carmen Ramírez, *The Ideology and Politics of the Mexican Mural Movement: 1920–1925*, unpublished Ph.D. dissertation, University of Chicago, 1989.

125. The search for "authenticity" goes on in the European and U.S. mentality, an "authenticity" which symbolizes the retention of the past, of primitivism, of what was produced under colonialism—because the veracity of conquered Indian cultures is no longer what it was before the sixteenth century. Frantz Fanon's words on the false search of contemporary intellectuals for "authenticity" have not yet been absorbed by western thinkers. For example, curator Erika Billeter distorted the history of Mexican art by just such a search. See her essay "Mexico's Contribution to 20th Century Art," in the German-organized *Images of Mexico* catalogue (Dallas: Dallas Museum of Art, 1988), 24–28, and my commentary in "La nueva estética del arte mexicano/Estheticizing Mexican Art," *Arte en Colombia*, no. 4 (May 1989): 39–47.

126. Guy Brett, "A Radical Leap," *Art in Latin America: The Modern Era*,

1820–1980, curated and edited by Dawn Ades with essays by Guy Brett, Stanton Loomis Catlin (New Haven: Yale University Press, 1989), 253–83.

127. From Mexico, Brett included only the work of German-born Mathias Goeritz, who pioneered minimalist (geometric) architecture, sculpture, and concrete poetry in the 1950s with ideas brought from Europe. By the 1960s and 1970s, there were two generations of geometrically oriented abstractionists. See Jorge Alberto Manrique et al., *El geometrismo mexicano* (Mexico City: Universidad Nacional Autónoma de México), 1977. There were also isolated geometric artists in Colombia and Peru.

128. Stanton Loomis Catlin and Terence Grieder, *Art of Latin America since Independence*, catalogue (New Haven: Yale University Press, 1966).

129. Dawn Ades (ed.), *Art in Latin America: The Modern Era, 1820–1980.*

130. The three terms have been flexibly adopted from the writings of Jürgen Habermas and Marshal Berman by Néstor García Canclini in *Culturas híbridas: Estrategias para entrar y salir de la modernidad* (Mexico City: Editorial Grijalbo, 1990), 19, n. 3.

131. Summarized by Marc Zimmerman in "Françoise Perus and Latin American Modernism: The Interventions of Althusser" in his critique of Perus' *Literatura y sociedad en América Latina: El modernismo* (1976), *Praxis: Art and Ideology*, no. 6 (1982): 158–59.

132. Nelly Richard, "Postmodern Disalignments and Realignments of the Centre/Periphery," *Art Journal* 51, no. 4 (Winter 1992): 57.

133. Renato Ortiz, "Lo actual y la modernidad," *Nueva Sociedad*, no. 116 (November–December 1991): 95.

134. García Canclini, *Culturas híbridas*, 70–71.

135. Escobar, "Identity and Myth Today/Identidad, mito: Hoy," p. 26 passim.

136. Celeste Olalquiaga, *Megalopolis: Contemporary Cultural Sensibilities* (Minneapolis: University of Minnesota Press, 1992), 83.

137. Gilbert W. Merkx, "Editor's Foreword," *Latin American Research Review* 27, no. 3 (1992): 3.

138. Merkx, "Editor's Foreword," 4.

139. Néstor García Canclini, *Arte popular y sociedad en América Latina* (Mexico City: Editorial Grijalbo, 1977) and *Las culturas populares en el capitalismo* (Mexico City: Ed. Nueva Imagen, 1982). Canclini's books followed that of Victoria Novelo, *Artesanías y capitalismo en México* (Tlalpan, D.F.: Centro de Investigaciones Superiores, Instituto Nacional de Antropología e Historia, 1976); and were themselves followed by Mirko Lauer's *La producción artesanal en América Latina* (Lima: Mosca Azul Ed., 1989). Another book on the same subject should also be mentioned: William Rowe and Vivian Schelling, *Memory and Modernity: Popular Culture in Latin America* (London: Verso, 1991), from the "Critical Studies in Latin American Culture" series.

140. Alice Littlefield, "Of Devils and Domination, Capitalism and Culture," *Studies in Latin American Popular Culture* 3 (1984): 178.

141. García Canclini, *La producción simbólica.*

142. García Canclini later abandoned his Gramscian-based theories, stating that one of Gramsci's most attractive cultural and political contributions was his notion of the national-popular, which was very pertinent to Latin Americans during the historical period of ethnic and regional movements for whom the "na-

tional" designation created a problem. What meaning, he asks, can this analytical perspective have in a globalized world where economic and cultural practices have largely been deterritorialized? See "Cultura y nación: Para qué no nos sirve ya Gramsci," *Nueva Sociedad,* no. 115 (September–October 1991): 98–103.

143. By the late 1980s, it became apparent that the economic privatization taking place in many Latin American countries in response to their overwhelming burdens of debt was gradually being accompanied by the accelerated privatization of culture. This is most readily apparent in Mexico, where culture since the Mexican Revolution has long been a high priority of the state as an underpinning to nationalist ideology, and where the ingress of private enterprise into cultural sponsorship—particularly that of the industrial elite of Monterrey, Nuevo León—can certainly be traced. To my knowledge, no general studies have yet appeared that document and analyze the recent privatization of urban Latin American culture, which varies in kind and degree. An update of my own writings on this subject in *Contemporary Mexican Painting* (chap. 3) can be found in English in Néstor García Canclini's excerpted essay "Cultural Reconversion," where he discusses the role of private businesses vis-à-vis the state in Argentina, Mexico and Brazil. See Yúdice et al. (eds.), *On Edge,* 34–37. On the economic front, see William Glade (ed.), *Privatization of Public Enterprises in Latin America* (San Francisco: ICS Press, 1991); and NACLA's *Report on the Americas* 26, no. 4 (February 1993), an issue titled "A Market Solution for the Americas? The Rise of Wealth and Hunger."

144. Herbert I. Schiller, *Mass Communications and American Empire* (Boston: Beacon Press, 1971), 82–84.

145. Mattelart et al., *International Image Markets,* 22–24.

146. See Cornelia Butler Flora, "The Fotonovela in Latin America," *Studies in Latin American Popular Culture* 1 (1982): 15–26.

147. Isadore Ducasse (1846–70), the Comte de Lautréamont, was born in Montevideo of French parents. He moved to Paris in 1867 and died at age twenty-four. Among the most important twentieth-century French surrealist poets, which included Eluard, Breton, Soupault, and Péret, he was considered one of the best before 1900, and a progenitor of the surrealist movement.

148. Rosaldo, *Culture and Truth,* 197, 199.

149. Henry A. Giroux, *Border Crossings: Cultural Workers and the Politics of Education* (New York: Routledge, 1992), 111. The expression "people of color" entered the vocabulary in the mid-eighties as a strategy of unification between disparate national and ethnic groups targeted by U.S. racism. Its use upset the traditional binary opposition of black/white antagonism, since Latinos, Asians, and Native Americans suffered from racism in addition to ethnicity, nationality, and other differences. The term remains in quotation marks because many Latin Americans, while experiencing xenophobia, and treated as "outsiders," are not identifiably "people of color," and therefore are not subject to racism, per se, except symbolically.

150. Giroux, *Border Crossings,* 112.

151. Giroux, *Border Crossings,* 113.

152. *Other Sources: An American Essay,* catalogue (San Francisco Art Institute, 1976). Participating Chicano artist Rupert Garcia noted in his essay (p. 23) that the title of the exhibit should have been just "Sources," since "we of the

Third World are not 'other'." In 1989, Villa returned to his original conception with a series of four symposia at the Institute, accompanied by cultural events, on the theme of "Sources of a Distinct Majority," which included European-Americans as well as the Third World people who now collectively comprise a majority in the state of California. A book on the proceedings, to be titled *Worlds in Collision*, is in preparation.

153. *Multicultural Focus: A Photography Exhibition for the Los Angeles Bicentennial*, catalogue (Los Angeles Municipal Art Gallery, 1981).

154. Lippard, *Mixed Blessings*, 5.

155. In a particularly felicitous framing of the role of affirmative action, Cornel West points out that it should not be viewed either as a major solution to poverty or as a sufficient means to equality. It was a "redistributive measure" to enhance the standard of living and quality of life for the have-nots and have-too-littles. It plays primarily a negative role—to ensure that discriminatory practices against women and people of color are abated. Without affirmative action, given the history of the U.S., it is a virtual certainty that racial and sexual discrimination would return with a vengeance. West, *Race Matters* (Boston: Beacon Press, 1993), 63–64.

156. "Frank Jewett Mather Award," *CAA News*, College Art Association 18, no. 2 (March/April 1993): 7.

157. Author's telephone conversation with Lowery Stokes Sims (chair of the CAA committee determining the recipient of the 1993 Frank Jewett Mather criticism award), April 1, 1993.

The question of co-option was hotly debated in San Diego concerning the funding received by the La Jolla Museum of Contemporary Art (now the Museum of Contemporary Art, San Diego, or MCA), for the "Dos Ciudades/Two Cities" (San Diego, Calif. and Tijuana, Mexico) project that opened March 5, 1993, as "La Frontera/The Border." Between the funding and the opening, meetings between the MCA and the Centro Cultural de La Raza of San Diego (home of the Border Arts Workshop, which pioneered the concept), finally brought about an agreement that the MCA and the Centro would co-curate, co-present the exhibition that emerged, and co-write the catalogue, a decision criticized by important former members of the Border Arts Workshop.

158. It should be understood that the multicultural discourse also has a neoconservative component, which is opposed to the practice of multiculturalism, including such writers and politicians as Allan Bloom (whose book *The Closing of the American Mind* (New York: Simon and Schuster, 1987) can be considered the cultural manifesto for the New Right), E. D. Hirsch, Diane Ravitch, Pat Buchanan, and Senator Jesse Helms, among others. From this vantage the argument works as a defense of "western civilization." "Implicit in the politicizing mandate of multiculturalism is an attack on the idea of a common culture, the idea that despite our many differences, we hold in common an intellectual, artistic, and moral legacy, descending largely from the Greeks and the Bible . . . it is this legacy, insofar as we live up to it, that preserves us from *chaos* and *barbarism* [emphasis mine]. And it is precisely this legacy that the multiculturalist wishes to dispense with." Roger Kimball, "*Tenured Radicals:* A Postscript," *The New Criterion* (January 1991): 6, cited in Giroux, *Border Crossings*, 230. It is interesting that the site of the debate locates in education and culture, specifically the arts. On a

political level, Bloom argues that the impulse to egalitarianism and the spirit of social criticism represent the chief culprits in the decay of higher learning. Thus the issues of multiculturalism and those of censorship meet on common ground.

159. From the 1987 manuscript by Guillermo Gómez-Peña, "Documentado/ Indocumentado," published in 1988 in *Multi-Cultural Literacy*, The Graywolf Annual 5 (1988). See also his article "The Multicultural Paradigm: An Open Letter to the National Arts Community," *High Performance* 12, no. 3 (Fall 1989): 18–27; rpt. in *The Decade Show* catalogue, 93–103. and in his book *Warrior for Gringostroika: Essays, Performance Texts, and Poetry* (Saint Paul: Graywolf Press, 1993, pp. 45–54.

160. George Yúdice, "We Are *Not* the World," *Social Text* 10, nos. 2 and 3 (1992): 202–16. All further citations are from this article.

161. Mari Carmen Ramírez, "Between Two Waters: Image and Identity in Latino-American Art," paper presented to the symposium "Arte e identidad en América Latina," at São Paulo, Brazil, September 1991.

162. It should be recalled that France, Spain, and Italy have represented, and still represent, other centers where Latin Americans have flourished while maintaining their own identity. The primacy of New York did not develop until after World War II as part of the world hegemony imposed on a fractured and broken Europe.

163. This view is not exclusive to Ramírez. "Postmodern interest in the Other," says Gerardo Mosquera, "has opened some space in the 'high art' circuits for vernacular and nonwestern cultures. But it has introduced a new thirst for exoticism, the carrier of either a passive or a second-class Eurocentrism. . . . Many artists, critics and Latin American curators seem to be quite willing to become 'othered' for the West." "The Marco Polo Syndrome: Some Problems around Art and Eurocentrism," trans. by Jaime Flórez, *Third Text*, no. 21 (Winter 1992–93): 37.

In 1980 I wrote that Chicano artists, like others, were subject to the temptations of commercial success within the mainstream system. One of the roads was abandonment of the critical or political content of their earlier work, but the maintenance of "ethnic" forms (i.e., their "difference" or "otherness"). See the article "Response" in this book.

"It is mainly the artists who voluntarily or unknowingly resemble the stereotypes who end up being selected by the fingers of the Latino boom." Guillermo Gómez-Peña, "The Multicultural Paradigm," p. 25.

164. Rosaldo, *Culture and Truth*, 202.

165. See "How Latin American Artists in the U.S. View Art, Politics, and Ethnicity in a Supposedly Multicultural World."

IN THE PUBLIC EYE

1

SIQUEIROS AND THREE EARLY MURALS IN LOS ANGELES

A vision of Latin America as a tropical paradise where happy mortals lie beneath palm trees whose fruits drop of their own accord into waiting mouths may have enchanted Americans on the northern side of the Río Grande, but it was no part of the vision of Mexican muralist David Alfaro Siqueiros when he came to Los Angeles as a political refugee in May 1932.[1] During that visit he painted three murals in different locations of the city, of which only one exists intact today. The largest of the three, *Tropical America*, painted on the second-story outside wall of a building in Olvera Street (original site of the city), has almost completely disappeared beneath the coats of whitewash applied in 1932 and 1934, and the exposure and neglect of over forty years. Despite the thousands of tourists who visit historic Olvera Street annually, the very knowledge of the mural's existence had almost vanished until new interest was generated by plans to have the mural restored several years ago.[2]

Interest in possible restoration was nationwide—though nowhere so strong as in the large Mexican American community of Los Angeles—particularly since these are the only murals Siqueiros ever painted in the United States. What were the circumstances surrounding the creation of the outdoor murals *Street Meeting* and *Tropical America?* Of the existing privately owned mural *Portrait of Mexico Today?* Why were the former two destroyed? What did they look like originally? These questions—and

This essay first appeared in *Art Journal* 33, no. 4 (Summer 1974): 321–27. Reprinted by permission of College Art Association, Inc.

the implications inherent in the existence and destruction of the murals—have become pressingly topical when one considers the current search of the Chicano in the Southwest for self-identity, a political voice, and economic justice, things which were of profound concern to the artist when he created his murals. For the growing Chicano art movement, the aesthetics of Mexican muralism coexist with the most avant-garde manifestations to express the particular life experience of the urban Chicano.

A more general, but equally urgent, imperative to reclaim these murals for the history of art is the splendid pictorial qualities of *Tropical America*, lost to sight for almost a half century.

The three murals marked an important turning point in Siqueiros's development. They exhibit the release and outpouring of a large creative energy denied walls to paint on for almost ten years. In the first encounter with the great industrial resources of the United States, Siqueiros's search for a new art style expressive of his revolutionary ideals was augmented by technical means to change the methodology of muralism itself—a methodology that had been fixed since the Renaissance. Important innovations of this period included the development of a dynamic pictorial surface for the moving spectator, and experimentation with cement and the airbrush for fresco application—innovations that resulted from the desire to create exterior murals "beneath the sun, beneath the rain, facing the street" and facing the passing multitudes—and were tremendously consequential for his mature work.

As the third major Mexican muralist to come to the United States, Siqueiros had been preceded by Jose Clemente Orozco, who had painted his monumental fresco *Prometheus* at Pomona College, Claremont, in 1930, had completed a series of murals in the New School for Social Research in New York, and had just been commissioned to do the great mural cycle at Dartmouth College, New Hampshire, during the time Siqueiros was in Los Angeles. Diego Rivera had painted murals at the San Francisco Stock Exchange, the California School of Fine Arts, and a private home, and had been commissioned to do *The Portrait of Detroit* by the Detroit Institute of Fine Arts. The famous "battle of Rockefeller Center" which terminated in the destruction of Rivera's mural was not to occur until the following year; however, it, along with the almost simultaneous destruction of Siqueiros's murals, seemed to reflect a shift toward the right in the political currents of the day. Controversy had surrounded, and continued to surround, the activities of all three muralists.[3]

One particularly blatant example of provincialism and chauvinism is the following: "Mexican art in Mexico is indigenous and entirely appropriate; . . . they like the graphic delineation of suffering and agony; they sympathize with and cherish the old pagan, primitive religions which took bloody sacrifices and required strange and physical rites." The writer could not understand why we "should imitate it and adopt it in

our country whose traditions are entirely alien to it all" or "put it on the walls of an educational institution [referring to Siqueiros's Chouinard Art School mural] where youth is imbibing its inspirations and ideals for life" or make it part of "our national expression when it is not and never can be." Ironically the article recognized Olvera Street as the place "where the old Mexican beginnings of Los Angeles are cherished"![4]

Siqueiros's political and artistic baptism started long before his trip to Los Angeles. At fifteen he participated in a student strike at the San Carlos Academy in Mexico demanding an abandonment of outmoded methods of art instruction. He served as an officer in the Mexican Revolution before going to study in Europe. In 1923 he became a principal organizer of the Syndicate of Technical Workers, Painters, and Sculptors, which sparked the mural renaissance, and was author of its manifesto, which hailed the Indian soldier who gave his life "in hope of liberating your race from the degradation and misery of centuries." Siqueiros had always considered his art a political tool and a vehicle of revolutionary thought, with concepts inseparable from aesthetics: "The makers of beauty," he said in the manifesto, "must invest their greatest efforts in the aim of materializing an art valuable to the people," with "beauty that enlightens and stirs to struggle."[5] Almost thirty years later he was of the same opinion: "My mural [Tropical America] was the mural of a painter who had fought in the revolution."[6] It is within this context that the 1932 murals must be understood. It forms the basis for his plastic expression, for his ceaseless technical and aesthetic experimentation to create a transformation of pictorial technique consonant with his views of the social and scientific developments of our time.

In 1932 the United States was in the throes of the Great Depression. Los Angeles was a city of over two million people emerging from its rural status under the impact of its most important industries: agriculture, oil, and the movies. Politics were highly polarized and volatile. Upton Sinclair, the Socialist and Communist parties, and members of the movie colony provided a fulcrum of left-wing activities. Labor conflict was widespread and often violent, particularly in the rich agricultural Imperial Valley, where many Mexicans were employed. Los Angeles (unlike San Francisco) was an antiunion town; it boasted a police anti-Red Squad led by a Captain Hynes; its constituency included thousands of retired old people who were impoverished by the Depression but remained set in their political conservatism.[7] In the months of Siqueiros's stay, Los Angeles newspapers reflected the tremendous difficulties and confrontations of the period: the Hynes Red Squad prohibited a speech by the Communist presidential candidate; a "slave block" auction, selling the labor of unemployed citizens to the highest bidders, was held in a local park; the unemployed panned exhausted gold deposits in San Francisco streams; the government investigated the vast holdings of the J. P. Morgan empire.[8]

Of particular significance to the artist, and of direct import to his choice of a theme for *Tropical America*, were the mass deportations of Mexican nationals[9] and the wretched conditions of Mexican migratory workers, whose efforts to organize for collective bargaining were repeatedly crushed by vigilantes and repressive laws.[10] There is little doubt that use of this theme—elaborating conditions which are strikingly repeated throughout the Southwest today—contributed to Siqueiros's own expulsion when his six-month visa expired.[11]

Word of Siqueiros's presence quickly spread (with the aid of Mexican artists Alfredo Ramos Martínez and Luis Arenal) in the small, tightly knit Los Angeles art world. Joseph von Sternberg, flamboyant director of the movie *The Blue Angel*, patron of artists, and collector "of the most violent modern art," helped him bring his detained paintings and lithographs across the border, and commissioned his first portrait. Painted in Sternberg's office at Paramount Studios on 40″ × 48″ coarse canvas with quart cans of paint and house-paint brushes, it showed "von Sternberg at his desk, ugly, intent, commanding . . . yet curiously . . . like him."[12] On May 9th an exhibition of Siqueiros's lithographs opened at the Jake Zeitlin Bookshop in downtown Los Angeles and, four days later, fifty paintings, lithographs, and mural designs were exhibited in the Stendahl Ambassador Gallery.[13]

Siqueiros's work of the preceding period (1929–32) was very dark and almost devoid of color. "He felt the times were so bad color should not be used," says Arthur Millier, former art critic of the *Los Angeles Times*.[14] His paintings at the Stendahl Gallery, wrote Millier in 1932, were "dark and unframed. The massive forms and heads emerge from an aura of blackness. The first impression is of brutality and darkness, of an absolute absence of all 'charm,' of that pleasant manipulation of pigment which is so significant for the English and Americans. There is, nevertheless, something more: a brooding sense of tragedy."[15] The somber paintings and sorrowful subjects did not recommend themselves to all critics: the huge canvases were felt to have "primitive subject matter" stirring "emotions of revulsion, horror, and other elemental feelings equally unprofound." Though Carl Zigrosser had written favorably of Siqueiros, said the reviewer, she found the "lack of pleasing color, stark outline, and untextured surfaces" were distasteful.[16]

Then, as later, Siqueiros was not satisfied with portraits and easel paintings; he longed for walls. Even in his easel paintings he used burlap-like canvas coated with lime upon which he painted with a mixture of oil, gum, honey, and paint, which produced a semifresco effect.[17] The scale of the figures was enormous. Many later Siqueiros works give this same impression: figures thrust from the surface, their huge size and energy seeming to violate the frame as if seeking a larger context.

In early June (following an exhibition at the Plaza Art Center and an

honorary dinner by the California Art Club) Siqueiros was contacted by Millard Sheets, an impressive young watercolorist and a Chouinard Art School teacher, to conduct a fresco class. Among various practice techniques, Siqueiros had the group make fresco panels of their own design, using plywood frames and chicken wire covered with layers of plaster. These were later exhibited as "fresco blocks." The group was composed of ten professional artists, each of whom paid a $100 fee. As a result of cubism, many artists had become interested in the Renaissance, and no information was available about fresco except from the Mexican muralists[18] who had revived its practice (and that of encaustic) 10 years earlier. By mid-June a wall of Chouinard Art School, then at 743 South Grandview, had been obtained from Mrs. Nelbert M. Chouinard, and the ten artists, as well as graduate art students, all of whom were now designated as the Block of Mural Painters by Siqueiros, began painting a 19' × 24' outdoor mural called *Street Meeting* in the sculpture court of the school. Fig. 1 "He worked out of his head," recalls Millard Sheets, "very exciting for us because we were accustomed to the idea of a very finished sketch. He started at the top of the mural and worked his way down."[19]

Within the unprecedentedly short time of two weeks, the mural was almost complete, with the exception of the key figure in the lower portion. On the upper portion of the wall, which could be seen from the street, were painted two scaffolds filled with massive figures of construction workers, arms intertwined, looking downward intently, and casting long dark shadows between the windows which pierced the wall surface. Stylistically the composition was strongly related to the 1931 painting *Accident in the Mine.*[20] What were the workers looking at? To whom were they listening? No one knew. To all questions Siqueiros laughed and said, "Wait a little while. The best is yet to come."[21] Millier recalls, "Siqueiros professed tiredness. They all went home. When the group returned in the morning the job was finished. A red-shirted orator harangued the hungry people." On either side of the soapbox, listening intently, were a black man and a white woman, each with a child.

Eight hundred people attended the July 7th unveiling, lecture, and art exhibit sponsored by the Art Committee of the Association for Founding a New School for Social Research in Los Angeles.[22] Public reaction to the mural was mixed: some thought it a bold and powerful painting unlike anything previously done in southern California; others attacked it for political connotations, as in the case of *California Arts & Architecture:* "The art of fresco in this country will languish until it is able to free itself from the sorrows of Mexico and the full red glow of Communism."[23]

There is disagreement as to the fate of the mural. Merrell Gage recalls that police (officials?) descended on the school to inform Mrs. Chouinard the mural had to be removed, and she had it painted over. Sheets, artist Phil Paradise, and Millier claim the experimental airbrush technique used

was so faulty the colors either chipped or ran from the wall with the first rain and had to be whitewashed.[24] In either case (or both) the mural was covered within the year and we can judge its merits only from reproductions. Despite its weaknesses its importance as a seminal work for pictorial techniques is considerable.

Experimentation was integral to the new mural possibilities Siqueiros was seeking in Los Angeles, and *Street Meeting* was the guinea pig for this experimentation. Los Angeles offered numerous modern buildings with concrete walls requiring, according to Siqueiros, a new method of execution complementary to the architecture and the dynamic activity of contemporary life. Of particular importance was the desire to make murals truly public by moving them out-of-doors, where, however, traditional fresco surfaces of lime and sand could not be used. After consultation with architects Richard Neutra (then newly arrived from Germany and employed by Chouinard) and Sumner Spaulding, Siqueiros experimented with waterproof white cement. The rapid drying caused him to turn to the airbrush for accelerated application of fresco color. Metal and celluloid stencils were used to give outlines to the "smoky effects" of the airbrush. The lower half of the mural was coated with encaustic applied with a blowtorch—originally pioneered by Diego Rivera ten years earlier. Thus an entire gamut of experimental techniques evolved with this first mural in California, recorded by the artist in an article written during the actual painting of the mural:

> After making our first sketch we used the camera and motion picture to aid us in elaboration of our first drawing, particularly of the models. To draw our figures from posing models would be like reverting to the ox cart for transportation.
>
> To replace the slow and costly method of pencil tracing and pounce pattern projection we used the camera projection. A method of enlarging our drawing and thereby projecting our design directly to the wall.
>
> In the preparation of our walls we adopted the pneumatic drill to roughen the wall surface and give greater adhesion to the finished coating of plaster, which was applied with an airgun. The airbrush we considered an essential instrument in the plastic production of our decoration.[25]

Street Meeting ended the first phase of Siqueiros's contact with the United States. Though stylistically tied to his earlier work, it nevertheless represented an incomplete but aggressive thrust toward modernizing the technology of muralism. After leaving the United States for South America, the artist produced his first works with pyroxylin paint in the search for a satisfactory outdoor material that could resist sun and rain.

An opportunity to experiment further soon presented itself. Shortly

after completion of *Street Meeting*, Siqueiros was offered a contract by
F. K. Ferenz of the Plaza Art Center in Olvera Street to paint a mural
called *Tropical America*. Since few funds were available, materials were Fig. 2
contributed by individuals and local companies, equipment was bor-
rowed, carpenters erected scaffolds, and electricians wired lights for work
which went on day and night. A much larger group of assistants com-
posed the team assembled to paint the enormous 18′ × 80′ second-story
wall of the old Italian Hall. A key figure was Dean Cornwell, who had
just completed a five-year mural project for the Los Angeles Public Li-
brary rotunda.[26] A contemporary account recreates the event for us:

> Plaza Art Center is the scene of a busy group of artists, who under
> the direction of Siqueiros, with Dean Cornwell as patron saint, are
> covering an outside wall with fresco. It was a dream of Mr. Ferenz
> even before the Chouinard School . . . made its decoration. But what
> to use for money in this bereft period? It needed plasterers, carpen-
> ters and cement mixers as well as artists. . . . As design it will be
> tropical Mexico, with Mayan ruins and a few figures. As each end of
> the wall will be seen from the streets below, it is planned to make
> them a complete picture, at the same time preserving a general
> unity of design.[27]

To Siqueiros, an outdoor wall in Olvera Street, located in a part of down-
town Los Angeles then known as Sonora Town (because of its large Mexi-
can population), close to the railroad terminal and City Hall, literally
available to the "flow of traffic and millions of people," must have been
especially attractive. He quickly signed the contract. However, his vision
of tropical America differed sharply from prevailing folkloric ideas: in-
stead of painting "a continent of happy men, surrounded by palms and
parrots where the fruit voluntarily detached itself to fall into the mouths
of the happy mortals," he said, "I painted a man . . . crucified on a double
cross, which had, proudly perched on the top, the eagle of North Ameri-
can coins."[28]

Starting in late August, work on *Tropical America* continued for over
a month. All accounts agree that Siqueiros did most of the painting him-
self, assigning to his assistants the tasks of roughing the brick surface
with drills, applying coats of white Portland cement, squaring the wall,
blowing up the design for the final cartoon, and painting small sections.[29]
The day before the unveiling the key figure was still a mystery. "Again,"
says Millier, " 'Tired. Let's all go home.' At 1:00 A.M. that night in a dead
Olvera Street I found Siqueiros sweating in an undershirt in the cold air,
sitting on a scaffold, painting for dear life the peon bound to a double
cross."[30]

Great crowds attended the unveiling. Millier wrote in the *Times*,
"When the scaffolding finally came down . . . onlookers gasped. No one

but the author had been able to visualize the close-knit powerful design so long shaded and concealed by those scaffolds."[31] Not only was the wall much larger than the one at Chouinard, but the concept had been expressed with great clarity in brilliant color. Despite the welter of billboards, posters, storefronts, and gas tanks with which it had to compete, it would have had no trouble attracting attention.

Siqueiros's composition had to deal with a door and two metal-shuttered windows which penetrated the wall, forcing a slight asymmetry. The stark geometry of the Maya-like pyramid and two cylindrical stelae inscribed with feather forms are counterpointed by great twisting trees and the curved body of the Indian. Blocks of stone fallen from the pyramid and pre-Columbian sculptures scattered among the trees speak of the destruction of ancient Indian civilization, while the screaming eagle with spread wings dominates the modern Calvary. The traditional spirit of passive Christian mourning is lacking. Two armed snipers menace the eagle from the roof of an adjacent building.

Central to the design is the crucifixion itself, which establishes the dynamic rhythms of the composition. We are caught by the circle circumscribed by the wings of the eagle, the spread arms, and the loincloth of the Indian. Semicircular repetitions appear in shell-like shapes on the pyramid, the semicircle below the eagle, and the torso of the Indian, and are reinforced by the ellipses of the stelae. The truncated shape of the pyramid is echoed in the geometric elements of the pyramid frieze and the Indian's legs.

Of the three murals there is no doubt the *Tropical America* was by far the most powerful and original and a clear departure from earlier work. It established Siqueiros as a master of monumental form. *Tropical America* is the final affirmation of the break with "folklorism" and "picturesqueness" which started with his murals in the National Preparatory School in Mexico. Speaking of the latter, but prophetically applicable to the Olvera Street mural, Jean Charlot said, "Until these murals were done, Indianism had been synonymous with folklore or folk art. . . . Siqueiros was the first to erect a naked Indian body as removed from picturesqueness as a Greek naked athlete, a figure of universal meaning within its racial universe."[32]

Most powerful of the influences at work in this painting is the baroque style, especially admired by the artist's father.[33] Sinuous forms, sculptural plasticity, strong chiaroscuro, and dynamic spatial movement all mark the impact of the most spectacular style of colonial Mexico. Appearing for the first time in this mural is a leitmotif of much later work: the recessive pyramid.

Italian futurist theories such as multiple points of view and prismatic perspective (which interested Siqueiros when he went to Europe in 1919) can be found in *Tropical America* despite disclaimers from the artist

such as appeared in *Script* (see note 25). The interior perspective of the pyramid includes the slight incline of both sides of the base, creating two planes which enhance the plasticity of the forms in front of the lower pyramid; the vanishing points of the stelae and the building of the snipers; and the perspective of the upper cross. Dynamic sensations derive from the rhythm, inclination, and movement of each object. The mysterious curved forms on the pyramid are a connective between the writhing, flamelike horizontals of the trees at either end of the composition. Siqueiros was particularly intrigued with movement; he later developed curved-surface painting with multiple-exposure figures in which the moving spectator served the function of a "switch" to set the work in motion,[34] a pictorial idea reinforced by his meeting in Mexico with pioneer filmmaker Sergei Eisenstein in 1931. The spectator, rather than passively receiving moving images, takes on the active role of the movie camera.

Veteran Los Angeles artist Lorser Feitelson, recalling the response to *Tropical America* in 1932, says, "The reaction in the art world was wonderful. In the case of Siqueiros we may not know what certain forms are, but they're magnificent as forms. He brought tenebrism, illusionism, and also this architectonic quality; it had guts in it! It made everything else of the time look like candybox illustrations. Many of the artists said, 'My God! This is a wonderful vocabulary.'"[35]

High quality and enthusiasm were not enough to save the mural however. Its powerful indictment of U.S. imperialism and exploitation could not be tolerated. After its completion and the deportation of the artist, Mr. Ferenz was forced to paint over the portion of the mural visible from Olvera Street, though he saw to it that a harmless covering was used. "There was provocation in the political hue of the painting, regarded by many observers as Communist propaganda," noted the *Christian Science Monitor* (April 27, 1935). Several years later, Mrs. Christine Sterling (the "mother" of Olvera Street, according to Millier) would only renew the lease of the upstairs club, which had been a bar, on condition the fresco was completely covered. We are forced to conclude that Clive Bell's "modernist" thesis (very popular in the 1920s and 1930s) dismissing subject matter as irrelevant in consideration of "significant form" was not applicable to a painting with explicit controversial content. It would seem that art *does* function within a specific social milieu rather than in the realm of pure aesthetic. It should also be recalled that only five years separate *Tropical America* from Picasso's *Guernica* and both were monumental protests against inhumanity, though differently treated.

By 1973 the years of rain and sun on the unprotected outdoor mural have taken their toll, removing both the whitewash and finally most of the color beneath. The final verdict of two restorers who came from Mexico in 1971 to examine the mural is that restoration is impossible.[36]

Fig. 3

Very little information is available about the third mural, known as *Portrait of Mexico Today* (originally *Delivery of the Mexican Bourgeoisie Born of the Revolution into the Hands of Imperialism*). It was painted in fresco in the covered patio of the Santa Monica home of movie director Dudley Murphy.[37] Dividing the wall surface in thirds are two painted columns behind which appears the familiar recessive pyramid. On the steps are a child and two women, apparently widows of the assassinated men painted on a contiguous wall. To the left of the pyramid is the seated figure of a revolutionary soldier, with sombrero and rifle, whose fallen red mask reveals the features of former Mexican president Plutarcho Elías Calles. Two bags of gold at his feet represent the betrayal of the Mexican people.

One can envision the color properties of *Tropical America* by reference to the well-preserved *Portrait of Mexico Today*. Blues, browns, greens, reds, and yellow ochres enhance the sculpturally modeled abstracted figures. Though not as dynamic a composition as *Tropical America* (the size is only 172 square feet), the Santa Monica mural maintains a fine balance between baroque sinuosity and geometric structure. Especially poignant and rhythmic are the horizontal figures of the two dead men.

Today a whole new generation of artists is demonstrating its interest in Mexican muralism. Street murals—many showing the influence of Siqueiros and Orozco—have mushroomed in New York, Boston, Chicago, Detroit, Santa Fe (New Mexico), San Francisco, and Los Angeles, particularly in the black ghettos and Puerto Rican and Chicano *barrios*. Among the active participants in these popular movements are former Siqueiros disciples.[38]

The city of Los Angeles was recently animated by the prospect of receiving a repainted *Tropical America II* on eleven movable wooden panels, 16' × 40', as a gift from the artist to the people of the city. It was to consist of the central portion of the mural (the pyramid and the crucified Indian) recreated in the original size. These plans were aborted by the unfortunate injury of Siqueiros in April 1973. The death of the artist in January of this year [1974] has put an end to the hopes that the 1932 mural could be resurrected to inspire future muralists in the Southwest.

Notes

1. At that time Siqueiros was in a delicate political situation. Upon release from jail in Mexico City, he was practically imprisoned in Taxco for many months. He considered the trip to the U.S. as a form of liberation given the political conditions of his own country. Interview between Siqueiros and Jesús Salvador Treviño, June 4, 1971.

2. Initiated by the author in 1969 and documented in Treviño's KCET-TV film *América Tropical* in 1971. Treviño kindly made his research available to me. The

only complete photograph of the mural was discovered by the author in the possession of a member of the original painting team. For newspaper coverage, see Jack Jones, "Disputed Mural May Emerge from Hiding," *Los Angeles Times,* May 23, 1971; "Bricks of Downtown Conceal a Classic," *Los Angeles Herald Examiner,* May 17, 1971: 8.

3. The "Publisher's Comments" of *California Arts & Architecture,* June 1932: 7, contain a mild version of a chronic complaint deploring the vogue for Mexican muralists while "our own capable American artists who have mastered the technique of fresco look on wistfully." Such comments, often more acerbic, reflect both the problems of the Depression (which left many artists unemployed) and holdovers of post–World War I isolationism.

4. Madge Clover, *Saturday Night,* October 15, 1932: 2.

5. Cited in Guillermo Rivas, "David Alfaro Siqueiros," *Mexican Life,* December 1935, quoted in Bernard S. Myers, *Mexican Painting in Our Time* (New York, 1956), 29.

6. David Alfaro Siqueiros, *La historia de una insidia. ¿Quiénes son las traidores a la patria? Mi respuesta* (Mexico City: Ediciones de "Arte Público," 1960), 32.

7. Walton Bean, *California: An Interpretive History* (New York, McGraw-Hill, 1968), 411.

8. In sequence: "Police Win Court Fight to Block Red Speaker," *Los Angeles Times,* June 26, 1932: front page; "Humans to Be Sold in Park," *Los Angeles Record,* July 6, 1932: 2; "10,000 Jobless Comb Streams Seeking Gold," *Record,* July 8, 1932: 8; "Morgan Power Combines Due for Early Quiz," *Los Angeles Examiner,* October 7, 1932: 3.

9. The *Los Angeles Record* story "1500 Mexicans Leave," July 7, 1932: 2, dealt with the deportation of nationals lacking self-support and not entitled to county charity.

10. Bean, *California,* 411.

11. Conversations with Ruth Hatfield, Dalzell Hatfield Galleries, and Mrs. Alfredo Ramos Martínez revealed that many were concerned he would be deported before finishing *Tropical America.* Federal agents were very anxious to deport him because they considered his art propaganda, wrote Don Ryans in the *Illustrated Daily News,* October 11, 1932. Walter Gutman in his column "News and Gossip," written after Siqueiros's departure for South America, stated that U.S. authorities refused to extend his permit, probably owing to his politics, *Creative Art,* January 1933: 75.

12. Arthur Millier, "Von Sternberg Dotes on Portraits of Himself," *Los Angeles Times,* June 12, 1932: 13, 19. Portrait reproduced in *Script,* July 2, 1932: 5. Current whereabouts unknown.

13. Conversations with Jake Zeitlin and Alfred Stendahl confirm that catalogues (now lost) were issued. Works displayed are listed in Raquel Tibol, *David Alfaro Siqueiros* (Mexico: Empresos Editoriales, S.A., 1969), 298. Most of the works date between 1930 and 1931. The portrait of Marguerite Brunswig (Staude) was painted in L.A. Mrs. Staude says she visited Siqueiros in his downtown hotel to learn lithography and he locked his door to prevent her leaving and painted an uncommissioned portrait which was later refused by her family as "ugly" (conversation with Mrs. Staude, April 1973). Present whereabouts unknown. The

portrait of Blanca Luz Brum, Uruguayan poet who accompanied Siqueiros, was purchased by a now unknown L.A. collector.

14. Interview with Arthur Millier, July 1973. Unless noted, all comments by Millier derive from this interview.

15. Arthur Millier, "The Pictorial Ferment of Mexico Agitates Present Day Los Angeles," *La Opinion*, June 30, 1932: 4.

16. Prudence Wollett, *Saturday Night*, May 21, 1932: 2.

17. "An International Portfolio: Mexico," *Arts & Decoration*, June 1934: 24.

18. Interview with Phil Paradise, July 1973.

19. Interview between Treviño and Millard Sheets, May 1971. The *equipo* (team) was composed of Millard Sheets, Merrell Gage, Paul S. Sample, Phil Paradise, Donald Graham, Katherine McEwen, Barse Miller, Henri de Kruif, Lee Blair, and Tom Beggs. Sheets, Sample, Miller, Paradise, and Blair were founders in 1921 of the well-known California Water Color Society; Beggs was art director of Pomona College. The idea of a "team," or artists' collective, was an important part of Siqueiros's ideology; however, the murals bear the vigorous stamp of his own artistic personality.

20. *Street Meeting* was most clearly reproduced in *California Arts & Architecture*, July-August 1932: 2; both it and *Accident in the Mine* appear in Raquel Tibol, *Siqueiros, Introductor de Realidades* (Mexico: Universidad Nacional Autónoma de México, 1961), figs. 22, 25.

21. Blanca Luz Brum, *El Universal*, Aug. 17, 1932, quoted in Tibol, *Siqueiros*, 1969, 244–46.

22. Affiliated with the New York institution that commissioned murals from Orozco in 1930. The L.A. Art Committee for Siqueiros included, among others, Mrs. Chouinard, Millier, Gage, Zeitlin, Richard Neutra, Sumner Spaulding, and F. K. Ferenz, director of the Plaza Art Center. From copy of invitation in author's possession.

23. *California Arts & Architecture*, June 1932, p. 2.

24. 1973 conversations with Gage, Paradise, Millier. For Sheets, see note 19.

25. David Alfaro Siqueiros, "The New Fresco Mural Painting," *Script*, July 2, 1932: 5. These ideas were expanded in a lecture to the John Reed Club of Hollywood, September 2, 1932, quoted in Tibol, *Siqueiros*, 1969, 101–15. A conversation with Leandro Reveles in April 1973 revealed that Dean Cornwell used an electric projector to transfer drawings to the mural surface. Conceivably this was the source for Siqueiros's innovation.

26. In addition to Cornwell, the team included, among others, artists from the movie industry: Wiard Boppo Ihnen, Richard Kollorsz, Martin Obzina, Tony and Leandro Reveles, Jeanette Summers, and John Weiskall; practicing artists Luis Arenal (later Siqueiros's lifelong associate), Jean Abel, Victor Hugo Basinet, Arthur Hinchman, Murray Hantman, Reuben Kadish, Myer Shaffer, Stephen de Hospodar, and Sanford McCoy, older brother of Jackson Pollock. (This list corrects and augments the fuller listing in Tibol, *Siqueiros*, 1961, 55.) There is reason to believe that Jackson Pollock may have seen (or even worked on) the Olvera Street mural during a summer 1932 trip, in which case it would be his earliest known exposure to Siqueiros predating his and Sanford's participation in the 1936 Siqueiros Experimental Workshop in New York. Siqueiros mentioned Jackson Pol-

lock in connection with 1932 in conversations with the author in 1971 and 1973. See Francis V. O'Connor, "The Genesis of Jackson Pollock: 1912 to 1943," *Artforum*, May 1967: 23, note 9, and passim.

27. Madge Clover, *Saturday Night*, August 27, 1932: 2.

28. Siqueiros, *La historia de una insidia*, 32.

29. Conversations with Kollorsz, Ihnen, Leandro Reveles, Weiskall, 1971, 1973.

30. From copy of Millier letter to Jack Jones of *Los Angeles Times*, May 1970. Reproduction of the unfinished mural in the *Los Angeles Times*, October 9, 1932, page 1, captioned "Great Art Work to Be Unveiled: Ceremony for Siqueiros's Fresco [sic] Scheduled for Tonight," and probably photographed October 8, shows no sign of the Indian.

31. "Power Unadorned Marks Olvera Street Mural," *Los Angeles Times*, October 16, 1932: 16, 20.

32. Jean Charlot, *The Mexican Mural Renaissance: 1920–1925* (New Haven: Yale University Press, 1967), 207.

33. Tibol, *Siqueiros*, 1961.

34. Interview with Siqueiros, August 1965.

35. Interview with Feitelson, July 1973.

36. A cursory examination of the mural was first made by Ben Johnson of the Los Angeles County Museum of Art, November 1968, but no final decision was made. In April 1971, restorers Jaime Mejía and Josefina Quezada spent a week minutely examining the mural, at which time it was ascertained that the mural could be preserved but not restored, and Siqueiros declined preservation. The restorers' report revealed a single coating of (white) cement over the base (instead of traditional coatings) causing the color to fix immediately on the surface without penetrating. By 1971, cracks and wall separation had occurred.

Despite repeated attempts between 1968 and 1990 to raise money for preservation, and its examination by several professional restorers from Mexico and the U.S., the mural continued to deteriorate. Not until April 1990 did a team of restorers commissioned by the Friends of Mexican Art Foundation, the Getty Conservation Institute, with help from the Los Angeles Endowment for the Arts, undertake to clean the mural in preparation for preservation. See Shifra M. Goldman, "Tropical Paradise: Siqueiros's LA Mural, A Victim of Double Censorship," *Artweek*, July 5, 1990: 20–21; and "El mural censurado de David Alfaro Siqueiros será 'preservado', *La Opinion*, June 24, 1990, Panorama Dominical: 8ff.

37. See "White Walls and a Fresco," *Art & Decoration*, June 1934: 29. The house was purchased in 1949 by Mr. and Mrs. Willard Coe, who kindly permitted the author to photograph the mural. It had been restored twice, the last time by Roland Strasser in 1960. When the Coes passed away, the house was inherited by their son, who eventually resold it. The mural was offered for sale *in situ* in 1991, estimated between at $1.5 and $2 million. To date, according to Christie's, it has not found a purchaser.

A third mural by Siqueiros, *Ejercicio plástico*, painted in 1933 for an Uruguayan millionaire in the basement of Villa Los Granados, in the suburb of Don Torcuato outside Buenos Aires (after the artist left Los Angeles), was restored and sold in 1988, to a private collector, who had ambitious plans for its exhibition

around the world. See Ximena Ortúzar, "Rescatan 'Ejercicio Plástico', el mural de Siqueiros perdido en un sótano de Buenos Aires," *Proceso*, October 21, 1991: 48–51.

38. Arnold Belkin (New York) and Mark Rogovin (Chicago). See Raquel Tibol, "Otra vez, muralismo en el E.U.," *Excelsior*, Diorama de la Cultura, Aug. 20, 1972: 3; and *Cry for Justice*, Chicago, Amalgamated Meat Cutters and Butcher Workmen of North America, 1972. For other mural activities see Melvin Roman, "Art and Social Change," *Américas*, February 1970: 13–20; Eric Kroll, "Folk Art in the Barrios," *Natural History*, May 1973: 56–65; Elsa Honig Fine, *The Afro-American Artist* (New York: Holt, Rinehart and Winston, 1973), 198–203.

2

MEXICAN MURALISM: ITS INFLUENCE IN LATIN AMERICA AND THE UNITED STATES

Mexican muralism was originally created to play a social role in the post-revolutionary period of modern Mexico. It was clearly an art of *advocacy*, and in many cases it was intended to change consciousness and promote political action. (Whether or not it succeeded is a matter for sociological investigation.) Its other role was educative: to convey information about the pre-Columbian heritage (in the 1920s, a new and revolutionary concept); to teach the history of Mexico from the Conquest to Independence; and to deal with national and international problems from the Reform to the contemporary period.

Since the muralists undertook to address a mass, largely illiterate audience in the 1920s, they chose a realistic style (often narrative) that would serve, as in the Renaissance, like a "painted book," and they contracted to paint their murals in accessible public buildings—government buildings, markets, schools, and so forth.

The argument for teachers today is that Mexican murals can still be used in an educative manner in schools. The same is true for the murals of other Latin American artists and for the Chicano murals of the seventies, which were influenced by the Mexicans. However, some words of

This essay was derived from a lecture given as part of the Arts and Music of Latin America for Pre-College Educators Conference, Institute of Latin American Studies, University of Texas, Austin, April 1980. It first appeared in print as "Mexican Muralism: Its Social-Educative Roles in Latin America and the United States," in *Aztlán: International Journal of Chicano Studies Research* 13, nos. 1 and 2 (Spring/Fall 1982): 111–33.

caution are necessary concerning the *method* of using art to teach other subjects in another time and another cultural framework.

First, artists are *not* historians. Some, like Diego Rivera, were encyclopedic in their research for the painted images they produced. Nevertheless, two points must be kept in mind: (a) the advocacy position already mentioned—meaning the interpretative function of the artist with his material according to his personal politics and ideology; and (b) the poetic license that accompanies even the most "objective" presentation of the facts.

Second, a historical perspective is necessary. *When* a particular mural was painted is important, since the issues concerned and attitudes toward those issues have certainly changed with time. It is also important to consider *where* and *for whom* a mural was painted, especially when different national, regional, and local issues and attitudes are addressed. I would argue that *all* viewing is more meaningful and emotionally stimulating when considered within its historical and cultural context. I hold the still unpopular view that the understanding and enjoyment of art is time-and-culture bound. The enduring works are those reinterpreted for each society's needs; the original context is invariably lost in a short time or across any distance. Art—except on a formal, decorative level perhaps—is neither eternal nor universal; it functions in a time-space continuum and is assigned a new meaning in a new framework.

These cautionary suggestions can work advantageously in an education situation. Art—particularly that being considered here, which is especially accessible because of its original purpose—can be used, as novels and films are, in history, sociology, or political science classes. Art becomes accessory to the facts and theories; it gives a human dimension and a personal point of view. Most important, art provides insight into the complexities of the time as interpreted by an individual artist or an artistic group.

An idea can appear in one time framework serving a given historical function, then reappear later transformed and charged with new meanings and implications. For example, the image of the Mexican revolutionary leader Emiliano Zapata had one meaning for José Guadalupe Posada, a Mexican engraver during the early revolutionary period; he was sympathetic but at times satirical of a contemporary. For Diego Rivera, at a later date, Zapata represented the promises of the Mexican Revolution for agrarian reform and land distribution. Rivera treated Zapata as a historical heroic figure (he was assassinated in 1919 before Rivera returned from his European studies). For contemporary Mexicans in the U.S., Zapata has become deified and sacrosanct. He has left history and become an abstract symbol. The fact that city-born youths from large urban ghettos in the United States transform a Mexican peasant leader into a hero image for

their aspirations gives insight into the contemporary Chicano dynamic. Zapata has since been supplemented by more contemporary and relevant hero models: César Chávez, Ché Guevara, and Rubén Salazar.

Indigenism

Diego Rivera in 1921 painted the first mural of what has become known as the Mexican Mural Renaissance. Many of his murals precisely depict the great Indian civilizations that existed before the Spanish Conquest. Rivera, one of the earliest Mexicans to appreciate and collect pre-Columbian artifacts, carefully researched the history, culture, and art forms and represented them with great accuracy and detail. Poetic license and substitutions of motifs and images can, however, be found in his paintings. After the Mexican Revolution Rivera was concerned with two issues, and these determined his artistic themes: the need to offset the contempt with which the conquistadores had viewed the ancient Indian civilizations, and the need to offset the anti-*mestizo* and anti-Indian attitudes of the European-oriented ruling classes during the *porfiriato* (the dictatorship of Porfirio Díaz). Mestizo and Indian peasants formed the basic fighting forces of the Revolution, and their economic needs were to be addressed on the political plane. The role of the arts was to restore understanding of and pride in the heritage and cultures that the concept of Spanish superiority had subverted. Postrevolutionary *indigenista* philosophy appeared in the work of writers, musicians, filmmakers, sculptors, and painters as a facet of Mexican nationalism. In an advocacy position, the early indigenistas tended to glorify the Indian heritage and vilify that of the Spaniards as a means of rectifying a historical imbalance and advancing certain political ideas.

The *tres grandes* (Big Three) of the Mexican mural movement did not all agree in their interpretations of the indigenous heritage. Rivera idealized the Indian past as seen in his depiction of the Toltec god Quetzalcoatl in the National Palace mural. Except for the small Indian group engaged in warfare at the lower left of the painting, all is peace and harmony. This contrasts with the realities of the ancient past; especially the conflicts of empire-building cultures such as the Olmec, Teotihuacano, Toltec, Maya, and Aztec, whose warring activities are reflected in their arts. Rivera shows ancient civilization almost without conflict; ideal and utopian like a lost Golden Age.

José Clemente Orozco had a very different view of history. He was a *hispanista*. As his paintings and writings make evident, he opposed Indian glorification, ancient or modern. However, he did add one ancient Indian to his pantheon of heroes: Quetzalcóatl. Orozco depicted him as a statesman, educator, promotor of the arts and civilization who, according to legend, was eventually exiled by the restored clergy of older gods he had

replaced, and sailed away on a raft of serpents. It is curious that Orozco chose a mythological figure whom legend described as having been white-skinned, bearded, and blue-eyed—the very antithesis of the dark-skinned, dark-haired Indians. Orozco's heroes were often of Greek origin (Prometheus, the Man of Fire) or Spanish (Cortés, Franciscan monks, or the *criollo* Father Hidalgo), or were allegories of spirituality, education, human rationality, or rebellion. He did heroize modern Indian/mestizo leaders like Felipe Carrillo Puerto, Benito Juárez, and Zapata. For him, these—like Quetzalcóatl—were the exceptional men who stood above the crowd.

The notion of a white hero/god as savior and civilizer of dark-skinned peoples is not unique to Orozco; more recently the idea has been promulgated by diffusionist anthropologist Thor Heyerdahl in books on the Ra reed vessels he sailed from Africa to the New World in an attempt to prove that the ancient Egyptians brought pyramids and mathematics to the indigenous peoples of the Americas. Ironically, the Egyptian civilization evolved in an African context, and the Egyptians themselves can certainly not be classified as "white," although the hierarchy of western civilization which rests on the Egyptian-Greek-Roman foundation has "sanitized" Egypt by conceptually separating it and its history from that of black Africa. Thus Orozco's Quetzalcóatl and Heyerdahl's Egyptians both underline a European ethnocentricity.

Rivera and Orozco again illustrate their dichotomy in differing treatments of ancient Aztecs. Rivera's mural of the marketplace Tlatelolco is an encyclopedic presentation of the multiple products, services, activities, and personages to be seen at the great Aztec marketplace. Presided over by an enthroned official, all is calm and orderly in the market. In the background is a topographical view of the Aztec capital city, Tenochtitlan, with its pyramids, plazas, palaces, and canals. The painting gives no hint of Aztec imperialism, which the market symbolizes. Tribute and sacrifice victims were brought to Tenochtitlan from the subject peoples.

Orozco, on the other hand, took a critical stance. He often painted the brutality and inhumanity of ancient Indian sacrifice. Aztec culture for Orozco was cruel, bloodthirsty, and barbaric. He illustrates a scene of priests holding a victim's body from which a priest is about to tear out the heart. Spanish conquest was also cruel and bloodthirsty, according to Orozco's images, but it brought the redeeming quality of a higher level of civilization and of Christianity, which Orozco compared favorably (in his Hospicio de Cabañas epic mural cycle) to the ancient religions.

Clearly, neither Diego Rivera's unqualified *indigenista* idealization of Indian cultures nor Orozco's *hispanista* condemnation of Indian barbarism are historically accurate. What teachers can extract from these representations are the *modern* interpretations of the past that accur-

ately reflect a clash of ideologies in revolutionary and postrevolutionary Mexico.

Many of Rivera's murals show that his indigenism was not just historical. It was intimately tied to the interests of modern Indians and mestizos who had been exploited and abused not only during the three hundred years of the Conquest, but by large landowners, the Church, and commercial enterprises during the Independence period up to the Revolution. Two of the most important planks of the 1917 Constitution dealt with agrarian reform and the rights of labor unions. Thus Rivera's mural in the Hospital de la Raza deals with modern medical treatment by the Social Security system as well as with the medicinal practices of the indigenist past. Presided over by Tlazolteotl, goddess of creation, the earth, fertility, and carnal love, and recreated from the Codex Borbonicus, the indigenous section is an excellent index for teaching this aspect of pre-Columbian culture. The modern section shows medical care available to contemporary Mexicans who are both Indian and mestizo. But even this aspect has been idealized; the greater portion of the Mexican people today are not covered by Social Security, and thus care is not the norm, but the aspiration.

David Alfaro Siqueiros, youngest of the *tres grandes*, took a different approach to indigenist themes. He did not recreate archaeologically accurate visions of the ancient world but used the indigenous motifs as allegories or metaphors for contemporary struggles. In two heroic images of Cuauhtémoc, the last of the Aztec emperors becomes a symbol for heroic resistance against invaders across time. These murals were painted in 1941 and 1944, during the period of World War II; they were meant to indicate that even overwhelmingly powerful forces could be defeated through resistance. *Death to the Invader* has reference to the invading Axis powers in Europe and Asia while *Cuauhtémoc against the Myth* refers to the myth of Spanish invincibility. Though the original Cuauhtémoc was killed, Siqueiros shows him conquering the Spaniards. Not the historical Cuauhtémoc, but the symbolic one is important.

Mestizaje

The Conquest brought the mingling of the races; it produced the mestizo who is referred to as the fusion of the Indian and the Spaniard. Actually *mestizaje* in Mexico (as in other American countries like Venezuela, Colombia, Brazil, the Caribbean, and the United States) has included intermixture with Africans who were brought in as slaves after the decimation of the Indians. Though modern murals do not often deal with this aspect, the colonial period produced a whole series of paintings that carefully delineated the various crossings with appropriate names for each caste.

Rufino Tamayo in *Birth of Our Nationality* treats the merging of two peoples in a poetic manner. His large Picasso-esque horse of the Conquest with a multi-armed figure on its back (the Spaniard) is framed by a Renaissance column on one side (European civilization) and a pre-Columbian moon/sun symbol on the other. Amid broken blocks of buildings (the destroyed Indian civilizations), an Indian woman gives birth to a child who is half red and half white. Deep rich color and the mythic quality of the figures give a mysterious and dreamlike quality to the event. It is non-narrative, fixed in time like a fable from the past that has eternal verity.

Orozco deals with mestizaje in terms of known historical personages, Cortés and Malinche. Malinche (Malintzin, or Doña Marina) was a Nahuatl and Maya-speaking Indian woman who became Cortés's guide and translator and helped him conquer the imperial Aztecs. She was also his mistress; their son represents the mestizaje of the upper classes, the descendants of Spaniards and Indians who were often incorporated into the Mexican ruling class. In Orozco's image, the two nude figures—like the Adam and Eve of Mexican nationality, as Octavio Paz considers them—are seated together and are of equal size. White and brown color and European and Indian features are accentuated for contrast. Their hands are clasped in union; however, Cortés is obviously dominant: his foot (and their union) rests on the fallen body of an Indian.

Rivera approaches the same theme in a more historical, narrative, and accurate vein that is neither poetic nor exalted. Within the context of the armed conflict of the Conquest, he picks out a small detail in which an anonymous Spanish soldier rapes an anonymous Indian woman. For the vast majority, this is how much mestizaje came to be.

Revolutionary History

Among the educative concerns of the Mexican muralists were a reordering and a revision of Mexican history from a revolutionary point of view. Like Mexican American scholars and artists today, who are revising U.S. history by mandating the inclusion of Mexicans, Mexican Americans, and Native Americans as the original occupants and the bearers of culture, so did Mexican intellectuals and artists in the 1920s challenge the European-oriented historical view. History did not begin with the "discovery" of the Americas by Spaniards or Englishmen; they were simply the latest comers, who chose, on the whole, to ignore or disparage the millennia of cultures and civilizations that had preceded them. By the same token, the Mexican muralists did not choose to represent Mexican history as a succession of colonial aristocrats or post-Independence rulers, but as a series of insurgencies and revolutions by the Mexican people and their leaders against colonizers and dictators.

The central portion of Rivera's epic mural at the National Palace recreates conflicts from the Conquest to the revolutions of 1810 and 1910. Though his theme is conflict, movement and violence are only in the Conquest scenes; the later periods are presented in a static manner with a dense cubistically composed piling up of human forms, many of them historical portraits in shallow space. Porfirio Díaz can be seen surrounded by his *científicos* (positivists), military men, and the clergy. Behind him are the haciendas of Mexican landowners and the buildings of the Pierce Oil Company of London, a reference to foreign capital exploiting Mexican natural resources during the Díaz dictatorship. The revolutionary opposition appears on the other side; among them Pancho Villa, Zapata, Felipe Carrillo Puerto, members of the Serdán family who fired the first shots of the 1910 Revolution, Ricardo Flores Magón, Francisco Madero, and caricaturist José Guadalupe Posada.

Siqueiros's treatment of the same subject also shows the alliance between Porfirio Díaz, the Mexican upper class, and the military, but in a more dynamic composition that openly confronts the ruling with the working class. His theme is a particular historical event: the 1906 strike by Mexican workers against the Cananea Consolidated Copper Company located in Sonora, Mexico, and owned by a North American, William Greene, known as the "copper king of Sonora." This event was one of several believed to have triggered the Mexican Revolution.

International Issues

The Mexican mural movement (which has been represented here only by the *tres grandes*, but which had a large following) did not limit itself to national issues; its view was international in scope. In the 1920s, Rivera and Siqueiros were members of the Mexican Communist Party. They had an unreserved admiration for the Soviet Union, whose revolution occurred seven years after the Mexican Revolution. Rivera's views later underwent a major change when his friendship for Leon Trotsky and his anti-Stalinism grew. However, he and Siqueiros remained strong advocates of socialism—not an uncommon phenomenon in the 1920s and 1930s. Orozco was an iconoclast; he was critical but not unsympathetic in these early years. The contrasting views of Rivera and Orozco in the mid-1930s are instructive. Rivera's *Man at the Crossroads* was originally painted in Rockefeller Center, New York, under the sponsorship of Nelson Rockefeller. The inclusion of Lenin's portrait was too upsetting for Rockefeller and the tenants of the center. The mural was covered and then destroyed, so Rivera repainted it in the Palace of Fine Arts in Mexico City. Surrounding the central motif of a Russian workman at the controls of the universe are the worlds of capitalism (soldiers with gas masks, unemployed strikers attacked by the police, the rich gathered around festive

tables) and of socialism (joyous youth, Lenin as a symbol of world broth-
erhood). In this mural, Rivera reflects the realities and horrors of World
War I, which were still fresh in memory, and the Depression, during
which the mural was painted. Nevertheless, Rivera applies the same uto-
pian vision that informed his treatment of indigenist themes to this new
work. By 1933 Lenin was dead, and Trotsky, after disagreements with the
Stalin government, had been exiled. The only indication of this rift is the
pointed inclusion of Trotsky's portrait and the exclusion of Stalin's beside
the figures of Marx and Engels in the socialist half of the mural.

Orozco's New York murals of the same period feature three heroic
leaders with their followers: the assassinated Maya governor of Yucatán,
Felipe Carrillo Puerto; the dead Lenin; and the Indian leader Mahatma
Gandhi in his confrontation with British imperialism. With Gandhi was
one of the few women Orozco placed in a heroic light, Madam Sarojini
Naidu. Though Carrillo Puerto and Lenin occupy similar spaces and ele-
vation in the mural, individualized followers surround Carrillo Puerto
while Lenin appears above robotized masked soldiers with ranks of sharp
bayonets. Through this subtle difference Orozco could heroize the indi-
vidual without necessarily accepting the society he constructed. This il-
lustrates Orozco's philosophy in general; he distrusted masses of people
and looked in a Nietszchean manner to individual supermen for social
reform or salvation.

After Siqueiros returned to Mexico from the Spanish Civil War, he
painted a complex mural on the walls, windows, and ceiling of a staircase
in a trade union building. For him, the world scene looked bleak. Spain
had been the proving ground for Nazi and Fascist militarism; the Civil
War presaged World War II. While the Axis consolidated its power in Eu-
rope and Asia, the western nations adhered to a "neutrality" and appease-
ment policy, which brought down the Republican government in Spain,
and allowed Hitler access to European conquest. Siqueiros had no sym-
pathy for either the Axis or the Allies. Beneath a huge steel-plated eagle/
dive bomber in his mural, he painted an anthropomorphic machine that
turns human blood from war victims into gold coins (profits from muni-
tions on both sides).[1] On one side are the British, French, and U.S. allies;
on the other are the Japanese, German, and Italian. On the left wall, a
parrotlike demagogue waves a fiery torch while masses of soldiers march;
on the right, as a symbol of opposition, is a powerful figure of the people's
resistance.

For U.S. historians and teachers, Siqueiros's mural highlights a mo-
ment in time that tends to be overlooked in the subsequent unity of
World War II: that period between the fall of Spain to Franco in 1939 and
the attack on Pearl Harbor in 1941 which finally brought together the
United States, the Soviet Union, England, France, and many other coun-
tries (including Mexico) against fascism. For artists, the mural is a fas-

cinating study of the new artistic technology developed by Siqueiros (synthetic paints, spray gun application on a wall, documentary photography incorporated into painting) and new formal methods (filmic movement on a static painted surface, illusionistic destruction of architectural space, creation of a containing "environment"). Many of these means presage artistic directions explored in the United States in the 1960s.

For all their power and command of pictorial means, Rivera's and Orozco's method and expressions were far more traditional, though all three shared revolutionary social content. Perhaps this is one reason why Rivera and Orozco were the major influences on U.S. and South American artists until World War II, and Siqueiros was the most admired and copied by the U.S. street mural movement of the sixties and seventies.

Before leaving Mexican terrain, one must note that issues and attitudes are changed and reinterpreted with time. In the aftermath of the Mexican Revolution, the muralists and other cultural workers were aware of the need to create a new formal and thematic language in the interests of social change. New aspects of history were to be emphasized, new heroic figures to be given prominence, and new views of social relationships to be advanced. This language would reflect political concepts that emerged from the revolutionary process: agrarian reform, labor rights, separation of church and state, Mexican hegemony over natural resources, defense against foreign economic penetration, and literacy and education for the masses.

Sixty years have passed since the termination of the Revolution. The Mexican state, economy, political structure, and international role have changed. Much revolutionary oratory has become rhetoric in the speeches of government functionaries. Younger generations of artists have reexamined and are revising concepts of the traditional heroes. For example, two murals on revolutionary themes face each other in a salon of the National History Museum in Chapultepec Park, Mexico City. One, by Jorge González Camarena, is a mannered, heroicized portrait of Venustiano Carranza, revolutionary general and early president of Mexico. Carranza at one stage fought against Zapata and was responsible for his assassination. Zapata had accused him of deceit and hypocrisy for preaching and not practicing agrarian reform. Directly opposite the Camarena mural is one by a much younger artist, Arnold Belkin.[2] He confronts the Carranza portrait with one of Zapata and Pancho Villa derived from a famous Casasola photograph. The irony of the placement has not escaped Belkin. In addition, the figures of Zapata and Villa have the flesh stripped away as if the artist intends to demythologize them as well as Carranza.

In a similar vein is Felipe Ehrenberg's easel painting/collage of Carranza and Zapata. In it Carranza appears twice: once as a general with the Mexican flag substituted for his face as though his true features are hidden behind his patriotism and again as president where he is

superimposed over the body and face of Zapata. Carranza destroyed the man but he absorbed his legendary aura. Beneath each figure is a ruler to take anew the measure of history and mythology.

The Mexican muralists accepted the role of guide, teacher, and conscience of their country and produced an art which played a social role. The very choice of means—muralism—underscores their consciousness of this role since the technique and form is public and not conducive to the expression of subjective or introspective material. It served the needs of the time objectively. It created a new plastic language, a new ideology, and a new iconography. For the first time, the anonymous peoples of Mexico appeared in art, but as heroes taking control of their own destinies: Orozco's villagers marching off to the Revolution; Rivera's masses of farmers receiving the divided lands of the great estates; Siqueiros's workers creating unions in order to benefit from the riches of their own lands. With them are the leaders who aligned with them or came from their own ranks.

The Caribbean and South America

The 1920s, a period of reassessment and reevaluation of European values, followed the devastation and slaughter of World War I. Until then, these values had been considered the acme of civilization. Europeans (and some Latin Americans) turned to dada, a self-mocking iconoclastic movement which questioned existing mores, customs, and the nature of culture itself. The Americas, from the United States to South America, turned inward upon their own resources in an exuberant expression of nationalism and regionalism and sought values indigenous to their own continent. In the United States, this took a politically isolationist form and an artistic celebration of varied regions of the nation known as Regionalism. Among African Americans from the Caribbean, Brazil, and Harlem came the celebration of "negritude" and the search for an identity. In Mexico, Guatemala, and the Andean area, nationalism took the form of indigenism—ancient and modern—tied to contemporary social reform. Artists and writers sought to cut their dependence on European models and develop their own artistic vocabulary and themes; they naturally turned to the Mexican muralists, particularly to Rivera, who was known internationally, for inspiration. Many traveled to Mexico to study. However—with the exception of U.S. artists who briefly worked in Mexico and who assisted with, or studied, the murals done by Rivera, Orozco, and Siqueiros in many cities of the United States during the 1930s—few artists had the opportunity to do murals. The social conditions, including government commissions and support, conducive to monumental public art existed only in Mexico and in the U.S. of the New Deal. In other areas, relatively few murals were executed, and no opportunity existed for a

national mural movement as in Mexico. Primarily, the Mexican influence can be seen in easel paintings, sometimes monumental in size. To my knowledge, no thorough study of modern Mexican influence on Latin American art has yet been compiled; a similar study of the Mexican influence in the U.S. has only just gotten underway.[3] At this stage, any conclusions must be tentative. Nevertheless, stylistic, thematic, and some documentary evidence exists on Mexican influence in South America and the Caribbean.

Two easel paintings by Cuban artists illustrate this influence. Eduardo Abela's *Guajiros* and Mario Carreño's *Sugar Cane Cutters* deal with rural workers. Abela's people are similar to Rivera's stocky, simplified, and static figures, and Carreño is influenced by Siqueiros stylistically and in the use of Duco, an automobile lacquer which Siqueiros adapted to fine art use in the 1930s.

Cândido Portinari, universally recognized as Brazil's greatest modern artist, was among several young artists in the 1930s committed to dealing with Brazilian social problems and contemporary life. His large painting *Coffee* brought him international recognition. The use of space, the simplification of figures, compositional devices, and the exaggeration of body proportions show Rivera's influence. Portinari painted many important murals at the Ministry of Education in Rio de Janeiro, the Library of Congress, Washington, D.C., the Pampulha Church in Belo Horizonte, and the United Nations. He continued to paint sugar and coffee workers, slum dwellers, blacks, mulattoes, whites, Indians, and other typically Brazilian subjects. *Burial in a Net* is part of a series of paintings dealing with a terrible drought in northeastern Brazil during the 1940s; it has elements of Picasso as well as the tragic expressiveness of Orozco.

In 1933, Siqueiros visited Buenos Aires, where, assisted by several local artists, he painted an experimental mural called *Plastic Exercise*. Among the artists was Antonio Berni, whose huge oil paintings, such as *Unemployment* of 1935, express his social realist concerns, though the style is not indebted to Siqueiros. In 1946, Berni was one of a group of artists who did frescoes in an arcade in Buenos Aires (the others were Colmeiro, Urruchúa, Spilimbergo, and Castagnino). Berni's monumental images in his two murals at this location owe a debt to Orozco and to the Italian Renaissance. Muralism, however, did not flourish in Argentina. There were no opportunities to do murals. The immense size of his canvases seem to express a frustration with the lack of walls.

In Peru, with a larger Indian population, Mexican indigenism and social realism flourished. In 1922, José Sabogal visited Mexico, where the impact of the muralists turned him into an ardent indigenist and nationalist. His influence produced a school of painters, among them Teodoro Nuñez Ureta, who shows the distinct influence of Orozco in his *Transmission of the Seed* and that of Siqueiros in *Allegory of Production and*

Work. Nuñez's heroic treatment of indigenist and working-class themes places him in the social realist tradition of the Mexican School.

César Rengifo of Venezuela has been a social realist since the 1930s. He did one tile mural in Caracas on an indigenous theme; but realistic public art had few patrons in Venezuela. One exception is the case of Héctor Poleo, who studied mural painting in Mexico in the late 1930s. He was influenced by Rivera, and executed a mural for the new University City in Caracas. Since the 1950s, geometric abstraction and kineticism have dominated Venezuelan art: thoroughly cosmopolitan art forms which reflect the urban-industrial development of Caracas that resulted from the discovery of large oil deposits in 1938 and 1973. Both Poleo and Rengifo dealt with the desolate life of the rural hinterlands (in contrast to the capital city, Caracas), primarily in easel paintings like Rengifo's *Settlement of Peons* and *What the Petroleum Has Left Us: Dogs*.

Chicano Muralism of the 1970s

Between the 1940s and the 1960s, public muralism in the United States suffered an eclipse. The New Deal art projects were terminated in the forties, and artists turned to other pursuits for the duration of World War II. In the complacent, prosperous, and individualistic fifties—overshadowed by the cold war and McCarthyism—introspective easel painting flourished, dominated by abstract expressionism. New York became the art capital of the world and centralized arbiter of taste in the United States. Critics fulminated against "narrative, propagandistic" art and attacked "literary content" in painting. Representational art in general faced lean times. Art history was revised as the Mexican School, South American social realism, U.S. Regionalism, and New Deal art were written out of the history books. Only in the mid-seventies have these movements been reassessed and reintegrated into art history, as a number of authors began to publish books on the New Deal and as regional exhibitions of New Deal art took place. The issue of regionality in art, of the validity of artistic pluralism in the United States, of resistance to the absolute dominance of New York's establishment over the nation has now come into focus.[4]

One of the key factors promoting this new decentralizing of artistic focus, reevaluating of the 1930s, and burgeoning interest in the art of Latin America and Latinos in the United States is the street mural movement, in which Chicano muralism has played a quantitative and qualitative part. The outdoor muralists turned to the Mexicans as an important source of knowledge, technique, concept, style, and inspiration. Nowhere was this more culturally important than among Chicanos, for whom the recovery of Mexican muralism was part of a larger recovery of heritage and identity after a century of deliberate deculturalization by the domi-

nant society. Looking at this last statement with a finer lens, however, research still in its initial stages suggests that the deprivation of Mexican models for Mexican American artists is only two decades old, and applies to those artists who came to their calling during the hegemony of abstract expressionism or the "art-for-art's sake" dictum of the art schools. The process of revitalizing the work of the Mexican muralists (as well as of younger artists) in the United States and making it available to artists of the 1960s and 1970s was the result of efforts by Chicano Studies programs and mural groups in the Southwest and Midwest, and the establishment of alternative Chicano cultural structures which researched and disseminated information about Mexican art.

In this brief consideration of Chicano muralism as influenced by the Mexican mural movement, there are examples of the transformation of themes that were important to the Mexicans at an earlier date and that were charged with new meanings and implications within the context of contemporary Chicano concerns. For example, the initial cultural-nationalist phase of Chicano consciousness in the mid-1960s produced a wave of neo-indigenism like that of the Mexicans in the 1920s but with certain important differences. First, the Americanist indigenism of the 1920s was part of an isolationist-nationalist wave following World War I. It was not necessarily exercised by the indigenous peoples themselves but by intellectuals on their behalf. Present neo-indigenism has made links with people of color throughout the developing Third World, and it is being promoted by the affected groups: Chicanos, Puerto Ricans, and Native Americans. Second, Rivera's indigenism responded to a largely agricultural nation where the landless or small farmers, Indian and mestizo, made up a great part of the population, and where agrarian reform was a major plank of the Revolution. Though Chicanos in the Southwest also have a large rural or semi-rural population, and the unionization struggles of the United Farm Workers were a focal point in the development of Chicano culture, this agrarianism is in a highly industrialized country, where even agriculture is a big business. Therefore, little probability exists that Chicanos would or could be the small farmers the Zapatistas aspired to be.

One of the earliest and strongest proponents of neo-indigenism was Luis Valdez of Teatro Campesino. He drew upon his interpretation of pre-Columbian religion to provide a non-European spiritual base for Chicano life. However, Valdez turned to this source at the point when he began to address urban Chicanos as well as farmworkers. He himself was urbanized through long residence in big California cities. The same is true of Chicano poets Alurista of San Diego, and Rodolfo "Corky" Gonzales of Denver, important figures in the popularization of neo-indigenism.

Another point of differentiation was the almost exclusively pre-Columbian focus of the cultural-nationalist phase; the fraternity between

mestizo Chicanos and Native Americans based on a commonality of "race" and oppression within the Anglo-dominated society did not occur until later. Mexico, on the other hand, has been a mestizo and Indian nation since the Conquest; indigenism in the 1920s served to emphasize the national fact. Mestizos and Indians were the *majority*, not the minority, and artists addressed their present problems.

Two Chicano murals, one from Los Angeles and the other from Denver, are taken directly from pre-Columbian sources; they are copied uncritically without concern for historical context. Charles Félix recreates in color a sacrifice scene from a ballcourt relief sculpture at El Tajín, Veracruz. Al Sánchez reproduces the single figure of the goddess Tlazolteotl—the same used as a central figure by Rivera in his Hospital de la Raza mural on ancient and modern medicine. Rivera related pre-Columbian to modern medicine as a continuum, the patients being Indians of the past and present. The murals by Félix and Sánchez are essentially decorative and unselective about content—surely Félix did not intend to glorify human sacrifice.[5]

La Mujer, an enormous collectively painted mural in Hayward, California, uses a variety of motifs that mingle the pre-Columbian with contemporary urban problems. The central female figure with tripartite head and powerful out-thrust arms is adapted from Siqueiros's 1944 *New Democracy* in the Palace of Fine Arts, Mexico City. On one side of the Hayward mural are the evils of the big city: contaminated food, arson, violence in the streets, drug abuse, and others. One of the great arms holds a destructive hammer over these scenes. The other arm terminates in a wheel incorporating the four elements; the Puerto Rican, Mexican, Cuban and Pan-African flags; and peace symbols of the Native American. Pre-Columbian figures intertwine with death and destruction on the left and with corn, peace, and growth on the right. Thus the indigenous motifs are selectively chosen and thematically enhancing.

Another elaboration of this kind which creatively adapts motifs and formal elements from indigenous sources and the Mexican muralists is *Song of Unity* in Berkeley, California. Its point of departure is contemporary social song (called *nueva canción* in Latin America) in North and South America, and therefore its central motif is a double image of eagle and condor. The mural has an irregular billboard-like cutout surface. One side of the mural pictures North American musicians and songwriters such as Daniel Valdez, Malvina Reynolds, and jazz musicians; the other side features the peoples of Latin America, particularly the Andean Indians. All the figures are dramatically foreshortened in space and seem to thrust from the surface in a manner typical of Siqueiros's paintings. Also adopted from Siqueiros's sculpture-painting technique is the dominant figure of the mural, which is modeled three-dimensionally and projects in relief from the surface. This is an image of Chilean songwriter Víctor

Jara, who was killed by the military junta during the fall of the Allende government in 1973. His severed hands continue to play a guitar, while the peoples of South America with their regional instruments march through his transparent mutilated arm.[6]

In Houston, Texas, muralist Leo Tanguma painted an enormous mural called *Rebirth of Our Nationality*. A Chicano man and woman emerge from a large red flower which rests in a bleak landscape on a platform of skulls. They are under the banner "To Become Aware of Our History is to Become Aware of Our Singularity." From either side, brown-skinned figures, who represent the multiplicity of Mexican peoples and the complexity of their history and struggles in Mexico and the United States, drive toward the central inspiration of their rebirth. The dramatic thrust of the composition and the violent expressionism of the figures owe a debt to Siqueiros and Orozco—whom the artist has long admired. The social responsibility of the artist to his community is a philosophy Tanguma derived from Siqueiros, whom he met personally.

Marcos Raya of Chicago borrowed figures from Orozco and the major composition of Rivera's *Man at the Crossroads* for his mural *Homage to Diego Rivera*. He substituted Mayor Daly of Chicago for the central figure of the worker in the original mural and surrounded him with images of corruption and violence.[7]

Chicano murals exist in all states of the Southwest, as well as in the Midwest/Great Lakes region. California has more than a thousand, scattered in cities and some rural areas. Texas has murals in Austin, San Antonio, Houston, Crystal City, El Paso, and other locations. No single style unites them. Their commonality, to the degree that it exists, derives from thematic factors and what might be called "the Chicano point of view," a difficult thing to define and one that, even now, is undergoing transformation; It derives from life experiences common to Chicanos living in the United States during the second half of the twentieth century: those Mexicans who are expressing a growing awareness of their long history on both sides of the present border. Murals also include the process of redefining and changing that history, and education has played no small role in that process.

References (Art works accompanying original lecture)

(All Mexican works are located in Mexico City unless otherwise noted. Specific location is given for murals.)

Mexican Works

Diego Rivera, *Totonac Civilization*, 1950–51. 2d floor, National Palace. Rivera, *Feather Arts*, 1945. 2d floor, National Palace.

Rivera, *The Ancient Indigenous World*, 1929–30. Staircase, National Palace.

José Clemente Orozco, *Coming of Quetzalcóatl*, 1932–33. Baker Library. Dartmouth College, Hanover, New Hampshire.

Rivera, *Great Tenochtitlan*, 1945. 2d floor. National Palace.

Orozco, *Ancient Human Sacrifice*. 1932–33. Baker Library.

Rivera, *Ancient and Modern Medicine*, 1952–54. Lobby, Hospital de la Raza.

David Alfaro Siqueiros, *Death to the Invader*, 1941. Mexican School, Chillán, Chile.

Siqueiros, *Cuauhtémoc against the Myth*, 1944. Presently at the Tecpan of Tlatelolco.

Rufino Tamayo, *Birth of Our Nationality*, 1952. Palace of Fine Arts.

Orozco, *Cortés and Malinche*, 1926. National Preparatory School.

Rivera, *History of Mexico: The Conquest*, 1929–30. Staircase, National Palace.

Rivera, *History of Mexico: The Present*, 1929–30. Staircase, National Palace.

Siqueiros, *Revolt against the Porfirian Dictatorship*, 1957–1965. National History Museum.

Rivera, *Man at the Crossroads*, 1934. Palace of Fine Arts.

Orozco, *Struggle in the Occident and the Orient*, 1930–31 (restored in 1988). New School for Social Research, New York.

Siqueiros, *Portrait of the Bourgeoisie*, 1939. Electricians Union.

Jorge González Camarena, *Venustiano Carranza*, 1970s. National History Museum.

Arnold Belkin, *The Arrival of the Generals Zapata and Villa at the National Palace on the 6th of December, 1914*, 1978–79. National History Museum (since removed).

Felipe Ehrenberg, *Carranza and Zapata*, 1979. Easel painting/collage.

South America and the Caribbean

Eduardo Abela, *Guajiros*, 1942. Oil on canvas.

Mario Carreño y Morales, *Sugar Cane Cutters*, 1942. Duco on wood.

Cândido Portinari, *Coffee*, 1935. Oil on canvas.

Portinari, *Burial in a Net*, 1944. Oil on canvas.

Antonio Berni, *Unemployment*, 1935. Oil on canvas.

Berni et al., untitled, 1946. Galería Pacífico, Buenos Aires.

Teodoro Nuñez Ureta, *Transmission of the Seed*. Oil on canvas.

Nuñez, *Allegory of Production and Work* (detail), 1958. Ministry of Agriculture, Lima.

César Rengifo, *Settlement of Peons*, 1956. Oil on canvas.

Rengifo, *What Petroleum Has Left Us: Dogs*, 1963. Oil on canvas.

Chicanos: United States

Charles Félix, *Sacrifice Scene from El Tajín,* 1973. Estrada Courts Housing Project, Los Angeles.
Al Sánchez, *Medicine Gods: Tlazolteotl,* 1973. National Chicano Health Organization, Denver.
Rogelio Cárdenas and Brocha de Hayward, *La mujer,* 1978. Market, "A" Street and Princeton, Hayward, California.
Ray Patlán, Osha Neumann, O'Brien Thiele, Anna DeLeon, *Song of Unity,* 1978. La Peña Cultural Center, Berkeley, California.
Leo Tanguma, *Rebirth of Our Nationality,* 1973. Continental Can Company, Houston.
Marcos Raya, *Homage to Diego Rivera,* 1973. 1145 W. 18th St., Chicago.

Notes

1. The original image within the machine showed dead children, victims of Fascist intervention in the Spanish Civil War. This image was changed in a difficult period of 1939–40 by a member of Siqueiros's painting team.

2. The portable Belkin mural has since been moved to another location.

3. Laurance P. Hurlburt, *The Mexican Muralists in the United States* (Albuquerque: University of New Mexico, 1989).

4. Three issues of *Art in America* reflect this new consciousness: the July-August 1972 special issue on the American Indian; the May-June 1974 issue dealing with public art, women's art, and street murals (hitherto an "invisible" category) across the country; and the July-August 1976 "Art across America" issue whose cover is dominated by Texas artist Luis Jiménez's sculpture, and whose perspective is epitomized by Donald B. Kuspit's article "Regionalism Reconsidered."

5. An interview with Félix by one of my former students after the publication of this article revealed that the artist was metaphorically addressing local gang warfare.

6. As of 1988, the mural was undergoing a process of restoration and change by three members of the original team. Some of the personalities represented in the original have been replaced, while the strong feeling prevalent in the 1980s against the wars being waged in Central America with U.S. financial aid has caused the team to add a Guatemalan Quetzal bird to the eagle and the condor.

7. In the early 1980s, Raya repainted portions of this mural to reflect new conditions in Central America. He added an MX missile to the military hardware.

3

RESISTANCE AND IDENTITY: STREET MURALS OF OCCUPIED AZTLÁN

The rebellious sixties are over. Young people seem universally to have abated their demonstrations and acts of defiance to settle into the normal channels of status quo life. Actually, upon closer inspection, it can be seen that anarchic rebellion, a response to deep-seated world malaise, has simply transformed itself into new conceptualizations and activities. Of these, the street mural movement of the United States which began in the late sixties is an important development.

When one thinks of muralism in the twentieth century, the achievements of the Mexican mural movement immediately come to mind. Many books have been written in Mexico and abroad about the *tres grandes* and their followers, and about the active role of painting in the formation of Mexican consciousness and awareness since the 1920s. Much less has been said about the internationalization of Mexican muralism and its influence on Europe and North America.

In the United States, we can speak of two great waves of influence from Mexico almost forty years apart, and certain similarities in the social circumstances that led to a receptivity to public art. The first was during the thirties at the height of the Depression. Between 1930 and 1934 Orozco, Rivera, and Siqueiros all worked in the United States with teams of U.S. artists. In spite of the sometimes unfavorable publicity and the destruction of several murals, the muralists were tremendously influ-

This essay first appeared as "Resistencia e identidad: Los murales callejeros de Aztlán, la ciudad ocupada," in *Artes Visuales* (Mexico City), no. 16 (Winter 1977): 22–25, 47–49.

ential among younger socially minded artists, who welcomed them as the avant-garde of the day. Major precepts of the Mexican mural movement were translated into U.S. terms through the intervention of George Biddle, who, in May 1933, wrote to his former classmate Franklin D. Roosevelt:

> The Mexican artists have produced the greatest national school of mural painting since the Italian Renaissance. Diego Rivera tells me that it was only possible because [President] Obregón allowed artists to work at plumber's wages in order to express on walls of government buildings the social ideals of the Mexican Revolution.[1]

President Roosevelt agreed to try the experiment in the U.S., and several programs were established under the federal Works Progress Administration (WPA) and the Treasury Department, which together subsidized a broad spectrum of artists to create a national public art (not all murals) modeled on that of the Mexicans, though more regional in theme and politically milder.

In this program, prestigious artists like Ben Shahn, Rico Lebrun, Stuart Davis, Anton Refregier, Rockwell Kent, and future abstract expressionists Arshile Gorky, Philip Guston. Willem de Kooning, and Jackson Pollock participated. The beginning of World War II ended the program, while subsequent McCarthyism, the cold war, and the formalist direction taken by U.S. artists terminated realist art as a mainstream direction.

A second period of receptivity to Mexican muralism arose out of the political ferment of the 1960s. It is generally agreed that Chicago's community-oriented street mural movement was the earliest and most developed, aesthetically and thematically. Of the Chicago artists, William Walker and John Weber were strongly influenced by Rivera, while Mark Rogovin and Ray Patlán owed debts to Siqueiros and Orozco respectively. On the West Coast, where Chicanos form the second largest minority in the U.S., an independent movement developed about 1970 (subsequent to awakened *raza* militancy) in the urban ghettos of major cities like San Francisco, Los Angeles, Fresno, Sacramento, San Diego (in California); San Antonio and Crystal City (Texas); and Santa Fe (New Mexico). Informed by the new nationalist and separatist philosophy of Chicano activism, many murals addressed themselves to overcoming the "colonial mentality" so aptly expressed by the poetry of Denver activist Rodolfo "Corky" González: "In a country that has wiped out / all my history / stifled all my pride. / In a country that has placed a different indignity / upon my ancient / burdens. / Inferiority / is the new load." Nationalism, expressed by such terms as "Chicano" and "Aztlán," stressed the Indian heritage and the fact that Chicanos (long treated as strangers in their own land) were indigenous to the Southwest.

In rejecting Anglo-American values, Chicanos felt the necessity of

devising their own communications media. In effect, they bypassed corporation-controlled mass media to establish newspapers, magazines, educational television programs, mobile theater groups, and street murals (wall newspapers), often "underground" in character. Students demanded and won curriculum changes in the schools reflecting their Mexican heritage. Chicano artists familiarized themselves with the pre-Columbian motifs they used for murals in the indigenous-nationalist phase. Later, as the movement became more politicized and less narrowly national, they turned to the Mexican muralists for inspiration. In doing so they reenacted (albeit unknowingly) a conceptual schism that occurred earlier in Mexico when Orozco and Siqueiros censured the kind of "archeologicism" practised by Diego Rivera.

Chicano artists are not as theoretical or as politically aware as the Mexican muralists were; the broadening of concerns and themes occurred in a sporadic and decentralized manner among individual artists working without a shared ideology. There is significance, however, in the correlation between politicized murals and the growing influence of the Mexican mural movement. As Chicano artists attempted to develop a thematic and plastic vocabulary to express their life experience, the indigenous elements tended to move into secondary position, appearing in murals as a pyramid, an Aztec warrior, or similar symbols uniting the past with the present but not displacing contemporary concerns. The most theoretically advanced Chicano artists (and obviously the movement is not monolithic) have understood that their focus must be the present, not the Indian past alone. Anything else is mysticism or archaicism.

In the age of "museums without walls" (André Malraux) or more accurately, the age of "mechanical reproduction" (Walter Benjamin), Chicano knowledge of Mexican muralism was obtained primarily from books. However, even these were limited, because of the prevailing "blackout" of information about the Mexican mural movement and U.S. art of the thirties. Though in California original works exist in San Francisco (Rivera), Los Angeles (Siqueiros), and Claremont (Orozco), they are neither well known nor easily accessible. When a campaign was initiated in Los Angeles (1968) to restore a whitewashed Siqueiros mural from the 1930s, it had tremendous resonance in the community. The point is that Chicano (and other) street muralists generally had to study Mexican muralism from an inadequate supply of printed material, much of it dated, little of it in color.

Until the appearance of the *Mural Manual*,[2] technical books were totally lacking. Because architectural wall painting was not taught in art schools, street muralists (even when they were trained artists) applied lessons learned from easel painting to walls, not understanding that a mural is not an enlarged easel painting. Stylistic mannerisms of the *tres*

grandes were adopted whole, with little understanding of the dynamic between form and content. In this aspect, Siqueiros has been the most widely copied in poor imitations of his dramatic foreshortening, with no concept of his polyangular perspective.

Stylistic absorption has varied. In Chicago, for example, the mural *Homage to Diego Rivera* by Marcos Raya reproduces (with many changes) Rivera's *Man at the Crossroads* and includes a figure from Orozco's *The Leaders and the Masses* from Guadalajara. Gil Hernández's Los Angeles mural incorporates Siqueiros's self-portrait *El coronelazo*, Orozco's *Hidalgo*, and Rivera's *Zapata*. In addition, two sunbathing figures are taken from images of torture victims on the side panels of Siquieros's *New Democracy*, which trivializes the original concept. This type of pastiche is common and not always happy. In some cases it is caused by a lack of skill and pictorial imagination. Far more exciting are the murals of the Chicago artists already mentioned, and those by such an artist as Carlos Almaraz of Los Angeles, whose stylistic influences from Rivera and Orozco—like Marcos Raya's—have been successfully synthesized with contemporary subject matter. Fig. 4

A number of street muralists have evolved their own styles, with an occasional nod to pre-Columbian or muralist sources. These artists have dealt imaginatively with such themes as drug addiction, local gang warfare, injustice, police brutality, mass deportation, unemployment, support for the United Farm Workers, unity between racial minorities, opposition to the Vietnam War, and the memorialization of *raza* martyrs such as murdered journalist Rubén Salazar. Since the muralists are working for, and frequently with, an inner community, they do not hesitate to use purely local iconography and symbolism as part of their strategy to stimulate identification.

It should be noted in connection with the previous point that territoriality has been a major factor in regionalizing urban muralism. Unlike the Mexicans, who spoke for an entire nation, these street muralists identify more closely with a local community and translate its aspirations and problems into paint. In most cases, their viewpoint is micro- rather than macrocosmic. Many minorities and poor residents of big cities live in isolated islands of community safety, seldom venturing into surrounding "enemy territory" except to work. Young people often grow up knowing only their small segment of the city. This type of provincialism in the heart of the cosmopolis has its own standards and life support systems, factors which muralists have to consider if they wish their pictorial imagery to connect with the community. At the same time. it is also their task to broaden horizons and create identifications with larger issues and other peoples. Murals that deal with heroes like Zapata, Pancho Villa, Ché Guevara, Martin Luther King, Jr., Pedro Albizu Campos; with Pan-Americanism (like the wall paintings of San Francisco's Mujeres Muralis- Fig. 6

Fig. 5

tas); or with unity between colonially divided blacks, Chicanos, Puerto Ricans, and Japanese serve this larger function. *Dove of Peace Enfolding People of All Races* in an almost totally Chicano housing project in Los Angeles is an example of the latter.

One final word must be said about funding for the U.S. mural renaissance. The earliest murals were often done with donated materials and the artists were minimally compensated or unpaid. As the movement grew, the pressure of its existence made monies available from city, county, and national agencies, in contradistinction to the Mexican and the Depression-era mural programs, which from the start employed professional artists who were paid with federal funds. Not until 1970 was funding for an Inner City Mural Program initiated by the National Endowment for the Arts. It was intended as a soporific to defuse potentially explosive situations in the ghettos and poverty pockets of the nation. The parallel to the much-publicized War on Poverty is obvious. For a period of time, large sums of money are poured into discontented communities, but nothing is done to ameliorate basic problems. Eventually funds are reduced or cut off. In addition, there is the subtle pressure to "depoliticize" mural subject matter, an objective with parallels to the Mexican and New Deal mural programs.

Funding today serves the same function for U.S. internal "colonies" as the Alliance for Progress did for external ones—a function aptly described by former Venezuelan president Rómulo Betancourt when he said: "We must help the poor in order to save the rich." Ironically, the funds invested to preserve the status quo strengthen and nourish the cultural expression and expectations of precisely those elements of the population whose best interest lies in its nonpreservation.

Notes

1. Quoted in Francis V. O'Connor, *Federal Support for the Visual Arts: The New Deal and Now* (Greenwich, New York: New York Graphic Society, 1969), 17–18.

2. Mark Rogovin et al., *Mural Manual* (Boston: Beacon Press, [1973], 1975). Such books as Siqueiros's *Cómo se pinta un mural* or *Por la vía de una pintura neorrealista o realista social moderna en México*, which deal with technique, are out of print. [Siqueiros's *Cómo se pinta un mural* was reissued in Mexico City the same year this article was published: Mexico City: Ediciones Taller Siqueiros, 1977.]

4

ELITE ARTISTS AND POPULAR AUDIENCES: THE MEXICAN FRONT OF CULTURAL WORKERS

Testimonies: Taking over the streets

1968: It was intolerable [to the government] that a veritable multitude of between three hundred and six hundred thousand people marched on the principal streets of Mexico, the Paseo de la Reforma, Juárez, Cinco-de Mayo, carrying banners and placards which mocked the "principle of authority." It was necessary to crush the student protest which was shaking the status quo, the PRI, the government-controlled unions, the damned lies. [1]

1968: Our propaganda included fences painted by students [covered with gray paint by the police], which we repainted again. . . . [We] printed slogans on the sides of urban buses and streetcars . . . on any available wall in the city. . . . The mimeographed leaflets, and our lungs were our newspaper. [2]

1969: The students, full of hope, gathered for a meeting—not a demonstration—in the plaza of Tlatelolco on the second of October. At the end of the meeting, when those attending it were about to leave, the plaza was surrounded by the army and the killing began. A few hours later it was all

This essay was first published in *Studies in Latin American Popular Culture* 4 (1985): 139–54.

*over. How many died! No newspaper in Mexico dared to print the number
of deaths. . . . Thousands must have been injured, thousands must have
been arrested. The second of October 1968 put an end to the student move-
ment. It also ended an epoch in the history of Mexico.*[3]

*1977: Eleven students [of the San Carlos Art Academy] are in the exhibit
"Introducción a la calle" (Introduction to the Street). . . . They consider
that amidst the political and social chaos that produces such alienation,
they have the right to take over the streets by assault. . . . They are con-
vinced that artistic work is a commitment to transform reality.*[4]

I

The story of the Mexican Front of Cultural Workers (*Frente Mexicano de
Trabajadores de la Cultura*), hereafter referred to as the "Front,"[5] rightly
begins in October 1968 with the events surrounding the October 2, 1968,
massacre of students and workers at the Plaza of the Three Cultures (Tla-
telolco) in Mexico City, though the groups that later comprised the Front
did not organize until the mid-1970s, and the Front itself did not exist
until 1978. There is no question that October 1968 represented a water-
shed for the Mexican student movement as a whole, and for the con-
sciousness of art students who were either personably involved in the
events or saw in them a tremendous symbolic significance. For the Front
in 1978, Tlatelolco was the signifying event of a decade of heightened
class confrontation and political repression.

Foreshadowing the 1968 crisis were a series of changes in class rela-
tionships under the conditions of a dependent state-monopoly capitalist
system. Among the trends that developed in Mexico in four areas of ma-
jor concern to our present theme were the proletarianization and im-
poverishment of the peasantry; the development of a sizable industrial
proletariat, some of it unionized and most of it low paid; a large under-
employed or unemployed labor pool marginal to the economic structure;
and the increasing misery of the majority of the population, many of
whom migrated to the large cities, which became paved with superhigh-
ways and filled with festering slums. "By 1970, Mexico was almost as
sharply divided between rich and poor as it had been in 1910. In spite of
an expansion of the intermediate classes, income distribution had wors-
ened over the years."[6]

II

On May 22, 1978, an unusual exhibition organized by the recently formed
Front opened at the House of Culture in Morelia, Michoacán. It was not

the *nature* of the exhibition, which was titled "Muros frente a muros" ("Walls Facing Walls"), that was so startlingly different from what usually transpires at such locations—the inauguration of an exhibit, a series of speakers and discussions, and a formal closing—but the unabashedly political content of the artworks and the unexpectedly experimental forms in which that content was expressed. The House of Culture anticipated an exhibit of young artists expressing "a humanist sentiment" and a means of "seeking a better relationship with society." Invoked with the usual rhetoric that accompanies such occasions were the "glorious mural movement" and the muralists Juan O'Gorman and Pablo O'Higgins, who had been invited to the event to symbolize the old "walls" facing the new and who had contributed monumental works to the state of Michoacán. The sponsors were impressed with the fact that the Front groups had "represented our country in Paris"[7] and therefore, doubtless, would present the type of "high culture" the House wished to promote. However when the Front opened its scheduled six-day event, there was dismay, censorship, and the early closing of "Muros frente a muros." It is hard to say whether the content or the form (including texts) was most upsetting to the administration of the House of Culture.

In attendance at Morelia were the groups Mira, Germinal, Proceso Pentágono (Pentagon Process), the Taller de Arte e Ideología (Art and Ideology Workshop, or TAI), and the Taller de Investigación Plástica (Art Research Workshop, or TIP). Two other groups, Suma and El Colectivo (the Collective), included essays in the catalogue, but did not present artworks.

Since it was local to the area (the other groups came from Mexico City), TIP—the organizer of the event—was able to display a large number of three-dimensional works. Headed by painter and muralist José Luis Soto, the group was then composed of Isabel Campos, Camilo Aguilar, Lugupe, Ariadne Gallardo, Eleazar Soto, Juan Manuel Campos, and Miguel Angel Mendoza.[8] Begun in July 1976, TIP had undertaken to service rural and urban communities in the state of Michoacán, Nayarit, and Guanajuato with collectively produced murals and sculptures articulating the needs and struggles of the particular communities. In general the murals were done in rural villages and the sculptures installed in towns or cities.

TIP murals were designed through consultation with a village or a group. After the design was approved, it was projected on a wall and painted by the villagers and the team. In 1977, TIP researched the relative artistic tastes of various classes of society. Taking a survey of bureaucrats and professionals, intellectuals and artists, and workers and peasants, they discovered that the first group preferred academic and landscape art; the second, abstract and avant-garde art; and the third, art which represented its social problems. Based on this necessary (and rarely done)

sociological research, TIP tried as much as possible to integrate itself with the villagers and urban workers in order to present their ideas and cultural concepts most effectively.

As a trained muralist in the Mexican tradition, José Luis Soto was less interested in erasing muralism as a national expression (as was preached by the internationalist wing of Mexican art in the 1950s) than in revising and reforming it to meet new historical conditions With respect for the traditional forms of the people while simultaneously trying to reevaluate that tradition and combat foreign alien cultural penetration, TIP emphasized the making of participatory community murals with no pretense at traditional aesthetics. Mural patronage also changed: instead of state or local civic commissions, murals were paid for by the communities themselves, with art materials and food. TIP thus brought relevant art to many rural communities whose only competing images had been signs for Pepsi, Coca-Cola, and PRI (Partido Revolucionario Institucional, Mexico's ruling political party).[9]

At the House of Culture, TIP presented single sculptural figures, and installations known as *ambientes,* or "environments"—art forms deriving from the pop art style of the 1960s, particularly from work by artists like George Segal and Edward Kienholz. Life-size figures in plaster, dressed in real clothing and functioning with objects of daily life, made critical social commentary about various aspects of modern Mexican life. A headless young man in blue and white shorts and T-shirt and holding a bottle of Carta Blanca beer seems about to kick a soccer ball at his feet which, on closer inspection, contains his missing head—a clear indictment of consumer sports clothing and of the inevitable beer which weans

Fig. 7 average people from their senses. Another work has a male figure dressed in suit and tie seated at a table on which are spread sensationalist newspapers and magazines. The head of the figure is faceless and hollow, filled with the trivia of the daily tabloids. A third installation features a television set facing a plain wooden chair with protruding spikes on the seat and painted waves of sound on the walls. The manipulative aspects of mass media metaphorically suggest their lack of real content and their danger (the spikes) to a comprehension of the real world. Thus they contribute to a lack of action and power.

TIP, like all the groups represented at the "Muros" exhibit, articulated its philosophy in the catalogue. All had in common their desire to do a new type of public art directed at working class audiences; to work collectively in order to submerge egotistical individualism; to use new visual plastic languages in place of what they considered the exhausted and coopted "social realism" of Mexican muralism—though all respected the political ideals of the founders, and admired the innovations and political dedication of the recently deceased Siqueros. All wished to avoid the elitism of galleries, museums, private collectors, the art market, and the con-

trol of state artistic mechanisms. "In the present exhibit," said the TIP statement, "we are tackling a system of signs which communicate social reality from a personal point of view, but supported by group collectivity and direct research of the different publics to whom we are directing our work; confirming the reciprocal independence between the individual and the public."[10]

TAI, the Art and Ideology Workshop (see section III below for personnel and history), was represented in Morelia by graduate art students from the Siqueiros Workshop in Cuernavaca, where they had worked in solidarity with a hundred-day strike of textile workers for whom they produced leaflets, placards, banners, and an environmental installation originally displayed in the main plaza of Cuernavaca. Installed in the exterior courtyard of the House of Culture, the large, flat, painted forms of their works represented a worker incarcerated within a huge bobbin, and a row of ferocious red-and-black striped jaws imprinted with the names of transnational textile corporations such as Burlington and Tex-Morelos which advanced in a file toward an enormous scissors-fist. All were tied together with colored threads. The corporations were to be symbolically cut apart not only by the scissors but by the workers, who in this manner freed themselves by exercising their power. In constructing this piece, the TAI members adopted the audacious example of Siqueiros's sculptural agit-prop floats manufactured in 1936 with his Experimental Workshop for a May Day parade in New York.[11] The TAI artists not only were presenting their installation as an alternative to muralism but were rescuing an experiment in public art from the past to explore its present possibilities.

Germinal, composed of students from "La Esmeralda" art school in Mexico City, was constituted by Mauricio Gómez Marín, Yolanda Hernández, Carlos Acequera, Silvia Ponce, Orlando Guzmán, and Cecelia Lazcano. Germinal, which had also worked with children's groups, centered its art efforts on producing banners for public demonstrations, arguing that while the mural, although also a public art form, is fixed in one place and therefore is not widely seen, the banner circulates, can be shown in many locations, and uses written texts to underline the visual. The virtue of the banner were that its form and content were immediately determined by popular demands during a demonstration and therefore it spoke for contemporary problems and alternatives; it was inexpensive and could be rapidly produced; and its message could be implemented by leaflets, placards, slogans, and shouted chants. Finally, by its very nature, it remained outside the art market, and could not be manipulated by that market.[12]

Of the banners Germinal displayed in the courtyard was one critical of PEMEX (Petroleos Mexicanos, the state oil company). The name PEMEX is made of stripes which gradually changed to red, white, and blue letters,

colors of the United States flag. Two seated figures below represent the U.S. and Mexico: one sports a dollar sign, and the other says "yes, yes, yes" to the deal. On the left a fisherman surveys a body of water above which rises billowing smoke, and says, "The water is no longer any good; the fish have all died." On the other side an oil worker says to his companion, "Hey man, don't you think they're making fools of us with all this progress?" Painted on cloth, the imagery would be hard to comprehend on a moving banner—though the word PEMEX and the dollar sign might quickly convey the essence of this caricature: the selling out of Mexican resources, peoples, and the ecology to United States interests.[13]

The group Mira (which can be translated as "Look" or "Sight") focused on graphic production. One of its key members, Arnulfo Aquino, had been a San Carlos art student during the 1968 demonstrations, for which graphic brigades had worked without stop to manufacture hundreds of banners and thousands of placards, handbills, and gummed stickers in a didactic-expressionistic style.[14] Graphics, therefore, were of enduring interest to the group, which also included Jorge Pérez Vega, Rebeca Hidalgo, Saúl Martínez, Eduardo Garduño, Melecio Galván, and Salvador Paleo. Mira took the urban environment as its artistic and political arena, considering Mexico City a "gigantic state" on which a daily struggle is conducted for elemental things like work, housing, and education, and where the possibilities did not even exist for a minimum solution to the problems of thirteen million inhabitants (in 1978) of the city. Mexico City was a microcosm of the entire country, and Mira proposed to engage these problems graphically. The group's exhibit in Morelia consisted of three portable wall presentations made up of forty-eight posterlike images, 24 × 18 inches each, reproduced through serigraphy and heliography (silkscreen and photo-engraving). These were accompanied by photographs of people from housing tracts, labor unions, and student bodies to whom the work had been presented and with whom it had been discussed.

Mira's techniques combined drawings, maps, emblems, graphs, lettering, and periodical-derived photographs organized on a montage format. Societal power relationships and confrontations were suggested by the juxtapositions of these various types of information. One such image featured a drawing of then-president José López Portillo with an elegantly lettered comic-strip bubble in which he said, "I ask the poor to pardon me." Beneath was the presidential limousine with police escort; a cluster of United States corporate names; and a graph showing the steady rise in prices and decline in salaries and purchasing power from 1973 to 1978. This overlapped the photograph of a mass demonstration in downtown Mexico City. Below were television sets with boxing and police images. Untrained viewers might have difficulty in deciphering such discrete bits of information and relating them to each other, and to abstract concepts

emerging dialectically through their fusion, but they would recognize many of the single images, which were ubiquitous in the mass media. Mira members did admit, in discussion, that popular audiences with low educational levels had many difficulties with the written texts which explained the meanings.[15]

Two indoor spaces at the House of Culture were given over to the group Pentagon Process (see section III for personnel and history). In one dimly lit room was a table holding a cup of coffee and an ashtray, before which stood an empty chair stenciled with the date "October 3, 1968." In another room was strewn used shoes covering the entire floor and looking as if their owners had quickly dropped them or left them behind. On the wall was another written reminder of 1968. Both works were direct references to the events at Tlatelolco. Saturated with melancholy, these installations evoked the missing persons of the massacre at the Plaza of the Three Cultures. The student missing from his study table the next day could be imprisoned or dead. The abandoned shoes had a basis in fact, as a photograph taken after the attack attests: pieces of clothing, trampled plants, and many shoes—mostly those of women—litter the ground, "mute witnesses to the disappearance of their owners."[16]

From the first day of the "Muros" exhibit, the House of Culture director was displeased. He retired the Germinal banners from the patio to a remote indoor area on a trivial excuse. Efforts to reverse the censorship were unavailing. The Front members decided on several public actions if the director remained obdurate; however, the event was canceled by the Front on the second day without any of the agreed actions taking place. Members trickled back to Mexico City, leaving the organizing group TIP upset at the lack of discipline and the easy concession. Not only was the struggle with the House of Culture lost, but there was resulting uncertainty about the Front's next planned event: a large show of graphics from Europe and the Americas called "América en la mira" (America on Target) which was scheduled for September 1978. It was held, in Morelia, but at the Museum of Contemporary Art.

Despite the dismal ending of the "Muros frente a muros," the Front itself was brimming with energy, enthusiasm, and ideals. The last two years had been full of activity, creative work, and the formulation of aesthetic theories for a new era in Mexican social art. Most of the groups had formed between 1975 and 1976, but their aesthetic language—so at variance with what was considered "new art" on the gallery/museum circuit in Mexico City—still had to "find" itself as form, and as viable theory.[17] As has been pointed out, the experimental forms of environments and the use of "found" objects from daily life derived from the pop art phenomenon, as did the montage technique of items from mass media sources. The other innovative mode being explored in the 1970s was that of conceptual (or idea) art, which rejected the notion of art as a precious,

handcrafted commodity for display or purchase. Responsive to new scientific developments such as "information theory," semiotics applied to the visual arts, and ecological concerns that blossomed with the New Left in the 1960s, conceptual artists experimented with earth art, body art, process art, "performance" events (called "eventos" in Mexico; not to be confused with theater), video art, and a host of other forms. Not only was the separation of art and life attacked by pop and conceptual art but the very definition of art was under question. Adherents of both forms were divided between those who sought for refined or hermetic expressions for a limited audience of cognoscenti and those who sought a more popular audience. Pop and conceptual art were prime raw material for Mexican artist groups who wished to "take over the streets" with a totally contemporary artistic language. The neo-Marxist orientation of some of the groups—who tried to apply the ideas of Althusser, Gramsci, and Brecht to their own endeavors—made the use of the flexible forms of pop and conceptual art especially attractive to them.

III

Tepito Arte Acá (Tepito Art Here)

Though only briefly a part of the Front, the group Tepito Arte Acá was one of the earliest art groups in a period which has been acknowledged as the decade of group art. Tepito is a slum neighborhood of about 100,000 inhabitants, located near downtown Mexico City, which became celebrated (though unnamed) through the writings of Oscar Lewis. With small shops and street carts, the residents support their very marginal existence by selling used products and inexpensive items produced by a cottage industry—mainly clothing and shoes—to hundreds of daily customers. Tepito functions outside the economy and the control of the state; the residents are part of the surplus army of labor that crowds the capital city.

Tepito Arte Acá was formed in 1972. Its members are Daniel Manrique and Alfonso Hernández (self-taught painters), writer Armando Ramírez, and Carlos Plascencia. The role of the group has been the elaboration of an arts program including mural paintings, poetry, theater, and the projection of a library and popular high school. Their written materials include the use of vernacular vocabulary popular with Tepito, such as the term "ñero," for "compañero" (or comrade/brother), which appears with artworks in the newspaper El Ñero, published by Arte Acá. The group arose in response to plans for urban renewal in the downtown district, and its activities are twofold: to unify the residents in order to resist government plans for what is, in fact, urban destruction; and to rescue and dignify the living culture of the indigenous neighborhood, which dates

itself back (according to a local plaque) to the Conquest (Tequipeuhcán). "Arte Acá was born," says Manrique, who comes from Tepito, "from the necessity of modifying our environment."

A "Plan for the Betterment of Tepito" produced for the Council of Representatives of Tepito Barrio by Workshop Five of the Self-Governing College of Architecture was exhibited at the Museum of Modern Art in the form of a large map which illustrated graphically, and with legends, the destruction or projected destruction of *viviendas* (apartments surrounding a courtyard); the projected private commercialization of the area; and the investment monies anticipated. As part of the fight-back, the plan sets forth the ways in which the tepiteños (residents) want to change and upgrade but not destroy their barrio (neighborhood). With the slogan "Tepito for the tepiteños," the plan outlines the fight: 1) strengthening the economy, 2) maintaining and improving life for a population with few resources, 3) reinforcing the intense and characteristic life of the community, and 4) appropriating control of the barrio to benefit the residents. The map is, in fact, a sociological and political document: a work of conceptual art.

Street murals painted with teams since the early 1970s are part of the cultural revivification of the tepiteños. Some are didactic—like the mural observed in 1976 in which nude figures are shown repairing and repainting the barrio while two clothed men sit heedlessly drinking beer. On other walls, parents sit with their child, two women stand beneath a moon, nude figures look down from a window lintel, and other figures hold up a cornice and try to break through the wall, or peer into a bricked-up window. The style owes a debt to the Mexican School, but on an elemental level. As has been pointed out, "the street artists' work is competent but not distinguished; as an act of social imagination, however, it is extremely important."[18]

Grupo Proceso Pentágono (Pentagon Process Group)

The germ for Pentagon was a series of exhibits in 1973 by recently graduated students of "La Esmeralda" art school: Victor Muñoz, Carlos Finck, and José Antonio. Pop and conceptual art—especially environments (the first seen in Mexico City)[19]—were accompanied by lengthy texts which established the artists' credo of class-conscious social criticism to be conveyed with new experimental forms. They hoped to provide the means by which a viewer would question the ideology-implantations of the dominant society in the areas of myth-creation, hero-creation, and consumerism, and to look critically at the mass media, the state-controlled labor unions, and the state itself. By a type of emotional "sensation-conditioning," the spectator would be introduced to new concepts and methods of action.[20]

The elevated intellectual tone of Muñoz, Finck, and Antonio was maintained by Pentagon Process in sophisticated artworks and written texts. During the group's history, its work was generally exhibited at galleries or museums which by their nature dictated audiences of educated middle and upper classes. Thus it stood at a polarity from the populism of Arte Acá and the street-and-public art of other Front groups, in practice if not in precept. About 1973, Muñoz, Finck, and Antonio were joined by Felipe Ehrenberg, one of the most exploratory and multitalented spirits of contemporary Mexican art. Ehrenberg, who had just returned from four years in England where he had been involved with the vanguard group Polygon Workshop, had experimented with mail art, performance art, conceptual art, artists' book publications with a Gestetner mimeograph (the Beau Geste Press, which in Mexico became the Libro Acción Libre Press), and the periodical Schmuck.[21] The important aspect of these activities is that they developed experimental art forms addressed to working-class and political issues, and upon his return, Ehrenberg adapted these experiences to his native context.

Crucial to the atmosphere of experimentation with artistic languages, methods, and techniques which pervaded the mid-1970s was Ehrenberg's fascination with and exploration of new technologies in multiple reproduction. A mural and an environment, after all, are stationary or ephemeral. Multiples, ranging from traditional prints to photography to new experimental modes, make up in quantity and portability what they lack in stability. Though not the first to use techniques borrowed from the commercial world, Ehrenberg popularized in Mexico duplication techniques for art like photocopy, blueprint, the mimeograph machine and its stencils. He invented an inexpensive "mimeograph machine" made from an orange crate, substituting silkscreen elements for the mimeo roller; it was used with stencils which could be manipulated for new effects. In a series of seminars, Ehrenberg taught the technique to groups in various communities of Mexico, where it was used for small local presses serving as alternatives to the controlled mass media.

In 1975, Ehrenberg gave lectures to Ricardo Rocha's Visual Experimentation Workshop (birthplace of the group Suma) at the San Carlos Art Academy, where seven years earlier the students and faculty had produced graphics for the student movement that culminated in the massacre of Tlatelolco. The idea of new multiples technology spread; Suma even used cardboard stencils for reproducible street murals.

Fig. 8 Pentagon Process coalesced as a group in 1976 (with the later addition of Lourdes Grobet and Miguel Ehrenberg) in direct response to a call for artistic groups to represent Mexico in 1977 at the Latin American section of the X Biennial for Young Artists (under thirty-five) in Paris. This was a highly important event in which four Mexican groups (of which Penta-

gon, Suma, and TAI were later to be united in the Front) took an antifascist position of challenge to the leadership and contextualization of the Latin American section (headed by Uruguayan art director Angel Kalenberg) and issued a Mexican-published counter-catalogue to be distributed in Paris. This whole story, however, must become the subject of a separate article.[22]

Taller de Arte e Ideologia (Art and Ideology Workshop, or TAI)

As a group, TAI was much broader in its interests and aims than the visual arts alone. As a matter of fact, TAI was able to perform in the arts arena because of the exceedingly flexible territory granted practitioners by pop and conceptual art. Only a few trained visual artists were associated with TAI, which was primarily a theoretical group formed in 1975 under the leadership of philosophy professor Alberto Híjar, who offered a Living Art Course (Curso Vivo de Arte) for students in philosophy, political science, theater, fine arts, and architecture. Studying pro-Marxist writings by Jean Baudrillard, Althusser, Gramsci, Brecht, and Pierre Macherey (whose work the group published in Spanish), TAI mounted commemorations of the Chilean military coup, the Cuban assault on the Moncada barracks, and the centenary of Lunacharsky at the Siqueiros Public Art Salon in Mexico City.

TAI's principal interest was to connect artistic theory with social praxis—an interest it shared with other Front groups. In 1976 the group focused on round table discussions dealing with the concepts and ideology of art and the mass media. It also published the *Periódico Vivo* (*Living Periodical*), and presented works at the Art and Communication Center (CAYC) in Buenos Aires—still considered antifascist in 1976—and in São Paulo and Barcelona. It organized several exhibits of Latin American posters and paintings. In addition to Híjar (who was much respected and a tireless worker), the members of TAI included Luis Acevedo, Andrés de la Luna, Morris Savariego, Felipe Leal, and Atilio Tuis. Híjar's theoretical and critical writing is widely published in Mexico, and casts its light on general artistic principles from a Marxist perspective as well as on the theories that sustained TAI and the Front groups.[23]

Suma

Suma's birth (mid-1976) at San Carlos has been detailed above. Conscious of the role San Carlos played in 1968, Suma, nevertheless, was not willing to revert to the didactic art forms borrowed from the Taller de Gráfica Popular (Popular Graphic Arts Workshop) of the 1940s and 1950s that were deemed appropriate in 1968. They opted for a combination of con-

ceptual art, abstract expressionism (in vogue during the early 1960s), and new graphic technology combined with "found objects" from the popular urban environment—artifacts and images from television, *fotonovelas* (photographic comic books), periodicals, product advertisements, and other objects which formed the "visual code of "the man [sic] in the street." It focused on the city because the city was considered the center

Fig. 9 of economic, political, and cultural decisions, and as a place where the constant bombardment by the mass media conditioned the individual to be a passive consumer of products and ideologies. Suma's task, as artists, was to create experiences which would criticize and cause reevaluation of these daily conditions.[24]

Early on, Suma adhered to the notion (popularized in 1968) of "taking over the streets"—in their case with art rather than demonstrations. They painted and stenciled murals on public fences and walls, created

Fig. 10 environments, produced graphics, and printed books (with Ehrenberg's imitation "mimeograph" and with rubber stamps), and made mail art (graphic works distributed through the post office).[25] Members of the group, in addition to Ricardo Rocha, were Gabriel Macotela, Jesús Reyes, Paloma Díaz, Santiago Rebolledo, Jaime Rodríguez, Armandina Lozano, José Barboza, Oliverio Hinojosa, Alfonso Moraza, and René Freire.

El Colectivo (The Collective)

This was a group of artists and writers with ties to the university structure and its trade unions, and oriented toward community service through the arts. The fusions and transformations of the Collective in its first stage, when it was formed, to stage three in 1983 is too involved to detail here. In 1976 it acted as an umbrella for the 1975 group TACO of the Perra Brava (Taller de Arte y Comunicación—Art and Communications Workshop—of the "Wild Bitch"), and briefly, too, for members of Tepito Arte Acá who, when they left to return to Tepito activities, were judged by the Collective as "vacillating between conservatism and populism.[26] The Collective, composed of writers and artists César Espinosa, Aaron Flores, Blanca Noval, Antonio Alvarez Portugal, Pablo Espinosa "Gargaleón," Areceli Zúñiga, and Roberta Cebada, also undertook to produce art in the streets, on which they expended considerable research. Working with children in popular housing tracts, they provided materials for art experimentation, and for a collective mural—which was only partially successful. They discovered that the adults in the housing tracts were only minimally interested, considering art essentially as "decoration," and not sufficiently concerned (or able) to continue with children's activities on the model established by the Collective. These ideas evolved into the "Internal Circuit" project: a portable mural which was circulated to various sites between 1978 and 1979.

The Front

On February 4 and 5, 1978, the Mexican Front of Cultural Workers (Groups) was convened by Pentagon Process, the Collective, Suma, and TAI. Attending the gathering at the Pentagon's center in Tlacopac, Mexico City, were thirteen groups from Mexico City and representatives from the states of Michoacán, Guanajuato, and Morelos, and the city of Monterrey, Nuevo León. The designation "cultural workers" (a term with a long history and symbolism) was deliberately chosen to indicate that the artists were not at the service of the art market or the dominant class.[27] Even the word "Front" resonated with usages by national liberation groups in Latin America and other parts of the Third World. In keeping with this stance, the Front almost immediately expressed itself in support of the Nicaraguan people fighting the Somoza dictatorship, popular Mexican struggles, and the triumphant liberation of Cuba, Vietnam, and Angola.

The Front's manifesto, signed February 1978, declared the necessity of transforming the production relations of the capitalist system and its ideological-cultural meaning, and the necessity of countering exploitation by national and international capital. To carry out this program, the signers called for 1) artistic and cultural production articulating proletarian and democratic struggles; 2) an alternative position to the apparatuses of production and reproduction of the artistic and cultural ideology of the dominant class; 3) theoretical and practical research and discussion that would result in aesthetic-ideological effects; 4) regaining control of the production, distribution, and circulation of their own work.

A series of projects were immediately proposed: the "Walls Facing Walls" exhibit in Morelia, shows of graphic art, and a number of political and social actions without specific artistic dimensions; these were in addition to ongoing activities of the individual groups and were publicly announced under the name of the Front. Among them was the exhibit of international political graphics called "América en la mira," which opened simultaneously in the cities of Morelia, Puebla, and Mexico on September 11, 1978, the fifth anniversary of the fascist coup in Chile, and then traveled to Los Angeles. Another was "Testimonios de Latinoamérica" (Latin American Testimonies), which included five hundred works by over sixty Latin American artists (including Chicanos) and was exhibited at the Alvar y Carmen T. Carrillo Gil Museum in Mexico City on September 19, 1978. It also traveled to Los Angeles.[28]

The Front was most active in 1978 and 1979 (though some groups withdrew shortly after its formation), after which, almost inevitably, it started to disintegrate as an umbrella organization. The name change dropping the word "groups" reflected the entry of individuals into the Front. The reasons for the disintegration are several: the tremendous

diversity of the formative groups, which represented a wide spectrum of political and artistic concepts, albeit on the Left; the problems of administering such an unwieldy body; and the egos and individualism of participants subject, despite their collectivist ideals, to pressures and temptations from the dominant ideology concerning artistic possibilities, especially the need for public recognition. According to one member, no real program developed; there was a lot on absenteeism from meetings; the group dynamics weakened—and the Front finally dissolved.[29]

Various of the groups continued to function. As a family collective, TIP still works with murals and installations among the Purépecha peoples of Michoacán, supporting the peoples' struggles to maintain control of their land and culture. In 1982, Mira was instrumental in publishing the graphics of the 1968 student movement in *La gráfica del 68—Homenaje al movimiento estudiantil* (see note 14). The Collective mounted exhibits of graphics and mail art in solidarity with the peoples of Central America. In 1981, Esther Cimet, and others, undertook to support the undocumented workers' organizations demonstrating in Los Angeles by providing banners, placards, and leaflets and mounting a documentary photography show. However, by 1981 Mexico was in severe economic and political crisis and, despite escalating class confrontation, the surge of reformist activity in the arena of cultural work which we have been examining was largely over.

IV

Despite its relatively short career, the Mexican Front of Cultural Workers was an important coalition of artists who, in the face of the tremendous atomization of artists' movements during the period of the 1950s and 1960s when artistic individualism and imported vanguardism dominated the Mexican art world, rededicated themselves to public artistic expression and support of popular struggle in the spirit, if not in the artistic language, of the Mexican School. Most significant, in my opinion, was the recognition by several of the Front's artistic theoreticians that the battleground had shifted since the inception of the Mexican School, when culture was an adjunct to political philosophy, to an era when culture on a mass scale has become a commodity in its own right; when concepts like the "culture industry" or the "consciousness industry" or the "information industry" have become central to the structures of industries, national states, and the transnational corporations that control these industries.

According to Armand Mattelart, so-called mass culture today is a political apparatus to the extent that one of its functions is to assure the adhesion of different groups and classes to a society's objectives; to pro-

duce consensus between (antagonistic) groups and classes.[30] As the 1960s and the Tlatelolco massacre proved in Mexico, such consensus was contrary to the realities. It was an artificial construct of the state and the dominant classes for which it mediated, and had to be unmasked and exposed. This the various artists groups, and later the Front, undertook to do, and they shaped to their needs two international artistic idioms, pop art and conceptual art, themselves derived from and responsive to mass consumer culture and information theory. An artists' coalition representing a tiny fraction of the Mexican art community, to say nothing of the country as a whole, could hardly be expected to persevere and succeed in such a Promethean task without the support and involvement of a massive political force. It is to the artists' credit that they tried, with the idealism of youth, and that many continue to speak critically in their art expression, albeit as individuals.

Notes

1. Elena Poniatowska, *La noche de Tlatelolco: Testimonios de historia oral* (Mexico City: Biblioteca Era, 1983), 17. PRI stands for the Partido Revolucionario Institutional, the official party of Mexico. All translations from the Spanish are those of the author.

2. Poniatowska, *La noche de Tlatelolco,* 65.

3. Octavio Paz, *The Other Mexico: Critique of the Pyramid,* trans. Lysander Kemp (New York: Grove Press, 1972), 16–17. Paz originally delivered these remarks at a lecture in 1969.

4. Raquel Tibol, "La calle del Grupo Suma," *Proceso* (Feb. 12, 1977): 78.

5. Originally called the Mexican Front of Cultural Workers Groups.

6. James D. Cockcroft, *Mexico: Class Formation, Capital Accumulation, and the State* (New York: Monthly Review Press, 1983), 187. I am indebted to Cockcroft for his incisive analysis of contemporary political, economic, and social history, especially in chaps. 6, 7, and 8, which cover the time period pertinent to this study.

7. Catalogue, *Muros frente a muros,* Casa de la Cultura de Michoacán, Morelia, Mich., May 1978, n.p.

8. All groups had fluctuating memberships during the years. I have not tried, as a rule, to be chronologically accurate about memberships.

9. Ida Rodríguez Prampolini, "Arte o justicia? El Taller de Investigación Plástica de Morelia," *Plural,* 2 época, 9–5, no. 101 (February 1980): 31–37; See also Eva Cockcroft, "Notes on Muralism in Mexico," *Community Murals Magazine,* Fall 1981, p. 17.

10. Muros frente a muros.

11. For complete information and photographs of these floats described by Siqueiros as "an essay of polychromed monumental sculpture in motion," see Laurance P. Hulburt, "The Siqueiros Experimental Workshop: New York, 1936," *Art Journal* 35, no. 3 (Spring 1976): 237–46.

12. Shifra M. Goldman, unpublished notes from Morelia, May 22, 1978. Also see the catalogue *Exposición: Arte, luchas populares en México*, Museo Universitario de Ciencias y Artes, Mexico City, February [1979], 14–17. This catalogue contains valuable information on all the groups.

13. 1978 was a high point in United States–Mexico negotiations for access to the vast, newly discovered oil reserves in southern Mexico. See Shifra M. Goldman, "Rewriting the History of Mexican Art: The Politics and Economics of Contemporary Culture," in Jerry R. Ladman (ed.), *Contemporary Mexico: Crisis and Change* (El Paso: Texas Western Press, 1986), 96–113, reprinted in the present volume. It was originally named "Painting, Petroleum, Politics, and Profits."

14. See *La gráfica del 68—Homenaje al movimiento estudiantil* compiled by Grupo Mira (Mexico City: Talleres de la ENAP-UNAM, 1982).

15. Shifra Goldman, unpublished notes from Morelia.

16. Poniatowska, *La noche de Tlatelolco*, n.p., photographic section.

17. In the late 1960s and the 1970s, the "latest" trend was geometric abstraction in all its variations. See Jorge Alberto Manrique et al., *El geometrismo mexicano* (Mexico City: Institute de Investigaciones Estéticas, Universidad Nacional Autónoma de México, 1977). Figurative artists and Front members rejected its so-called rationality, scientism, and materialism, which they considered antithetical to Mexican expressionism, and to human and social values.

18. Alan W. Barnett, "The Resurgence of Political Art in Mexico?" *San Jose Studies* 2, no. 2 (May 1976): 15–16; see also Arte Acá, "Grupos pictóricos en México," *La Semana de Bellas Artes* 16 (March 22, 1978): 4–6.

19. Interview with Alberto Híjar, Mexico City, August 1, 1983.

20. See catalogue *A nivel informativo: José Antonio, Victor Muñoz, Carlos Fink* [sic], Sala Metropolitana, Palacio de Bellas Artes, Mexico City, 1973.

21. For the publications aspect of Ehrenberg's work, see Martha Gever, "Art Is an Excuse: An Interview with Felipe Ehrenberg," *Afterimage* (April 1983): 12–18.

22. See catalogue *Presencia de México en la X Bienal de Paris*, Instituto Nacional de Bellas Artes and Museo Universitario de Ciencas y Arte, Mexico City, 1977, and *Expediente Bienal X* (Mexico City: Editorial Libro Acción Libre [Beau Geste Press], 1980).

23. Alberto Híjar, "Cuatro grupos a París," *Plural*, 2 época, 73 (October 1977): 51–58.

24. *Presencia de México* and Suma, "Grupos pictóricos," 2–3.

25. Tibol, "La calle de Grupo Suma," and the catalogues *México Sociedad Anónima (Imágenes crónicas de una cuidad)*, Escuela Nacional de Artes Plásticas, Mexico City, 1977, and *Grupo Suma: La Calle*, Salon Nacional de Artes Plásticas, Sección Anual de Experimentación en México, Auditorio Nacional, Mexico City, 1979.

26. El Colectivo, "Grupos pictóricos," 16.

27. César H. Espinosa, "Arte y praxis política: Frente de Trabajadores Culturales," *El Universal*, February 8, 1978: 1–3.

28. See *América en la mira: Muestra de gráfica internacional*, Frente Mexicano de Trabajadores de la Cultura, Mexico City, 1978; "Testimonios de Latinoamérica," First and Second Parts, *La Semana de Bellas Artes*, nos. 42 and 43

(September 20 and September 27, 1978); Joan Hugo, "Communication Alternatives," *Artweek* 10, no. 31 (September 29, 1979): 5.

29. Interview with Felipe Ehrenberg, Mexico City, August 1, 1983.

30. Armand Mattelart, *Transnationals and the Third World: The Struggle for Culture* (South Hadley, Mass.: Bergin and Garvey, 1983), 10–14.

MULTIPLES

5

PAINTERS INTO POSTER MAKERS:
A CONVERSATION WITH TWO
CUBAN ARTISTS

Raúl Martínez and Alfredo J. González Rostgaard are two of Cuba's most distinguished poster makers within a trajectory that has achieved international recognition. Martínez, born in 1927, was an abstract expressionist painter who earned his living before the Cuban revolution, and for a brief period after, working for a commercial advertising agency in Havana. His entry into poster production in the mid-sixties so influenced his thinking that his "fine art" paintings completely changed their character. In both, he employed a distinctive style: richly colored serial images combined with letters and words derived from Cuban popular forms, merged with elements from the pop style of the United States. Martínez Fig. 11 focuses on the portraits of revolutionaries, from José Martí to Ché Guevara and Fidel Castro. Rostgaard, born in 1943, presently [1984] heads the Visual Arts section of the Cuban National Union of Writers and Artists (UNEAC). Trained in an old-fashioned provincial academy, his professional life was formed after the revolution. He turned to abstract expressionism after graduation, then in 1963 became a cartoonist and the artistic director of the magazine *Mella*.[1] Since the early sixties, he has been making posters for ICAIC, the Cuban Film Bureau, and for

This essay first appeared as "Painters into Poster Makers: Two Views Concerning the History, Aesthetics and Ideology of the Cuban Poster Movement," in *Studies in Latin American Popular Culture* 3 (1984): 162–73.

OSPAAAL, the Organization of Solidarity with the Peoples of Africa, Asia, and Latin America, as well as designing its magazine *Tricontinental*. Like many OSPAAAL artists, Rostgaard tailored his design to the message of his poster; therefore, without a signature, his posters are not readily identifiable. His best-known image is the famous pink rose with a bloody thorn that appears on the cover of the book *The Art of Revolution, Castro's Cuba: 1959–1970*.[2] It was originally a *Casa de las Américas* poster announcing a 1967 concert of protest songs.

Fig. 12

Debate about the style of Cuban posters and their relationship to communication has been continuous since the inception of the movement, and is marked by an admirable sense of praxis. Socialist realism, on the Russian model, was rejected in 1961 after an intense flurry of discussion that opened the way for great freedom and experimentation. At a later date, polemics shifted to the problems pro and con of eclecticism, foreign influences, and the necessity (or the lack of it) for a national, or even a personal, identity in graphic design.

Most Cuban poster artists were not trained in design but came out of prerevolutionary academies where they studied traditional drawing and painting. Raúl Martínez was an exception, since he studied for a year in 1953 at the Chicago Institute of Design. Confronted by the need for mass communication in a country lacking a developed poster tradition, and lacking materials owing to the United States' blockade of Cuba, artists trained as painters transcended their limitations through creative adaptations of poster and fine arts techniques and forms borrowed from contemporary movements throughout the world. Posters from France, Switzerland, Poland, and the United States became visual sources for Cuban designers, as did pop and op art. The successful amalgamation of international avant-garde styles with national sources (particularly the baroque line and brilliant color characteristic of some Caribbean painting) is attested to by the superb political and cultural posters produced during the sixties and the seventies. The choice of silkscreen, in a country where the lithograph was widely used for commercial and illustrative purposes in the nineteenth century, was determined by necessity as well as by aesthetic factors. Pop artists like Andy Warhol made the silkscreen popular; however, it was also an expedient technique, because it needs no press for printing, can be produced completely by hand, and is capable of large runs without deterioration of the matrix (the screen itself).

Conditions in Cuba today have changed considerably. Offset materials and equipment are once again available, opening up the possibility of new design techniques such as the combination of photography, painting, and collage which Raúl Martínez is now using in poster and book design. Other artists can employ sophisticated methods of photo-silkscreen as darkrooms, photographic equipment, and chemicals become more available, though they are still in short supply compared to need.

This interview has been transcribed and slightly edited from a taped conversation held with Raúl Martínez and Alfredo Rostgaard at the offices of UNEAC in Havana, December 29, 1982:

RM: I was born in Camagüey province, in a town which today is a city called Ciego de Avila. From there my family moved to a village called Périco, in Matanzas province, a very important sugar center. My mother was a teacher;[3] my brother and my father were sugar workers. When I was eleven years old, we moved to Havana in order to get a better education for the younger children, and there I began eagerly to study painting. My first encounter with art came from my older brother, who painted and made signs. He was a people's sign painter, and a good one. Later my schooling helped in my development, but I did not finish school. It was ironic that my parents came to Havana to give the children an education, because the economic situation in the 1940s was such that at sixteen years of age I had to go to work for the first time. From a human aspect I think it was a good thing to have been a student living at the margin of things. However it affected my studies. I completed two years of preparatory studies in painting, and then had to wait two years to enter the graduate art school (Academy of San Alejandro) because there were no night classes. There I studied two more years, but never finished because I had to continue working.

SMG: Some of your work in the Museo Nacional de Bellas Artes is in an abstract expressionist style. Was your work always abstract in those years?

RM: Yes. I started to exhibit very early and became well known. Despite my youth, it was fairly easy to become known because the cultural world was so small. This was the period in which informalism (abstract expressionism) was popular; however, I received all kinds of artistic impressions and didn't quite know what to do with it all. For a while I worked in a semifigurative style influenced by Picasso; then I tried still-life influenced by European painting and the work I saw around me by Cuban artists like René Portocarrero and Amelia Peláez. But the truth was that I had nothing of my own to say. It was important to say something, but I didn't know how to say it, and I suffered a lot from this consciousness. This is what happens to young people. They choose a certain style in order to call attention to themselves, or to do something original, rather than look for a sustained truth. I wasted a lot of time in this way. In 1953, the movement called *Los Once* [The Eleven] was born. It was called Los Once by accident because in actuality it was a large heterogeneous group formed in the first year of the [Fulgencio] Batista coup [1952]. There was a great fervor among the artists and they put up two exhibitions in which many participated. It was a very important group which included three generations of modernist artists.[4]

SMG: What concepts guided Los Once?

RM: It was a question of consciousness; of taking a position both ethical and aesthetic. It was decided that Cuban painting would have to be destroyed, in a manner of speaking, because it had always been backward. Modern Cuban painting was initiated by Victor Manuel in the 1920s in the style of Gauguin. We decided we had to be up-to-date; to discover a new vision of our country. We were tired of the palms and the fruits, of the idyllic vision. We decided we had to take a different direction. We had to look at this continent, not at Europe. We decided to use North American abstraction as our form, because in Cuba there was no tradition, there was nothing to explore. The political and social situation was terrible, therefore it would be better to search for forms and experimentation outside of the country. However, the bad state of the country made us more conscious of the problems, and though the content of the paintings did not reflect our social consciousness, it seemed sufficient to us. We expressed our attitudes in the titles of the paintings. For example when Fidel [Castro] appeared [1953], we titled our paintings of vegetation *Sierra Maestra*. We played around a great deal with these things. We put up exhibitions. We were in favor of and participated in the movements for cultural liberty. We participated in the activities of the university. In other words, we supported with our presence all activities against the tyranny. The paintings did not reflect this specifically, but I imagine—given that we were living through all this—something must have been reflected even though it is really more difficult to extract such content from an abstract painting. Perhaps some works reflected the times more than others. The group Los Once was a point of attack that transformed the artistic ambience. In Cuba there was an attitude called *estar en la cerca*, which meant that one should not participate on one side or the other, one should not be committed. It appeared to us that this attitude was not good for the country, nor was it good for painting, and we fought against it. Our position was firm and this obligated us to confront the other artists. As an example: it is said that art is for art's sake and it is not necessary for the artist to have commitments. We believe that art is for art's sake, but what one does *with* the art is a problem of individual conscience, and that is already political. We also discovered that abstract art was the only weapon with which we could frighten people. When we mounted an exhibition, people were left in a state of shock. They said we didn't know how to paint, they attacked us. Then it seemed to us that our painting served as a means to raise consciousness.

SMG: I understand that all this was new to Cuba. In other words, you were carrying out a revolution in formal terms rather than a social revolution which was not yet possible. In the 1950s, however, you were

also working with foreign influences in painting. You are aware that during the year of the cold war, the United States was exporting abstract expressionism to other countries, including those of the Third World, in the name of freedom of expression, in the name of offering a contrast to the artistic policies of the Soviet Union. How did you view this at the time?

RM: Within the context of the backward painting that existed in Cuba at the time, to do abstract painting was a revolution in itself. The social revolution was being made by what we were doing with the work after it was finished. There was not unity, but a duality which our work reflected: on one hand an aesthetic search for form; but on another level, our daily attitude was that we gave battle with our work. It seemed to us that it was a necessary language with which to discover our country aesthetically.

The fight for liberty also took the form of the fight against the Biennial of 1953. Francisco Franco and Batista organized the Hispanic American Biennial in Cuba. We established an Anti-Biennial, explaining that artists shouldn't exhibit because we were fighting against the dictatorship.[5] The artist put in charge of the Fine Arts section of the Biennial was a very important Cuban painter, Mario Carreño, who later went to live in Chile. Carreño called together all the older and younger painters to inform us that the Senate was planning to pass a law protecting the artist, particularly the visual artist, because that is what Batista wanted. If I remember correctly, they were to institute a rule that one percent of the cost of every building was to be used to embellish the structure with art. Actually this proposal was a form of blackmail because Carreño said that if artists offended the government with demonstrations, the Senate would not pass the law. Some people believed him. Others opposed the proposals. There was a great deal of conflict. Since they had not had exhibits, many people wanted to participate in the Biennial. We also had serious problems because [José] Gómez-Sicre of the Pan American Union[6] organized an exhibition of Cuban painting in Caracas with the support of the Venezuelan dictator [Marcos] Pérez Jiménez. This was a very difficult period. The Cuban painter had no possibilities of exhibition, and Gómez-Sicre's offer was a temptation. He brought dealers to Cuba and they bought paintings at liquidation prices. For example, they bought works from Portocarrero for prices from twenty to fifty dollars. The dealers then donated these works to museums in their own country declaring that they paid a thousand to fifteen hundred dollars, and deducted the price from their income taxes. We attacked the exhibition in Venezuela, arguing that if artists were boycotting the Franco Biennial because of the Spanish dictatorship, why should they participate in Venezuela, which also had a

dictator. We used the example of Spain because it was dangerous to speak of the dictatorship in Cuba, though it was obvious to whom we were referring.

Los Once later dissolved. Batista tried to buy us with scholarships. One of the most talented artists in the group accepted a scholarship to Paris and, as a result, the least convinced, the ones who participated the least, aspired to scholarships. Rather than waiting until the group was destroyed from outside, we decided to break it up ourselves.

SMG: What happened after the dissolution of Los Once?

RM: I continued painting. At the same time I worked for my living at a local advertising agency which belonged to a United States company. It produced advertising for the newspapers, radio, and television. At that time Havana was full of billboards: "Drink Coca-Cola," "Bacardi Rum," and so forth.[7] When the revolution arrived, I worked two more years in advertising to promote tourism, until the United States blockade left Cuba isolated and there was no further advertising. However, I left before that. I became interested in photography. Though I had utilized it for advertising, I had never made photographs, and I decided to dedicate myself to photography. I wanted also to leave advertising, which is an alienating and hypocritical world. I earned a lot of money, but I preferred to earn less and be the master of my own life. I became a teacher of basic design at the School of Architecture of the University of Havana, where I spent four years. I continued to paint abstractions until about 1964 when I realized that this painting didn't reflect the new changing reality. Society was changing and I realized I wasn't. Emotionally as a human being I felt there had been a transformation and I was losing interest in abstraction.

In 1966, I took a rest; I stopped painting for a while and dedicated myself to design. I considered it socially more important than painting. Painting is a search; it does not deal with revolution and its dynamic process. I needed something direct and went to work doing posters and book design. I worked at this with great pleasure until recently. I consider the art of our epoch to be design, not painting.

In 1967, I decided to paint again, but without intellectual aspirations, without aiming for anything in particular. I painted a portrait of Martí.

SMG: The large canvases you have in the Museo Nacional de Bellas Artes, those that are flat in form, utilize framed portraits of revolutionaries, and use words and letters suggesting poster technique; are they of this era?

RM: Since I believed that the poster was the most effective method of mass communication, I thought the painting should also have the function of a poster. I consider that the art most truly ours is the poster, therefore I applied the theory of the poster to my painting. I

began with the subject of Martí, and the style of popular painting one could see in the plazas and the headquarters of the Committees for the Defense of the Revolution. All of this impressed me. Therefore I decided to initiate a reencounter with the person I truly was, without external influences of any kind, and finally to accept what I was, because earlier I had pretended to be more than I actually was in reality. At the same time, I began to intellectualize and to fill myself with poster theory. I had lost my ability as a draftsman, so that the faces emerged with a certain torpidness that I liked. This stage was quite good; I felt quite proud. I believed I was making something unique, very genuine, completely my own. At this moment, I encountered pop art, which was not new to me and which I had seen in publications.[8] (In Cuba, even with the blockade, we have more information about international movements in general than they have, for example, in Mexico.) Thus I discovered that I had made nothing new, but simply used pop in another form. The aesthetic and formal means were born of pop, and I had arrived at it not by imitation, but because of popular images which I considered very beautiful, or very aggressive, or very tranquil.

Since I like landscape so much, I asked myself, "What is Cuban landscape?" The answer was, "the heroes, the revolution, the people." Then I recalled how the people had painted heroes in popular art forms: for the demonstrations, in the murals of the Committees for Defense of the Revolution, on the placards. The people tried to paint in a manner considered realistic, but it came out flat. Later the poster movement influenced these popular expressions and one could see faces on placards that no longer tried to be realistic, that were done in flat colors of red and blue. By then, popular art had been influenced by the posters.[9] In my own work, when I had an image I wished to enrich, I used the same image repeatedly, which created a magic world of repetitions. Later I noticed that Andy Warhol had also used repetitions and I said to myself, "How stupid, how could I forget?" But the aspirations of Warhol are different. My art is pop in the sense of being popular.

SMG: Before we discuss the poster movement in detail, I wonder if Alfredo would tell me something of his history.

AR: I was born in Guantánamo, Oriental province. My mother was Cuban, and her mother was Jamaican—a group that suffered a great deal of discrimination in this country. My parents lived in Caymanera. My father is Cuban, with Chinese descent in his background. My paternal grandmother married a man of Mexican descent whose grandfather had been Dutch, from which comes the name Rostgaard. My mother, who came from the working class, was a teacher, and since I was a child I felt a great attraction toward the visual arts—especially toward painting, because it was considered the most important in the arts. Later we

moved to Santiago de Cuba, at which time I was able to study in the art school "José Joaquín Tejada." I came to Havana in 1964 at twenty years of age, and studied painting and drawing. I agree with Raúl that it is of utmost importance to know the context in which we developed. When I joined the "Tejada" art school, I was twelve years old, and the directors of that school ran it like the French academies at the end of the last century. The models from which we copied in our classes were still the plaster casts of the past, even in 1959 when I graduated—which was the year of the revolution. Our history of art classes had not yet arrived at Picasso; only as far as impressionism. It is interesting to read the speeches of Armando Hart [Minister of Culture] in this respect because we have a long tradition of artistic vanguards who have also been political vanguards, beginning with José Martí, or even a little earlier. It can be said the the most backward painters were also politically backward.

RM: In my time, corruption was more widespread. There were good painters but they were very confused.

SMG: Were the painters also political leaders, as was the case with the Mexican artists in the 1920s after the Mexican Revolution?

AR: No. Nevertheless it was common for artists to be involved in struggle against the dictatorship, because it was not only a subtle political matter. The dictatorship represented oppression, torture, and death, and all the people were against that. Another fundamental question is that we have not rejected the fact of our continuity. In other words, we have always transmitted the achievements of past generations. We feel we have inherited the victories of past generations. For example, I have always considered Raúl Martínez my teacher. If we were not Marxists, I say to Raúl, the revolution would appear as something almost magical, because what was thought impossible happened. There was a common saying in Cuba to the effect that it was possible to wage a struggle *with* the army, but never *against* the army. And the revolution headed by Fidel Castro conquered this army, which until then had been impossible. With the triumph of the revolution we saw workers, masons, farmers who were great military leaders, great strategists. All this is magic; it demonstrates that things one believed impossible can be done. In my case, I graduated as a painter, and then discovered the possibilities of graphic design. The majority of graphic designers came from academies, or the world of painting.

SMG: When you studied art, did you have classes in design?

AR: No. They were classical studies only: painting, sculpture, and drawing. We discovered in graphic design that we could establish a more direct communication with a very wide sector of the people. For me, it made communication much more possible than is true for the painter or the sculptor. I began with humor. With caricature. Communication

with the largest sectors of the people began with humor, and later we worked with graphic design.[10] As Raúl said, graphic design after the revolution was completely distinct from what existed before. It bothered us a lot that in order to communicate social messages the graphic language generally used was very elemental: the worker with a strong left arm, a small head, etcetera. It also mortified us that to sell stockings, drinks, automobiles, a much superior graphic idiom of better quality was used. Therefore we tried to raise the level of social messages—messages which were not imposed on us, but based on our own ideas—by using a good formal quality. In attempting to do this, we had no tradition upon which to draw, and therefore we searched abroad and accepted influences that could help us with our communication. In those years [the early 1960s], the work of [United States designer] Saul Bass was very important, especially his film designs. The Polish artists showed us that we could make completely political posters, for the First of May or the anniversary of the October Revolution, with poetry, with beauty, with an indirect language. Direct language produces messages of poor formal quality. For us there is no direct influence of a single artist, but, more accurately, the position of artists facing political problems. Later, coming to Havana and working on the magazine *Pensamiento crítico* and then on the completely political magazine *Tricontinental* at the end of 1967, we tried to find a new formal importance to the message, or the content. Our principal concern was to communicate and we used form that was adequate for the message.

RM: What really influenced the poster movement was the well-organized commercial advertising before the revolution. There were very few posters and those that existed were also very commercial. There were also some very nice posters for popular dances that used decorative typography, but this is just a historical note. The poster was invented by the revolution.

SMG: How did the use of silkscreen start?

RM: It is not well known, but silkscreen workshops existed in Cuba for a long time. In earlier times, Havana was filled with political posters made with silkscreen for the election campaigns. There were people who earned their living completely from these election posters, and did nothing else. Workshops existed in many places and the silkscreen was well known.

SMG: Did the poster movement begin at the suggestion of the government, or of the political organizations, or through the artists themselves?

RM: When the October 1962 [missile] crisis occurred, a workshop was created that brought together a number of artists, some of them painters. Many factors contributed to the characteristics of the Cuban poster. No movement existed, but posters were made for mass organi-

zations like the Confederación de Trabajadores de Cuba [the Workers' Confederation of Cuba, CTC] in which one could find the clichés mentioned by Rostgaard: stereotyped images, simple design, direct messages without other concerns. We wished to enrich and broaden the possibilities. The Cuban Film Institute (ICAIC) began to produce its own posters, and therefore a group was formed that worked for ICAIC.

AR: This was very important, because ICAIC decided not to use the posters for films coming from capitalist countries; it was decided that we should make our own posters in Cuba. This was about 1960 or 1961, and in spite of our great limitations of equipment and materials. Before the revolution, Cuba was an important printing center for Latin America. The Omega Workshop printed the *Reader's Digest* for Latin America. But with the blockade, as all our machines were offset and machine parts were no longer available, it began to be difficult to print ICAIC posters. We, therefore, resorted to the former artisans who make silkscreen prints by hand. Through the use of the serigraph, we were able to have the greatest fidelity in the reproduction of the original colors we used. Everything was done by hand.

There was a period in which ICAIC proposed that we use only 50 percent of the poster surface because of the shortage of ink and paper. We therefore left the backgrounds in white. It came to a point where certain theoreticians of graphic design claimed that this was a characteristic of Cuban design! But actually it was a necessity. All these limitations after the revolution were a challenge to the imagination and we, instead of resenting it, tried to transcend the limitations with imagination and good quality. ICAIC played an extremely important role.

RM: When the ICAIC posters (which were the most artistic of the time) appeared, Haydée Santamaría, [then director] of the Casa de las Américas, asked: "Why can't we have political posters as beautiful and as effective as those of ICAIC?" Lots of people worked for ICAIC. I did, Rostgaard. A group was formed that later worked for Casa de las Américas. Then a workshop was set up, which was also good, where we came and created posters that were not commissioned. In this way many people became familiar with the poster. The Casa de las Américas was very efficient and democratic. Since the designer doesn't have the painter's vanity, we had collective and self-criticism in order to decide among ourselves which designs were to be reproduced.

SMG: A similiar process was used by the printmakers of the Taller de Gráfica Popular in Mexico during the 1930s and 1940s. The problem of collective work and criticism, especially in the arena of visual arts where the ideology of individualism is so strong, is a very interesting one. Many progressive artists have subscribed to the principle; how-

ever, many have had difficulty adhering to it. How did the question of the artist's ego work itself out in Cuba?

RM: A designer cannot have an ego. That's what I tell my students when they grumble at the people who tell them something is bad. It's logical. They are working for the public, and the public has a right to give its opinion. The designer works with a concrete problem, which continues being objective. When the Departamento de Orientación Revolucionaria [Committee on Revolutionary Direction, DOR] was set up, it assumed political control of the campaigns to be conducted on an educational or political level when there was a crisis. They achieved magnificent poster production with a group of young and older artists who had been influenced by the initial group. All of these things continue creating the movement. The only genuine values in visual expression that Cuba has are cinema and the poster, because painting has not reached the same level. We are just like Poland, which has brilliant painters, but whose best art form is the poster. The fact remains that the demand exists in the country, and since one is working in a medium that has no tradition, the creator invents it. We didn't force the emergence of the Cuban poster; it arose out of necessity. The painter, following tradition, aspires to show in the museum, to achieve glory, to travel. That is why I say painting has to be destroyed. In a society like ours, methods have to be different; we are living in another epoch. In the beginning, Mexican-type muralism was spoken of here; it was planned, and Siqueiros wanted it that way, but we are not muralists.[11] Our muralism has been the poster.

SMG: It seems to me that your billboards are a kind of portable or changeable muralism.

RM: What is happening is that billboard production has decreased. In the first place, there are problems in the construction of billboards. Those that have deteriorated have been eliminated. There are very few billboards in Havana today, where before there were a great many. Respecting the poster, we have not been in a state of political crisis that necessitated a campaign, as was previously the case. The movie and cultural poster is more visible today than the political poster.

AR: There has been a great national expansion of poster making. In the beginning, the participating artists could be counted on the fingers of one hand and they were centralized in the capital. Today there is a large scale, major and constant participation from all over the country. DOR has an annual graphics salon, and increasingly the prizes are won by *compañeros* [comrades] from the interior of the country. In addition, we have to consider the selectiveness of time. In my case and those of other compañeros, we have made both good and bad posters; generally more bad than good. However time has been generous and the bad ones

are forgotten while the good ones remain and are remembered. In to-day's production there are also good and bad, but the bad still haven't been weeded out.

SMG: But Raúl says the movement has been falling off.

AR: Raúl was talking about the crises created by emergency situations during which artists and designers stepped forth. The idea is to change reversals into victories. For example when we failed to attain the sugar harvest of 10 million tons [in 1970], one designer made an extraordi-nary poster, one which he has never again equaled.

RM: Right now there is no crisis; however, I do believe there is a crisis of quality. I believe that the strongest poster group, of which Alfredo was a member, has now passed into history. The one artist from this group who continues to work is René Azcuy, but the rest hardly do anything today. We're all doing other things. I am more dedicated to painting and to book illustration. Today's posters are made in offset, a technique which is not yet totally understood. There are a great many new people who, according to the School of Design, are badly trained. I don't be-lieve these young designers have a good grip on their work, or sufficient curiosity or excitement. Alfredo said that what we made seems im-pressive because the bad has been forgotten and the good is exhibited. Perhaps when the bad of today's production is forgotten, we will dis-cover that we are mistaken.

SMG: No artist in the history of art has made all masterpieces. We judge the value and contribution of a movement or an individual artist by the high level attained in a limited number of works supported and built toward by many experiments, failures and semi-successes. Also by the high level of its social and aesthetic communication to regional and international audiences. This process has taken place in Cuba without the artificial pressures and distortions of the art market. What is interesting to me is the extraordinary work that has emerged in spite of, or perhaps partially because of, the blockade and the lack of mate-rials, when artists responded to the imperatives of national needs by rising to new heights of aesthetic production. Is there one last word before we end?

RM: There is no last word because that would be very sad. The word continues, continues in the air . . .

Notes

1. Named after the Cuban Communist Julio Antonio Mella, assassinated in Mexico in 1929 by the Gerardo Machado regime of Cuba. His murder was initially blamed on his companion, the Italian-born photographer Tina Modotti. *Mella*, now defunct, was founded in 1944 and published eighty clandestine issues before it moved aboveground.

2. By Dugald Stermer, with introductory essay by Susan Sontag (New York: McGraw-Hill Book Company, 1970). More recently the image appeared on the cover of *Los diapositivos en la flor. Cuba: Literatura desde la revolución,* edited by Edmundo Desnoes with Willi Luis (Hanover, New Hampshire: Ediciones del Norte, 1981).

3. Most of Cuba's provincial teachers were women.

4. Modernism in the pictorial arts began in Cuba in 1927 and developed a rich vocabulary of traditional Cuban elements. See Shifra M. Goldman, "La década crítica de la vanguardia cubana/The Critical Decade of the Cuban Avant-Garde," *Art Nexus/Arte en Colombia,* no. 53 (January–March 1993): 52–57/201–204. (A vital line of type omitted on page 55/203 is the following: "In 1934, Fidelio Ponce de León completed a painting titled *Tuberculosis.*")

5. The Biennial, jointly sponsored by Franco's Council for Spanish American Countries and Batista's National Institute of Culture, coincided with the 1953 attack on the Moncada barracks led by Fidel Castro. Both occurred, deliberately, on the centenary of José Martí's birth, and served to coalesce *Los Once* and launch them to antigovernment activity. The Anti-Biennial of January 1954 (in Havana, Santiago de Cuba, and Camagüey) culminated in the First University Festival of Contemporary Cuban Art, organized by the Federation of University Students. After Moncada, strict censorship was imposed on political caricature, and the fine arts faced a period of very bleak prospects. This was the only occasion on which artists successfully confronted the government.

6. Cuban-born José Gómez-Sicre, who recently retired after forty years from his position as Visual Arts director of the Pan American Union, organism of the Organization of American States, has had a long history as "taste maker" and apparently apolitical manipulator of modern Latin American art. For his ties with multinational corporations functioning in Latin America, see Shifra M. Goldman, *Contemporary Mexican Painting in a Time of Change* (Austin: University of Texas Press, 1981), 33–35.

7. A 1973 silkscreen poster by René Mederos from the *Moncada* series graphically illustrates Havana at this time. Below an image of Uncle Sam, whose stringed marionettes overlook the capitol, are the signs of advertisements for Shell, Mobil, and Gulf; *Life* magazine; Goodyear and Firestone tires; Western Electric; Coca-Cola and Royal Crown Cola; Chevrolet and Pan Am. A speaker's stand is marked PAU for the Pan American Union, while below the Cuban people mass against the dictatorship.

8. Pop art, as we know, drew upon commercial consumerism advertising and the world of mass media for its imagery. While some of its practitioners used its form critically, most blandly absorbed the sources without comment. Andy Warhol was most noted for his serial images in which a single object or person is repeated in photo-silkscreen color, sometimes off-register like the color comic strips of newspapers. Roy Lichtenstein's comic book characters from adventure series, with all their violence and sexism, and Robert Rauschenberg's collages of contemporary urban life were adapted by Cuban poster makers to their needs.

9. David Kunzle pointed out, in 1975, that the Cuban public had learned to read and enjoy posters in relatively ideogrammatic styles, but he was not sure how a dialogue with the public had affected artists' styles as such. Martínez goes beyond this question in suggesting not only the stylistic influence on his own

work by popular art, but a popular absorption of artistic style. See Kunzle, "Public Graphics in Cuba: A Very Cuban Form of International Art," *Latin American Perspectives* 2, no. 4, issue 7 (Supplement 1975): 91.

10. Cuba had a tradition of critical humor that carried on after the revolution. The most notable and popular caricaturist from 1916 to 1934 was the renowned painter Eduardo Abela, who created the comic character *El Bobo* (The Simpleton) in the late twenties, descendant from a long line of personages originating in the nineteenth-century colonial period. René de la Nuez, famous for his *barbudos* (the Bearded Ones) in *Granma,* began his career during the Batista regime with *Loquito* (the Little Crazy Man). Caricaturists were numerous enough to have their own Salon of Humorists in 1925—a tradition that continued in the UNEAC 1982 Salon of Visual Artes, which included twenty-one humorists. On *El Bobo,* see Adelaída de Juan, *Hacerse El Bobo de Abela* (Havana: Editorial de Ciencias Sociales, 1978)—reprinted in Adelaida de Juan, *Pintura cubana: Temas y variaciones* (Mexico D.F.: Universidad Nacional Autónoma de México, 1980), which also includes material on René de la Nuez. Also see Kunzle, "Public Graphics in Cuba," section on "Magazine Graphics: Cartoon and 'Comic'," 102–110.

11. Siqueiros painted two murals in Havana in 1943, one of which was destroyed. Siqueiros had impact on older Cuban artists, particularly Orlando Suárez, Vice Dean of the Faculty of Plastic Arts of the Graduate Art Institute, who, from 1955, dedicated himself to muralism, and published the book *Inventario del muralismo mexicano* (Siglo 7 a de C./1968), (Mexico, D.F.: Universidad Nacional Autónoma de México, 1972). The book covers twenty-six centuries of muralism, from the seventh century B.C. through 1969 A.D.

6

MASTER PRINTS FROM PUERTO RICO: LINOLEUM AND WOODCUTS BY THREE GENERATIONS OF ARTISTS

Lorenzo Homar's magisterial woodcut *Unicornio en la Isla* (*Unicorn on the Island*) combines facets of a sensibility that was to influence more than three generations of Puerto Rican printmakers: a love of the sea and the tropical landscape; a passion for literature; and dedication to an elegant but muscular calligraphy. Other island nations of the Caribbean share the first two enthusiasms, which derive from their natural geography and their Latin American heritage. The ongoing fascination with calligraphy, however, is unique to Puerto Rican printmaking—which has flourished from the 1950s to the present and enjoys international prestige—and was brought to the very highest aesthetic level by Homar himself.

Fig. 13

Linked from its inception to a volatile political situation—that of a colonized people dedicated to independence after almost five hundred years of foreign rule—the graphics movement was distinguished from the start by two characteristics: an intense national consciousness that undertook to portray the landscape of the nation, the flora and fauna, the

This essay first appeared in a catalogue of the Rancho Santiago College Art Gallery, in 1987. I am indebted to the excellent essay on Puerto Rican woodcuts by Flavia Marichal, "Aproximación al desarrollo histórico de la xilografía en Puerto Rico: 1950 a 1986," in the catalogue *La Xilografía en Puerto Rico: 1950–1986*, Museo de la Universidad de Puerto Rico, Río Piedras, 1986.

life and culture of the people in country and city, as well as the revolutionary heroes of past and present; and the need for communication which took the form of combining images with texts utilizing a constantly inventive calligraphy. Starting with the first generation—which includes Homar (considered by many to be the "father" of indigenous Puerto Rican printmaking),[1] Carlos Raquel Rivera, Rafael Tufiño, Antonio Maldonado, José A. Torres Martinó, and the late Carlos Marichal (an emigré Spaniard who arrived in Puerto Rico from Mexico in 1949 and established a graphics workshop)—these themes have been handled with imagination and skill.

Homar's *Unicorn on the Island* originated as one of several illustrations for a book of poetry, *Cuatro Sones*, by Tomás Blanco. In 1965, Homar decided to cut it in its present monumental size. His wood engraving *Betances* also has a quality of monumentality despite its small size; it is one of a series of portraits of revolutionary heroes which includes a large woodcut of Pedro Albizu Campos, a militant *independentista* (independence fighter) from the mid-thirties until his death in 1965. Homar worked in New York for many years as a jewelry designer for Cartier's. His experience with metal engraving and his fascination with lettering and book design prompted him to study historical Spanish calligraphy and penmanship at San Juan's Casa del Libro when he returned to Puerto Rico in 1950, and laid the basis for his woodcut mastery.

If the woodcut was the major form of relief printing in the 1960s, the 1950s was a decade in which linoleum cuts flourished, inspired by their extensive use since 1937 by Mexico's Taller de Gráfica Popular (hereafter in this essay referred to as the Taller). In the late forties, after service in World War II, Rafael Tufiño and Antonio Maldonado studied in Mexico City under the G.I. Bill of Rights, where they were stimulated by the works of the Taller. Many Puerto Ricans, including Tufiño and Maldonado, flocked back to the Island after the election of Luis Muñoz Marín as governor in 1948, in order to participate in the cultural efflorescence that accompanied the dynamic social program instituted by the victorious Popular Party. *Goyita y su niño* (*Goyita and Her Son*) by Tufiño was an early autobiographical linocut that illustrates his Mexican-influenced realism in the treatment of San Juan's working people. In 1954, after Tufiño completed a portable mural on themes taken from popular Puerto Rican songs called *plenas*, he and Homar executed the portfolio of *La Plena*, twelve linocuts based on the same songs. Here we see the threatening, rearing, three-horned black horse; the personified Hurricane San Felipe, which destroyed parts of Puerto Rico in 1928; and other legends and scandals. The crisper, precise, and elaborately ornamented style of Homar (signed with an "H") can be distinguished from Tufiño's more full-bodied, flowing realistic manner. In the early sixties Tufiño began to

work with woodcuts, producing the dramatically designed composition *La Ceiba de Loísa,* which is dominated by a massive hundred-year-old tropical silk-cotton tree. The villagers of Loísa, descendants of African slaves and Borinquen Indians, celebrate the traditional Fiesta of Santiago (St. James defeating the Moors) in their own way. In their version, the coconut-masked *vejigante* (shown in the print) paradoxically mocks the Spaniards while paying homage to the Spanish saint. Fig. 14

Carlos Raquel Rivera is noted for his "social surrealism," or "magic realism" with social content in both paintings and graphics. His linocuts *1898* and *Elecciones coloniales* (*Colonial Elections*) deal with Puerto Rico's colonial status vis-à-vis Spain and the United States. *Huracán del norte* justifies the label of "social surrealism." A skull-headed "northern hurricane" (metaphor for the U.S.) strides before unfurled banners manipulated by ropes above the wooden shacks of the poor. Puerto Rican men and women are swept toward the bag held by this creature which spills coins and bills. In power and skill, this work certainly ranks with prints on contemporary issues by Mexico's Taller. Fig. 15

José A. Torres Martinó, an artist, journalist, and teacher, is represented by strong abstracted woodcuts. *Inriri Cahuvial* was originally part of a set of illustration for Juan Antonio Corretjer's book of poems *Yerba bruja.*

Myrna Báez and Antonio Martorell both studied with Homar, but their works demonstrate the original way in which these teachings were utilized by individual personalities without losing those national characteristics which mark them as Puerto Rican. Báez is best known internationally for the subtlety, delicacy, and dreamlike quality imparted to her recent paintings by glazes of transparent color. At the same time she is fiercely nationalistic, and conveys this sentiment through graphic images of landscapes, such as those of the Yunque rainforest (one of which is cut on plexiglass) and other works of tropical trees and flowers. Her self-portrait, combining linoleum and woodcut, portrays her as a very young artist who already conveys the seriousness and strength for which she is still known.

Antonio Martorell is one of the most innovative, exploratory, and multifaceted artists of the second generation. Constantly active since the early sixties as a graphic artist, Martorell is also a book illustrator, poster maker, theater designer, and performance artist. Shaping his calligraphy, use of color, type of paper, and imagery to suit varied themes—nostalgic, lyrical, witty, or political—his two woodcut portfolios celebrate the deceased Mexican popular singer Toña La Negra (*Luto absoluto* or *Absolute Mourning*) and counterpoint a literary work (*Nocturno rosa* or *Rose-Colored Nocturne*). Martorell can swing with facility from these small works to giant woodcuts of 5 × 7 feet and larger, using a wooden door as his plank. He often prints a single image or form in multiple posi- Fig. 16

tions—a technique called "modular graphics," influenced by Uruguayan master printer Antonio Frasconi and by pop art, which is known for serial imagery.

A still younger generation includes artists such as Luis Alonso, Consuelo Gotay, and Jesús Cardona, who have learned from their predecessors and have added their own dimensions. Luis Alonso continues in the tradition of monumental woodcuts with modular techniques and color. He studied with Homar and Homar's student José Alicea, and has been influenced by Frasconi and U.S. master printer Leonard Baskin. Unlike most Puerto Rican artists, Alonso's artistic formation has taken place wholly in Puerto Rico. His knowledge of artists from abroad has come through books and the important San Juan Biennial of Latin American Graphics, which began in 1970. His woodcut *El Visitante* (*The Visitor*) has a dense and complicated textured surface that adds to its hermetic and mysterious quality.

Consuelo Gotay is rare for her generation in that she has worked extensively with linoleum. Like Myrna Báez, images of women are central to her work, as is an interest in the workings of the psyche: the interior life that colors us all and which women artists have striven to liberate in a constantly changing visual form. Gotay's printmaking has been influenced by a stay of several years in Santo Domingo.

Jesús Cardona is the youngest of the artists. His large color woodcut introduces new perspectives. *Reportaje* (*Report*) draws on the page format of a newspaper, with its lines of text, logos, and news photographs. Closer inspection, however, reveals the urbanization, the crowded skyscrapers that dominate the sky, and small areas where trees and birds still exist. The texts prove to be not news stories, but poetry. Cardona employs to good advantage the natural grain of the wood.

"Master Prints from Puerto Rico" does not pretend to be a survey of printmaking on the Island, but an introduction to this rich graphics tradition. It is to be hoped that other exhibits will follow so that Puerto Rican art, which so rarely comes to the West Coast, will become better known and expand our knowledge about the modern art of Latin America in all its diversity.

Notes

1. A silkscreen poster workshop was begun in 1946 by Irene Delano, a North American who, with her husband, photographer and filmmaker Jack Delano (until 1946 a member of the photography team of the New Deal's Farm Security Administration), was dedicated to the literacy and self-improvement programs pioneered by Muñoz Marín's Popular Party. With Muñoz's election to governorship, the graphics program passed to the auspices of the Division of Community Education, where it continues in modified form to this day, presently headed by

Antonio Maldonado. Silkscreen posters were used to publicize educational film showings, while early illustrated pamphlets utilized linoleum cuts. The first Puerto Rican–generated art movement was the Centro de Arte Puertorriqueño (CAP), begun exactly at mid-century by a collective of artists: Félix Rodríguez Báez, Homar, Tufiño, Torres Martinó, and Julio Rosado del Valle.

7

A PUBLIC VOICE: FIFTEEN YEARS
OF CHICANO POSTERS

The Chicano poster movement—and it must be viewed as a movement rather than simply as a collection of individuals making posters—arose toward the end of the 1960s. Although Chicano posters share stylistic characteristics with poster making and fine art trends of the period, their iconography, content, and social functions are distinctive: they have drawn on bicultural and bilingual resources that reflect the history of Mexican peoples in the United States and on the separatism, cultural nationalism, search for identity, and sociopolitical struggles that marked the Chicano movement of the late sixties and the seventies.

The history of Chicano poster making, like that of street muralism (the other public art form that arose simultaneously), can be divided into two periods: from 1968 to 1975 and from 1975 to the present. The kind of posters made in the first period was marked by a totally noncommercial, community-oriented character in the attitudes and expectations of the individuals and groups who made posters, the purposes they served, the audiences they addressed, the facilities that were established to promote poster making, and the collectives that flourished. The second period witnesses the changing dynamic of an art movement subject to the fluctuations of the political movement and to the imperatives of the dominant society to which that art movement has been opposed. Crucial to this second period is the changing perception of the Chicano role in the

This essay originally appeared in *Art Journal* 44, no. 1 (Spring 1984): 50–57. Reprinted by permission of College Art Association, Inc.

United States and in the international arena—a perception that brought an end to separatism for most Chicanos and a closer alignment with Third World (especially Latin American) liberation struggles. At the same time, other segments of the Chicano community became more assimilationist in relation to the dominant society and its values, and more commercial in the content and dissemination of their art.

The Chicano Political Movement

The Chicano political movement grew out of an alliance formed by exploited farmworkers struggling to establish unions against the powerful agribusiness and ranching interests of California and Texas, the disenfranchised and dispossessed land-grant owners of New Mexico, the urban working classes of the Southwest and Midwest, and the growing student movement. All these were essential participants in the Chicano movement, although not all of them can be embraced by the term Chicano.

Although great economic struggles, supported by nationwide boycotts, took place in rural areas—and were the unifying symbol of the Chicano movement—many of the political and cultural activities of the 1960s and 1970s were centered in the cities, where the greatest number of Mexicans and Chicanos lived. Issues in the cities included police brutality, violations of civil rights, low-paid employment, inadequate housing and social services, gang warfare, drug abuse, inadequate and irrelevant education, and lack of political power. The Vietnam War was a crucial issue, and antiwar sentiment was growing. From the mid-sixties on, students were the shock troops of the urban movement.

A high sense of idealism was intrinsic to the 1968–75 period. It explains the emphasis on community-oriented and public art forms such as poster making and muralism and on the development of artistic collectives, as well as insistence on political and ethnic themes. Art was part of a whole movement to recapture a people's history and culture, albeit at times romantically, as part of the struggle for self-determination.

The cultural-nationalist philosophy was also developed by the youth of the movement and expressed most influentially in the utopian "El Plan Espiritual de Aztlán," adopted in March 1969 at a huge Chicano Youth Conference in Denver. Key points were a call for reclamation and control of lands stolen from Mexico (the United States Southwest), anti-Europeanism, an insistence on the importance and glory of the brown-skinned Indian heritage, and an emphasis on humanistic and nonmaterialistic culture and education. "Aztlán" (the Southwest, from which, presumably, the Aztecs came), it proclaimed, "belongs to those who plant the seeds, water the fields, and gather the crops, and not to foreign Europeans. . . . We are a Bronze People with a Bronze culture." The "Plan" committed all levels of Chicano society to the Cause: "We

must insure that our writers, poets, musicians and artists produce literature and art that is appealing to our people and relates to our revolutionary culture. Our cultural values of life, family, and home will serve as a powerful weapon to defeat the gringo dollar value system and encourage the process of love and brotherhood."[1] Thus, in a few pages of text, were established not only the ideals but also the themes of Chicano art and letters: the life, history, and heritage of a working-class, Indian, spiritual, and revolutionary people.

The Poster Movement: Context and Development

By far the largest, most prolific, and sophisticated Chicano poster and mural movements developed in the state of California, particularly in the San Francisco Bay area and Sacramento (abutting vast farming regions) and in the southland from Los Angeles to the Mexican border. The Los Angeles area led in mural production, while the Bay area and Sacramento led in poster making. The reasons for these developments may be sought in the history and demographics of each area, which influenced the forms, styles, and even the content of their visual arts. Los Angeles County has the largest Mexican and Mexican-descent population in the United States: so large that, until the great influx of Central and South American refugees in recent years, most Spanish-speaking peoples were "absorbed" by or "disappeared" into the Mexican and Chicano communities. By contrast, the Bay area, since World War II, has been multinational as well as multiracial. The term *raza* (our people) used in northern California refers to the mix of peoples from Central and South America, the Caribbean, and Brazil, as well as Mexicans and Chicanos.

Los Angeles architecture, consisting of low-rise stuccoed and concrete buildings spread over vast areas, promotes a "car culture" and has lent itself to the street mural, which serves a billboard-like function in the *barrios* (neighborhoods) and on the walls of schools and public buildings and businesses. Great concentrations of outdoor murals (probably six hundred to seven hundred in East Los Angeles alone) transformed many areas. The Bay area, in contrast, is much smaller, denser, and more compact, with good public transportation. In San Francisco and Berkeley, there is a large pedestrian population. As a result, although there are many murals, the poster has flourished as a major means of communication. Linda Lucero, a member of San Francisco's La Raza Graphic Center, notes, "I really like it when a poster from the Center is in store windows all over town announcing an event and bringing an artistic interpretation of the event to people. . . . The most interesting posters have been those that illustrate an important event and because of their personal meaning to the artist transcend the 'advertising' of the event into the production of art."[2]

In the Bay area, graphic arts movements for public and political communication date back to 1950, when the Graphic Arts Workshop, a large group that produced images of political, social, labor, and ethnic themes, was established. Initiated by the California Labor School's art department and influenced by Mexico's Taller de Gráfica Popular, with which some of its members were associated, it had counterparts in New York and Los Angeles. In the mid-sixties, Emory Douglas, a graphic artist for the Black Panther newsletter, became a respected and widely known figure in the Bay area. The great surge in poster making, however, began in 1970 in response to United States bombings in Cambodia. Many Bay area arts schools—the California College of Arts and Crafts, San Francisco State University, the University of California, Berkeley (UCB), and the San Francisco Art Institute—briefly closed in protest. The Printing Project, a collective of about fifteen artists organized by Bruce Kaiper, which later that year became the Media Project, was a major source of posters for antiwar, civil rights, American Indian, and feminist organizations of the time. Students of UCB art historian Herschel B. Chipp organized a poster collective, as did students of Frank Rowe's silkscreening workshop at multiethnic Laney College in Oakland. The Japanese Arts Movement and the Chinese Kearney Street Workshop poster collectives also appeared.[3]

Nineteen hundred sixty-eight was a year of international student protest. Chicano students were particularly sensitive to student demonstrations in Mexico during the 1968 Olympics, the graphics of that movement,[4] and the Tlatelolco massacre of protesters by government troops that brought these events to world attention. Of greatest moment for the Chicano poster movement was the 1968 Third World strike at San Francisco State College, organized by the Third World Liberation Front. (A year later there was a similar strike at UCB.) The immediate issue at San Francisco was the failure of the educational system to meet the needs of Third World students, but the Front reflected the larger issues of racism and imperialism. During the San Francisco strike, art students, aided by faculty members, set up a poster-making workshop, which lasted about a year. "My participation in the strike," says Rupert García, who later became one of the Bay area's most prolific and respected postmakers,

was both physical and through making silkscreen posters in support of the strike and on other issues. I was critical of the police, of capitalist exploitation. I did posters of Ché, of Zapata, and other Third World leaders. As artists, we climbed down from the ivory tower. We abandoned notions that the artist was supposed to be against society, against people, be different, exotic, bohemian. It was in the workshop, not the classroom, that I learned silkscreen printing. I also learned to work in a collective—critiquing, sharing, subdu-

ing one's ego. I had planned to be an easel painter, but the strike changed that.[5]

In 1970, a new influence affected Bay area poster makers. The recently established Galería de la Raza mounted an exhibition of photographs of Cuba and a series of silkscreen posters by the Cuban artist René Mederos. That same year, McGraw-Hill published in full color and large format *The Art of Revolution: Castro's Cuba, 1959–1970*.[6] Chicano and raza poster artists were tremendously impressed by the quality of the posters and their content. The link between Chicano oppression at home and United States imperialist actions abroad (in Indochina, but also directed at Cuba and incipient Latin American liberation movements) had already been emphasized politically; now it was brought home artistically. Of particular importance were Cuban color and the relationship between form and content. According to García, his encounter with Cuban posters, particularly the originals by Mederos, was a highly emotional experience: "I was more moved by the Cuban posters than even the San Francisco dance posters of the 1960s. The dance posters were visually exciting, but I couldn't identify with them as I could with the Cuban posters. The incredible quality of the designs and the use of revolutionary experience moved me deeply."[7] The impact of Cuban posters was heightened in 1974, when the Chicano artist Juan Fuentes, aided by an art student from San Francisco State University, organized a Cuban poster exhibition at the California Palace of the Legion of Honor.

Almost invariably, in the 1968 to 1975 period, Chicano posters were communicative and educational. Poster making was taught to the public, especially young people, at Chicano and raza centers and galleries and in the schools where Chicano artists taught. In working-class and relatively powerless communities with little access to mass media, the poster became an important form of conveying information and cultural pride. In the hands of its most skillful and talented creators, it became a major art form. The dedicated Chicano, raza, and other poster artists of the era shared the philosophies and political positions they articulated in posters and considered their production a form of political activity. Accepted, welcomed, and appreciated by the large audiences their posters served, and not restricted by commercial requirements, they felt that the gap between art and life was closed.

Poster Collectives

The Chicano poster movement has been characterized by collectives and, in some cases, a policy of anonymity—the antithesis of competitive individualism found in the mainstream art world. In these respects, poster groups have followed the social example of Mexico's Taller de Gráfica

Popular, which produced collective portfolios and practiced collective criticism, and of the Cuban poster makers whose political posters are unsigned.

La Raza Graphic Center, Inc.

One of the major producers of posters has been La Raza Graphic (formerly Silkscreen) Center of San Francisco, an independent, nonprofit organization founded by Latinos and Chicanos. It is affiliated, under the umbrella organization La Raza en Acción, with other centers for community service such as the information, legal, and tutorial programs. The center's various summaries of its own history so clearly delineate its purposes that they are worth quoting at length:

> La Raza Graphic Center was established in 1971 by a group of community organizers to serve the community by using art as a means of communication and as a center of art and culture. In 1971 the Mission District was a community affected by the social, economic and political issues of the day . . . such as the Vietnam war, the United Farm Workers movement, police brutality, housing discrimination and drug abuse. . . . The organizers and artists at La Raza Graphic Center responded to this need by considering art as an excellent medium of communication for both artists and community. With the passage of time it became clear to the staff that silkscreen printing by itself was not enough to meet the growing needs of community organizations nor . . . the Center's need for . . . some degree of independence and economic self-sufficiency. In 1978, the Center . . . purchased two offset presses and a typesetting machine to set up an economic development component.[8]

With the diminution of government grants to the arts, the Center, like other institutions, was forced to become more self-supporting. It has not abandoned its responsibility to the community, however, and maintains a sliding scale of prices for its clients.

In an earlier historical summary, the center more exactly articulated its relationship to United States culture, its role as a recorder of history, and its relationship to the immediate community of the Mission District, a shopping and living area for working-class Latinos, Asians, and other Third World people:

> La Raza culture is not isolated from the "mainstream" or dominant North American culture, but in fact is "influenced" by and affects the dominant society. . . . The posters of La Raza Silkscreen Center make up a revealing pictorial history book of the life of the urban Spanish-speaking Mission community. . . . The windows and walls

of small stores and businesses from butcher shops to clothing stores provide public space for a truly popular gallery.[9]

The artists who founded, administered, and produced posters at the center represent a spectrum of Latin American nationalities. Among the Chicanos with long associations at the center are Peter Gallegos and Linda Lucero (the only woman consistently active in the Center); among those who have worked at the Center for shorter periods of time are Michael Ríos, Rayvan Gonzáles, and Juan Fuentes. Many others have used the center's facilities for particular projects. The center's posters have by no means been limited to local viewing: from 1975 to 1982, they have been shown throughout the Southwest and in Washington, D.C., Chicago, New York, Paris, Rome, Mexico City, and Havana.[10]

Fig. 17

Royal Chicano Air Force/Centro de Artistas Chicanos.

Since its founding in 1970, the Royal Chicano Air Force (RCAF) of Sacramento has focused on murals and silkscreen posters with a dedication to the community. Its cofounders, the poet and artist José Montoya and the artist Estéban Villa, both members of the art department of Sacramento State College, had been active participants in the dynamic Chicano art groups of the Bay area in the late 1960s.

RCAF grew out of the Mexican American Liberation Art Front (MALAF), a group established in 1969 by Montoya's brother Malaquías, René Yáñez (codirector of the Mission District's Galería de la Raza)[11], Estéban Villa, and Manuel Hernández Trujillo. The four remained together as a group for only a year, but during that year held widespread discussions among Chicano artists seeking definitions and a philosophy of Chicano art.

MALAF's ideas spread throughout California during the next five years, and were carried to other states by visiting artists. Montoya and Villa carried MALAF's art philosophy to Sacramento by establishing the Rebel Chicano Art Front. Because its initials were the same as those of the Royal Canadian Air Force, its name was soon wryly transformed by its founders to the Royal Chicano Air Force, and a mural sporting an aviator and a plane became a symbol of its new identity.

The RCAF involves not only local community people, but also students from Sacramento State College (now University). The more active members in the poster and mural programs have been Ricardo Favela, Max García, Armando Cid, Juanishi Orozco, Rudy Cuellar, and Louie "The Foot" González. The poet Luzmaría Espinoza has run the Center, while Lorraine García and Stan Padilla worked on murals. "What the Royal Chicano Air Force is really all about," says José Montoya, "is to get people living in Sacramento *barrios* involved in positive activities, to play

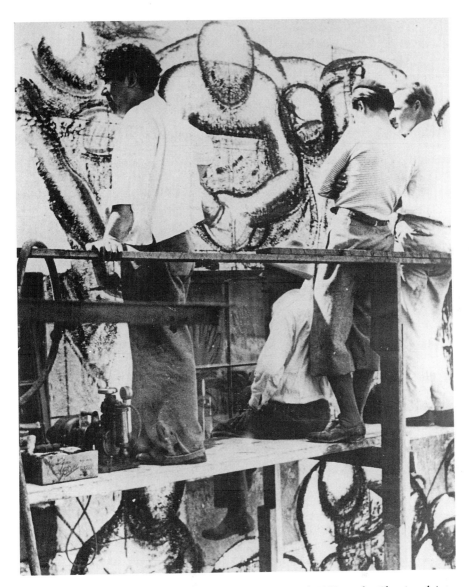

Fig. 1. Siqueiros working on *Mitin obrero* (Street Meeting), 1932, at the Chouinard Art School in Los Angeles. (Photo: courtesy of Mary Lee Murphy.)

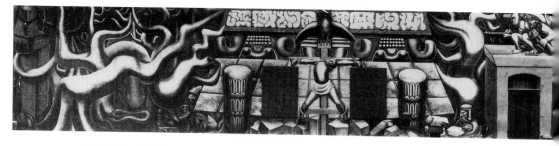

Fig. 2. David Alfaro Siqueiros, *América tropical* (Tropical America). 1932. Mural, paint on white cement, 18 ft. x 80 ft. Olvera Street, Los Angeles. (Photo: Shifra M. Goldman Archive.)

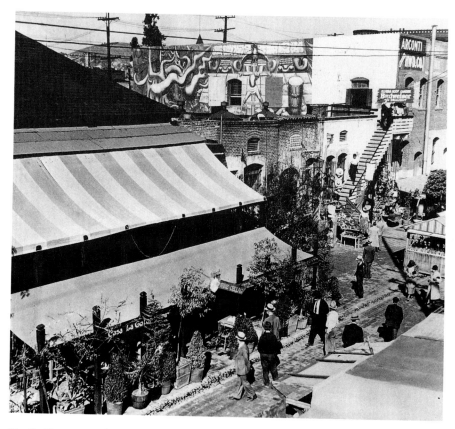

Fig. 3. Siqueiros. Olvera Street in 1934, showing *Tropical America* mural partially whitewashed. (Photo: *Los Angeles Times*.)

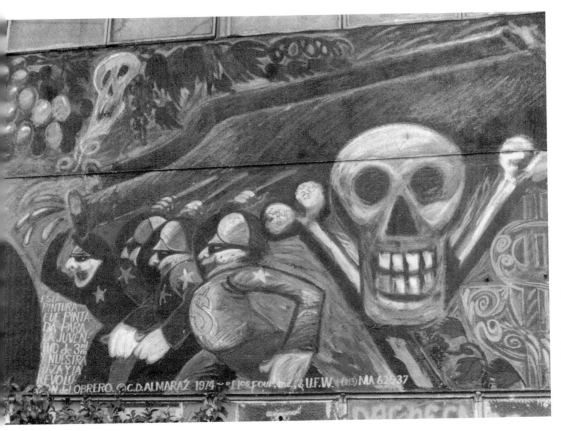

Fig. 4. Carlos Almaraz and neighborhood children, *Don't Buy Gallo Wine/No compre vino Gallo.* 1974. Mural detail (destroyed). All Nations Neighborhood Center, Los Angeles. © Carlos Almaraz Estate 1993. (Photo by author.)

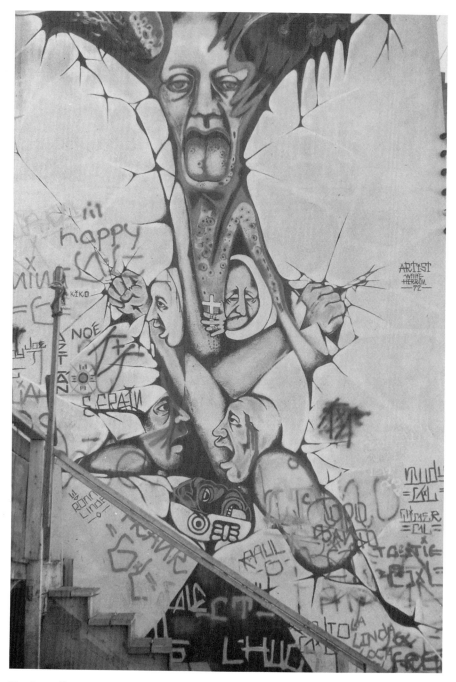

Fig. 5. Willie Herrón, *The Cracked Wall.* 1972. Mural, acrylic. Los Angeles.
(Photo by author.)

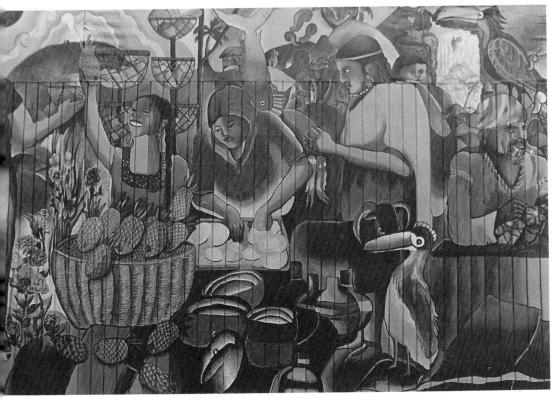

Fig 6. Mujeres Muralistas, *El Mercado* (The Market). 1974. Mural detail (destroyed).
San Francisco. (Photo courtesy of Ray Patlán.)

Fig. 7. Taller de Investigación Plástica (TIP), *Hombre de los medios masivos* (Media Man). 1978. Mixed media, lifesize. (Photo by author.)

Fig. 8. Grupo Proceso Pentágono, *Pentágono*. 1977. Mixed media. Overview of five-sided structure first exhibited at the X Biennial of Paris. (Photo by Lourdes Grobet.)

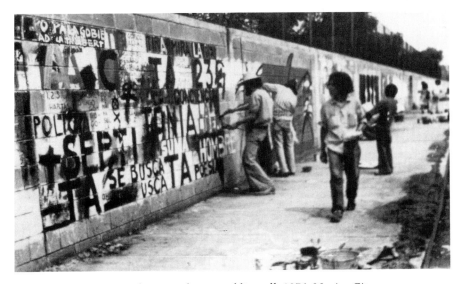

Fig. 9. Grupo Suma, outdoor murals on a public wall. 1976. Mexico City.

Fig. 10. Grupo Suma, stencil for making murals. 1976.

Fig. 11. Raúl Martínez, *Cuba en Grenoble.* 1969. Silkscreen poster.

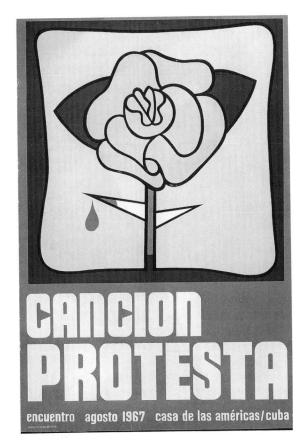

Fig. 12. Alfredo Rostgaard, *Canción
protesta* (Protest Song). 1967. Silkscreen
poster, 44 in. x 29-3/4 in. Collection of
Center for the Study of Political Graphics.
(Photo by Adam Avila.)

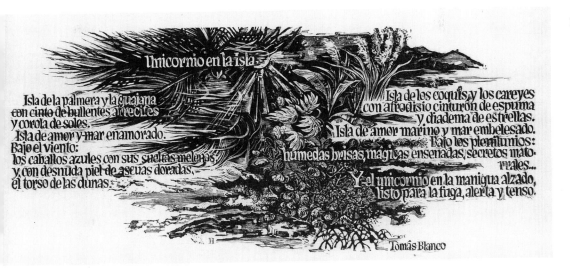

Fig. 13. Lorenzo Homar, *Unicornio en la isla* (Unicorn on the Island). 1965–66.
Woodcut, 20 in. x 48 in. Collection of the artist. (Photo, by J. E. Marrero, courtesy of
the Museo de la Universidad de Puerto Rico, Río Piedras.)

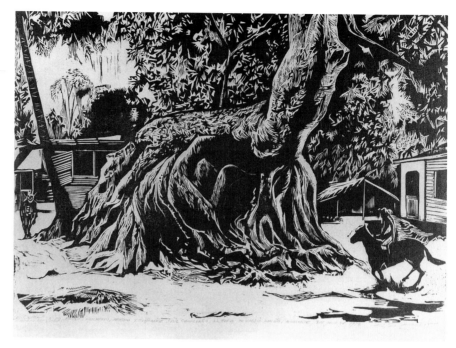

Fig. 14. Rafael Tufiño, *La Ceiba de Loísa* (The Silk-Cotton Tree of Loísa). 1963. Woodcut, 16-1/2 in. x 24 in. Collection of Antonio Maldonado. (Photo, by J. E. Marrero, courtesy of the Museo de la Universidad de Puerto Rico, Río Piedras.)

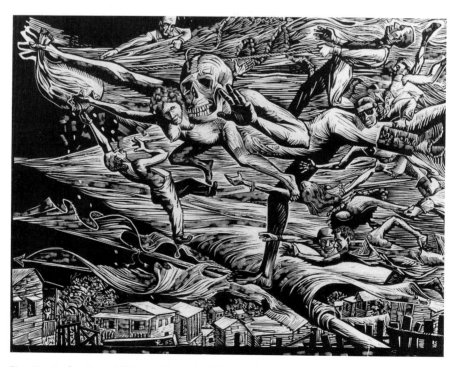

Fig. 15. Carlos Raquel Rivera, *Huracán del norte* (Northern Hurricane). 1955. Linoleum, 12-1/8 in. x 16 in. (Photo, by J. E. Marrero, courtesy of the Museo de la Universidad de Puerto Rico, Río Piedras.)

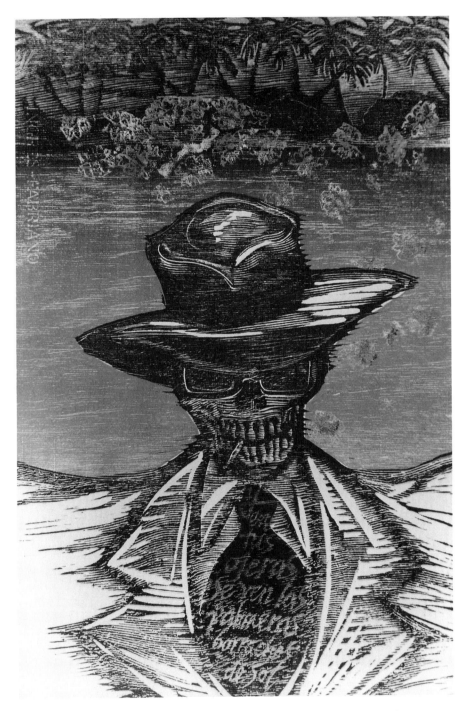

Fig. 16. Antonio Martorell, *Luto absoluto* (Absolute Mourning). 1983. Woodcut, 18-7/8 in. x 12-5/8 in. (Photo, by J. E. Marrero, courtesy of the Museo de la Universidad de Puerto Rico, Río Piedras.)

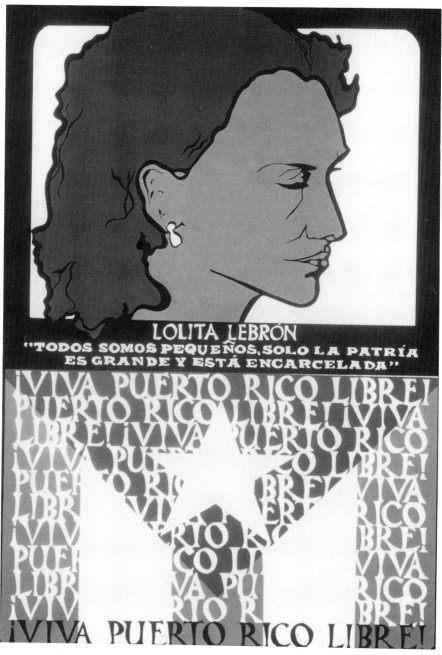

Fig. 17. Linda Lucero, *Lolita Lebrón. ¡Viva Puerto Rico Libre!* (Lolita Lebrón: Long Live Free Puerto Rico!). 1975. Silkscreen, 28 in. x 22 in. (La Raza Silkscreen Center.)

CORTÉS NOS CHINGÓ IN A BIG WAY THE HÜEY

Cortés nos chingó in a big way
españa nos chingó in spanish
francia nos chingó with music
los estados unidos nos chingó un chingote
santa ana nos chingó like a genuine chinguista
porfy nos chingó for a long long time
y nosotros nos chingamos
i swear!!!
something's very wrong
con tanto corazón que tenemos
maybe if gloria stops hassling maría
and josefina quits messing around with josé
whose carnal héctor is gonna put ramón's luces out
y tal vez if jorge makes up with carlota
maybe things wouldn't be so bad
but you know how it is...
juan's tio hates antonia
because she was screwing ernie
and ernie's brother rufino is after anybody
while manny's cousin got jumped by chuy and tavo
after the dance where chris got shot in the earlobe
by one of the garcías who was really trying to get
paula's little sister for spreading chismes
about how unreasonable and hot tempered the garcías are
man.... que tiempo tan chingado,
excuse me please,
i'm gonna go look for ricardo
to watch me kick
clint eastwood's honky ass

RCAF

Fig. 18. Ricardo Favela, *Cortés nos chingó in a Big Way, the Hüey.* (Cortés Screwed Us in a Big Way). 1974. Silkscreen. Text by Louie "The Foot" González; graphics by Ricardo Favela. (Royal Chicano Air Force.)

Fig. 19. Rupert García, *El Grito de rebelde* (The Rebellious Cry). 1975. Silkscreen, 26 in. x 20 in.

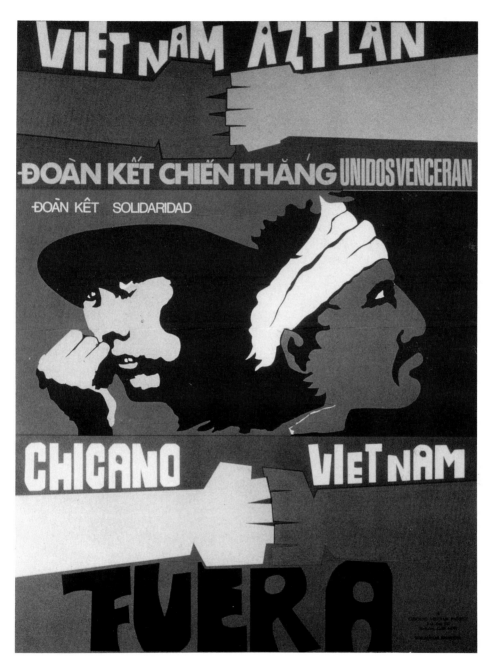

Fig. 20. Malaquías Montoya, *Vietnam/Aztlán: Fuera* (Vietnam/Aztlán: Out). 1973.
Offset from silkscreen, 23 in. x 17 in.

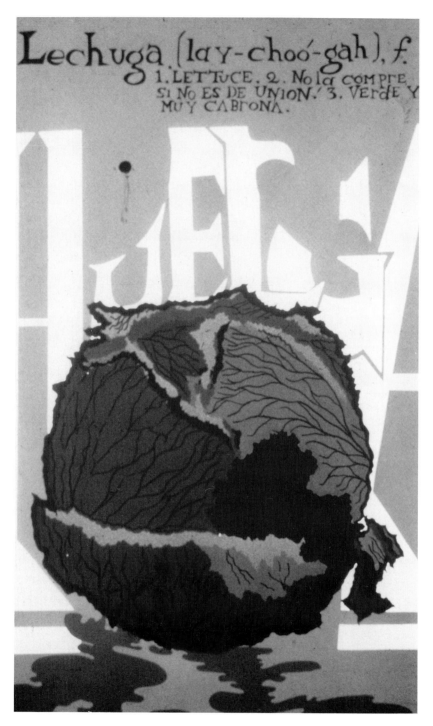

Fig. 21. Amado M. Peña, *La Lechuga* (Lettuce). 1974. Silkscreen, 17 in. x 14 in.

an active role in demonstrating to the community at large that there is much to be admired in the Chicano culture."[12] Other spokespersons for the RCAF add that it is an organization committed to change by "safeguarding, maintaining, and proliferating the *cultura* of the *Indio/Mexicano/Chicano* people in a positive way."[13]

Like other Chicano collectives, the RCAF has also used the silkscreen poster as a substitute printing process for literature: an ingenious idea when one has little access to the publishing industry, which for years rejected Chicano manuscripts. (Chicano poets and writers still publish and distribute extensively through their own alternative press structures.) Ricardo Favela's 1974 poster *Cortés nos chingó in a Big Way the Hüey* (*Cortés Screwed Us in a Big Way*, with an untranslatable play on sounds between "way" and "hüey") is a screen print of a slangy bilingual poem signed by Louie "The Foot."

Fig. 18

Mechicano Art Center

In Los Angeles, the now defunct Mechicano Art Center, established in 1969 near the fashionable "gallery row" as a showcase for Chicano artists, moved by 1971 to the East Los Angeles *barrio* as a nonprofit, community-oriented workshop and gallery. Mechicano's strongest programs included an open-wall exhibition space, a silkscreen poster workshop for the community, and a mural program, with which its members intended to replace "neglect with pride in the area, and act as a catalyst to counteract the present defacement." Mechicano succeeded in enlisting the enthusiastic involvement of the newly formed Gang Federation. "Instead of spray can graffiti as an outlet for frustration and a search for identity, [the gang members] can be involved as working contributors to an art experience which can be enjoyed by all in the community."[14] Mechicano murals and posters on occasion incorporated a stylized graffiti-like lettering, a practice adopted by many Chicano artists. Like other centers, Mechicano also produced silkscreened annual calendars as a fund-raising activity.

Self-Help Graphics and Art, Inc.

Los Angeles–based Self-Help was initiated in 1972 by Sister Karen Boccalero, who was trained in silkscreening by Sister Mary Corita, well known in the 1960s for her beautifully designed peace posters. From its inception, Self-Help, funded by the Catholic Church and public and private sources, was dedicated to community uplift and teaching "barrio youth about the value and ideals unique to the Mexican heritage and culture."[15]

Silkscreen and craft workshops have been at the heart of its program aimed at school children and young adults. Over the years, the main

activity of Self-Help has been celebration of the Día de los Muertos (Day of the Dead), and great energy has been given to preparing silkscreen posters, announcements, cards, T-shirts, and calendars for this annual event. Each year, masked and costumed celebrants gather at a local cemetery where a Catholic mass and an indigenous ceremony are held. A succession of Chicano artists have been employed to produce the silkscreen materials and teach the technique to young people: Antonio Ibañez, Michael Ponce, Richard Duardo, Linda Vallejo, and Leo Limón, among others. Self-Help also runs master classes in silkscreen. Its approach to the community is that of cultural participation infused with religious undertones; it has skirted the more "troublesome" and controversial politics of the Chicano movement and Chicano art addressed to these issues.

Individual Artists

California is the only state in which a high quality, professional Chicano poster movement has flourished simultaneously with a grassroots art movement. In other areas where there were strong enclaves of Chicano artists, either muralism became the primary popular medium (as in Chicago and Denver) or Chicano artists turned to nonpublic art forms (easel paintings, graphics, photography, etc.). Although community classes in silkscreen were taught sporadically in those areas, and although individual artists produced posters for political and cultural events, neither a cohesive movement nor the poster collective developed.

Because of the nature of the Chicano political and public art movements the distinction between poster collectives and the individual artist is blurred. The stress on individualism (or on the individual business firm), on competitiveness, personal fame, and personal gain—characteristic of the establishment art world—was not a standard for Chicano artists serving *la causa:* in fact, it was considered antisocial and antimovement in the early years. Nevertheless, certain outstanding poster makers—Rupert García, Malaquías Montoya, and Ralph Maradiaga—emerged from the poster movement in California and their work is now known both throughout the country and internationally.

In Chicago, although the artist-designer José González made several hundred posters for causes and cultural events he organized (he has been one of the key figures in establishing and administering Chicano and Latino arts organizations in Indiana and Illinois from 1970 on), he does not consider himself a poster artist. By the same token, although the muralists and painters Salvador Vega, Marcos Raya, Aurelio Díaz and the recently arrived Mexican artist Alejandro Romero have all made posters, this is not their main interest. The only Chicano functioning primarily as a graphic artist in Chicago is sixty-year-old Carlos Cortez.

No poster movement exists in central Texas's "golden triangle" (Aus-

tin, Houston, San Antonio); the single outstanding Chicano poster maker in Texas is Amado Maurilio Peña, Jr.

I shall now consider each of these artists individually.

Rupert García

As mentioned above, Rupert García (b. 1941) is one of the artists who came to the silkscreen poster as a result of the 1968 student strike at San Francisco State College. Raised by a family of agricultural and cannery workers, he was encouraged by his family when he showed an aptitude for art. A veteran of the Vietnam War, García came to political maturity in San Francisco. The posters he and the collective made for the strike were eventually sold to obtain bail money for people jailed during the long struggle at the college. Silkscreening became his chosen medium. He enjoyed its visual and tactile qualities: the way it enabled him to achieve bright, bold, and flat shapes of unmodulated color and the way the matte finish of the ink absorbed the light—unlike the reflecting surface of a painting with a glossy finish. "I want the viewer to be able to see my pictures with as little outside interference as possible," he said. Besides, the democratic idea behind making multiples also made sense to him, although he is aware that medium and message do not necessarily merge: "You can use a democratic medium (like television, for example) and deliver a fascist message."[16]

Fig. 19

García's message, and the skill with which he delivers it, has gained him international renown. Working freely from documentary photographs, he favors the single figure or the portrait in close-up. He often uses brilliantly juxtaposed primary or secondary colors and black, combined with a short message in English, Spanish, or both languages. He keeps forms, colors, and lettering to a minimum, unless the poster is to serve as an announcement. Political, labor, and artistic heroes and heroines from the United States, Mexico, and the Third World are his most frequent subjects. García has portrayed Angela Davis, Salvador Allende, and Pablo Neruda, leaders of liberation movements from Africa, Mexico, the Philippines, and Puerto Rico, as well as César Chávez and the Chicano martyr Rubén Salazar. He has made posters about Indochina, Cuba, Native Americans, New York State's Attica prison uprising, and the harassment of Mexicans by the U.S. Immigration and Naturalization Service. His silkscreen of a blinded man about to be executed derives from a photograph taken in Iran under the Shah.

Malaquías Montoya

Montoya was born (1938) in New Mexico to a migrant farm family that settled in northern California when he was ten. He learned silkscreening

Fig. 20

with a commercial printer in San Jose and started to do posters for the Chicano movement before coming to Berkeley in 1968. In 1970, he graduated from the University of California (UCB). "I hardly went to school," he says, "because of the grape strike, the Third World strike, and the reconstitution of classes. All the time I was there [UCB] I used my art work to help in different causes."[17] Before graduating, Montoya began to teach a well-attended graphics class for the Chicano Studies department at UCB. As a teacher, Montoya felt it was his responsibility not only to teach design, but also to raise his students' consciousness about the conditions of their existence. He left Berkeley after four years because of dissatisfaction with what he considered the institutionalization of UCB's Chicano Studies program, and moved to Oakland's School of Arts and Crafts, where he continued his nontraditional teaching methods. Montoya has been an enormous and positive influence in the Bay area both as a teacher and as a productive artist. Many of his original silkscreens have been offset for wider dissemination. These include anti–Vietnam War posters and posters on behalf of community protest actions and demonstrations, black prisoners such as George Jackson, and liberation struggles in Africa and Latin America. He has also made posters for two Chicano television series, the Peoples College of Law in Los Angeles, and health clinics. His early style is hard-edge with closely interlocking forms; later works utilize tusche for more painterly effects.

Ralph Maradiaga

For fifteen years, the Galería de la Raza of San Francisco has been an important cultural force in the Mission District—exhibiting Latin American, Caribbean, Chicano, and raza art; promoting murals; maintaining an archive and a design studio; and functioning as a nucleus for many Bay area artists. For almost all of those fifteen years, Ralph Maradiaga and René Yáñez have been the codirectors of the Galería, and Maradiaga has been the central figure for poster production—primarily announcements for the Galería's activities.

Maradiaga (b. 1934) came to silkscreen printing from a background in graphics and was taught the handcut screen technique by Rupert García. Maradiaga's earliest poster in the silkscreen medium was an announcement for a California-wide Mexican American–Latin American traveling exhibition in 1969 called *Arte de los Barrios*, in which he limited himself to black silhouetted forms on colored paper. By 1970, his handsome poster in three inks on yellow paper—for the second *Arte de los Barrios* exhibition—already demonstrated mastery of the medium.[18] The first breakthrough to the brilliant color that characterizes many of his posters after 1973 was the thirteen-color, split-fountain (color blend) screen for a Peruvian poster exhibition. Thereafter his exhibition posters grew in rich-

ness and complexity, especially those for Latin American folk arts, which themselves vibrate with luminous colors and strong geometric designs.

Carlos Cortez

Self-taught artist Carlos Cortez was born in Milwaukee (1923) and presently resides in Chicago, where he is active with the group Movimiento Artístico Chicano (MARCH). He describes himself as the son of a "Mexican Indian" who was an organizer for the International Workers of the World (IWW, or "Wobblies") in the first decade of the century. Cortez himself has been a "harvest hand, construction worker, loafer, jailbird . . . vagabond, factory stiff."[19] He joined the IWW after World War II and has submitted articles, short stories, poetry, book reviews, photographs, comic strips, and linoleum-cut illustrations to its newspaper. His Mexican heritage and his dedication to the IWW—one of the first labor organizations to organize Mexican workers in the Southwest and one that stressed the importance of songs and art in organizing—have come together in posters of Joe Hill, the song writer and organizer for the IWW who has been immortalized in a song, and Ricardo Flores Magón, one of the early leaders of the Mexican Revolution. Another poster executed for MARCH is a portrait of the nineteenth-century Mexican engraver José Guadalupe Posada embraced by one of the *calaveras* (animated skeletons) for which he was famous. Posada's *calaveras* have influenced generations of Mexican artists from Diego Rivera and José Clemente Orozco to the present and have been accepted with enthusiasm by Chicano artists.

See fig. 47

Amado Maurilio Peña, Jr.

Peña was born in the small border town of Laredo (1943) and educated at Texas A&I University in Kingsville, Texas, which, in the late 1960s, became a center for Chicano artists trying to have an impact on entrenched Texas prejudice. Recruited to teach art in Crystal City by the city's newly emergent and potent Chicano political movement, he found himself in the midst of spinach workers' strikes and the early movements of the Raza Unida Party. His most trenchant and political posters were produced from this time to 1975, during which period he moved to Austin to live and teach. With rare exceptions, Peña's posters treat themes of Mexico and the Southwest borderlands. In many of his works, Ché Guevara appears as a symbol of revolutionary spirit and idealism. Peña's posters of Benito Juárez, Emiliano Zapata, and Pancho Villa are tributes to reform and revolutionary Mexico. The proud traditional Mexican song "De Colores," which has had much currency in farmworkers' culture, was the subject of a series of lyrical, beautifully crafted posters with semiabstract designs in flowing color. Peña has also depicted the farmworkers them-

selves as newly arrived migrants who constantly cross the border, or as laborers in the fields. Another subject he has treated is the urban Chicano, both the *bato loco* (street guy) and the self-defense paramilitary group of the early 1970s known as the Brown Berets. Some of his most effective works are those that combine satiric or tragic images with salty, colloquial Spanish or English, such as his ironic "Wanted" poster for the hated Texas Ranger or his *huelga* (strike) poster of a bleeding head of lettuce that warns the viewer not to buy "unless it is union lettuce" and sardonically teaches the meaning and pronunciation of the Spanish word *lechuga* (lettuce).

Fig. 21

Changing Directions

By 1975, or even earlier, the Chicano political movement was changing course, and rifts opened in the early alliance among students, urban workers, and farmworkers. The fraternal, unified community of the early period began to fragment as more Chicanos entered the middle class, attained professional or business status, and established a stake in the status quo. Simultaneously, a schism opened between artists who chose to continue serving the still largely working-class Mexican population and those who were beginning to enter the mainstream art world of elitist museums, private galleries, and collectors. In 1980, Malaquías Montoya sounded an admonishing note about the cooptation of Chicano art and the transformation of its focus from "liberation" to "validation."[20]

Obviously, the posters and murals of artists who continue to make political protest and activism the subjects of their work are not very marketable. Poster collectives and galleries are still active on behalf of the community, but diminishing public and private funding has necessitated some changes in the way they operate. La Raza Graphic Center, for example, has established a commercial printing service. It has not diminished its dedication to community activism, but it now does less silkscreening and more offset for that purpose.

Among individual artists, Rupert García has changed from hand silkscreen to offset posters, which he creates for special campaigns. His main interest at present, however, is monumental pastel portraits and figures, executed in the same style and treating the same militant themes that have always engaged his interest. Amado Peña is now producing handsomely handscreened prints—without lettering—of decorative and stylized images of the Indians of Santa Fe. They are highly successful in the western "cowboy and Indians" art market.

Changing trends, especially for the younger generation, are perhaps best illustrated by the career of Richard Duardo (b. 1952) in Los Angeles. A skillful silkscreen designer and technician, he moved in and out of the collective groups: Méchicano, Self-Help, and, finally, the Centro de Arte

Público, established in the late 1970s by Duardo, Carlos Almaraz, John Valadez, Guillermo Bejarano, and Leo Limón. This last group tried to fuse Chicano consciousness with a commercial design and silkscreen printing business, but the mix proved to be uneasy. Duardo eventually established his own business under the name of "Aztlán Multiples," with the intention of providing interior decorators with fine posters that, for the first time, would include those of Chicano artists. He found market pressures to be such, however, that most of his time was spent printing other people's designs. Duardo has done some posters in recent years on Chicano themes; he is immersed as well in the punk/New Wave scene of Los Angeles, and many of his jazzy posters reflect this interest. The ideal of a poster presence in the commercial market for Chicano artists with a specifically Chicano voice is a rapidly vanishing one.

The future of the Chicano poster is difficult to predict.[21] In the past, public poster movements reached their zenith during times of political crisis and protest. They have been tied to specific types of consciousness, animated by sharp social criticism and a soaring idealism. When such moments passed, the movement either changed its course, or declined.

The future of the Chicano poster will depend on the individual consciousness of each artist. It does seem clear, however, that Chicano artists with a political orientation and a dedication to public art will increasingly express their support and solidarity for liberation movements throughout the world and will view the problems of Mexicans in the United States as part of this global upheaval.

Notes

1. Luis Valdez and Stan Steiner (eds.), *Aztlan: An Anthology of Mexican American Literature* (New York: Vintage Books, 1972), 402–6.

2. Linda Lucero, letter to the author, November 22, 1983.

3. I am grateful to Bruce Kaiper for supplying this summary history of the poster movements of the Bay area. The still extant Graphics Art Workshop, of which Frank Rowe was a member, was most active between 1950 and 1965. In 1972, Kaiper organized the Working Peoples' Artists collective to do posters on labor themes. Jane Nordling and Miranda Bergman produced posters for it between 1972 and 1976. In the mid-seventies, Rachael Romero (who is not Latina) and Leon Klayman started the Wilfred Owens Brigade (now known as the San Francisco Poster Brigade). And in the 1980s, Native American artists began making posters pertinent to their movement.

4. The graphics of the Mexican student movement of 1968 were published as: Grupo Mira (ed.), *La gráfica del 68—Homenaje al movimiento estudiantil* (Mexico City: Grupo Mira, 1982.)

5. Rupert García, taped interview, March 1978.

6. Dugald Stermer, *The Art of Revolution: Castro's Cuba, 1959–1970*, with an introductory essay by Susan Sontag (New York: McGraw-Hill Book Company), 1970.

7. Rupert García, taped interview, March 1978.

8. Printed informational sheet issued by La Raza Graphic Center, n.d. A similar statement appeared in *La Raza en acción local: Entering the Second Decade—1970–1982* (San Francisco: La Raza Graphic Center, Inc., n.d. [1982]), 12–17.

9. Catalogue, La Raza Silkscreen Center, *"Images of a Community": An Exhibit of Silkscreen Posters and Graphic Works from 1971 to 1979*, introduction by Rupert García, statement by La Raza Silkscreen Center, San Francisco: Galería de la Raza, May 19 to June 23, 1979.

10. *La Raza en acción local* (cited in n. 8), 12–17.

11. Yáñez left the Galería de la Raza in 1987.

12. Charles Hillinger, "The Royal Chicano Air Force: Activists in Sacramento Use Humor to Instill Pride." *Los Angeles Times*, July 22, 1979, I-3.

13. Excerpted from Luzmaría Espinoza and Lonnie Miramontes, "Muralism: A Decade of RCAF Chicano Art," unpublished manuscript, n.d. [1981].

14. Undated flyer [c. 1971] issued by Méchicano Art Center, Los Angeles.

15. National Endowment for the Humanities Youth Projects Application, August 8, 1978.

16. "Rupert García," *Toward Revolutionary Art* 2, no. 2 (1975): 20. See the magazine cover and pages 20–27 for reproductions (some in color) of major García posters from 1972 to 1975. Other García posters in reproduction, as well as posters by Linda Lucero, Ralph Maradiaga, and La Raza Silkscreen Center can be found in: *Images of an Era: The American Poster, 1945–75* (Washington, D.C.: National Collection of Fine Arts, Smithsonian Institution, 1975), 168, 169, 142, 238, and 172, respectively.

See also *The Art of Rupert García: A Survey Exhibition*, text by Ramón Favela (San Francisco: Chronicle Books, 1986); and *Rupert García: Prints and Posters/ Grabados y afiches, 1967–1990*, texts by Robert Flynn Johnson and Lucy Lippard (San Francisco: Fine Arts Museums, 1991).

17. "Malaquías Montoya," *Arte* (Fall 1977), n.p.

18. This poster is reproduced in *Images of an Era* (cited n. 16), 142. Ralph Maradiaga passed away in 1985.

19. Carlos Cortez, taped interview, May 1982.

20. Malaquías Montoya and Lezlie Salkowitz-Montoya, "A Critical Perspective on the State of Chicano Art," *Metamorfosis* 3, no. 1 (Spring/Summer 1980): 3–7.

21. In 1993, it is safe to say that the Chicano poster movement is essentially over, though silkscreen posters continue to be produced around certain topics (the Columbus Quincentenary was one such occasion, and the silkscreen portfolio that was printed was multicultural in character). Of the thousands of posters produced during the heydey of the movement, many remain in academic, institutional, and private collections.

WOMEN SPEAKING

8

SIX WOMEN ARTISTS OF MEXICO

Elizabeth Catlett, Fanny Rabel, Mariana Yampolsky, Susana Campos, Pilar Castañeda, and Lourdes Grobet, although not all natives of Mexico, have produced their most significant work there. They span two generations and work in a variety of media and styles. Rabel, Campos, and Castañeda are painters; Catlett is a sculptor; and all four are printmakers. Yampolsky is a printmaker, photographer, and book illustrator, while Grobet is a painter turned photographer. Rabel, Catlett, and Yampolsky immigrated to Mexico (Rabel from Poland, Catlett and Yampolsky from the United States) and became active in the 1940s. Campos and Castañeda started to exhibit in the 1960s; Grobet in 1970. The three younger women, all native Mexicans, have lived and studied abroad.

To present the work of these six contemporary Mexican artists in its social and historical context, I first explore the role of art in twentieth-century Mexico, and then examine both the opportunities and restrictions faced by professional women artists.

International Women's Year

As a result of the First World Conference for International Women's Year sponsored by the United Nations and held in Mexico City, there was intensive activity centered on women's issues in Mexico during 1975. Public and private art institutions mounted a number of important exhibitions of the painting, sculpture, photography, and graphics of Mexican

This essay first appeared in *Woman's Art Journal* 3, no. 2 (Fall 1982/Winter 1983): 1–9.

women artists, among them "La mujer en la plástica" (The Woman in Art) at the Palacio de Bellas Artes; "La mujer como creadora y tema del arte" (Woman as Creator and Theme of Art) at the Museo de Arte Moderno; and "Pintoras y escultoras en México" (Painters and Sculptors in Mexico) at the Polyforum Cultural Siqueiros. Painter Fanny Rabel had a one-person exhibition at the Palacio de Bellas Artes, and the Museo de Arte Moderno held a vast exhibition of paintings by women from fifty countries and five continents to close the celebrations.

"La mujer como creadora y tema del arte" opened at the Museo in June 1975, and included works by pioneer women artists María Izquierdo and Frida Kahlo; surrealist painters Remedios Varo,[1] Leonora Carrington, and Alice Rahon; abstractionists Lilia Carrillo and Cordelia Urueta; realist Olga Costa; and sculptors Helen Escobedo, Angela Gurria, Geles Cabrera, Marysole Wörner Baz, and María Lagunes. Along with these thirteen women, considered "creators of art," were thirty-six men who took women as their "theme of art."

In August, a more extensive showing of women artists opened at the Polyforum Cultural Siqueiros, a privately owned gallery that is part of the Hotel de México complex and houses David Alfaro Siqueiros's last mural, The March of Humanity on Earth and toward the Cosmos. Among the forty-six artists shown were eight—Carrillo, Costa, Escobedo, Izquierdo, Lagunes, Urueta, Wörner Baz, and Cabrera—whose works also appeared at the Museo de Arte Moderno, as well as Susana Campos, María Elena Delgado, Pilar Castañeda, Sofía Bassi, Olga Dondé, Elvira Gascón, Angelina Beloff, Celia Calderón, Fanny Rabel, Maka Strauss, Rina Lazo, Tosia Rubenstein, Elizabeth Catlett, Beatriz Zamora, Charlotte Yazbek, and others, representing several generations of women and a great variety of styles.

At the Palacio de Bellas Artes exhibit (July-August 1975), fifty women artists were shown. Without counting overlaps, a total of eighty-three women artists residing in Mexico City or environs was represented in the three exhibitions, including most of the best-known women artists of the modern period. Many of these women previously had had one-person showings, were regularly included in prestigious group exhibitions, were represented by important galleries, and were members of the government-sponsored artists' gallery, the Salón de la Plástica Mexicana. In addition, their works were in the permanent collections of the Instituto Nacional de Bellas Artes and on display in the subsidiaries of the Secretaría de Educación Pública, which includes all the national museums, galleries, and art schools. In the highly centralized Mexican educational/cultural structure, women artists were not peripheral to the activities of the art world but were integrated into it on all levels. Nevertheless, despite their advantageous position, many discrepancies existed.

Women Artists: Some Contradictions

Several apparently contradictory facts come to light when one examines the role of women in modern Mexican art. The first is that women born in the twentieth century, despite their prominence today, did not participate in the professional art world until the 1930s.[2] María Izquierdo (1902–55), the "magic realist," was one of the earliest.[3] Her first solo exhibition took place in 1929 at the Galería de Arte Moderno, run by painters Carlos Mérida and Carlos Orozco Romero, at a time when no private galleries existed in Mexico. Another was Frida Kahlo (1907–54), wife of Diego Rivera, who has become a legend in Mexico for her fantastic and surreal easel paintings.[4] Nevertheless, Kahlo did not have a major exhibition of her work in Mexico until 1953 (Galería de Arte Contemporáneo), or a major retrospective until the Exposición Nacional de Homenaje at the Palacio de Bellas Artes in 1977. Her legend has grown from the admiration of persons visiting the Frida Kahlo Museum in Coyoacán (established by Rivera after her death in the home where she was born and died), and from the remembrances and commemorations of her students.

But in spite of the early emergence of Izquierdo and Kahlo, women did not enter the Mexican art world in numbers until the post–World War II period when Mexico itself was becoming a rapidly industrializing capitalist nation and had begun to develop a middle class, a large tourist trade, and a private art market for easel paintings, graphics, and sculpture. Since then women have been present not only as creative artists but as directors of prestigious art institutions, private galleries, and art magazines, as university professors in art history, and as top-level critics.[5]

Women in the Mural Movement

Women have been minimally present in the single most important and influential Mexican art form of the twentieth century—the mural movement. Indeed, from its inception in 1921, muralism was a male-dominated field of activity. According to the most complete figures available, 289 artists worked on murals between the years 1905 and 1969.[6] Production peaked in 1964 under the patronage of President Adolfo López Mateos, although by then the movement was long past its prime. Of the total number of muralists, only thirty-two (or approximately 11 percent) were women, and they produced few murals. In 1933 the Mexican government commissioned the New York–born sisters Grace and Marion Greenwood to paint murals; they later created murals for the Public Works of Art Project during the Roosevelt administration. In 1936, Aurora Reyes became the first Mexican-born woman to paint a mural, and in 1943 Frida Kahlo and Fanny Rabel joined their ranks.

Rabel was a member of a team organized by Kahlo as part of a study program for painting students; it was one of the few murals that Kahlo's fragile health permitted her to supervise. Rabel, however, went on to paint five other murals in Mexico City, including a large work, *Survival of a People* (1957), in the Centro Deportivo Israelita and a 20 × 2.5 meter mural for the Museo de Antropología (1964). Other women commissioned to paint murals included Angelina Beloff (1945), Rina Lazo (1949), Olga Costa and Esther Luz Guzmán (1952), María Elena Delgado (1954), Elvira Gascón (1956), Sara Jiménez (1957), Mariana Yampolsky (1960), Angela Gurria (1967), and Helen Escobedo (1968). While over twelve hundred murals were produced from 1905 to 1969, a spot check suggests less than 10 percent were painted by the thirty-two women.

It thus appears that women have been far more active in the areas of easel painting, printmaking, photography, and sculpture than in the dominant art form, muralism. Since muralism exercised hegemony over all other forms until well into the 1950s, we must conclude that women's relatively large presence in the Mexican art world (where acceptance and recognition have been more available to them than to their counterparts in other areas of the world) did not come about until the 1960s and 1970s, though many women artists were practicing much earlier. Their numbers today constitute about 25 percent of the total of art professionals;[7] nevertheless, this 25 percent is central to the national art scene.

Collectives and Artists' Groups

Collectives and artists' groups have proliferated in Mexico for a variety of reasons, and by chance all the six women discussed here have been part of such associations.

The mural movement, which set the artistic and ideological tone for the avant-garde and for socially conscious artists on the American continent during the first half of the twentieth century, was dedicated in principle to public art for the masses and to collective working arrangements. The structures set up to carry out these concepts considered the artist a "cultural worker" rather than an individual "genius," and were developed not only in Mexico, but imported into the United States with the New Deal art programs during the Depression. Numerous artists from the United States visited Mexico, and several, including Catlett, Yampolsky, and Pablo (Paul) O'Higgins, remained there permanently, participating in a series of politically oriented artists' organizations over the years.

Concomitantly, artists' groups based on social cohesion and common aesthetic interests also proliferated. With the decline of public art and the privatization and commodification of art after World War II, the number of groups geared toward exhibition and market exposure increased, the

largest being the Salón de la Plástica Mexicana, founded in 1951. Funded by the government and managed by its members, it maintains a gallery (until recently, with commission-free sales), holds large annual exhibitions, and helps formulate government arts policies. Smaller groups are often composed of little-known younger artists, such as Susana Campos, who find it easier to have an impact on the art market as part of a group than as individuals. Neither the Salón nor the smaller groups are ideological collectives.

As a result of radical political activities during the 1960s and early 1970s, art collectives similar to those formed in the United States by blacks, Chicanos, and women emerged again in Mexico. The group of young artists to which Lourdes Grobet belongs—Grupo Proceso Pentágono (an ironic reference to the U.S. Defense Department building)—typifies the newer organizations, most of which are dedicated to critical and public art.

Women Artists and Machismo

The six women artists interviewed for this article (during July 1978) agree that the cult of *machismo* exists on a personal but not on a professional level. Young women from the middle class, or from upwardly mobile families who have opted for artistic careers, have had to confront the *machismo* of fathers or husbands opposed to their aspirations. As one young artist pointed out, her family was against art school not because she chose art, but because the life of an artist was considered bohemian—not respectable for a woman. Once these women entered professional life, the path was smoother. The availability of domestic help and the continued support of the extended family in Mexico allows women with children and households a good deal of mobility and free time for work. However, it is still clear that if open hostility and disapproval have been silenced to some degree for professional women, covert chauvinism and patronizing attitudes have not. Alaída Foppa, commenting on the comparative role of women and men in the arts on the occasion of a 1977 women's exhibition run simultaneously with the First Mexican-Central American Research Symposium on Women, states that an exhibition of this type previously would have elicited a sentiment something like "for women, they're not doing too badly." Now the idea of organizing exhibits of women's art is not relevant, she claims, because women have equivalent representation.[8]

The earlier, condescending attitudes of male artists and the general public, in addition to the changing situation, are also reflected in painter Fanny Rabel's comment: "In earlier periods, we had no problems because there were few women artists and they were petted and treated with sympathy. Now, however, there are more and, with competition, it is more difficult."[9]

The Artists

Elizabeth Catlett

The title of an article, "My Art Speaks for Both My Peoples,"[10] expresses best the essence of the art and life of Elizabeth Catlett Mora, a black sculptor and printmaker who has made Mexico her home for over thirty years. Born in Washington, D.C., in 1919, she studied at Howard University, the University of Iowa, the Art Institute of Chicago, the Art Students League (New York), and the painting and sculpture school "La Esmeralda" in Mexico City. Her father, who died before she was born, taught mathematics at Tuskegee Institute, then at a high school in Washington, D.C. Her widowed mother supported the family as a truant officer.

Catlett taught at a number of schools in the United States before coming to Mexico on a Rosenwald Fellowship in 1946. She quickly became a member of the Taller de Gráfica Popular. (In 1949, Catlett and Mariana Yampolsky were the only two women members.[11]) The Taller represented the realization of Catlett's idea that art could be directed to the people—an idea that crystalized after she finished her studies in the United States and taught, without salary, at the community-oriented George Washington Carver School, whose students were predominantly black chauffeurs, maids, and other working-class people "hungry for culture."

Catlett never lost her interest in and desire to portray the history and contemporary life of black people, nor did she lose her link with the black community of the United States. At the same time, she deeply identified with the artistic movements and people of her adopted country—where she married painter Francisco Mora, also a member of the Taller, and raised three sons. When her children were small she concentrated on printmaking, which was easier to do at home, but soon returned to her major love: sculpture. Her prints of the late 1940s included themes such as Sojourner Truth and the nobility of black womanhood, as well as black organizers, black sharecroppers, and lynchings of blacks, all executed in a realistic style akin to the work being done in the Taller. Over the years, her graphic style simplified and became more experimental. In a 1969 woodcut, *Malcolm X Speaks for Us*, the head of Malcolm X is counterpointed with the heads of black children in brown, blue, sanguine, and green, repeated in horizontal bands. *Watts/Detroit/Washington/Harlem/Newark* (1970) was her response to the wave of "riots" in black communities across the nation. On the flat surface of the print, irregular womblike shapes contain bodies of slain men, while at the right a black man hides in a doorway. Two blue-shirted police officers point their rifles at the community and at the expressionistically rendered abstract buildings set against a flaming red background.

Women have formed a central thematic core of Catlett's sculpture. Proud, dignified, thoughtful, protective of their children, strong, active, triumphant, sensual, assertive, they emerge in compact stone, terra-cotta, bronze, or beautifully polished wood. While most of her subjects are black, the essence of Mexican art is formally integrated into her work. Her prizewinning sculpture *Mujer* (Xipe-Totec Prize, 1964) is a large, splendid standing figure of a woman, legs apart, arms behind her head, gazing joyously upward. Several abstract folds of drapery wrap across her body, adding dynamism to the solid figure which ascends in a spiral-like motion. In 1973, Catlett completed a bronze, life-size bust of eighteenth-century black poet Phyllis Wheatley for Jackson State College in Missis- Fig. 22
sippi. Wheatley, according to historical accounts, claims Catlett, was an introverted woman—a "little tight black woman." She used such a woman as a model for the bust but more importantly—with a method that gives insight into the empathetic feeling she imparts to her sculptures—she rehearsed the pose with her own body. Wheatley is lean, small, intense, closed within the framework of her arms, resting one hand on her face in thought.

Catlett's style was influenced by Ossip Zadkine, with whom she studied in New York for six months in 1942, and by Francisco Zúñiga in Mexico. From Zadkine, an expressionistic cubist who worked with solid, closed forms and interchanging solids and voids, she retained a strong sense of planar surfaces that form the architecture of her figures. From Zúñiga she learned pre-Columbian methods of clay sculpture: the coil, slab, and pastillage (additive modeling of a clay surface) techniques which give the hollow feeling of a pot. From this source comes also the monumentality and the organic, rounded forms. Other influences are also evident: that of Henry Moore, who in turn drew upon pre-Columbian sculpture for his reclining figures; and more recently a strong infusion from African masks—a formal response to the civil rights struggles and the growing Pan-Africanism that emerged in the 1960s. Nevertheless, Catlett has achieved a distinct style and expression that reflects her own personality. She radiates a great sense of calm and inner security, speaks slowly and deliberately with a wry sense of humor, and is a tireless, often irreverent storyteller. Her concern for humanity is as strong as ever, expressing itself in personal, political, and artistic ways.

Fanny Rabel

"Fanny Rabel, shaped by Mexican realism, and leagued with the Taller de Gráfica Popular—that is, to those who have aggressively waved the flag of socialist realism—has managed to escape almost completely the overly dogmatic expressions of the school and cross over into a lyrical vein that nourishes her painting." So wrote Alaída Foppa in the newspaper *Excél-*

sior in 1968.[12] This expression of the artist's search for new forms and levels of meaning while maintaining her social commitment sums up the thirty-year career of painter and printmaker Fanny Rabel.

Rabel was born in Poland in 1924, into a family of Yiddish theater actors. Her father was a singer, actor, and theater director, her mother and grandmother were both actors. The family traveled a great deal, lived in Paris for a time (where Fanny went to school), and in 1938 immigrated to Mexico, where her sister Malkah is a well-known theater critic. Fanny studied muralism with Siqueiros in 1939–40, was a student of Frida Kahlo in "La Esmeralda," and assisted Diego Rivera on his frescoes in the National Palace. For twelve years (1950–62) she studied and worked with the Taller de Gráfica Popular and was also a founding member of the Salón de la Plástica Mexicana.

The word "tenderness" emerges in all the articles, catalogues, and books written about Rabel. Tenderness is indeed the touchstone of her art and the feeling most poignantly expressed in her paintings, prints, and drawings of children. Small and gaminlike herself, and surrounded in her home by numerous precious objects, she apparently has never felt like the proverbial giant among children. She paints them with a sweetness (which occasionally borders on the pretty) that tempers even those portrayals of children in distress like *The Jewish Child* (1948) or the children in several paintings dealing with immigrants. Without losing her sense of European Jewishness, which heightened and personalized her response to World War II, she also entered into and absorbed the unique qualities of Mexican life and art. Her palette, warm with yellows and browns, vibrant with sharp pinks, violets, purples, rich greens and blues, is Mexican, and reflects the influence of folk and popular art and the Indian presence. There are images of skulls, masks, magic, and mystery, and portraits of the dead (a common theme in Mexican painting). There is also the violence, sensuality, and chiaroscuro of Mexican life.

In the early 1960s a sense of existential solitude appeared in her work—a kind of *interiorismo* that expressed postwar and post–atomic bomb anguish. Also known as "neofiguration," or "neohumanism," this desolating quality had entered the work of artists in many parts of the world—artists who had rejected social realism and total abstraction and opted for a "new image of man": fragmented, lonely, lost, marked and pitted with the signs of internal pain. In Mexico, *interiorismo* was represented by the all-male Nueva Presencia (New Image) of the early 1960s, and while Rabel was never part of the group, she was close to its members. It was about this time that her forms began to change. Her paintings and prints became darker and more textural; figures were buried in shadow, crowded into corners, hemmed in by bars, brambles or nets, or swathed in gauze. Titles such as *The Cornered Ones, The Caught Ones,*

Fear, and *The Voiceless Scream* began to appear on her works in the 1960s.

Rabel neither lost herself in this world of despair nor did she leave behind its oneiric quality. Out of it emerged a less frightening tremulous imagery that is almost Proustian in feeling. The bars, rocks, and gauzes hollow out to form a geological womb-cave in which figures glowing with jewel-like colors float in dark space. Rabel still paints children; on occasion there are also ironic portraits of *Señoras*—shriveled juiceless women with their mouths puckered in scorn; or the squat robotlike features of a military man. In the mid and late 1970s there are satiric drawings such as *Social Whirl* (1972), or the triptych *Mexico, D.F.* (1978), in which the city's overcrowded population is tumbled about in streams of automobiles and pollution.

Fig. 23

Mariana Yampolsky

From the beginning of her residence in Mexico (1945), Mariana Yampolsky has been dedicated to printmaking and photography—both of which she considers graphic arts since both produce a print from an original source (a negative, a copper plate, a stone, a wood or linoleum block). The essence of graphic art is its reproducibility: the fact that multiples can be printed from the original design or negative, that they can be widely disseminated, and that (apart from artificial market conditions) they can be reproduced inexpensively. These are important attributes for an artist dedicated to the concept of public art, as is Yampolsky. "I can't conceive of art without a social context," she says. "It's not just what you as an individual want to express; it must be understandable by others."

It was this attitude that brought Yampolsky to the Taller de Gráfica Popular. Born in 1925, she lived on her grandfather's farm in Illinois until finishing high school. Her father was a prizewinning sculptor and painter whose poor Russian Jewish family had immigrated to the United States. He married the daughter of an upper-class Jewish family during a trip to Germany and brought her back to the farm, where she carried out the duties of a "farmer's wife" while her husband worked in his studio. This multilingual, cosmopolitan, progressive family did not fit well into the conservative rural community, and Yampolsky, an only child, escaped to Chicago at an early age. After receiving her B.A. from the University of Chicago, she settled in Mexico City, where, as a member of the Taller working at the side of Leopoldo Méndez, Alfredo Zalce, and Alberto Beltrán, she participated between 1945 and 1958 in a number of collective exhibitions in Mexico, the United States, Germany, Japan, Italy, Yugoslavia, France, Africa, and Asia. Yampolsky says that her "years in the Taller

were formative ones." There she "acquired discipline through collective work and through criticism—through give and take."

In 1947, the Taller collectively produced a portfolio called *Estampas de la revolución mexicana* (*Prints of the Mexican Revolution*). Yampolsky's contribution, the linoleum cut *Emiliano Zapata's Youth: Objective Lesson*, shows the young Zapata observing the toil of his people on their confiscated land. Legend has it that Zapata vowed someday to retake these lands. *Bivouac of Revolutionaries* celebrates the resurgence of the revolutionary *cancion,* sung whenever soldiers rested between battles. Yamapolsky includes not only the women who followed the troops to cook and wash for them, but the *soldaderas* who fought alongside the men.

Yampolsky also studied photography with Lola Alvarez Bravo at the San Carlos Academy, and used her camera to document the activities of the Taller. Thus from the start, the two media—graphics and photography—have been the twin tools with which she expressed her social convictions and recorded the world about her. *Osario* is a particularly effective photograph of a quintessential element in Mexican village life: the cracked adobe building which houses the remains of the dead. It is one of a number of photographs taken during the three years Yampolsky traveled in villages and backwoods for the editorial house Fondo de la Plástica Mexicana, where she worked with Leopoldo Méndez until his death in 1969. Under their joint editorship, high-quality books on the mural painting of the Mexican Revolution, printmaker Posada, European painting in Mexico, and popular art were published. She then worked for six years as graphic arts editor for primary school textbooks which were distinguished by an abundant use of artworks—full pages of paintings, graphics, sculpture, and photography—in books on mathematics, literature, and the natural and social sciences. Five hundred and fifty million books illustrated by Picasso, Vasarely, O'Higgins, Costa, Rivera, Tamayo, Orozco, Zalce, Beltrán, and others were produced in five years. Yampolsky, whose didacticism and sense of social responsibility remain unabated, takes great pride in this accomplishment.

Two points of view about printmaking exist in Mexico today; they reflect generational and ideological differences. For Yampolsky, an artist allied with the Taller and its commitment to social/political art, contemporary printmaking has become too exquisite and elitist. She therefore has turned to photography as the most pertinent and useful contemporary print medium. For young artists such as Susana Campos and Pilar Castañeda, who entered the domain of art in the 1960s when it was convulsed by the confrontation between the mural movement and the Taller and the new tendencies of formalist abstraction imported from Europe and

Fig. 24

the United States, the choices were not so simple. Both Campos and Castañeda studied at the San Carlos Academy, where their most influential teachers were the Spanish-born painters Antonio Rodríguez Luna and Francisco Moreno Capdevila. Luna and Capdevila themselves had come from a social realist matrix, and both had begun to explore abstraction.

Susana Campos

Campos, who was born in 1942 into a middle-class family, opted for abstraction, a direction that was reinforced by a year of study in Paris (1968–69) with a scholarship from the French government. There she attended classes at English printmaker Stanley W. Hayter's Atelier 17.

In the mid-1960s, she and her husband, Carlos Olachea, were among the founders of Nuevos Grabadores, a group of ten abstract printmakers who sought new forms of subjective expression through renovative and experimental techniques. Instead of the linoleum, woodcut, and lithograph techniques of the Taller, which permit pulls of thousands of prints for mass dissemination, the younger artists preferred limited editions of intaglio (etching, aquatint, engraving, drypoint, or combinations thereof) because of the richer and more complex formal possibilities these techniques offered. Etching was considered an unsuitable medium by the Taller artists, as they were not concerned with formal subtlety, or with the requisites of collectors. However, conditions in Mexico had changed and public art was on the wane. Artists in great profusion turned to intaglio and looked to Europe and the United States for the most advanced printmaking techniques.

From 1968 to 1975, Campos was seeking her own formal language, concentrating on etching and engraving. Her style was characterized by the movement and rhythms of undulating and swirling forms. The color aquatint *Micromacroforms* (1968) is composed of enclosed organic shapes produced by separate impressions from cutout zinc plates printed to form a single composition. Campos and Olachea had married in 1966 and these subconsciously produced womb- and fetus-like images reflected Campos's awareness of the maternal function, which continued to be an important theme during her childbearing years.

After 1975, she turned to painting and her expression became more open and undulating. Titles such as *Obsessive Rhythms* (1975) and *Sustained Movement* (1976) describe these free-swinging linear canvases. The artist reveals the emotion and method with which she creates her paintings:

> To give free play to my hand; to allow the lines to flow in curves and rhythms as an expression of a lyrical and vital feeling, as testimony

of a way of being; to display an open delineation of curves and colors; to give priority to feeling without departing from a rational method of composition; to leave behind cold geometricism.[13]

Only recently has Campos begun to achieve her own language and expand her personal expression. Divorced from Olachea, she feels free finally of his influence. Her latest paintings, though still fluid and abstract, have become more compact and suggest human and natural forms: profiles, bodies, geological strata, and bones, in a rich chromaticism of earth colors, blues, and violets.

Pilar Castañeda

Born in Mexico City in 1941, Pilar Castañeda, the granddaughter of artist Santiago Sabas Sánchez, studied painting, printmaking, and drawing with Luna and Capdevila and sculpture with Catlett. Before traveling in Europe (1966–67), she taught third-year painting students at the Universidad Iberoamericana for two years. Since 1969 she has been on the faculty of the Centro Activo de Arte Infantil.

"In spite of the imperative wave of abstract art that prevails," wrote Castañeda in the early 1970s, "I have not left my figurative form of expression. Contact with surrounding reality is of vital importance to me. The human being as a witness, actor, or victim of everything that happens."[14] Thus does Castañeda express the strong pressure on her generation to abandon representation. Despite an abstract relief mural created in 1971 in the Centro Residencial Morelos, Castañeda feels she must have objects before her eyes in order to paint: "I need a plate of lemons in order to create lemons, or I am lost for a point of contact."

Indeed, lemons, fruit of all kinds, flowers, and still life constitute an important part of her *oeuvre*, but they are not the realistically rendered objects that the foregoing statement describes. Castañeda combines a strong sense of geometric structure (derived from her teacher Rodríguez Luna) with a rich and inventive play of textures and surfaces that sometimes derives from, and often actually is, collage or assemblage. For the latter she uses thin pieces of wood, burlap, gold or silver paper, bits of zinc, tin, crystal, mirrors, colored papers, and rags. Three-dimensional works, whether freestanding or relief, are often made of ceramic, enamel, copper, wood with nails, resin, and fiberglass.

With these materials, Castañeda creates a world of totemic and masklike human and animal figures, frontal and static, that seem to have magical properties. There are references to pre-Hispanic, African, and Polynesian sources, and on occasion to Mexican popular arts such as toys, paper cutouts, and clay animals. Though style and content differ from Catlett's, there is little doubt that some of Castañeda's interest in African

traditional art was inspired by its incorporation into Catlett's recent prints and sculptures.

On the occasion of Castañeda's major exhibition at the Palacio de Bellas Artes in 1974, Raquel Tibol commented that her work awakens hopes that she will flower as an artist of strong temperament about to definitively cross narrow academic boundaries and give her textures their own symbolic, evocative, and oneiric meanings.[15]

Lourdes Grobet

Born in 1940 in Mexico City to a Swiss father and a Mexican mother, Lourdes Grobet is a photographer who can best be designated (insofar as "pigeonholes" are helpful) as a conceptual/environmental artist. She is concerned primarily with the communication of ideas, and distorts, changes, and stretches the limitations of her medium toward that end. Neither permanence nor the creation of beautiful and precious objects interests her. After returning from two years in Paris (1968–70) and two years of studying in England (1975–77), Grobet has been part of Mexico's experimental avant-garde. These *inquietudes* (as they are called in Mexico) were first prompted by her encounters with avant-garde sculptor Mathias Goeritz, painter/sculptor Manuel Felguérez, and surrealist photographer Kati Horna while Grobet was a painting student at the Universidad Iberoameriana in Mexico City, a small private university which her old-fashioned parents insisted she attend. She also studied for a year with painter Gilberto Aceves Navarro. However, her first contact with Paris—particularly an exhibit of objects and environments at the Musée de l'Art Moderne—turned her irrevocably toward photography; she feels painting is regressive.

Grobet's first exhibit in Mexico took place in 1970 at the Galería Jack Misrachi in conjunction with her friend Silva Gómez Tagle, an anthropologist and artist, and was titled *Serendipiti*. No names appeared on the invitations or catalogue since the artists wanted neither to publicize themselves nor to explain their art. Their idea was to present the work and let it speak for them. The entire display was a multimedia photographic labyrinthian environment with built-in "shock" characteristics to provoke thought. As people entered the gallery, they walked through a larger-than-life image of a male nude, split down the middle to allow passage. They then encountered a box in which a man's shape had been cut out, and the silhouette filled with photographs of slaughtered animal guts and layered with mica, the whole of which moved kinetically to induce a feeling of nausea. Spectators then proceeded through a narrow corridor with a false oscillating floor that shook them about, to rooms that subjected them to a number of experiences connected with violence. One room had strips of cloth and parts of dolls hanging from the wall—

Fig. 25

looking like intestines and mutilated bodies—in combination with a huge photomural collage of police/military repression dominated by a banner reading "Abajo la farsa electoral" ("Down with the Election Farce"). Another room had two photomural collages of people behind bars: some were political prisoners, others were free people in their "psychological jail." In still another room, floor, ceiling, and walls were covered with mirrors in which "one could look at oneself with infinite projections" and, apparently, tie the self-image to the ones provided by the artist. By thrusting the spectator through bodies, among mirrors, in confrontation with imprisonment; by surrounding the spectator with aggressive experiences; by projecting slides, music, strobes; by challenging kinetic and visual stability, the artists forced the visitor, through visceral means, to confront the brutalities of the contemporary world.

In 1973 and 1974, Grobet participated with the Grupo Nuevisión in presenting collectively organized environments around the theme of metamorphosis. Her contributions included a series of photographs with synchronized images that juxtaposed soft breasts with sharp thistles, an eye with spiky lashes, and a thorny plant with an opened center like an eye. From the indigenous fantastic and magical art that influenced painters like Frida Kahlo to the infusion of European surrealism brought to Mexico by refugee artists during World War II, metamorphosis has been a widely used theme in Mexican art. Grobet is heir to this tradition, which she applies to photography.

Grobet has also been associated with Grupo Proceso Pentágono. By its very nature, Pentágono was antiestablishment and opposed to the commercialization that has infiltrated the Mexican art market since the 1950s. In 1978 Pentágono became affiliated with a number of other young militant artists' groups seeking a new language for public and socially critical art and formed the Mexican Front. Espousing many concepts that had informed the mural movement and the Taller (service to the working class, public political art, collective art production, the notion of "cultural workers" rather than "fine artists") the Front, in reality, had a different historical/social matrix. It was the offspring of the 1960s New Left, particularly the 1968 government massacre of students at Tlatelolco in Mexico City, and it addressed a sophisticated, literate, urban audience, though its sympathies lay with the erupting rural and working-class protests that marked the 1970s.

Grobet's constant association with group projects and collectives since she began her professional life is not accidental; it is part of her ideology and her perception of the role art should play: "As a language, photography is employed to inform, to deceive, to make propaganda, to amuse, and even to make art. Its importance rests in the manner in which it is used, and its application. . . . My intention since returning to Mexico

(1977) has been to utilize photography in a social sense and make my work a service."[16]

Notes

1. See Janet Kaplan, "Remedios Varo: Voyages and Visions," *Woman's Art Journal* (Fall 1980/Winter 1981): 13–18; and Kaplan, *Unexpected Journeys: The Art and Life of Remedios Varo* (New York: Abbeville Press, 1988).

2. Since this article was originally published, Mexican and U.S. scholarship has augmented our knowledge of women artists active from the eighteenth to the twentieth centuries. See Leonor Cortina, "Artes visuales: Las místicas, las dóciles, las rebeldes," in *La mujer mexicana en el arte* (Mexico City: Bancreser, S.N.C., 1987); and *La mujer en México/Women in Mexico*, catalogue, texts by Linda Nochlin and Edward J. Sullivan (Mexico City: Fundación Cultural Televisa, 1990).

3. See *María Izquierdo*, text by Carlos Monsiváis (Mexico City: Casa de Bolsa Cremi, 1986).

4. See Gloria Orenstein, "Frida Kahlo: Painting for Miracles," *The Feminist Art Journal* (Fall 1973): 7–9; Hayden Herrera, "Frida Kahlo: Her Life, Her Art," *Artforum* (May 1976): 38–44; Hayden Herrera, "Portrait of Frida Kahlo as a Tehuana," *Heresies* (Winter 1977–78): 57–58. Kahlo, through the effort of the women artists' movement and the Chicano movement is achieving legendary status in the U.S. as well.

Since the above list was compiled, the literature on Frida Kahlo in English has proliferated, some of great interest, some spurious or with poor scholarship. The most comprehensive is Hayden Herrera, *Frida: A Biography of Frida Kahlo* (New York: Harper and Row, 1983), which has also appeared in Spanish. See also the translation of Raquel Tibol's 1983 source book, *Frida Kahlo: An Open Life*, trans. by Elinor Randall (Albuquerque: University of New Mexico Press, 1993); and Sarah M. Lowe's revisionary book, *Frida Kahlo* (New York: Universe Publishing, 1991).

5. A few examples from a long list are the appointment in 1964 of Carmen Barreda as director of the Museo de Arte Moderno, newly constructed that year (her appointment was equivalent in importance to that of a director of the New York Museum of Modern Art, a position no woman has held since its founding in 1929); the founding of Galería de Arte Mexicana by her sister in 1934 and its continued existence under the direction of Inés Amor from 1935 until her retirement in 1984 and now under that of Mariana Pérez Amor and Alejandra R. de Iturbe; the position of Carla Stellweg as editor of Mexico's most important art magazine, *Artes Visuales* (now defunct); the presence of professors Ida Rodríguez Prampolini, Rita Eder, and Teresa del Conde in the Instituto de Investigaciones Estéticas of the Universidad Nacional Autónoma de México; and the reputation of critics Raquel Tibol and the late Margarita Nelken.

6. Orlando S. Suárez, *Inventario del muralismo mexicano (Siglo VII a. de C.)*, (México, D.F.: Universidad Nacional Autónoma de México, 1972).

7. Judging by their representation in the Salón de la Plástica Mexicana in 1978,

and by a count of women artists who participated in exhibits held in government and private art spaces in Mexico City for the year 1970. See Justino Fernández (ed.), "Catálogo de las exposiciones de arte en 1970," Suplemento del Num. 40 de los *Anales del Instituto de Investigaciones Estéticas* (México, D.F.: Universidad Nacional Autónoma de México, 1971).

8. "Exposición de obras plásticas con motivo del Primer Simposio Mexicano Centroamericano de Investigación Sobre La Mujer," Museo de Arte Alvar y Carmen T. de Carrillo Gil (Mexico, D.F., 1977). Introduction by Alaída Foppa. (Foppa, an ardent feminist and editor of *Fem*, is numbered among the "disappeared" in her native Guatemala.)

9. All uncited quotes come from interviews with the artists in Mexico City, June 1978.

10. Marc Crawford, *Ebony* (January 1970).

11. Organized in 1937, by Leopoldo Méndez, Luis Arenal, and Pablo O'Higgins (with Siqueiros's encouragement) upon the dissolution of the three-year-old anti-fascist League of Revolutionary Writers and Artists, the Taller was dedicated to public art and functioned as a graphic counterpart to the mural movement. Membership soon grew to sixteen; in its midst stood as a symbol a "lithographic press boasting the label 'Paris, 1871' which is said to have served the Paris 'Commune.' This press, witness to a venerable tradition, was more effective in banding together the artists than any theoretical program." The Taller issued posters, illustrated popular calendars, portfolios on topical themes, huge paper hangings for popular assemblies, and lithographed handbills. The Taller artists sought to show the working class that art and artists were not strangers, that artists were ready to put their creative capacity at the service of the people. Taller artists wanted workers to realize that art was a career and a useful social activity, not an idle pastime. (*El Taller de Gráfica Popular: Doce anos de obra artística colectiva.* Prologue by Leopoldo Méndez, introduction by Hannes Meyer [México, D.F.: La Estampa Mexicana, 1949], VII passim.)

12. Reprinted in Enrique F. Gual, *La pintura de Fanny Rabel* (México, D.F.: Anáhuac Cia. Editorial, S.A., 1968), 128.

13. "Exposición de Susana Campos: Ritmos obsesivos," introduction by Francisco Moreno Capdevila (Mexico, D.F.: Salón de la Plástica Mexicana, 1975).

14. "28 artists" (México, D.F.: Galería Mer–Jup, 1972), 51.

15. "Pilar Castañeda," introduction by Raquel Tibol (Puebla, México: Casa de la Cultura, 1974).

16. Lourdes Grobet, "Sobre mi labor fotográfica," *Los Universitarios*, no. 111–12 (January 1978): 18–19.

9

"PORTRAYING OURSELVES":
CONTEMPORARY CHICANA ARTISTS

The Chicana struggle is not an off-shoot of the Chicano movement, but is the next step within the movement to bring Chicanos and Chicanas even more closely together to form an even stronger *unidad*. To accomplish this unity Chicanas need to be able to share, need to be listened to, but most of all, need to see themselves . . . in works done by other Chicanas. La Chicana needs to come to know the many-faceted woman that she is.[1]

Wearing My Critical Hat—the One I Never Take Off

Writing art criticism and history in the field of modern Latin American art in general and Chicana(o) art specifically, is an exercise in second-class citizenship (vis-à-vis U.S. mainstream publications) similar to the conditions suffered by the artmakers themselves in the art world, as in the political, economic, and social worlds. In 1986 I, who live in Los Angeles—a city with the greatest number of Mexicans outside Mexico City, and a growing population of Central Americans numbering close to half a million—had the opportunity to spend considerable time in New York inquiring into the status of Latin American artists on the other coast. Many Latin American artists reside there because of the art market, because of forced political exile, or owing to a more propitious social climate for creative production. Not to my great surprise, I discovered that

This essay first appeared in Arlene Raven et al. *Feminist Art Criticism: An Anthology* (Ann Arbor, Mich.: UMI Research Press, 1988), 187–205.

their situation in terms of recognition and acceptance is marginal. Though some "stars" have little difficulty exhibiting and selling in mainstream galleries, and might occasionally be invited to a museum exhibit, the great majority of talented artists have to overcome the "stigma" of being Latin American before they are accepted on equal terms with their peers.

This is even more pointedly true for the two colonized populations in the U.S.—the Puerto Ricans of New York and the Chicanos, some of whose ancestors lived in the Southwest before it was militarily added to United States territory. And the situation has been even further exacerbated for women of these groups. Gender, in their case, was added to discrimination based on race, ethnicity, and class.

I have found that art professionals dedicated to writing about modern Latin American art are also treated as second class: their contributions are usually considered with indifference or rejected by major art magazines owing to the subject matter. The few exceptions serve to prove the rule. What is sad but certain is that no body of knowledgeable criticism can develop since no systematic coverage, as is the case with European movements or regional U.S. movements, has been built into the policy of mainstream art magazines. Thus it can be said that better coverage exists about Latin Americans and Latino-descent artists living in the U.S. in prestigious journals of Europe and Latin America, or alternative magazines in this country, than can be found in the most widely circulated art publications of the United States. The net result of such exclusionary policies based on disinterest is a distorted view of the whole of modern art, generally, and the scope of art from the Americas in particular.

A century dominated by not only modernism, but also its corollary art-for-art's-sake ideology—from Clive Bell to Clement Greenberg—and by the linear history of art constructed by Alfred H. Barr, Jr., and his successors at New York's Museum of Modern Art, excluded most women in the history of modern art as well as most modern Latin Americans, Africans, and Asians, and inevitably led to a formalist art history and art criticism that was both male dominated and Eurocentric in its focus. From these imperatives I prefer to distance myself.

I imagine that I share problems with feminist critics. In the same way that feminist artists and critics saw fit to establish their own exhibition structures and publications, so did the two Latin American communities previously mentioned. A similar situation is doubtless true for other artists of color (Native Americans, blacks, Asians, etc.) and the critics who write about their work.

One qualifier is necessary: this second-class status adheres specifically to those critics who share the views and respect the sensibilities of the rejected groups on a consistent basis: who take an "advocacy" position. Lucy Lippard defines an "advocate critic" so succinctly, so appropriately, that I would like to quote it here. She says:

an advocate critic . . . works from a communal base to identify and criticize the existing social structures as a means to locate and evaluate the social and aesthetic effect of the art. Ideally such a critic avoids star making or promoting a single style; openly supports art that is openly critical of, or openly opposed to, the political powers that be; and perhaps most importantly, tries to innovate the notion of "quality" to include the unheard voices, the unseen images, of the unconsidered people.[2]

Advocacy criticism should suggest broad endorsement and support for "minority" voices—those whom the ideology of hegemonic forces have marginalized in the interests of domination—without relinquishing the right and responsibility to be critical, *within* that advocacy, of individual works of art as well as of ideological formulations. The role of the critic should always include the large view, the societal and global views which give dimension and placement to art production. Our role is to assert, and reassert, that the art of women and of peoples of the Third World (women and men) are crucial elements in the construction of the history of art.

Chicana Artists in Occupied America

The first and most important thing that can be said about Chicana artists is that they *are* artists. The second fact concerns the number of women today who can be counted in their ranks, whether in the fields of literature, drama, dance, or the visual arts. The third matter to be considered is the multiple oppressions Chicanas had to confront and conquer before they could achieve the first state: that of being artists. The pith and essence of what is presented by Chicana artists derives from a specific social history, the lived experiences of that history, and the matured reflections made *on* that history by artists born Chicana in "occupied America."

The Chicano sociopolitical movement (as differentiated from the Mexican and Mexican American movements preceding it) began in 1965, as a result of the grape pickers' strike in Delano, California, that triggered the imagination of a whole generation of Mexican-descent young people. It was followed in 1966 by a demonstration in Albuquerque, New Mexico; by the founding of the Crusade for Justice in Denver, Colorado, the same year; by the courthouse raid on behalf of land grant rights in northern New Mexico in 1967; by the founding in 1967 of campus organizations throughout the Southwest, and the consequent birth of terms like "Chicano" and "*chicanismo*"; by the formation in 1967 of the Raza Unida Party in El Paso, Texas; by the 1968 student "blowouts" from East Los Angeles high schools and the Third World strike at San Francisco State University; by the anti–Vietnam War demonstration of 1969 and

the Chicano Moratorium of 1970, both in Los Angeles. These and many other economic and political events in the Southwest and the Midwest were accompanied by a cultural explosion with a sufficient number of unifying symbols and characteristics to be considered a cultural *movement*—one that articulated the Chicano experience in the United States.

The Chicano experience was not a simple one to express, beginning with its self-designation. Mexicans in the United States have called themselves by a variety of names corresponding to historical and social pressures faced by a colonized people. Variously the terms have included Spanish American and Hispanic (the latest "fashionable" term, rejected by many because it ignores the Indian component so important to the Chicano movement); Mexicano, Mexican, Mexican American; Raza and Chicano. In their search for a national denominator, Chicanos faced other problems of diversity; not all were brown, not all were Catholic, not all were Spanish-surnamed, not all were Spanish-speaking. Many identified equally as Native American and Mexican. There were also regional diversities, and, finally, the question of sexual differentiation.

Mexican and Chicana women have traditionally faced a series of stereotypes, misconceptions, and restrictions from society at large, and from within their own communities. Many of these are similar to those shared by women in general; some are specific to a so-called Latin American ethos. According to various studies, Latin American women, continentally, were expected to be gentle, mild, sentimental, emotional, intuitive, impulsive, fragile, submissive, docile, dependent, and timid; while men were supposed to be hard, rough, cold, intellectual, rational, farsighted, profound, strong, authoritarian, independent, and brave. The Mexican family, in particular, was purportedly founded on the supremacy of the father (*machismo*), the total sacrifice of the mother (*hembrismo*), the elders having authority over the young, and the men over the women. Chicano men were seen as dominating their wives and overprotecting their daughters, expecting passive compliance from both.[3] In actuality, the Chicana is a product of two cultures: the traditional Mexican culture experienced at home in diluted forms and the dominant North American culture (with its own share of sexism, but a greater liberty for women) outside the home. But the final point to be made is that Chicanas, like women everywhere, have never conformed to the stereotypes manufactured about and for them by male historians, psychologists, and other apologists or contributors to female oppression. Chicana and Chicano historians and sociologists are revising the history of Mexican women in the United States and Mexico: reexamining the legends, discovering and publishing the names and deeds of writers, intellectuals, labor leaders, and social reformers, as well as the lives of thousands of unnamed working women whose combined actions have shaped history.

There is no question that Chicanas living in North America were also

influenced by the feminist movement, whose modern reincarnation was almost simultaneous with that of the Chicano movement: both products of the turbulent and reforming sixties. Though women played a prominent role in the Chicano movement, they felt the need for a clearer articulation of their own role in society. The movement called for an end to oppression—discrimination, racism, and poverty—goals which Chicanas supported unequivocally; but it did not propose basic changes in male-female relations or the status of women. A commonly expressed attitude on woman's role was, "It is her place and duty to stand behind and back up her Macho."[4] As Martha Cotera has pungently pointed out, when the men (and even some of the women—those she calls the "chickie-babies" and the "groupies" of the movement) spoke of liberation, "you found that they literally meant liberation for men, and they couldn't care peanuts about you or your little girls or your little sisters, or your own mother."[5] However, precisely through strong, perceptive, and outspoken feminists such as Cotera and Inés Hernándes Tovar of Texas, Alicia Escalante and Francisca Flores of California, and many others, Chicanas began to sense their power and speak out on their own behalf. They established organizations such as the Mexican American Women's Organization, the Comisión Femenil Mexicana, the Mexican American Business and Professional Women, the Hijas de Cuauhtémoc, and the Concilio Mujeres. In Texas, the art group Mujeres Artistas del Suroeste (MAS: Southwestern Women Artists) organized exhibits for Chicana and Latina women. Publications such as *Encuentro Femenil, Regeneración, Popo Femenil*, and *La Razón Mestiza* appeared. The relations of Chicanas with the main groupings of white, middle-class U.S. feminists were not always cordial. Racism and classism within these movements often came under attack. "We are an integral part of [the feminist] movement," says Dorinda Moreno, "but the often brutal clashing of ideas have made the building of that bridge to be a sometimes painful encounter."[6] As Third World women discovered in Mexico City at the 1975 International Women's Year, their differences with the U.S. movement were sometimes irreconcilable. For these women and for Third World women in the United States, there is more to the question of women's rights than equality with men. While insisting on their right to be equal and have the same opportunities for advancement as men, they are dedicated, by necessity, to liberating their whole people from the injustices of the dominant society which oppresses both men and women. Sexism, for Chicana women, is coupled with racism and economic exploitation. The direction of Chicana feminism, therefore, has particularly stressed issues affecting the victimization of women owing to their color, national origin, and poverty as well as to their sex. Organizations have dealt with problems of welfare, battering, birth control, involuntary sterilization of genocidal proportions, inadequate health care, lack of child care facilities, unequal

pay, unemployment, and lack of meaningful education and educational opportunities. For Chicanas in, or aspiring to, the middle class (which includes most artists), the priority toward upward mobility was often in competition not only with men, but also with white women.

In conclusion: Chicanas participated from the beginning in the struggles and accomplishments of the Chicano movement, including its cultural expression. In addition to questions of identity as a people, Chicanas also wished to clarify their identity as women with its special problems and concerns. It was necessary to confront the racism, classism, and sexism of society at large and the sexism within their own ranks in order to achieve full personhood. Simply becoming artists frequently involved breaking stereotypes within the patriarchal family (or the working-class family that conceived no economic advantage to be derived from entering the arts); persisting within the educational system, especially in opposition to its insistence on "mainstream" culture and art forms; juggling duties as lovers, wives, mothers, and workers with the time for creative work; and finally, being sufficiently self-confident and assertive to obtain exhibition space or commissions.

The Many Facets of Chicana Art: New Needs, New Themes

A few historical notes are in order to position Chicanas in the world of work, economic and cultural. During the Spanish colonial period, in the Río Grande Valley—which today encompasses much of the states of New Mexico, Texas, and Colorado—women worked as tanners, weavers, and seamstresses in a primarily rural economy. They were also gardeners, midwives, servants, nurses, *curanderas* (healers), and even overseers of Indian women slaves. In more recent years, the artisanship which formerly supplied internally needed domestic and religious articles for the isolated colonizers of northern New Spain/Mexico, has been transformed into production for collectors, tourists, and the new Chicano middle class. In northern New Mexico, women are engaged in work as artisans, alone, or with husbands and families, in making ornamental tinwork, straw inlay, rawhide work, embroidery and quilting—as well as weaving and plastering adobe structures.[7]

By the 1920s, their number swelled by the great increase in Mexican migration to the United States resulting from the chaos of the Mexican Revolution, women entered the wage labor force in large numbers because families could not survive on men's wages alone. The cooking, canning, weaving, and other work previously performed at home were transferred to industries like packing, canning, textiles, garment factories, laundries, restaurants, and domestic labor. By the time of World War II, Mexican Americans had been urbanized throughout the South-

west, and were migrating to the great industrial centers of the Midwest.

Insufficient research exists to ascertain the extent and kind of artistic activities in which Mexican Americans as a whole were engaged. We know that a certain number of men were designers, caricaturists, commercial photographers, and printers—especially for Spanish-language publications—while a smaller number were professional fine artists generally creating along mainstream guidelines. The information about women is even more sparse. Jacinto Quirarte's book on Mexican American artists mentions only two women, both born in the early years of this century.[8] However, there is little doubt that Mexican American women exercised their creativity in a multitude of ways within their own homes. Extrapolating from the evidence that is slowly coming in, women decorated their homes, crocheted, embroidered, knitted, made lace, and painted on a variety of surfaces. Eighty-one-year-old Alicia Dickerson "Monte" Montemayor, whom I interviewed in 1980 at the home where she was born in Laredo, Texas, exemplified this artistic creativity. Monte's great-grandparents settled in Laredo before Texas became part of the United States. From her strong frontier grandmother, she absorbed family stories and folktales, including those having to do with relations with the Indian peoples. As Monte's family was growing up, she knitted afghans, crocheted, made dolls for her children and for church sales. In 1973, when her husband became ill, Monte started painting gourds she raised in her garden to pass the time while she cared for him. She then began to work on canvas, on which she did still lifes of fruit and flowers, imaginary images, and fantastic landscapes. Monte's entry into painting corresponded with the florescence of the Chicano art movement, and the Chicana women's art organization MAS, of Austin, showed her work in galleries. Like the men, contemporary Chicana artists are a product of the struggles in the sixties and seventies that, to a certain degree, opened higher education to Mexican-descent people. The same period saw an efflorescence of a grassroots artistic movement within which some women made their appearance. Both trained and self-trained women, in small numbers, painted murals and made silkscreen posters. Not many of the self-trained remained in art, owing to the problems of economic survival and lack of a support structure geared to their needs. (Trained artists, men and women, have fallen away for the same reasons.) In general, the public phase of Chicano art—street murals and posters—which reached its production nadir in the mid-seventies was not conducive to much female participation. The problems of working outdoors on a large scale, of being subject to the comments or harassments of the passing public, the strenuous nature of the work in light of how women are socialized for physical effort, militated against their participation.[9] Judith (Judy) Baca, director of the Mural Resource Center in Los Angeles, early recognized this prob-

lem and, in addition to her regular mural manual for art directors and neighborhood teams, produced and illustrated the *Woman's Manual: How to Assemble Scaffolding.*

Despite convention and the attitudes of their menfolk, some women entered into mural production, particularly in California, where the even climate and the existence of stuccoed buildings (which offered excellent surfaces for the priming and painting of outdoor murals) resulted in the largest production of Chicano murals existing in any state of the nation. Women began to be active in muralism by 1970, when Baca (later recognized nationally for the *Great Wall of Los Angeles* project)[10] began to work on walls with teams of young gang members from East Los Angeles. By 1974, women became active as muralists in the San Francisco Bay area with the organization of the Mujeres Muralistas, a team including three Chicanas and a Venezuelan woman. Short-lived though the group was, it became germinal for women artists throughout the state who took courage from its example and even, with variations, adapted its name as their own.

The great surge of women artists, however, corresponded with the "privatization" of Chicano art in the later seventies—which itself corresponded to a diminution of the intense activism of earlier years. As the Chicano gallery structure expanded in many states of the Southwest and Midwest, and community and feminist galleries became aware of Chicanas, the possibilities for exhibitions of smaller, more intimate work also expanded. To these possibilities were later added college and university galleries, and certain museums. The aperture is not large, even for the men who were on the scene earlier, but it exists.

Women's art (overwhelmingly representational in the Chicano art movement) has engaged many new themes and interpretations that reflect different realities and perceptions. From the beginning, positive images of active women began to appear. One of the most ubiquitous images in male art (derived from Mexican calendars) has been the sexy, often seminude figure of the Aztec princess from the Iztaccíhuatl/Popocatépetl legend, carried "Tarzan-Jane" fashion by a gloriously arrayed warrior prince. This Hollywoodized rendition epitomizes the notion of the passive woman protected by the active man. In its place, Chicana artists substituted heroines from the Mexican Revolution (especially those culled from the Agustín V. Casasola Photo Archives), labor leaders, women associated with alternative schools and clinics, working women, women in protest, and so forth—in other words, *activated* women who shape their lives and environments.

The single most influential source of imagery for all Chicano artists was the 1976 bilingual book *450 Años del pueblo chicano/450 Years of Chicano History in Pictures,* produced in Albuquerque, with a text by

Elizabeth Sutherland Martínez.[11] Mexican peoples from both sides of the border, of all periods, ages, occupations, and activities appear in its pages and provide an iconography of struggle, work, and culture. The role of women in all these areas is clearly delineated in historical photographs.

If *450 Years* provided a rich vein of extroverted imagery, the life and art of Mexican painter Frida Kahlo provided an introverted model: woman focused on her interior life, on the cycles of birth and death, on pain and fortitude, on the sublimation of the self in art. The whole feminist movement was fascinated by Kahlo, but for Chicana artists she provided a needed role model. Not only was her art of great interest and beauty; not only did it incorporate or absorb the pre-Columbian and folk imagery of Mexico which was a vital strand of Chicano cultural nationalism in the seventies, but her whole life, lived as a work of art, was intriguing. Kahlo's brilliant color, minute detail, exuberant use of plant forms, fusion of the pre-Columbian and the modern, and use of the self-portrait as a mode began to appear in many Chicana works.

Another source of female imagery and inspiration was the vernacular art of the Southwest: particularly home altars and the smaller *nichos* (religious niches) which are created and tended by women.[12] Reinforced by Mexican altars for the Día de los Muertos (Day of the Dead), the altar, as a cumulative sculptural object, passed into Chicano/a art in numerous variations. Other popular religious imagery includes the Virgin of Guadalupe—traditional and transformed—and the *curandera* (female faith healer), whose roots are older than Catholicism.

The first half of the 1970s was dominated by militant and pre-Columbian images denoting Indian ancestry; the second half was more nostalgic. Or perhaps it has also been a search for roots, but closer to home and more familiar. This search is perhaps best symbolized by the Luis Valdez play and movie *Zoot Suit*. Many artists dipped into family photograph albums to recreate the Pachuco of the 1940s and older eras. (Interestingly enough, the *Zoot Suit*/Pachuco revival did not extend to the Pachuca: the female embodiment of cool hip and distinctive dress during World War II. In one of the rare cases where a woman artist refers to the Pachuco era, she does so in terms of a pair of "Stacies," the fashionable pointed shoes associated with some Pachuco males. See the "testimony" of Carolina Flores below.) So infused with *machismo* has the Pachuco revival been that the Pachuca is almost completely lost from sight. Instead, women became interested in female ancestors and their activities, tracing back family members—especially in long-settled areas like New Mexico and Texas—as much as five generations. Others have revived the domestic arts, which owe a strong debt to Native American influence and intermarriage. Weaving, pottery making, and *enjarrando* (the plastering of adobe constructions traditionally done by women) have

long been practiced by Pueblo and Mexican women in New Mexico and southern Colorado. These crafts were revived in New Mexico in the 1920s and 1930s by Anglo artists and tourists as well as by federal patronage, and again in the 1970s by the impetus of the Chicano movement and the land grant struggle. New Mexican women engaged in these practices also pay tribute to their ancestors of several generations back who have passed on these skills. In the more alienated urban areas, Chicana artists have also turned their attention to *barrio* women, especially to the young *cholas* characterized by heavy dramatic makeup, chic barrio-style clothing, and tattoos, with the toughness and tenderness to survive in a difficult environment. Others have documented grandmothers, aunts, mothers and children, and the family affection (immediate and extended) that provides a support structure throughout the Southwest.

This is by no means a complete list of the concerns that occupy Chicana artists; it is intended merely as an indicator. By the same token, Chicana artists employ a wide range of styles and techniques, from traditional *retablos* (altarpieces) to the most avant-garde methods of manipulated photography, xerography, and book art. If there are unifying characteristics, they include the overwhelming concern with images of women, their condition, and their environment. Many works are directly or indirectly autobiographical; a certain number deal with sexuality. Another common denominator that has emerged is the tendency to use organic rather than geometric form: the rounded corner, the flowing line, the potlike shape shared by clay vessels, the pregnant body, and the adobe fireplace.

Testimonies

Teresa Archuleta-Sagel (Española, New Mexico)

I knew I wanted to be a *tejedora* (weaver) at an early age. My family was involved and supportive in every aspect. My father built my looms. My mother told me rich stories about great-grandfather Juan Manuel Velásquez. She remembered him at his loom weaving and singing, while the *abuelitas* (old women) sat together on evenings telling *chistes y cuentos, cardando e hilando lana* (jokes and stories, carding and spinning wool). My mother intrigued me with those wonderful stories of the past, stories that compelled me to seek spinning tools I had never seen, and scarcer still, good fleece. I also started experimenting with the *yerbas* (wild plants) that grow abundantly in the Río Arriba area.

I dreamt of *Electric Ikat* (a dyed wool blanket) on three separate occasions before actually starting to weave it. I believe the dreams guided and reassured me during the five months of working through an unfamiliar process.

Alicia Arredondo (Austin, Texas)

The techniques I use, finger weaving and macramé, are not unique; they come from ancient folk art and trade crafts. The work I am involved in I have named *tejidos en nudos* (knotted weavings). It is the *tejidos* that reflect my people, my culture, my personal experiences, and a physical history of where I have been. The *nudos* (knots) symbolize the complexities of life—life as it is common to all people.

Santa Barraza (Austin, Texas)

My artwork [drawings and prints] has been influenced by the Chicano movement of the late sixties and early seventies, my culture, historical background, the Mexican muralists, and shamanism. At the beginning of my creative endeavor, I created art about my physical experiences and struggle for my Raza (people). Today I utilize images from the unconscious, working intrinsically to convey a personal, indiscernible, and emotional experience.

Liz Lerma (Mesa, Arizona)

I was pregnant with my first child. I was impressed [as a ceramist] with my body's ability to change so easily. My belly was large and round. My skin was shiny and elastic. I just had to do something with my beautiful body.

The *Body Mask* series was cast by my husband Tom in six-week intervals: June 23, August 8, September 21, and November 8 (just two weeks before my daughter Roxana was born). The masks have lacings on the sides to allow people to tie them on and experience the volume of a pregnant body.

Fig. 26

Barbara Carrasco (Los Angeles, Calif., b. El Paso, Texas)

The lithograph *Pregnant Woman in a Ball of Yarn* portrays an oppressed pregnant woman trapped by the fear of fighting her oppressors. Actually it was inspired by the effect my brother's chauvinism had on his wife (he has since changed for the better). Others who have viewed the lithograph see it as the unconscious message of forced sterilization, a present-day reality.

Isabel Castro, (Los Angeles, Calif., b. Mexico City)

The body of work *Women under Fire* is a series of manipulated color slides transferred to color xerox. This high technology process allows me

to have instant feedback on the image. The work is processed and altered four times: once through the lens of the camera when the image is taken, the second through the lab slide processing, the third through direct manipulation of the slide itself (scratching, coloring, bleaching, tearing), and the last process through the lens of the camera again. In *Women under Fire*, I intended to contrast the calm look on the woman's face with the danger of the gunsight focused on her.

The images of women have always been of great interest to me. Women within the Chicano community have to be strong in order to survive. Such has been the experience in my particular family. But women outside their family structures have greater obstacles imposed on them by their communities and society in general.

Yreina Cervántez (Los Angeles, Calif., b. Garden City, Kansas)

Fig. 27

My artwork is the strongest aspect of me. At its best, it is the most honest reflection of everything I want to say, not only in the subject matter, but through the colors I use, which have a voice of their own. Art for me has always been an intense experience and, I realize now, a spiritual experience also. I often use the traditional "Madonna" figure, and the indigenous concept of the *Nahual* which appears in the form of animal counterparts—jaguars, cats, birds, etcetera, all representing duality. Some of my most satisfying works are my self-portraits, where I can relate my private feelings about myself as a Chicana and as a woman. My other concerns in art are of a political and social nature. At times there is conflict between the personal statement and the political content in my work.

Carolina Flores (San Antonio, Texas; b. Fort Stockton, Texas)

Los Stacies de Javier are a pair of shoes belonging to Javier Piña of Laredo, Texas. They are personal in nature—about Javier's personal rebellion against family, society, etcetera. They symbolize our own rebellion against two oppressive societies—Mexican and Anglo—in relation to CHICANOS!

Mi abuela Francisca y su amiga Cruz is taken from an old photograph of my grandmother and her best friend Cruzita—as we knew her as children. This painting became part of a series of family portraits (taken from old photographs) which I did as a student at the University of Texas in Austin. They formed a link between the home and cultural environment of my west Texas hometown and the alienated rootless Anglo environment of the Austin campus.

Diane Gamboa (Los Angeles, Calif.)

I was always interested in fashion from the time my aunt used to sell things at the swap meets and I played with the stuff. In the early 1960s, I went to elementary school in short white go-go boots and fishnet stockings. Later I became interested in hippie fashions and bought vintage clothes at thrift shops in East Los Angeles. I have always collected accessories, jewelry and hats. I admired the Pachuca and Chola looks, but I wanted to dress unusually.

I started doing paper fashions in 1982 for a Día de los Muertos show with three male artists. Paper fashions are so unusual, very original, instant and spontaneous, like a *piñata* (paper-ribbon covered clay pot filled with sweets for blindfolded children who break it with a stick): so beautiful, but destroyed later. *Leopard-Spotted* is a custom handmade paper dress, one of six from the *Lizard* line. These dresses are specifically designed for the cold-blooded.

Estér Hernández (Oakland, Calif.; b. Dinuba, Calif.)

I am an ex-farmworker of Yaqui-Mexican ancestry. I have worked in many media, but I consider myself a printmaker. My images are always those of *la mujer chicana* (the Chicana woman). My ideas and inspiration come from life itself—the beautiful as well as the gross. I made the print *Sun Mad* as a very personal reaction to my shock when I discovered that the water in my hometown, Dinuba, which is the center of the raisin-raising territory, had been contaminated with pesticides for twenty-five to thirty years. I realized that I had drunk and bathed in this water.

I have always enjoyed taking apart well-known images and transforming them to what I believe is their true nature. As a cultural worker, it is my way of moving people toward positive action.

Juanita M. Jaramillo (Taos, New Mexico)

My grandmother is a person who socializes easily and has a lucid memory for names and genealogical connections. Her mother and aunts are now remembered for the impact they had on northern New Mexico weaving, more specifically for the El Valle Style blanket, distinguished by the eight-pointed star. She provided me with a vivid network of my weaver ancestors, and the extended family, the *parentela*.

Visits with elders in the family reveal more and more, especially when they have gone back into their old storage trunks to bring out wonderful heirloom textiles, along with family stories that go with them. I began to

spin and weave on the traditional loom in 1971. I also spent a brief period in Mexico City studying Mesoamerican art, including textiles. I could never continue my weaving without my research.

Adivinanza is a mixture of handspun and commercial wool singles. The colors are vegetal dyed. This work evolves out of change, working toward the finer yarns I have been spinning. The title points at innuendos in communication . . . *Adivinanza* is a riddle, a prophecy.

Yolanda López (San Francisco, Calif.; b. San Diego, Calif.)

Fig. 28 For many Chicanos [the Virgin of] Guadalupe still has a religious and spiritual force. But I suspect her real power exists as a symbol of our national pride. There is something also nostalgic in our attitude towards her. She is an image infused with a certain kind of sentimentality for us. I looked at Guadalupe as an artist, as an investigator of the power of images. I was interested in her visual message as a role model. Essentially she is beautiful, serene, passive. She has no emotional life or texture of her own. She exists within the realm of magical mythology sanctified as a formal entity by religious tradition. She remained the Great Mother, but her representation is as plastic as our individual fears and aspirations.

Because I feel living, breathing women also deserve the respect and love lavished on Guadalupe, I have chosen to transform the image. Taking symbols of her power and virtue, I have transferred them to women I know. My hope in creating these alternative role models is to work with the viewer in a reconsideration of how we as Chicanas portray ourselves. It is questioning the idealized stereotypes we as women are assumed to attempt to emulate.

Linda Martínez de Pedro (Chimayo, New Mexico; b. Denver, Colo.)

My *retablos* (in this case, painted wood panels) are considered traditional by some and nontraditional by others. I, however, believe being a Native Woman is a matter of perception rather than name, skin color, and birthplace. My ancestors have blessed me; of that there is no doubt.

Judy Miranda (Long Beach, Calif.; b. Los Angeles, Calif.)

My work, in this case, is non-silver [photographic] printing [on a sheet, then quilted]. The process begins with sensitizing material with a light-sensitive chemical. The material is then exposed to light and developed.

The images I have chosen for this quilt were taken from magazines, periodicals, nature, and previous photographs. These images reflect society, politics, and all the bullshit our culture tries to implant upon women.

Celia Alvarez Muñoz (Arlington, Texas; b. El Paso, Texas)

I call this series [of images made into an artist's book] *Enlightenment Stories* because they deal with aspects of reasoning. An experience is told as seen by a child's eyes in a deceptively simple prose. The enlightenment is actually my enlightenment when I realized that my experience, good or bad, could be material for my pieces. The bilingual and bicultural upbringing in the border town of El Paso is what I portray.

Anita Rodríguez (El Prado, New Mexico; b. Taos, New Mexico)

The *enjarradoras* (plasterers) of northern New Mexico are those women who have finished, embellished, and maintained the native architecture of the Río Grande Pueblo area since pre-Columbian times. Passed on by oral tradition, the technology of the *enjarradoras* represents the accumulated experience of centuries of adobe builders.

I have eighteen years of experience as a professional *enjarradora*, and am skilled in all phases of *enjarrando*, including fireplace construction. My fireplaces are functional sculptures, combining the use of modern materials with traditional New Mexican forms, and techniques learned in the earth-building countries of Mexico, China, and Egypt.

Patricia Rodríguez (San Francisco, Calif.; b. Marfa, Texas)

Boxes were the beginning of a new medium for me. I had spent years painting murals in the community[13] and I felt the need for a smaller, more personal work. My first box experiments were masks of well-known Chicano artists. The latest boxes speak in more general terms about the religious aspects which influence the Mexican culture, and the conflict one experiences being a Chicana artist. *Dreams of My Ancestors* functions on two levels. On the lower level there are Indian dolls laid on foamlike cotton—they are dead and this is a level of earth which is underground. Psychologically it shows another level of death, that of another world. The upper world is the reality in which we live today. The hand in the piece is reaching out for bags being handed out by the ancestors but is not able to reach them. As the door of the box opens, the panel has a dollar bill locked behind it, signifying that we have been oppressed

through the means of money. We have lost our identity; the original dreams of the ancestors. The bags are representative of precious secrets and mementos handed down through time.

Contemplation is personal and deals with my conflict over a decision between having a child and being a career woman. Both together are very difficult to achieve if you're a starving artist. There are fetuses, there is a heart, and there is a pomegranate, which is a very beautiful natural thing that shrivels up and yet holds its shape, and it has nails driven through it. To the side are gears which show energy, movement, and bravery. The whole refers to being brave enough to dive into something and complete yourself as a Chicana. The little section of ridges below are levels of time.

Camilla Trujillo (Española, New Mexico)

The clay I work with is dug from local hillsides. It is then cleaned, thoroughly dried, ground to a fine powder, and sifted together with water and a temper. After it has aged, it is ready to be worked. I use the coil technique to form my pots and figurines. My pottery is fired using the "pit method," outdoors, in a tin box covered all around with cedar wood which burns steadily for about one hour. I don't consider the clay to be inanimate material. I approach it with the same respect I would any living thing. Making pottery is a quiet process. I try to work with the laws of the clay, keeping lines simple and clean. I try to bring out the beauty and personality that lives within the clay. To me, good pottery evokes a feeling, a knowledge, that we are part of the earth.

In conclusion, Chicana art displays a great variety of motifs, forms, and techniques—a reflection of the multifaceted woman with whom this essay opened.

> *birth and death hot in my thighs: I see*
> *death grin between my legs and my*
> *body hold back and I'm*
> *bursting*
> *to birth houses and trains and wheat and*
> * coal and stars*
> *and daughters and trumpets and volcanoes*
> * and hawks and*
> *sons and porpoises and roots and stones and worlds and*
> * galaxies*
> *of humanity and life*
> *yet to be born . . .*[14]

Notes

1. Rita Sánchez, "Imágenes de la Chicana," in *Imágenes de la Chicana* (Menlo Park: Nowels Publications, 1974), 2.

2. Lucy Lippard, "Headlines, Heartlines, Hardlines: Advocacy Criticism as Activism," in Douglas Kahn and Diane Neumaier (eds.), *Cultures in Contention* (Seattle: The Real Comet Press, 1985), 243.

3. María Nieto Senour, "Psychology of the Chicana," Sue Cox (ed.), *Female Psychology: The Emerging Self* (New York: St. Martin's Press, 1981), 137.

4. Alfredo Mirandé and Evangelina Enríquez, *La Chicana: The Mexican American Woman* (Chicago: University of Chicago Press, 1979), 235.

5. Martha P. Cotera, *The Chicana Feminist* (Austin: Information Systems Development, 1977), 31.

6. Dorinda Moreno, "Un paso adelante," *La razón mestiza*, June 20–22, 1980: 1.

7. See William Wroth (ed.), *Hispanic Crafts of the Southwest*, The Taylor Museum of the Colorado Springs Fine Arts Center, 1977.

8. Jacinto Quirarte, *Mexican American Artists* (Austin: University of Texas Press, 1973).

9. It was pointed out to me at a women artists' conference in 1986 that I should except lesbian women from this statement, and there may be some merit in this contention. However, the point has to do with the way women (lesbian or not) were *socialized*, not with their sexual preferences. Among Chicanas, some of the women who went into street muralism were lesbians and some were not. For either group, it took social strength in the seventies for women to assume this role in what was, in any case, a very marginal art form for men *or* women. In addition, women had to learn the manual skills from which they were often persuaded to abstain as children.

10. In 1976, Judith Baca painted with teams what was to be the longest mural in Los Angeles—possibly anywhere: *The History of California*, also known as *The Great Wall of Los Angeles* and the *Tujunga Wash Mural*. *The Great Wall* was done in segments starting with a thousand feet, and continuing during the summers of 1978, 1980, 1981, and 1983 in 350-foot segments.

11. *450 Años del pueblo chicano/450 Years of Chicano History in Pictures* (Albuquerque: Chicano Communications Center, 1976).

12. See Kay Turner, "Mexican American Home Altars: Towards Their Interpretation," *Aztlán: International Journal of Chicano Studies Research* 13 (Spring and Fall 1982): 309–26.

13. Patricia Rodríguez was one of the founding members of Mujeres Muralistas of San Francisco in 1974.

14. Excerpt from Alma Villanueva, *Blood Knot*, reprinted in *El Tecolote Literary Magazine* 13, no. 6 (March 1983): 8.

10

MUJERES DE CALIFORNIA: LATIN AMERICAN WOMEN ARTISTS

Muralists

Perhaps the most visible presence of Latin American women's art is that which covers the walls of many cities in California: the monumental (and not-so-monumental) murals produced primarily by Chicana artists from the late 1960s to the present. Acknowledged as the largest (or longest, over one-third of a mile) is Judith Baca's (California, born 1946) *The Great Wall of Los Angeles,* painted with teams of professional artists working with community youth during the years 1976 to 1983. Its theme is California's multicultural history from prehistoric to contemporary times, including the history of Third World peoples and the women not always encountered in textbooks. While Baca is certainly one of the earliest (beginning in 1969) and the most enduring of Chicana women muralists in California, she is not the only one. Los Angeles has seen murals painted by Lucila Villaseñor Grijalva and Norma Montoya in the early 1970s, and since then by Judith Hernández, Barbara Carrasco, Yreina Cervántez, Patssi Valdez, and Margaret García.

Fig. 29 Latina women have also been active muralists in northern California. Three Chicanas—Patricia Rodríguez (Texas, 1944), Irene Pérez (California, 1950), and Graciela Carrillo (California, 1950)—and a Venezuelan artist, Consuelo Méndez (1952), were the original team comprising the

This essay first appeared in Sylvia Moore, ed., *Yesterday and Tomorrow: California Women Artists* (New York: Midmarch Arts Press, 1989), 202–29.

Mujeres Muralistas (Women Muralists), organized in San Francisco in 1974 and remaining active for about two years. The four had been students together in 1971 at the San Francisco Art Institute and they grouped together for support. In 1973, Rodríguez, Carrillo, and Pérez did their first experimental mural work in Balmy Alley near Rodríguez's home. The following year their mural collective coalesced when Méndez was commissioned to do a "monstrous" wall that required a group and they painted *Panamerica* at the Mission Model Neighborhood Corporation parking lot. "The mural movement was happening," as Rodríguez says, and the women temporarily left their painting and graphics to plunge into community art. "We had to prove ourselves," continues Rodríguez. "Women were starting to get hired by PG&E [Pacific Gas and Electric] to climb telephone poles. It was an age of women becoming involved in men's work." Other Latina women joined them: Estér Hernández (California, 1944), Miriam Olivo, and Ruth Rodríguez, as well as non-Latina Susan Cervantes. However, male muralists were not very supportive. "A lot of women came around," says Hernández, "but I think that first of all the men were the ones that had an attack. Most of the large walls up until that point—the very few that had been done in the Bay area—had been done by men. People were really shocked that a group of women were going to do the whole thing, from setting up scaffolds to doing the drawings to doing cartoons. Some people were very arrogant and rude and others were supportive. But we were clear about insisting that the work was going to be done just by women."[1] The last work done by three of the Mujeres (without Carrillo) as a team was the *Rhomboidal Parallelogram*, a six-paneled painting-construction ten feet high and thirteen feet long on which was depicted the life of Latin American women and children—the theme that pervaded their murals as well.

Subsequently, each of the women returned to their painting and printmaking. Two years later, Méndez returned to her native Caracas, where she continues to produce her distinctive graphics and has been recognized in Venezuela and in international exhibitions. By 1979, Rodríguez had chosen a new direction for her art: plaster masks of Chicano/a artists surrounded by found objects that detailed their lives. This laid the groundwork for her impressive series of boxes, an ongoing project which she continues to develop and refine today. Carrillo continued to paint murals in and out of California; she also illustrated bilingual children's books and did portraits in oils, watercolors, and colored pencil for a living. The influence of Frida Kahlo (the San Francisco Galería de la Raza held homages to Frida Kahlo) appears most notably in her pencil and watercolor self-portraits. Pérez did silkscreens for many years in compositions of foods, symbols of Indian cultures, and other Mexican themes, working with clear, flat outlines and colors. In recent years, she has turned to gouache. Hernández has done large abstract paintings, but it is in print-

making that she has produced her most impressive work. Widely disseminated is the serigraph *Sun Mad* (1982), with a skeletal version of the Sun Maid raisin box logo and text, about the life-threatening use of pesticides and herbicides. Hernández didn't lack a sense of humor when she reconstructed the Statue of Liberty on a pre-Columbian model (1975), or made the Virgin of Guadalupe a Black Belt karate fighter defending Chicano rights (1976). In 1984 she addressed the subject of Central America with a print about the civil war in Guatemala, and the use of U.S.-funded helicopters to kill civilians.

In the 1980s, other women gravitated to murals. Chief among them has been Juana Alicia (New Jersey), who came to California in 1970 from Detroit and whose twelve murals, created alone or with teams from 1982 to 1987 (one in Nicaragua; one about Guatemala with the Balmy Alley PLACA Central American Project in San Francisco), establish Alicia as a major muralist. Her themes concern labor and cultural history, women and children. They demonstrate an uplifting and positive point of view that matches that of the Mujeres. As for them, the earth and the things that grow on it form a vital part of Alicia's imagery.

Chicana women from Sacramento and from Fresno also collaborated for brief periods on mural projects. Sacramento artists Rosalinda Palacios, Antonia Mendoza, and Celia Rodríguez (some accounts also include Irma Lerma and Barbara Desmangles) were inspired by the first International Women's Year conference in Mexico City (1975) and painted a pillar mural in San Diego's Chicano Park celebrating women of Latin America. Fifteen Fresno women, taking their lead from San Francisco's Mujeres Muralistas, established themselves in the mid-seventies as Las Mujeres Muralistas del Valle. The group included Helen Gonzáles, Celia Risco, Sylvia Figueroa, Theresa Vásquez, and Lupe González, who worked together on a mural in their city. In addition, San Francisco artist Yolanda López, originally from San Diego but not generally known as a muralist, painted a mural at Chicano Park with a team of young women from San Diego. Nevertheless, considered in relation to the enormous number of murals produced in California during the 1970s and 1980s, Latina women have actually played a relatively small role.

Though this essay is not meant to focus on muralism because that topic is covered in another contribution, it is well worth sketching in some of Judith Baca's activities in Los Angeles during the almost two decades of her artistic production. Her experience epitomizes both the difficulties Latina women faced when they entered the field of art, and the successful way women can build supportive structures and organizations without losing an iota of their vision or integrity. In the process, Baca learned the skills she now possesses.

In the early 1970s, with an assumed braggadocio that conquered politicians accustomed to ignoring both Mexicans and women, Baca managed

to wrest $100,000 for a citywide mural program from a reluctant Los Angeles City Council (at that time without a single Mexican member to represent the enormous Spanish-speaking community). Her earlier wall paintings were completed with Chicano gang members in the East Los Angeles *barrio*. However, the City Council would neither countenance such a focus, nor supply funding for it. Consequently, Baca broadened her sights. She proposed an audacious venture that undertook to produce murals all over the city. By so doing, she learned to work in multiethnic situations with sensitivity that could counter interethnic racism.

The nonprofit organization Baca set up in 1976 to carry out mural projects without government interference was, appropriately enough, named SPARC—acronym for the Social and Public Art Resource Center. Run almost exclusively by women, SPARC managed to procure (inexpensively) an ancient, three-story former jailhouse located in a beachside suburb of Los Angeles. Converted into an arts space. it now has studios, offices, meeting rooms, a slide archive, and a gallery that opens its doors to many previously unheard artistic voices. Not only can murals be planned in this location, but lectures, concerts, poetry readings, workshops, and resident artists make it an active alternative cultural site based on precepts of multiethnicity and feminism.

Very early on, Baca was conscious of the difficulties confronting women who wished to do murals. She recalls that, as she worked with Chicano gangs in the early 1960s, few girls participated. "It was much easier organizing among the young men," she says, "because girls were not allowed the same mobility. It's been a long process drawing the young girls in. You see, Latin women are not supposed to be doing things like climbing on a scaffold, being in the public eye."[2] Baca as then-director of the city-sponsored Mural Resource Center, produced and illustrated—in addition to her regular mural manual for art directors and neighborhood teams—a special photocopied *Woman's Manual: How to Assemble Scaffolding*. This was intended to help remedy women's socialization, which militated against working outdoors on a large scale, being subject to the comments of the passing public, and knowing how to handle tools and successfully construct such large objects as one- or two-story scaffolds.

Chicanas and Latinas in the United States

Any history of Latin Americans in the United States must of necessity root itself in the momentous struggles of the 1960s and the succeeding decades as well as in recent Latin American history. These concurrent histories can give us insight into the work and lives of the women artists surveyed here. Since feminism and feminist artists of Europe and the U.S. have been widely treated in books, articles, and exhibition reviews over the last two decades, there is little need to do more than suggest the par-

ticularities of the feminist presence in California, where key artists profoundly shaped feminist artistic philosophy on a national level. The history of Latin Americans, on the other hand, is much less well known. In general, the presence of Latin Americans in California, male and female, has been determined by the politics, socioeconomic history, and cultural opportunities of their countries of origin, as well as by the history and environment of California.

Demographically speaking, it becomes quickly apparent to any observer that the Mexican-descent population of California overwhelmingly exceeds that of all other Spanish-speaking groups. This is so because the Southwest was settled by Spaniards and Mexicans before the Mexican American War made it U.S. territory in the mid-nineteenth century. Moreover, there has been continuous migration—especially during the Mexican Revolution of 1910–1920, and during periods of intensive labor recruitment. It follows that any discussion of Latin American women artists in California will be dominated by information about Mexican, Mexican American, and Chicana artists. The latter's emergence during the sixties was marked by a young, active, militant, and educationally/culturally oriented movement with outposts throughout the United States. It was strongest in the Southwest, where some Mexican Americans and Chicanos can claim an ancestry that goes back five and six generations.

Recent statistics indicate that the numbers of Latin American-descent peoples in the U.S. will reach nearly twenty-five million by 1990. If present trends continue, this will be "the largest ethnic minority in the country" by the year 2000.[3] The 1980 census revealed over four million in California (out of a total population of almost twenty million), of which 80 percent are Mexican. Necessary to keep in mind, however, is that constant migration, both officially recognized and nonofficial, has been going on steadily. Between 1970 and 1980, the state's Latin American population almost doubled. For example, the Central American refugee population grew to a calculated 350,000 in Los Angeles alone, with more settled in other locations. Most are from El Salvador, with some from Guatemala—the two Central American countries with the most desperate record of death squad killings, kidnappings, and disappearances. Beset with severe problems of survival, not many artists surfaced. Those that have—with some notable exceptions—are males working part-time at their art. Mexican professionals began arriving in greater numbers after 1982, when their country's economic crisis became critical. Likewise, Latin Americans have moved to the U.S. (or to the Southwest from the East) in search of a more propitious social climate or better creative opportunities.

Within little more than a decade (from 1964 to 1976), five countries spanning the area from the Andes to the Southern Cone of South America entered a period that has been called "the long night of the gener-

als." Repressive military-dominated dictatorships took power in Bolivia, Chile, Argentina, Brazil, and Uruguay, often with assistance or training by the United States, which sees Latin America as its bailiwick. Jailings, tortures, massacres, and disappearances became a daily occurrence. Exiles from these countries, including a large contingent of intellectuals and artists, sought asylum in Mexico, European countries, and (when permitted entry) the United States. Perhaps the largest exile group is that of Chileans, in whose country General Pinochet still rules (as of this writing), fifteen years after the coup d'état of 1973. Chileans continued to leave in voluntary or involuntary exile for a decade after the coup.

Caribbean immigrants come primarily from Puerto Rico and Cuba; most reside in New York, Miami, or Chicago. While many of the Puerto Ricans share the working-class status of Mexican immigrants, the Cubans who arrived from 1959 to 1965 (right after the Cuban Revolution) and from 1966 to 1980 have been described as "significantly older, more urban, more educated . . . and much more conservative" than other Latin Americans.[4] Most Cubans do not want to (or cannot) return to their native land, but members of the younger generations have taken a more open attitude to Cuban-U.S. relations.

Movements of the Seventies

Though both the Chicano political movement and the feminist movement were emerging in California at the same time, there was very little political contact. For the community at large, Mexicans and Chicanos were an invisible presence; how much more unlikely was it that even a pioneer artist like Judith Baca should be known to the women's art community seeking its own identity and parameters at the same time.

The Feminist Art Movement

In the early 1970s, the Los Angeles area was a central site for feminist art. In February/March 1973, the first issue of *Womanspace Journal* appeared, published by the newly opened Womanspace Gallery. It contained articles by such now well-known feminist artists and historians as Judy Chicago, Wanda Westcoast, Miriam Schapiro, Ruth Iskin, and Arlene Raven. Gala opening night for the gallery was January 27, followed by a series of events that included exhibitions, a celebration of Womanhouse, which had opened almost a year earlier, a lecture on the 1893 Women's Building at the Chicago World's Fair, a reception for Anaïs Nin, a week devoted to an examination of lesbian sensibilities in art, a "menstruation weekend" performance imported from the Berkeley Art Museum, plays, workshops, poetry readings, music, films, and a reception for "pioneer woman artist" June Wayne. A new experimental program called the

"Feminist Studio Workshop" opened in the fall of 1973, conducted by Arlene Raven, Judy Chicago, and Sheila de Bretteville. At the same time, the Woman's Building was launched in the two-story renovated building that for many years had housed the Chouinard Art School.

Though Womanspace has long disappeared, the Woman's Building continues to maintain a vibrant program of activities.[5] In 1973, Womanspace chose Olivia Sánchez for inclusion in a juried exhibit and the Woman's Building invited Rosalyn Mesquita to participate in a three-woman show. In 1976, another contact was made between Chicana artists and the feminist movement when a group of five artists who called themselves "Las Chicanas" created an installation and multimedia event in the new, three-story Woman's Building. Involved were photographer Isabel Castro, muralists Judith Baca and Judith Hernández, Olga Muñiz, and Mexican painter Josefina Quesada. Titled *Venas de la mujer* (*A Woman's Veins*), the installation was a rich compilation of Mexican/Chicana culture and realities, including a garment factory segment which illustrated the working conditions of the many undocumented Mexican women employed at such labor in Los Angeles sweatshops with substandard wages and working conditions.

By 1976, the Woman's Building had changed its location when the building located near MacArthur Park was sold. Those at the old building had probably never been aware that in the Chouinard structure they had been living with Mexican art history, that it was the site where one of Siqueiros's major murals had been painted.[6] When muralists such as Baca, Hernández, and Quesada presented their work at the new Woman's Building, events had been brought, in a certain sense, to full circle. Siqueiros was the Mexican muralist who most influenced Chicano (and other) street wall painters throughout the 1970s. Though he died in 1974, his Taller (Workshop) in Cuernavaca, Mexico, continued, and Judith Baca had an opportunity to learn about his use of deep space and dramatic foreshortening. As director of the *Great Wall*, Baca translated what she had learned of Siqueiros's style and methods to California walls in a new configuration.

The contact begun between white feminist artists and Chicana artists continued sporadically. In 1982, thirteen artists and poets brought together by Linda Vallejo and assisted by Susan E. King, studio director of the Woman's Graphic Center at the Woman's Building, worked on a limited edition portfolio with serigraphy, offset, and letter press published under the name of Madre Tierra Press. The inauguration was held on December 12, a date sacred to the Aztec fertility goddess Tonantzin, and to the Virgin of Guadalupe. Included were artists Juanita Cynthia Alaníz, Cecelia Casteñeda Quintero, Anita Rodríguez, photographers Judy Miranda and Rosemary Quesada-Weiner, as well as Vallejo, Olivia Sánchez, and Yreina Cervántez.

The Chicana Movement

Chicana artists in California are relatively easy to locate compared to other Latin American women, owing to the existence of a network of Chicano cultural organizations and publications that emerged with the political movement to aid, nurture, and expose the cultural expression of Chicanos. The years from 1968 to about 1975 saw an emphasis on public art—murals, posters, and filmmaking which were militant, nationalistic, and Indian-oriented.

Until the mid-seventies, Chicano art was largely dominated by men. Though some were sensitive to women's issues, the images that emerged predominantly depicted women as passive wives, helpmates and mothers, Indian princesses, pre-Columbian and Catholic goddesses, sex symbols, and occasionally as betrayers such as "La Malinche," the Indian interpreter and mistress of Hernán Cortés in the sixteenth century. As a more pervasive feminist consciousness developed and greater numbers of Chicanas became visible as artists and writers, new concepts emerged— among them the recuperation of women's achievements within Mexican and Mexican American history. Historical sisters such as "La Malinche" and Sor Juana Inés de la Cruz—a nun who rejected marriage and became one of Mexico's greatest literary and intellectual figures in the seventeenth century, an early exponent of women's rights—were reexamined by writers, while artists undertook to define and redefine the Aztec goddess Coatlicue/Tonantzin, the Virgin of Guadalupe, and the Mexican painter Frida Kahlo.

The second half of the decade and the 1980s saw a turn toward more personal, gallery-oriented work. It was also the period in which many more women emerged into public view. Los Angeles's Mechicano Art Gallery, opened in 1969, the Goez Art Gallery, Self-Help Graphics and Art, and Plaza de la Raza were among the alternative spaces available to Chicano/a artists when most mainstream institutions and commercial galleries were closed to them. At the same time, Judith Baca's mural and gallery programs, whether for the city or sponsored by SPARC, provided a strong feminist awareness that encouraged women to participate in art-making and show their work publicly. San Diego's Centro Cultural de la Raza, headed until September 1988 by Veronica Enrique (whose focus is Mexican dance), also offered space. Its gallery, considerably enlarged several years ago, has hosted shows from all over California which have included a number of women as well as artists from its sister city in Mexico, Tijuana.[7]

Alternative spaces were also established in the San Francisco Bay area by the late 1960s, branching into Sacramento and other northern California cities during the 1970s. Unlike southern California, where Chicanos dominated, the term "la raza" was employed in the north to signify that

artists of all Latin American backgrounds were working together. The Galería de la Raza and La Raza Silkscreen Center—presently called La Raza Graphic Center, Inc., to reflect a shift in direction, and headed by Chicana Linda Lucero, one of the few women consistently working with the Silkscreen Center—signaled the unity. Later the Mission Cultural Center catered to an even wider spectrum of Latin American artists. All three functioned in San Francisco's heavily Latino Mission district, and were crucial spaces where Latino artists, women and men alike, could learn and exhibit.

Southern California

Latin American women of California have been involved with a great variety of media and techniques. Painting, drawing, and printmaking dominate; however, sculpture and installation, video, filmmaking, photography, and performance are very much in evidence. Rather than attempting an approach based on national origin alone (the exception being the Chicanas, for reasons explained below), it seems more logical to present women artists in clusters determined by geography and chronology. The latter category has been made difficult, owing to the proscription against women revealing their age. During my research I tried to convince women that giving birth dates was a necessity so that their life experiences, artworks, and influences could be situated historically. Dates that don't appear result from prohibitions to the author, or from the consistent omission of this information in published sources. Despite feminism, the old rationalizations—reflecting old and new fears: sexual attractions, employment possibilities, age justifications for career advancement, and so forth—are still operational. As one artist expressed it, "Maybe it's time for us to come out of the closet on this issue."

Cuban painter Gloria Longval (Florida, 1931) is the daughter of a Cuban mother and an absent French father. Raised by her grandmother in the Florida slums, she learned from her about Cuban *brujería* (witchcraft) and later about Puerto Rican *santería* (the syncretic African-derived religion widely practiced in the Caribbean) when she lived in New York's Spanish Harlem in the 1940s and 1950s. Imagery of these magical practices remained in her repertoire when she came to California in 1962. Longval paints with subdued, somber but rich acrylic color on canvas (which sometimes includes collaged papier-mâché masks) and with clear glazed low-fire engobe on clay. Her acrylics evoke Goya, Manet, Ensor, and Picasso in simple subjects that take on an ominous and mysterious quality through ambiguous space, the use of blue and gray-green light, and clothing from another time. Birds such as penguins, dodos, and roosters (important in *santería* rituals) appear in her small ceramic pieces.

Ceramic sculptor and architectural designer Dora de Larios (California,

1933) comes from Mexican families who migrated to California because of the Mexican Revolution; she herself was born in Los Angeles where she lives today. As a child, she endured the standard discriminatory treatment of non-English speakers in school and, like many Mexican American and Chicana women, was raised with and received great comfort from Mexican myths, folk legends, and the healing knowledge of her grandmother. De Larios spent summers in Mexico City with relatives as a child and was enormously impressed by the great Aztec Calendar Stone at the National Museum of Anthropology, which later led her to an interest in pre-Columbian art. Also as a child she was very drawn to the Japanese truck gardener families who lived near her grandmother's house: many spoke Spanish and were very kind to her, in contrast to the hostile Anglo world with which she had to deal. One day all the Japanese disappeared, she recalls. In later years, she (like many others) became aware of the 1943 evacuation to concentration camps of West Coast Japanese during World War II. Her favored clay slab technique owes a debt to both Japanese Haniwa sculpture and to pre-Columbian Mexican clay figurines. In 1979, de Larios donated a large Portland cement mural, 6 × 26 feet, to Nagoya, Japanese sister-city of Los Angeles. Constructed with styrofoam modules encased in twenty-four wooden frames, the cement was poured to form deep textural reliefs. At USC, the University of Southern California (where she and Camille Billops were the only Mexican and black art students in the 1950s), she met and later married an architectural student. Both were intrigued by the Bauhaus-oriented concept of designing beautiful utilitarian goods for prices affordable to masses of people. When hired by Interpace in 1964 to design architectural tile and tile murals, de Larios found a direction for her future career. Since then, she has focused on architectural commissions in ceramic, concrete, stainless steel, and other materials, in addition to smaller works such as ceramic masks, bronze sculpture, and mixed media pieces of wood, porcelain, gold leaf, and paint.

Esperanza Martínez (Mexico, 1933), though living in the Los Angeles area since 1962, considers herself a Mexican. Born in a small village now part of Mexico City, she studied art secretly against the express wishes of her family, and married in the same manner. Forced to earn her living, Martínez sold paintings from her studio and through the Mexican Bureau of Tourism. Martínez travels regularly to Mexican and Central America Indian villages to sketch the people (primarily women and children) whom she paints when she returns home. Of modest size, the figures are idealized, folkloric, and meticulously executed in an almost photographic style very popular with her middle-class patrons, who are frequently Mexicans and Chicanos. She uses Prismacolor pencils overpainted with glazes and impastos of oil and acrylic.

Josefina Quesada of San Diego is also an older Mexican artist, who first

came to Los Angeles about 1970 as a consultant for the possible restoration of the 1932 Siqueiros mural in Olvera Street. (She and Jaime Mejía appear in the PBS film *América Tropical*, produced and directed for KCET television by Jesús Salvador Treviño in 1971.) Some years later she emigrated to Los Angeles as a restorer and skilled painter, and worked in the Goez Art Gallery of East Los Angeles. She also directed a mural funded by CETA for the Chicana Service Action Center which trained women for employment. Quesada's painting style follows Mexican realism of the 1940s period, with little innovation; she tends toward genre and pre-Columbian themes.

Mexican American (or Hispanic, according to New Mexican custom) Rosalyn Mesquita (1935) has lived in California since 1952—first in San Francisco, where she turned from classical music to art; then, since 1963, in Los Angeles. Trained at the University of California, Irvine, which boasted a roster of vanguard California and New York artists, Mesquita became fascinated with "process" art and for a number of years she made huge shallow-relief environmental paintings on paper; topographies in earth colors which recreated aerial views of landscapes and were rich in textures. These pieces were expandable: they could be layered to form rectangles of twenty feet in any direction or, correspondingly, decreased to five feet. A fine conceptual drawing from the 1970s called *Frijoles* creates a field of over forty outlined pinto beans within which several have been shaded or textured. This was a period in which Mesquita was most in touch with the California Chicano movement, and her piece was displayed at the 1975 Chicanarte exhibition. A committed feminist, however, she found the young movement too sexist, and its criticism of her experimentalism too limiting.

Mexican American Mary Lou Ynda (California, 1936) of East Los Angeles is a "graduate" of what she calls "gang consciousness." A 1966 silkscreening class captivated her, and she turned to art from her previous jazz music career. Christian and Native American spirituality is central to her work, which became increasingly abstract and more three-dimensional from 1978 to the present. Her *Annie Christian* series of 1982 are black-painted abstract collages of wood and wire. The pointed sticks, sometimes crossed, suggest either crucifixion or impalement. The series *Dogs, Wolves, and Women in Alphabetical Order, Loving the Alien* and *The Family* of 1985–86 are constructed of painted wood, plaster, and found objects with forms reminiscent of fetishes or tribal totems. A syncretism of Christian and "primitive" motifs remains constant in her work.

A resident of the United States, Magda Santonastasio (Costa Rica, 1937) has spent part of each year since 1971 in San Diego. She received her education at the University of Costa Rica (UCR) in San José, and is a noted watercolorist in a nation where watercolor has for many years been

a preferred medium. Since participating in 1980 in a creative graphics program sponsored at the UCR by the Organization of American States, she worked on series of color intaglios and relief prints with the Brighton Press of San Diego. Limited edition books containing original prints were published by the press between 1984 and 1987: *The Window, Letters to an Owl, Via de la Rosa—The Way of the Rose, Retratos (Portraits), Rescue of Indian Weavings,* and *Meinschatz.* In *Meinschatz* she worked abstractly with gridded, textured, and patterned surfaces etched with acid and printed with a viscosity technique. Organic forms in line are engraved over the geometric. In 1984, she embarked on a series of black-and-white relief etchings, among which are two outstanding works titled *El Salvador* and *Central America.* The dense background patterns con- Fig. 30
tain human and symbolic animal and bird images related to the present sufferings of Central American peoples.

Mexican American painter and printmaker Margaret Gallegos (California, 1938) resides in Santa Monica, a suburb of Los Angeles. A figurative artist, she works from life but does her finished work in the studio so as not to get overly involved in detail. Central to Gallegos's work is capturing an initial emotional response. Her broad horizontal landscapes of sea and sky, or urban streets, show mastery of traditional painting techniques and a sense of drama.

As in Europe, literature has always played an important role in Latin American art, generally as imagery inspired by poetry or novels. Literary-based art, however, had a lean time of it in the fifty (or sixty) years of modernism until pop art, conceptual art, and postmodernism opened the way to the reintroduction of texts with visual forms. In the semiabstract work of Argentine-born Susana Lago (1942) we find not only densely piled paint combined with found materials but the actual inscription of words from poems. Lago lived for brief periods in Brazil, Chile, Italy, Switzerland, New York, Illinois, and, finally, California, where her family moved in 1957. In her homages to four poets, Brazilian Cecilia Meireles, North American Emily Dickinson, Spaniard Vincent Aleixandre, and Italian Eugenio Montale, the words are buried beneath wire mesh, layers of translucent papers, acetate, and the very thick gestural strokes of paint themselves. The writing cannot be read except in fragments, like half-seen words hidden by graffiti. Fragments of polaroid photographic figures sometimes accompany the words, caught in boxes or behind jail-like mesh.

Gloria María Alvarez (Arizona, 1945) writes of herself, "I have not been part of the Chicano art movement—actually I only within the last two years have become aware of its history, though I admire the work of Rupert García and Malaquías Montoya. However, I tend to disagree with Montoya in viewing the role of art as social commentary. I do identify with being Chicana, but it is an expression of self only."[8] Alvarez came

to California in 1969, and now lives in central California. She considers printmaking her medium, enjoying the process and its surprises. A recent MFA graduate (1987), her work favors nonreferential images. Nevertheless, a series of color etchings—as formal, delicate, spatially and texturally refined and poetic as a Japanese private house and employing oval, rectangular, and fan shapes in subdued golds, blues, purples, and greens—combines these elegant forms with photographically derived images of female goddesses, from the Venus de Milo to the Virgin of Guadalupe. Having come from hard-edge geometry and gestural abstraction, the most recent work carries a personal symbolism and a new richness of color obtained through the layering of the etching plates.

Olivia Sánchez (Mexico, 1946) of Los Angeles is a painter and printmaker who constructs three-dimensional objects. Art served as compensation and escape during a very difficult childhood. Her initial participation with Womanspace Gallery in 1973 was crucial; she received encouragement from feminist artist Wanda Westcoast, who was her college teacher, and continued this association with the Woman's Building, where she took classes and found an outlet for her poetry. A central motif in her work is long abstract strands of color that represent brainwaves, electrocardiograms, or the forward motion of cars on the freeway. On these forms made with graphite, pastel, Prismacolor, and silkscreen, she positions apples, peaches, and bananas. For Sánchez, combining abstraction with realism is a way of uniting two worlds: that of her Mexican grandfather who was an artisan skilled in the production of beautiful candies made as vegetables, animals, and fruit and painted with food coloring; and her need for symbols that would address her urban life. Meditating on the disastrous freeways that dissect and disrupt many Mexican neighborhoods led to her freeway series of mixed media boxes enclosed in Plexiglas. Images of chile peppers crossed by lines symbolizing freeways are combined with ceramic tortillas and real peppers.

The work of Armandina Lozano (Mexico, 1952) is rooted in the student protests of Mexico City that tragically ended with the 1968 Tlatelolco massacre of unarmed demonstrators in a downtown plaza by the Mexican military. As a first-year student in the San Carlos Academy, members of whose faculty and student body clandestinely produced great numbers of graphic placards and handbills for street use, Lozano helped with the printing. These events not only politicized her, but determined her future artistic course. The 1970s for many emerging artists was a decade of return to political art drawing on new artistic languages and media. In 1976, Lozano joined with ten other artists to form the group "Suma," which sought to integrate its art with the visual images and symbols of average street people. Employing cardboard stencils, spray cans, and paint, Suma members covered walls and sidewalks with serial graphics accompanied by texts. Inexpensive graphic publications used a variety of new tech-

niques such as mimeograph stencils, photocopies, blueprints, and rubber stamps which were dubbed "neo-graphics" by their users. When Lozano came to California in 1983, she brought these skills with her, teaching them to Chicano artists and using them for her own work, which remains politically oriented. She is also a skilled security engraver, who makes plates for paper currency, stock certificates, commemorative stamps, and traveler's checks. It is a difficult profession previously closed to women— a fact she is never permitted to forget.

Like Lozano, Paz Cohen (Mexico, 1951) is a recent arrival in Los Angeles, whose first exhibit opened in 1988, though she participated in group shows presented in Mexico City from 1980 to 1983. Her paintings are of headless, fragmented human figures enclosed in boxes and circles, covered with wire mesh, attached to gears, wires, and screws. Cohen's installation of seven dress store mannequins whose lower bodies terminate in metal pipes and bars is arranged as a *March* toward a traffic stop sign. From this, and other pieces, Cohen has created a Dante's inferno of mechanized and depersonalized urban life. Among the most poignant is a complex piece made of metal sections, with rusty metal ribs, representing a female figure stretched on a black metal frame like a Christian martyr. Reaching upward from a gear and an automobile steering column and wheel are two desperate pink plastic hands. Movement, sound, and light animate this construction, which seems an almost autobiographical statement.

The child of a Mexican mother and a U.S. Cuban–born father, Linda E. Picos-Clark (Venezuela, 1958) lived three years as a child with her mother's family in Mexico City before coming to the United States. Fighting against figural painting, suspicious of love relationships with men after bad experiences, Picos-Clark is profoundly involved with Catholic mystic philosophy based on Platonic thought which she translated in the early 1980s into luminous black-and-white abstractions in charcoal and lithograph. Two works refer to themes of seduction from the Old Testament: *The Wife of Potiphar* and *The Fight against Concupiscence.* Another series is titled *Cloud of Unknowing,* in which the artist explores Dionysian aesthetics—a system of mystical theology that entered the Catholic church along with Christian Neoplatonism. Indeed, geometry and light are the two elements that inform Picos-Clark's most impressive work. In her two lithographs *Luz (Light)* and *Cueva (Cave)* the specific reference is made to Plato's Cave: the mythical parable of the uninstructed human as one chained up in a world of shadows which can only be escaped by moving toward the sun, or the highest good. Thus Picos-Clark's framework can be seen as a search for an ethical structure through art. Apparently, seduction and sexual desire are evils, and mystical faith expressed as light is the Good, the True, and the Beautiful.

As the first college graduate of her family (repeatedly true for artists

of her generation from Southwest Mexican families), Patricia Murillo (California, 1950) has lived all her life in Santa Ana. Emerging from this provincial environment with the personalized and humorous recycled "constructional prints" she makes from handmade paper, into which everything from washing machine lint, wood slivers, cut-up older prints, chips of peeling paint, porcupine quills, and electrical wire are either embedded (with a blender) or added, has been quite a feat. Fascinated with found objects and kitsch, with which she likes to play and experiment, Murillo also incorporates beads, chevrons, weaving, and other Indian symbols into her work, as well as the ubiquitous Southwest nopal (prickly pear) cactus. The small wall-mounted abstractions have series titles such as *This Bulb Is On* (*aren't you tired of too many parties*), in one of which a photocopy of huge sexy lips emerges from a spiked cactus-like container; or *Many a Tear Has to Fall*, which evokes eyes with lashes and tears. Never directly associated with the Chicano movement, Murillo nevertheless shares an interest in Native American imagery, and in the now iconized nopal cactus.

Without in any way diminishing the individual characteristics and talents of the artists, it seems logical to deal with those artists who consider themselves Chicanas as a group since there are so many common denominators, not the least of which is the association with a movement that in the early 1970s established an iconography of public art that can be traced nationally. It should be understood that not all Mexican-born, or even U.S.–born, artists identify themselves as Chicanas.

Judith Hernández (California, 1948), like most of the Chicana women mentioned, came from a working-class family and possibly would not have gone to college without the movement's insistence on opening higher education to Chicanos. Politicized by the movement, Hernández continued her art education into graduate school. Some of her most effective easel paintings were done with spray cans—the same cans with which neighborhood youth paint their graffiti on walls and which Chicano artists were beginning to integrate into their murals as a new paint medium. She was influenced in this direction when she joined an all-male art group called Los Four which, as early as 1973, was painting wall murals in some of the pilot programs of Los Angeles. She became a muralist, working with Judith Baca for a period of time. Hernández's themes usually focused on women: as tough street types, as heroic mothers, as political women fighting the Mexican Revolution, working in sweat-shops, organizing the farmworkers, and so forth. In her drawings for Chicano magazines as in her paintings, she evolved an idealized monumental woman whose type served many of these functions.

Both artist and efficient arts coordinator (curator, coordinator of a publication, etc.), Linda Vallejo (California, 1951) spent her formative years

as an "Air Force brat" living in the United States and Europe. The Chicano movement was in full swing when she settled again in Los Angeles, and she established ties with its Indianist ideas and activities to capture what she felt was a lost identity. As a Catholic-educated printmaker and sculptor, Vallejo is most attracted to pre-Columbian and Native American spirituality and ritual. "All my pieces," she says, "contain archetypal, mythological, or dream world imagery. I use archetypal subject matter found in ancient cultures combined with the modern idea of self-knowledge through the interpretation of dreams."[9] Vallejo works extensively with monotypes and hand-dyed paper (like Murillo, whom she admires, she layers some of her abstract work with remnants of old silk-screen or lithographic prints), and with three-dimensional works of cast paper embellished with Welsh wool, electrical wires, honeysuckle vines, papier-mâché, feathers, fur, plastic, and other materials.

Patssi Valdez (California) met the future members of the experimental conceptual and performance group ASCO ("Nausea" in English) while most of them were still in high school; she was the only woman. Creative and iconoclastic personalities, Gluglio "Gronk" Nicandro, Harry Gamboa, Jr., Willie Herrón, and Valdez formed a team by 1972 that worked individually and collectively. Murals, photography, Super-8 films, costumes, street theater, and tableaux, "No Movies" (real films with no film), magazine illustration, mock interviews, short stories and essays, installations, performances, and, in later years, video—all were produced with sharp wit, irony, and pointed social commentary on the state of being Chicano in East Los Angeles. Poking fun even at the flourishing mural movement—within which Herrón and Gronk were pioneers—ASCO performed "walking murals" (in elaborate costumes) and "instant murals" (Valdez taped to a wall). Valdez, in the early years, was often the "target" of the men's actions, whether taped up in a Super-8 or on a wall. She began the fashion of appearing in thrift-shop "chic" outfits—extravagant costumes (often in black), old jewelry, and lavish cosmetics that became part of her persona. She also modeled for imaginative costumes invented by Gronk—such as a "tumor hat." Paper fashions came into vogue and formed part of the action. Valdez did early "photo-booth" conceptual pieces. She then turned to manipulated photography in which she dressed and posed her models, shot with high-contrast film printed on grainy paper, and handpainted the works or covered sections in colored acetate. Her early installations have now changed to more complex and refined pieces, always with a stress on extravagantly clothed women who, nevertheless, impart the underlying sadness or despair that reflects Valdez's very difficult life. Harry's younger sister Diane Gamboa (1957), who participated in some of ASCO's activities from 1971 on, has also become an artist who, like Valdez, dresses from thrift stores, and has produced a line of paper clothing, including the *Lizard* series for "cold-blooded people."

Until it disintegrated in the mid-eighties, ASCO attracted a shifting group of participants to its performances, including a number of women. When Valdez left to do her own work, Marisela Norte was active in English/Spanish performance pieces.

Yreina Cervántez (Kansas, 1952) was raised in an area close to San Diego near an Indian reservation, a proximity crucial to her development as an artist. As a result, Cervántez has maintained a dialogue between Catholic religious ritual and what she considers a deeper, more personal Indian-based spirituality. Very early in her artistic training she turned to self-portraits, utilizing to good advantage her distinctive moon-shaped face, long dark hair and snub-nosed features. With watercolor as a preferred medium, she creates densely populated small paintings that accumulate a multitude of images around a strong central figure: a mural-like technique that resembles the accumulated paintings of Diego Rivera, or those of Frida Kahlo, whom she very much admires. Animals (as Nahual dual spirits), body organs, plants, symbols, *calaveras* (the animated skeletons popular in Mexican lore and popular art, widely adopted by Chicano artists), appear in her paintings in brilliant harmonious colors. In recent years, Cervántez has begun to experiment with silkscreen prints, a technique learned at Self Help Graphics workshops.

Among the Mexican families who made the trek to California from Texas seeking better opportunities and less racism was that of Barbara Carrasco (Texas, 1955). In the mid-seventies, Carrasco fought her way into the prejudiced art school of the University of California, Los Angeles, where she spent two years as a student activist earning her B.A. The activist role continued for six years with the United Farm Workers (a commitment that remains strong), for whom she made graphics and banners. Carrasco's muralism started in 1978, as she worked with an all-male team on the *Zoot Suit* imagery for the Aquarius Theatre in Hollywood, where Luis Valdez's play (later a movie) opened. She has painted other murals: a censored work for the Community Redevelopment Agency that required legal action on her part to retain her rights, in the Soviet Union, and with a Latino team in Nicaragua. However, her most dazzling works are her miniatures: tiny exquisite drawings with Prismacolor pencil, ballpoint pens, or silverpoint on coated paper. Ranging over the years from portraits of Siqueiros (whom she much admires), portraits of or self-portraits with Frida Kahlo, and the skeletal *calaveras* with which she makes rapierlike comments on friends and foes, personal and political, Carrasco has established a personal presence in the art world.

Other Southern California Chicanas deserve mention, though space does not permit more extensive treatment: Olga Muñiz, whose early drawings and watercolors showed great promise and who later worked with installation; printmaker Muriel Olguin; Margaret García, recently returned to Los Angeles, where she was born in 1951, and working with

large-scale expressive figure paintings and silkscreens in fauve-like color that show excellent command; Anita L. Rodríguez, who, in rejecting realism, turned toward delicate evocative paintings with paint and collage that drew on personal and symbolic mythology; Elizabeth "Liz" Rodríguez of the youngest generation, totally dedicated to avant-garde experimentation in installations, video, and printmaking, and now living in New York.

Northern California

Chicana Artists

Yolanda López (California, 1942) from San Diego is today a longtime resident of San Francisco. López began as a painter and is best known for her critical and iconoclastic "Guadalupe" series, in oil pastel on paper and with collage, in which she replaces the figure of the most sacred Catholic icon of the Mexican nation with images of her grandmother, her mother, herself as a runner, an Indian mother, and other images, enclosed in the Virgin's typical oval halo. The Virgin's star-studded cloak, the little winged angel, her typical roses, the snake she tramples are incorporated into these portraits of ordinary women whom López feels "also deserve the respect and love lavished on the Guadalupe." Thus she questions the idealized stereotypes women are supposed to emulate. López moved her theme from painting to three-dimensional works when she portrayed herself in shorts and shirt as a runner within a living tableau in which objects from life were incorporated. From that to installation was a short step, and other mythologies with which Chicana women live were explored. Her critical mind always engaged, López collected a slide show of advertising images that denigrated Mexicans and eventually translated the slides into a video production called *When You Think of Mexico: Commercial Images of Mexicans.*

Offering a polarity on religious issues to her contemporary Yolanda López, Amalia Mesa-Bains has, since the mid-1970s, focused on altars associated with Day of the Dead ceremonies in Mexico (and now among Chicanos who have institutionalized the ritual) and with home altars accumulated by Mexican Catholic women. With a Ph.D. in clinical psychology earned with a dissertation on Chicana women artists, Mesa-Bains has concentrated (though not exclusively) on drawings and altars dedicated to women: the Virgin of Guadalupe, Catholic nuns, fertility goddesses, Mexican actress Dolores del Río, and (most importantly to her) Frida Kahlo. Long-standing interests in textile design and *papel picado* (cut paper) lead naturally to the altars as accumulative installations, and to the innovative additions of light-reflecting fabrics and mirrors. Aware of—if not directly inspired by—altars by René Yáñez (who made his first

altar in 1967, and instituted Day of the Dead celebrations by 1972 in the Galería de la Raza, of which he was codirector), the traditional altars with offerings, candles, and *papel picado* by the older artist Yolanda Garfías Woo, and similar works by Carmen Lomas Garza, who also celebrates Kahlo—Mesa-Bains has changed her "earlier didactic and functional" altars geared toward the political period of the Chicano movement to culturally based but personal venerating symbols.

Linda Zamora Lucero (New Jersey) was raised in Detroit, coming to California in 1970. Most of her silkscreen work was done between 1973 and 1980 at San Francisco's La Raza Silkscreen Center (later known as La Raza Graphic Center, when the silkscreen component was closed). There she found gratification in being part of a group of artists that "illustrated historical and social movements, questions, etcetera, of the Latino community, and who as artists constitute an important part of that movement." The posters were used for public announcements in the streets—in store windows, on walls and poles. In 1981, Lucero published an international cookbook, *Compositions from My Kitchen/Composiciones de mi cocina*, which she wrote and illustrated. She also worked on layouts for the bilingual Children's Book Press, for which several Chicanas did writing and illustration. In the 1980s, she became executive director of the Graphic Center, a nonprofit community arts organization (which also runs a gallery) that now limits itself to the design component of offset printing.

Kingsville, Texas—a rural town in the southern part of the state dominated by the King family ranch—may have been a site of poverty and racism, but for Carmen Lomas Garza (1948) it is also the site of her most precious childhood memories: the cakewalks, the backyard lotteries, the *curandera* coming to heal the sick, the revered healer of South Texas, Don Pedrito Jaramillo, the fairs, the tamale feasts, the cutting of nopal cactus leaves for breakfast, the syruped-ice cones and all the world of small town pleasures, folk myth, and sense of community. Unlike her political and poetic work from Texas, Garza developed a highly detailed, pseudo-primitive style to recreate these scenes. Since coming to San Francisco in 1976, she has cultivated *papel picado* as a high art, cut copper for small altarlike triptychs, developed her etching and lithography, painted small gouaches, and constructed beautifully crafted large altars, among them, one to Frida Kahlo.

In addition to the women from northern California mentioned in the mural section above, other artists who enrich the area are Etta Delgado (San Jose), whose work is concerned with the Chicana, and whose media include pastel, watercolor, acrylics, and silkscreen, as well as murals;[10] Eva C. García and Lorraine García (both from Sacramento), the former of whom is self-taught and has worked photorealistically in charcoal, and the latter of whom works in an assortment of media so as not to be lim-

ited in her vocabulary. Since having a child, Lorraine García has dedicated a series of mixed media works that use single and double photographs of her daughter. She and Celia Rodríguez have both worked on murals in Sacramento and San Diego, while Rodríguez's small format pieces are constructed with ancient Mexican glyph writing and symbolic figures in color. Rosa Baron works from the human body, particularly of soccer players in plaster, and with Indian techniques and textiles. Along with Kathryn García and Patricia Carrillo, these Sacramento women have exhibited in San Francisco (where Lorraine and Eva García now live[11]) in a 1980 show titled "What We Are Now." Xochitl Nevel, with Consuelo Nevel, of the San Francisco Bay area has painted a large mural for a health center in a colorful realistic style, while Blanca Florencia Gutíerrez works in oils and Bea López in cast paper and felted wool.

Latin Americans of northern California include women from Chile, El Salvador, Puerto Rico, Colombia, Argentina, and Mexico. The most recent arrival is Cristina Emmanuel (Boston, 1935), born of Greek parents, who moved to Puerto Rico in 1956 and has lived in Somalia (East Africa), Peru, and Venezuela. She arrived in San Francisco from Puerto Rico in 1987 and received invitations to exhibit locally and in New Mexico for 1988 and 1989. Emmanuel's box altars with drawing, collage, and assemblage richly encrusting their surfaces with Virgins, Christian saints, religious medals, photocopied devotional prints, family photographs, fragments of lace, tiny silver body parts called *ex-votos* in Puerto Rico and *milagros* in Mexico (to cure bodily illnesses located in the part designated), and, in one case, a banana—the "daily bread" of Puerto Rico—have tremendous resonance with Mexicans and Chicanos of the Southwest, many of whom, as we have seen, embody their Catholic faith in their art.

Valeria Pequeño (Chile) is a self-taught artist who came to San Francisco in 1962 where she found herself "in a society of many artists with access to major museums and art libraries." Although these resources helped her sense of historical and formative trends in the art world, she felt it important to occupy her own niche with influence only from a constructivist woman artist. "Pequeño" meaning "small," it is perhaps a felicitous coincidence that many of her superbly crafted paper collages and paper boxes with found objects are tiny; the largest, perhaps, is a book/box on Frida Kahlo. Among the flat collages, modernist European abstraction has exerted an influence. When Pequeño starts to introduce images of dolls, little figures, plants, skeletons, crosses, and other objects, the playfulness and delicacy are completely her own. This is a world of grown-up toys in which boxes grow legs with shoes, or round pedestal cups are stuffed with treasures. The strict geometry totally prevents any sense of the maudlin.

Also from South America comes puppet sculptor Linda Haim (Colom-

bia, 1949), who began as a painter. Always interested in theater and pup-
pets when visiting the *barrios populares* (working-class neighborhoods)
in Bogotá where she did social and political work, her frumpy, grotesque
puppets of all sizes function as political and social caricatures of soldiers,
presidents (Reagan, Carter, and Nixon, in particular), cardinals, and even
nuns. Her nun is pregnant, deriving from stories of wealthy young Co-
lombian women who hid in convents when they got pregnant. It is not at
all unusual for Latin Americans to satirize presidents, the military, and
the church—the paintings of Colombia's most famous artist, Fernando
Botero, is filled with similar caricatures. What is unusual is the use of
puppets.[12]

Educated as an architect in El Salvador, Martivón Galindo displays
multiple talents in her San Francisco area home where she arrived as an
exile in 1981. Coming from a middle-class family "where matriarchy was
the rule," Galindo worked in El Salvador as a language teacher, an archi-
tect, an interior designer, and a gallery director for three years. She was
named Professional Woman of the Year in 1975, and has published poetry,
short stories, and essays. These activities continue in California, where
she added visual arts to her accomplishments. Presently Galindo also
serves as director of the Cultural Documentation and Investigation Cen-
ter of El Salvador (CODICES), which was established in 1986 to maintain
links among artists, writers, and the Salvadoran community, and to dis-
seminate the expressions of Salvadoran culture. Overt political messages
and love of her land suffuse Galindo's drawings, pastels, and paintings.
Titles such as *It Shouldn't Hurt to Be a Child, Chaos, Endless Suffering,*
and *The Past Is Always Flourishing* are not at all rhetorical, but reflect a
real and desperate situation. It comes as no surprise to find a recent ex-
hibit poetically called "From Our Earth Kneaded with Sweat and Tears."

Having lived in New Jersey, Miami, and Puerto Rico after leaving
Havana in 1971, Maritza Pérez (1955) earned a degree in printmaking at
the San Francisco Art Institute in 1984. Her cutout and embossed etch-
ings, photo-silkscreens, mixed media assemblages, and paintings deal
with very private personal symbolisms as well as with more accessible
images. In 1983, the etching series *Los mutilados* (*Mutilated Persons*)
showing fragmented bodies, continues the antiwar dialogue begun by
Fig. 31 Goya. A 1986 assemblage containing an image of Spanish dictator Fran-
cisco Franco combined with bones, an old radio, and other found objects
accuses men of bringing destruction with their technology. Pérez's most
recent works recall images and symbols rooted in the Catholic and Afri-
can Yoruba traditions of Cuban *santería*. Beans with rice are very Cuban,
she says, but coconuts (which appear in one piece) are known as a cleans-
ing agent against witchcraft.

In the Bay area, performance is represented by Guadalupe García (Mex-
ico, 1946). Having already participated in performances while living in

Mexico, García was prepared, upon her arrival in San Francisco in 1986, to launch a sequence of what she calls "performance-rituals"—a term coined in Mexico which García defines as a bridge between myth (which embraces historical memory, cultural symbols, and past experiences), and ritual, which provides the dynamic connection between lived experience and the mythic order. Her performance piece *Cruz/Cross* works out in time and space the evolution of the ancient Aztec mother goddess Coatlicue, who is attacked by her daughter Coyolxauhqui (the moon goddess) for being pregnant with the future sun god Huitzilopochtli. Using draperies about her seminude body, projected images on the wall, and a series of props, García's most effective scene in this work is the silhouette of the goddess's pregnant body as she parades around the space. Transformed into the dark Madonna, the Virgin of Guadalupe (the reincarnation of Coatlicue when the Spaniards came, and yet her antithesis in being virgin), and then into women from other phases of Mexican history, García secularizes the mythology while surrounding it with mythical form and movements. A modern myth was utilized in *Viva la vida*, when she transformed herself into Frida Kahlo in a street performance before a painting of the artist.

As a ceramic artist, Puerto Rican Anna de León's work is most publicly visible in the large plywood mural *Song of Unity*, mounted on the facade of Berkeley's La Peña cultural center in 1978 and now being repaired and refinished. She contributed two sizable ceramic pieces in relief of a condor (South America) and an eagle (North America) which symbolically unite the music of the continent, and balance the large papier-mâché head and arm on the other side of the mural of Chilean folk musician Victor Jara, murdered after the 1973 coup. In the present repair of the mural, de León added a large green quetzal bird (Central America), whose long tail feathers continue in paint across the flat pavement and will later be reinforced with tile. De León, who is also an attorney, is known as an activist of many years' standing, and as a sculptor who works figuratively and abstractly on door- and wall-size pieces, as well as on smaller pieces in porcelain.

Photography, Video, and Film

Space doesn't permit anything more than listing the many talented Latin American women involved in the arts of the still and motion picture camera, the negative, and the projector—certainly a legitimate part of the visual arts.

Photographers: Silvia Ledesma (U.S./Mexico), Frieda Broida (Mexico), Deborah Netsky (Puerto Rico), and Chicanas Isabel Castro, Judy Miranda, Theresa Chávez, María Vita Pinedo, Rosemary Quesada-Weiner, Laura Aguilar, Monica Almeida, and Cyn Honesto (now deceased).

Video and Film: Lourdes Portillo (Chicana) and Susana Muñoz (Argentina), with a film on the mothers of the Argentine Plaza de Mayo; Sylvia Morales and Susana Racho (both Chicanas), Lyn Picallo (Cuba), Elia Arce (Costa Rica), and the Bay area collective Más Media (More Media/mass media), which is composed of Ana Berta Campos (Mexico), Ana Perla (El Salvador), María Elena Palma and Juanita Rieloff (both from Chile), Mary Ellen Shurshill and Toni Lewis Osher (both from the U.S.).

The Present Situation

Increasingly women of Latin American descent are being invited to show their work in galleries and museums of California and throughout the United States. The ratio of Latina women to Latino men in such exposure is dismally low, even lower than similar ratios for non-Latina women. And correspondingly—since one fact illuminates the other—Latin American male artists receive low exposure vis-à-vis the general artistic community. If women and Third World people have mutually recognized linkages between their combined exclusions, the exclusions themselves are compounded for Latina women: later starts, less acceptance, sexism within their own ranks, sexism plus racism in the world at large. One remedy has consisted in taking matters into their own hands by organizing their own shows and making demands for educated curating and consultation by male-run (or even Anglo female-run) institutions.

The whole question of Latin American women artists is tied to larger convulsions in the body politic of the United States: its position as the wealthiest nation of the Americas and also the most imperial and aggressive; its need for cheap labor in its Latin American spheres of influence and at home; and its compulsive subversion of nationalist Latin American governments. The tendency for professionals, intellectuals, and artists to gravitate toward the more rewarding economic structures of the U.S. is also causing a "brain drain" from Latin American countries as economic neocolonialism impoverishes their lands.

We in the United States need to realize that such unartistic and unaesthetic terms as "national debts," "falling prices for raw materials," "currency devaluations," "coup d'états," "tortured and disappeared" have their almost immediate impact on the cultural arena, including the world of women artists. While we delight in and welcome the rich contribution to modern and contemporary art of Latin American women, the vacuum they have left in their countries of origin must give us pause to consider our own responsibilities in the artistic world and without.

Notes

1. Patricia Kerr, "Las Mujeres Muralistas," in Moira Roth (ed.), *Connecting Conversations: Interviews with 28 Bay Area Women Artists* (Oakland, Calif.:

Eucalyptus Press, Mills College, 1988), 132–33. Uncited quotes derive from personal conversations at different periods of time.

2. Judy Baca, "Our People Are the Internal Exiles," in Douglas Kahn and Diane Neumaier (eds.), *Cultures in Contention* (Seattle: The Real Comet Press, 1985), 67. My information is culled from this interview, from conversations with Baca, and countless visits to SPARC.

3. Geoffrey Fox, "Hispanic Communities in the United States," *Latin American Research Review* 23, no. 3 (1988): 227. Other statistics have been taken from Albert Camarillo, *Chicanos in California: A History of Mexican Americans in California* (San Francisco: Boyd & Fraser Publ. Co., 1984), 105–6.

4. Fox, "Hispanic Communities," 228.

5. The Woman's Building closed its doors August 1991.

6. The author was the original promoter, and remains a consultant, for a restoration of the Siqueiros mural at Olvera Street in Los Angeles. It was her research that brought to light a complete photograph of the original mural which permitted Chicano artists—including Barbara Carrasco, who painted the artist and his mural in a mural of her own—to be aware of its content and appearance.

7. The Centro also afforded exhibition space to Las Comadres (The Godmothers), a fluid group of approximately twenty women—Anglo-European, Mexican, Chicana, black and Native American—who are painters, video artists, performers, photographers, sculptors, filmmakers, writers, and critics from San Diego (U.S.) and Tijuana (Mexico). They first came together in 1988 as a study group, then decided to function as an artistic-activist collective on border issues, and to maintain anonymity for all collective projects (primarily installations) by not signing their art. By 1993, the group had disbanded. See *Border Issues/La Frontera*, catalogue, text by Shifra M. Goldman, El Paso: Bridge Center for Contemporary Art, 1991–92.

8. Letter to the author, July 15, 1988.

9. Quoted in Kelly Hollister, "Linda Vallejo," *Caminos* 1, no. 6 (October 1980): n.p.

10. Sybil Venegas, "The Artists and Their Work—The Role of the Chicana Artist," *ChismeArte* 1, no. 4 (Fall/Winter, c. 1978): 3.

11. Eva García unexpectedly passed away in 1991.

12. All information about Haim obtained from Sandra Benedet-Borrego's interview with the artist in *Estos Tiempos* 4, no. 2 (Stanford University; Fall 1988): 18–19.

11

ANA MENDIETA: A RETURN TO NATAL EARTH

In 1986, at the Second Biennial of Havana, Marina Gutíerrez, a Puerto Rican artist from New York, rendered homage to the memory of Ana Mendieta with a series of biographical works. Mendieta had fallen the previous year from the thirty-fourth-floor apartment she shared with her husband, minimalist artist Carl Andre, who was acquitted in 1987 (some felt unfairly) from murder charges. Most striking was Gutíerrez's painted image of Mendieta with real twigs extending in space that visually associated Mendieta with Frida Kahlo. The logic of the comparison was immediately evident.

With wholly different histories, both artists shared great psychological anguish (which in Frida's case was also physical) that found an outlet in their art. Both were autobiographical, erotic, and body-conscious; both established ties to the earth as an extension of being. Both made reference to blood in the lives of women: Frida to birth and miscarriage, Ana to rape and menstruation. Both died young, a little more than thirty years apart and a little more than ten years apart in age. Both invoked the traditional belief structures of their respective lands: in Kahlo's case, pre-Columbian imagery and colonial folk Catholicism; in Mendieta's, the rituals of Afro-Cuban *santería*, which she sought out in the United States. Both were Latin American artists who lived their lives with passion, with power, and with political conviction. Beyond that, the comparison fractures. Though she traveled widely, Frida Kahlo was securely rooted to her native Mexico and its revolutionary art whereas Ana Mendieta became an exile

This essay first appeared as "A Return to Natal Earth," in *Artweek*, April 15, 1989: 1.

at an early age. Finally, the language of art and the politics of women had radically changed in the interim. Kahlo's frank and sometimes brutal subject matter and her feminine focus were anomalies in pre–World War II Mexico; Mendieta, on the contrary, was attuned to the new winds of feminism in the 1970s, including the focus on the artist's body as a work of art in *propria persona*. When she moved to New York in 1978, her first contacts were with the feminist movement. She also established close ties with many of New York's Latin American artists.

Ana Mendieta's violent and loving return to earth stands as a metaphor for her life; for her return to her natal Cuba, from which she (then twelve years old) and her sister had been torn as adolescents; and for her return to herself, within art, when she emerged from a Catholic orphanage and foster homes where she had been "stored" for desperate years after her exile from Cuba. Mendieta arrived in the Midwest as part of the *Patria protesta* (or Campaign Peter Pan), a campaign of fear masterminded by the U.S. CIA and the Cuban Catholic Church after the Cuban revolution which convinced upper-class families that their children would be sent to the Soviet Union. She was one of fourteen thousand children shipped to the United States in 1960. Five years after her arrival, she felt her only two choices were to become a criminal or an artist. She chose the latter.

The violence done her, and the search for self-healing and a new identity continued in her art. She abandoned painting: the elements she chose to work with after 1970 (when she first used her own body in tableaux, performances, and body-earth works) were blood, fire, earth, water, and air, the latter symbolized by the outdoor locations in which she executed many works. Blood, mixed with tempera paint, was dripped slowly over her face from her hair in the 1973 piece *Sweating Blood*. Or it was smeared on her bound half-naked body to express her emotion and fright in response to the rape and murder of a female student while Mendieta studied at the University of Iowa. Or it became the tracks made by her sliding hands and arms on large sheets of paper as she lowered herself slowly to the floor in a performance.

Fire became a tool when silhouettes of her body made of bamboo armatures were lighted with firecrackers—a technique reminiscent of traditional Judas figures exploded in Mexico which she first visited in 1971. Gunpowder, at times associated with volcanic action, burned body images into wood, grass, earth, or rocks. A cast-iron "brand" of her hand was burned into wood and paper—most notably the handprint on the title page of the book *Rites and Rituals of Initiation*. It was as if Mendieta needed to leave her "mark" on nature and on culture, her signature made not with the hand alone but with the whole person so that she, as an individual and as the archetypal female presence, would not disappear without trace. It is true the works themselves vanished or were disintegrated into nature, but in the mode of much conceptual art (of which

Fig. 32

earthworks and body art were a part) the pictorial information remains. Mendieta documented her pieces, often carried forth in solitude, with photographs, films, and videos, techniques she had studied in the graduate Multi-Media and Video Program at Iowa. Today these serve as the major record of her work.

Fig. 33 A coming to terms, a reintegration of her divided self, a sense of fulfillment and positive growth began with her first return to Cuba in 1980 when she saw members of her family, re-explored Havana, and embraced revolutionary Cuba and its young artists with passion and joy—an act not without its consequences from the exile Cuban community. On her second trip to Cuba in 1981, she executed the series *Rupestrian Sculptures.* Named in Taíno Indian terminology, as well as in Spanish, and dedicated to goddesses and primal females, these works marked the new phase in her art. Reminiscent of ancient petroglyphs from the Caribbean, or pre-Columbian fertility deities, they were carved and painted in the soft limestone caves at the Escaleras de Jaruca. In her earlier *Tree of Life* and *Fetish* series, Mendieta had begun to model body forms in relief, going so far as to cover herself completely in mud and straw as a living sculpture leaning against a tree. From 1977 on, the negative image scooped or burned into the earth (whose hollows one critic suggested were also vaginas) became a positive one, slowly detaching itself from its base. Mendieta, the artist, and the figures of her creation had exorcised their demons with fire, blood, and water, and were ready to emerge as fully developed presences, extensions of her self but no longer autobiographical, though still linked by material and technique to the earth. Now they were emancipated as freestanding, upright tree trunks carved and burned inside or out with suggestive shapes, as images made of fernroot, of twigs, of stone chips, or of raised earth with binders over wood that lay flat on the ground. As conceptual art receded and artists returned to the portable art object, so did Mendieta, though not necessarily as a conscious concession to the art market.

The power and magic of Ana Mendieta's *oeuvre,* better defined in the retrospective exhibition now showing at LACE than by any single work, was most cogently explained by the artist herself when she said, "I am overwhelmed by the feeling of having been cast from the womb (nature). My art is the way I re-establish the bonds that unite me to the universe."

12

ISABEL RUIZ: THE MYTHOPOETICS
OF ANGUISH

Frogs, cockroaches, bats, snakes, spiders, bulls, flies, rats, fish, lizards, rabbits, owls: a bestiary of known and unknown zoomorphs, insects, piscatory and aviary creatures; monstruous nude bodies of women (an imaginary Venus of Willendorf), men, children, dismembered corpses, soldiers, devils, angels,—all these and more inhabit the symbolic world of Isabel Ruiz. Like indigenous masks and costumes, they are metamorphic, transmuting from one form to the other, emerging from or crawling into each other, attached by sinews of line, highlighted by bursts of light within the penumbra of their atmosphere. Is this simply a tale of gothic horror or is there another level of meaning?

Careful perusal of the densely painted and textured watercolors and the installations that form part of the series, *La historia sitiada* (*Besieged History*), not only convinces one that this is not a random selection, but that the individual creatures and humans, as well as the crosses, crowns, texts, graffiti, collage, and numbers are emblematic of specific human conditions filtered though the emotional and intellectual web of a painter with both courage and passion. *La historia sitiada* is Isabel Ruiz's response to the lengthy history of oppression and resistance that begins with the arrival of Columbus and continues to the present. With this series, she becomes part of a continental artistic movement dedicated to critically examining the implications of the Quincentenary.

Fig. 34

This essay first appeared in a catalogue entitled *Historia sitiada: Isabel Ruiz*, trans. Alejandro Rosas (Valencia, Venezuela: Ateneo de Valencia, 1992).

239

For Isabel Ruiz, a *ladina* partially raised by her grandmother in the northeastern village of Sololá near Lake Atitlán (and south of the ancient highland capital of the Quiché Maya of Utatlán—a history recorded in the *Popol Vuh*), there is a strong sense of identification with the indigenous communities, although she was born and resides in Guatemala City. Ruiz has turned her desire toward her art and her personal life, using the resources of the *altiplano* (its foods, herbs, rituals, and *artesanía*), and those of the city barrio where she lives, to enrich her artistic production. Thus she lives on the brink between two cultural universes, two cosmovisions, and two sets of poetics, using the transformative power of her twentieth-century art to unite her personal life with the collective life of her country.

Ruiz's style—which is less a "style" than a necessary language that embodies her emotion—has been transformed (reincarnated) from the existential semiotics of sixties' neofiguration in Latin America to a language of protest and mourning. She is not concerned so much, as were her "new image" predecessors such as José Luis Cuevas, with monstrosities born of individual and internal corruption, as with the monstrosities produced by a corrupt and brutal social regime.

At the core of the paintings which animate her cast of characters are four major elements: line, color, texture, and chiaroscuro. Her line is elastic, insistent, melodic, or staccato; it provides the circuitry that elucidates the inner surface of thought and feeling. It contours the morphology of her pictures, it delineates the complexity of suffering and of strength. She uses it—gouged out of the surfaces of her paper with knives, or "combed" into the paint as Maya women comb their hair—to create the splintered, fragmented, corroded human, animal, and vegetable life whose gyrations and textures express their pain. Color is of the earth, of the clays from which the Maya make their pottery, and of the sky and water. On thick absorbent paper, she sponges and tips in a base of yellow, then builds up controlled and partial layers of oranges, ochres, greens, alizarin crimson, burnt siennas, umbers, and black, working from light to dark in the traditional watercolor method. Blues vary from ultramarine to Prussian and are applied last, in chosen areas of the painting, sometimes over the black layer. Opacities and transparencies are controlled by the degree of water used, by the degree of wetness or dryness of the pigment before she begins to work on the figurative and textural elements. The fluidity of the paint leads not only to brilliant areas of color, but also to subtle grays compounded of mixed colors which most fascinate the artist.

As much as the iconography, Ruiz's method of working is at the heart of her project. The very acts of scratching, tearing, gouging, combing, and slicing, of rapidly and dynamically attacking the paper surface with knives of different sizes to create her imagery, her tonalities, her color choices, and her textures, are a fundamental and cathartic aspect of her

expression; they provide a formal vehicle for her social criticism. She is able to articulate in this manner the rage, pain, sorrow, and hope she experiences (especially as a woman) facing the daily events of her life and her country's life. As a technique, it is one adapted from the Maya method of ornamenting *jícaras*—a procedure on gourds which begins with three or four layers of lacquer into which designs are then carved, exposing the colors beneath. Applied to watercolors, whose extensive color layers are far more dense and complex, it becomes an integral part of her pictorial language and its meaning.

If the lacerated surfaces and veiled whiteness of the paper themselves provide a range of changes from light to dark in Ruiz's paintings, her installations call upon fire—the very source of light—for luminosity within the darkness of earth tones. The lighted candles that articulate her three-dimensional works of mourning—whether wall-hung altars, niches, or spatial environments—are associated with syncretic pre-Columbian and Catholic rituals. Part of the *Historia sitiada* series is a site-installation suggesting the ritual of a wake (*velorio*): two rows of burned pine chairs with black candles on the empty seats—as if to suggest that even the mourners are missing—frame a large painted cross on the ground delineated by the orange flowers of death and marked at its junctures by candles. In its darkness and silence, illuminated by candles whose smoke rises like spirits of the dead, it seems to invoke not only the thousands of tortured and disappeared persons of the last forty years in Guatemala, but the millions of indigenous peoples who were sacrificed during the five hundred years of conquest.

FACING BIG BUSINESS AND THE STATE

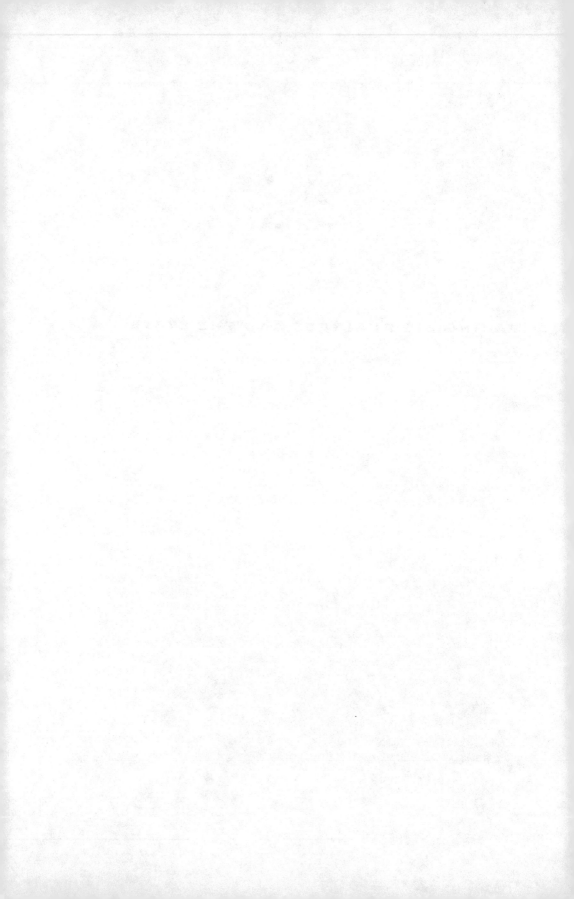

13

ART AND POLITICS IN THE 1980S

Even a cursory look through contemporary art magazines of the past year make it evident that nationally there is a rising tide of politically oriented or politically supportive art and art exhibits. *Newsweek* in its issue of February 6, 1984, signaled this fact with an "Art on the Barricades" report which pointed out that artists are again bringing politics into their work to protest the arms race and U.S. policy in Latin America.

Political art, of course, has always been on the scene, though denigrated or ignored during the heyday of formalism. That it is not only flourishing again but also being given exposure in major museums and galleries might be attributed to postmodernist pluralism and the reacceptance of realism and figuration that was ushered in during the 1970s. Limiting oneself to this proposition, however, would give credence to the argument advanced in *Newsweek* that political art is "back in fashion." To judge the present resurgence as simply a turn in the wheel of artistic "fashion" would be simplistic. Changes of "fashion" (or "style," as the artistic community prefers to call it) may be manipulated by art-market conditions, but overtly political art has not been very marketable, at least not in the United States, during the last fifty years. If artists in the 1980s are increasingly turning to such expression, other determinants must be sought.

The obvious ones are: the "wars" in Central America and the Reagan administration's aggressive resurrection of the cold war, with its nuclear arms buildup and the danger of global destruction. Involved in the former

This essay first appeared in *Artweek*, April 21, 1984: 13.

are the U.S. government's support of brutal military-backed regimes in El Salvador and Guatemala that are genocidally decimating their populations on behalf of a feudal upper class and U.S. investors; and the CIA-supported mercenaries based in Honduras and Costa Rica who are conducting a not-so-secret war aimed at the overthrow of the sovereign nation of Nicaragua. The specter of another Vietnam, of another Southeast Asia, now in Central America, is alarming artists and all people of conscience as it previously did in the 1960s.

Of the issues, the nuclear one had the longer currency and the wider appeal. Political opposition to nuclear buildup and government plans for "winnable" nuclear warfare gave rise, in 1980, to the nuclear-freeze campaign. Artists have joined forces with that campaign in two ways: through pro-peace activities and through the creation of apocalyptic art. The Peace Museum of Chicago, established in 1981, has opted for the former course with a very catholic selection of material. Thus it could exhibit "Three Centuries of Posters on War and Peace," "Patchwork and Peace Quilts," and John Heartfield's photomontages of the Nazi period. Its most spectacular event in 1983 was "Give Peace a Chance," an exhibit based on the posters, manuscripts, and memorabilia of folk and rock musicians; its centerpiece was the guitar John Lennon used to record the 1969 song from which the exhibit took its title. An equally well-attended event was "The Unforgettable Fire," the first U.S. exhibit of original drawings by survivors of the Hiroshima and Nagasaki atomic bombings.

In the apocalyptic vein, L.A. Artists for Survival presented its 1983 "Fallout Fashion" show, a performance and exhibition of wearable art pieces—fashions designed for surviving a nuclear blast. "The bomb just fell and I don't have a thing to wear," said the first flyer for this parody of fashion. Ensembles included a "tri-power tunic," "radiation hazard headgear," a lead-lined jogging suit, "his and her portable shelters," and dresses that could be converted to an instant body bag or a burial plot complete with headstone headdress. In 1982 and 1983, L.A. Artists for Survival also produced "Target L.A.," a series of multimedia events lasting several days in downtown Los Angeles and in Pasadena. A closely related performance group, garbed symbolically as nuns, is the Sisters of Survival. They have presented installations such as *Shovel Defense*, in which rows of upended shovels, backed by a banner reading "Civil Defense: A Grave Mistake," make reference to the notorious statement by a Defense Department official that the U.S. could survive a nuclear war if there were only enough shovels to go around—a modern version of the "duck and cover" slogan of the 1950s.

The Central American "holocaust" (as it was described recently in a speech by Argentinian-Israeli journalist Jacobo Timmerman in relation to massive human rights violations and massacres in El Salvador) has taken longer to elicit a public and artistic response. It began to snowball

as increasing numbers of North Americans visited Central America and brought back political, social, and artistic evidence that contradicted the U.S. government's claims about the nature of the conflicts. Films, photographic journals, poster exhibits, slide talks, and illustrated articles began to circulate in the art community, as well as among the general population. U.S. intervention in Central America became more visible and better understood. Artists were particularly incensed by the cultural destruction: the closing of universities; the imprisonment, torture, and murder of teachers and artists; and the decimation of Indian populations and the loss of their rich heritage.

In the summer of 1983, more than sixty North American and Latin American artists and art critics in New York formed the Artists Call Against U.S. Intervention in Central America. The plan was to present several exhibitions in homage to the people of Central America, in conjunction with INALSE (the Institute of the Arts and Letters of El Salvador in Exile). Such tremendous enthusiasm greeted the Call's effort that, in January and February 1984, New York City hosted more than sixty-seven exhibitions, film showings, poetry readings, and performances involving hundreds of artists. Claes Oldenburg designed a three-color poster (repro- Fig. 35 duced on the cover of the January 1984 issue of *Arts Magazine*) featuring a sexy, splintering banana being pulled down by the people of the so-called banana republics (with shadings of Keinholz's parodic quotation of the Iwo Jima memorial). Its text opened with, "If we can simply witness the destruction of another culture, we are sacrificing our own right to make culture," and went on to condemn U.S. intervention in Central America and Grenada.

Although reports are not yet in from all of the twenty-seven other cities that participated in Artists Call (Lucy Lippard is organizing a documentary of the national activities for exhibition at New York's Franklin Furnace), it can be reported that Chicago, stimulated by a visit from Call member Leon Golub, organized nineteen exhibitions, performances, and programs, and Los Angeles printed full-page ads with two hundred signatures in each of three publications, sponsored a six-hour radio festival of music and poetry as well as local readings, hosted a teach-in at the University of California, Los Angeles, and presented several street performances. Not even during the Vietnam War did the art community respond in such numbers.

Characteristic of the present moment is not just an air of crisis—which animated the Vietnam period as well—but the recognition that the crises are becoming more severe and more frequent; that crisis is an endemic state in today's world. Even young artists remember—or may have taken part in—vast student protests against the Veitnam War, and they are distressed at their country's continuing policy of foreign intervention. U.S. intervention in Central America, in Grenada, in Lebanon, in south-

ern Africa, and the provocative "war games" with Honduras and with South Korea (the largest ever this year)—these not only alarm artists, but they have the potential to erupt into a nuclear exchange. The large question is, What is the artist's responsibility? To this question, many artists have already given their answer—not only as political activists, but in the very grain of their artistic production.

14

DISSIDENCE AND RESISTANCE:
ART IN CHILE UNDER THE DICTATORSHIP

Never before in Chile has there been such a concentration of power and wealth in the hands of such a small sector of the population. This was the purpose of the force and the repression: to consolidate this new domination by totally authoritarian forces.[1]

At this time it is almost impossible to find in Chile any writer, painter, singer, dancer, or artist who identifies himself [sic] with the regime. Moreover these artists make a deliberate and active point not to. The dictatorship cannot count on their silence or their fear.[2]

The Long Night of the Generals

Within a little over a decade, from 1964 to 1976, repressive military-dominated governments took power in Brazil (1964) and three other Southern Cone nations: Uruguay (1973), Chile (1973), and Argentina (1976). The upsurge of popular movements in these areas in the 1960s and early 1970s presented a challenge to U.S. multinationals operating in these countries and to their clients, the ruling national elites. As a result, U.S.-backed and trained military leaders seized control of the states. The problem to be explored in what follows concerns the effect of brutal military dictatorship and the suppression of expression in the visual arts.

This essay is a revised and expanded version of a paper given in Mexico City at the XI International Congress of the Latin American Studies Association in 1983.

Chile can be seen as an example of the problems (and their solutions) encountered in other nations subject to special histories and circumstances. Today, Brazil, Uruguay, and Argentina have been restored to democracy—albeit shaky and facing tremendous financial problems resulting from the period of military rule—but Chile still remains under the oppressive rule of the military junta.[3]

Pushing beyond Limits

In an article called "The Invisible Chile: Three Years of Cultural Resistance," Ariel Dorfman (exiled Chilean literary critic and novelist) discussed cultural resistance after the 1973 coup in Chile in the following terms: "There are legal initiatives; there are others that border on the prohibited and explore the permissible; and there are still others that are underground. These manifold efforts have one trait in common: they constitute the determination of a people to preserve their identity, to affirm their dignity, to fire up their consciousness." In such circumstances "the mere organization of a cultural event is a victory, a preliminary step to further organizing, to making more contacts, to pushing one more inch beyond the limits which the authorities can tolerate."[4]

Since the last several years have witnessed a number of effective challenges from many sectors of the Chilean population to the military dictatorship of General Pinochet, we can understand more readily Dorfman's concept of cultural resistance as a series of small steps "pushing one more inch beyond the limits." As a matter of fact, this is precisely what has been happening. Chilean cultural resistance started at the moment of the coup with the surreptitious circulation of verses by Pablo Neruda. It continued with posters of denunciation, with art of a political dimension, and with acts of vanguard art whose hidden language permitted forbidden social commentary.

Four arenas of cultural activity might be said to exist under a repressive dictatorship such as Chile's: (1) official or accommodationist art which directly transmits the regime's ideology, or indulges in art-for-art's sake under official patronage; (2) dissident art which develops a critical stance within a country through a cryptic language that utilizes symbolism, allegory, and metaphor, or by the use of new materials and techniques which in themselves constitute a visual language able to surmount censorship, but understood by people sharing the same experiences and beliefs; (3) an art of open resistance and denunciation which is, by necessity, clandestine and is the most difficult to fabricate and distribute owing to the economics of working underground and the consequences of discovery; and (4) the art-in-exile produced by artists who have been forced to leave their country because of past political associations or involve-

ment in dissident and resistant art activities after the imposition of the dictatorship.[5]

Nuñez, Parra, Jaar: Three Dissident Artists

Guillermo Nuñez (born 1930) and Catalina Parra (1940) are two Chilean artists who have produced dissident art within Chile, and are presently in exile: one involuntary, the other self-imposed. Ten years apart in age, they represent two generations of artistic practice in Chile: that which characterized the 1960s and the early 1970s (Nuñez) and was based on a matrix of contemporary painting, printmaking, and sculpture derived from Chile's artistic traditions expanded by international currents; and that of the late 1970s and the 1980s (Parra), which focused on a system in which "language itself and the texture of communication had to be reinvented," representing a rupture with what went before necessitated by the coup, "which destroyed all the languages and models of signification by which these experiences could be named [during] what was a real crisis of intelligibility."[6] The language considered most effective was that of conceptual art in its many variations, tempered and reorganized to serve the immediate needs of the Chilean situation.

Alfredo Jaar (1956) comes of a still younger generation of artists, whose formation occurred totally within the parameters of the military government, its controls on action and thought, and the widespread suffering inflicted on the Chilean population. Each of these artists responded in an individual way to the crisis, and each represents a different facet of this response. Unifying the three is the act of dissidence itself; the decision to confront Chilean fascism as artists.

From 1975 until his return to Chile in 1987, Nuñez lived in France; Parra and Jaar both reside in New York. Influenced to some extent by the unique surrealist style of his Paris-based compatriot Roberto Sebastian Matta, and also by the neofiguration which was a dominant mode in Latin America during the 1960s, Nuñez was profoundly traumatized by his prison experiences. In May 1974, he had been arrested by the military and held five months with his eyes bandaged. (The same mentality that brutalized the hands of songwriter-guitarist Victor Jara in the Santiago sports stadium, where he was killed in 1973, covered the eyes of a painter—although it is true that cutting off visual communication has been and remains a standard practice for the political prisoners of right-wing regimes.) "This cruel experience," testified Nuñez in 1975 at UNESCO in Paris, "was rendered in drawings, paintings, engravings, sculpture and poetry [in which] I would speak of man alienated, destroyed, annihilated, humiliated, blindfolded, forced to see a distorted reality."[7]

In March 1975, Nuñez mounted exhibitions of these works at four different locations, all but one of which was canceled before opening, while the fourth—at the Instituto Chileno-Francés de Cultura—closed in twelve hours. Using the notion of Duchampian ready-mades, Nuñez exhibited "cages" which contained various allegorical objects: a reproduction of the Mona Lisa, bread, paper hands, birds, flowers, names, mirrors in which spectators could see themselves, and a red, white, and blue necktie (the colors of the Chilean flag) which was knotted and hanging like a noose.[8] This last item was too much for the Chilean authorities; Nuñez had passed the limits of the dissident artist. Arrested again and imprisoned for four and one-half months at a torture center and a concentration camp, Nuñez was expelled from Chile the same year. Nevertheless, his short-lived exhibit produced a very strong impact on the national artistic consciousness, which was to have consequences within a few years after its closure when artists began to employ even more allegorical forms to contain their artistic dissent.[9]

In exile, Nuñez continued to work through the traumas of his Chilean experiences in prints and paintings. His graphic semiabstract images of this period are more powerful for what they suggest of brutalized, violated, and bound bodies, of bones, teeth, and blood, of monstrous creatures with howling mouths, and of the occasional presence of flies crawling over the putrefaction, than any realistic presentation of torture or pain could be. They attack us at a visceral level, at the level of the nightmare. Created in exile, they are an accusation and denunciation to the world at large of the Chilean condition during the worst years of the dictatorship.

As late as 1981, Nuñez's gradually changing style continued to refract his experiences in Chile. The more recognizable and more painterly human forms of this period are torn, bound, stitched, taped, mutilated, and crisscrossed with bloody reds.[10] In this aspect of his work, the process of the technique acting on the forms is similar to that of Catalina Parra, though her experience in Chile was on a psychological rather than a physical level.

Catalina Parra, daughter of poet Nicanor Parra and niece of the late folksinger Violeta Parra, had been a domestic woman—running a house, cooking, sewing, and caring for her three children until she traveled to Germany in 1968 with her husband, German-born Ronald Kay. There her artistic direction changed dramatically, influenced by an exhibit she saw of British and U.S. pop art; by the German vanguard art of the 1920s and 1930s; and by the political movements of the 1960s. Her experience in Europe convinced her that the strongest art was that employing materials of everyday life, an attitude first embraced in recent years by pop art and extended by *arte povera* (to which her work has been compared) and Fluxus. Thus, upon her return to Chile in 1972, she began to collect

<div style="float:left">Fig. 36</div>

newspaper clippings, which, after the September 1973 coup, became one of the major materials for her artworks. Her first works after the coup (never exhibited) included postcards of the infamous stadium in Santiago where thousands were held captive, tortured, or killed. By 1977, when she exhibited her *Imbunche* series in the Galería Epoca to enthusiastic crowds drawn by the magic of the name "Parra" in Chile, her works were made of materials loaded with allegorical meanings. She used collages of her newspaper clippings, of periodicals, and of Chilean maps cut, shredded, and sewn together in graphic presentation of Chilean society; gauze which spoke of hospitals, wounds, and the dead; desiccated animal hides, plastic bags, barbed wire from fences, and other "trash." In one case large burlap potato sacks were inserted into plastic bags looking like body bags, and hung with ropes from the walls of the gallery. These *imbunches* reconstituted the memory of the people killed during the height of the coup whose headless bodies floated down the Mapocho River in the central area of Santiago.[11] Thread and stitches (or sutures) invoked the myth of the *imbunche* which comes from Chilean Indian lore: it is an infant whose bodily orifices have been sewn shut to prevent suspected evil from expressing itself—a metaphor used in a novel by Chilean novelist José Donoso, *The Obscene Bird of Night.*[12]

In *Diariamente* (Daily, in Spanish), also from the *Imbunche* series, Santiago's most important newspaper, *El Mercurio*, is "daily" bound into a loaf of bread, which is then sliced for distribution and consumption. Crude stitches hold the rifts in the torn paper together while stories are displaced, turned on their side. The key ideas, visually, are binding, slicing, tearing, displacing: processes related to censorship or the construction of an official tissue of lies in print communication. Another of the series, *Diario de vida*, features whole pages of *El Mercurio* covered with acrylic sheets and molded into a block sculpture held tightly together by bolts—an impressive metaphor for the control exercised over the news. Nevertheless, Parra was able to exhibit these works in Chile without interference from the censors. Why was this the case? Parra herself answers: "The message, if there is one, is *in* the material and *in* the technique—in the cuts, the tears, the ruptures, as well as in the stitches, the sutures, the bindings, the gauze. If you know how to read, the message is *there*. Besides, how can you censor a knot or a tear? And I don't say anything myself. I don't have to."[13] According to Parra, the whole thing was a question of reading between the lines.

Since coming to New York on a Guggenheim grant in 1980, Parra's works have become more explicitly political. Substituting the *New York Times* for *El Mercurio*, such 1981 works as *Is Pleased to Announce* uses tearing and stitching to put together an "America" of prison cells and desolation. The *Reunited States of America* interlaces football players Fig. 37 between words (themselves taken from the *Times*), as metaphors for

the Santiago sports stadium that was turned into a concentration camp. In the work *Welcome Home* the title words (which express the profound desire of many Chilean exiles) are juxtaposed against an atomic explosion.

In Chile itself, other artists continued making dissident statements with seemingly innocuous subject matter. Within the painting tradition, for example, René Miranda's *Still Life* combines fruit on a table with a huge lock and a horizontal metal bar as still-life elements. One exhibit in the conceptual mode included, as the only objects on display, envelopes stamped with the word "exile" while in another, photographs of the city of Santiago had the commercial announcements erased and replaced with the ironic phrase "Are you happy?" This latter project by Alfredo Jaar, was two years in process (1980–81), and was titled *Studies about Happiness.* The artist asked people on a major Santiago street, as a sort of game, to respond to the question by dropping candy mints into Plexiglass boxes. Close to a thousand other persons were polled with the same question as part of a museum installation. The results were exhibited as statistical graphs (34 percent said "yes" and 66 percent said "no"; those who declined to answer could eat their mints), accompanied by photographs taken when the data was collected. The graphs measured the degree of happiness in the world, and the degree in Chile.[14] On this subtle personal level, what has been called the "micropolitics of perception, behaviour, affectivity or interpersonal communication"[15] could be carried out as a dissident strategy.

Since his 1982 arrival in New York, Jaar (a practicing architect) has continued to make installations based on a juxtaposition of found or constructed objects with enlarged photographs. Through these means, he has explored—in a more transparent and accessible manner—the condition of the Third World vis-à-vis the First World that is foreseen in the *Happiness* project. In 1984, for example, he presented for exhibition in Los Angeles a caustic installation titled *Motherland, Motherland. What Mother, What Land?* Conical piles of earth (the mother's "breasts?" the Andes?) contrast with high-technology neon tubes placed like tall candles in the cones' tips that shine forth to illuminate four photographic blow-ups illustrating phases of conquest: pre-Columbian Indians, the arrival of the Spaniards, the North American military, and Chilean police with clubs.[16] These have been followed by projects such as his visual exploration of the great pit in Brazil's Amazonia wilderness where thousands of impoverished workers toil like ants to extract grains of gold which might relieve the misery of their lives. The luxury of gold for the West is counterpointed by images of the weary and soiled miners, magnified in large light-filled boxes, which make the point subtly but powerfully. A more recent project concerns the dumping of toxic wastes from industrialized nations in African sites (symbolic of other Third World dumps). "My

Fig. 38

work," says the artist, "focuses on the widening gap between the 'so-called' Third World countries and the 'so-called' Developed Nations. My work deals with both worlds at the same time because no other alternative seems to me real enough."[17]

All of Jaar's works show great respect for facture; at the same time he has embraced a principal theory of the young Chilean avant-garde: to keep each work open-ended, requiring the thought and response of the audience for closure. Like his colleagues, he resists the label "political" to the extent that it connotes an ideological posture; however, social engagement is intrinsic to art from Latin America, in his opinion, and any activity can have political connotations.

Cultivating Cultural Dissidence

Chilean government policy toward culture has gone through several phases. The first, from 1973 to 1975, was directed at the eradication of the cultural model that existed under Allende. This was the period of jailings, assassinations, and deportations of thousands of people, intended to destroy the political-social movements. The destruction of culture took the form of book burnings, whitewashing of murals, and the establishment of censorship which prohibited mention of violence, sex, or poverty in the fine arts, to say nothing of political criticism. Chile's cultural movement was in a state of disarray, of trauma, of chaos. Though dates differ, it is clear that within a few years of the coup, there began the development of an alternative cultural movement, especially in the areas of poetry, popular song, and semipublic theater, which took the place of social and political actions that could not be exercised owing to the repression. This artistic discourse, and the spaces generated by it, played an essential role in the maintenance of identity. Facing the disappearance of other signs of identity—those derived from political or other social practices—art provided a symbolic substrata of basic identity. However, artistic practice originally became such a mode of expression and congregation because of the absence of other possibilities, rather than being an alternative cultural-artistic movement offered as a new form of political practice.[18] In other words, when political practice was absolutely dammed up in the early years, the river of political opposition cut new cultural channels to maintain itself, and as a holding action against complete annihilation. The rich stratum of popular participation during the Popular Unity period of Salvador Allende was not allowed to vanish. Instead it became a barely visible subterranean stream until it could, as Dorfman argued, push inch by inch beyond the limits of authority.

In the specific arena of visual arts, artistic practice was dismantled after the coup through the direct repression of artists and intellectuals, many of whom were expelled from the universities and art schools (the

University of Chile was particularly hard hit), or jailed and exiled. As a result, a generation of artists who carried the rich accumulation of Chilean artistic development and its collective memory, as well as those, such as José Balmes, who were instrumental avant-garde figures in contemporary Chilean art, were cut off from their role as teachers. Among these artists, in addition to Balmes, are figures such as his wife, Gracia Barrios, Nemesio Antúnez, Roser Bru, Guillermo Nuñez, and many others who went abroad to live, primarily in Paris, where a large community of exiled Chilean artists and intellectuals gathered.[19]

By 1977, the government felt sufficiently secure to vary its tactics. Repression still functioned, but it was more selective and indirect. At this point, corresponding with the rigid restructuring of the Chilean economy, private business and financial institutions entered the camp of the arts, offering an alternative to government control. The arts were promoted through scholarships, exhibitions, and workshops. Somewhat freer, artists nevertheless discovered that control was still exercised: works were censored, certain artists were not shown, scholarship recipients had to comply with certain conditions or repay the monies granted them. On a more subtle level, though artists were permitted to exhibit and earn a living (if they could), they limited their own expression in anticipation of what would be allowed by patrons.[20]

It is under these circumstances that conscious dissident art could find an audience, using ingenuity and creativity to make a statement and avoid censorship. Conceptual art seemed to offer such a means, and a younger generation of Chilean artists turned to the codes available to them through the international avant-garde of the 1960s and 1970s and through the experimentation of artists such as Francisco Brugnoli, an art professor expelled from the University of Chile after the coup. Brugnoli had been exploring the manipulation and possible significations of found objects from daily life since 1963 (an idea triggered by the collaged objects introduced into informalist paintings by his professors, and by himself as a student), and he disseminated his ideas to younger artists through the Visual Arts Workshop, which he established in 1976. In this period, artists began to reject pictorialism, representation, illusion, and the traditional aesthetic formulas and elements. Art was to "present" rather than "represent" daily life, and thus to break the boundaries between the two.

The languages found most attractive were those of the contemporary currents in Europe and the United States which ranged from land art (earthworks), derived from ecological interests in the sixties; body art, in which the artist's own person becomes the terrain of experiences and statements; art language (or lettrism), which employs letters and texts with or without images as a means of visual communication; and the whole area of happenings and performance. The embryonic type of objects with double meanings employed by Guillermo Nuñez in 1975 proved too

transparent, as was evidenced by their immediate comprehension and suppression by the State. A more complex visual language was required: one that undermined the precepts and structures of the dictatorship, that was more opaque but whose message was available to reasoned viewing. The theoretical foundation for this new language was established in his writing and teaching a year before the coup by Ronald Kay, an aesthetician of the University of Chile, and was based on European precepts of structualism and semiotics. Kay was instrumental in bringing an exhibition by German artist Wolf Vostell to Santiago in 1975. Vostell's combination of mixed media works, film, happenings, and conceptual art had an enormous impact on young artists seeking new means of artistic communication. Within the same period, Kay, Catalina Parra, and Eugenio Dittborn organized themselves into the group VISUAL to produce publications, among which were catalogues of exhibitions by Parra and Dittborn. Kay also published the more theoretical *Manuscritos* magazine.

Art critic, theoretician and committed defender of the post-coup avant-garde, French-born Nelly Richard (who worked closely with Kay after 1976) uses the term *avanzada* ("advanced," or avant-garde) to refer to the experimental art movement that developed from 1977 until 1982. Richard subscribes to the idea that the introduction of photography into the work of art was an early sign of the displacement of traditional pictorial imagery in Chilean art with a series of new codes. This displacement, she argues, coincides with the end of the period of silence after the 1973 coup. Since the photographic image functions as a substitution for the scene it documents, it appealed to Chilean artists at a time when all comprehension of the real and the transformation of living structures was subject to censorship and prohibition. The photograph, says Richard, was able to intervene as a *correction* of so-called reality; as a substitution or analogical copy of the denied reality.[21]

Among the artists employing avant-garde languages modified to respond to their necessities and interests were (in addition to Brugnoli) Virginia Errázuriz, Eugenio Dittborn, Francisco Smythe, Catalina Parra, Carlos Leppe, Gonzalo Mezza, Gonzalo Díaz, Carlos Altamirano, and Alfredo Jaar. Street actions and video also attracted a group of young artists who formed the Colectivo de Acciones de Arte (CADA; "Actions of Art" Collective), including, among the visual artists, Lotty Rosenfeld and Juan Castillo; writers Diamela Eltit and Raúl Zurita, and the sociologist Fernando Balcells.[22]

Though many of the *avanzada* artists reject the art production of the Allende period as being outmoded in light of their current realities, CADA claims that its closest antecedents were the Brigadas Ramona Parra, the most prominent of the mural brigades that painted walls in a graphic and uniquely Chilean style during the years of the Allende presidency. There is little doubt that the "art actions" of CADA are the most

overtly political projects of the *avanzada* artists. Its 1979 action, *Para no morir de hambre en el arte* (*Not to Die of Hunger in Art*), used milk as a symbol of human and artistic survival. Four activities were mounted in one day: (1) 100 liters of milk in plastic bags were distributed in the *poblaciones* (marginal neigborhoods) of Santiago by the artists, aided by popular artists from the *población*. Each bag was stenciled "Half a liter of milk" (a reminder of the Allende campaign slogan "Half a liter of milk for every Chilean child") and the recipients were asked to return the empty bags so artists could make artworks of them for a gallery exhibition. (2) A text in five languages—Spanish, English, Russian, French, and Chinese—denouncing the marginalization of the Third World, was read over loudspeakers in front of the United Nations building in Santiago. The military appeared, but soon left, another indicator that the critical language codes employed were understood neither as art nor as social criticism of the establishment. (3) A blank page in the magazine *Hoy*, which circulated throughout Chile, included a brief text which said "Imagine that this page is completely blank / imagine that this blank page is the milk needed every day / imagine that the shortage of milk in Chile today resembles this blank page." (4) Finally, thirty liters of milk that had not been distributed, along with the empty plastic bags, were displayed in the Imagen Gallery as a negative reflection on the problem of malnutrition in Chile. Simultaneously, similar actions were carried out by Chilean artists Eugenio Tellez in Canada and Cecelia Vicuña in Bogotá, Colombia.

In a sequel six months later, *Inversion of the Scene*, ten milk trucks, obtained at great risk from the milk factory where the liters had been purchased and obtained with the most imaginative type of subterfuge, were driven through Santiago and stationed at the National Museum of Fine Arts (purportedly as an homage to its tenth anniversary). At the same time, the facade of the museum was covered with a blank banner, effectively closing down the establishment and symbolizing the continuing hunger. All these "social sculptures," as the group refers to them, were carried out "in the cracks of the system" and documented with video and photography.[23]

Censorship and the Critical Code

Like artists, critics are also subject to self-censorship, or to selective "blindness." Faced with dissident art, critics may write reviews about art forms that express "universal anguish," thus defusing a latent and very specific political message. In one instance, an official Chilean critic, confronted by a cryptic display and not wishing to be backward in the face of vanguard art, appeared not to understand—or *chose* not to understand—the subterranean message of the works.[24] Other critics have been

known to take refuge in the label "surrealist," which signifies "dream-like; not of this world," when confronted by works whose honest and favorable review might place the critic (and the artist) in jeopardy. There have also been cases when official criticism has celebrated the new direction taken by the avant-garde, thus showing off its own good taste in choosing radical works and bringing itself up-to-date. Of course, such selections had the effect of neutralizing the critical content of the works by treating them as museum pieces or as simple episodes in the history of Chilean art. It was made sufficiently clear to the artists that "any work, regardless of its original intention, always runs the risk of being embraced by institutions and tailored to the needs of authority,"[25]—a situation not unique to Chile, or even to dictatorial regimes.

Resistance at Home and Abroad

At the same time that the dictatorship allowed its middle class and intellectuals a supposed modicum of relaxation and "liberation" (the well-known *apertura* of such governments), its ideological control of the mass media, and of popular art forms (street theater, *nueva canción* (new song), and visuals such as comics, caricatures, street murals, posters, photography, and film) which reached a majority of the people, remained in place. Nevertheless, in both the mass media and the popular arts there also exist forms of dissidence and resistance.

For example, the Santiago group AFI (Asociación Gremial de Fotografós Independientes; Fraternal Association of Independent Photographers), organized in 1981, provided an umbrella of protection and support for professional photographers and photojournalists recording daily Chilean life, by which is meant the visible signs of political resistance and repression and the terrible impoverishment of the Chilean working class. From organizing photographic exhibits to protecting the integrity and physical safety of photojournalists recording the most varied type of street activity (including scenes of military and police violence), AFI engaged the social scene determined to maintain free access to information and the exposition of its work without interference or censorship. Toward these ends, it worked to establish a collectively administered Photographic Agency; it set up methods of obtaining quality materials at low costs through group purchases; it sought spaces for exhibitions and funding for photographic publications that could present to the public the real problems and possibilities of photography; and it undertook to aid its members in constantly developing their technical and visual abilities.[26] One of AFI's tactics, which may seem minor but actually protects photojournalists from police attack, arrest, and brutality, by identifying them as working professionals, was the issuance of an AFI press credential. On such details can dissidence and resistance depend.

Chilean photographers found their way into documentary books with the most moving and denunciatory of their photographs. Marcelo Montecino, who made his home in Washington, D.C., and is probably Chile's best-known photographer abroad, published *Con sangre en el ojo*, an extraordinary collection of photographs which documented oppression and insurrection in a number of Latin American countries from 1973 to 1980. A more modest effort is a small book published in Chile, *El pan nuestro de cada día*, similarly recording events from Chilean life since the coup. None of the young photojournalists in this book is identified except the five courageous men who worked so hard to produce this publication, which, as they say in the introduction, may be common in other countries but is a genuinely novel testimony in Chile.[27]

On a popular level, the famous Chilean *arpilleras* (appliqued and stitched political narratives by women from families of prisoners or the disappeared) are disseminated throughout the world. The first *arpillera* workshop was established in 1974 under the protection of the Vicarate of Solidarity of the Catholic Church to provide aid and a means of survival for the families. Functioning entirely within the strict ecumenical laws of the Church and the office of the Archbishop, the workshops cannot be dissolved by the government, though the government has attacked the Vicarate and confiscated shipments being sent abroad of *arpilleras*. When an exhibition of *arpilleras* was mounted in Santiago's Paulina Waugh Gallery in 1977, the gallery was burned down during the night. Nevertheless, the *arpilleras* continued to be made. The Vicarate provided the materials, bought the finished articles from the workers, and undertook to sell the work (mostly abroad), using money from the sales to buy more materials. While the *arpillera* is not unique to Chile, those of Santiago are the only ones to have political themes.[28]

Following the example of the wall murals of the Allende period which were eradicated from the walls after the 1973 coup, murals have been created in other countries by groups of artists such as those of the Orlando Letelier Brigade in the U.S. (various locations), the Victor Jara Brigade in France (1975), and the Salvador Allende Brigade in Mexico (1981). The earliest homage to Chile's murals was painted as a protest by Latin American and North American artists in the streets of New York's Soho district in October 1973, one month after the coup. This was the recreation of a 100-foot mural originally located by one of the Ramona Parra Brigades along the River Mapocho in Santiago. A week later, the mural was set up outside the Chilean National Airlines.[29]

In Chile itself, messages against the junta, combined with images, continued to be painted secretly on walls during the night. However, a more characteristic form of protest was scrawling messages for circulation on paper money, and on the seats of buses. By 1984, when the repression eased and the art of the *avanzada* was slowly being erased from center

stage by a return to painting and a return of exiled artists from abroad, a group of artists calling themselves the Asociación de Artistas Jovenes (APJ; Young Artists Association) resumed painting murals in the shanty-towns and made protest posters for a trade union.

Though criticized by the theoreticians of the *avanzada*, clandestine posters of high quality flourished during the 1970s and into the 1980s, produced by groups such as the Trabajadores del Arte (Art Workers), the Taller Nueva Gráfica (New Graphic Workshop), Gráfica, and Sol; by individuals such as "Alex," "Vicente," and "Toño" (whose last name was Larrea; the last names of the others are unknown), who were postermakers during the Allende period; by artists in exile; or anonymously. In silkscreen and offset, the posters contained political statements (such as one posted on a wall admonishing soldiers not to shoot their own people), announcements of cultural events, and portraits of proscribed cultural personalities such as Pablo Neruda, Violeta Parra, and Victor Jara. In Europe, the Pablo Neruda Brigade, in addition to painting new murals in 1975, produced a series of posters based on the synthetic mural style of the Chilean brigades before September 1973. In San Francisco, California, exile René Castro is known for posters with a focus on social and political issues produced by a silkscreen workshop that has been operating from the Mission Cultural Center for many years.

Artists-in-Exile

In a 1983 speech, Chilean writer Fernando Alegría, living in northern California for many years, pointed out how indispensable it is for artists in exile to give their testimony. In accord with this perception, and freed of constraints that hampered them after the coup, the exiled artists have produced a body of work that makes Chile its center of protest and anguish. Not all exiles followed this course, but there was a sufficient number to make possible a traveling exhibition in 1980 of paintings, sculpture, drawings, and prints by artists of several generations living in Paris, London, Caracas, Mexico, San Francisco, and San José, Costa Rica. Titled *"Chile Presente": Images of Betrayal and Defiance,* the presentation included Nemesio Antúnez, José Balmes, Gracia Barrios, Juan Bernal Ponce, René Castro (one of the organizers), Irene Domínguez, Patricia Israel, Helga Krebs, Eduardo León Rodríguez, Humberto Laredo, Roberto Matta, and Guillermo Matta. To this constellation were added Sergio Castillo, Belisario Contreras, Leonardo Ibañez, Hugo Rivera, Carlos Solano, and Raúl Sotomayor. The only shared characteristic was a common vision of denunciation and warning, contained by their presence in the exhibit, if not in the work itself. Neither was this the first nor the only demonstration of the vitality achieved by the artists in exile. With changing personnel, with different works reflecting the heterogeneity of

Chilean art, exhibitions (which should be seen as gestures of denuncia-
tion and of support by the institutions and their supporters) have been
held in France, Italy, Spain, Australia, Germany, Czechoslovakia, and
many other nations. Chilean culture continues to be Chilean culture, be-
tween this new culture of external exile and that of the "internal exile."

Unfortunately this is not the reality that prevailed when, beginning in
1982 and concurrent with a state of crisis in Chile which led to a more
permissive cultural environment, artists began to return home from ex-
ile. Tension arose between the younger generation of the *avanzada* that
had filled the void left by the exiled artists and those who returned after
bitter years abroad expecting to reinstate themselves in their old posi-
tions. Among the returned exiles were leaders of the artistic movement
during the Allende period who had supported the mural brigades and
popular culture, and had been critical (like remnants of the Left in Chile)
of what they viewed as the elite procedures of the *avanzada* during the
late 1970s. This period also coincided with the gradual recovery of the
student and union movements. As Nelly Richard phrases it, "This return
to contestation changed the order of priorities: most of the Chilean dis-
sidents and artists felt the need to have closer ties with the working class
struggle, to have a greater voice in the mobilisation of the people. Hence
they moved away from the relatively restricted sphere of the avanzada
towards forms of expression with greater popular appeal."[30]

Fig. 39 At the same time, another generation of artists, under the influence of
Gonzalo Díaz, who had returned from a stint in Italy bearing with him
the international modes of transavantgardism and neoexpressionism, re-
turned to painting and the pictorial utilizing new techniques of mixed
media. The return to painting, including the use of the new media of
spray painting, stenciling, serigraphy, and so forth, which Díaz continues
to employ as part of powerful and critical works and installations, is not
as serious as the loss of critical content on the part of the younger artists.
Postmodernism has invaded Chile, seducing younger artists without a
clear view of either Chilean or international politics, and interested in
being in fashion during a decade in which Latin American art has been
gaining increased visibility in the industrialized world. This is not a phe-
nomenon unique to Chile, but one which is occurring in many of the
more cosmopolitan Latin American nations, nevertheless it marks the end
of Chile's internal isolation from the international arena just as the for-
mation of the *avanzada* in 1977 marked the beginning of that end.

The more serious problem, however, is the fracture between the exiles
and the *avanzada* who needed to make common cause as opponents of
the Chilean dictatorship as long as it existed. One might venture to disa-
gree with Nelly Richard in her finding that the reappearance of painting
in its new forms automatically means the disappearance of dissident and

resistant art. There is certainly a degree of modish and superficial paint-
ing in Chile on display, as my visit in 1988 attested. However, there are
painters of considerable weight and substance from both the older and
the younger generations, as well as artists at home and abroad who con-
tinue to work in the traditions of the *avanzada* but, as already pointed
out, with greater transparency and accessibility. Finally there is the grow-
ing presence of Chilean photography, doubtless encouraged by the three
Colloquia and Exhibitions of Latin American photography that occurred
in Mexico in the years 1978 and 1981 and in Cuba in 1984, though Chi-
lean photographers only participated in the second event. The February
1988 issue of *Punto de Vista,* published by the Association of Indepen-
dent Photographers, joined the historical researches launched by the Col-
loquia with an article on Chilean photography from 1840 to 1940; and
published a lecture given by Pedro Meyer of the Mexican Photography
Council which launched the Colloquia.

By 1987, according to one knowledgeable observer, the people of Chile
were losing their fear—a fact demonstrated by the majority "No" vote to
the continued reign of General Pinochet at the October 1988 plebiscite.
Symbolic of this new phase was the appearance of a huge poster on the
side of a building in the middle of Santiago which said, "Now that we
have lost everything, let's also lose our fear." Preceding the plebiscite,
from the 11th to the 17th of July 1988, was an immense festival widely
publicized in the alternative press as "Chile Crea" (Chile Creates), an
"international encounter of art, science, and culture on behalf of Chilean
democracy." During the seven days of the festival, from early morning
until late at night, at various sites in Santiago and in cities across the
nation, Chile Crea presented films, videos, poetry readings, art exhibits,
mural paintings, theater, discussion panels, lectures, dances, song, and
music to thousands of participants. Instrumental in organizing this vast
endeavor were the returned exiles José Balmes, Gracia Barrios, Patricia
Israel, and many others.

Though some members of the *avanzada* carped at Chile Crea as an
ineffective gesture and declined to participate, it was, nonetheless, an
event of major importance considering the results of the plebiscite, which
few people expected. Apparently the former exiles had accurately mea-
sured the mood of the time, and perhaps contributed to its success—
something very hard to prove. Even the "no" vote was not an automatic
guarantee of democracy. Both events, however, were a measure of change
occurring in Chile on a mass level; of a unity across groups and classes
that might shatter if democracy were actually instituted again, but is
functioning to check, even if not to totally dislodge from power, the mili-
tary junta.

Dissidence and resistance in the arts remain the touchstones of Chi-

lean opposition to the fascist dictatorship, and have proved their viability as cultural processes that raise consciousness, give new insight, and support the morale of an embattled people.

Notes

1. Osvaldo Aguila M., *Propuestas neo-vanguardistas en la plástica chilena: Antecedentes y contexto* (Santiago: CENECA, 1983), 8. All translations from the Spanish are mine.
2. Reynaldo Ramírez and Raúl Silva, "Nelson Osorio: Chilean Culture Under Pinochet," *El Tecolote* (April 1988): 8.
3. The dismantlement of the Pinochet regime occurred in three stages: a plebiscite in October 1988 in which a yes or no vote in favor of the regime was allowed and 57 percent of the votes registered "No" in spite of the fear; elections for president set up in 1989 (Pinochet decided not to be a candidate); and the turning over of power by Pinochet in 1990 to the newly elected president Patricio Aylwin.
 By 1990, the newspapers were filled with reports of unearthings of mass graves of the "disappeared." Conceptual artist Gonzalo Díaz installed his 1990 metaphorical work *Lonquen*, the entrance to such a grave inside a mine which had been investigated by human rights advocates ten years earlier. Wired together against an A-frame of wooden beams like those of a mine were numbered stones for each of the victims, and a series of black-framed *via crucis* that led to the entrance.
4. Ariel Dorfman, "The Invisible Chile: Three Years of Cultural Resistance," *Praxis* 2, no. 4 (Goleta, Calif.; 1978): 192.
5. This framework has been adapted from one established by Teresa Latorre in "Arte oficial y arte disidente en Chile," in *Chile vive* (Mexico, D.F.: Centro de Estudios Económicos y Sociales del Tercer Mundo, A.C. y El Instituto de Investigaciones Estéticas, Universidad Nacional Autónoma de México, 1982), 63–75.
6. Nelly Richard, "Margins and Institutions: Art in Chile Since 1973," *Art & Text* (May–July 1986): 17.
7. Reprinted in *Arte* (Berkeley, Calif.; Fall 1977): 2.
8. Soledad Bianchi, "El movimiento artístico en el conflicto político actual," *Casa de las Américas*, no. 130 (Havana; February 1982).
9. Osvaldo Aguilo M., *Propuestas neo-vanguardistas*, 12.
10. See *Guillermo Nuñez: Chilenisches Tagebuch*, a catalogue with texts by Sigrun Paas-Zeidler and Georges Raillard, Wilhelm-Hack-Museum, Ludwigshafen am Rhein, April–May 1981. Author visited the artist at his home in the outskirts of Paris in September 1986; and in Santiago de Chile in July 1988.
11. Author's interviews with the artist: in New York, June 28, 1989, and by phone, October 8, 1989.
12. See Ronald Christ, "Catalina Parra and the Meaning of Materials," *Arts-canada* 38, no. 1 (Toronto; March–April 1981): 3–7.
13. Christ, "Catalina Parra," 5.
14. Author's interview with the artist, New York, April 12, 1986. An illustra-

tion of the project can be found in Gaspar Galaz and Milan Ivelic', *La pintura en Chile desde la colonia hasta 1981* (Valparaíso: Universidad Católica, 1981), 367.

15. Richard, "Margins and Institutions," 19.

16. See Shifra M. Goldman, "Latin Americans Aquí/Here," *Artweek* (December 1, 1984): 3–4.

17. Quoted in the catalogue *Freedom Within*, Fine Arts Center Art Gallery, State University of New York at Stony Brook, 1985. For an overview of Jaar's work, see *Alfredo Jaar*, text by Madeleine Grynsztejn (La Jolla, Calif.: La Jolla Museum of Contemporary Art, 1990); also see Shifra M. Goldman, "How Latin American Artists in the U.S. View Art, Politics, and Ethnicity in a Supposedly Multicultural World," in this book.

18. Anny Rivera, *Notas sobre el movimiento social y arte en el regimen autoritario 1973–83* (Santiago: CENECA, 1983), 3–4.

19. It is said that one million Chileans, about 10 percent of the population, became exiles. Chilean artists can be found in many countries of Europe, Latin America as well as in the United States and Canada; however, the largest contingents are to be found in the two international art centers: Paris and New York. Paris offers many support structures, among them the almost three hundred Latin American artists who live there (including Chilean Roberto Sebastian Matta), a certain degree of interest from the French government, the academic world, the Left, and some galleries—both public and private. The Maison de l'Amérique Latine, sponsored by the Centre d'études et de recherches sur l'Amérique Latine et le Tiers Monde, has regular art shows. In addition, the Espace Latino Américain is a gallery maintained by Latin American artists, as is the gallery of the Anysetiers du Roy, directed by a Chilean artist. (This latter space is now closed.)

Though artists have been returning to Chile since 1982, a certain number—having made homes abroad and had children who are now in the their teens and twenties—will never return to live in Chile.

20. For a more extended discussion of the two phases, see Soledad Bianchi, "El movimiento artístico." The visual arts in the second period enter the market as consumer commodities. Privatization of all forms of culture, including education, is characteristic of this phase.

21. Richard, "Margins and Institutions," 36.

22. See Gaspar Galaz and Milan Ivelic', *La pintura en Chile desde la colonia hasta 1981* (Valparaíso: Universidad Católica de Valparaíso, 1981), 342–65.

23. From the author's interview (and video viewing) with Lotty Rosenfeld, Santiago, July 17, 1988.

24. Teresa Latorre, "Arte oficial y arte disidente," 68.

25. Nelly Richard, "Margins and Institutions," 27.

26. *Punto de vista*, AFI bulletin, no. 1, October 1981.

27. Marcelo Montecino, *Con sangre en el ojo* (Mexico, D.F.: Editorial Nueva Imagen, 1981). *El pan nuestro de cada día* (Santiago: Terranova Editores S.A., 1986). Author's interview with the latter photographers, July 1990.

28. *Arpillera* in Spanish means burlap, the fabric on which many of the narratives are embroidered. Chilean women have long had a tradition of using leftover scraps for practical or decorative articles. The nearest form to the Santiago *arpilleras* were the tapestries made by folksinger Violeta Parra in the 1950s. See Marjorie Agosin, *Scraps of Life: Chilean Arpilleras. Chilean Women and the Pinochet*

Dictatorship, trans. by Cola Franzen (Trenton: The Red Sea Press, 1987). For information about Violeta Parra's tapestries, see Isabel Parra, *El libro mayor de Violeta Parra* (Madrid: Ediciones Michay, S.A., 1985), 13, 71–72, 113–16. Also see David Kunzle, "El mural chileno: Arte de una revolución. La arpillera chilena: Arte de protesta y resistencia," in *Chile vive.*

29. See "The Death of a Mural Movement," an edited version of an article by Eva Cockcroft in Lucy R. Lippard, *Get the Message? A Decade of Art for Social Change* (New York: E. P. Dutton, Inc., 1984), 43.

30. Richard, "Margins and Institutions," 106.

15

REWRITING THE HISTORY OF MEXICAN ART: THE POLITICS AND ECONOMICS OF CONTEMPORARY CULTURE

Because they share a common border and a situation of economic interdependence very heavily weighted in favor of the United States, any discussion of cultural exchange between Mexico and the United States which takes the realities into account must consider not only the artistic activities themselves, but the contexts in which these activities take place.

The purposes of this paper are three. First, to show the interplay between corporate and government policies regarding the visual arts of Mexico resulting from economic and political negotiations between Mexico and the United States during the 1970s and the early 1980s, particularly around the issue of Mexican petroleum. Second, to show the impact on modern Mexican art of a sudden speculative boom on the international art market for Mexican and Latin American visual arts as investment commodities. Third, to demonstrate the distortion of Mexican art history resulting from these activities that are extrinsic to art production and enjoyment.

This essay first appeared in Jerry R. Ladman, ed., *Mexico: A Country in Crisis* (El Paso: Texas Western Press, University of Texas, 1986), 96–115. I wish to thank Dan Lund and Norris Clement for their perceptive comments and suggestions on an earlier version of the essay.

It has long been something of a heresy to suggest that artists are affected, even subtly, in their styles and themes by economic and political considerations. Or that artists become celebrated not only for their superlative aesthetic qualities but also in consequence of the policies of governments and businesses on the one hand and the speculations and manipulations of the art market on the other hand. Or that art history and public taste can be shaped by issues presumably outside the sphere of artistic concerns.

However, in this era when multinational corporations and banking firms are openly entering the realm of culture and the arts, from the purchase of film companies and book publishing houses to the underwriting of art exhibitions and the operation of art galleries; and when communications has become a major international industry for the shaping of consciousness and ideology, it should come as no surprise that private, corporate, and public state interests are increasingly reflected in visual arts policy. It is also hardly surprising that public tastes in the arts can be molded by the choices of museum curators, the opinions of art critics with prestigious publications, and the degree of "hoopla" surrounding any given art event.

Commodification of the fine arts—presumably one of the bastions of hand craftsmanship and intellectual, affective, and sensuous dimensions which are valued for their human content apart from utilitarian function and market exchange value—is a new proposition. For a number of years, it has been discussed in U.S. and European art journals in reference to the "mainstream" art of the metropolitan centers which set the trends. The political and ideological uses of the mass media in the Third World have an extensive literature,[1] and the objectification of crafts and folk culture for tourist consumption to generate dollars is a growing field for investigation.[2] However, the proposition that modern and contemporary Mexican (and Latin American) fine art, and the *consciousness* it represents, can be viewed as a "raw material" from a dependent country, a "resource" of a particularly valuable character that can be manipulated at home and exhibited or sold abroad for the ideological and financial "profit" of foreign investors, with the assistance of the Mexican ruling class and government, is a fairly new one.[3]

A Chronology of Mexican Art as a Part of Cultural Exchange

1930s to 1970s

In the United States, modern Latin American art for the most part has been held in low esteem and considered as "second class" to that of Europe and the United States, except at very special junctures. There are four periods in which a strong U.S. interest in the art of Mexico and Latin

America can be clearly seen. First, during the Great Depression of the 1930s, the U.S. government attempted to salvage artists-as-workers from economic disaster and used the Mexican muralist model as a guide. At that time, major capitalists like Edsel Ford and Nelson Rockefeller commissioned murals from leading Mexican artists, while liberal and radical artists welcomed and learned from the Mexicans. Second, in 1940, recognition was extended to Latin American art as part of President Roosevelt's "Good Neighbor" policy, one year before the United States entered World War II and two years after Mexico had nationalized the U.S. oil companies. Third, during the 1960s renewed U.S. interest in Latin America followed in the wake of the Cuban revolution and the development of the Alliance for Progress. In this period Latin American art exhibits proliferated as part of cold war policies. Fourth, during the 1970s two processes occurred: (1) Chicanos, seeking to recover a nationalist-cultural heritage in response to conditions of exploitation and racism, looked to their mother country for artistic inspiration; and (2) large U.S. financial interests, concerned about U.S. energy needs and anxious to participate in the Mexican oil boom, used Mexican art as a means to court their southern neighbor under the guise of "cultural awareness." During this same period, U.S. investors purchased Mexican art as an investment against inflation.

It is this last aspect which is developed below, beginning with a selective chronology and contextualizing artistic happenings with economic and political events.

The Years 1973 to 1978

U.S.-Mexico cultural exchange from the mid-seventies to the present has had as an economic backdrop the discovery of vast reserves of Mexican oil and natural gas; the U.S. need of this energy resource as a result of the Iranian and other crisis in the Middle East; and, finally, the worldwide inflation and recession which caused speculators to seek stable investments in the field of fine arts.

The cultural exchange outlined below is already part of history. However, the argument which postulates the commodification of Mexican fine arts by their use to advance international business deals at those times most favorable to U.S. financial and political interests, and by their sale as investment commodities, can not only be considered valid, but historically predictable. With the onset of the international oil glut and the breakdown of U.S.-Mexican oil negotiations in terms favorable to the U.S. economy, it can be assumed, following past patterns, that there will be few or no major Mexican art exhibitions in the United States until another special economic or political need arises.

In 1973, the United States experienced its first major oil shortage, with

long lines at the pumps and higher prices. The following year large petroleum deposits were discovered in Mexico. At the end of 1976, with the inauguration of José López Portillo as president, Mexico was laboring under a huge $28 billion public foreign debt and facing three years of austerity under the eye of the International Monetary Fund following two devaluations of the peso during the previous Echeverría regime. The pressure of these loans—over 50 percent of which derived from U.S. financial institutions—plus double-digit inflation and massive capital flight produced rumors of a miliary coup d'état in a previously stable political state: rumors which later proved to be false. Mexico's economic future appeared very bleak.

Fig. 40 In order to ransom the country, López Portillo ordered Petróleos Mexicanos (PEMEX, the state oil company) to release reserves hidden from foreign eyes by the staunchly nationalist agency, and to redouble exploration. The results were spectacular. Billions of barrels of petroleum were discovered in the southeastern region, while the northern deserts were found to be honeycombed with natural gas pockets. Mexico, which had been importing oil for several years, saw itself once again as a major exporter, and viewed petroleum as the motor of the country's economic resurgence and a solution to its internal social problems. It was also seen as a means to relieve its exploitable dependence on the United States. None of these hopes, however, have been realized.

As Mexico's oil reserves rose, so did its credit rating. The International Monetary Fund relaxed its restrictions on Mexican borrowing and advanced another $1.2 billion for oil exploration and development, while many private U.S. banks that had earlier balked at loans also freed up funds. U.S. oil companies offered equipment and technology. By 1978, most of the new petroleum infrastructure was being very profitably built by U.S. firms, since Mexican firms—traditional suppliers of PEMEX needs in line with its nationalist policies—were unable to meet the sharply increased demand for capital goods.

By mid-1977 the North American media reacted to the new discoveries with great enthusiasm, and by 1978 both *Fortune* magazine and the *Wall Street Journal* greeted Mexico as a petroleum superpower.[4] The U.S. executive branch of government now became interested in reestablishing "good neighbor" relations—though it was wary of Mexican nationalism, which, since the oil expropriations by the Cárdenas government in 1938, had been strongly expressed through the concepts of sovereignty and the utilization of natural resources for the internal benefit of the nation. At a February 1977 meeting in Washington, D.C., between the newly inaugurated U.S. president, Jimmy Carter, and López Portillo, a mechanism was set up to discuss political, social (including cultural), and economic matters.

In spite of this meeting, disagreements existed on both sides. There

were questions in the United States as to whether Mexico had sufficient reserves of petroleum to make it an important world producer; whether it had sufficient technical capabilities to extract the petroleum; and whether the United States could depend on Mexico to supply its necessities. Mexico itself was not ready to commit most of its production to a single purchaser. Of decisive importance was the question as to whether Mexico would be willing to sell its petroleum below OPEC prices, in effect undercutting the unity of world oil producers, including its own neighbor, Venezuela. Internal Mexican politics were polarized between the desire to sell petroleum and reap immediate profits and political benefits and cautions against exhausting an irreplaceable natural resource (by 1990, it was estimated) with insufficient compensation. Bargaining over these issues went on during 1977, with agreements and cancelations of agreements.

By 1978, despite the pessimistic expectations in the United States, PEMEX was two years ahead of schedule in production. In April 1978, Senator Edward M. Kennedy jumped into the fray with a speech to the U.S. Senate intended to ameliorate Mexico's fears, but still insisting on special pricing privileges for the United States. Kennedy pointed out that few Americans had considered the evidence that Mexico would soon be the most important oil producer in the world, an important resource to resolve the problem of energy scarcity. He hoped Mexican concern that much of its foreign currency would depend on U.S. sales would be treated "with sensitivity." Kennedy wanted his listeners to understand that Mexico would allow the United States to satisfy its needs and avoid oil prices that had gotten "completely out of hand."[5]

Against this backdrop, modern Mexican art once again assumed importance in the United States. There were two main arenas. First, the visual arts were an important component of U.S. programs designed to court Mexico's favor for its North American neighbor. It was used this way in a major national symposium, as well as in traveling art shows. Second, and related to the first, Mexican art began to assume its highest monetary values on the international art market. Though it had always found some purchasers among the North Americans who make up 90 percent of Mexico's tourists, it had been bought at relatively "bargain" prices, particularly in the postwar era when modern Mexican art was written out of U.S. art history books. For these collectors, and for Europeans, modern Mexican art was not generally seen as an "investment." All this changed when the major auction house, Sotheby Parke Bernet of New York, set up its first auction of modern Mexican art as a "trial balloon" in May 1977. International collectors who had previously displayed very little interest in this field of fine art but now found themselves priced out of the European and U.S. art markets made the event quite successful, with the auction house grossing over $700,000.[6]

How these events were manipulated and what impact they had on Mexican art are the subjects to which we now turn.

1978: Year of the Great Cultural Explosion

The "Mexico Today" Symposium: The most conspicuous cultural event in the wooing of Mexico was the "Mexico Today" Symposium, described as the "largest and most comprehensive presentation of contemporary Mexico ever to be opened in the United States."[7] It consisted of seminars and cultural events that took place in Washington, D.C., New York, and other U.S. cities. John Jova, former U.S. Ambassador to Mexico and president of the Meridian House International, one of the Symposium sponsors, succinctly made the connection between culture and petroleum: "In terms of its culture, GNP [Gross National Product] and population, Mexico already is one of the world's more important countries. Now with the discovery of raw oil, our southern neighbor is certain to become an even more significant economic force in world affairs."[8] Other sponsors included the Smithsonian Resident Associate Program and the Center for Inter-American Relations of New York, a Rockefeller-sponsored institution for Latin American culture which had been surrounded with controversy and boycotted in the late sixties by forty Latin American artists residing in New York. Symposium funding was provided by the National Endowment for the Arts and Humanities.

In September and October 1978, art exhibits opened in New York, Washington, D.C., and Atlanta. They ran through September 1979 at various locations, with additional programs in Detroit, four cities in California, and San Antonio. Included were Indian costumes, pre-Columbian clay figures, masks, pottery, and folk art, tapestries, and colonial art. In the area of modern art were prints and posters of the twentieth century (exhibited in the Library of Congress), twentieth-century Mexican prints (George Washington University), Frida Kahlo, 1910–1954 (Neuberger Museum, Purchase, New York), and photographs of architectural works by Luis Barragán, a well-known International Style architect who developed the Pedregal area in Mexico City (Georgia Institute of Technology).

The showpieces of modern art were major retrospectives of painters Rufino Tamayo and Carlos Mérida and photographer Manuel Alvarez Bravo, with Tamayo clearly the dominant figure. These premiered in Washington, D.C. (the Phillips Collection, the Pyramid Gallery, the Corcoran Gallery of Art, respectively), and then traveled. Handsome catalogues were produced in Washington, D.C., for Tamayo and Alvarez Bravo.[9] In New York, the Center for Inter-American Relations mounted a Tamayo retrospective of works on paper in 1979, and the Solomon R. Guggenheim Museum expanded the Washington, D.C., show to present "Rufino Tamayo: Myth and Magic" with accompanying catalogue.[10] The original Tamayo

Fig. 41

exhibit also traveled in 1978–79 to the Marion Koogler McNay Art Institute in San Antonio.

The Alvarez Bravo exhibit was also shown at the Center for Inter-American Relations. Two other Corcoran shows, "Four Young Mexican Photographers" and "Photographs of Mexico: (Tina) Modotti, (Paul) Strand, (Edward) Weston," were sent to El Museo del Barrio, a New York–based Puerto Rican–run gallery.

Representing younger generations of Mexican painters was the exhibit organized by Mexico's Museum of Modern Art, "Different Expressions of Contemporary Mexican Painters," also with a color catalogue. It was shown at the Organization of American States Museum of Modern Art of Latin America in Washington, D.C., the Alternative Center for International Arts in New York, the High Museum in Atlanta, and the Mexican Museum in San Francisco. This show, featuring geometric abstractionists, abstract expressionists, existential figurative painters, and neosurrealists, included works by Gilberto Aceves Navarro, Rafael Coronel, Francisco Corzas, Enrique Estrada, Manuel Felguérez, Fernando García Ponce, Luis López Loza, Agueda Lozano, Teresa Morán, Emilio Ortiz, Antonio Paláez, Vicente Rojo, and Ignacio Salazar. In all cases, these artists have represented an alternative to what has been called the "declamatory, politicalized art in fashion in Mexico."[11]

Strikingly conspicuous by their absence were the *tres grandes* (Big Three) muralists of Mexico: Diego Rivera, José Clemente Orozco, and David Alfaro Siqueiros, and their followers of the Mexican School. Younger generations of socially critical artists were also absent. Exceptions were a slide presentation of the muralists by Cityarts of New York, a community-oriented street muralists group; a symposium on "The Impact of the Art, Politics, and Related Activities of the Mexican Muralists (Orozco, Rivera, Siqueiros) on the 1930s New Deal Mural Project Artists, Post World War II Artists, and Contemporary Chicano Artists," at the Detroit Institute of Art, which has an entire cycle of Rivera murals commissioned by Edsel Ford in the 1930s; and a show featuring the *tres grandes* by the San Francisco Museum of Modern Art from its own collections.

Aside from the obvious connection with the politics of oil, the "Mexico Today" Symposium indulged in what, in effect, might be called the "laundering" of modern Mexican art, excluding the political and the controversial, both old and new, regardless of aesthetic merit. Because of this focus on Tamayo, Mérida, and Alvarez Bravo, who comprise the "aesthetic" or "contemplative" wings of modern Mexican painting and photography, and who, in the case of the painters, are concerned with formal problems and "universalism" as opposed to what they consider "narrow nationalism," the public's view of modern Mexican art was distorted. In these shows, the Mexican School was written out of history.

This is not the time to enter into the universalist/nationalist debates

of Latin America. However, since one of the theses herein is that Mexican art was manipulated not only on behalf of petroleum, but on behalf of ideology, some comment must be made. When advancing the term "universalism"—a popular one with Tamayo—it is cogent to consider whose definition of universalism is being considered. Craig Owens has pointed out that despite their claim to disinterestedness, "the humanities actually work to legitimize and perpetuate the hegemony of Western European culture (and) . . . the history of Western European art, from its origins . . . through its culmination on this continent."[12] In general, universalism has been defined in terms of metropolitan standards, or, as it has recently been placed in connection with Mexican art by a writer connected with the Center of Inter-American Relations, "the usual orientation of artists and audience is still centralist, with regional and provincial communities looking abroad to the acknowledged cultural capitals for approval and often for inspiration, too. . . . This is apparent not only in the sequence of clearly identifiable styles and movements . . . but also in institutional attitudes towards exhibitions . . . and in methods of marketing and distribution."[13]

Treasures of Mexico Exhibit: In early 1978, Armand Hammer, president of Occidental Petroleum Corporation and trustee of the Los Angeles County Museum of Art (LACMA), also entered the arena of "cultural diplomacy." To cement ties with useful nations and ingratiate himself with their governments through cultural exchange is clearly part of Hammer's thinking, and has been for many years. He began by sending his Old Masters art collection to the Palace of Fine Arts in Mexico City, where its "high profile" publicity drew 210,000 people in three weeks. Then, with the aid of López Portillo, he brought the "Treasures of Mexico from the Mexican National Museums" to the Smithsonian, the Knoedler, and Hammer Galleries in New York, and to LACMA, from which it traveled to the Monterrey Museum in Nuevo León, Mexico. "Art is an emissary," Hammer said at the time of the LACMA show, and through art, "ties between nations can be strengthened." Almost in the same breath, he pointed out how useful the new Mexican gas and oil discoveries could prove to the United States.[14]

"Treasures of Mexico," the first major show of Mexican art in Los Angeles since the 1963–64 "Master Works of Mexican Art," was organized and mounted in an unprecedented six months—in itself a pointed commentary considering that most museum exhibits require several years of prior commitment—and it reveals in small scale the same slanted vision as the "Mexico Today" program. The show was clearly dominated by very fine examples of pre-Columbian art, including pieces that had never before left Mexico (dead cultures are always "safer" than living ones; even Porfirio Díaz exalted the ancient Indian cultures to the detriment of living Indians). Also included was a sparse sampling of colonial art, a tiny

grouping of Orozco, Rivera, Siqueiros, and one painting each by Frida Kahlo and Dr. Atl (the Nahuatl name of artist Gerardo Murillo) tucked away in corridors at the end of the exhibit. So inverted was the balance that *Los Angeles Times* art critic William Wilson was forced to observe the "unfortunate circumstance of an exhibition where the *finale* comes first."[15] Rivera was represented only by his pre-mural and Cubist periods, and Siqueiros by a poor selection of his work, though the Kahlo was one of the best of her paintings.

Numbers alone are seldom an index to an art exhibit's concept; however, in this case quality and quantity were wedded and determined the ideological emphasis: one hundred *treasures* of pre-Columbian art, twenty-three viceregal works, and thirty-one of the nineteenth century, and forty of the modern period. Wilson pointed out that "the exhibition's political overtones are so weighty that Governor Jerry Brown attended the opening . . . along with the mother and two sisters of . . . López Portillo. The air was heavy with implications, ranging from the importance of the Mexican-American vote to the international negotiations over Mexican oil."[16]

The Mexican Connection

Some comments that will cast light on the Mexican end of the petroleum and cultural negotiations are in order here. The last stop on the "Treasures of Mexico" circuit was the Monterrey Museum. It is one of the few private museums of Mexico, underwritten by the large brewery Cervecería Cuauhtémoc, S.A., which is a subgroup of the most powerful industrial complex in Mexico, the Monterrey Group, with open ties to foreign capital and financial institutions.[17]

Cervecería Cuauhtémoc and its banking consortium, Serfín, supported the "Mexico Today" Symposium, while another subgroup, Alfa, with its television subsidiary, Fundación Cultural Televisa, A.C., underwrote the costs of building the Rufino Tamayo Museum of International Contemporary Art, which opened in 1981. A lot of scandal surrounded that opening, since it is the only private museum permitted in Mexico City's Chapultepec Park, a national historical zone.[18] Unlike the situation in the United States, the promotion and dissemination of culture in Mexico has traditionally been in the hands of government, based on the European model. In the postrevolutionary period the government, through its education minister José Vasconelos, took the initiative for the visual arts, especially public muralism, as part of its mass educational policies; and the National Fine Arts Institute, which controls most of the museums and art institutions in the country, is still subsumed under the Ministry of Public Education. For many artists and other observers, the insertion of private initiative into internal cultural life is viewed disfavorably or

Fig. 42

with suspicion. There is a distrust of motives, of whose interest will be served, and whether such insertion will signify an increasing and undesirable "north-americanization" of culture, since many Mexican corporations and banking firms are allied with U.S. capital. At the same time, however, some artists approve of government-private collaboration in culture, which in their view reflects Mexico's mixed economy.[19]

The Board of the Rufino Tamayo Museum represents such a mixed collaboration. The 1981 list of board members includes, as honorary president, the late Miguel Alemán Valdés, former Mexican president and for many years head of the National Tourism Council; Emilio Azcárraga Milmo, president of the private sector T.V. monopoly, Televisa; Alemán's son Miguel Alemán Velasco, vice-president of Televisa; Antonio Ariza, connected with Alemán's tourist council; Margarita Garza Sada de Fernández of the Nuevo León family that controls the Monterrey Museum; and Agustín Legorreta Chauvet of the private sector Banco Nacional de México (National Bank of Mexico, known as Banamex), whose art holdings of about six hundred works comprised one of the most important private collections in the country.

One can be forgiven for assuming that these "interlocking directorates" had something to do with Tamayo's primary role in the "Mexico Today" Symposium and the virtual elimination of the Mexican School, or at least its more political and controversial works. Until the early 1950s, Tamayo's art, which had been ignored in Mexico during the hegemonic years of the Mexican School, was accorded a central role as the art that most corresponded to the tastes and the increasingly internationalist stance of the Mexican entrepreneurial class. Since he is a great painter whose work is very "Mexican" without being controversial, who has always preached "universalism" and "pure painting" and rejected art with a social message, Tamayo's work is attractive not only to upper-class Mexicans such as the Monterrey Group family enclave, but to art collectors and mural patrons in the United States (where McCarthyism had resulted in writing the Mexican School out of modern art history) and in Europe. With the death of Siqueiros in 1974, Tamayo occupied unchallenged the leading artistic position in Mexico. Nevertheless, as a Latin American, Tamayo did not receive national homage in the U.S. from major art institutions in Washington, D.C., and New York such as the Phillips Collection and the Guggenheim until the 1978 "Mexico Today" Symposium.

Images of Mexico

By the end of 1978, owing to the situation in Iran, the rising prices of OPEC (Organization of Petroleum Exporting Countries), of which Mexico is not a member, and the declining availability of Venezuelan and Cana-

dian oil, the Carter administration initiated a new U.S.-Mexico policy which involved energy, the migrant worker issue, and bilateral trade.

Shortly thereafter, in June 1980, Banamex was able to acquire controlling interest through a holding company in the Mexican American National Bank (with branches in San Diego, Calexico, and San Ysidro), which was merged under the name of California Commerce Bank with the Community Bank of San Jose, all serving predominantly Spanish-speaking populations in California. In order to "engender in the people of the United States a deeper perception of the artistic wealth of Mexico and consequently of the sensitivity of its peoples," the exhibit "Images of Mexico," featuring 148 paintings and drawings from the eighteenth to the twentieth centuries from the Banamex collections as well as pre-Columbian works loaned by the painters José Chávez Morado and his wife Olga Costa, was shown at the Mandeville Art Gallery of the University of California, San Diego, in April and May 1980.[20] Similar exhibitions were mounted in San Jose (1980) and at the bank's corporate headquarters in Los Angeles (1981).

"Images of Mexico" was modest compared to the extravaganzas of the Armand Hammer/"Mexico Today" exchanges. It was unusual in that a private Mexican business had taken over the role of cultural diplomacy from the government. It is also notable that Rivera, Orozco, Siqueiros, and Tamayo, as well as other painters (both associated and not associated with the Mexican School), were equally represented in the San Diego exhibit. Banamex could do no less than present a balanced, historical view of Mexican art, though, as one local critic noted, the exhibition was "shot through with weak examples and, at least in its extremities, too tenuous to be cohesive." The same critic also noted that "we would be less skeptical if the exhibition didn't coincide with the bank's expansion in California."[21] Obviously the financial hand in the glove, so successfully camouflaged in the "Mexico Today" Symposium, was too blatant in the "Treasures of Mexico" and "Images of Mexico" exhibits to escape critical notice.

The irony of Mexico's exuberant "oil mentality," carefully fostered and financially supported by the United States and translated into cultural diplomacy through the use of "blockbuster" art shows, lies in its sequel— a sequel that underlines and highlights Mexico's continuing dependency status. Until 1981, Mexico was on its way to becoming a one-product petroleum-based economy, on which were founded its hopes for industrial development and alleviating internal social problems. Caught between the world oil glut, falling prices, and its enormous foreign debt at high interest rates—much of it for the optimistic expansion of petroleum capacities—Mexico found itself in its worst financial crisis of sixty years. The Alfa Group, which from 1976 to 1980 had become the largest private industry in Latin America, was forced in mid-1981 to halt payments on

huge foreign debts, sell 40 percent of its assets, and fire ten thousand of its forty-nine thousand workers.[22] As the crisis spread and the peso was devalued, Mexico's largest cities were choked with millions of homeless and jobless workers and peasants, and López Portillo decided, in September 1982, to nationalize Mexico's private banks to prevent the flight of capital abroad. As an unforeseen result, Banamex's art collection, believed to be worth 200 million pesos, has now passed into government hands.[23]

The Art Market: Sotheby Parke Bernet Auctions

"Art: the New Booming Investment in Mexico," reads the headline of a San Francisco Chronicle story datelined Mexico City. "Oil booms are not normally a source of artistic inspiration, but when sudden economic growth brings inflation and when investors start looking to safeguard their profits, oil can translate into a convincing stimulus to the creative process." The article goes on to point out that the art market has expanded as fast as the oil production, and that not only Mexico's top artists—who are earning ten times more for their work than they did four years ago—but younger artists are finding a new demand for their work. The irony is that the impetus for the "art inflation" came from New York's Sotheby Parke Bernet auction house. "When Mexicans saw that their national art could sell for dollars in New York as well as pesos in Mexico City, they became more interested in art as an investment," said Sotheby's director of painting. "Even the Mexican subsidiaries of such United States companies as the Container Corporation of America, Anderson Clayton, and Monsato are avid collectors of Mexican art. It is significant that a company can classify works of art as part of its office furnishing and depreciate the cost over ten years. Once depreciated, the art can revert to the collections of the stockholders or be sold, in the words of one gallery owner, 'for pure profit.'"[24]

Sotheby's 1977 "trial balloon" was so successful that not only Mexicans but potential buyers from over a dozen other countries appeared. The star performer in 1977 was Diego Rivera, whose works went for higher than estimated prices, including some tourist potboilers which used to sell for twenty dollars. A Mexican collector bought some of Rivera's works as well as Tamayo's Woman Arranging Her Hair and Siquieros's cubist-futurist painting Black Woman, which sold, under the auction house's estimate, for $15,000. An extraordinarily fine Frida Kahlo, Tree of Hope Remain Firm, also was under estimate, at $19,000. The artists whose work sold close to or higher than estimate were Tamayo, Francisco Zúñiga, and Franciso Toledo, all of whom are represented by important New York galleries.[25]

In 1978, the Sotheby auction had about 165 pieces, or "lots," and the

highest sale was a Tamayo for $47,000, with a Rivera at close second at $38,000. By spring 1979, however, following the national exposure of the "Mexico Today" Symposium, the lots almost doubled and prices really boomed. A work by nineteenth-century landscape painter José María Velasco went for $115,000, followed by $77,000 for Tamayo and $62,500 for Rivera. Two Kahlos sold for $49,000 and $27,000. By fall 1979, at the first Latin American art auction, Riveras sold for $130,000 and $100,000, followed by the Cuban Wifredo Lam at $95,000 and the Colombian Fernando Botero at $49,000.

The 1979 peak prices for Mexican works appear to be high until compared with U.S. and European moderns: $750,000 for Man Ray; $330,000 dollars for Miró; $620,000 dollars for Max Ernst; and $560,000 for Cézanne. Contemporary U.S. artists sold at $135,000 for David Smith to $80,000 for Franz Kline.[26]

The peak for Mexican art was hit December 1981, when Tamayo's *The Smile* sold, according to Sotheby's publicity, "for the highest price ever paid at auction for a Latin American painting," shown on the Sales Result sheet as $275,000.

The sale of art continues: Christie's, another important auction house, entered the area with a June 1982 auction of Latin American art. For the Mexican capitalist class as well as Europeans and North American capitalists, who regularly follow the international art market, Mexican art seems a more stable and profitable speculation than gold, real estate, and other inflation hedges.

Conclusion

The themes of this essay are the distortions of Mexican art history resulting from its manipulations owing to economic and political negotiations for Mexican petroleum, and the commodification of Mexican art when it becomes an object for speculative investment. It is hoped that the facts marshaled above, granted they are not exhaustive by any means, provide a case for these theses.

A number of corollary issues can be raised in consequence of exploring the relationship between art, artists, and the politics of economics. One such issue is the connection between art as a pawn to petroleum negotiations and the art market, which have been presented as separate arenas. These are not unrelated phenomena. In his comprehensive book *The Art Museum: Power, Money, Ethics*, Karl E. Meyer devotes a chapter to "the hard coin of art," in which he develops the relationship between collectors, museums, art dealers, and art auction houses (which by the 1960s replaced art dealers as the foremost merchandisers of the fine arts, just as dealers earlier replaced the European academies). Museums, particularly in the postwar period, have become the major validators of works of art

through scholarly publications, exhibitions, and authentication of the unique commodity. "Curatorial opinions," says Meyer, "have become a vital ingredient in the everchanging concensus about the real worth—aesthetic and monetary—of objects or the work of individual artists."[27] For dealers and auction houses, both purchases and temporary loan shows may have market implications. For this reason, Meyer continues, "auction galleries try to time major sales to coincide with museum exhibitions."[28]

In considering the activities of Sotheby's, the world's largest art auction house, one is struck by the chronology of its entry into merchandising Mexican art. The first sale took place May 26, 1977, a year before the "Mexico Today" Symposium, an event of which Sotheby was surely aware, with very satisfactory results. In 1977, Diego Rivera, as the Mexican artist then best known in the United States, was represented by a painting gracing the cover of the handsome bidder's catalogue; correspondingly, Rivera's works brought the highest prices. A year later, on April 5, 1978, Tamayo replaced Rivera on the cover, and the prices rose. By then the full program of the Symposium was publicly known, including its keynote address by Octavio Paz, the artists to be exhibited, and its formidable array of scholars, writers, politicians, art administrators, and art historians from both countries.

Two more Mexican auctions were scheduled; for May 11, 1979, and May 9, 1980, with catalogue covers by Carlos Merída and Gunther Gerzo, at which time Sotheby expanded its offerings to include the nineteenth century. Thereafter, with the yearlong Symposium over, Sotheby's and Christie's turned to auctions of works from all over Latin America. If the rise and fall of art "futures" suggest the stock market, it is not too inept a comparison. The late eminent art critic Harold Rosenberg commented in 1973 that "the texture of collaboration between dealers, collectors and exhibitors has become increasingly dense [and the artist] has been forced to recognize that the market-centered complex which determines values in art is a realm of chance, since the standards it sets are often influenced by conditions that have nothing to do with art—for example, by the rise and fall of currencies—and that therefore success as an artist is both fortuitous and transitory."[29]

The art market can be capricious about monetary value and, in some cases, about what is a genuinely aesthetic article, but collectors and art museums are presumably concerned only with aesthetic quality. Even they, however, are not exempt from extra-aesthetic considerations. Highly critical political art has often been given a bad time through censorship and outright destruction, despite its aesthetic values. Even the wealthiest and supposedly most passionately devoted collectors have sold parts of their collections for tremendous profits at propitious moments. Museums, as the depositories and guardians of the arts for public edification and enjoyment, have been involved in controversial deaccession-

ing in which they sell donated works during periods of financial difficulty or to "upgrade" their collections.

It is obvious that the modern argument for the totally "autonomous" nature of art and its separation from nonaesthetic terms is a fallacious one. Art was sold at auction during the Roman Empire; both Roman and Italian Renaissance patrons are known to have purchased faked antiquities—in one case, by Michelangelo—for their prestige value. Nevertheless, in the past or the present, when art is commodified it temporarily loses some of its transcendent and therefore human qualities and becomes alienated from its original creative purpose. The difference between Roman and Renaissance commodification and the present conditions is one of *degree*. In our time the discrimination of the connoisseur-collector has begun to be countered by the impersonal calculations of syndicates, investment trusts, and international consortiums. The ultimate alienation arises in the case of works placed in bank vaults until they have acquired sufficient financial appreciation to be resold; or when collectors rush to buy or sell works by an artist whose recent decease guarantees future scarcity of his/her work. An apropos example is the well-publicized supposedly mortal heart disease of Mexican artist José Luis Cuevas and the collector who rushed to buy a quantity of his works. When Cuevas's hypochondriacal fears were reversed by medical opinions, the collector disgruntledly resold his purchases.

Despite the foregoing, it should not be assumed that the creative and communicative function of art has been totally negated in the second half of the twentieth century by commodifications of various sorts—including the great rash of spectators who rush to museums to contemplate with awe an Old Master work for which two to five million dollars have been paid: a process of turning a painting into a financial icon. There is no question that thousands of persons in the United States—quite innocent of behind-the-scenes petroleum negotiations—benefited on a very human and pleasurable level from the national exhibitions of modern and contemporary Mexican art during the "Mexico Today" Symposium. Regrettably, this audience was deprived of a truly panoramic view of modern Mexican fine art in all its variation and richness and, therefore, received a distorted view of Mexican cultural reality. In addition, infrequent "blockbuster" events tend to become a type of "exotica," not comparable to the continuous, varied, and solidly presented exhibitions of European and North American art. The scarcity of such presentations distorts the whole history of modern art though exclusion of more than half the American continent.

From the Mexican side of the picture, there was an ongoing battle in the 1950s and 1960s—similar to one which successfully occurred earlier in the United States regarding American Scene and social realist art—to aesthetically write the Mexican School out of existence as retrograde, a

battle which was not successful. To denigrate the *tres grandes* and their followers would be to wipe out a half-century of Mexico's most prestigious and influential art production. Furthermore, with the death of the controversial Siqueiros—the last of the *tres grandes*—it was much easier to safely consign the Mexican School to the glorious historical past.

In the early 1980s, however, the situation has become more serious. Although younger artists in the social-critical vein are not denied a voice in Mexico, contemporary Mexican art is being increasingly defined by standards established outside of Mexico, promoted by the "universalist" ideology on the one hand and the international art market on the other. The very content of art as a national expression can be determined by selection, placement, and labeling within the galleries and museums, and by marketing. Here we confront the difficult argument that even an artist's consciousness, and therefore the nature of art production itself, can be manipulated through exhibitions offered, location and prestige of the gallery or museum, publicity and fame, to say nothing of a steady income though sales. This process becomes a superexploitation when conducted from a developed to a dependent country.

Sufficient evidence has been presented to advance a theory not only about the falsification of art history, but about cultural imperialism in the area of the fine arts. The U.S.-Mexico experience of the last decade offers a classic example.

Notes

1. See chapter 8, "The Developing World under Electronic Siege," in Herbert I. Schiller, *Mass Communications and American Empire* (Boston: Beacon Press, 1971), 109–25; "U.S. Media Empire/Latin America," *NACLA Newsletter* 2, no. 9 (January 1969); "U.S. Advertising Empire/Latin America," *NACLA Newsletter* 3, no. 4 (July-August 1969); "Toward a New Information Order," *NACLA: Report on the Americas* 16, no. 4 (July-August 1982); Ariel Dorfman and Armand Mattelart, *How to Read Donald Duck: Imperialist Ideology in the Disney Comic*, trans. and introduction by David Kunzle (New York: International General, 1975).

2. See Nelson H. H. Gradburn (ed.), *Ethnic and Tourist Arts: Cultural Expressions from the Fourth World* (Berkeley: University of California Press, 1976); Victoria Novela, *Artesanías y capitalismo en México* (Mexico, D.F.: Centro de Investigaciones Superiores, Instituto Nacional de Antropología e Historia, 1976); Mirko Lauer, "Artesanía y capitalismo en Perú," *Análisis*, no. 5 (Lima; 1979), 26–48; Néstor García Canclini, *Las culturas populares en el capitalismo* (Mexico, D.F.: Editorial Nueva Imagen, 1982); Néstor García Canclini, "Fiestas populares o espectáculos para turistas?" *Plural*, 2ª época, no. 126 (Mexico, D.F.; March 1982), 40–51.

3. See Eva Cockcroft, "Abstract Expressionism, Weapon of the Cold War," *Artforum* 12, no. 10 (June 1974): 39–41; and Shifra M. Goldman, *Contemporary Mexican Painting in a Time of Change* (Austin: University of Texas Press, 1981), 29–35.

4. Unless otherwise noted, facts on oil economics and politics come from Olga Pellicer de Brody, *U.S. Concerns Regarding Mexico's Oil and Gas: Evolution of the Debate, 1976–1980* (La Jolla: University of California at San Diego, Working Paper #10, Program in United States-Mexican Studies, 1981); and George W. Grayson, *The Politics of Mexican Oil* (Pittsburgh: University of Pittsburgh Press, 1980).

5. Quoted in "México, garantía para controlar precios: Kennedy. Los nuevos yacimientos petroleros, 'lotería' para el gobierno," *Proceso*, no. 78 (Mexico, D.F.; May 1, 1978): 6.

6. Judith Hancock de Sandoval, "Latin American Artists in New York, USA," *Artes Visuales*, no. 15 (Mexico, D.F.; Fall 1977): 54. Catalogues are issued for every Sotheby auction in New York.

7. *The Mexico Today Symposium, 1978–1979.* Introduction by Joseph John Jova, president, Meridian House International; Janet W. Solinger, director, Smithsonian Resident Associate Program; Roger D. Stone, president, Center for Inter-American Relations, (Washington, D.C.; n.d., n.p.).

8. "Mexico Today" Symposium Press Release, Washington International Institute, Washington, D.C., September 23, 1978.

9. The Phillips Collection, Washington, D.C., *Rufino Tamayo: Fifty Years of His Painting.* Introduction, "Tamayo Revisited," by James B. Lynch, Jr., 1978; David R. Godine and the Corcoran Gallery of Art, Boston and Washington, D.C., M. Alvarez Bravo, with essays by Jane Livingston and Alex Castro and documentation by Frances Fralin, 1978.

10. Solomon R. Guggenheim Foundation, New York, *Rufino Tamayo: Myth and Magic.* Essay by Octavio Paz, 1979.

11. Veronica Gould Stoddart, "Mexico Today: Art as Ambassador," *Américas* 31, no. 2 (Washington, D.C.: February, 1979): 38.

12. Craig Owens, "Representation, Appropriation & Power," *Art in America* 70, no. 5 (May, 1982): 10.

13. John Stringer, "Books in Review," *Art Journal* 42, no. 1 (Spring 1982): 79.

14. Jody Jacobs, "Preview of Mexico's 'Treasures,'" *Los Angeles Times*, August 4, 1978, part IV: 2.

15. William Wilson, "Mexico 'Treasures': A Panoramic Southern Exposure," *Los Angeles Times*, August 13, 1978, Calendar Section: 80.

16. *Los Angeles Times*, August 13, 1978, Calendar Section: 80.

17. Francisco Ortiz Pinchetti, "Del echeverrismo surgió todopoderoso el Grupo Monterrey," *Proceso*, no. 78 (May 1, 1978): 16–19.

18. See Raquel Tibol, "Se inauguró el museo: Con Tamayo, la iniciativa privada al poder cultural," *Proceso*, no. 239 (June 1, 1981): 44–47. In a conversation with the author, Mexico City, July 6, 1982, Tibol provided information about two other private museums in Mexico: the Museo Pape in Monclova, Coahuila, connected with the steel industry, and the Centro Cultural Chihuahua, underwritten by the Grupo Chihuahua (Vallina-Banco Comermex). A third, and most important, is Banamex, which is discussed in the text. For further information about these powerful banking groups and their relationships with the industrial sector, see Victor M. Juárez and Juan Antonio Zúñiga, "Los 'cuatro grandes' multiplican sus ganacias y extienden su podería," *Proceso*, no. 239 (June 1, 1981): 22–23.

19. Sonia Morales and Armando Ponce, "Entre artistas, dos posiciones con-

trarias: Participación interesada; aportación saludable," *Proceso*, no. 239 (June 1, 1981): 44–45.

20. Quoted from the foreword by Gustín Legorreta, chairman of Banamex, in the catalogue *Images of Mexico: An Artistic Perspective from the Pre-Columbian Era to Modernism*, Mandeville Arts Gallery, University of California, San Diego, 1980.

21. Suzanne Muchnic, "Plus, Minus in Mexican Exhibition," *Los Angeles Times*, May 18, 1980, Calendar Section: 88.

22. Beth Nissen, "Mexico's Fading Promise," *Newsweek*, July 5, 1982: 21.

23. Adriana Malvido, "A raíz de la nacionalización de la banca, la colección del arte Banamex, una de las más importantes del pais, pasó al estado," *Uno más Uno*, September 8, 1982: 19; and Susana Cato, "'Confidencial,' la lista completa de la colección de arte Banamex; su monto, 200 milliones de pesos," *Proceso*, no. 308, September 27, 1982.

24. *San Francisco Chronicle*, August 4, 1981: 44. Reprinted from the *New York Times*.

25. Judith Hancock de Sandoval, "Latin American Artists," 54.

26. Josine Ianco-Starrells, "Art News," *Los Angeles Times*, December 2, 1979, Calendar Section: 100–101.

27. Karl E. Meyer, *The Art Museum: Power, Money, Ethics* (New York: William Morrow and Company, 1979), 164.

28. Meyer, *The Art Museum*, 182.

29. Cited in Meyer, *The Art Museum*, 167.

16

MEXICAN AND CHICANO WORKERS
IN THE VISUAL ARTS

Those colorful murals that one can see nowadays throughout the Southwest in which figures like Captain Luis de Velasco are depicted in all their finery might well be balanced by a few murals showing Mexican migratory workers sweating in desert cement plants, in the copper mines of Morenci, the smelters of El Paso, and the great farm-factories of the San Joaquin Valley. Captain de Velasco and his colleagues may have discovered the borderlands but Spanish-speaking immigrants from Mexico have built the economic empire which exists in the Southwest today.
Carey McWilliams[1]

It must be said immediately that images of Mexican workers[2] in the visual arts of the United States were practically nonexistent before the 1960s except in documentary photography. Such images as do appear glamorize the Spanish conquistadores and missionary fathers, or idealize *caballeros* and *vaqueros* (Mexican horsemen and cowboys) as free and daring spirits within the mythology of the "Old West." Occasional references to Mexicans and Mexican Americans as workers present them anonymously as symbols in static conflict-free situations rather than as actors on the historical stage. Even stereotypical images such as proliferated in the mass media of the twentieth century did not appear with any

This essay first appeared as "Mexikanische und Chicano-Arbeiter in der Bildende Kunst," in Philip S. Foner and Reinhard Schultz, *Das Andere Amerika: Geschichte, Kunst und Kultur der amerikanischen Arbeiter-bewegung* (Berlin: Elefanten Press, 1983), 428–48.

285

frequency in the fine arts. The New Deal period saw the greatest explosion of working-class images in the history of U.S. fine arts. However, Mexicans—unlike black, Asian, and white workers were largely invisible. Not until Chicano artists (themselves largely from the working class) were propelled on the scene by the civil rights movements and farm workers' strikes of the 1960s did Mexican and Chicano workers become the subject matter of painters and printmakers.[3]

Art during the New Deal

The murals to which Carey McWilliams refers, writing before 1948, are those produced in post offices, courthouses, schools, hospitals, and other public buildings during and after the Depression and subsidized from 1933 to 1943 by the New Deal Art Programs, particularly those of the Section of Fine Arts (Treasury Department) and the Federal Art Project of the Works Project Administration.[4]

Section of Fine Arts. Edward Bruce, lawyer, art patron, and artist who organized and headed the Section of Fine Arts was committed to works of art that would embellish public buildings in a pleasant and positive way without arousing controversy. Bruce was interested in "quality," defined as a limitation of subject matter to the regionalist variant of American Scene painting. Unconventional art or anything that smacked of radicalism in technique, form, or content was discouraged. Bruce vowed to oppose "classical ladies in cheesecloth," abstractionist "tripe," and to deal with social protest by stopping the "Mexican invasion on the border," a reference to the Mexican muralists. What he wanted for the Treasury Department were representational competence, the ability to render detail literally, and wholesome American themes. Government art, he told artists, should make people's lives happier and not be solemn and intellectual.[5] Eighty-five hundred artists received the Section's free *Bulletin* and knew its thinking on mural art. Using art as a weapon of social criticism was considered negative. The need was for murals to deal constructively with chaos and conflict.[6] Artists who offended the aesthetic and political sensibilities of the Section risked exclusion from patronage. Local committees who usually judged Section competitions for mural designs and raised part of the funds for each project also took the opportunity to advance their special interests and ideologies.[7] Working under these conditions, not many muralists raised the realities of Depression years or the surge of labor and left-wing activity. Historical subject matter was interpreted in a fairly traditional or innocuous manner. Those artists who were more militant encountered the threats of prior censorship, or destruction after the fact—not only during the New Deal, but for many years thereafter.[8]

In addition to these general prohibitions, overt and covert, which af-

fected subject matter, there was also the question of racism. One incident comes down to us from the New Deal period representing, without doubt, widespread attitudes. In the early 1940s, a prepackaged show was sent around the country by the Farm Security Administration's photography division. When it reached West Texas, a regional director of the agency criticized what he considered a breach of the "Southern code of ethics": "[T]he photographs of Negroes to be used in Region 12 are quite objectionable. . . . [K]nowing the people in this region as I do, I doubt the wisdom of using a panel showing a Negro farmer beside a panel showing a white farm woman. . . . Even a Spanish-American farmer's picture would not be popular in West Texas."[9] If "Spanish-American" farmers were considered objectionable in a temporary photography exhibit, how much more unacceptable would their presence be in permanently located regional murals? Thus historical paintings focused on the more acceptable Spanish conquerors and friars, believed to be wholly European without the admixture of Indian ancestry, or an occasional picturesque Mexican. Indians themselves were depicted as placid converts to Christianity (local communities frequently objected to more warlike images), seldom as serfs or workers.

Work Progress Administration/Federal Art Project. The considerably larger Federal Art Project (WPA/FAP), established in 1935 with Holger Cahill as head, had a more catholic approach toward style and subject matter—or as one writer puts it, "a more populist and pluralistic spirit."[10] The official description of WPA/FAP work emphasized "art rich in social content" as well as "a fresh poetry of the soil."[11] More locally oriented than Bruce's Section, it was correspondingly more subject to pressures not only from local supervisors but from the anti–New Deal press, which attacked certain murals—particularly those made or influenced by the Mexican muralists—as "un-American in theme and design" and possessed of "communistic influence" which might exert an alien effect upon children and adults who viewed them.[12] In Chicago, for example, the works of Mexican-inspired muralists Mitchell Siporin and Edgar Britton were singled out for attacks of this sort.

Mexican Muralists in the United States

Bruce's reference to the "Mexican invasion on the border" was occasioned by the presence of Mexican artists, particularly the muralists Diego Rivera, Jóse Clemente Orozco, and David Alfaro Siqueiros, all of whom painted murals in the United States between 1930 and 1934 and in 1940 with teams of U.S. artists as helpers. They were undeniably influential from the 1920s on in establishing the terms of social realism in the United States.[13] They were also particularly subject to attack as "communists," "pernicious foreigners," "un-American," as well as to destruc-

tion of their murals for controversial content. Rivera's Rockefeller Center mural in New York was covered and destroyed before completion and his murals in the Detroit Institute of Arts were threatened. Rivera and Orozco murals in New York became an embarrassment in the Truman and McCarthy eras and were covered for many years or removed to other locations. One of Siqueiros's Los Angeles murals was whitewashed two years after completion.[14] Nevertheless, not the least part of the Mexicans' influence on radically inclined artists was their concern with working-class subject matter. All three, in these years, included Mexican and Indian imagery in their murals. Orozco at the New School for Social Research in New York pictured assassinated Yucatecan governor Felipe Carrillo Puerto surrounded by Maya peasants. His mural was later covered because he had included Lenin and Stalin in various panels. His Dartmouth College murals included a Mexican peasant revolutionary and a reclining construction worker reading a book. Siqueiros's whitewashed mural had as a central theme the crucifixion of an American Indian by U.S. imperialism; in another mural he painted assassinated Mexican industrial workers. Rivera's Detroit murals showed the multiracial workers in Ford's River Rouge automobile plant, which certainly included Mexican American workers.

Given the relative absence of Mexican and Mexican American working-class motifs in U.S. fine arts prior to the late 1960s, I propose to examine primarily those few examples of New Deal paintings that show Mexicans at work, and then focus on the history of Mexican labor in the United States as seen in the work of Chicano artists. Since the U.S.-Mexican border has always been a fluid one across which people, information, and ideologies flow, it is also pertinent to connect Mexican American labor history with that of Mexico itself. Thus murals and prints by artists from Mexico concerning labor events in the twentieth century will also be considered.

Mexican and Mexican American Labor in the Nineteenth and Twentieth Centuries

Any history of Mexican/Chicano labor in the United States must take into account its uniquely binational character. With the signing of the Treaty of Guadalupe Hidalgo in 1848 after the Mexican-American War and the Gadsden Purchase of 1853, half of Mexico's territory and three-fourths of its natural resources were annexed to form what eventually became the Southwest United States. Included are Texas, New Mexico, Arizona, California (the four major states), Colorado, and parts of Utah and Nevada. The legal political border, which follows the Rio Grande River for almost two thousand miles, has always had a continuous movement of peoples and resources in both directions: the northern flow of

labor power (documented and undocumented); investment capital and tourists flowing south; families and individuals born on both sides changing residences; and constant social and cultural exchange. In fact, the border is so fluid in terms of peoples and cultures that northern Mexico (Tamaulipas, Coahuila, Chihuahua, Sonora, Baja California) and the Southwest United States are referred to as the "borderlands," an area of two separate but contiguous nations in which a cultural homogeneity flourishes, but distinct differences also exist.

In actuality, the border area has been characterized as a "unique contemporary example of the contrast between rich and poor nations" or between "developed and underdeveloped" nations.[15] Intervention in the Mexican economic process by U.S. investors and companies has been going on since the late nineteenth century; while starting in the mid-1960s the legal border has in some ways become a "fiction" characterized by the rise of multinational corporations and a veritable mass exodus of labor-intensive industries from the U.S. into low-wage Mexico.[16]

Mexicans in the nineteenth century were largely employed in occupations involving the soil and subsoil. Juan Gómez-Quiñones has established four general areas of economic production in the Southwest: livestock, transportation, mining, and agriculture.[17] To these should be added the work of artisans. In addition, the unpaid domestic labor of women, which has not been considered part of economic production in a capitalist system until recent feminist thought revised the definitions, must be included.[18] In the twentieth century, Mexican nationals and Mexican Americans also entered light and heavy urban industry, as workers fanned out from the Southwest to other parts of the United States looking for better wages and conditions. Women left their homes for outside employment, rural and urban. They, and undocumented workers, presently staff many of the lower-paid and more onerous jobs in non-unionized factories and service industries.

Livestock

During the nineteenth century when Mexico became independent of the Spanish empire and was established as a nation, ranching was one of the principal economic pursuits in the area now known as the U.S. Southwest. *Vaqueros* (cowboys) formed the laboring force, along with many Indians, on the great Spanish land grant ranches of California and the Lower Río Grande Valley of Texas. These were patriarchal setups in which a few large owners (who stressed their Spanish descent to differentiate themselves from the *mestizo* or mixed-blood workers) lived an idle but lordly existence based on unpaid Indian labor and a system of peonage, vestiges of which still survive today in southern Texas.

Arrival of the railroads after the annexation of northern Mexico deci-

sively changed the economics of the region, as land, with the help of the U.S. State, began to change hands from large, medium, and small Mexican landowners to Anglo ownership (sometimes through marriages with the Mexican owning class). Whereas Mexicans had been both owners and laborers, after 1848 they were increasingly relegated to the status of laborers. By the 1880s, after forty years of Anglo domination, the landowning structure had been largely undermined. Great ranches broke up as second-generation ranchers encountered the encroachment of railroads, fences, mortgages, and low beef prices. The proud cattle-raising "Spaniards" began experimenting with wheat farming, which they formerly despised. Some even entered the sheep-shearing circuit, upon which they were forced to put aside their rancher finery and appear in brown overalls and red bandannas.

Nevertheless, as late as 1877, James Walker, an English-born artist who migrated first to Mexico in 1941, and then to California, painted *Vaqueros at the Roundup* with all the trappings of the supposedly halcyon days of the great California ranches. Walker's *vaqueros* are stylishly dressed in straight-brimmed Spanish sombreros, trimmed broadcloth suits, and ornamental chaps. Their graceful palomino horses sport silver-trimmed bridles and stirrups, tooled leather saddles, and beautifully woven horse cloths. A foreground figure lassoing a steer sets up the type. Vast spaces with violet mountains in the distance suggest the huge acreage of the original ranches and provide a backdrop for the large herd of cattle and a great many *vaqueros*. Walker, a rather mediocre painter, used a deliberately romantic stylization which was already an anachronism in the developing realistic style of western painting. His glorification of the "Spanish" ranch culture is in line with Helen Hunt Jackson's famous sentimental treatment of Indians in her novel *Ramona* (1883), which persists as annual theater in Los Angeles to this day.

The actual *vaquero* of the day presented a far different appearance. Most *vaqueros* owned only their own clothes and saddles; they often did not own their own horses.[19] A photograph of a *vaquero* taken near Los Angeles in the late nineteenth century shows a mestizo, a young man with a soft, small-brimmed hat, a pair of overalls over a light shirt, a crossed bandanna, and very simple functional horse gear.[20] Walker's *vaqueros* are actually dressed as ranch owners, who considered themselves *caballeros*, literally "horsemen" but understood as "gentlemen." An unidentified painting from the ranch period reproduced in *Hispanic Culture in the Southwest*[21] makes the class distinction very clear. The Mexican *jinete*, prototype of the rancher, is dressed in the elaborate formal costume found in Walker's painting and rides a palomino with golden mane and tail. He is accompanied by his elegantly dressed lady on horseback and a (black?) servant. Wearing a head bandanna, simpler clothing, and mounted on a plain dark horse is the *vaquero*, who doffs his hat humbly.

Not only costume but body carriage differentiates the two. According to one historian, *vaqueros*, though highly skilled, self-reliant, and occasionally challenging an employer, were as a rule impoverished, highly dependent, and obedient workers. Labor protest by *vaqueros*, like the later Anglo cowboys, was rare.[22]

In the early 1940s, Lew Davis executed two murals with oil on canvas for the Los Banos, California, and the Marlow, Oklahoma, post offices (the former mural is presently in the Los Banos Museum). His 1940 painting *Early Spanish Caballeros* shows a spirited group of five riders on palomino horses in a circular composition reminiscent of the Italian Renaissance. The central caped figure with a Spanish hat has his back to us, while the other four are symmetrically arranged in pairs on right and left, like an exercise in anatomy. The 1942 Marlow mural *The Branding* is a less romantic, more workaday subject. Four cowboys are circularly arranged around a wood fire within a corral with a horse and several cattle. One coils his lasso while the other three, working vigorously, are branding a fallen animal. Two of the branders are hidden behind their hats; the third is dark-skinned with a long black mustache: very probably a Mexican *vaquero*. He wears a black hat, white shirt, and blue jeans. Davis was employed by the Section of Fine Arts to do both murals.

Transportation

Long before rail lines and highways were built in the Southwest, the Spaniards and Mexicans organized an elaborate system of packtrains that operated over the trails blazed by the conquistadores. Until 1880, the proud, flamboyant, and elegantly dressed *arrieros* (loaders) provided an efficient and economical mode of transport for cargos of all types: merchandise, mail, equipment, supplies, and ore to and from the mining camps. When in the last quarter of the nineteenth century the Southern Pacific and Santa Fe Railroads began construction in the Southwest, they followed the Spanish trails, using Mexican labor to construct their tracks. "From that day to this," says Carey McWilliams, "Mexicans have repaired and maintained western rail lines,"[23] constituting 70 percent of the section crews and 90 percent of the work gangs and earning a dollar a day. In a 1912 article, Samuel Bryan recorded the fact that "most Mexican immigrants have at one time been employed as railroad laborers. At present they are used chiefly as section gangs and as members of construction gangs . . . but a number are also to be found . . . about the shops and powerhouses" as boilermakers and pipe fitters.[24]

Nevertheless, those New Deal murals that show railroad construction and maintenance crews focus on the white worker, the Asian, and the European immigrant to the exclusion of the Mexicans who formed the majority of the railroad force, at least in the Southwest. A detail of James

Fig. 43 Michael Newell's mural in New York shows three sturdy workers wielding sledgehammer, jackhammer, and welding torch, constructing tracks in the path of an oncoming engine. In the background are cotton plants, sheaves of wheat, and cattle (herded by a placid *vaquero*), which will be transported on the completed railroad tracks. None of the workers are Mexican, though a western setting is suggested by the cattle and the *vaquero*. Edward Laning's Ellis Island mural, *Role of the Immigrant in the Industrial Development of America*, shows the construction of the Central and Union Pacific Railroads by Chinese and Irish laborers. Both Newell and Laning painted in New York, albeit about the West; however, even Anton Refregier, widely known as a radical and prolabor artist, limited his depiction of Hispanics in the twenty-seven mural panels at the Rincon Annex of the San Francisco Post Office (started 1941, completed 1948) to the traditional conquistadores and friars. Panel 17, *Building the Union Pacific*, shows Chinese and white workers only. Located hard upon the fertile San Joaquin Valley, where thousands of Mexicans worked in the crops, this multiethnic San Francisco mural cycle gives no hint of these workers and the great farm strikes of the 1930s.

More than thirty years were to pass before artists engaged as an important subject the presence of Mexican workers. Chicano artist Emigdio Vásquez's oil painting *The Gandy Dancers* pictures the Mexican laborers who maintained the railroads. Though the image was adapted, with color, from *The Family of Man*, a huge 1955 photography exhibit with a well-circulated catalogue organized by Edward Steichen for the Museum of Modern Art in New York, Vásquez remembers such scenes from his childhood in the citrus-growing areas of southern California. He has not approached the photograph with the vision of a photorealist painter, but as a social realist with strong class consciousness. In the raking light of early morning, the men work as teams, pushing their weight against the railroad ties. The tracks stretch into the distance in a desolate country area; one can sense the continuing monotony of the work, and the men sweating long hours under the sun.

Fig. 44 Vásquez has also gone to a photographic source for the figure of a Mexican boilermaker from the railroad shops of Albuquerque, New Mexico, which he included in his mural *Tribute to the Chicano Working Class*. The stern-faced, dignified older man in blue overalls and shirt, striped cap, and goggles is taken from the captioned picture book *450 Years of Chicano History*, which, with *The Family of Man* and New Deal photographs from the Farm Security Administration (many reproduced in *450 Years*), has proved a pictorial gold mine for Chicano artists seeking to recreate their history. Vásquez is alive to those photographs that offer dramatic possibilities for his paintings. From the same book he took the two women working in agriculture, one standing, one stooping, that make the connective between the boilermaker, the miner, and the ranch

hand on the left, and César Chávez with a Filipino farmworker on the right of the mural.

Mining

The cast concrete sculpture, *The Arizona Miner*, executed in 1935 by R. Phillips Sanderson for the Federal Relief Administration and placed near the Cochise County Courthouse in Bisbee, Arizona, is a "rather regal barechested worker"[25] in a rhetorical mode that contrasts sharply with the realities of Bisbee—a major copper-mining area dominated by the Phelps Dodge Corporation, headed (as the Phelps Dodge Mercantile Company) in the early twentieth century by Walter Douglas, son of the developer of Bisbee's Copper Queen mine. In 1917, Phelps Dodge, using vigilantes (headed by the local sheriff), deportations, and other notorious extralegal measures, broke the organizing drives of the Industrial Workers of the World in Bisbee and Jerome.

Even earlier, Phelps Dodge had broken what were proving to be successful organizing efforts of the Western Federation of Miners in Arizona, which had, as early as 1902–3, made substantial gains in bringing Mexican Americans into existing unions.[26] By 1907, union-busting techniques eliminated the Bisbee local.

Nor did Phelps Dodge restrict its antiunion activities to Arizona. During the 1906 Cananea miners' strike in Sonora, Mexico, Walter Douglas personally armed the Arizona Rangers who, in a cavalier manner, crossed the international border to help break the strike at a U.S.-owned mine. Mexican miners were exploited on both sides of the border by affiliated companies. Ironically, Sanderson's *Arizona Miner* was sprayed with molten copper through a process then available at the nearby Phelps Dodge facilities. The company apparently had no objection to this somewhat harmless image appearing in front of the courthouse that had been the scene of so many union-busting activities. The proud, clean-cut miner carrying his tools belies the actual working conditions in the huge open pit and underground mines of Bisbee, and the men whose unionizing activities were met with violence.

Mexican miners—many from Sonora, which borders Arizona— brought their skills to the United States from the days of the California gold rush in 1848. They have continued to be employed to this day in coal, mercury, gold, silver, and copper mines in Arizona, New Mexico, California, and Texas. The same conditions of racism, low pay, rejection by traditional unions (such as the American Federation of Labor), and deportation in times of economic crisis plagued the miners from the beginning, as they did Mexican workers employed in other industries. Racism was a tool deliberately used by the mining companies to divide the workers and, unfortunately, some labor unions fell into the trap. At

its first strike in 1896, even the Western Federation of Miners (WFM) put forth a demand that Mexicans not be hired.[27] However, this policy changed. By 1906, the WFM urged members to make special effort toward recruiting Mexican miners into the union. The companies, however, persisted in maintaining what was called the "Mexican rate" of pay, lower than that of Anglos, and numerous strikes resulted from this discriminatory practice, which exacerbated for Mexicans the generally poor economic conditions in the mines.

The 1906 WFM convention also passed a resolution of solidarity with the Cananea strike in Mexico, recognizing "class struggle throughout the world," and knowing "no race or creed in the battle for industrial freedom." That same year, the WFM became the mining department of the Industrial Workers of the World (IWW, Wobblies),[28] which had close ties with Mexico's revolutionary group, the Partido Liberal Mexicano (PLM), led by Ricardo and Enrique Flores Magón, at that time in exile in the United States. Members of the PLM assisted the Cananea strike and, though it was broken in a few weeks, it gave major impetus to the Flores Magóns, the PLM, and their publication *Regeneración*.[29]

Cananea is an instance of transnational investment encouraged by the dictatorial Porfirio Díaz regime. Between 1880 and 1890, large mining development was initiated in the Mexican states of Coahuila, Chihuahua, Durango, Zacatecas, and Baja California by foreign investors. Huge U.S. conglomerates such as the Guggenheim interests (who today underwrite the Solomon R. Guggenheim Museum and Foundation in New York) spread over much of Mexico, owning numerous mining enterprises. The Cananea Consolidated Copper Company, one of the largest in the world, was owned by Colonel William Greene, a U.S. entrepreneur who became a multimillionaire in Mexico. On June 1, 1906, two thousand Mexican workers struck over the issue of the "Mexican rate" of pay, particularly onerous in their own country. (As in the later New Mexico strike immortalized in the 1953 film *Salt of the Earth*, mothers, wives, sisters, and daughters supported the miners' demands with demonstrations, and their action is documented in a contemporary photograph showing the women gathered on a rocky hill holding aloft their banners.)[30] Violence broke out during which thirty Mexicans and two U.S. managers were killed. The strike was put down by the Mexican *rurales* (federal troops) who followed the Arizona Rangers into the area. However, the Mexican labor movement dates from the "Battle of Cananea," which has been called the first major labor strike in Mexican history.[31]

Between 1957 and 1967 (interrupted by a jail term from 1960 to 1964 for "social dissolution" occasioned, among other things, by his support for 1950's labor strikes in Mexico), David Alfaro Siqueiros painted *Revolution against the Dictatorship of Porfirio Díaz*, a 4500-square-foot mural in Mexico City based on the Cananea strike—an event considered to be

Fig. 45

a precursor to the Mexican Revolution. Wrapping itself around several walls, the mural is a dynamic exposition of the process leading from the dictatorship of Porfirio Díaz, who is shown on one wall surrounded by big landowners, generals, and *científicos* (progress-oriented positivists in the government), to the confrontation between the strikers (carrying their dead) with the Arizona Rangers, the *rurales,* and the North American owners. Out of this struggle emerges the Mexican Revolution, symbolized by the figures of Emiliano Zapata and his peasant soldiers on another wall, and dead revolutionaries cut down by a firing squad, which Siqueiros took from a historical photograph. In his quest for realism, Siqueiros individualized the strikers; however, his ideological program caused him to include in the forefront of the mass of strikers (male and female) portraits of Marx, Engels, and Ricardo Flores Magón, as well as other personalities who were obviously not present. The center of interest is the struggle between two men over the Mexican flag, making visual the political significance of the Cananea strike.

Flores Magón and Joe Hill. There is no question that the Cananea strike had widespread support in U.S. Mexican communities[32] as well as by the Western Federation of Miners. The Flores Magón brothers, especially Ricardo, who died in Leavenworth Prison for his political beliefs and actions, embodied the discontent over the abuses of the Porfirio Díaz dictatorship. The 1906 Liberal Plan of the Partido called not only for traditional freedoms but for new socially oriented measures including the eight-hour workday and six-day workweek, the abolition of company stores, the payment of workers in legal tender, and the prohibition of child labor—demands long on the agenda of the U.S. labor movement. As a matter of fact, the labor movement in Mexico was largely initiated by returning immigrants who had observed the ways of organized labor in the United States.[33]

Ricardo Flores Magón has been celebrated in art not only by Siqueiros but by Diego Rivera, Leopoldo Méndez, Alberto Beltrán, and many other Mexican artists. The Taller de Gráfica Popular's portfolio *450 años de lucha: Homenaje al pueblo mexicano* includes Pablo O'Higgins's print *The Strike of Cananea (Sonora)* and two prints by Fernando Castro Pacheco concerning the 1907 textile strike at Río Blanco, Veracruz (which followed on the heels of Cananea), one of whose leaders, Lucrecia Toriz, is celebrated by Castro Pacheco. That the Flores Magóns play an important symbolic role in the work of Chicano artists should not be surprising. In fact, for one artist, Carlos Cortez, Ricardo Flores Magón and Joe Hill reunite the ties of the early twentieth century between the Partido Liberal and the IWW.

Chicano artist Rupert García's monumental pastel diptych of the *Brothers Flores Magón* is taken from a well-known historical photograph Fig. 46 which was also the basis for a recreated characterization of the two broth-

ers in Jesús Salvador Treviño's 1972 film *Yo Soy Chicano* (*I Am a Chicano*). Like many Chicanos, García and Treviño (Californians who came out of the political and artistic movement generated in the 1960s by the U.S. civil rights and anti–Vietnam War movements and by the farmworkers' strikes led by César Chávez) consider the history of militant Mexican organizers and artists part of their tradition. García follows the example of Siqueiros to the degree that he adapts his works from documentary photographs; however, he is wholly contemporary in his style, which is a combination of vanguard graphic techniques drawn from 1960s pop art (which also based itself on photography) and from the Cuban poster movement. Starting as a silkscreen poster artist during the student uprisings in San Francisco and Berkeley, he developed a technique of flat, high-contrast shapes with unmodulated tonal changes in the brilliant colors that characterized the Cuban movement but are also present in Mexican colorism. Both color and the use of Spanish words in a poster's text affirm García's Mexican heritage. Employing single portrait figures in close-up, like Andy Warhol and Chuck Close, García—unlike these artists—is always concerned with militant content. His pastels add large scale and rich texture to the themes he previously executed in serigraphy, and he moves back and forth between the two media depending on whether he wishes a single work or needs multiples for a political cause.

In simulated historial sequences on the Flores Magón brothers, Treviño used an animation technique he calls "kinaesthetics," in which two or three forms of a photo are shown in rapid sequence, followed by another sequence of a different photo. Applying these techniques to the actors who played the Flores Magón brothers, he produced images experienced as historical photographs in action.

Self-taught graphic artist Carlos Cortez has also done prints of Ricardo Flores Magón, who has a particular attraction for this sixty-year-old construction worker, an active member of the Wobblies as well as of the Movimiento Artístico Chicano of Chicago. According to his own testimony, Cortez (who was born in Milwaukee, Wisconsin, and who presently resides in Chicago, home of the IWW) is the son of a "Mexican Indian" who was an organizer for the IWW, a soapbox orator during the 1912 Free Speech campaigns in San Diego, and a singer of songs "in seven languages."[34] Cortez himself has been a "harvest hand, construction worker, loafer, jailbird . . . vagabond, factory stiff." He joined the IWW after World War II and has submitted articles, short stories, poetry, book reviews, photographs, comic strips, and linoleum-cut illustrations to its newspaper. For the May 1970 edition of the *Industrial Worker*, of which he was then editor, he designed the cover in red and black with a worker in a checked shirt, a woman holding an IWW banner, and a newsboy selling the paper; and contributed a linocut of a woman and child with "We Want to Live in Peace" spelled out in English, Spanish,

and German. He also published a poem by Práxides Guerrero, an asso-
ciate of the Flores Magón brothers, translated from the PLM tabloid
Regeneración.

There are other ways in which Cortez unites the Wobbly and Mexican
traditions. In 1977, he designed an IWW poster in English and Spanish
versions which advanced a major Wobbly position in favor of the general
strike. *¡Será toda nuestra! con la huelga general por la libertad industrial*
(*All Will Be Ours! With the General Strike for Industrial Freedom*) in-
cludes six figures of workers all wearing the IWW button: black, Mexican,
Anglo, and two women, one, inexplicably (considering the context) ap-
pearing bare-breasted. The idea is completed by a fat hand with starched
cuff and diamond cufflink handing over a set of keys (to industry?) to the
working class.

Cortez's 1973 poster of Joe Hill was reproduced in 1979 along with a
button design, on the centenary of Hill's death. In Swedish and English, Fig. 47
the poster shows the spare figure of Joe Hill holding his accordion and
a song sheet. The text describes him as an "itinerant worker, union or-
ganizer, labor agitator, cartoonist, poet, musician, composer" who was
"murdered by the judiciary in collusion with the mine owners who
wished to silence his songs. They killed a man but gave birth to a legend."

Joe Hill became a member of IWW as a maritime worker in San Pedro,
California, in 1910. This was the year the IWW organized workers of the
San Diego Consolidated Gas & Electric Company in a successful strike
for higher wages and shorter hours. It was also the year that IWW-
influenced workers of the Los Angeles Gas Works, 90 percent of whom
were Mexican, won their demands. San Pedro is part of Los Angeles, and
San Diego is only 130 miles away. Joe Hill could easily have participated
in both actions. It is known that the *magonistas* (followers of the Flores
Magóns) were active in Los Angeles, and that in 1911 Joe Hill and a num-
ber of Wobblies participated in an abortive revolutionary action in Baja
California led by the PLM.[35] This effort was supported by a rally hosted
by writer Jack London, who came to Los Angeles for the purpose. Two
years later, John Reed was reporting the Mexican Revolution from the
encampments of Pancho Villa in northern Mexico.

The Wobblies felt that revolutionary consciousness should be fostered
by working-class intellectuals, and they employed literature and the arts
to disseminate their ideas. In addition to soapbox orators and the use of
songs (such as the Wobblies' famous *Little Red Song Book*, which nour-
ishes working-class and radical movements to this day), there were leaf-
lets illustrated with cartoons, comic strips, pamphlets, and "stickers"
with gummed backs that could be pasted up on any convenient space by
the thousands. The IWW also published newspapers in five languages,
including Spanish.[36] It is not too far-fetched to draw parallels between the
IWW use of public graphics and illustrated newspapers, the Taller de Grá-

fica Popular's inexpensive linocut posters and handbills started in 1937, the production of the United Farm Workers' illustrated newspaper *El Malcriado* in the 1960s, and Chicano linocut and silkscreen posters in which the graphic arts are used as direct vehicles for labor organizing. Carlos Cortez—himself a self-educated working-class intellectual, union organizer, songwriter, newspaper editor, and graphic artist—carries out the IWW prescription in his own person.

Miners' Images by Chicano Artists. The Mexican and Chicano miner has been painted in works by Chicano artists in a less historically specific way. One of the earliest appears on a 1972 mural in Santa Fe, New Mexico, by the group Artes Guadalupanos de Aztlán. Wrapped around a corner of a building is a giant muscular figure of a miner, one arm raised in a clenched fist, the other holding a book titled *Viva la Raza* (*Long Live Our People*). The stance of the figure is echoed by a pre-Columbian personage along one wall and a modern Mexican woman on the other, and is set in an agricultural landscape with a rising sun and bulbous clouds. The self-taught Guadalupanos, part of the grassroots mural movement emerging from the political and economic struggles of the 1960s, drew heavily on various Siqueiros murals seen in books. They expressed an ideology popular with the fledgling Chicano political movement of the time: social change and uplift (a new dawn symbolized by the sun) is to be achieved through education "of the race," revival of the ancient Indian cultures, the spirituality of the Virgin of Guadalupe (red roses in the jar under the miner's arm), and the cessation of fratricidal gang warfare (a youth with a knife being restrained at one corner of the wall). No symbols of labor unionism or of class struggle, explicit in Siqueiros's murals, appear.

Antonio Pazos includes two eloquent figures of miners within a large mural on a community center in Tucson, Arizona. Pazos immigrated from Sonora to Arizona shortly before the mural was painted and was aware of the mines on both sides of the border. His oppressed miners, kneeling head to head, assume a posture derived from Maya paintings and relief sculpture generally associated with slaves or conquered persons forced to kneel before the throne of a Maya ruler. In this adaptation, the throne is replaced by silhouetted smokestacks of the mines.

Emigdio Vásquez included a miner modeled after his father, who had been a copper miner in Jerome, Arizona, in his California mural. Unionism is emphasized here by the active position of the union leaders, and by the red union button worn by the miner. In a 1974 oil painting, *Black Lung,* Vásquez addresses a major health problem confronting miners. Malaquías Montoya, originally from New Mexico and living in northern California, combines text with his black-and-white image of two miners with pickaxes, helmets, and gloves: "Comrade miner/Bound by the weight of the earth/When your hands take out the metals/Fashion daggers/Then you will know the metals are for you." Montoya has been an

active muralist and graphic artist for many years in the nurturing climate of San Francisco and Oakland, which has produced a major poster movement within the last fifteen years. His silkscreen technique, derived from early training as a commercial designer, effectively uses flat and tightly interlocking designs combined with text; more recently, he has experimented with looser, more "painterly" application of color in silkscreen, and with expressionistic black-and-white posters using handwritten script as text. His miners' image is one of several works done in this style. Like Rupert García, with whom he has been linked in exhibits,[37] Montoya is frankly didactic: "It is my objective . . . to show the relationship between artistic creativity and community action as both an educational tool and a catalyst for social change."

Agriculture

Large-scale agricultural production in the Southwest, in fact the creation of an economic empire, dates from the Reclamation Act of 1902, which made possible the use of federal funds for reclamation and the construction of irrigation projects. The other side of the equation was cheap labor. Recruited in Mexico, brought to the Southwest by railroads with the assistance of Mexican American labor contractors known as *jefes* (chiefs), *papacitos* (little fathers), and more recently as *coyotes* (a scavenging desert animal), or crossing the border without contract (illegals or undocumented workers), or coming in the 1940s under special contractual arrangements and known as *braceros* (working arms), Mexican labor since the beginning of this century has been the staple of Southwest agriculture. Mexican workers were systematically exploited and targeted by discrimination: racial, social, and cultural.[38]

One of the earliest and strongest pictorial statements on economic and racial exploitation by the United States was made in continental terms by Siqueiros in his 1932 mural *Tropical America*. One of three political murals painted in Los Angeles during a six-month stay, it was executed with a team of local artists in a section of the city known as "Sonora Town" because of its high Mexican population. Before a crumbling pre-Columbian pyramid, an Indian figure is crucified on a double-shafted cross surmounted by, according to Siqueiros, the eagle of U.S. currency. To the right, in this strongly baroque composition, are two snipers perched on a rooftop aiming at the eagle: one is Mexican, the other a Peruvian Indian. The meaning is clear: throughout the American continent indigenous peoples have been exploited, "crucified," for U.S. profit, and revolutions are the only way to end this exploitation.[39] Siqueiros had always orchestrated his painting with political action and union organizing. He came to Los Angeles during the Depression in a period of widespread and violent labor conflict, particularly in the rich agricultural

Imperial Valley of southeastern California, where many Mexicans were employed under wretched conditions. Vigilantes and repressive laws repeatedly crushed the strikes, accompanied by mass deportations presumably for "getting Mexicans off relief" but actually because the so-called "docile Mexican" worker was unionizing. With scarcely an exception, every strike in which Mexicans participated in the 1930s was broken by the use of violence and followed by deportations. In most of these strikes the Mexican workers stood alone, that is they were not supported by organized labor.[40]

Siqueiros's mural was an isolated effort to protest these conditions. The same cannot be said for New Deal images of the time. George Samerjan's mural *Lettuce Workers* in the Calexico, California, Post Office was rare for Section murals in that it depicted "stoop labor." Nine men are choreographed against the sky. Five wear characteristic large-brimmed sombreros, while four non-Mexicans have smaller hats or are bareheaded. Shown in profile with almost Egyptian simplicity, the men occupy the foreground planes of the painting. They are weeding growing lettuce plants with long-handled hoes. Painted in blues, ochres, dark greens, and white, the clean stylized forms are simple and modernized. No suggestion of strain, fatigue, or sweat is permitted, though temperatures in the Imperial Valley (where Calexico is located) are known to rise well above 100° Fahrenheit. In fact, many Mexican workers of the desert and semidesert Southwest labored in physically punishing conditions, none of which are suggested in the mural.

In 1935, Dorothea Lange, photographer with the Farm Security Administration who documented rural life and labor during the Depression, photographed another group of stoop laborers imported into California between 1923 and 1930 from the Philippines, then a U.S. territory. The Filipinos worked primarily in asparagus and lettuce. Lange's photograph from the San Joaquin Valley, shot head-on from a worm's-eye view, shows four men against the sky working among the grown heads of lettuce. They offer a tremendous contrast to the antiseptic Samerjan mural. Covered from head to foot against the blazing sun in dark hats and wrinkled shapeless clothing, the men are completely bent over as they grub among the plants with *short*-handled hoes. The length of the back-breaking hoe is decisive, and became a major point of contention in the sixties and seventies when the United Farm Workers were organizing the lettuce fields.

Farm Labor Organizing in the Sixties. A multitude of visual images, as well as theater, film, and dance, emerged with the organization of California farmworkers in 1965 by César Chávez. The outpouring of cultural expression from working-class Chicano artists, many studying in colleges, universities, and art schools as a result of the political movement, was so passionate and pervasive that it has been dubbed a "renaissance,"

parallel to the Harlem Renaissance of the 1920s with one important exception: these artists neither came from, nor pretended to, the middle class. Like the Harlem Renaissance, which turned to African sources, and the black movement of the 1960s, which did likewise, Chicanos looked to Mexico for inspiration: to its pre-Columbian, colonial, and revolutionary cultures; to Olmec, Maya, and Aztec art; to the image of the Virgin of Guadalupe, patron saint of Mexican independence, which was carried at demonstrations and painted on innumerable walls and canvases; and to Emiliano Zapata, leader of revolutionary Mexican farmers and landless peasants.

A very early two-panel mural painted in 1968 by Antonio Bernal on the building that housed the Teatro Campesino in Del Rey, California, is a clear exposition of the pictorial sources and ideological associations the Chicano art movement was to utilize in the following decade. Organized as a linear procession of flat figures, like Maya painted walls at Bonampak, one of the panels shows pre-Columbian aristocrats in single file; the other features figures of nineteenth- and twentieth-century Mexican, Chicano, and black revolutionaries, militants, and civil rights activists. From left to right are "La Adelita," a legendary woman who fought in the Mexican Revolution; Pancho Villa and Emiliano Zapata; Joaquin Murieta, a miner (from either Sonora or Chile) who became a "bandit" in the face of Anglo oppression in California; César Chávez holding the *huelga* (strike) banner; Reies López Tijerina, who led the land grant movement in New Mexico; and two black figures representing Malcolm X and Martin Luther King.

El Malcriado. From 1964 on, the United Farm Workers Organizing Committee published the bilingual twice-monthly newspaper *El Malcriado: The Voice of the Farmworker,* in which graphics and photography played a major role. Andy Zermeño was the staff cartoonist for many years, producing extremely effective caricatures on issues affecting the farmworkers, from the boycott of grapes to the activities of Richard Nixon. Zermeño's crisp and highly legible style is reminiscent of Fred Wright, who for years produced penetrating cartoons for labor publications. One Zermeño image shows a huge bloated grape grower wearing a ten-gallon hat, leather belt, and dark glasses, staked to the ground like Gulliver while Lilliputian strikers parade gaily over and around his body with picket signs and flags flying. Another features Nixon juicily gobbling boycotted grapes while he tramples farmworkers in a tub with his bare feet. "Stop Nixon" reads the slogan, which refers to government purchases of grapes for shipment to the armed forces, Vietnam, and Europe in order to break the boycott.

In the spirit of nineteenth-century popular Mexican engraver Jóse Guadalupe Posada's bumbling "Don Chepito," Zermeño invented a folksy character whom he called "Don Sotaco," the underdog, who is constantly

Fig. 48 the butt of outrageous behavior by the *patroncito* (the boss) and "Don Coyote" (the labor contractor). With bit and collar like a horse, he pulls a rickshaw holding the bloated boss and is whipped by the contractor; in another, he is the filling of a sandwich held by the boss; in still another, the boss and the contractor wring him out like wet clothing. Don Sotaco only triumphs when he joins the union; his weapon then becomes the *huelga*.

 El Malcriado used the graphics of Posado and the Taller de Gráfica Popular for its covers, publishing a calendar of these covers in 1969. Its photographers produced documentary photos that are works of art; among the best are those of George Ballis, whose splendid photographs illustrate the bilingual book *Basta! La historia de nuestra lucha/Enough! The Tale of Our Struggle.*[41] Chicanos have drawn upon Ballis's photographs for paintings and drawings. In 1971, a large painting in red, white, and green, based on the cover of *Basta!*, appeared in a traveling Chicano exhibit in California.

 Murals, Paintings, Prints. A number of Chicano artists focused on the lettuce and grape boycotts. In 1974, Carlos Almaraz did an enormous
See fig. 4 (now disintegrated) mural in Los Angeles which translated into pictorial form Chávez's statement "there is blood on the grapes." He pictured the deputy sheriffs who attacked picket lines, clubbing the strikers and occasionally causing a death, supporting huge bottles of dripping wine on their backs. Above them are skulls and grapes; below, a large dollar sign. On a band above the mural is the slogan "NO COMPRE VINO GALLO" (DON'T BUY GALLO WINE). San Francisco artist Xavier Viramontes's striking silkscreen poster combines a rather fanciful pre-Columbian Indian holding grapes with the admonition to "Boycott Grapes," while Amado M. Peña
See fig. 21 of Austin, Texas, pictures a bleeding dark-green head of lettuce before the large white letters "*Huelga*," above which is an ironic "Spanish lesson" for Anglos: "*Lechuga*, f. (lay-choó-gah); 1) lettuce 2) *No la compre si no es de unión* 3) *verde y muy cabrona*," it reads. The reader is admonished not to buy nonunion lettuce, which is green and very "bitchy." Peña's silkscreen posters of the 1970s were widely circulated and highly successful in Texas. Rudy Treviño of San Antonio, Texas, in his 1974 work *Lettuce on Ice* paints a head of lettuce (the "bread and butter" of farmworkers) surmounting a champagne ice bucket. His *Lettuce Garden for Alamo* organizes horizontal bands of lettuces below and a *huelga* eagle above, between which is sandwiched the Alamo fortress, symbol of the Anglo attack which led to the separation of Texas from Mexico and the eventual annexation of the Southwest. The Alamo, according to Treviño, was the first step toward the historical exploitation of Mexican labor in agriculture; the eagle symbolizes the reversal of that exploitation.

 Two Californian murals also deal with farm labor. In the center of a blue map of the United States, Ernesto Palomino of Fresno (in the heart

of the San Joaquin Valley) painted a stylized truck whose flatbed opens to
our vision two symmetrical rows of farmworkers huddled on either side
of a madonna and child, an eagle, and a large sun with radiating rays bor-
rowed from the logo that appears on every box of Sun Maid raisins. In-
stead of the pretty red-bonneted young woman holding a tray of grapes,
Palomino shows us the miserable conditions in which the workers who
pick them are transported to the fields. The contractors drove open or
stake (canvas-covered) trucks which were loaded with fifty or sixty work-
ers—men, women and children, as well as bedding and equipment when
transport was to a new region. Palomino's truck is one used for day labor-
ers who were arbitrarily picked from male work gangs assembled on
street corners at dawn—a practice that was bitterly fought by the union
in favor of rotational hiring halls.

The History of the Chicano is an eighty-foot mural painted in Santa
Ana College by the Chicano student organization MEChA (Movimiento
Estudiantil Chicano de Aztlán, directed by Mexican-born architect/de-
signer Sergio O'Cádiz working with fifty students. It features—along
with farmworkers, the huelga eagle, and a clenched brown fist—a direct
transposition of the crucified Indian from Siqueiros's Tropical America.
For the eagle, the artist substituted a more direct symbol of money: the
dollar bill, with unbalanced scales of justice. Beneath this figure, a
mourning woman sits beside a tomb labeled "Rubén Salazar."[42] Moving
toward the future are Chicano workers of all kinds, and a 1940s scene of
Pachucos in their distinctive dress with a customized car painted by
Emigdio Vásquez.

Working Women

Mexican and Chicano women have always been part of the working force,
even within the pre-capitalist family when it was the basic economic unit
that produced material goods and services. In later periods, women
worked outside the family for wages. However—with the exception of
documentary photography and film—they are insufficiently depicted in
their roles as workers, even by Chicano artists. Until the mid-seventies,
Chicano art was largely dominated by men. Though some were sensitive
to women's issues, the images that emerged predominantly depicted
them as wives and helpmates, earth mothers, Indian princesses, pre-
Columbian and Catholic goddesses, sex symbols, and, occasionally, as be-
trayers such as La Malinche, the Indian mistress of Hernan Cortés in the
sixteenth century. As a more pervasive feminist consciousness developed
and greater numbers of Chicanas became visible as artists, new concepts
emerged in the work of both women and men. The "individuality cult"
of Frida Kahlo in the United States, which had the unfortunate side effect
of separating her from Mexican history and other women artists of her

time, resulted in many artistic homages, which, on the positive side, provided an admired model for Chicana artists, albeit in an introspective direction. Heroines from the Mexican Revolution (specifically "La Adelita"), and from other Latin American revolutions, made an appearance, though not in any quantity. In group scenes of workers, women might be part of a crowd, but the active employed woman or the labor leader rarely appeared. I was recently made acutely aware of this when seeking a painting or print of Dolores Huerta, Vice President of the United Farm Workers. Multiple images of César Chávez were available in murals, easel paintings, and prints, but few of Huerta.

In the Spanish colonial period from 1600 to 1800, women in northern New Spain (now the U.S. Southwest) worked as tanners, weavers, seamstresses, and gardeners. They plastered the walls of their adobe homes, served as *curanderas* (healers), midwives, servants, nurses, and even as overseers of Indian women slaves. Two WPA/FAP artists have pictured women working in adobe house construction. Manville Chapman's *Laying 'Dobes* is a view of a partially constructed house in which the man mortars the sun-baked mud bricks and the woman carries them to him; Lloyd Moylan's *The Plasterers* is a rather ungraceful, almost cartoonlike view of three women, one on a ladder, carrying out a traditional task of plastering the finished house, while the man sits lumpishly on a log holding a small child.[43] The *curandera* is an ongoing phenomenon in the Southwest and has been treated in a series of etchings by Texas-born artist Carmen Lomas Garza.

Aspects of this pre-capitalist mode endure to this day (or rather have been revived and modified) in isolated parts of New Mexico, where women are engaged in work as artisans with husbands and families in making painted or carved religious images, silver jewelry, ornamental tinwork, straw inlay, rawhide work, embroidery, quilting, and weaving.[44]

By the 1920s, Mexican American women had entered the wage labor force in large numbers because families could not survive on the man's income alone. Agriculture employed large numbers of women and children in seasonal, migratory labor; however, even in this low-paid employment, occupations and wages were sexually (as well as racially) divided.[45] Until the success of the United Farm Workers Union, little consideration was given to pregnancy or the care of small children, nor were proper housing and sanitation available—making women's unpaid domestic labor much harder. At all times, women workers carried the double burden of wage work and housework.[46]

The film *Salt of the Earth* dramatizes a case in which women's domestic grievances became an issue in union organizing. An important dynamic in the film's plot concerns the men's slowly growing awareness of the importance of women's labor in the home, which the men tended to trivialize. A dramatic moment of the film shows the women silhouetted

against the sky with a picket sign reading, "We want sanitation, not discrimination." After the strike was won, hot water was piped into the homes for the first time in this company town.[47]

Among the images of women workers made by Chicano artists is Judith Hernández's mural *La mujer* (mid-1970s) in a low-rent Los Angeles Chicano neighborhood. Only in the modern period are women shown as workers. Hernández pictures female presences in Mexican/Chicano history: the Aztec moon goddess, the Virgin of Guadalupe, *soldaderas* (soldiers) of the Mexican Revolution; then sewing machine operators and farmworkers on strike. The whole is dominated by a large, archetypal figure of Woman. In 1976, a group called Las Chicanas, including painters Hernández, Judy Baca, Olga Muñiz, Josefina Quesada, and photographer Isabel Castro, opened the multimedia exhibit "Las venas de la mujer" (Veins of the Woman) at the Los Angeles Woman's Building. Tracing the history of the Chicana, the five utilized paintings, a mural, performance, and an environment built as a sweatshop. Muñiz's environment included a tiny window opening into a garment factory, a sewing machine, bins of cloth, racks of finished garments, and the black silhouette of a woman, the operator, painted on the wall. A sign on the sewing machine listed the wages paid per piece.

The history of Mexicans in the United States includes a number of women who were leading figures in political and labor organizations. One of the first national figures was Lucy Eldine Gonzáles from Texas, who married Albert Parsons, executed as a conspirator in the Haymarket Riot of 1886. She was an anarchist, writer, lecturer, and charter member of the Chicago Working Women's Union in the 1870s, as well as a founding member of the IWW in 1905. However, to my knowledge, no image of her appears in contemporary Chicano art.[48] The two labor organizers whose lives have attracted the attention of artists were both active in the 1930s: Luisa Moreno and Emma Tenayuca.

Moreno was a national organizer for the United Cannery, Agricultural, Packing and Allied Workers of American (UCAPAWA), which was involved in the pecan workers' strike in San Antonio, Texas, during the thirties. She served actively with the CIO and was the principal organizer in 1938 for the Congreso de los Pueblos de Habla Español (Congress of Spanish-Speaking Peoples). Her portrait appears as part of a six-year project, the Great Wall of Los Angeles, a mural stretching more than a third of a mile and officially known as *The History of California*, which is directed by Judy Baca, executive director of the Social and Public Art Resource Center. Painted with large teams of local youth and assistant artists, the dynamic figure of Moreno, influenced by Baca's studies at the Siqueiros mural workshop in Cuernavaca, Mexico, is juxtaposed with a scene from the "zoot suit riots," (made into a play and then a film by Luis Valdéz of Teatro Campesino). Baca painted Moreno with strong brown

features and a red dress and wrapped her in a yellow flag of the Congreso, backed by flags of her union. Her figure thrusts sharply forward, contrasting with the use of escalated deep space provided by a railroad train and a plowed field behind her—spatial devices typical of Siqueiros. "The Great Wall of Tujunga," said one reviewer about the mural, "has the same heroic pioneer types you can see in your local post office, but often their skins are brown and black."[49]

Emma Tenayuca, who appears in the upper-right-hand corner of Emigdio Vásquez's mural *Memories of the Past and Images of the Future*, was purportedly a "fiery little Mexican woman about twenty years old" who was a leader among strikers and allegedly an admitted communist.[50] In 1938, thousands of pecan shellers of San Antonio, primarily women who worked for about two dollars a week in sweatshops packed with as many as one hundred workers without ventilation or sanitary facilities, walked off the job when the company reduced wages. Organized by the UCAPAWA, the walkout proved to be the largest Chicano-led strike of the 1930s. Police and tear gas were brought in to disperse the pickets and charges of "Communistic influences" were unsuccessfully tried as a means to break the strike. Tenayuca was a special target of city officials; she participated in a sit-down at City Hall and was jailed along with one thousand other strikers. Vásquez derived his image of Tenayuca raising a clenched fist from an old photograph in a pamphlet of the Texas Civil Liberties Union, recently republished,[51] but she appears more bland in the painting than in the original photograph. Rupert García freely adapted a photograph of Tenayuca in jail from the same republished source, for a 1977 photo-offset poster commissioned by the National Association of Chicano Social Scientists. Working with black, white, and subtle tones of orange, García contrasts the polka-dot dress pattern of Tenayuca's shoulders and collar with the untextured head, hair, and background. The bars of the cell are simplified into a flat grid behind the head.

Dolores Huerta is the most recent in a long line of women labor organizers. Born in Stockton, California, of a family that had lived in New Mexico since the seventeenth century, she is the daughter of a migrant farmworker and an ambitious mother who never allowed her daughter to pick crops in the field. Huerta is articulate and self-confident and has been politically active since age twenty-five, following the example of her mother. She is not troubled that César Chávez, whom she admires, is the person receiving all the publicity; she thinks of herself as a "*soldado razo*" (common soldier) of the movement. I am "just a person working at what I am supposed to be doing. The fact that I get publicity is sort of a by-product of the union. But there's an awful lot of people who have worked continuously since the union started, a lot of women, for example, who nobody even knows."[52] But her leadership is undeniable. She convinced one Democratic Party Convention to support the lettuce boy-

cott; she is one of the union's chief negotiators, where she has held her own with highly paid lawyers; and she is a tough, optimistic, and dedicated organizer at the grassroots level. She is strong-minded enough not to feel guilty in the face of criticisms that she neglects her children; she feels she is raising them to be independent and socially conscious. It's important to teach children "that other people besides themselves are important, and that the best thing they can do with their lives is to use it in the service of other people," she says.[53]

These are the qualities one senses in Rosemary Quesada-Weiner's photograph of Huerta taken in 1980 at the Democratic National Convention. Fig. 49 Casually dressed in a union T-shirt, baseball hat set jauntily on her head, political buttons spangling her clothing, black hair touched with gray and freely cut for comfort, Huerta is totally and actively involved in what is going on around her. Quesada-Weiner has heightened her heroic qualities by shooting from below and emphasizing the strong diagonals of shoulders and hat with dark and light contrasts. By moving in close, the photographer has caught the sculptured planes of the face and the vivacity that shines in the eyes. There is a total lack of self-consciousness or of posing in public—traits that are instilled in many women from childhood on and which Huerta has apparently rejected or overcome.

After World War II, the Chicano population became urbanized and employment patterns changed. By the 1970s, only 8 percent of the resident Mexican-origin population was involved in agricultural work. Forty-five percent of working women entered white-collar jobs, of which 31.5 percent were sales and clerical personnel but only 6.1 percent were managers and professionals[54]—a figure that has undoubtedly risen by the 1980s. Increasingly newer immigrants and undocumented workers from Mexico and Latin America have filled the lower-paid and more onerous jobs as domestics and baby sitters, as well as the most exploited sectors of factory labor, particularly in the garment industry, where labor and legal violations are rampant.

Mel Casas of Texas has translated one of these realities into a bitingly satirical painting called *Kitchen Spanish*, from his *Humanscape* series. Using a "pop realism," *Kitchen Spanish* features a cartoonlike Mexican maid standing before a close-up of a modern kitchen sink, surrounded by a realistically painted Anglo family, its cat, and its dog. The comic-strip balloon reads "Sí niño, sí niña, sí señoras, sí gato, sí perra" ("Yes, little boy, yes, little girl, yes, ladies, yes, cat, yes, dog"). In this world, only the Anglos are "real" (three-dimensional) and have power. The level of verbal communication (the "Spanish" of the title) is determined by class status—just enough to function in the kitchen, passively. The meek maid is subservient to all present, from the two generations of white women to the household pets. Casas's paintings are based on "movie-screen" close-up format with titles often stenciled on the canvas just as titles

appear on the screen. They often rely on a play of verbal and visual puns, or "conundrums"—a riddle based on a pun. "The conundrum," says the artist, "plays with our cultural concepts, with our cultural vision."

Notes

1. Carey McWilliams, *North from Mexico: The Spanish-Speaking People of the United States* (New York: Greenwood Press, 1968), 163.

2. In this article three terms to designate persons of Mexican birth or descent are used as follows: (a) "Mexican" refers to people living in Mexico, or Mexican nationals in the United States who have not established lengthy residence. It is also used generically to encompass all three designations, which are not readily separable; (b) "Mexican American" refers to persons living for lengthy periods in the United States or their descendents; (c) "Chicano" refers to Mexian Americans from the 1960s on who have assumed this formerly pejorative term and given it a militant political and Indian-oriented connotation (including the use of the word "Aztlán" as a title of pride and new consciousness. "Chicano" is an ideological rather than a national or ethnic designation. All terms present definitional difficulties, since U.S. residents of Mexican descent do not agree among themselves. In the border regions north of the Río Grande River, terms such as "Spanish American" and "Hispanic" are used by persons who may call themselves "Mexicano" when not speaking English. All such terms are historically conditioned and responsive to social conditions and concepts such as racism and nationalism.

3. Patricia Hills in her article "The Working American" points out that historically we can find relatively few paintings of Americans at work. Most work was considered too mundane or vulgar for the "fine arts," or perhaps too subversive for social and political norms. Printmakers, illustrators, and photographers (to which we should add caricaturists), on the other hand, had greater freedom, because these media have been considered "less important" then painting and therefore have a long tradition of working class images, often radical in content. In *The Working American*, National Union of Hospital and Health Care Employees District 1199 and the Smithsonian Institution Traveling Exhibition Service, 1979, 15–16.

4. PWAP (Public Works of Art Project, Treasury Department: 1933–34); Section of Painting and Sculpture, changed in 1938 to Section of Fine Arts: 1934–43; TRAP (Treasury Relief Project, Works Progress Administration: 1935–39); WPA/FAP (Works Progress Administration, Federal Art Project: 1935–43).

5. Richard D. McKenzie, *The New Deal for Artists* (Princeton: Princeton University Press, 1973), 57.

6. McKenzie, *The New Deal for Artists*, 57.

7. For an interesting examination of this process, see Susan Silberberg, "New Murals in Los Angeles: Federal Ideals and the Regional Image," *Journal: The Los Angeles Institute of Contemporary Art*, no. 11 (May–June 1976): 18–24.

8. See chapter 6, "The Controversy over the Rincon Annex Murals," in Gladys M. Kunkel, *The Mural Paintings of Anton Refregier in the Rincon Annex of the San Francisco Post Office*, San Francisco, California, unpublished Master's thesis, Arizona State University, Tempe, 1969, 54–69; Steven Lafer, "Victory for

Historic Refregier Murals," *People's World,* March 24, 1979. Concerning the closing for almost twenty years of San Francisco's Coit Tower as a result of vandalism against political motifs in the 1934 murals by twenty artists, see *New Deal Art: California* (De Saisset Art Gallery and Museum, University of Santa Clara, California, 1976), 75, and Pele De Lappe and D. Imshenetsky, "Whatever Happened to Victor Arnautoff?" *People's World,* May 14, 1977: 10. Ironically, Arnautoff's WPA frescoes at San Francisco's George Washington High School were destroyed in 1972 as a result of student protests "against the depiction of Blacks and (American Indians) in demeaning fashion" and repainted by Black artist Dewey Crumpler. *Other Sources: An American Essay* (San Francisco Art Institute, 1976), 26. See also Francis V. O'Connor (ed.), *The New Deal Art Projects: An Anthology of Memoirs* (Washington, D.C.: Smithsonian Institution Press, 1972), 34–35; and McKenzie, *The New Deal for Artists,* 110–12—to mention but a few. The most recent publication on Coit Tower's murals is Masha Zakheim Jewett, *Coit Tower, San Francisco: Its History and Art* (San Francisco: Volcano Press, 1983).

9. F. Jack Hurley, *Portrait of a Decade: Roy Stryker and the Development of Documentary Photography in the Thirties* (New York: De Capo Press, Inc., 1977), 144.

10. Marlene Park, "City and Country in the 1930s: A Study of New Deal Murals in New York," *Art Journal* 39, no. 1 (Fall 1979): 37.

11. McKenzie, *The New Deal for Artists,* 108.

12. McKenzie, *The New Deal for Artists,* 110.

13. See Leslie Judd Ahlander, "Mexico's Muralists and the New York School," *Américas* 31, no. 5 (May 1979): 18–25; Greta Berman, *The Lost Years: Mural Painting in N.Y. City under the WPA Federal Art Project, 1935–1943* (New York: Garland Publishing, Inc., 1978); Shifra M. Goldman, *Contemporary Mexican Painting in a Time of Change* (Austin: University of Texas Press, 1981), 5–7; Joshua C. Taylor, "A Poignant, Relevant Backward Look at Artists of the Great Depression," *Smithsonian Magazine* 10, no. 7 (October 1979): 45–53; Joshua C. Taylor, "El artista norteamericano en el New Deal," unpublished paper.

14. See Bertram D. Wolfe, *The Fabulous Life of Diego Rivera* (New York: Stein and Day, 1963), passim, but especially "The Battle of Rockefeller Center," 317–40; Max Kozloff, "The Rivera Frescoes of Modern Industry at the Detroit Institute of Arts: Proletarian Art under Capitalist Patronage," *Artforum* 12, no. 3 (November 1973): 58–63; Shifra M. Goldman, "Siqueiros and Three Early Murals in Los Angeles," in this book; Olav Münzberg and Michael Nungesser, "Die mexikanischen Wandmaler Orozco, Rivera und Siqueiros in den USA," in *Amerika: Trauma und Depression, 1920/40* (Berlin: Neue Gesellschaft für bildende Kunst, Akademie der Künste, 1980), 383–84. A recent publication specifically about the Rockefeller Center controversy which contains copies of the original press stories is Irene Herner de Larrea, *Diego Rivera: Paraíso perdido en Rockefeller Center* (Mexico, D.F.: Edicupes, S.A. de C.V., 1986).

15. Raúl A. Fernández, *The United States–Mexico Border: A Politico-Economic Profile* (Notre Dame: University of Notre Dame Press, 1977), 4.

16. Fernández, *The United States–Mexico Border,* 8. Among the common manifestations today are the *maquiladoras,* nonunion assembly plants established by U.S. industry in the northern Mexican border areas with the agreement of the Mexican government. These runaway shops employ thousands of Mexi-

cans, particularly women, at one-tenth of what would be paid in the United States. The feature film *Raíces de Sangre* (*Roots of Blood*), produced in Mexico in 1977 by Los Angeles Chicano filmmaker Jesús Salvador Treviño, treats this subject and points out the transnational exploitation of Mexican nationals and Chicanos in the U.S. by the same companies.

17. Juan Gómez-Quiñones, *Development of the Mexican Working Class North of the Río Bravo: Work and Culture among Laborers and Artisans, 1600–1900* (Los Angeles: University of California, Chicano Studies Research Center Publications, Popular Series, no. 2, 1982), 27–31.

18. Marx established the germinal concept from which this idea developed. In volume 1, chapter 6, of *Capital*, Marx describes, among the characteristics of labor power, the subsistence needs of the laborer (food, clothing, fuel, housing) and the reproduction of labor power which must be continuously replaced (children and their care and training). The labor power of women in this context, though not mentioned by Marx, is crucial in both areas. Emile Burns (ed.), *Handbook of Marxism* (New York: International Publishers, 1935), 455. For a contemporary theoretical examination of these issues, see Eli Zarotsky, *Capitalism, the Family, and Personal Life* (Santa Cruz, Calif.: Loaded Press, n.d.; reprint from *Socialist Revolution*, January–June 1973).

19. Gómez-Quiñones, *Development of the Mexican Working Class*, 24.

20. See Leonard Pitt, *The Decline of the Californios: A Social History of the Spanish-Speaking Californians, 1846–1890* (Berkeley: University of California Press, 1966), illustration following p. 148.

21. Arthur L. Campa, *Hispanic Culture in the Southwest* (Norman: University of Oklahoma Press, 1979), 95.

22. Gómez-Quiñones, *Development of the Mexican Working Class*, 24.

23. McWilliams, *North from Mexico*, 167.

24. Samuel Bryan, "Mexican Immigrants in the United States," *The Survey*, September 7, 1912, reprinted in Wayne Moquin et al., *A Documentary History of the Mexican Americans* (New York: Bantam Books, 1972), 335.

25. *The New Deal in the Southwest: Arizona and New Mexico* (Tucson: University of Arizona Museum of Art, n.d. [c. 1980]), 17.

26. James C. Foster, "The WFM Experience in Alaska and Arizona, 1902–1908," in James C. Foster (ed.), *American Labor in the Southwest: The First One Hundred Years* (Tucson: The University of Arizona Press, 1982), 22.

27. Gómez-Quiñones, *Development of the Mexican Working Class*, 34.

28. Philip S. Foner, *History of the Labor Movement in the United States*, vol. III, *The Policies and Practices of the American Federation of Labor, 1900–1909* (New York: International Publishers, 1964), 402.

29. A new *Regeneración* was published during the mid-1970s by Los Angeles activist Francisca Flores. Its considerable artistic production was contributed by a Chicano experimental art group, ASCO (Nausea).

30. Original photograph in the Bancroft Library, University of California, Berkeley, California; reproduced in Michael C. Meyer and William M. Sherman, *The Course of Mexican History* (New York: Oxford University Press, 1979), 489.

31. McWilliams, *North from Mexico*, 203.

32. Rodney Anderson, "The Historiography of a Myth," in Foster, *American Labor in the Southwest*, 175.

33. McWilliams, *North from Mexico*, 203.

34. All information about Cortez derives from a resumé compiled by the artist and a taped interview with the artist conducted in Chicago on behalf of the author by Irwin Weinberg, May 1982.

35. Foster, *American Labor in the Southwest*, 159.

36. See "Ideology and Tactics," Foner, *History of the Labor Movement in the United States*, vol. IV, 147–57.

37. See Lisa Puyplat, "Plakatkunst der Chicanos," *Tendenzen* (Munich) 23, no. 139 (July-September 1982): 75. The poster *Back to Roots Music Festival* is García's, erroneously attributed to Montoya. The poem on Montoya's poster was written by Carlos Gutíerrez Cruz, assistant to Diego Rivera, who, it is said, painted it into a scene of miners.

38. A good case has been made by sociologist Mario Barrera that racism and classism are intimately related in the superexploitation of Mexican American and Chicano workers as an "internal colony," a condition Chicanos have shared with other racial groups. See *Race and Class in the Southwest: A Theory of Racial Equality* (Notre Dame: University of Notre Dame Press, 1979).

39. Siqueiros's murals are discussed in detail in Goldman, "Siqueiros and Three Early Murals in Los Angeles," in this book.

40. McWilliams, *North from Mexico*, 194.

41. Delano, California: Farm Worker Press, Inc., 1966.

42. *Los Angeles Times* journalist killed by a police tear gas projectile during the 1970 anti–Vietnam War Moratorium organized in a Los Angeles Mexican neighborhood.

43. *Laying 'Dobes* (n.d.) is in the collection of the Museum of New Mexico in Santa Fe; *The Plasterers* (n.d.) is in the collection of the University of Arizona Museum of Art, Tucson. Both are reproduced in *The New Deal in the Southwest*, 48 and 57. A photograph of New Mexican women plastering a house appears in E. Boyd, *Popular Arts of Spanish New Mexico* (Santa Fe: Museum of New Mexico Press, 1974), 4.

44. See William Wroth (ed.), *Hispanic Crafts of the Southwest* (Colorado Springs: The Taylor Museum of the Colorado Springs Fine Arts Center, 1977); and Charles L. Briggs, *The Wood Carvers of Córdova, New Mexico: Social Dimensions of an Artistic "Revival"* (Knoxville: University of Tennessee Press, 1980), in which pages 36–98 deal with Anglo patronage and the resulting modification of local art forms. The number of women involved in crafts production can be seen in Wroth, *Hispanic Crafts*, 97–114.

45. Margo McBane, *The History of California Agriculture: Focus on Women Farmworkers* (San Francisco: The Coalition of Labor Union Women of Santa Clara County, Retail Store Employees Local 248, The Youth Project, 1975), n.p.

46. One of the most important visual sources of Mexican women in agriculture is Dorothea Lange's photographs for the Farm Security Administration.

47. Michael Wilson and Deborah Silverton Rosenfelt, *Salt of the Earth* (Old Westbury, New York: The Feminist Press, 1978). Rosenfelt's "Commentary" gives a good account of the strike, the making of the film, and the lasting effects (if any) of the women's struggle. She approaches *Salt* from a feminist point of view, and revisited the strike participants in 1975 for a "postmortem."

48. For her history see Olga Sánchez, "Lucía Gonzáles de Parsons: Labor Or-

ganizer," in *Imágenes de la Chicana* Stanford, Calif.: Chicano Press, Stanford University, n.d.), pp. 10–12. In 1986 Carlos Cortez of Chicago, on the occasion of the hundredth anniversary of Chicago's Haymarket Square affair and the fight for the eight-hour day, produced a dramatic linoleum cut celebrating the widow (claimed by both Chicanos and blacks) of the Haymarket martyr Albert Parsons.

49. Kay Mills, "The Great Wall of Los Angeles," *Ms. Magazine* (October 1981): 66. Also see a well-illustrated review of the mural in Carrie Rickey, "The Writing on the Wall," *Art in America* 69, no. 5 (May 1981): 54–57.

50. Cited in Rodolfo Acuña, *Occupied America: A History of Chicanos*, 2d ed. (New York: Harper & Row, 1981), 235.

51. *Four Hundred and Fifty Years of Chicano History/ 450 años del pueblo chicano (In Pictures)* (Albuquerque: Chicano Communications Center, 1976), 100.

52. "Dolores Huerta Talks: About Republicans, César, Children, and Her Home Town," *Regeneración* 2, no. 4 (1974): 20–24.

53. "Dolores Huerta Talks."

54. Rosaura Sánchez, "The Chicano Labor Force," in Rosaura Sánchez and Rosa Martínez Cruz (eds.), *Essays on la mujer* (Los Angeles: Chicano Studies Center Publications, University of California, Los Angeles, 1977), 3–15.

17

LA CASA DE CAMBIO /
THE MONEY EXCHANGE

"The border is a laboratory in which we can experiment. We are focusing regionally, but our purpose is to break down the borders that exist between people of all cultures."
 Guillermo Gómez-Peña.

San Diego and Tijuana artists of the Border Art Workshop/Taller de Arte Fronterizo (BAW/TAF), in their fourth multimedia installation of "Border Realities" since 1985, have evoked one of the oldest architectural constructions of ancient history—the labyrinth—as a metaphor for the social and political complexities and absurdities of the U.S.-Mexico border.

According to a Greek myth older than Homer, the original labyrinth was built on the island of Crete by the magician-engineer-artist Daedalus, who later invented wings cemented with wax so he and his son Icarus could escape their imprisoning environment. The labyrinth hid at its heart the most fearsome symbol of human irrationality: the Minotaur. Half human, the bull-headed monster exacted terrible tribute from the bull-worshipping Greeks. Now the children of another miscegenation— the Olmec were-jaguar; half human and half tropical tiger—have built their own labyrinth, at whose heart is the monster of "border relations," whose guardians are the officers of the Immigration and Naturalization Service (INS), and whose rituals are often as heartless and bloody as those of the Minotaur. Invoking, exploring, revealing, through simile, meta-

This essay first appeared in *La Opinion*, July 10, 1988, Panorama Dominical: 4–5.

phor, allegory, and pun; playing with visual and verbal texts, with image and sound, with interface and juxtaposition, the BAW/TAF has caused the House of Change (where pesos and dollars confront each other in daily and deadly equivalencies) to become the House of Changes, where realities are deconstructed, stripped of their ideological clothing and legalistic accessories, and made visible in new ways to their victims on both sides of the border. "Change" can be a noun or a verb; can be coins or reforms; can be superficial or structural.

To carry out this (re)formation of consciousness, the Mexican, Chicano, and North American artists of the BAW/TAF (Victor Ochoa, Michael Schnorr, Emily Hicks, Berta Jottar, Guillermo Gómez-Peña, Robert Sánchez, Deborah Small, and others) have installed their huge tunnel, La Casa de Cambio, made of wood draped with immense sheets of pliable black plastic in San Diego's Centro Cultural de la Raza. As one navigates in almost claustrophobic darkness, various niches or room-size spaces open in the wall to reveal not only the inner workings of "border relations" but the idea of the border "line" itself—that geopolitical line dividing two nations whose territories were reconstituted by virtue of a nineteenth-century U.S. conquest (the second in Mexico's history) whose apologia was "Manifest Destiny," and where economic power is juxtaposed with and exploits economic necessity. In the hands of the BAW/TAF magician/artists, the line has been broken, an idea celebrated in a bilingual, interdisciplinary magazine published by Guillermo Gómez-Peña (and friends) titled *The Broken Line/La linea quebrada* (now in its third number), excerpts from which occupy one of the "galleries" hollowed out within the winding tunnel.

Entering the labyrinth, our experience starts with miniature dioramas scooped from the wall: palm trees in ghostly white; a money exchange booth; a performance-art installation. Suddenly one breaks into open space. The first "gallery" contains two black velvet paintings (shades of Tijuana tourist art). One, *La frontera es de moda*, features a Mexican revolutionary masked as the famous wrestler "El Santo." The other, *Souvenir de la frontera*, is of John Wayne (with black eye patch) as an immigration officer. Thus immediately the two protagonists of the scenario are thematically confronted: the ultimate Mexican fighter with his opponent—the ultimate jingoistic Anglo. Both have been popular mythic heroes in their respective universes; now they become Tijuana-style "souvenirs" of their confrontation. Beyond these two, the "gallery" is hung with visual and verbal documents from *La linea quebrada* by artists and intellectuals who have undertaken to redefine the geographic, economic, cultural, and psychological spaces known as "borders."

Fig. 50 Proceeding through a door marked by a large chained and handcuffed heart of leopard-skin fabric, we enter the "passport room." On a table adjacent to a gigantic thumbprint, visitors find green paper passports

(green cards?), which they are invited to initial with their thumbprint and signature and deposit in a wire basket. Displayed are a gardening tool, a kitchen utensil, a car washing tool, an ironing board with iron—all the implements necessary for the low-paid jobs on the U.S. side of the border for which green cards can be issued.

Beyond is a bridge which passes over a huge underground pipeline through which undocumented workers can (at the risk of their lives) cross the border surreptitiously, as shown in the film *El Norte*. The bridge straddles a "colonization" room. Here history starts with a 1492 quotation from Columbus stating that "all the inhabitants could be taken away to Castile, or made slaves on the island. With fifty men we could subjugate them all and make them do whatever we want." A Spanish conquistador followed by a nude Indian are blown up on the wall from an old print. On another wall appears a historical drawing of the infamous slave ships showing how many Africans could be efficiently crammed into the hold of a ship; counterpoising this image is a reproduction of a 1939 mural by black artist Hale Woodruff commemorating the centenary of a slave mutiny on the ship *Amistad* which resulted in the return of the Africans to their native lands. Resistance offsets conquest and enslavement. Facing this image is a photo blowup of contemporary "colonizers" behind a blue rowboat identified as the U.S.S. *Amnesty*, referring to the present law which pretends to solve the problem of undocumented workers in the United States. Through another door, a life-size cartoon cutout (with movable armholes and faces through which visitors can substitute themselves for the painted areas) is fully equipped with the "blessings" the U.S. can bestow upon the new immigrants: evangelical preachers, skateboards, blaster radios, cars, immigration officers, and factory assembly lines.

The final major space might be dubbed the "ideal home" installation, complete with patio, umbrella, table and chairs, a television set on which is being shown the specially prepared video *Erasing the Line*, white picket fences behind which photographs and statements taken from residents of San Diego and Tijuana give "testimony" of their viewpoints. The "ideal home" itself, provided with a green lawn, a fence, a neatly coiled water hose, and a trellis, is startlingly framed by a tube of red flashing lights, and provides the gate through which one proceeds toward the exit. Opening night visitors were plentiful, and could be seen at every stage slowly navigating the labyrinthian tunnel, looking, reading, thinking, and discussing. Humor and shock effects were not lacking and provided that element of entertainment so many demand from art. Nevertheless, the process of reframing conventional notions and stereotypes about the border, and the relationships in which people living on both sides are entangled, had obviously been set in motion through the experience.

If the artwork that comprised the *Casa de Cambio* installation was

powerful and effective, it was, correspondingly, far from being polished. Eclectic postmodernist strategies were employed throughout, but the success of the work did not depend either upon their utilization, or on the elitism of an audience prepared for avant-garde visual languages. One young Mexican woman living a green-card existence in the United States exclaimed, "This is just how I feel; this explains things I have experienced, but didn't understand." "Border art," says Professor Harry Polkinhorn, who teaches on the Calexico side of the border, "since it undoes power, extends the traditional function of avant-garde art . . . to include its own unmasking. This it does in a variety of ways. Imperfection, blurred edges, ugliness, incompletion, disharmony, mixed modes and registers, polyvalencies can all be discerned in the art object or event. The matrices for power's appearances then shift." In other words, the art is accessible—not because of postmodern populist or "pop" strategies, but because images and the relationships they represent are recognizable. Though raw in execution, though pushed to their extremes, though speaking a conceptual language, they are not foreign to the understanding, and this is the secret of their comprehensibility. They demystify, and therefore empower the viewer to analyze reality; if not all, at least portions of it.

This account of Border Realities IV would not be complete without mention of the performance-art piece *Border brujo*, presented by visual poet Guillermo Gómez-Peña, assisted by Tijuana artist Hugo Sánchez. Over the nude and motionless body of Sánchez lying on the ground (the assassinated, the destroyed, from Cuauhtémoc to the undocumented worker of today), Gómez-Peña, dressed in an incredibly bedecked military-style jacket and boots, circumnavigated the "victim" proclaiming his rich effusion of meditations on the border. Past history lives again, grafted to the most contemporary permutations of border punk, to the fusion of cultures and languages, to the inseparability of Latin American/ North American experience, each feeding on and spewing out the other. This ritual, this incantation, depended heavily on the earthy yet incandescent use of words. Dazzling, energetic, and visually evocative as the words were, the performance depended somewhat too heavily on text, to the detriment of the external visual elements which are just as fundamental to performance-art. Nevertheless, the performance was an integral part of the whole; it contained whole constellations of ideas that underscored the structure of the labyrinth. Gómez-Peña became Daedalus to the imprisoned Minotaur.

Fig. 51

18

LOOKING A GIFT HORSE IN THE MOUTH

The decade of the 1980s has ushered in an amazing proliferation of Latin American art shows at major U.S. art museums and numerous galleries, a phenomenon unknown since before World War II and, indeed, unknown since the cross-fertilization between Mexico and the United States during the 1930s and 1940s. At that time, U.S. exhibitions of Mexican art were common practice and North Americans learned about murals from the Mexicans. Historically, blockbuster shows of Latin American art have appeared at politically strategic moments. Such was the case with the 1930 "Mexican Arts" show at the Metropolitan Museum of Art during the Depression years, when Diego Rivera and José Clemente Orozco were becoming known in the United States. Scheduled ten years after the end of the Mexican Revolution, it was one of the earliest events triggered by U.S. needs for Mexican petroleum, an issue that remained a vital plank of U.S. foreign policy from 1919 until the 1970s oil crisis.[1]

"Twenty Centuries of Mexican Art" at New York's Museum of Modern Art was mounted in 1940 (a year before the United States entered World War II), when it sought support and allies among Latin American countries that were also being wooed by the Nazis. The traveling exhibition "Masterworks of Mexican Art" took place in the 1960s, when the cold war was in full swing. It was followed a full fifteen years later by the yearlong "Mexico Today" Symposium in 1978, when U.S. petroleum and natural gas negotiations were again at stake. As the closest nation and the

This essay first appeared as "Latin American Art's U.S. Explosion: Looking a Gift Horse in the Mouth," in *New Art Examiner* 17, no. 4 (December 1989): 25–29.

most important Latin American trade partner (to say nothing of the fact that Mexico has been a major artistic force throughout all the Americas during the twentieth century), it is not surprising that the U.S. has directed great attention toward Mexican art. But this is now changing. Though Mexico still has primacy, the art of other Latin American nations is becoming increasingly visible. Not enough, not free from distorted museum presentations, not sufficiently to have any kind of parity with the Euro-American axis, but, nevertheless, no longer invisible.

Recent traveling blockbusters begin and end with Mexico. "Diego Rivera: A Retrospective" opened at the Detroit Institute of Arts in 1986; "Hispanic Art in the United States: 30 Contemporary Painters and Sculptors" started its odyssey at Houston's Museum of Fine Arts in 1987; "Art of the Fantastic: Latin America, 1920–1987" was organized by the Indianapolis Museum of Art in 1987; the Bronx Museum of the Arts opened "The Latin American Spirit: Art and Artists in the United States, 1920–1970" in 1988; the same year, the Dallas Museum of Art received "Images of Mexico" from the Schirn Kunsthalle of Frankfurt. UCLA's Wight Gallery is organizing "Chicano Art: Resistance and Affirmation" for 1990, and the Metropolitan Museum of Art is scheduled for the largest Mexican art show *ever* (so rumor has it), also in 1990.[2] All, of course, are or will be accompanied by luxurious, well-illustrated catalogues which help to fill the lacuna created when the last survey of modern Latin American art in English went out of print in the United States.[3] (How accurate and balanced a view is presented by the catalogues is, of course, another matter. The best of the catalogues, obviously, will be those whose editors turned to essayists conversant with the field.) Thus far, the exhibitions have been handsomely mounted in their home institutions (though some have suffered on the road), and many were complemented by programs of various kinds, from concerts and films to symposia.

All of these shows have been (or will be) surrounded by a flurry of reviews in each of the locations they visit. But judging by what has already appeared, there is little analysis and even less critical evaluation. Critics—to say nothing of art historians—know very little about Latin American art. Therefore the reviews, with important exceptions, have generally ranged from gushing to stereotyped. This essay undertakes to explore an aspect of the "boom" in Latin American art that has not been previously considered: the extra-artistic agendas behind the scenes.

Recent art criticism has tended to scrap older notions about art such as its "transcendentalism" or its universal aesthetic appeal, and focus on social forces and the art/investment market which frame the presentation of art today. (*Art in America* even published an extraordinary issue in July 1988 on "art and money.") Some historians and critics (including this one) are faced with the uncomfortable realization that everything they write is, willy-nilly, grist for the art market mill. Nor is this

a new phenomenon; the workings of the art market have been traced back to the whole concept of the modernist avant-garde in a provocative article revising our views of cubism.[4] What *is* new, in the United States, is its application to Latin American and Latino art suddenly become "fashionable."

It is probably more comfortable (and not necessarily contradictory) to be an idealist, with faith in the ultimate capabilities of the human race to create social structures in which art is not simply a commodity but has a communicative and emotional function not tied to its exchange value for a tiny elite group of international collectors. Nevertheless, facing the conflictive and manipulative world in which we presently live, the tendency (and the responsibility) is to continue to deconstruct the surface appearance of things, looking for the reasoning behind the many dense ideological smokescreens which mask our apparent realities. Thus, while one celebrates the fact that U.S. mainstream art institutions have opted, throughout this decade, to seek funds for, to research, and to mount an unprecedented number of exhibitions featuring the art of Latin Americans—whether they reside in their native countries, in Europe, or in the United States—it is necessary to take a closer look at the projects and intentions of the presenters. There is also the need, in my opinion, to cast a critical eye at the actual configuration of these exhibits: their inclusions and exclusions of artists and movements, their museography, their publicity, their catalogue essays, their surrounding events, and their funding sources. Last, but not least, is the need to consider the social, political, and economic relationships that provide the framework and ambience for exhibitions that in a sense violate "the usual course of things." *Why* these exhibitions, *why* at this moment in time?

"The use of artworks as symbolic carriers, as mediators of politics and as propaganda for secular and religious ideologies . . . is an old phenomenon."[5] The imperial Greeks and Romans were the first to recognize that the aesthetic power of artworks transcends their creators by enhancing the identification of the audience with that power. So, too, the status of the artworks' sponsor, in a halo effect, is enhanced in the eyes of that audience. If the artworks are of universal significance, speaking across cultural boundaries, so is their discerning patron or owner. However, the presentation of the artwork must be carefully orchestrated if the patron is to reap the benefits of the desired "halo." Patrons today range from national to local governments, from giant corporations to smaller businesses, from oil companies to banks, from private foundations to private collectors.

Such orchestration has become more complicated and more necessary in recent years, as the world's great artworks have been increasingly used in the competition between various national powers and are assigned various roles in international propaganda.[6] What is presented here is a sug-

gested outline for considering the relationship between the phenomenal increase in the number of Latin American art shows and the electoral politics, foreign policy, and international economics of the United States during this period.

Electoral Politics

Mexicans in the U.S. have traditionally been Democrats, and Mexicans represent the largest Spanish-speaking voting bloc in the country. It was already clear during the 1988 elections to what lengths the Republicans would go to capture what might be a swing vote in the Southwest. Candidates for the presidency and for local offices in the Southwest, New York, and Miami are forced by sheer demographic considerations to appeal to the Latino vote. Supporting and promoting the arts and culture has been one of the methods used. Three bits of news spanning two Republican administrations point to those connections:

1) The appointment by Ronald Reagan of Texan Lauro F. Cabazos, president of Texas Tech University in Lubbock, to be Secretary of Education and the first "Hispanic" (for which we can read "Mexican") in a U.S. Cabinet post. In the words of *Time* magazine, Cabazos was proposed "as a lure to draw Hispanic votes from the Democrats in November [1988]."[7] The irony of this appointment is that it occurred during the waning months of the Reagan administration, which had not been known during its eight years for its interest in Latino politicians or in the mass of impoverished Mexicans living in the U.S., or, for that matter, in the problems of Mexico itself. George Bush (so proud of his command of Spanish on the campaign trail) was similarly careful to appoint Manuel Luján to his cabinet as Secretary of the Interior.

2) The presentation, by former President Reagan, of the prestigious Hispanic Heritage Award for a visual artist, to an almost unknown Colombian artist from Laguna Beach, California, whose fifteen years in the United States passed with no ties to the large Latino arts population of nearby Los Angeles. This truncated Latino, calling himself Orlando A.B. (his surnames "Agudelo-Botero" apparently being too much for non-Spanish speaking patrons to master), seems to have had as his major virtues the fact that he enjoyed apparent commercial success, that he publicly supported Nancy Reagan's pet antidrug project, and that he painted a picture described as one containing a dancer, the American flag, the words of the Bill of Rights, and the words of the Battle Hymn of the Republic. The award was considered an insult by Representative Albert G. Bustamante of Texas, chair of the Congressional Hispanic Caucus, because longtime resident Latino artists who participated with and contributed to the community were ignored.[8] No one seems to have mentioned or considered the quality or importance of the artist's work.

3) The appearance of a special July 11, 1988, issue of *Time* magazine titled "Hispanic Culture Breaks Out of the Barrio," and subtitled "A Latin Wave Hits the Mainstream." Featured on the cover was a hastily painted mural portrait of Chicano actor Edward James Olmos. Apparently Mexican, Cuban, and Puerto Rican visual and performance artists of the United States, the primary (though not the only) ones featured, have "arrived" when they are not only noticed but given major space in *Time*. The magazine presented a melange of visual and performing arts, literature, food, fashion, and design. Ostensibly, the coverage in *Time* was to advise readers that the U.S. was ever ready to borrow the best from other cultures and that a new chic wave of Hispanic influence was exploding into the American cultural mainstream. Tucked away in one of the *Time* articles, however, was a more mundane consideration. According to this source, the past ten years have seen an explosive increase in U.S. immigration from Latin American countries and, consequently, "major advertisers are eager to tap the estimated $134 billion in spending power wielded by Spanish-speaking Americans" (p. 53).

Foreign Policy

The proliferation of modern Latin American art shows in the U.S. seems to begin in the early 1980s. The Reagan administration came aboard in 1981 with an ideological commitment to upset the Sandinista government in Nicaragua and to quell whatever revolutionary aspirations the peoples of El Salvador and Guatemala entertained toward ridding themselves of military dictatorships and oppressive living conditions. No easy solutions were forthcoming with military intervention via the contra forces in Nicaragua, nor through the militarization of Honduras, nor through massive military assistance to El Salvador and Guatemala. These were (and still are) unpopular wars for a majority of North Americans, who want no repeat of Vietnam. By 1982–83, opposition to Central American policies arose among major Latin American countries as well. Mexico, Venezuela, Colombia, and Panama formed the first Contadora group suing for political rather than military solutions in Central America. By 1986, they were joined by Argentina, Uruguay, Brazil, and Peru. These eight countries contain more than 80 percent of the total population of Latin America, and, it might be mentioned, they also include countries with the greatest names in modern art. Their political weight and influence on world opinion were not to be taken lightly. It is hardly surprising, therefore, to discover that it was indeed in January 1986 that Frank Hodsoll, chairman of the National Endowment for the Arts (NEA) and a firm Reagan supporter, made a special appearance at the meeting of the American Association of Art Museum Directors held in Puerto Rico to offer funds for cultural exchange between the United

States and Latin America. NEA funds in sizable amounts have been channeled into exhibits already mentioned, and more exhibits are on the drawing board.

The reasons why artworks are considered politically useful vary depending on the speaker. According to Norton Simon, Los Angeles industrialist and Medici-like art collector: "Art can take a person and open him up in a way you couldn't any other way." Peter Solmssen, Advisor on the Arts for the U.S. State Department in 1976, was more explicit: "A visitor who has spent some hours admiring masterworks from a foreign collection is unlikely to have his political views significantly altered . . . [but] if the visitor acquires in the process a better understanding of the culture which produces the art, *and of the people who now treasure it,* that . . . has political value for the U.S. [emphasis mine]." Others continue to insist on the traditional notion that art is above politics: "At its highest," said *New York Times* editor Walter Goodman in 1977, "art has an integrity that sets it apart from the unending give and take of politics."[9] While this may be so for the artist—though the production of art that is directly political in its content might gainsay even that idea—it certainly has not been the case for extra-artistic organizers of art events. The ultimate irony is that nonpolitical works of art, and works of art in opposition to the ideology of the users, can just as readily be pressed into service.

Finally it can be said, and documented, that when a group of high quality artworks are too embarrassingly political in their open opposition to the ideology of the presenters, they can be eliminated. It is difficult for an art critic to complain about exclusions in any art show unless such exclusions can convincingly be shown to be ideological in nature. Such was the case with a collection of exhibitions of modern Mexican art that circulated throughout the United States for an entire year as part of the "Mexico Today" program in 1978, which was conspicuous (with a few exceptions) for the absence of any artists connected with the Mexican School—including Diego Rivera, José Clemente Orozco, and David Alfaro Siqueiros—and of any younger artists with socially critical artworks.[10] By "Mexico Today"'s focus on three artists (of great merit) who comprise the "aesthetic" or "contemplative" wings of contemporary Mexican art, the public's view of Mexican art in general was distorted.

International and Domestic Economics:

To pursue the relationship between art and economics demonstrated in the "Mexico Today" year, it would be interesting to consider the implications of Central America and the Contadora nations once more, this time economically. It is hard to believe that economics doesn't enter into consideration when one recalls that U.S. intervention today is occurring within a region whose countries were long known as "the banana repub-

lics" and dominated by the United Fruit Company. Company names change; Coca-Cola and other industries have entered the arena, but the dynamics remain similar. For the Contadora countries, there is the question of the foreign debts, great portions of which are owed to U.S. banks. When such countries talk about, and even implement, cessation of interest payments or renegotiation of interest rates, the discussion must turn to political economy. It must be recalled that Mexico and Venezuela, both of whom are major oil producers and major debtors, were the original organizers of the Contadora peace activities. If Latin American art exhibits can demonstrate U.S. goodwill, in spite of these formidable problems, their use becomes warranted.

Touching on domestic economics, it is only needful to recall the interesting statement culled from *Time* magazine about the potential $134 billion of possible sales to the Spanish-speaking community. This community is largely working class, but it also boasts a growing and prosperous middle class, increased by the Chicanos and Puerto Ricans who fought for higher educational opportunities in the 1960s and 1970s. Slick magazines now represent this upwardly mobile group and advertisers fill the pages of the magazines and local newspapers. Hard- and soft-drink manufacturers have been in the forefront of solicitation for goodwill, and the polishing of their images, within these communities. Among them are Miller, Budweiser, and Canadian Club whiskey, which have made considerable outlays for Latino art shows across the country. Canadian Club, with its three years of circulating the "¡Mira!" Hispanic art show is a case in point. The Colorado-based Coors Beer Company opened its "Expresiones Hispanos" touring art show in 1988, aiming to rectify (without a great degree of success) years of union-busting, racism, and other ultraright activity. Big contributors to art shows have been the Rockefeller Foundation and the ARCO corporation, who underwrote the expensive traveling exhibit "Hispanic Art in the United States: Thirty Contemporary Painters and Sculptors."

On a purely local level in Los Angeles (and surely there are similar stories in other cities), the large supermarket chain Vons opened a Mexican-style bilingually labeled supermarket called "Tianguis" in East Los Angeles. In addition, a well-known gourmet restaurant, Spago's, collaborating with TELACU, which is a huge nonprofit group geared to supporting Mexican small businesses, opened the Tamayo Restaurant (supported by the artist in person), which plans for crossover business by luring non-Mexican clientele to a normally avoided Chicano neighborhood where they will dine in luxury along with the Chicano middle class.

The biggest and most direct economic impact on Latin American art and artists, however, is found within the confines of the art market. This began on an international scale in 1977, almost concurrent with the "Mexico Today" program, when Sotheby Parke Bernet of New York

opened its first auction of modern Mexican art. So successful was it that Sotheby's has continued with modern Latin American art auctions every six months since. As the market for Old and Young European "Masters" soared, investors and speculators (including many Latin Americans) looking for high returns in a crisis market turned to Latin America, where prices were—and still are—relatively low on the international art market. Since the "boom," prices for Latin American works have been rising, though not nearly as fast or as high as the works of Europeans and North Americans.

As a result, galleries throughout the country that previously had no interest whatsoever in Latino or Latin American art are rushing to find artists, and new galleries open continuously. The "instant success" of a small number of U.S. artists (just like "instant success" for many present-day international "stars") has not always been salutary. "From murals to mainstream," "from rags to riches," "from politics to personalities" might be the slogans. Nevertheless, this exposure is to be welcomed when it brings into public view artists and original art forms that were held in scorn just a few short years ago. It is hoped that this is not just a fashion, or a passing fad.

Raised here briefly, and perhaps in an oversimplified manner, are some of the cogent points about extra-artistic considerations in the national phenomenon being experienced vis-à-vis Latin American art. These remarks are meant to offset the overly easy reaction heard repeatedly from Latin American artists and their supporters: "Oh," they say, "finally we are being recognized; finally people are having a change of heart about our cultures." It is more accurate to suggest that the change of heart is not based wholly on aesthetic considerations. But beyond that, Latin American art should be presented and valued in the international arena *on its own terms*. Young artists should not be swayed to tailor their work to what sells, or to what is acceptable to the art establishment. This is the ultimate consideration if Latin American art is to maintain the power and originality, the sense of fantasy as well as the sense of social purpose, the irony, wit, and sardonic criticism, the quality of the regional in fusion with the international that have inspired admiration even when this art was not "fashionable." That is why it is necessary to look this gift horse in the mouth: to see if it really is a gift.

Notes

1. In 1927, Dwight Morrow of J. P. Morgan and Company, an astute and diplomatic man who had similarly intervened in Cuba during its 1921 sugar crisis, was appointed U.S. Ambassador to Mexico. His agenda was to persuade the Calles government not to enforce Article 27 of the revolutionary Mexican Constitution, which mandated that Mexican resources not remain in the hands of foreign inter-

ests. In the course of his activities, Morrow commissioned Diego Rivera to paint a fresco in the Cuernavaca town hall, thereby appealing to Mexican national pride. Between 1927 and 1930 (when the Metropolitan exhibition opened), Morrow convinced Calles to safeguard the interests of foreign capitalists who invested in Mexico. The principal holders of petroleum interests at the time were Great Britain and the United States. In 1932, two years before his political attack on Rivera (who had received mural commissions in the 1930s from Edsel Ford in Detroit and Nelson Rockefeller in New York), David Alfaro Siqueiros painted a mural in Los Angeles in which a portrait of the traitorous Calles was juxtaposed with one of J. P. Morgan.

2. The Diego Rivera retrospective featured 248 paintings, drawings, and mural studies; "Hispanic Art" includes thirty artists (five works each) from six countries, including the U.S.; "Art of the Fantastic" had twenty-nine artists from eleven countries with 125 works; over 230 works were chosen for the "Latin American Spirit" from 160 artist and fourteen countries, including the U.S.; "Images of Mexico" had over 350 works. (All figures are based on catalogues, checklists, or publicity of the original shows.) In 1990, the Metropolitan Museum of Art opened the blockbuster exhibit "Mexico: Splendors of Thirty Centuries." See "Metropolitan Splendors" and "Three Thousand Years of Mexican Art" in this book.

3. Gilbert Chase's *Contemporary Art in Latin America* (New York: The Free Press, 1970).

4. See Robert Jensen, "The Avant-Garde and the Trade in Art," *Art Journal* 47, no. 4 (Winter 1988): 360–67. An earlier consideration of the ideology of vanguardism and its market relationship is Nicos Hadjinicolaou's "On the Ideology of Avant-Gardism," *Praxis*, no. 6 (1982; originally 1978): 39–70.

5. Judith Huggins Balfe, "Artworks as Symbols in International Politics," *International Journal of Politics, Culture and Society* 1, no. 2 (Winter 1987): 5[195].

6. Balfe, "Artworks as Symbols in International Politics," 5[195].

7. "Milestones," *Time*, August 22, 1988: 69.

8. Betty Cuniberti, "An Artist's White House Award Draws a Puzzled Look from Latinos," *Los Angeles Times*, Orange County edition, September 16. 1988, Part V: 1.

9. Cited in Balfe, "Artworks as Symbols in International Politics," 6[196].

10. See "Rewriting the History of Mexican Art" in this collection.

19

METROPOLITAN SPLENDORS

While there is a long history of utilizing artworks and art exhibitions as symbolic carriers, as metaphors for political ideologies and economic transactions—eminently between Mexico and the United States—this process has entered a new phase in the last decades of the twentieth century. A prime example is the massive traveling exhibition "Mexico: Splendors of Thirty Centuries" inaugurated in October 1990 at the Metropolitan Museum of Art. Accompanied by a wave of publicity, "Splendors" triggered a host of activities throughout New York City under the umbrella term "Mexico: A Work of Art"—a double-edged title that seems to have been invented by someone in Mexico's Tourist Bureau. Among the players in the "Splendors" and "Work of Art" activities are figures such as Emilio Azcárraga, head of the giant Mexican audiovisual conglomerate Televisa, which underwrote most of the exhibition; Octavio Paz, honorary co-curator of the Metropolitan display; the present president of Mexico, Carlos Salinas de Gotari; and the regular and adjunct staff of the Metropolitan Museum of Art. It is also worth noting that the Met's last blockbuster exhibition of Mexican art took place exactly sixty years ago.

The argument I made in the early 1970s for the existence of a one-way cultural imperialism and its corollary, "cultural dependence," that flowed

This essay first appeared in *New Art Examiner* 18, no. 8 (April 1991): 16–19. It was adapted from a lecture at the symposium "Mexico: Here and There, Crossing Artistic Frontiers," delivered in November 1990 at Columbia University, New York City.

primarily from the United States (and Europe) to the countries of the Third World (specifically Latin America), is no longer a valid construct for the 1990s (although in its time it was an essential step in creating an awareness of cultural domination). Today we need to consider instead the global alignment of power elites from nations of the First and Third Worlds (and perhaps even the Second World) whose objective is the control of resources and cultural configurations *across national boundaries.* Indeed, increasingly we see—when we consider the whole debate about multiculturalism in the United States, as well as in England, France, and other First World nations—that the basic questions are no longer confined to national boundaries but reflect the fact that those boundaries were breached a long time ago as labor (manual, intellectual, and artistic) flowed from the Third into the First World. Trinh T. Minh Ha's much-quoted phrase, "There is a Third World in every First World, and vice-versa," admirably sums up this idea.

Of particular cogency is the case for the exhibits that can be subsumed under the rubric of the Latin American "art boom," an unprecedented outpouring of presentations from Latin America and from Latinos in the United States during the 1980s, the decade of the Reagan/Bush administrations. In fact, the process of utilizing art in this fashion can no longer be seen solely as the product of competing nations or nationalities, but rather as a phenomenon consistent with the transnational or multinational realities of global political economies and their strategies. On this new, postmodern chessboard, further complicated by the Eastern European upheavals, the role of "high culture" includes not only its unprecedented commodification on U.S. and European art markets, but its manipulation by an international elite which includes players from the entrepreneurial class of wealthier Third World nations (such as Mexico, Brazil, etc.), as well as those from the traditional metropolitan centers (New York, Paris, Rome, Madrid, and various German cities). I don't mention Japan, a new player within the international elite, because its circumstances and role are historically different at this juncture.

In using the term "postmodernism," it is well to remember that it exists in the political and economic arenas as well as in the social and cultural ones that have privileged its various discourses. In a cogent argument on postmodernism and politics, Stanley Aronowitz recently suggested that the postmodern era is marked by the renunciation of foundational thought; of the rules governing art; and of various ideological master discourses. In mapping changes in the contemporary political and cultural problematic, he established certain characteristics of postmodern society from which I have culled a few pertinent points: 1) production in the now global economy is dispersed and deterritorialized (we might consider, for example, the present negotiation for a more unified

European Common Market, and President Bush's call for an equivalent American common market), 2) new corporate metastates (the transnational corporations) are now entering into the balance of world power; 3) nationalism and national politics are in a state of crisis, and 4) certain types of political "terrorism" have emerged, among them the consumer society, privatization of national resources, and the withdrawal of masses of people from participation in the sham of parliamentary democracy.[1]

It is clear that the so-called Age of Information—in which the metropolitan centers have moved beyond industrialism as a major form of commodity production into the realm of communications (and thereby, what has been called "packaged consciousness")[2]—presents us with a new paradigm in which both commercial mass media and the arts are aligned as "information" and "communication" and are consequently subject to the political and market manipulations of these categories.

At the same time, it is necessary not to oversimplify when dealing with relations between the First and Third Worlds. While a small club of multinationals from the Third World (including the Televisa empire of Mexico and TV Globo of Brazil) appears to have been included among the "power elite" (to revive an old-fashioned term) of the developed world, in actuality, the developing country only incorporates some features of hegemony to mimetically reproduce the power relationships traditionally reserved for the affluent nations. The appearance on the international scene of what Armand Mattelart has called the "secondary peaks of economic and political domination" (in the Third World)[3] have not led to a redistribution of financial power. This industrialization (and the growth of a transnational communications network) has been carried out at the cost of gigantic debts owed primarily to private banks in the industrialized countries, and may eventually signal the incorporation of the "secondary peaks" into a world economy still dominated by the First World multinationals. Obviously this scenario would include cultural products as well as other kinds. For example, though by 1980 Televisa exported twenty-four thousand hours of programming, including that to twenty-five million households in the United States and 90 percent of Spanish-language cinema, a great number of the films shown in Mexico are dubbed North American commercial products, as are the video cassettes circulated by its subsidiary, Videocentro.[4]

Televisa of Mexico has played an increasingly visible role in cultural promotion since the 1970s, both at home and abroad—the latest example being its commitment to the present exhibition "Mexico: Splendors of Thirty Centuries." Today it is the symbol and signifier of the privatization of culture in Mexico concomitant with the increased trend toward the privatization of natural resources and public services under the Carlos Salinas de Gotari government. Some background on Televisa is therefore in order.

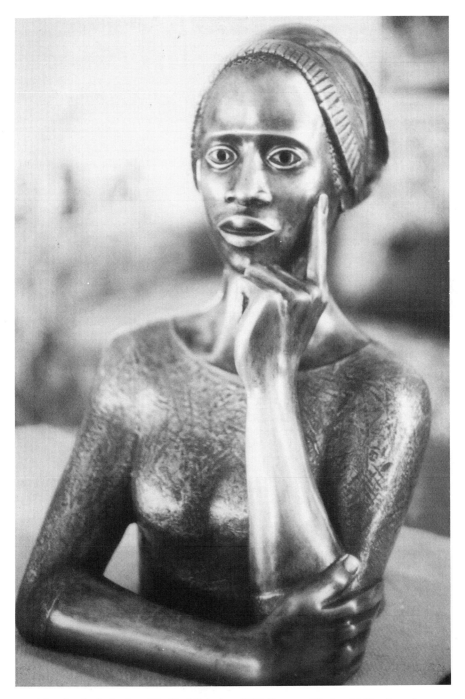

Fig. 22. Elizabeth Catlett, *Phyllis Wheatley*. 1973. Bronze, lifesize. Collection of Jackson State University, Jackson, Mississippi. (Photo by author.)

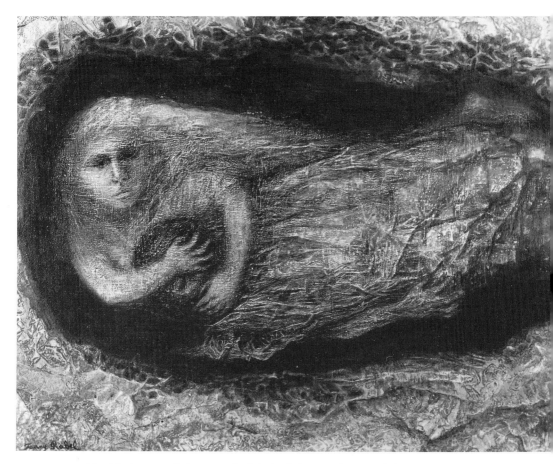

Fig. 23. Fanny Rabel, *Recuerdo del olvido* (Remembrance of the Forgotten). 1974. Mixed media, 19-1/2 in. x 23-1/2 in. Private collection. (Photo courtesy of the artist.)

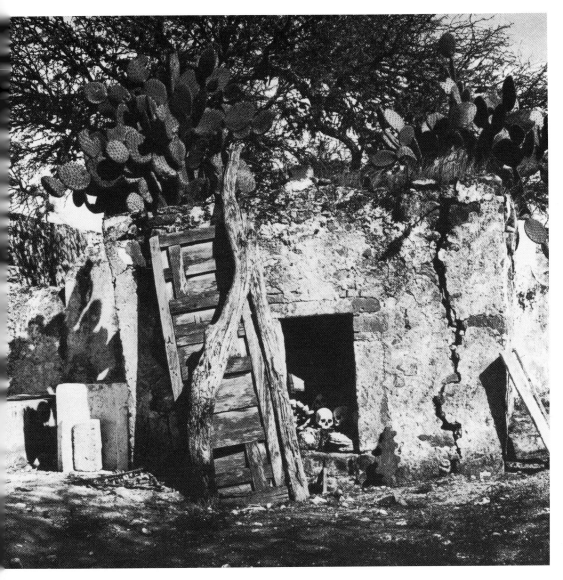

Fig. 24. Mariana Yampolsky, *Osario* (Ossuary: Dangú, Hidalgo). 1960s. Gelatin-silver print. (Photo courtesy of the artist.)

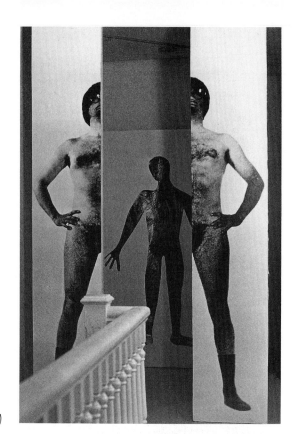

Fig 25. Lourdes Grobet, *Serendipiti* series. 1970. Photomurals. Entrance to the exhibit with view of kinetic silhouette with photographs and mica. (Photo courtesy of the artist.)

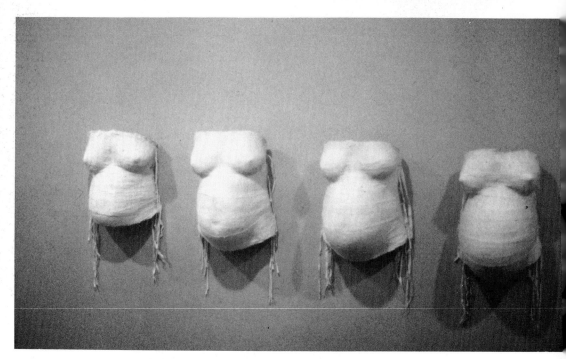

Fig. 26. Liz Lerma, *Body Mask* series. 1979. Plaster cast bandages, cotton lacing, and trim, lifesize. Collection of the artist. (Photo by author.)

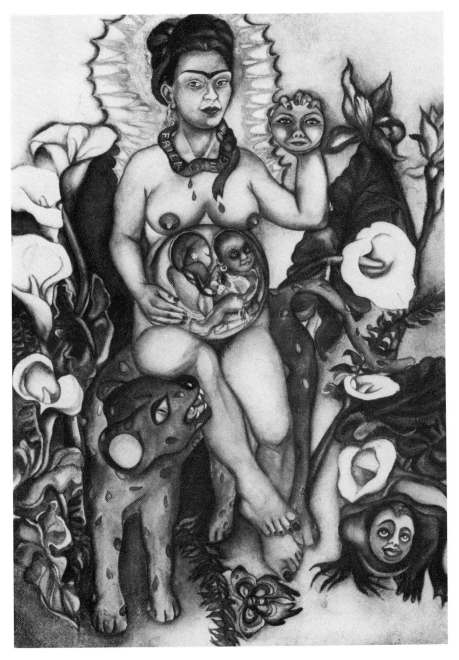

Fig. 27. Yreina Cervántez, *Homage to Frida Kahlo.* 1978. Watercolor and oil pastel, 1978. 19-7/8 in. x 14 in. (Photo courtesy of the artist.)

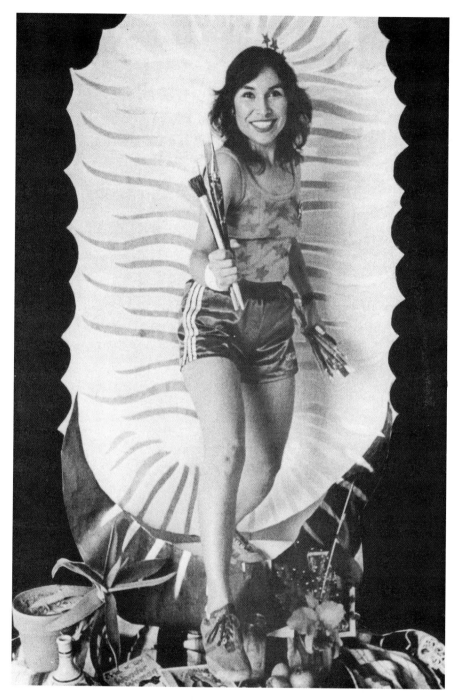

Fig. 28. Yolanda López, *Portrait of the Artist as the Virgin of Guadalupe.* 1978.
Tableau vivant. Photo by Susan Mogul. (Photo courtesy of the artist.)

Fig. 29. Mujeres Muralistas, mural group, 1974. Left to right: Irene Pérez, Consuelo Méndez, Patricia Rodríguez, Graciela Carrillo. (Photo courtesy of Patricia Rodríguez.)

Fig. 30. Magda Santonastasio, *América Central* (Central America). 1984. Zinc etching, 7-1/5 in. x 9-3/5 in. (Photo courtesy of the artist.)

Fig 31. Maritza Pérez, *Generales de la muerte* (The Generals of Death). 1986. Mixed media, 13 in. x 10 in. x 2 in. Collection of the artist. (Photo courtesy of the artist.)

Fig. 32. Ana Mendieta, *Untitled.* From the series *Fetish.* 1977. Colored photograph mounted on board. 20 in. x 13-1/4 in. Collection of Whitney Museum of American Art. Purchase, with funds from the Photography Committee. 92.112.

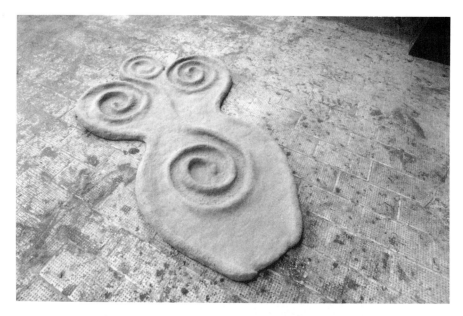

Fig. 33. Ana Mendieta, *Untitled.* 1983. Sand and binder on wood, 63 in. x 39 in. x 2 in. (Photo courtesy Galerie Lelong and the Estate of Ana Mendieta.)

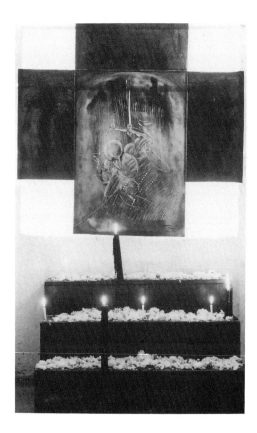

Fig. 34. Isabel Ruiz, Serie: *Historia sitiada, Num. 10* (Besieged History series, #10). 1991. Watercolor with installation, 55 in. x 48 in. x 26 in. (Photo courtesy of the artist.)

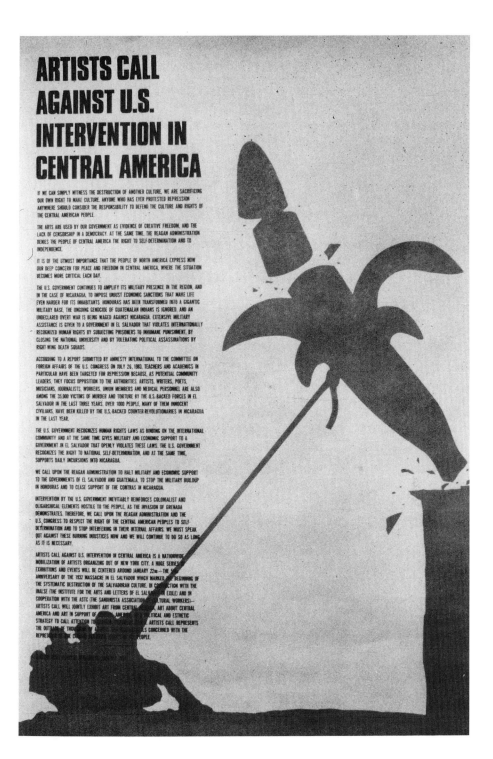

Fig 35. Claes Oldenburg, offset poster for Artists Call against U.S. Intervention in Central America. 1983.

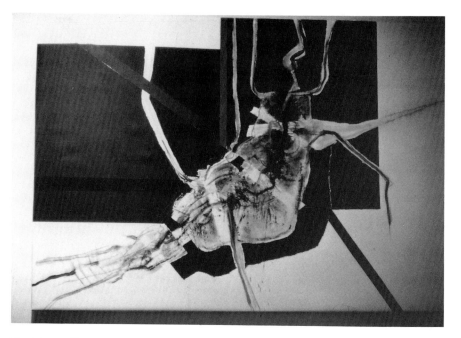

Fig. 36. Guillermo Nuñez, *Patria que te enjaularon . . .* (Oh, Caged Motherland . . .).
1977. Acrylic on canvas, 51 in. x 64 in. (Photo by author.)

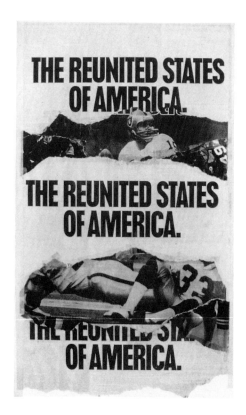

Fig. 37. Catalina Parra, *The Reunited
States of America.* 1981. Newspapers
and tape, 28-1/2 in. x 22 in. Collection
of the artist.

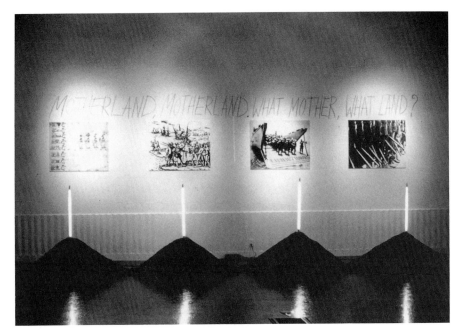

Fig. 38. Alfredo Jaar, *Motherland, Motherland, What Mother, What Land?* 1984. Installation, mixed media, 12 ft. x 20 ft. x 6 ft. (Photo by author.)

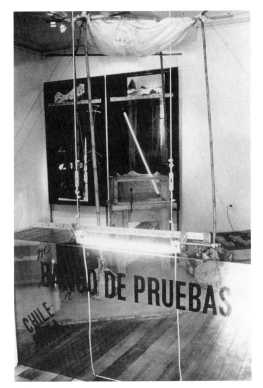

Fig. 39. Gonzalo Díaz, *Banco/Marco de pruebas* (Testing Bank/Frame). 1988. Installation detail, mixed media. Collection of Archer M. Huntington Art Gallery, University of Texas at Austin. (Photo by author.)

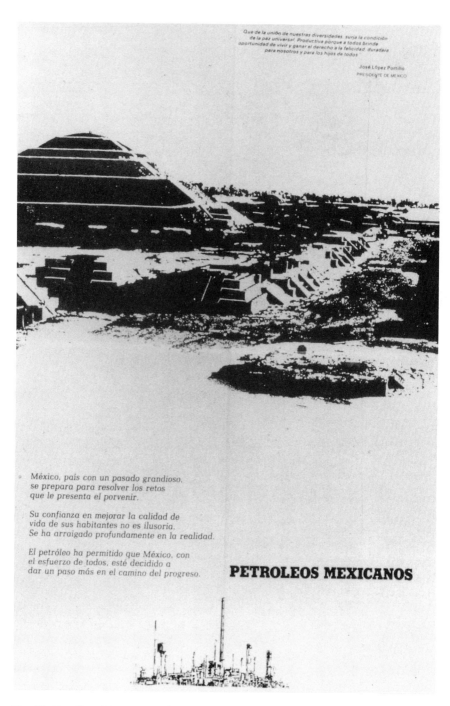

Fig. 40. Petróleos Mexicanos advertisement, from *Le Monde Diplomatique en Español*. December 1981.

THE MEXICO TODAY SYMPOSIUM
1978-1979

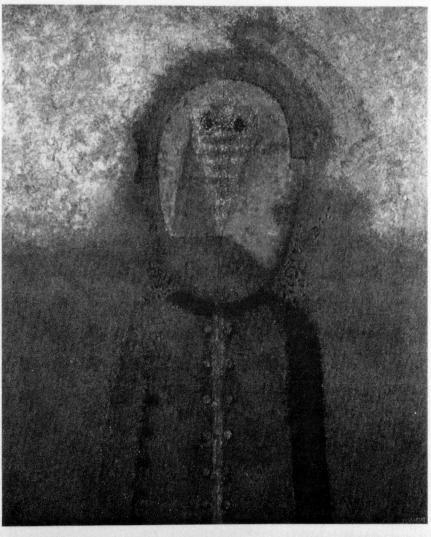

Washington	Oakland	San Antonio
New York	Los Angeles	Detroit
Atlanta	San Diego	San Francisco

Fig. 41. The "Mexico Today" Symposium catalogue cover.

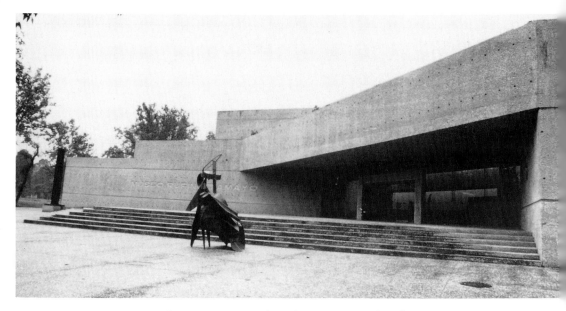

Fig. 42. Museo de Arte Internacional "Rufino Tamayo," Chapultepec, Mexico City.
(Photo by author.)

Fig. 43. James Michael Newell,
*The Development of Western
Civilization.* 1938. Mural
detail, Library of Evander
Childs High School, Bronx.
(Photo 1943, Collection of the
City of New York. Courtesy of
the Art Commission of the City
of New York.)

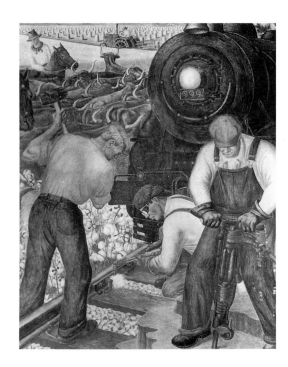

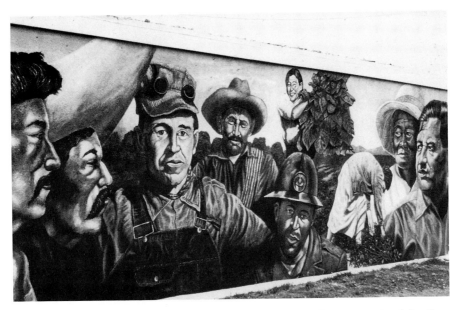

Fig. 44. Emigdio Vásquez, *Tribute to the Chicano Working Class.* 1979. Mural detail, acrylic on gessoed stucco, 8 ft. x 64 ft. Orange, California. (Photo by author.)

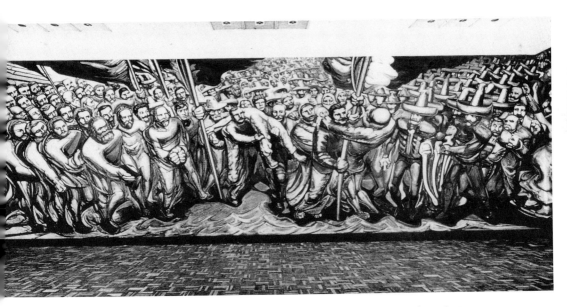

Fig. 45. David Alfaro Siqueiros, *Revolución contra la dictadura porfiriana* (Revolution against the Porfirian Dictatorship). 1957–67. Mural detail, acrylic on celotex and plywood. Museo Nacional de Historia, Chapultepec, Mexico City.

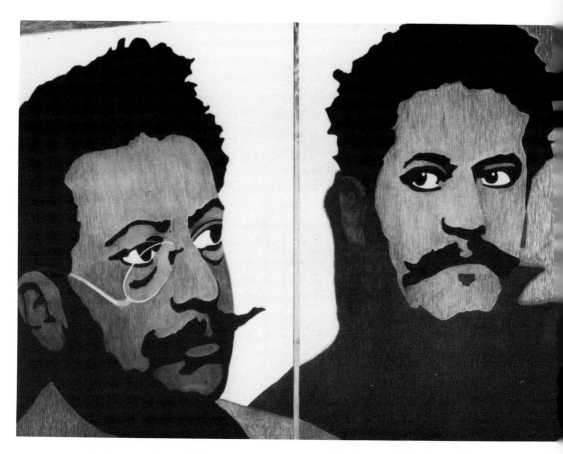

Fig. 46. Rupert García, *Hermanos Flores Magón* (Flores Magón Brothers). 1979–80. Diptych, pastel on board, 60 in. x 80 in. (Photo by Bob Hsiang.)

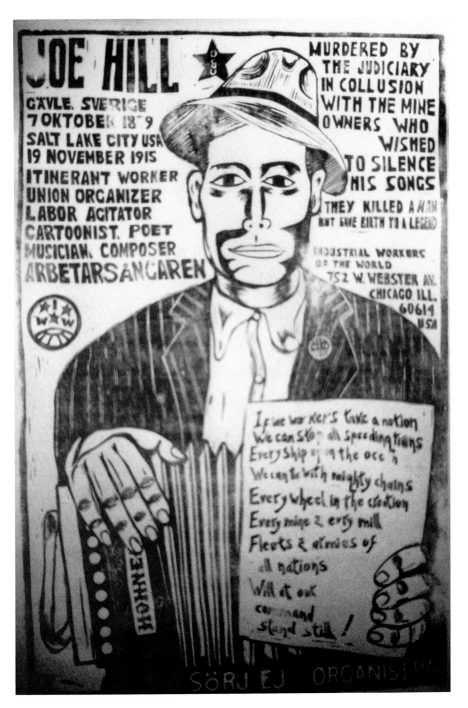

Fig. 47. Carlos Cortez, *Joe Hill*. 1979. Linoleum cut, 35 in. x 22 in. (Photo by author.)

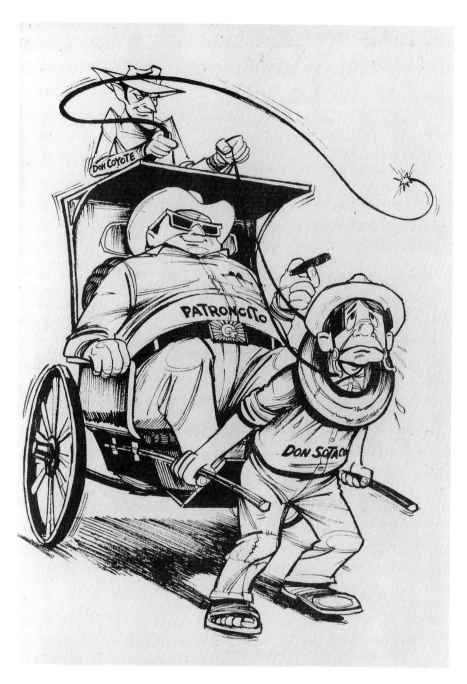

Fig. 48. Andrew (Andy) Zermeño, series *Don Sotaco: Cartoons from the Delano Strike.* 1966. Pen and ink on paper, 17 in. x 11 in. From *El Malcriado* (Delano, Calif.: United Farm Workers Union, 1966). (Photo courtesy of Wight Art Gallery, University of California, Los Angeles.)

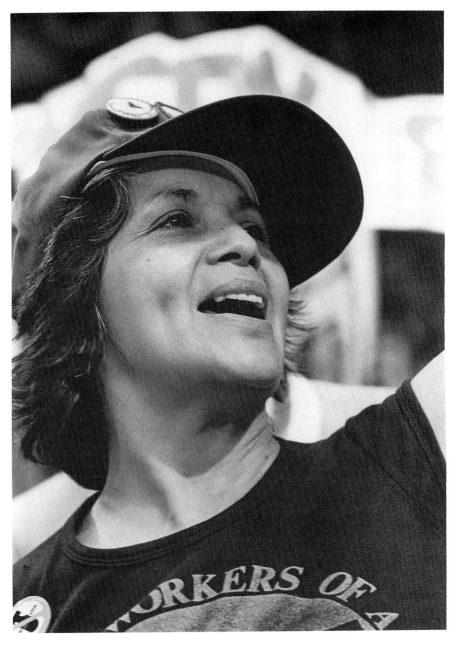

Fig. 49. Rosemary Quesada-Weiner, *Dolores Huerta*. 1980. Gelatin-silver print.
© Rosemary Quesada-Weiner. (Photo courtesy of the artist.)

Fig. 50. Border Art Workshop/Taller de Arte Fronterizo, *Passport Room (Green Cards)*. 1988. Installation. (Photo by author.)

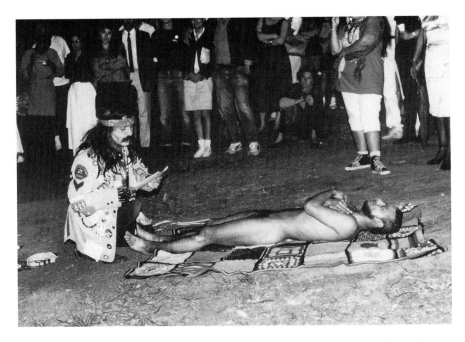

Fig. 51. Guillermo Gómez-Peña and Hugo Sánchez, *Border brujo* (Border Shaman).
1988. Performance. (Photo by author.)

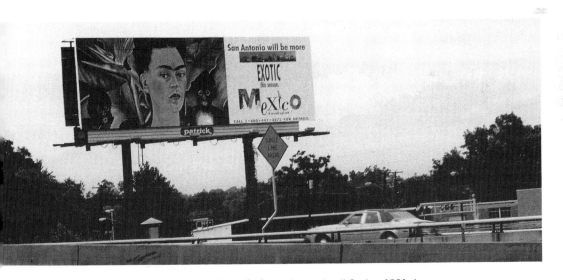

Fig. 52. Billboard for "Mexico: Splendors of Thirty Centuries." Spring 1991, in
downtown San Antonio along Interstate 35. (Photo by R. Alexander Labry.)

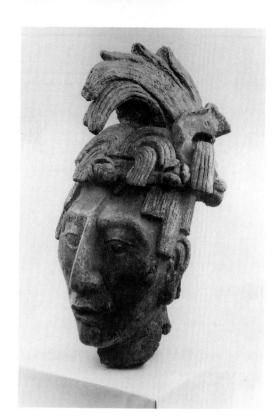

Fig. 53. Maya head, from
Palenque, Tomb of the Temple of
the Inscriptions, Chiapas, Mexico.
Stucco, mid to late 7th century.
Height 16-7/8 in. CNCA-INAH,
Museo Nacional de Antropología,
Mexico City. (Photo courtesy of
the Los Angeles County Museum
of Art.)

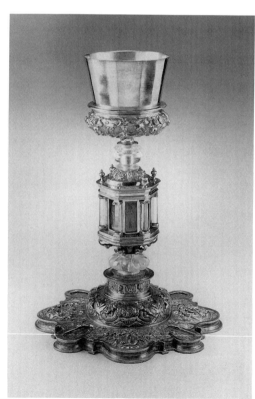

Fig. 54. Chalice, Mexico City.
Silver gilt, rock crystal, boxwood,
and hummingbird feathers, 1600–
50. 13 in. x 9-1/4 in. Collection
(and photograph): Los Angeles
County Museum of Art, William
Randolph Hearst Collection.

Sociologists and political economists are well aware of the powerful industrial complex based in Monterrey, in the state of Nuevo León, Mexico. Known as the Grupo Monterrey, dominated by one of Monterrey's most prominent and wealthiest families, the Garza-Sadas, its history dates back to the 1890s when it represented the foremost thrust of entrepreneurial capitalism under the *porfiriato*. By the 1930s, after the Mexican Revolution, the Monterrey elite was in open conflict with the pro-reformist government of Lázaro Cárdenas, whose nationalization of the foreign-controlled Mexican oil industry in 1938 almost caused a rupture with the United States, though it was widely supported by the Mexican people. Both Cárdenas and the Petroleos Mexicanos (or PEMEX, as the national oil company is known) are names to remember. The late president's son, Cuauhtémoc Cárdenas, ran against present President Salinas de Gotari of the ruling Institutional Revolutionary Party (or PRI), and it is widely believed that Cárdenas won at the ballot box. Furthermore, in the present privatization of national Mexican industries and territory by the Salinas de Gotari government, even in violation of the postrevolutionary constitution, not only are telephones, airlines, goverment-owned television, and other vital services being sold to private interests, foreign and domestic, but PEMEX will very probably also go on the block, over the protests of a great number of Mexicans.

As a horizontal cartel, the Monterrey Group includes a number of firms in addition to Televisa, which controls almost 100 percent of Mexican television. One of the oldest and largest, the brewery Cervecería Cuauhtémoc, established the Monterrey Museum, one of the few private museums in Mexico. In 1981, the Televisa Cultural Foundation, underwrote the costs of building the Rufino Tamayo Museum in Mexico City, the only private museum in Chapultepec Park. Televisa has been a major patron of Tamayo's, and in more recent years, has also patronized the youngest group of artists, called by some the "Neo-Mexican" generation. At the same time, Televisa has been accused by Mexican intellectuals of North Americanizing Mexican culture through its control of mass media.

The close relationship between Tamayo and Televisa suffered a rupture in 1985 when its president, Emilio Azcárraga, acted unilaterally to vacate the contemporary art collection, donated by Tamayo to the Mexican nation, from the Tamayo Museum of Contemporary Art built to house it. The large collection was stored in a warehouse without the knowledge of the artist, who, understandably, was enraged. It was common knowledge that Azcárraga took the advice of William Lieberman of the Metropolitan Museum, who allegedly claimed the Tamayo contemporary art collection was not of world-class caliber. On Lieberman's recommendation, a young New Yorker, Robert Littman—who neither spoke Spanish nor had much sympathy for Mexican art—was appointed

as director of the Tamayo Museum. This situation lasted approximately one year, when Mexican president Miguel de la Madrid, pressured by Tamayo's threat of a hunger strike at the age of eighty-seven, nationalized the museum and restored its collection. The Televisa museum and its U.S. director were transferred to another space, now functioning as the Centro Cultural/Arte Contemporáneo. Robert Littman has been instrumental as an adviser to Lieberman in the organization of the present exhibition at the Metropolitan Museum, as well as of subsidiary exhibits in New York. In addition, the Centro Cultural has been a major patron of the young generation, as has the Monterrey Museum, and private galleries in Monterrey and Mexico City.

Inviting comparison to the present blockbuster at the Met is another event in the United States that showcased (carefully selected) Mexican art and culture: the 1978 "Mexico Today" Symposium (see "Rewriting the History of Mexican Art"). At that time, making a connection between the multiple events (including a number of large art exhibitions) mounted during the yearlong Symposium and the discovery of vast reserves of petroleum and natural gas in Mexico at the beginning of the 1970s required extended research. Not until Armand Hammer, president of Occidental Petroleum Corporation, brought an exhibition called "Treasures of Mexico from the Mexican National Museums" to the Smithsonian, the Knoedler and Hammer Galleries in New York, and the Los Angeles County Museum of Art (of which he was then a trustee), and from which it traveled to the Monterrey Museum, did the smell of oil (that was *not* oil paint) slightly penetrate the consciousness, for example, of *Los Angeles Times* art critic William Wilson. Doubtless this was so because Occidental Petroleum is headquartered in Los Angeles, and because Hammer was unusually candid to the press in pointing out how useful the new Mexican gas and oil discoveries could prove to the United States during the then-publicized "oil crisis."

As we all know, Mexico's petroleum discoveries did not, as the Mexican government anticipated, raise the internal revenues of the nation and allow much-needed social programs to be installed that would ward off the growing political unrest among Mexico's disenfranchised—to say nothing of increasing profits for Mexico's entrepreneurial classes. Instead, in the typical neocolonial pattern of a Third World underdeveloped capitalist nation, the exploitation of raw resources led to both their possible exhaustion and a deepening of the nation's economic crisis. Since the world oil markets are controlled by multinational corporations deriving from the countries of the developed world, this is not a surprising result. It has been functioning in this manner for the last five hundred years throughout Latin America, put in motion by colonists and neocolonists alike, and is the mechanism by which the developed world is enriched

while impoverishing the underdeveloped world. Thus Mexico is in an even more precarious state of crisis today than it was in the 1970s when the oil bonanza promised relief. Today this crisis takes the form of a staggering national indebtedness to U.S. and European banks.

In 1978–79 the scenario outlined above was very much behind the scenes. What is amazing today and what can only be called "postmodernist" in character—is the blatant transparency of the public relations and economic transactions taking place. So devoid of modesty and circumspection are these manipulations that even mainstream critics are clearly aware of the international implications of the event. For example, from New York art critic Mark Stevens, writing in the October 1990 *Vanity Fair*,[5] comes the following:

> The huge celebration of Mexican culture now at various New York institutions [has something] inevitably . . . suspect about it; art is being used yet again for public relations. . . . The exhibition at the Met is the centerpiece. Three Mexicans in particular stand behind it like presiding "angels." The principal instigator and backer of the Metropolitan exhibition is Emilio Azcárraga, Jr., perhaps the richest and (after the president) most powerful man in Mexico. Azcárraga has a natural interest in the power of an image; he is the principal shareholder in Televisa, which owns almost all the television stations in Mexico.
>
> Carlos Salinas [de Gotari; Mexico's president] is the exhibition's second angel. . . . A technocrat in search of a vision, he immediately saw that an exhibition like the Met's would serve the intention of his government to enhance Mexico's image, thereby attracting [North] American investment. . . . Representatives of the Met visited Salinas at the presidential palace in Mexico City to win his support for the project.
>
> The poet Octavio Paz [is] the third angel behind the Metropolitan show. Paz's position [in the Met show] is more complex.

It is Paz, the acclaimed poet and author now in his seventies, hailed in 1968 when he resigned his ambassadorial post and spoke out publicly against the Mexican government's massacre of students at Tlatelolco, but steadily turning to the right since then, who was fortuitously awarded the Nobel Prize for literature just as the Met show opened in New York. His essay is the one that dominates the catalogue of the exhibition, described by another critic as being "as thick as the Manhattan telephone book" and weighing seven and a half pounds.[6] In his essay, according to Stevens, Paz's task is to show the continuity between the diversity of works and epochs covered in the huge exhibition and, presumably, surviving to the present day and the present administration. Paz's most recent

affiliations and ideology are known sufficiently for a *Los Angeles Times* staff writer to point out that in Mexico

> in recent years, Paz has been . . . criticized for his ties to the establishment of the Institutional Revolutionary Party (PRI). He is friendly with President Carlos Salinas de Gotari and so close to the king of the Televisa empire, Emilio Azcárraga, that critics call him "Pazcárraga."[7]

It's ironic, said another critic,

> that Televisa—long condemned by Mexico's intellectuals for its Americanization of the country's popular culture—should now be in the business of selling an image of Mexican high culture to the United States. But the image is carefully edited. There is little sense at the Met that Mexico's art has anything to do with its history of social conflict. Toltec sculptors, Spanish chroniclers of imperial wealth and 20th century Marxists like [Frida] Kahlo and Diego Rivera, are all packaged into a handsome continuum of genius, detached from their historical context.[8]

The editing referred to also involved the censorship exercised on the text commissioned for the catalogue from New York critic Dore Ashton, allegedly objected to by Miguel Angel Corzo, president of the Friends of the Arts of Mexico, who works out of the offices of Univisa, Televisa's marketing operation in Manhattan, but whose committee is based in Los Angeles.

The word "Metropolitan," in the title of this article has a double signification: it is the name of the institution but also refers to the "metropolis" which stands in contradistinction to the "periphery," or the marginalized nations of the Third World. The buying and selling appears to be about art, vis-à-vis the idea of Mexico as a "Work of Art." Considering the recent commercial promotion of Mexican art, from the Sotheby and Christie auctions to a multitude of commercial galleries, the selling is actually taking place. However, the buying and selling can be seen on another level: that of the "selling," by a master entrepreneur of public media, of a sanitized image of Mexico—devoid of its terrible economic crises and social disintegration—and the deeper question of selling off the Mexican patrimony by Salinas de Gotari. The question that remains is the buying. Was the Metropolitan Museum of Art, ancient bastion of art established in 1870 by the "robber barons" of the nineteenth century and their cohorts (though it is technically owned by the City of New York), bought by Mexico's Azcárraga? Or was this a public relations trade (like the Mexico Today Symposium of 1978–79) for the present and future selling of Mexico itself? After all, other nations than the United States are interested in that kind of investment.

Notes

1. See Stanley Aronowitz, "Postmodernism and Politics," *Social Text,* no. 18 (Winter 1987–88): 99–115.

2. Herbert I. Schiller, *The Mind Managers* (Boston: Beacon Press, 1973), 8.

3. Armand Mattelart et al., *International Image Markets: In Search of an Alternative Perspective,* trans. David Buxton (London: Comedia Publishing Group, 1984), 56.

4. Florence Touissant, "El poder ecónomico de Televisa acapara el mercado de los videoclubes," *Proceso,* no. 454 (July 15, 1985): 48–49.

5. Mark Stevens, "South of the Border," *Vanity Fair,* October 1990: 156–72.

6. George Black, "Mexico's Past, as Edited for U.S. Display," *Los Angeles Times,* October 9, 1990.

7. Marjorie Miller, "Mexico's Paz: Ideology Rift?" *Los Angeles Times,* October 19, 1990: A5.

8. Black, "Mexico's Past." For complete details on the excisions and substitutions made on Ashton's manuscript—and allowed to stand despite the author's spirited protests—see Carlos Puig, "Censura en el catalógo del Met suaviza el porfiriato y protege a los mecenas del arte," *Proceso,* no. 727 (October 8, 1990): 48–49.

20

THREE THOUSAND YEARS OF MEXICAN ART

> In order to hide its nakedness in times of scarcity, the jewels and treasures of Mexican "official culture" have been sent to New York, the northern metropolis. Its proponents dream of flaunting their artistic splendors before the stunned eyes of savage millionaires, thus warming the cold heart of the United States . . . and, in doing so, strengthen the waning legitimacy of the Mexican political system.[1]
>
> Roger Bartra

Fig. 52 So much was written about the mammoth exhibition "Mexico: Splendors of Thirty Centuries" during its fifteen-month tour in the United States[2] that I will avoid reiterating descriptive and/or eulogizing texts published across the nation about the almost four hundred works of art of which it was composed. Instead I propose to consider this exhibit as a cultural artifact in itself, in terms of its audience, patronage, history, museography, and ideological functions.

Any evaluation of "Splendors," probably the last of the great Latin American "blockbusters" that marked the decade of the eighties, would be incomplete without acknowledging that no exhibition has been more important for large communities of Mexicans in the United States than this one.[3] At every city included in its tour it attracted record crowds, especially in the two "Mexican" cities, San Antonio and Los Angeles. While I have no statistics for the San Antonio Museum of Art, the Los

This essay first appeared in *Art Journal* 51, no. 2 (Summer 1992): 91–95. Reprinted by permission of College Art Association, Inc.

Angeles County Museum of Art (serving a population of probably two million Mexicans and over a half-million Central and other Latin American nationalities) reported an estimated half-million visitors during its three-month tenure, of which an unprecedented 30 to 40 percent were Latinos.[4] In addition, in order to update the "Splendors" show beyond its 1940s cutoff date, the Mexican-sponsored "Mexico: A Work of Art" organized visual events in each of the three venue cities, as did the Chicano-organized "Artes de México" festival in Los Angeles. There were nearly two hundred such events, many them well attended.

For Mexicans, Chicanos, and Latinos, the great spread of artistic production that could be seen in "Splendors of Thirty Centuries," from the ancient indigenous civilizations of Mesoamerica up to the twentieth century, and the supplementary exhibits of contemporary works, offered an opportunity to gain an aesthetic and historical overview of artworks never before gathered together at one place and time. For the marginalized Mexican/Chicano communities of the Southwest, hungry for the rare opportunity of having their symbolic culture available to them and even validated by its presentation in prestigious institutions, this show was a source of considerable satisfaction and pride. Furthermore, it was anticipated that many false ideas and stereotypes about Mexicans could be curbed, or even reversed, through its presence. Finally, local artists retained the hope that their almost complete invisibility or occasional token appearances within the mainstream art institutions (of Los Angeles and San Antonio) would now be remedied. This remains to be seen.

While "Splendors of Thirty Centuries" was abundantly filled with masterpieces, the exhibition—organized and curated by the Metropolitan; underwritten primarily by Emilio Azcárraga, head of the giant Mexican audiovisual conglomerate Televisa (which also established a fundraising entity known as the Friends of the Arts of Mexico in the United States); and lent official presence by Mexico's president, Carlos Salinas de Gotari, and by Nobel Prize winner poet Octavio Paz, who wrote the overarching catalogue essay—had some serious omissions and equivocations.[5] I should mention that I saw the show both in New York and Los Angeles and that many works did not travel to the West Coast venues. Nevertheless, the conceptualization of the exhibition rests with its didactic, unilinear, sometimes disinformative history (presented bilingually with wall text and explanatory labeling for which the organizers should be complimented), as well as with the expensive catalogue and the curatorial selections.

There is little question that the heart of the enormous exhibition was the art of the colonial period—actually and emblematically. Even the term "splendors" does not quite fit the monumental display of pre-Columbian art representing sites throughout Mexico and focused on

works from the twelfth century B.C. to the sixteenth century A.D., from the Olmec civilization to the Aztec. Nor does it apply to the sparser collection of twentieth-century works—mostly painting, since no sculpture was chosen to complement that of the other epochs—which functions almost like a postscript to what precedes it. When one thinks of "splendors," words like brightness, brilliance, shining, resplendent, glorious, and even sublime come to mind, and the organizers and curators of "Mexico: Splendors of Thirty Centuries" went to considerable trouble (and doubtless expense) to assure that such a presence dominated the exhibition. Though this was never explicitly referred to in the publicity, or in the catalogue, it is hard to escape the conclusion that the colonial emphasis, beyond any with which I am familiar in previous comprehensive exhibitions of Mexican art in the United States,[6] was in the nature of a salute and homage to the Columbus Quincentenary of 1992, without concern for the fact that many Mexican Indians have condemned the advent of the Spaniards as a conquest that destroyed their cultures and cost many millions of lives.[7]

The panorama of pre-Columbian art which occupied so large a portion of the "Splendors" outpouring served the function of establishing Mexican roots, that hidden and buried part of the national self which has been used by Mexican official rhetoric to cement the Mexican people across the vast chasms created by economic and ethnic inequalities. As to the millions of marginalized indigenous peoples today, as Roger Bartra points out, they are the "maltreated bridge that remains; they are a symbolic reference of the past, but they are accustomed to being rejected as an active presence."[8]

Mesoamerica (or Middle America) encompassed today's nation-states of northern Central America, all of Mexico, and a goodly portion of the southwestern United States. After the hunter-gatherers, there were centuries, perhaps millennia, of agricultural villages. The oldest high civilization, that of the Olmecs, flourished in the tropical lowlands of the Gulf of Mexico from approximately 1500 B.C. until its disappearance in the first century B.C. There a theocratic, possibly militaristic, ruling class enlisted great reserves of labor under highly skilled engineers and artisans to produce pyramid-temples within religious complexes. Stone sculpture predominated: monolithic, colossal basalt heads weighing up to forty tons, and smaller freestanding or relief sculptures of priests, warriors, and other unidentified human and semihuman figures, deities, animals, and serpents, of jade and other stones, in styles ranging from near-abstraction to interpretive realism. Much of this is suggested in the Olmec display of the "Splendors" exhibition. The Olmecs also developed hieroglyphic writing, an arithmetical system, and a calendar, and elevated the tropical spotted jaguar to the status of a principal ancestor and god. Olmec cul-

ture, recognized through the intervention of artist and archeologist Miguel Covarrubias as the most ancient, is considered the parent of the great classic cultures; hardly any region in Mesoamerica escaped its influence.

In addition to the Olmec, the exhibition featured Izapa; the great Central Mexican city, Teotihuacán; the Oaxaca ceremonial site of Monte Albán; the Maya complex of Palenque, and that of El Tajín from Veracruz; Fig. 53 the late Maya site of Chichén Itzá; and finally, the capital city of the imperial Aztecs, Tenochtitlán. From the neolithic villages to the great empires of the classic and postclassic epochs, not only had technology changed and social stratification been accentuated, but increasingly subtle and symbolic art forms and literature had developed, knowledge of which is greatly restricted owing to the burning of hundreds of codices (painted books) by the Spaniards.

For the general visitor, the pre-Columbian section was impressive. Redolent of antiquity and "otherness," its monumentality and preciousness could be equated with the fascination that westerners feel when confronting the arts of ancient Egypt, Greece, China, Persia, and other exotic peoples—peoples, it should be added, whose modern artistic production is so unimportant in the western scheme of things that it neither appears in museums nor on the pages of the most widely used textbooks of world art history.

Ancient Mexico, in this exhibit, had the possible advantage of being presented in tandem with its more modern history. However, the advantage was torpedoed by the flattening and ahistorical introductory catalogue text by Octavio Paz, "Will for Form." As Paz succinctly points out in his essay, Mesoamerica could be thought of as a constellation of nations with different languages and conflicting concerns but similar political institutions, analogous social organizations, and related cosmogonies. No one could disagree with his argument that civilization is not measured solely by its technology. Its thought, its art, its political institutions, and its moral achievements must also be weighed. This being said, Paz goes on to justify not only the Spanish Conquest, but conquests by many European nations across hundreds of years. "The fall of Mesoamerican civilization was inevitable," he claims. "More powerful societies with greater defensive capacities—the Chinese, Arabs, Turks, Hindustanis—were similarly incapable of withstanding the onslaught of the great European wave."[9] (So does the history of colonization become affirmed and rationalized with a few pregnant phrases.) Despite its high level of civilization, Mesoamerica was conquered, says Paz, because of its technical and military inferiority, its vulnerability to European diseases, and its circular concept of history which led to its inability to resolve the perpetual state of war between its nations by the establishment of a supernational state. Part of this curious argument, it seems to me, could

just as easily be applied to both ancient and modern Europe, but Paz has another aim in mind. The signal achievement of the Spanish, he finds, was their ability to establish such a supernational state—i.e., the Spanish-American colonies—and "to reign in peace for three hundred years." [10]

But such a claim is a falsification in the face of historical facts. Spain was constantly harassed for supremacy by its European neighbors; furthermore, there was no peace even in Mexico, where rebellious Indians required the building of fortress-churches, where entire areas were never conquered, and where many openly resisted until the end of the sixteenth century and covertly for much longer. The existence of a military force and of the Inquisition contradicts the so-called harmony of Spanish rule. [11]

Everything about the colonial portion of the display—from the great number of religious paintings, sculptures, illustrated manuscripts, graphics, and photographs of embellished buildings, to an enormous *retablo* (a carved, gilded, polychromed altar screen from a church), an entire pulpit, a large repoussé and engraved white silver altar frontal, an entire room (shrouded in dark-toned drapery) whose lighted cases were filled with luxurious embroidered vestments and highly ornate church silver, to the secular portraits of high dignitaries and colonial elites whose dress and domestic furnishings amply illustrate their great wealth—scintillates with the "splendors" (gold, silver, precious and semi-precious stones, velvets, embroideries, mirrors, cut-glass, intricate workmanship, etc.) promised by the Metropolitan Museum of Art. This portion was meant to dazzle, and it did. However, both the displays and the didactic text mounted on the walls obscured the immensely important fact that the conquered Indian peoples—who were enslaved, forcibly converted, punished for retaining practices of their own cultures, decimated by overwork and imported diseases, and supplemented by the importation of African slaves for many years—formed the basis for the extraction of this wealth from the colony, for the enrichment of the conquerors, their descendants, and the Spanish Crown. The Indians, Africans, and racially mixed *mestizos* who comprised the bulk of the Mexican population by the time Mexico achieved its independence from Spain in the second decade of the nineteenth century almost disappear from pictorial view shortly after the Conquest (according to museum museography), except for their invisible presence as the artisans who produced both religious and elite artifacts. One exception is evident in the four eighteenth-century paintings which were displayed casually, like room decorations, on the wall behind the carved, painted, and inlaid chairs, tables, chests, wardrobes, and other furniture that originally adorned elite residences. Known as "caste" paintings, these oils, three from a set of sixteen by Miguel Cabrera and one by José Joaquín Magón, are depictions of racial mixtures, appropriately labeled with divisions and subdivisions of the names carefully

Fig. 54

assigned to each possible variation of *mestizaje* between Europeans, Indians, and Africans. Thus was the economically and racially discriminatory caste structure visually articulated to provide an exact calibration of admixture that coincided with status: the Indians and Africans (who occupied the lowest social strata), the mestizos, the Mexican-born Spaniards (or creoles), and the peninsula-born Spaniards who provided the personnel for the top echelons of Spanish colonial rule.

Also in the eighteenth-century galleries was a resplendent portrait of *The Duke of Linares, Viceroy of Mexico* (c. 1717) by Juan Rodríguez Juárez, member of a well-known family of painters, who embraced a sober European style with rococo elements to depict the gorgeously vestured, wigged nobleman in a rigid three-quarter pose, with his coat of arms amid the draperies and a lengthy inscription proclaiming his Spanish pedigree. Obviously the inlaid furniture and decorative arts displayed were for use by his class; however, his portrait is in sharp contrast with the livelier and more informal caste paintings of families. His pale visage, high forehead, long nose, disdainful glance, tapered fingers, and outstretched leg displaying a red-heeled shoe (like Hyacinthe Rigaud's rendition of Louis XIV) reinforce the strictly observed hierarchy of class and race.

At the start of the colonial section, close to a small display labeled "The Conquest," appeared another label, announcing "The Mission: 1523–1600." The succession of galleries following this legend was filled with religious art, leaving the impression that the Church's functions were not only predominant but benign and utopian, and that the major cause of Indian decline was due to European-imported diseases. To say that this is historically lopsided would be an understatement. Most scholars are agreed that the conquest of Mexico was a joint venture of sword and cross, the groups being the Spanish Crown's conquerors and bureaucrats and the Catholic Church. Bernal Díaz del Castillo, one of Cortés's soldiers, states clearly that they came "to serve God and His Majesty, to give light to those living in darkness, and also to gain riches."[12] Cortés estimated that one hundred thousand Indians were killed at Tenochtitlán. Subsequent overwork, malnutrition, poor hygiene, starvation, floggings, killings, and disease caused more than 90 percent of Mexico's Indian population (about twenty-five million before the Conquest) to be wiped out; by 1650 only one and a half million pure-blooded Indians remained. Not only did the conquistadores divide up the Indians as slaves and sources of labor power in a feudal relationship, but the Catholic clergy helped to subdue and discipline the Indians as well, not only ideologically, but as labor on immense tracts of Church land.[13] Thus, to argue, as did one wall history under the label of "The Implantation of European Style: 1550–1650," that "the rapid and extensive decline of the Indian population in the second half of the 16th century was accompanied by a

growing influx of Europeans" is disingenuous, to say the least; as is the catalogue chapter titled "The Mission: Evangelical Utopianism in the New World (1523–1600)." While it is certainly true that Indians were decimated by disease—smallpox killed many Aztecs during the conquest of their city and seven major plagues inflicted Mexico by 1600—it falls into the realm of half-truth to claim that disease was the sole culprit.[14]

The last section of the exhibition, devoted to the nineteenth and early twentieth centuries, reveals a two-pronged development in the arts: *bellas artes* (high art) represented by academic painting and sculpture; and art produced for the public's desires by self-taught artists and trained provincial artists whose oeuvre was recognizably Mexican compared to the Europeanized academic output. A third major category, *artes populares*, which includes work by artisans of all kinds who have continued a syncretized pre-Columbian tradition of weaving, pottery, lacquerware, masks, and other domestic and ritual items for local use, was not included in this exhibition. The works in the exhibition by José María Estrada, Agustín Arrieta, and, particularly, the portraits and still lifes of Hermenegildo Bustos are excellent examples that fall within the second category, as do the *ex-votos*. These small "miracle" paintings on metal were probably included because they were admired and popularized by Frida Kahlo and others of the postrevolutionary period.

Other artists who also belong to the second category were the popular caricaturists such as Manuel Manilla and José Guadalupe Posada, both of whom employed the *calavera* (animated skeleton). Posada was, posthumously, the most influential for the protagonists of the avant-garde Mexican School, notably Diego Rivera and José Clemente Orozco.

In the postrevolutionary modern period, despite some choice examples of Siqueiros, of Frida Kahlo, Rufino Tamayo, María Izquierdo, Antonio Ruiz, and other second-generation painters adapting international avant-garde modes to Mexican concerns, the quantity and quality of works did not do justice to what is available in Mexican museums and international private collections. Rivera and Orozco suffered, as did Siqueiros, from a number of mediocre selections that were inexplicable compared to the general high quality of the other historical areas. Thus the modern period appeared anticlimactic when, in actuality, the Mexican School of the 1920s to the 1940s was the most powerful avant-garde movement of the Americas as a whole, influencing artists from New York to Buenos Aires, from Lima to Havana. What is generally not known, accepted, or admitted is that even Frida Kahlo, whose work has been disengaged from its roots in the Mexican School, shared the movement's politics and its admiration for and revival of pre-Columbian and popular art. Without these influences, her work would doubtless have taken a wholly different direction.[15] Omissions played a major role: there was no photodocumentation of the epic murals whose impact spread to the United States during

the New Deal and beyond, and to all of Latin America. In fact, although the catalogue included two reproductions of Rivera murals in the modern section (five more are included in Paz's introduction), an obvious curatorial project was neglected when Orozco's 1931 oil painting *Barricade,* taken from his earlier mural at the National Preparatory School in Mexico City, and his 1943 painting *Christ Destroying His Cross,* from the 1932 Dartmouth College mural cycle, were not accompanied in the galleries by photographic reproductions of the originals. Nor was this done for Rivera's 1931 fresco panel *Agrarian Leader Zapata,* reproduced for the Museum of Modern Art in New York after a 1929 fresco mural in Cuernavaca, Mexico. Granted the murals are mentioned in the catalogue's explanatory text, but this is not a substitute for creative museography. The net result was that people who did not buy the catalogue came away with no knowledge or impression of the most important mural movement in the western hemisphere.

In addition to the omission of sculpture, the entire Taller de Gráfica Popular, begun in 1937, was omitted rather than following as a natural sequence to Posada whom, they heroized. Finally, there was no photography—although the famous documentary photographs of the Agustín Casasola Archives (housed in Pachuca, Hidalgo) were contemporary with Posada and even influenced some of his work.

In the final analysis, one might say that a careful detour was made around the more provocative and controversial aspects of twentieth-century art (a fault that extended itself to the subsidiary exhibits of "Mexico: A Work of Art," mentioned above, which skipped entire generations); that the colonial period was an elaborate construct that attempted to downplay the realities of the Conquest and utopianize the role of the Catholic Church; and that the pre-Columbian period was the monumental base upon which this social/cultural structure was rested. One final word needs to be said about Octavio Paz's essay "Will for Form." Though I very much admire certain qualities of this great poet's writing and his use of language, metaphor, fantasy, and nuance, he has violated history in his effort to establish a seamless culture without conflict, united across some three thousand years, by using the formalist propositions of Wilhelm Worringer's outmoded aesthetic philosophy, "the will to form," from the first decades of a century about to close.[16]

Notes

1. "Mexican *oficio:* The Miseries and Splendors of Culture," in *Third Text,* no. 14 (London; Spring 1991): 7. Bartra is a Mexican anthropologist, and editor of *La Jornada's* weekly cultural magazine.

2. "Splendors" was shown at the Metropolitan Museum of Art in New York from October 10, 1990–January 11, 1991, the San Antonio Museum of Art from

April 6–August 4, 1991, and the Los Angeles County Museum of Art from October 6–December 29, 1991.

3. The only comparable exhibit is CARA (Chicano Art: Resistance and Affirmation), which opened at UCLA's Wight Gallery September 1990, a month before "Splendors" at the Metropolitan, and traveled until 1993. Though presented at many more venues, it has neither the scope, chronologically or physically, nor the public relations budget of "Splendors." It also does not feature international art market "stars" of the stature of Frida Kahlo, Diego Rivera, and Tamayo. Nevertheless, it will be interesting to compare its impact after it closes.

4. Shauna Snow, "Temporary Splendors? LACMA's 'Mexico' Exhibit Has Struck a Chord but Art Leaders Wonder if Interest Will Remain," *Los Angeles Times*, December 3, 1991, Calendar Section: 1. The figures were compiled by the museum.

5. In addition to my article "Metropolitan Splendors," contained in this book, see details about the Los Angeles venue and difficulties between the Mexican government and local Chicano art groups about the subsidiary art shows in Shifra Goldman, "Mexican Splendor: The Official and Unofficial Stories," *Visions Art Quarterly* 6, no. 2 (Spring 1992): 8–13.

6. The immediate and most recent comparison would be the 1963–64 Mexican-organized "Masterworks of Mexican Art: From Pre-Columbian Times to the Present," curated by the late Fernando Gamboa, which included the folk and popular art, and an extensive display of twentieth-century graphics, lacking at the Met.

7. An article in the January 9, 1990, Mexican political magazine *Proceso* titled "El descrubimiento de América no fue un encuentro, fue una invasión" ("The Discovery of America Was Not an Encounter, It Was an Invasion"), and commenting on the visit to Mexico of Spain's king and queen, reports that the Restoration Council of Indian Peoples (composed of Indians from Mexico, Central America, and the Caribbean), the Indian Council of South America, and the World Council of Indian Peoples rejected the celebrations of 1992. In 1989, claims the article, the Commission to Study the History of the Church in Latin America stated that 1492 marked one of the major genocidal and ethnocidal programs in human history.

8. Bartra, "Mexican *oficio*, 9.

9. Octavio Paz, "Will for Form," in *Mexico: Splendors of Thirty Centuries* (Boston: Little, Brown and Company and the Metropolitan Museum of Art, 1990), 20.

10. Paz, "Will for Form," 20.

11. On the military front, it is rarely mentioned in popular histories that the Maya were not completely conquered until well after the fall of the Aztec empire and that the northern nomadic tribal groups known as the Chichimeca remained unconquered almost to the end of the sixteenth century (see Philip Wayne Powell, *Soldiers, Indians & Silver: North America's First Frontier War* (Tempe: Arizona State University, 1975). On the religious front, see Anita Brenner's classic book *Idols behind Altars* (Boston: Beacon Press, 1970 reprint), which parallels other accounts from African America to the effect that Catholicism never totally subdued indigenous religions; there was, rather, a process of syncretization.

12. Cited by Donna Pierce on page 243 of the catalogue (note 9).

13. James D. Cockcroft, *Mexico: Class Formation, Capital Accumulation, and the State* (New York: 1983), 19–21.

14. Art critic William Wilson, following the lead of the exhibition's explanatory material, maintained that no evil intended by Hernán Cortés was fractionally as tragic as outcomes he could not have foreseen. "Most of the native population that died," said Wilson, "succumbed to diseases unwittingly imported by the conquistadors." *Los Angeles Times*, December 23, 1991: F5.

15. For reconsiderations of Frida Kahlo, see my essay in the catalogue *Women in Mexican Art*, Iturralde Gallery, Los Angeles, 1991; a book-length revisionist history by Sarah M. Lowe, *Frida Kahlo* (New York: Universe Publishing, 1991); and Raquel Tibol's germinal book *Frida Kahlo: Una vida abierta* (Mexico City: Editorial Oasis, 1983), translated into English in 1993.

16. See the excerpt "Abstraction and Empathy" from Worringer's 1908 publication, in Melvin Rader (ed.), *A Modern Book of Esthetics: An Anthology*, 3d ed. (New York: Holt, Rinehart and Winston, 1961), pp 382–91.

LATIN AMERICAN ART IN THE UNITED STATES

21

LATIN AMERICAN VISIONS AND REVISIONS

Considering long-existing North American attitudes toward countries of the South, it is perhaps not surprising that a major North American art exhibition surveying Latin American modernism is called "Art of the Fantastic." However, Latin Americans are understandably sensitive when outsiders brand their culture "fantastic," "primitive," or "colorful;" these adjectives suggest exotic tourist attractions. Latin Americans also resent the notion that they are basically visceral or emotional peoples thinking from the "solar plexus" (as one critic has suggested) and with an inability to think cognitively. And yet the appellation "fantastic" continues to have a special appeal for North Americans. As the Brazilian art historian Aracy Amaral observed recently, the prevalence of the term is either symptomatic of a "moment in the art fashion of our day or simply a cliché of how hegemonic nations view Latin America."[1] Either way—fashion or cliché—the notion of the fantastic allows foreign visitors to Latin America to ignore the debilitating poverty and misery, the violent dictatorships (often supported by European or North American powers), the thriving urban culture, and the complex histories of colonization and subjugation. By focusing narrowly on a particular reading of the fantastic, North Americans and Europeans observe Latin American culture from a cool distance. It is constructed as the Other.

But in Latin American countries themselves there is a sense in which many people, artists in particular, accept and cherish their version of the

This essay first appeared as "Latin Visions and Revisions" in *Art in America* 76, no. 5 (May 1988): 138–47 +.

fantastic. Since the 1940s, when an interest in magic realism and the marvelous surfaced, Latin American artists (like North Americans) have used many affirmative strategies to counteract European chauvinism toward their art. A principal figure in this regard has been the Cuban writer Alejo Carpentier, who pointed out the differences between European and New World reality. In a seminal essay, he felicitously called his new insight *lo real maravilloso americano*, or "marvelous American reality."[2] Surrealism, said Carpentier, was the marvelous obtained with tricks of prestidigitation: uniting objects that have no business being together (the old and deceitful history of the fortuitous encounter between an umbrella and a sewing machine on a dissecting table). Thus, when André Masson tried to sketch the tropical forest of Martinique with its incredible tangle of plants and the obscene promiscuity of certain fruits, the marvelous truth of the theme consumed the painter, leaving him impotent before the white paper. "It had to be an American painter, the Cuban Wifredo Lam, who taught us the magic of tropical vegetation, the unbridled creation of forms in our natural setting."

Carpentier's lyrical exposition of the differences between programmatic French surrealism and the indigenous marvelous reality of Latin America was underscored by the Mexican art historian Ida Rodríguez Prampolini in her influential book *El surrealismo y el arte fantástico en México*.[3] Rodríguez argued that the cultural atmosphere in Mexico when André Breton arrived in 1938 was the antithesis of French surrealism; that Latin American culture with its magic vision of life and intuition of the self already contained all the characteristics and possibilities yearned for by the surrealists. To draw a clear line of distinction, Rodríguez labeled this Latin American essence "the fantastic."

As Jean Franco of Columbia University, literary historian and author of the classic text *The Modern Culture of Latin America*, also makes clear, the cultures of Latin America rely on an understanding of magic and the fantastic, which have a broad meaning and are tied to their daily life as well as to religious, social, and political practices.[4] The western routinization of everyday life, the reliance on rational assumptions, the mechanization and removal from nature, and the automatic nature of behavior have made the fantastic necessary. The modern fantastic is experienced not by a traditional community sharing a worldview, but by individuals who use remnants of ancient beliefs in liberating ways. Magic realism and the marvelous in Latin America today allow ancient beliefs to coexist with modern ones as fragments or living memories. These images and dreams offset western notions of normality that mask terror, injustice, and censorship. Finally, the fantastic is a subversive concept for Latin Americans because it questions the very nature of "reality." For populations suffering from physical oppression and psychological terror, the fantastic can be both an escaope and a challenge.

Carpentier's passionate polemical defense of the marvelous embedded in the very landscape of a pristine Latin America points up another factor: because of their geographical isolation, early Latin American artists (like their U.S. counterparts) considered European study essential to their development. Almost all the major artists spent time—some most of their lives—outside their countries. This was the accepted method of connecting with the European avant-garde; it also offered opportunities for recognition and financial stability not possible in countries with an almost nonexistent art-buying public and tastes turned toward academic European art of the nineteenth century.

Foreign travel, however, had its paradoxical aspects. Even today, Latin American artists often become more keenly aware of the essence of their native lands while living abroad than when they are enveloped in its daily realities. It was certainly true for many of the early modernists that when they came back to their home countries, a new vision emerged, a hunger to know and understand more fully the ambience that had been sharpened for them by absence and nostalgia. Thus Diego Rivera, returning to Mexico in 1921 after almost fifteen years in Europe experimenting with styles from Cézanne to cubism, traveled throughout Mexico in the 1920s. He saw with new eyes the incredible flora and fauna of the country and learned about its diverse geography and social history, both ancient and modern. These insights became the basis for the great cycles of murals that he created over the next eight years and that are generally acknowledged to be the finest work of his protean career. Similarly Wifredo Lam, returning to Cuba in 1941 after seventeen years in Madrid and Paris, rediscovered the African heritage of *santería* and the latent powers of the tropical landscapes of Martinique.

Today, in the world of the imagination and in the paradoxes of Latin America, where magic and high technology coexist because underdevelopment and consumerism coexist, reality cannot only be inextricably linked to fantasy, but can be used as an aesthetic or didactic device. The use of the fantastic is familiar in Latin American literature, especially in the writings of the late Argentinian Jorge Luis Borges, who questioned the very nature of reality, and those of the much younger Gabriel García Márquez, whose allegorical fantasies are embedded in the strange realities of his native Colombia. The same is true for Chilean Isabel Allende, whose book *The House of the Spirits* weds magic, spiritualism, folklore, and contemporary urban life with history, sociology, and politics. Allende, niece of the assassinated Chilean president Salvador Allende, creates a generic culture through her metaphorical text. The country and its historical personalities are never named, but their clear descriptions combine with fantastic allusions to root this novel in the Latin American experience of everyday life.

The notion of the fantastic proposed by the exhibition "Art of the Fan-

tastic: Latin America, 1920–1987" is both more particular and more generalized. Organized by Indianapolis Museum of Art curators Holliday T. Day and Hollister Sturges, the exhibition comprises the work of twenty-nine artists (including five women) from eleven countries (Argentina, Brazil, Chile, Colombia, Cuba, Mexico, Nicaragua, Peru, Puerto Rico, Venezuela, and Uruguay) and covers the historical development of modernism in Latin America from the early 1920s to the present. Needless to say, in order to encompass such broad geographical and historical frameworks, the curators employed a broad notion of the fantastic. As they explain in their catalogue introduction, "Fantastic art is characterized by the juxtaposition, distortion, or amalgamation of images and/or materials that extend experience formally or iconographically. . . . The fantastic may be an ingredient in almost any style, including geometric art."[5]

Although this theme, suggested by the Argentine critic Damián Bayón,[6] is generally developed from a strongly sympathetic, Latin American point of view, there are instances in which the curators stretched the concept of the fantastic beyond the boundaries of plausibility. In the case of the Venezuelan painter Armando Reverón (1889–1954), for instance, inclusion in the exhibit actually skews the meaning and interpretation of this artist's work. For, despite his eccentric lifestyle and use of imaginative props, Reverón's paintings suggest little that is fantastic. Reverón was an impressionist whose works have vaguely erotic and symbolist overtones, yet he was represented in the show largely by the full-size "dolls" and furniture that he made as models for his paintings. A misanthropic hermit who exiled himself to a small Venezuelan coastal town to paint the searing tropical light, Reverón seems to have regarded the dolls as puppets or playthings. As Hollister Sturges notes, "Toward the end of his life [the late 1940s and early 1950s], he would stage the dolls as players in royal balls, mock orgies, ballets, and other performances that acted out his inner fantasies."[7] This peculiar hobby, developed late in life, still does not seem to suggest that a fantastic vein is central to Reverón's work.

Similarly, Joaquín Torres García, the great master of Uruguayan constructivism, does not become "fantastic" for his inclusion of pre-Columbian motifs in his paintings and sculptures any more than Picasso does for his references to African forms in proto-cubist works. In my opinion, neither Colombia's Beatriz González, who effectively uses Latin American themes in a critical pop vein, nor Cuba's José Bedia Valdés, who is within the tradition of young Cuban artists currently exploring indigenous American heritages with contemporary artistic idioms, is "fantastic" in intent or result. Nevertheless, the exhibition is meaty and thought-provoking and contains a great many excellent works by three generations of artists from nearly a dozen countries.

"Art of the Fantastic" is that rare bird among modern Latin American art exhibitions in the U.S.—a historical show within a complex, multi-

faceted framework. The exhibition has been organized into three periods: 1) the early modernists (1920s–40s) whose work broke with conservative academic standards and demonstrates a search for Indian and African roots, an affirmation of American identity, and a concern with the unique characteristics of their lands; 2) a more cosmopolitan generation of artists of the 1960s–70s who reflect the economic modernization and expanding urbanism of Latin America, and the influx and influence of European artists, and who question the social, psychological, and political values of their countries in the postwar period; and 3) the contemporary generation of the 1980s, which functions within (and resists) a world increasingly controlled by the values of the metropolis and of exported consumerism. Of necessity, the format of "Art of the Fantastic" bypasses the mid-1940s and the decade of the 1950s, because that period of postwar industrialization fueled more concrete poetry and geometric abstraction than visions of the fantastic.

In the extensive catalogue for the exhibition, the curators and their Latin American advisers and contributors postulate a number of subtexts that link these three periods: the Latin American response to cultural and political influences from Europe and the U.S.; the awareness of so-called primitive art (once so much in vogue with the European avant-garde); the role of Catholicism in shaping Latin American culture; the still potent effects of the colonial past; the responses to political oppression and the growing social commitment of artists; and, finally, the geographic and psychological isolation of Latin America from the First World. The elaboration of these themes fills a lacuna in general studies of modern art, especially for North American audiences whose art histories have systematically excluded Latin American art. Unfortunately the catalogue suffers from a superficial and inaccurate introduction by the English critic Edward Lucie-Smith. But the lengthy biographies of the artists and the copious illustrations provide a number of important insights into the interchanges between Europe, North America, and Latin America throughout the modernist period.

Many of the early modernists were already familiar to North American viewers, artists such as the Chilean Roberto Matta, the Cuban Wifredo Lam, and the Mexicans Rufino Tamayo and Frida Kahlo. In this exhibition they were represented with outstanding works. There were also many artists who should be better known, in particular the Argentinian Alejandro Xul Solar. His small and exquisite watercolors of cubistic figures interwoven with texts appear almost shamanistic but actually represent his personal fantasies. Two of his works, the Klee-like watercolors *Not a Couple* (1924) and *Other Port* (1929), are original and whimsical evocations of the cosmopolitan city life of Buenos Aires. Part Italian, part German—as are many Argentinians—he changed his name in 1916 from Schultz Solari to Xul Solar (to suggest light; "lux" spelled back-

ward, and "solar" for the sun). He was an active member of the most influential, nationalistic Argentinian avant-garde movement in the 1920s, the *Martínfierristas*.

But of all the early modernists, Brazil's Tarsila do Amaral was perhaps the greatest revelation to North American audiences. Her brilliant color, simplified and exaggerated figures and forms (some of which owe a debt to Léger), tropical symbolism, and Afro-Indian references (that have nothing to do with "exoticism") fuse native "primitivism" with European vanguardism to establish a modernist Brazilian identity. Amaral's paint-

Fig. 55 ing *Abaporu* (1928) became the pictorial metaphor for a cultural philosophy known as *antropofagia*, or cannibalism, which was articulated by her companion (later husband), the poet Oswald de Andrade. "Cannibalizing" European art and culture (the "sacred enemy," according to Andrade), absorbing what was useful and rejecting what was not (such as the "sins" of Catholicism and of Freud), these Brazilian intellectuals sought to establish precisely the sort of cultural self-definition that they felt had been denied them by their colonizers. (In this respect, the anthropophagus movement romantically paralleled that of the indigenist movements in the same period which took a social realist turn in Mexico, Central America, and the Andes.)

For artists emerging in the 1960s, the terms of discourse had changed. The sixties were marked by introspection and critical positions based less on nationalist paradigms or Jungian formulas than on existential angst, irony, and skepticism. These sorts of criticisms of the establishment and of existing values were typical of the international New Left, and they were strongly felt in Latin America. Ideologies, political postures, social mores, and artistic practices of the past were open to reevaluation and reconfiguration within the language of the fantastic. In the catalogue these artists are termed the "generation in conflict."

Of this generation, the best-known figure is the Colombian Fernando Botero, whose inflated forms and meticulous detailing reflect the wit and irony with which he regards icons of the past, foibles of the middle class, and the presumptions of the Latin American oligarchs (presidents, the military, the clergy). In particular, Botero is typical of his generation's fascination with redefining the European Old Masters (especially those of

Fig. 56 the baroque period). In his *Self-Portrait with Louis XIV (After Rigaud)*, 1973, the elegant royal portrait is transformed into a caricature, with the king a pompous, overdressed toy balloon and the artist himself as a diminutive and complacent co-conspirator. The grotesquerie makes a wry political comment by boldly inserting the artist's Latin American presence into European culture.

Another artist of Botero's generation, Alberto Gironella of Mexico, has maintained an ongoing dialogue since the late 1950s with the work of

Fig. 57 Diego Velázquez. Gironella's particularly imaginative collage *The Queen*

of the Yokes (1973) disintegrates and reconstitutes a Velázquez portrait of Queen Mariana of Austria, constructing her wide, horizontal hairdo from bottle caps and her even wider panniers from wooden ox yokes (seemingly incongruent materials that coexist in modern Mexico). Gironella has been called "a fantasizer of history," and is an admirer of the filmmaker Luis Buñuel, who spent many years in Mexico and gave the painter his first introduction to surrealism.

On the other hand, Uruguayan José Gamarra's dialogue with past masters is principally manifested in his use of Old Master–like oil glazes, which he laboriously applies to his canvases. Taking as his subject the impact of the European colonizers, Gamarra paints dark and mysterious rain forests penetrated by intruders impervious to their enchantments. In *Five Centuries Later* (1968), two Europeans are depicted employing a South American Indian slave to carry off their treasures. Gold is the attraction for these Spaniards, yet they are blind to the symbolic gold of the waterfall before them. The title suggests that the ravages of the colonizers (Spanish and North Americans) have not altered over a 500-year history.

Venezuelan Jacobo Borges's fantasies explore other dimensions; they represent the constant flux of space, time, politics, and people that he sees as "past, present, future, superimposed upon each other." "As a result," he explained at a symposium in connection with the exhibition, "transparencies are necessary to me. This is not Renaissance window space, nor cubist space, but ambiguous space, like memory, which contains all time. I paint the rupture in space between what is inside and outside, between dream and reality."[8] Borges is an outstanding exponent of sixties' neofiguration, the existential return to the figure by many Latin Amercan artists (and some Europeans and North Americans) during the height of international abstraction. Neofiguration was best known through the work of the Nueva Presencia group in Mexico (also known as Interioristas, or "Insiders") with which José Luis Cuevas was associated, and through the Otra Figuración group in Argentina (represented in the exhibition by Jorge de la Vega). Influenced visually by the work of James Ensor and Willem de Kooning, Borges also associates himself with the kind of ambiguous space that exists in the writings of the late Argentine novelist Julio Cortázar. Borges's highly political painting *Meeting with Red Circle* (or *Circle of Lunatics*), 1973, actually inspired Cortázar's short story "Reunión con un circulo rojo," written in 1976 and dedicated to the painter. Within this same group from the sixties, the work of Tilsa Tsuchiya, an heir to the early indigenist movement of Peru, departs totally from the fantastic as embedded in historical or political contexts. Tsuchiya's paintings are works of pure imagination and seek to invest her private dreams with the rich pre-Columbian tradition of ancient Peru. Her mythological creatures are frequently female spirits and in their surreal appearance might be linked to similar imagery by older artists like

Remedios Varo and Leonora Carrington in their Mexican phases, or to contemporary feminist conceptions concerning mother goddesses.

The artists of the third generation are working in an era in which the dissemination of news via satellite from metropolitan news agencies (as part of what has been called "the industrialization of dependency") has accelerated the international diffusion of artistic styles and intellectual modes. Sometimes these arrive mistranslated and ill-digested, but they signal market viability to younger artists with reputations to make. If anything cohesive can be said of these contemporary artists, it is that their work exhibits a tendency toward eclecticism, pastiche, and increasingly personalized symbolism. Those maintaining closest ties with their national traditions of expression are Mexicans Germán Venegas, who juxtaposes ancient spiritual symbols with contemporary mass culture; Rocío Maldonado, whose dolls and ornamented frames combine folk-art sources with feminist speculation; and Alejandro Colunga, whose invocations of El Greco are reminiscent of Gironella's work.

Three artists of this generation still in formation make a particularly potent impact: Siron Franco of Brazil, Arnaldo Roche Rabell of Puerto Fig. 58 Rico, and Luis Cruz Azaceta, a Cuban exile. The oldest, at forty, is Franco, whose paintings are arresting for their brilliant color and startling images, which are called "hybrid human-animal creatures" in the catalogue and are related to the artist's dedication to Brazilian ecological issues. Roche's Fig. 59 brooding self-portrait with palms and thorns, *You Have to Dream in Blue*, is both powerful and suggestive. Azaceta's triptych *The Mysteries* is a metaphysical exploration of the human condition, with human figures confined by symbols of the church, the jail, and the coffin.

Needless to say, exhibitions such as "Art of the Fantastic" can play an important role in the construction and perpetuation of cultural myths. Not only do exhibitions create their own versions of art history based on particular aesthetic and ideological criteria, but they can also serve a diplomatic function, promoting international goodwill, masking the more pragmatic aspects of foreign policy, and often greasing the wheels for foreign economic intervention. In this case, "Art of the Fantastic" served as the primary cultural event of the Pan-American Games, held in the summer of 1987 in Indianapolis. Inaugurated by Vice-President George Bush and accompanied by considerable fanfare, the opening ceremonies for the games included (according to the Associated Press) "eighty Walt Disney personalities, a squadron of aerial acrobats, and a multicolor display of dances and songs."

The original concept for the "Fantastic" exhibition came from the Latin American Arts Association of Great Britain, formed in 1983 to provide a platform for the promotion of Latin American culture. The show was intended to be part of a larger program of activities leading to the celebration of the five hundredth anniversary of Columbus's "discovery"

of America. News has recently been released that the anniversary is being promoted in the United States as well, with funding available from the National Endowment for the Humanities. A number of Latin American governments are also planning to participate in the 1992 events, though it is not certain that their approach will be celebratory. Many Latin American intellectuals and artists regard Columbus's voyages as the beginning of the Spanish Conquest. For them, the date 1492 marks the onset of oppression and is no cause for celebration. In fact, Conquest themes, sometimes equating the conquistadores with contemporary conquerors, appear to be on the rise in contemporary Latin American art. Such tensions, both diplomatic and artistic, provide the backdrop for a recent crop of exhibitions organized in the U.S. and focusing on Latin American art (e.g., the Diego Rivera retrospective, "Hispanic Art in the United States," and now "Art of the Fantastic"[9]) and the more general reevaluation of Latin American art in the art market. Underlying these revisionist attitudes (however motivated) is a central question: to what extent and toward what ends have U.S. museums and galleries altered their traditional perceptions of Latin American modernism?

Unfortunately, even given the very real contributions of an exhibition such as "Art of the Fantastic," I see the changes as superficial or cosmetic rather than substantial and structural. The second-class or nonexistent status accorded the modern art of Latin America, Africa, or Asia—that is, art coming from former colonies and from existing neocolonies such as Puerto Rico—is grounded in long-established attitudes. The racism and culturally exclusionary ideologies of the colonizers go back many centuries and have been perpetrated right up to the present.[10] Any structural change would require, first of all, a recognition of the neocolonial relationships currently maintained by the United States and several countries in Europe toward Latin American nations. Thereafter, it would be necessary to investigate the art historical omissions and exclusions, and to scrutinize as well the fundamental ideologies of Euro-American aesthetics. Hierarchical notions of aesthetic quality, of a linear avant-garde dominated by U.S. and European artists, and anachronistic, elitist conceptions of art (such as "art for art's sake") all militate against the central concerns of many Third World artists. These ideas—as is often the case with outmoded ideologies—did not die with the so-called death of modernism.

Certain clues help explain the current surge in exhibitions of Latin American art. For example, in a special November 1987 bulletin, Sotheby's advised potential clients of "selected museum exhibitions [that] Latin American art collectors may find of interest;" listed were the Diego Rivera retrospective, "Hispanic Art," and "Art of the Fantastic." Sotheby's, which only recognized Latin American art as a discernible commodity in 1977, has found the market sufficiently profitable by now to

acknowledge the well-known reciprocations between dealers, collectors, the auction houses, and musuem exhibitions.

Political currents are playing a part as well. The National Endowment for the Arts appears to be involved in a proliferation of Latin American exhibitions (NEA funding helped underwrite the three major traveling shows mentioned here). This of course was hardly the first time that cultural exchange had been used as a trade-off for economic or political concessions. But considering the uncompromising posture the Reagan administration maintains toward five Central American countries and toward the eight major Latin American nations comprising the Contadora group that sued for peace in Central America, this sudden interest in cultural exchange seems, at the very least, paradoxical.

At the same time, within the United States, there are large and growing communities of Latin Americans, some of recent vintage, others predating U.S. incursions into Latin American territory. Since the mid-seventies, these groups have been lumped together (often against their will) under the rubric "Hispanics," primarily because they now have substantial electoral and consumer strength.[11] Among the sponsors of the recent Latin American art shows are foundations and multinational corporations such as the Ford Motor Company, the Rockefeller Foundation, AT&T, and the Atlantic Richfield Foundation, and, on a smaller scale, corporations such as Metropolitan Life, Canadian Club, and Coors (which is trying to break a long boycott by the black and Latino communities); they have entered the Latin American arts arena to garner prestige, to improve domestic consumer markets, and to facilitate relations with governments in Latin America.

Given these motivations, one can hope that the net effect of the traveling exhibitions of Latin American art (both the ones already circulated and others still in the planning stages) will be to make North American cultural institutions, and thereby their publics, revise their perceptions about Latin American art. Latin American artists must be seen as major contributors to international modern art, but on their own terms and not simply because of their successful assimilation of contemporary styles. Anything less perpetuates old hegemonic patterns. If the recent attention to Latin American art is to be more than a passing fad, arising only as the exigencies of market conditions and domestic and foreign policy are translated into cultural ideology, informed education on a massive scale will be needed to offset years of neglect.

Notes

1. Quoted from a panel discussion, "New World Dialogue," held at the Indianapolis Museum of Art on July 11, 1987, in conjunction with "Art of the Fantastic."

2. Alejo Carpentier, "De lo real maravilloso americano" (1966), reprinted in *Revolución, letras, arte* (Havana: Editorial Letras Cubanas, 1980), 188–200. Translation mine.

3. Ida Rodríguez Prampolini, *El surrealismo y el arte fantástico en México* (Mexico City, Instituto de Investigaciones Estéticas, Universidad Nacional Autónoma de México, 1969).

4. Jean Franco, panel discussion, "New World Dialogue" (see note 1).

5. Holliday T. Day and Hollister Sturges, "Introduction," in *Art of the Fantastic: Latin America, 1920–1987*, Indianapolis Museum of Art, 1987, 38.

6. Damián Bayón specifically rejects the use of surrealist nomenclature, preferring the concept of the fantastic in relation to Latin American art. See Damián Bayón, "La pintura fantástica en América Latina," in his *Aventura plástica de Hispanoamérica: Pintura, cinetismo, artes de acción (1940–1972)* (Mexico City: Fondo de Cultura Económica, 1974), 119–40.

7. Hollister Sturges, "Armando Reverón," in Day and Sturges, *Art of the Fantastic*, 38.

8. Quoted from the panel discussion "New World Dialogue."

9. "Diego Rivera: A Retrospective," opened at the Detroit Institute of Arts and traveled to the Philadelphia Museum of Art; the Palacio de Bellas Artes, Mexico City; the Centro de Arte Reina Sofía, Madrid; and the Staatliche Kunsthalle, Berlin. It closed at the Hayward Gallery, London. "Hispanic Art in the United States: Thirty Contemporary Painters & Sculptors," 1987, traveled from the Museum of Fine Arts, Houston, to the Corcoran Gallery of Art, Washington, D.C., and then to the Lowe Art Museum, University of Miama, Coral Gables; the Museum of Fine Arts, Santa Fe; the Los Angeles County Museum of Art; and the Brooklyn Musuem; "Art of the Fantastic: Latin America, 1920–1987" opened at the Indianapolis Museum of Art and traveled to the Queens Museum, New York, and the Center for the Fine Arts, Miami.

10. European and North American hegemony was demonstrated most blatantly in the "1985 Carnegie International" [sic]. The advisory committee of "high-powered art world operators" decided to simply omit from consideration artists from Japan, Australia, Latin America, Eastern Europe, and the Third World. This exclusionism was countered by the "Segunda Bienal de La Habana '86" in Cuba, which focused on the development of modern art in Latin America, Africa, and Asia.

11. The redefinition of Latin American national characteristics by uninformed U.S. curators was especially evident in the show "Hispanic Art in the United States." The depth of chauvinism in North American art criticism was clear in the review of this exhibition by Mark Stevens in *Newsweek* (September 7, 1987). The two shows were conflated under the title "Devotees of the Fantastic," and every primitivizing or exoticizing convention of the "Hispanic Art" catalogue was reiterated. Although Stevens rejected the practice of "cheap stereotyping" in his review, he nonetheless indulged in many blatant examples of it.

22

THE BOOMING (SPIRIT) OF LATIN AMERICA

If the decade of the sixties became known for a literary boom that brought writers such as Carlos Fuentes, Jorge Luis Borges, Gabriel García Márquez, José Donoso, and Mario Vargas Llosa to U.S. attention, the eighties is surely the decade of a Latin American art boom. Booms in the art arena can be identified by numerous blockbuster museum shows, lots of mainstream critical attention, a proliferation of gallery exhibits, and sustained activity on the auction market. All of these "symptoms" have occurred since the early 1980s, and the stage is set for the 1990s—at least through the 1992 Quincentennial of Columbus's voyages to the New World. The latest arrival is "The Latin American Spirit: Art and Artists in the United States, 1920–1970," a large exhibit organized by the Bronx Museum of the Arts which has opened at the San Diego Museum of Art, handsomely and intelligently installed by Mary Stofflet.

Fig. 60

All this activity has brought new names to our attention. Artists such as Diego Rivera, José Clemente Orozco, David Alfaro Siqueiros, Frida Kahlo, and Rufino Tamayo (whose work helped shape that of the United States from the 1930s to the present) have long been known in the U.S. However fewer museum visitors have heard of Joaquín Torres García, whose 1940s utopian constructivism influenced not only philosophically inclined Uruguayan disciples such as painter Julio Alpuy and sculptor Gonzalo Fonseca, but many younger artists. No history of European surrealism is complete without the fluid universes of Chilean Roberto Matta or the Afro-Cuban evocations of Wifredo Lam. Unfortunately many mod-

This essay first appeared in *Artweek*, July 1, 1989: 1–2.

358

ern art students never get much beyond a few illustrious European names, nor are they aware of the impact Matta and Lam had on the New York School in the 1940s and 1950s.

Even less known are the works of the Argentinian social realist Antonio Berni or social surrealist Raquel Forner; the murals and expressionist paintings of Brazilian Cândido Portinari; the glowing color and abstracted Andean forms of Peruvian Fernando de Szyszlo; the semifigurative presences of Colombian Alejandro Obregón, and the detailed, inflated, and ironic human figures of his compatriot Fernando Botero; the social critiques of Ecuadorian Oswaldo Guayasamín; and the superlative silk- Fig. 61 screens and woodcuts of Lorenzo Homar, from Puerto Rico, in which calligraphy becomes an advanced art form. These are (or were) the artistic "deans" of their nations whose work in the U.S. is rarely seen outside of New York and only infrequently in major institutions. Even towering draftsmen and printmakers such as Argentinian Mauricio Lasansky and Uruguayan Antonio Frasconi, who made their homes in the United States after the 1940s, remain relatively unknown. And this is to mention but a few of the almost 150 artists deriving from thirteen Spanish- and Portuguese-speaking nations of Latin America and the U.S.in the exhibit. Can we really say that we know the history of modern art, lacking knowledge of artists from such a vast area?

Since San Diego only received about half of the original exhibition (losing stellar pieces in the process), the full achievement of this exhibit can only be judged through the catalogue, a well-illustrated and excellently written production which is a *must* for visitors and scholars alike. One word of caution, however. It is a great mistake to try to shrink or stretch the art of the world to fit the procrustean bed of U.S. and European art history. The international bank of ideas, forms, and imaginative constructs is available to all, but its riches come from many sources, including those of Latin America, Africa, and Asia and the various nations and cultures of these areas. An open mind and emotional receptivity should be part of one's equipment, and it is better to leave pigeonholes at home.

During the half century covered by the exhibition, Latin American art underwent a series of changes, categorized in the exhibit by thematic areas. In the "Figurative Perspective" section, Botero and a number of Mexican realists are joined by Rómulo Macció of the Argentine "Other Figuration" group (which also included Jorge de la Vega, Ernesto Deira, and Luis Felipe Noé) and was part of a continental neofigurative move- Fig. 62 ment in the 1960s. The Mexican component included José Luis Cuevas, Arnold Belkin, and others, and the movement spread north from Argentina and south from Mexico throughout the Americas. These artists by-passed social realism to generate an existential and critical type of painting which drew from Goya, German expressionism, Francis Bacon, Willem de Kooning, elements of pop, and the regional sources of their

respective countries. For example, Macció's brutal, almost abstract caricature *The President on the Balcony* reduces this official to a series of diagonal and curved splashes of paint that make up his face, shoulders, and presidential sash. Noé's *When the Sun Hits the Fatherland* is equally sardonic, while Leonel Góngora's oil and collage, *Stop!*, concerns the sexually inhibiting role of the Catholic Church in his native Colombia.

"Abstraction" (constructivist, geometric, and lyrical) begins with 1930s synthetic cubism, as exemplified by Argentinian Emilio Pettoruti's *Coparmónica* (*Harmonious Glass*), with its yellow, brown, and black symmetries, as well as the brilliant Cuban color of Amelia Peláez's still lifes. From the second half of the century are semiorganic forms structured of riveted and painted industrial aluminum by Colombian Edgar Negret, and the fascinating optical illusions of folded forms in black, grays, and white by Negret's compatriot, Omar Rayo. These offer a contrast to the brilliantly colored interlocking minimalist geometry of Cuban Carmen Herrera. Kineticist Jesús Rafael Soto of Venezuela focuses on perceptual vibrations produced by metal squares elevated above striped wooden surfaces, while Rogelio Polesello of Argentina seduces the viewer with the sensuous and transparent color layers of his *Phase A* abstraction based on sprayed, painted, and photo-derived forms and meshes. Guatemalan Rudolfo Abularach departs from his overly familiar eye-orb theme with an extraordinary 8 × 4 feet abstraction, *Light Imprisoned*, in which luminous white areas emerge from grays and blacks composed of tiny hatchings with pen and China ink on paper. Broadly speaking, the several "camps" of Latin American abstraction displayed in this exhibition include the formal, the purely perceptual, and what might be called the "romantic" or "metaphysical."

"New World Surrealism" lost an impresssive Frida Kahlo in transit to the West Coast—the monumental double self-portrait, *The Two Fridas*, painted when Diego Rivera briefly divorced her. Her split selves, displaying two open hearts and dressed in an upper-class nineteenth-century gown and a more revolutionary *tehuana* folk costume, speaks worlds about the personal as political. By the 1960s, Cuban Mario Carreño (living in Chile since the 1950s) combined classical human forms derived from De Chirico with compositions in which sensual organic shapes are arranged like iconic or totemic presences. Brazilian Marcelo Grassman brings together a classical Picassoesque "beauty" with a strange Boschian winged "beast" in an etching rich in tonalities and textures. Carlos Raquel Rivera of Puerto Rico is one of many Latin American artists who straddles the line between the fantastic and the socially critical—an area denominated as "social surrealism." The foreground of his nightmarish *Paroxysm* is occupied by a blue crocodile-like beast behind which are situated three evil-looking persons and a terrified family.

In the "Committed Art" section Carlos Irizarry's sophisticated *Biafra*,

a photoserigraph on graph paper; New Yorker Jorge Soto's convoluted acrylic and ink drawing of a truncated Afro-Indian "Adam" and "Eve" beneath a blazing tropical sun; and Rafael Tufiño's linocut, *Cane Cutter*, present fine examples of the graphic mastery that has characterized Puerto Rican art since the 1950s. In the same section are Luis Jiménez's more than life-size gleaming red fiberglass and epoxy sculpture *Man on Fire*, influenced by Orozco, and his sardonic pop sculpture *The American Dream* featuring a bosomy blonde copulating with a shiny red automobile. Along with Mel Casas's theatrical pop invocation *Humanscape No. 65 (New Horizons)*, of field laborers under the United Farm Workers' black thunderbird flag, the Texas component of critical Chicano art is well represented.

No account of this exhibition would be complete without the "Idea and Process" section, which turns on its head any claim by the recently exhibited "Hispanic Art in the United States" to give an adequate represention of this community. Argentinian Leandro Katz's typewriter spews hundreds of words on a long roll of paper, Cildo Meireles's installation of three Coca-Cola bottles is nested in U.S. dollars and Brazilian cruzeiros, Chilean Juan Downey's interactive electronic environment *Against Shadows* lights up electric bulbs in response to human movement, Argentinian Liliana Porter's sequence of ten photoetchings follows the life of a sheet of paper progressively being wrinkled into a ball, while Uruguayan Luis Camnitzer's *Leftovers*, eighty stacked and stencil-numbered cardboard boxes covered with "blood-stained" gauze, speak eloquently, if indirectly, of Latin America's (or any country's) disappeared and murdered.

Rich with meaning, experimental and traditional, freely commingling personal ideas and forms with international styles and methods, the art in this exhibit demonstrates meditative, speculative, psychological, political, formal, sensuous, emotional, and highly rational concerns. Engaging the work of Latin Americans who visited, exhibited, and lived in the United States during a fifty-year period gives us a raking view of the immense variety and complexity of Latin American imagination and invention in the continent as a whole.

23

UN PUNTO EN COMÚN!/COMMON GROUND:
JUAN EDGAR APARICIO AND LISA KOKIN

Joan Didion, after a two-week visit, decided in her book *Salvador* that "terror is a given of the place" and that "everyone has killed, everyone kills now, and, if the history of a place suggests any pattern, everyone will continue to kill." However, many North Americans with a better grasp of history and the facts understand that government-sponsored murder and torture of civilians, underwritten economically and politically by the United States government, are simply the latest form of repression imposed on a Central American people to keep them (unsuccessfully) pliant and unresisting to foreign domination, and not a factor wherein "the lust for blood is its own cause and effect," as one *Los Angeles Times* reporter placed it.

A large number of North Americans have been kept in ignorance about events in Central America through a blizzard of "disinformation" and downright lies. Nevertheless there is a growing consciousness of why certain North American church members are willing to risk prison sentences to provide sanctuary for Salvadoran refugees; why various municipalities have proclaimed themselves "sanctuary cities;" and why automobile bumper stickers call for "No Vietnam in Central America." Artists in twenty-seven U.S. cities, as well as in Paris and Mexico City, made their opinions known when they organized Artists Call Against U.S. Intervention in Central America in 1983.

This essay first appeared in *La Opinion*, March 8, 1987, La Comunidad: 6–7.

Among the many positive "fallouts" of Artists Call nationally has been the increasing contact between North American and Latin American artists, including those few Central Americans who are managing to produce art in spite of the desperate struggle for survival as refugees. It is my opinion that every such cultural alliance should be celebrated in the name of a people-to-people contact that short-circuits the callous foreign policy of our government.

Juan Edgar Aparicio and Lisa Kokin

Juan Edgar Aparicio and Lisa Kokin are both artists in their thirties: the former born in San Miguel, El Salvador; the latter, in New York. Kokin was trained in academic institutions but follows her personal predilection for the centuries-old craft of batik, to "paint pictures" of realities in the Third World. Aparicio is self-taught, and draws upon crafts methods learned through practice and observation in El Salvador as a child, and upon skills acquired in the United States (where he came as a refugee in 1982) in commercial wood furniture carving used to support himself and his family. These techniques are now applied to painted wood carvings which come from his personal and bitter experience of oppression in Central America. Both live in California, and both have independently become known in recent years for the originality and power of their art. Both make the subject of injustice and the resilience of the human spirit in travail and in revolution the main motifs of their work. Both have expanded the parameters of traditional crafts techniques to enable them to create works of art based on contemporary themes and concepts.

Aparicio: Painted Carvings

Edgar Aparicio (as he is known to his friends) developed his love for wood carving and all forms of handicraft at school, when he was eight or nine years of age, in a class of "manual arts." He did a face of Christ in painted wood, and carved landscapes of the volcanic mountains and *ranchos* of San Miguel, made textured and more three-dimensional by the addition of papier-mâché made of newspaper and yucca starch. Within the family, Fig. 63 his father, over a period of thirty years, variously earned his living as a musician, brick maker, ceramicist, and maker of firecrackers and ornamental rockets for festivals. Edgar also experimented with wood pieces left in his house by a local carpenter; learned as a child to cut, solder, and hammer metal in molds; and observed leather decoration in a local workshop. From his mother he learned to use a sewing machine and mastered other domestic skills. He maintains a deep respect for the indigenous

crafts of El Salvador (as distinguished from tourist production), which include figural ceramics, unpainted cutout wood carvings, and textiles woven from the threads of the maguey plant.

Aparicio began his small relief carvings in Los Angeles about 1984, after experimenting with paintings on canvas. As a professional accountant and evening student in economics, he was forced to leave El Salvador when six members of his family were killed or "disappeared" and his own life threatened. Living in exile, his longing for his own country and his sense of political responsibility were so intense that he was reluctant to learn English, considering his stay in the United States to be temporary. His painted wood carvings have been a form of release for his feelings as well as an urgent political expression. Their first exhibition, fittingly enough, took place at art exhibits organized in October 1984 by the Los Angeles Artists Call Against U.S. Intervention in Central America, where they immediately aroused admiration and emotion among viewers who knew nothing of his background. Though his work is referred to as "folk art," and indeed has a strong base in Salvadoran crafts practice, each piece is original in both theme and treatment, and transcends the inherited skills of folk art production.

Aparicio starts a piece by thinking of a situation he would like to portray. When a definite image has formed in his mind and he has considered the materials he wants to use—primarily wood, but enriched with added substances such as leather, cloth, a photograph, cutout metal and wire, and pieces of mirror, as well as acrylic paint—he makes and refines a sketch in the finished size and begins to carve. As a self-taught artist, his earlier works were in shallow relief done in profile or frontally. Though all remain "wall pieces" to be hung for display, increasingly his carvings are becoming more three-dimensional, with limbs separating from the body, figures turning in space, images being carved in deeper relief and breaking away from the background. These are all risks the artist takes, step by step, on behalf of greater realism and the impact of his work.

Kokin: Batik Sculptures

Lisa Kokin's interest in batik began when she studied Spanish, macrame, and batik in San Miguel de Allende, Mexico, at age sixteen. While there, she became sensitized to Latin American life and became aware of the contrasts between U.S. wealth and Latin American poverty, the fruit of imperialism. Upon returning to the United States, Kokin began to read about Vietnam, Africa, and Latin America, her studies intensified in 1973 by the military coup in Chile and her move to San Francisco. With the end of the Vietnam War in 1975, she began her political batiks, creating, over the years, series on Vietnam, Cuba, Chile, El Salvador, Nicaragua, South Africa, Jewish history, the Palestinian struggle. These were occa-

sionally based on visits to the countries from which she drew her themes. Since her parents had been upholsterers, the skills of machine sewing and stuffing were familiar to her, and she began to incorporate new methods into the traditional batik technology.

Batik is a process in which imagery is produced by brushing hot wax on cloth to form designs and patterns. The cloth is then submerged into various baths of colored dyes which penetrate all areas except those protected by the wax. Repeated overlays of color, with protective waxing between each color, produces a rich effect. Finally, the wax is boiled or ironed out of the cloth. Widely used in Asia and Africa, batik is thought of as a decorative textile art form, but it has also been used, as Lisa Kokin does, to produce narrative scenes. However, Kokin carries the medium far beyond the traditional usages by stuffing, quilting, and then embroidering the dyed cloth. Her final break with tradition is the stuffed cutout: the profiling of images so they project out from the wall without a frame. This step changes the works—which are basically soft, foldable, and crushable—into sculptures: three-dimensional forms which we usually associate with rigid materials such as wood, stone, metal, or plastic.

Fig. 64

If batik as sculpture is the first part of a paradox which forms part of our pleasure and emotion in observing Kokin's work, the second paradox revolves around the contradiction between what we anticipate from a decorative fabric, using traditionally domestic and female skills such as quilting and embroidering, and the narrative documentary images which are usually associated with painting and photography. The very nature of the technique encourages simplification of forms: flat areas of color surrounded and defined by lines. However, the placement of figures, the angles at which they are presented, and the use of deep space contradict the notion of decorative flatness. At the same time, Kokin enriches the surfaces by sewing on beads or metallic threads which also add dimensionality and realism. Kokin also handsews around each image (trapunto) to emphasize the shape. In her most recent work, she backs her quilted and cutout forms with black fabric, increasing the sense of volume.

There are many affinities between the work of Juan Edgar Aparicio and that of Lisa Kokin; they share common ground: similar political perceptions, similar exaltation of crafts into fine art without repudiating the pleasure we experience in fine workmanship, and—ultimately—the need and desire to communicate their vision of the revolutionary potential within every oppressed people. Finally, there is an aesthetic delight in seeing together painted and shaped wood that has been pared down to a thickness of six to twelve inches sharing wall space with dyed and shaped cloth that has correspondingly swelled up to match it. A possible collaboration between these two artists to produce a work uniting their separate skills has been mentioned. We look forward to that future.[1]

Note

1. Nine months after the above was written, Aparicio and Kokin were shown together in an exhibit, "Un punto comun/Common Ground," at the Pro Arts Gallery, Oakland, California, July-August 1987. My brief essay was excerpted for the catalogue.

24

CLIMA NATAL: WORLD OF FANTASY; DREAM OF REALITY

The art of these artists is young in its fulfillment but mature in its pespectives. An alternative is arising in our youngest painters who are trying to synthesize or couple many worlds within this more concrete one in which we live. [It is the rise of] a world of fantasy and the dream of reality.
 Roberto Cabrera, 1985[1]

There is almost fifteen years of age difference between Fernando Carballo and his Costa Rican compatriots Rolando Faba and Fernando Castro. Carballo is at one end of the spectrum of existentially grounded neofiguration which had advocates and practitioners in Europe and the United States in the two decades after World War II but enjoyed its richest and most profound expression in Latin America during the 1960s. Castro also chose to work with this tradition. Faba, however, has appropriated newer modalities from the world of international art. These include borrowings from pop, op, conceptual and certain postmodernist languages which he has shaped toward his own Latin American sensibilities and concerns. All three, with their stark and powerful black-and-white drawings and collages, speak to our concern with the human condition and the political turmoil and changes taking place throughout Central America.

This essay first appeared in a catalogue entitled *Clima Natal: A Traveling Exhibition of Three Artists from Costa Rica* (Los Angeles: Artists Call against U.S. Intervention in Central America, 1988–89).

Though Costa Rica has been somewhat isolated from the volatile politics of the other four Central American countries to its north—Nicaragua, Honduras, El Salvador, and Guatemala—it has not been able to fend off incursions into its territories by the U.S.-supported contra forces. It has also been subject to increasing pressure from the United States to reestablish a standing army, eliminated in 1948 as part of the reforms by a progressive president. To their credit, the Costa Rican people have resisted the proposed Honduras-style militarization and have permitted their country to become a haven for political (and artistic) refugees from war-torn countries such as Guatemala and El Salvador. When Costa Rican President Oscar Arias put forth his now-famous Peace Plan which proposed that each of the conflicted nations be permitted to exercise its own sovereignty by resolving internal problems without outside intervention, he did so with an eye to regional peace that would, as well, protect his own nation from war.[2]

Young Costa Rican artists and intellectuals were impacted by the profound changes in Central America, which entered a state of crisis in the 1980s. Poetry from El Salvador and Guatemala was circulated, and artists such as Roberto Cabrera and Arnaldo Ramírez Amaya visited or made their homes in Costa Rica. In addition, a team of Costa Rican filmmakers went to Nicaragua in 1979 to establish a filmmaking unit there. Art exhibitions in solidarity with El Salvador were mounted in Costa Rica and Mexico. The organization of the independent multinational group Clima Natal (Native Climate)[3] in 1982 by eleven visual, photographic, theatrical and film artists marked the rising consciousness of the younger generation of Central American artists. "We could not fully develop," wrote members of Clima Natal in one of their manifestos, "if we sought to detach ourselves from the dynamic historic moment propelling our countries." They feel that the "expression and evolution of contemporary art in Central America are closely linked to the social transformation and social stagnation of the countries." Thus, they say, a period of acute militarization, of great repression and overwhelming social changes has given rise to some of the finest poets of contemporary Latin American literature—such as Roque Dalton and Manlio Argueta of El Salvador and Otto René Castillo of Guatemala. (Dalton and Castillo both died in the revolutionary process.) We might add that the same imperatives have also produced a movement in Costa Rica of extraordinary young visual artists.

While the local organization of Clima Natal provided a poetic, philosophical, and political framework of thought for its members—as well as influencing other artists—their sources for aesthetic and stylistic experimentation came from both regional and international currents. When Costa Rican artist Juan Luis Rodríguez (who had spent twelve years in Europe immersed in avant-garde experimentation) returned home in

1972, he set up the first intaglio printmaking workshop at the University of Costa Rica (UCR). There he inspired many students to enrich their training with new techniques, which they then applied to a range of new social ideas. A few years later—with sponsorship and funding from the Organization of American States—the creative graphics program known as CREAGRAF was established at UCR to train graphic artists in the latest techniques of commercial advertising. Facilities for lithography, serigraphy, intaglio, and varieties of photographic printmaking were added to the curriculum, and artists from Guatemala, Venezuela, Peru, Canada, and the United States were invited to teach courses in these various areas. Fernando Carballo and Rolando Faba (then a student) took advantage of these opportunities to amplify and refine their artistic vocabularies, but channeled their application to visual expression of their social concerns. Thus, rather inadvertently, the original intentions of Rodríguez and CREAGRAF both contributed to the emergence of a strong "graphic presence" dedicated to humanist, rather than commercial, concerns.[4] It was a continuation, though with contemporary print media, of the humanist current to be found in the color woodcuts of Costa Rica's most prominent artist, eighty-one-year-old Francisco Amighetti.

Fernando Carballo (Born 1941)

Mexican existential neofiguration of the 1960s, the most direct influence on Carballo, has been described as follows: the figure making its solitary, painful stand against cosmic indifference; the violent distortions of the human body matching the evocation of personal emotion through violent paint application; the immediacy of expressive content overriding the importance of creating a "precious object." Stylistically, color was secondary to drawing. Artists used strong value contrasts, minimal color, expert draftsmanship with emphasis on line, thin washes, intimate scale, expressive distortion and monstrosity, large single shapes, and empty backgrounds.

The three Clima Natal artists in this exhibition certainly share elements of these characteristics. Over the years, however, Carballo has most consistently adhered to these aesthetic and philosophical ideas. As he wrote in 1976, he sought a confrontation with the world and his time, but he also desired to let loose the images of his interior world. Prior to the loosely painted, almost abstract heads of the *Family Gallery* series, Fig. 65 his ink drawings and paintings—using thinned oil paint, color pencil, or ink—featured distorted and anguished figures combining fine lines with tinted masses in dark subdued colors. An interpenetrating sense of space is a crucial element in the articulation of the heads and in their compositional placement.

Fernando Castro (born 1955)

Though sharing certain artistic qualities with Carballo—especially a focus on draftsmanship and a sense of existential anguish—Castro's history is very different. He is largely self-taught and his work is not produced with the same facility and rapidity as that of Carballo. He works very slowly and patiently, cloistered from people, evolving his ideas and their forms on paper with pen, brush, and black ink. Subtle changes and refinements in style often occur over long periods of time.

Fig. 66 Except for great sweeping brushstrokes that seem to have the force of a blow when combined with human figures in motion, Castro does not paint. He achieves his spattered surfaces by running a toothbrush over wire mesh until he gets dense blacks (as well as lighter values), a technique resembling aquatint effects in intaglio printmaking. His human and skeletal figures are interrelated: the flesh revealing the bone structure within; the skeletons still showing shreds of their outer envelopes. Change is constant, whether in the filmic sense of body movement or in the shifting and volatile backgrounds, or in the dialectic process of the disintegration and reconstitution of body parts. One is forced to think of the hills of corpses left to rot by death squads in El Salvador and Guatemala within which bodies are found in various states of corruption. The note of hope resides within the active posture of all the images. People and movements may be violated, but human hope and struggle remain.

Rolando Faba (born 1954)

Of the three Clima Natal artists, Rolando Faba is most directly the product of the graphic design emphasis introduced at the UCR Art School in the 1970s; he is also the most experimental. His study of photography and industrial design can be seen in his work. An overview of his art production yields a dizzying kaleidoscope of styles, techniques, and materials. In spite of the apparent eclecticism, which can be found among a number of younger artists in Latin America today—children of McLuhan's "global village" in an epoch of unprecedented mass media communication via satellite and the exportation of consumer commodities and publications from the metropolitan centers to the peripheral states—there is the firm current of human content flowing through all of his pro-

Fig. 67 duction. Whether we deal with the fragmented, faceless, target-numbered bodies of *Wrinkled* and the *Endangered Species* series, or with the cinematic quality of the military *Hunters* moving ever closer to their human victims, or the broadly brushed, ever-present military helicopters that have become the archetypal symbols of repression in contemporary wars, it is evident that stylistic changes are not for their own sake but serve as a multifaceted visual lens with which Faba examines Central American reality.

It is sincerely hoped by the sponsors of the exhibit "Clima Natal: A Traveling Exhibition of Three Artists from Costa Rica" that visitors can achieve a new vision of contemporary Central American art. At the same time, we hope they can gain greater insight into the tormented reality of the Central American people, who strongly desire peace in their region, as well as justice, adequate food, and health care. They certainly want a surcease of murder at the hands of the government-sponsored death squads or military units who wage war on their own people when they try to achieve a better life for themselves. We feel that support for such aspirations are part of our United States heritage, just as intervention in the affairs of other countries—whether through military assistance to corrupt governments or through brutal counterrevolutionary mercenaries who have little support in the countries they attack—are against that heritage.

Notes

1. Cabrera is a well-known Guatemalan artist and critic who has resided in Costa Rica for many years.

2. In 1987, President Arias was awarded the Nobel Peace Prize for his Plan.

3. First conceived while its members were students in the mid-seventies; reorganized in 1985. The name "Clima Natal" was taken from a collection of poems by assassinated Salvadoran poet Roque Dalton. Among the members of Clima Natal are Salvadoran filmmaker Paula Heredia (now in New York) and Los Angeles-based theater and film student Elia Arce.

4. It is evident, in driving around Costa Rica's capital, that the seventies was a period of developmentalism in which national and international corporations set up industrial and marketing headquarters or dealerships in San José, a time when good designers for glossy public relations magazines and advertisements were needed. Lachner & Sáenz, a major corporate dealer of foreign automobiles and products, established a biennial for Costa Rican art, and maintains a permanent collection in its own museum.

25

SOCIAL ILLUMINATIONS: THE ART OF GUILLERMO BERT

I

The Altar/Temple: Recycling Social Images series

What does it mean to "recycle social images?" The prefix "re" refers to using again, recalling, renewing; while "recycling" signifies altering, re-covering, passing through a series of changes, processing to regain mate-rial for human use. Environmentalists have long advocated recycling the products we use daily so as to eliminate wastefulness and preserve natu-ral resources. Recycling in this sense, then, refers to the juncture between culture (the social) and nature (the earth), since products are the result of human action and labor that modify nature to satisfy human needs. Fi-nally we arrive at the word "image," which translates as the reproduction, the imitation, the semblance, the incarnation, the illusion, the impres-sion, the idea, the concept of something not actually present. At the same time, "image" is the root of the word "imagination," which advances our thinking into the realm of creation and creativity.

Guillermo Bert's *Altar/Temple* series springs from a nexus of crea-tivity that seeks fusion between these various imbedded meanings. As an

This essay first appeared as "Revelaciones sociales: El arte de Guillermo Bert" in *La Opinion*, September 30, 1990, Panorama Dominical: 8–9. It also appeared, with the English title, in *Altar/Temple: Recycling Social Images*, catalogue, Los Angeles Theatre Center, September–October 1990.

artist, he has pondered the large social questions of contemporary society and then sought for visual equivalents that would resonate not only in our immediate apprehension and recognition of the social images he presents, but on that deeper level of psychic and emotional terrain which carries away the fugitive shadow of new conjunctions to be reexamined in memory at a later time, to be reexplored in the light of a recycled understanding. Shadows and light, in the form of photographs that are composed of these elements, are the basic visual tools—whether expressed with photographic negatives, with television monitors, with light boxes, or with the discarded materials of film. Metaphorically or physically, these forms will cast light upon the social terrain, will dispel some of the shadows in which our understanding is buried.

To deepen the experience of contemporary social images, the artist has drawn upon older images and a symbology so pervasive within Christian iconography that they have infiltrated the consciousness even of those who subscribe to other religious modes. This casting back in time to recuperate powerful human reminders of the past in order to recycle them for the present begins with the two altarlike forms illuminated with light boxes titled *Madonna: Sacred and Secular.* Rendered in photographic Fig. 68 negatives—which reverse the world as rendered in film—are a famous Renaissance painting of the Madonna and Child, and an anonymous African mother with her starving child. The framing shape itself, with its arrows, was suggested to the artist by those Polaroid cameras that hold the negative until it is exposed, ejected from the camera, and thrown away. For the artist, the disposed negative and frame have an aesthetic dimension in that they resemble the elaborate frames used for icons and religious images; nevertheless, he retains the markings that identify them as coming from a filmic source. Enlarged and placed side by side, the two frames form a diptych: the two-panel altarpiece that dates back to the Middle Ages and was displayed in churches and chapels for devotional purposes. Thus the ancient and the modern, the sacred and the secular are linked together within a nimbus of new meanings.

Confronting the Madonnas (one of which is a symbol of life and hope for the future; the other of which displays the perversion of that hope) are three large triptychs (three-panel altarpieces) which juxtapose history with contemporaneity. Symbolically each triptych, and the fact that it is multiplied into three installations, is a reminder of the Trinity, which here has its sacred and secular aspects. Ideally, they should be placed in an oblong space facing the Madonnas, whose "holy light" (the light boxes) would be echoed in *The Urban Trinity.* One piece, consisting of a car fire, Fig. 69 a grouping of police, and the misery of a homeless individual, is fronted by three television monitors radiating flames. Flanking this triptych is that of *The Pollution of Gold,* in which the halolike golden forms derive their shape from the sieve used for gold panning and are echoed in the

empty gold-colored plate of a hungry child on either side of the recycled shopping cart (itself a symbol of food) used by the homeless as a portable closet, now converted into a vehicle that serves as the missing home and its possessions. Finally, the third triptych, *The Money Changers of the Temple*, displays the temples of finance, with drifting clouds of gold, in their alienated and inhuman city environments.

II

Conversations with the Artist

The Conception: Guillermo Bert's conception for the *Altar/Temple* was quite clear from the beginning. His intention (articulated in bilingual discussions with the author over a period of time) was to address several aspects of the social realities of our present world and to use new means of visual juxtapositions and formats to give expressive form to a series of ideas about the interrelationship between poverty in our world, poverty in the Third World, and the links that connect the two. Adjunct to these ideas are other considerations such as the questions of violence, racial and political conflict, the natural world in opposition to the technological world, and the problems of waste and pollution as they interact with consumerism and form a polarity to the poverty. Implicit in these juxtapositions is the central fact that the various conditions are *related* to each other; they do not constitute separate sets of facts and social conditions.

To clarify: Bert believes that, paradoxically, in the United States, which can be seen as a temple of riches and high technology, there exist the possibilities for a poverty so extreme that highly urbanized people are forced to live in conditions more terrible than the so-called primitive tribes of Third World countries. Tribal peoples may live without technological tools, but their structures are established to provide for basic human needs: food, shelter, and clothing. Homeless people in our technological societies, however, cannot turn to nature for these needs; cannot find their satisfactions on the concrete streets and freeways of big cities. If Third World people are marginalized by the First World, the homeless are marginalized *within* the First World. Thus the artist creates the links between the Third and First Worlds, conceptually.

In addition, Guillermo Bert wants to explore visually the role that mass communication plays in our comprehension, or lack of comprehension, of these problems and their interrelatedness. The process of consuming media information is related to the process of consuming other products—even food. His idea is to rescue images that have been concealed by the mass media and redirect them to a public that previously had consumed this information without reflecting upon it.

The Process: In the original Polaroid camera, the frames and their

negatives, though expensive, become throwaway products similar in wastefulness of global resources to the disposable paper diaper, or the disposable bottle or can. The artist wished to symbolically recycle such waste products by incorporating them into his artwork. The internal images contained by these filmic frames are also photographic negatives (reversing the world, as rendered in film, from a positive to a negative). Furthermore, he used the techniques of paint and photoserigraph on canvas. The light boxes were made of translucent plastic and aluminum.

III

A Brief Portrait of the Artist

Guillermo Bert is a Chilean-born artist who studied at the Catholic University of Santiago during the period of the former Pinochet dictatoship, and emigrated to the United States in 1981. The rich evocation of forms derived from the baroque period of Latin American Catholicism is central to his work. His earlier paintings and pastels draw upon the crucifixion as a major motif; however, it is a motif that had been metamorphosized into empty shirts suspended from wire hangers, or tied at the elbows with rough cord or draped over a pole, or wooden constructions touched with gold and silver paint and adhering to canvas which suggest the ladder of the crucifixion and the altarpiece which reproduces the scene. The television monitor (with its glowing light and mundane images) is another major motif responding to the alienated communications of the urban environment which Bert discovered in the United States, as well as expressive of a certain fascination for pop imagery which itself plumbed the mass media and consumerism for subject matter. Guillermo Bert, after nine years in Los Angeles, is speaking with a language of biculturalism in addressing those issues of social import and concern which is one of the legacies of modern Latin American art.

26

HOW LATIN AMERICAN ARTISTS IN THE U.S. VIEW ART, POLITICS, AND ETHNICITY IN A SUPPOSEDLY MULTICULTURAL WORLD

> What if suddenly the continent turned upside down? what if the U.S. was Mexico? what if 200,000 Anglo-Saxicans / were to cross the border each month / to work as gardeners, waiters / 3rd chair musicians, movie extras / bouncers, babysitters, chauffeurs, / syndicated cartoons, feather-weight boxers, fruit pickers, & / anonymous poets? / what if they were called waspanos, waspitos, wasperos or waspbacks? / what if we were the top dogs?
> Guillermo Gómez-Peña[1]

Three themes are married herein: the naming and mapping of America; the coming celebrations (or anticelebrations) of the Columbus Quincentenary; and the significance of "multiculturalism" for second-classed ethnic groups of artists. All these themes are addressed in terms of art production by Latin American artists residing in the United States.

On the eve of the 1992 "celebration" of the Columbus Quincentenary, and two years before the seventieth anniversary of the Monroe Doctrine, which gave political leverage to the U.S. concept of Manifest Destiny, it seems urgent to start this presentation with a consideration of the name "America." Not its "etymology" in the corrective solution given by Florentine navigator Amerigo Vespucci to Columbus's notion that he had arrived on Indian soil (thus misnaming the continent's indigenous popu-

This essay first appeared in *Third Text* (London), Autumn/Winter 1991: 189–92.

lations), but its political/social usages. When Chilean conceptual artist Alfredo Jaar first came to the U.S., he, like many other Latin Americans, was shocked to discover that the United States had appropriated this continental designation as its national identification without allowance for the other countries which also inhabit the Americas. Jaar's testimony indicates that he considered himself an "American" (of Chilean nationality) as a matter of course, without thought or further embroidery; but he discovered in New York that he was an outsider, a foreigner in *this* America. The question was not one of semantics but one of hegemony; the usage reflected real power relationships. Challenging this appropriation with images and texts, Jaar located *A Logo for America* (1987), a computerized Fig. 70 Spectacolor lightboard, in the public space of New York's Times Square, long known for its profusion of neon light signs and a famous moving light-strip of daily news headlines that dates back at least to the 1940s. To counterappropriate U.S. electronic technology in order to redefine First and Third World interaction displays a fine sense of irony. "This is not America" and "This is not America's flag" were superimposed respectively on a map and the flag of the United States; Jaar also spun the continental map of America—North, Central, and South—on an axis of the letter "R."

Jaar is neither the first nor the only Latin American to employ an imaginative geography to reframe the American discourse. In 1936 Uruguayan constructivist master Joaquín Torres García published a drawing which inverted South America (facing north to south, and vice-versa) to emphasize its autonomy from European aesthetics, and to justify the right of southern artists to recuperate the northern pre-Columbian cultures regardless of where the artist was located in the continental scheme.[2] (A similar argument has recently been made by a Cuban critic concerning African sources.) Another aspect of the mapping process is the comparison between the extremely distorted sixteenth-century Mercator map created during the period of imperialistic endeavors by European navigators during their discovery, colonization, and exploitation of Third World regions and the 1974 Peters map which shows the Northern hemisphere countries to actually be half as large as those of the Southern,[3] thus reversing the earlier order. The Peters projection (upon which Jaar, in another work, had inscribed an image of western toxic waste dumped in Africa) visually symbolizes, by its very creation and dissemination, the beginning of the West's loss of its dominant position vis-à-vis those countries it has considered peripheral and marginal.

Remapping projects have long interested other U.S.-based Latin Americans, such as Chileans Juan Downey and Catalina Parra. Downey's fascination with maps that demonstrate the flow of invisible energies across space and the distinctions cartographers make between topography, national boundaries, travel, and communication networks is illustrated in

his large drawings *Twomaps* (1985) and *World Map*. In 1981, upon her arrival in New York, Parra collaged text from the *New York Times* with clippings of football players that raise the specter of the football stadium in Santiago which the Pinochet coup d'état turned into a concentration camp and killing field in 1973. The enclosing frame (whether intentionally or not) suggested the long narrow shape of Chile turned horizontally, while the text *The Reunited States of America* emphasized the close relationship of U.S. power (symbolized by the *Times* headline) to disastrous events in South America. Distances are eclipsed on this political map which unites two American states.

Finally, Brazilian Jonas dos Santos emphasized the complicity of both Americas in the destruction/salvation of the ecological and human environments. Focusing on the Amazon rain forests and their aboriginal inhabitants, who bond with each other without shame, the artist mirrored himself in performance with two horizontally reversed maps within the installation of *Brazil via New York: Oxygen Share* of 1989.[4]

Multiple are the ways in which Latin America artists globally have addressed the question of the Spanish Conquest, and of successive neo-conquests up to the present. Obviously some of the works mentioned earlier can be seen as overlapping into this related discourse. New York artist Fernando Salicrup fictionalized the gentle pre-Hispanic Taíno Indians of Puerto Rico peering through the leaves like shy wild creatures in his painting *Once More, Columbus*, or *Before Discovery* (1976), while Argentine Leandro Katz put an ironic spin on the Conquest with his 1982

Fig. 71 installation *Friday's Footprint*, which is based on the eighteenth-century British allegory *Robinson Crusoe* by Daniel Defoe, a novel which is as impregnated with colonial ideology as any that one can find. Set in South America near the Orinoco River, the wrecked mariner Crusoe survives on an uninhabited island for twenty-four years. With the most primitive means, and by reading his bible, he lives alone in rude comfort until he discovers the naked footprint of a "native" whom he names "Man Friday" and whom he rescues from cannibals. Friday is converted into a companion and servant. The cannibals (who miraculously made *no* appearance for a quarter of a century) are again defeated, while Crusoe and Friday find the means to return to England. *Crusoe*, said a book reviewer in 1948,[5] is a manual of the qualities that have won the world from barbarism— courage, patience, ingenuity, and industry—qualities much admired in the industrializing capitalist world for many centuries. Recast from the Renaissance to a later period, the story seems to repeat that of Shakespeare's *Tempest:* Man Friday takes the place of Ariel as a native servant devoted to his master, while the cannibals represent the coarse and unfaithful Caliban, an anagram constructed by Shakespeare from the word "cannibal."

This is not the moment to review the literature, but Latin American intellectuals have been involved in a central (often metaphoric) discourse about identity since 1900, stretching from the essay *Ariel* by Uruguayan José Enrique Rodó to Cuban Roberto Fernández Retamar's (1971)[6] Calibán—or Man Friday—in which Shakespeare's monster is taken as a more appropriate symbol of America's people. *Calibán* allegorically rejects the colonialism that Columbus brought to the New World, while Man Friday, in Katz's installation, is superseded by another image. Directly above the footprint is reflected an extremely sophisticated stone carving from the Maya civilization. Neither pliant servant nor barbaric cannibal, Katz seems to say, was the true condition of the autochthonous American peoples. Both the footprint and the epithets were European constructions. Puerto Rican Rafael Ferrer made more direct references to the Caliban persona: in his tent installation, *El gran canibál (The Great Cannibal)* of 1979 he erected a pseudoprimitive residence on whose surface games with words reflect the European/American semiotic encounter.

Multiculturalism is an idea whose time has been coming since the early 1980s when the feminist and civil rights movements for blacks, Latinos, Asians, and Native Americans, generated in the 1960s and culturally activated in the 1970s, achieved a certain visibility. Demographic changes across the U.S. resulting from revised immigration laws which brought increasing numbers of Third World peoples to North America made the handwriting on the wall much clearer. By the mid-1980s, a series of blockbuster exhibits of modern Latin American art, related to the art market, prompted me in a 1988 *Art in America* article to compare the "art boom" to the 1960s Latin American literary boom. Two recent books, the 1990 catalogue for "The Decade Show: Frameworks of Identity in the 1980s" and Lucy Lippard's *Mixed Blessings: New Art in a Multicultural America* (1991) fixed this phenomenon and its exciting new conception in the public eye. No longer would North American art be dominated by white Anglo/European males; the cultural, national, and gender diversity now characterizing the United States must be given equal place and time. To which we said "Hurrah!

Unfortunately, multiculturalist discourse coexisted with the most conservative/reactionary political agenda imaginable, as the Reagan/Bush administrations increasingly signaled a return to nineteenth-century codes and the subversion of all gains made since the days of Franklin Delano Roosevelt and the New Deal. Racism, sexism, anti-Semitism (against Jews *and* Arabs), ageism, homophobia, xenophobia and censorship accompany joblessness, homelessness, deepening poverty at home, militarism and imperialism abroad. Increasingly the U.S. population is polarized and fragmented as the ultraright leads its attack on all fronts.

In the arts, many of the groups under attack have made a certain amount of common cause. Thus "The Decade Show," curated by and exhibited in the Museum of Contemporary Hispanic Art, the New Museum of Contemporary Art, and the Studio Museum of Harlem (all of New York) represents a true multiculturalism, however chaotic and unfocused. Lippard's *Mixed Blessings*, while generally accepted, has been criticized for compiling only artists of the Third World. The problem with these sprawling outlays, however, is that while the concept is utopian, the reality is not. The true hybridization and cross-culturalism that can rally different viewpoints and aesthetic configurations around common issues and that can realistically define a multicultural American continent with comprehension of the confrontation which is taking place (and must take place) between the forces of power and the disempowered has not yet occurred. As a result, the hegemonic power is able to confuse and disorient this new inclusive democratic urge represented by the term multiculturalism. The symbolic and *Realpolitik* social meanings of multiculturalism are obscured: some use the term as a synonym for the discarded "minority" designation; others as a tool for a new neocolonialist maneuver to contain, divide, and defeat. The idealists don't always understand that inclusion is not sufficient—that access to power, decision making, and funds must be included. A retranscription of past cultural history is simply not sufficient.

Notes

1. Guillermo Gómez-Peña, *High Performance*, no. 35 (1986): 34.
2. The Torres García drawing was published in his magazine *Círculo y Cuadrado*, 1936. Brought to the author's attention by Mari Carmen Rámirez-García and reproduced by Susana Torruella Leval on page 147 of *The Decade Show: Frameworks of Identity in the 1980s* (New York, 1990).
3. Madeleine Grynsztejn, *Alfredo Jaar*, La Jolla Museum of Contemporary Art, Calif., 1990, 35.
4. See page 13 of *Art Journal* 51, no. 4 (Winter 1992) for an illustration of this piece.
5. William Rose Benet, *Reader's Encyclopedia*, 2d ed. (New York: Thomas Y. Crowell Co, [1948], 1965).
6. Published in *Casa de las Américas*, no. 68 (Havana; 1971), as "Calibán y otros ensayos." Available in English as *Caliban and Other Essays*, trans. Edward Baker (Minneapolis: University of Minnesota Press, 1989).

NATIONALISM AND ETHNIC IDENTITY

27

RESPONSE: ANOTHER OPINION ON THE
STATE OF CHICANO ART

"The enemy is not abstract art but imperialism."
 Fidel Castro

Los compañeros Malaquías Montoya and Lezlie Salkowitz-Montoya, in their article "A Critical Perspective on the State of Chicano Art,"[1] have raised for consideration one of the most difficult problems confronting the radical (or reformist) artist functioning within a capitalist context—that of co-optation—a problem which is neither new nor necessarily solvable in that context except by degrees. Final solutions depend on basic structural changes in the society itself.

To begin, I would like to state that I am grateful for the opportunity to comment on the article, and that I agree with many of its general premises. My purpose here is one of clarifying certain definitions, refuting what I perceive as some unwarranted assumptions, and pointing out certain contradictions. Whatever conclusions will be advanced are of a tentative character, since the problem is part of a much larger, ongoing debate.

The main argument of the Salkowitz/Montoya article seems to be that separatism from the dominant culture is desirable since the dominant culture a) espouses a harmful philosophy which Chicanos oppose, and b) is all-powerful and capable of totally co-opting any artist who unwisely

This essay first appeared in *Metamorfosis: Northwest Chicano Magazine of Literature, Art and Culture* 3, no. 2, and 4, no. 1 (1980–81): 2–7.

participates in any of its facets. The article further states that such participation consists of exhibiting in museums, galleries, colleges, and universities (and waging the fight to do so), and being exposed in the mass media as Chicano artists. It concludes that "art that is produced in conscious opposition to the art of the ruling class and those who control it has, in most cases, been co-opted [by these means]. It has lost its effectiveness as visual education working in resistance to cultural imperialism and the capitalist use of art for its market value."

Among the subsidiary issues raised by the article are variously phrased statements to the effect that Chicanos embracing only the cultural nationalist aspects of the movement (not its political aspects) were middle-class oriented, and that the Chicano movement was based on defining its status under capitalism, breaking the yoke of imperialism, and making common cause with Third World nations.

An alternative method for Chicano artists to proceed, according to the article, was that of participating minimally in the system, limiting production to posters, leaflets, and street murals, and exhibiting only in community centers and agencies. In other words, severe restrictions on both the productive forms and consumption of visual arts produced by Chicanos.

Leaving aside for the moment the main argument concerning the present danger of Chicano artists' co-optation, I would like to point up some of the fallacies of the subsidiary issues. Since the original article considered the Chicano art movement and its ideas over a period of time, it should not leave the mistaken impression that the movement from its inception was based on a conscious opposition to capitalism and/or imperialism. This may have been the net result of its struggles and the reason why various Latin American cultural workers welcomed the Chicano artistic movement to their ranks, while reserving the right to criticize its romanticism, mysticism, and lack of theoretical rigor in regard to the internal and international class struggle. This was true in the early 1970s when theater groups like Teatro Campesino participated in Latin American encounters, and it was still true in 1979 when Chicano filmmakers were honored during the First International Festival of New Latin American Cinema in Havana, Cuba. However, not only have participants within the Chicano political and artistic movement been notable for a range of ideologies, but the predominant thrust of the movement has been basically reformist (seeking changes within the structure instead of structural changes), not revolutionary. Those who have been anti-imperialist were decidedly a small minority, and they were more manifest in the political than in the artistic arena.

By the same token, it is inaccurate and unhistorical to characterize the adherents of cultural nationalism (expressed by the uncritical immersion in Mesoamerican pre-Columbian culture, Catholic belief, and the glori-

fication of everything Hispanic or Chicano regardless of merit) as middle-class oriented. Cultural nationalism was the single issue that united very diverse elements in the artistic sphere in the early years of the movement. It was a common rallying point that brought together the urban and the rural, the big city and the small, the student and the worker, the artist and the political activist. For a period of time, until its inadequacies became apparent, it dominated the slogans of the movement: however, as occurred earlier in Mexico, where cultural nationalism was appropriated from the Revolution and converted into a governmental rhetorical tool to impose a false national unity across class boundaries, Chicano cultural nationalism became a respectable motif for middle-class aspirants at the expense of its political implications.

Is Separatism Possible or Desirable?

To return to the main argument, I would like to engage the issue of separatism from the dominant culture. Let me start by stating that separatism (unlike resistance) is an illusion, and to preface that statement with the following modification: that the recent history of minority and oppressed groups within the racist and sexist United States has required an initiatory period of separatism from the majority culture for self-articulation (knowledge of history and heritage, awareness of unique culture, challenging imposed doctrines of inferiority); political formulation (isolating the specifics of economic, racist, and sexist oppression and determining a platform of opposition); and organizing a constituency. By 1980, the Chicano movement has attained many of these objectives, and can confront the mainstream from a position of strength and self-awareness. Its vanguard—political militants, artists, intellectuals, self-educated workers, students—now have the twin obligation of disseminating and testing constantly evolving new ideas within the U.S. Mexican community, and among potential allies outside the community. To accomplish that means moving away from separatism and functioning within the mainstream, including the media, always bearing in mind the difficulties and dangers in so doing.

Let me further suggest that for Chicano artists, as for others, separatism in the production and consumption of art has never been possible even if it was desirable. To develop this point, I would like to clarify certain definitions, and outline some conditions that pertain to art produced within a capitalist context.

Characteristics of Art Production

The several properties of art production include 1) the technology of art, 2) its formal expression, 3) its ideology. These three properties can be

controlled by the individual artist (or even an artistic collective) to a limited extent, since neither the individual nor the collective can function completely outside the social/economic structure of the society in which they live and its dominant ideology. The artist can legitimately assume a stance of *resistance,* but not of separation, and this stance is most operational in art production within the territory of the "ideology" of the work of art.

Technology of art. Technology of art includes under its rubric such things as canvas, paint, brushes, paper, presses, inks, sculptural materials, tools, kilns, cameras, film, projectors, photocopiers, chemicals, and so forth. These materials are controlled at some point in their manufacturing process by large national or international corporations who determine quality, availability, and price. It was brought to my attention while traveling that artists in Latin American countries suffer the same problems with artistic materials that affect them when importing other manufactured goods from the developed industrial nations: limited access, insufficient supply, higher prices than those paid in the metropolis. In addition, protective tariffs in their own countries raise prices even further, sometimes double or triple what is paid in the United States. This is particularly true, for example, with film and related products dominated by the U.S.-based multinational Kodak corporation. In Argentina, certain types of film can be developed only in the United States, making them inaccessible to professional photographers with time deadlines. In Peru, the cost of a roll of 35mm film is three to four times higher than in the U.S. In Mexico, the costs of lithographic inks and presses are so much higher relative to Mexican income that artists are limited in their production; they have met the problem by experimenting with producing their own. And so forth. It is a well-known fact that economic imperialism draws its profits from the production of raw materials and the merchandising of goods in (neo-)colonized countries, a process which enriches the ruling classes and cushions the exploitation of workers in the dominant economy. If we extend this to artistic materials (an aspect of cultural imperialism), it is obvious that Chicano artists, though part of an oppressed and economically exploited group by U.S. standards, function with a favored domestic price structure for their materials, and greater personal income, actually or potentially. Thus, willingly or not, Chicano artists cannot be separatist in this sphere of art production over which they have no control. They are subject to the same economic rules as all U.S. artists.

Style and technique of art. The other two categories, the formal means and ideology of art, are more subjectively determined, though they also are subject to the ubiquitous pressures of the dominant culture. My position, however, is that not everything produced by the dominant culture is necessarily negative; a great deal depends on what is utilized, and toward what ends. Since the "ends" of art production fall into the category

of art consumption, I would like to return to that aspect later, and deal first with formal means. Formal means refer to style (the "isms" of art), and to technique (procedural methods and skills), and the two are interdependent. Likewise, both style and technique are based on ideological determinants. In other words, the techniques and styles chosen are those which best serve the burden of the message or statement the artist wishes to make. This is further defined by the audience the artist wishes to address.[2]

Within this framework, artists who were consciously Chicano from the mid-sixties on overwhelmingly opted for some type of representational visual art to best convey objective messages. The self-taught artists or the art students having, as the Salkowitz/Montoya article pointed out, "very little knowledge of the craft or lacking technical skill" often opted for a naive naturalism, or an "arty" art-school semiabstraction. They also indiscriminately copied the Mexican masters, folk art, or the works of pre-Columbian America, mixing them with U.S. commercial, illustrative, and mass media visual sources and blending the pastiche together with great conviction and sincerity, if not always with aesthetic success. This aspect is not to be despised; it is an important part of the creative explosion of people's art that formed a unique part of the early Chicano cultural movement. It had its counterparts in theater, dance, and literature. Two factors have to be understood about this aspect: 1) a great deal of it, particularly in street murals, was understood and appreciated by its mass audience in the barrios, whose aesthetic tastes had been formed, in part, by many of the same sources, and 2) the true range of Chicano artistic ideology can only be determined by considering this outpouring. It is elitist to think otherwise.

Without detailing the subject matter covered in this phase of visual art, it is clear that the bulk of expression was neither anticapitalist nor anti-imperialist, though it overwhelmingly contained elements of cultural nationalism. Its producers were generally of working-class origins.

Along with self-taught and student artists were also mature and maturing artists who made conscious choices about technology, technique, and style from the multiplicity of such choices available to them as a result of education and exposure to Euro-American as well as to world art. There was (and is) a range of means, from traditional mural and easel painting and print technique to avant-garde photo-silkscreen, photocopy, conceptual, and performance methods to be found in the Chicano art community. There are also varied uses of vernacular materials (folk and popular) such as altars, *calaveras*, *papel picado*, Mexican foodstuffs, Chicano costume and personal ornamentation, items of car culture, and so forth, that have been integrated into the material resources.

The Salkowitz/Montoya article argued, using the 1970 traveling show "El Arte del Barrio" as an example, that Chicano artists using contem-

porary styles such as pop and funk have given these styles, institutional-
ized by Anglos, legitimacy (in the barrio?). I would argue that Chicano
artists should feel free to utilize any of the contemporary formal discov-
eries of Euro-American art—abstract expressionism, pop, op, funk, photo-
realism, etc.—as long as they do not permit themselves to be drawn into
experimentation for its own sake (art-for-art's-sake) or into the sterility of
endless variations of the formal means. In the course of seeking a visual
and plastic language to contain and express a whole set of new ideas and
formulations, Chicano artists who wish to draw on the aesthetic products
of their own country should certainly do so without qualms. It is not a
question of giving such forms legitimacy, but of using whatever is avail-
able in existing technology, technique, and style to evolve a new content.
For all of us who admire the outstanding example of Cuban poster art,
this point has already been made. The Cubans freely appropriated the
most contemporary artistic modes of the capitalist world and placed
them at the service of revolutionary content. The Mexican masters, es-
pecially Rivera and Siqueiros, drew upon the aesthetic experimentations
of their time (cubism, futurism, neoclassicism, photomontage, photo-
documentation, filmic technique) to express the imperatives of the Mexi-
can Revolution and to criticize national and international capitalism.
Siqueiros sought out a Dupont product (Duco) in the United States which
led to the use of pyroxilins, vinylites, and other synthetic paints that
made outdoor murals possible.

The only valid conclusion possible is that there is no betrayal to the
Chicano movement involved in the flexible and experimental use of tech-
nology and style if it is infused with a Chicano vision and worldview. It
is also to be remembered that the so-called Euro-American styles owe a
great debt to the Third World from the nineteenth century to the present.
The Far East, Africa, the South Pacific, pre-Columbian Latin America
were all mined by European artists to evolve the styles of postimpression-
ism, cubism, German expressionism, and so forth; while some op and pop
artists have wrought variations on indigenous materials of the Southwest
and Mexico. Third World artists need feel no reluctance in (re)claiming
these forms.

Ideology of art. Of what is a Chicano vision and worldview composed?
This is a most difficult question to answer, partly because the Chicano
people are so heterogeneous, and also because the Chicano is a product of
two cultural structures, those of Mexico and the United States, but not
fully a product of either. Chicano identity and consciousness is in a con-
stant process of formation, evaluation, and reformation. The present-day
Chicano is heir not only to Mexican political/cultural lore, but that of a
150-year history of resistance to Anglo domination, racism, and eco-
nomic exploitation that have left their imprint on culture. To seek and
know these two histories, to understand their twin impress on person-

ality, thought, manner of life, customs, political struggle, has been the content of Chicano art. It may express itself with equal validity in the production of a traditional blanket, a geometric abstraction playing variations on pre-Columbian motifs, a poster on atrocities in Vietnam or Iran, or a performance piece questioning general contemporary values, to name but a few. It may be positive and life-affirming, starkly critical, humorous or macabre, agonizing, fantastic, or realistic. In other words, it will express the multiplicity of Chicano experiences and reactions in an extremely complex modern world in which all corners are tied together by means of the mass media.

Artistic Survival and Art Consumption

We must finally address the extremely important question of artistic consumption, in which lies one of the major problems raised by the Salkowitz/Montoya article: that of co-optation through assimilation into the capitalist art market. The article seems to argue that the only valid outlet for Chicano art is the Chicano community; in fact, they go beyond this to argue that a valid work of Chicano art viewed and interpreted outside the community has little impact and loses its political significance and strength.

There is no question that the United States has developed an all-encompassing art market structure comparable to Eisenhower's military-industrial complex: the art critic-art historian-museum-gallery-collector complex, the taste makers, validators, and consumers of elite cultural products. The struggle of mainstream reformist artists who have tried to change some aspect of this structure while remaining within its confines and reaping its material benefits is well documented in national art magazines and other periodicals. The Chicano art movement, both as a result of its exclusion from mainstream art institutions (it *did* knock violently on the doors to be accepted in its own terms), and by attempting to by-pass the alienating aspects of art as a consumer product within a consumer society, sought diffusion for its art through an alternative community-based cultural structure: *centros, talleres,* storefront galleries, small presses, street murals, and so on (though Rupert García has pointed out elsewhere the contradiction of public art on nonpublic walls). Everywhere the movement encountered an insoluble problem: the working-class communities it wished to address did not have the economic resources to support an artistic constituency. In addition, the communities were frequently not conversant with the kind of art being brought to them, and sometimes—being caught up with primary problems of survival—did not welcome it, or were indifferent to it. To solve the second problem, educational programs were organized. To solve the first (since artists must have materials, space, walls, rent, transportation,

and living expenses), the artists sought support for their endeavors from small businesses, government on all levels, educational institutions, and corporate agencies, in addition to community fund-raising. It very early became apparent that the former alternatives to the commercial art market were not only of small quantity and limited duration, but engaged in direct or indirect pressure on art content, if not outright censorship. The area of greatest pressure was on those Chicanos in mass media since the means of both production (cameras, projectors, studios) and distribution (TV sets, movie houses) were completely in the hands of major corporations or government-funded institutions, and these will not lightly yield their most costly, yet most ubiquitous and persuasive medium of ideological communication to "subversive" producers. Part of the answer has been alternative film production, independently financed when possible, but the consumption end of this process still remains an arena for battle.[3]

Co-optation. Means and methods of co-optation are many and they do not begin when an artist enters the public arena. Colleges and universities are purveyors of ideology as well as producers of artists. They educate not only the artists but the art critics and the art historians, and thus play their role by creating the components that feed the art market complex. As Ché Guevara pointed out:

> The law of value is not simply a naked reflection of productive relations; the monopoly capitalists—even while employing purely empirical methods—weave around art a complicated web which converts it into a willing tool. The super-structure of society ordains the type of art in which the artist has to be educated. Rebels are subdued by its machinery and only rare talents may create their own work. The rest become shameless hacks or are crushed. A school of artistic "freedom" is created, but its values also have limits even if they are imperceptible until we come into conflict with them—that is to say, until the real problem of man and his alienation arises.

The key inducement to co-optation is "success," which may be translated as financial rewards, middle-class amenities, and prestige accruing to the artist who has "made it" in the system. Its side products are individualism, competitiveness, insistence on an illusory creative "freedom." This is invariably accompanied by a change in artistic ideology reflected directly in the work of art. Technology, technique, or style become ends in themselves resulting in "slick" products; content becomes vapid or empty; the exploration of new ideas and new forms to express them declines or ceases. The tendency of the art market, which is very contradictory, is to "freeze" the successful consumer product at its point of greatest salability. However owing to the throwaway nature of present consumerism, it also demands constant novelty and change, but change on a superficial, stylistic, formal level.

Chicano artists, like others, are subject to the temptations of this system. Sacrifices that many undertook in the early years to contribute to political and artistic struggle were, after prolonged periods of time, found increasingly unpalatable, having been predicated on the notion of short-term victories. Some were overextended in their dual role as artists and activists and tired of their roles; others, achieving a new level of professionalism, felt the newly emerging Chicano middle class should now be willing private patrons. Still others opted for the usual road to commercial success and abandoned whatever critical and political content their earlier work contained though they maintained "ethnic" forms.

Given all these factors, we still have to ask if it is necessarily true that any Chicano artist who exhibits in a museum or gallery, or is featured in the mass media, or pursues a dialogue with the mainstream, is therefore automatically co-opted. Is it necessarily true that artists who express complex ideas, not easily comprehensible on the lowest common denominator, or who use avant-garde methods are also co-opted? Is it even true, as expressed in Ché's too black-and-white analysis quoted above, that capitalist society (in the United States) allows for only three categories: subdued or crushed rebels, shameless hacks, or "rare talents" who may produce their own work? Putting aside the "rare talents" category as too exclusivistic for a general discussion, would we agree that all other artists fall into the two other categories? This would suggest that our society is monolithic and impregnable, that there are no divisions and power struggles within it, and no chinks in the armor. It would suggest that artists, and people in general, completely accept and internalize whatever ideological frameworks are set forth by the dominant culture. Experience would suggest that this is an incorrect formulation; if it were not, *any* kind of ideological struggle could be deemed useless, and nihilism would triumph.

I am aware that some people will argue this is an assimilationist position, a rationalization for participation. To that argument I would counter that I have proposed a model above: a set of criteria for determining if an artwork has been co-opted which, while subjective, can still provide a guide for judgment. Slickness, emptiness, static ideas and forms, repetitiveness, superficial novelty are some of the measuring devices, to which more could be added.

Let us, however, make no mistakes about the nature of the system. The U.S. ruling class is able through manipulation and co-optation to catch more flies with honey than with vinegar. This means that the facade of bourgeois democracy is still in place and considered preferable to a naked display of ideological control through repression such as occurred during the McCarthy period, or as regularly occurs in dictatorial Latin American countries where the political power structure is insecure. In the United States, certain urgent black and Chicano demands (such as

Affirmative Action, or recognition of the Farmworkers' Union) were won (despite later dismantling) so that the fabric of society would not be further exposed or torn asunder, in a period of liberal reform, by escalated class struggle. Some aspirations were satisfied, including limited access to the middle class. Confrontational challenges, however, such as those of the Black Panthers, the Brown Berets, or the militant phases of Chicano activism (farmworkers' picketing, the Moratorium), were ruthlessly repressed. Despite the defacement of street murals, the diminution or denial of funding, obstructionism, censorship, and the operation of co-optive methods, Chicano protest art has, by and large, been permitted to exist under present permissive methods. However, constant activism is necessary to maintain and enlarge whatever gains were achieved during the last fifteen years.

Artists' options today. There still remains the pragmatic question of the economic survival of the artist, and the ultimate consumption of his/her product. In a capitalist society there are two, perhaps three, economic options for the artist. First, for the chosen few who are carriers of capitalist artistic ideology, the art market complex provides ample rewards based on a highly competitive system. Secondarily there are artists who earn their primary living outside of, or in addition to, sales of their work, but remain in their artistic discipline as educators, administrators, illustrators, designers, technicians, commercial artists, and so on. Finally there are those who practice their art part time and are primarily employed outside their field. Traditionally the great majority of opposition artists are of the last two categories, both Chicano and non-Chicano. The degree to which artists maintain and aesthetically express their oppositional stance depends on their perception and evaluation of their position. No single perfect model exists for balancing economic necessity with artistic integrity.

The key question, it would seem to me—since none can be "pure" within any given society—is not whether an artist exhibits in a museum or commercial gallery or choses to do easel paintings rather than posters and public murals. (Not every painter, after all, can be a successful muralist.) It lies with the ideological stance assumed by the artist in reference to the production and consumption of art, to the uncompromising quality and content of the work, and the refusal to capitulate on either aspect in exchange for prestige or financial rewards. For those artists who opt to work in the direct service of grass-roots organizations, appropriate forms would be posters, public murals, handbills, local magazines, comic strips and *fotonovelas* with new content, community art classes, art-mobiles, traveling exhibitions, inexpensive reproductions of paintings and prints, etc. Dangers to be avoided are oversimplification (either assuming that all art must be understood by everyone or that working people are obtuse), folklorism, populism, and parochialism. Not every-

thing produced by the "folk" is valid and progressive culture; it is often impregnated with regressive values or with capitalist ideology. Chicano artists should be selective about what they exhibit and what they integrate into their own art forms.

Others will function within established parameters (though the two roles are not mutually exclusive) where, correctly, Chicanos have every right to be: museums, funding agencies, colleges and universities, the media, where mass ideologies are shaped and disseminated. They will have a difficult task: not to be dislodged but also not to be seduced, to maintain ties with community and Third World struggles but also to learn and use the sophisticated methods of the establishment on behalf of their own conceptions. They should be situated so as to educate younger generations to their ideals by percept and example, not leaving the field to the opposition.

It is not technology, style, or even the art structure that is at fault—we are not opposed to the *existence* of galleries, museums, schools, art criticism—but to the philosophies and practices that inform them. They must be adapted to the needs of the people, in small ways and large.

Notes

1. Malaquías Montoya and Leslie Salkowitz-Montoya, "A Critical Perspective on the State of Chicano Art," *Metamorfosis* 3, no. 1 (Spring/Summer 1980): 3–7. All quotes and paraphrases are taken from this article.

2. Let us not be deterred in this line of reasoning by the argument of some that they produce only for themselves and are not concerned with any audience. A work of art consumed by the artist alone does not exist as a social act and need not concern us. This does not gainsay the fact that the act of production may (and perhaps should) be individual and the content not weighted down by the need for *pleasing* a specific audience, as a critical work may be, as long as some audience is a given.

3. Unlike painting and printmaking, voluntary separation from the mainstream art consumption structure is not only very difficult but self-defeating, because of film's vast viewing potential. In this respect, the story of involuntary "separation" (blacklisting) of the 1953 film *Salt of the Earth* is very instructive.

28

INSIDE/OUTSIDE MAINSTREAM

> Minority artists denied access to mainstream exhibitions have been histori-
> cally relegated to exhibitions based on ethnicity or gender. . . . Many ques-
> tions arise as to the role these exhibitions play within the context of the
> contemporary art scene. Are these exhibitions exposing or isolating mi-
> nority artists? Do we still require exhibitions of this nature?

These questions were posed to a panel of five persons (including the au-
thor) who participated in a symposium titled "Minority Art Exhibitions:
Opening or Closing the Door?" during the recent show "¡Mira!: The Ca-
nadian Club Hispanic Art Tour III," held at the Los Angeles Municipal
Art Gallery during April and May 1988. It seems to me that the basic
premise is much broader than the particular exhibition for which the dis-
cussion was organized, and that 1988 is a good year in which to take an
evaluative look at this premise. Twenty years have passed since the first
women's, Latino, and black shows were organized across the country in
makeshift alternative spaces to give a voice and a place to these invisible
artists who were ignored by mainstream cultural institutions. For those
in California with long memories, there was the Mechicano Art Gallery,
which showed the first Chicano artists on La Cienega Boulevard and later
in East Los Angeles, and the Galería de la Raza, which opened its walls
to Latino artists of many nationalities in San Francisco. Womanspace
Gallery (which preceded the Woman's Building) hosted many exhibits
of work by women, while Brockman Gallery and Contemporary Crafts

This commentary first appeared in *Artweek* 19, no. 22 (June 4, 1988): 6.

showcased black artists in Los Angeles, and Blackman's Art Gallery did likewise in San Francisco. Some of these artists whose early exposure took place in alternative spaces eventually were accepted—tentatively and not too frequently—for exhibits in mainstream museums during the 1970s; and some are now entering the commercial gallery circuit with success. One might justifiably ask, therefore, why are specialized exhibitions still necessary two decades after the struggles began? My answer would be, regrettably, that racism and sexism are far from banished in contemporary society; that, indeed, we are in a state of regression that began with the Reagan administration and its rollback of civil and gender rights through cuts in social and cultural spending as well as through legislative and judicial conservatism—to say nothing of ideological conservatism. Furthermore, the mainstream art historical and critical community is far from having integrated "minorities" into its educational or aesthetic apparatus.

What, then, are the tactics and strategies that correspond to this moment in time in terms of what some call "special interests," whether these are political or artistic? Perhaps we should collapse the two terms into "politico-artistic" (since that is the essence of the debate, not the quality of the art produced and displayed) and recognize that these particular "special interests"—whether artists, union members, tennis players, welfare mothers, the homeless, or those against nuclear war—mean *us* in the conglomerate, actually or potentially.

To engage this proposition, I'd like to start with a kind of "parable" taken from the story of the Women's Caucus for Art—a feminist art project arising during the same early 1970s that produced the Chicano, black, Native American, and Asian alternative art movements. The Caucus began as an adjunct to the College Art Association (which has yet to give support and a voice to modern black, Asian, Latin American, and Latino artists and art historians[1]). The Caucus's strategy has been to hold panels and events simultaneously (though at a different location) with those of the College Art Association for whom women's issues had low priority. My parable concerns 1988 events: this year in Houston, the Women's Caucus not only had its parallel events as usual but had "infiltrated," had "subverted," if you will, the College Art Association program with several "prime time" panels presented on topics and by art historians not generally associated with feminist activities. (That more women had previously been elected to the formerly male-dominated board possibly made a difference as well.)

My point is that so-called "minority" exhibitions are still a strategy to offset not only years but centuries of discrimination from the dominant Euro-American institutions. Personally, I don't accept the term "minority" as descriptive of women or of people of the Third World living in the U.S. Demographic figures will show that women are at least 50 per-

cent of the population, and Third World peoples collectively in some states, such as California, are edging into majority populations. (It will be instructive to contemplate the figures that come in from the 1990 census!) In my opinion, Chicanos, Latinos, blacks, Native Americans, Asians, and women should not abandon their alternative spaces or exhibitions. These are activities that put their presence forward in society *on their own terms*, and, additionally, give support to upcoming artistic generations who shouldn't have to once more challenge a still prejudiced establishment without any support structures. This by no means indicates, however, that I advocate "ghettoizing" Third World or women artists. In fact, I even question the term. It's interesting to note that we don't have such fears when New York's Museum of Modern Art, or the Metropolitan Museum, or the National Gallery, or the Los Angeles County Museum of Art puts on shows of *French* impressionist art, or *Russian* art, or *Italian* Renaissance art—ad infinitum—or when exhibits of U.S. art travel abroad. Why should the "ghettoizing" concept arise only in connection with Third World and women artists? Why should we not say that a show of white male artists from Germany, or from the United States, or from Chicago, New York, or San Francisco, for that matter, is "ghettoized?" If there is a ghettoizing ideology, it is coming from the dominant society, not from the affected groups themselves. However, let's place this in another light. If the dominant society and its art institutions indicate by their exclusionary policies that art by Latinos, blacks, Native Americans, Asians, and women is inferior—is there any justifiable imperative for us to accept such a verdict, unless we secretly suspect they are right? In other words, should we internalize such myopic, bigoted, and outmoded attitudes? The splendors of much of the art (if not the ideology of the organizers) exhibited in the traveling show "Hispanic Art in the United States," or the exhibition "Art of the Fantastic: Latin American Art, 1920–1987," or the many excellent works by Latin American artists in the traveling "¡Mira!" show—most of whom are better known on the East Coast than on the West, and some of whom have long received international acclaim—are ample evidence that neither the attitudes, nor the narrow aesthetic prescriptions, nor the arrogant appropriation of what constitutes modern art by white Euro-American males has validity.

My proposal would be two-pronged. By all means carry on with exhibits of Third World and women's art until everyone can see and know that all these groups contain fine (as well as not so fine) artists. Then these discriminated-against populations will be able to know and have pride in their own best work—just as Frenchmen, Italians, and Germans have in theirs (as Frantz Fanon once said). The other strategy is to continue beating on mainstream doors for absolute recognition across the board, and a widening of standards to recognize and value the different artistic modes

of the human race. White hegemonic Euro-American males have been colonizers and taste-determiners, to their own advantage, for far too long.

Note

1. This began to turn around as of the 1990 College Art Association meeting in New York and, despite opposition within the ranks of traditionalist academics and administrators, has been maintained to date.

29

THE ICONOGRAPHY OF CHICANO
SELF-DETERMINATION: RACE,
ETHNICITY, AND CLASS

In several cities in the Southwest and Midwest with sizable enclaves of Chicanos, there are to be found considerable numbers of images that have become leitmotifs of Chicano art. In their ubiquity, these motifs demonstrate that the Chicano phase of Mexican-American art (from 1965 to the 1980s) was nationally dispersed, shared certain common philosophies, and established a network that promoted a hitherto nonexistent cohesion. In other words, it was a *movement*, not just an individual assembly of Mexican-descent artists. In what follows, Chicano art is examined as statements of conquered people countering oppression and determining their own destiny, though not all the producers of these images necessarily saw their production in the political way they are framed below. Examples have been chosen specifically to show how, in response to exploitation, artists have taken an affirmative stance celebrating race, ethnicity, and class.

Race

Without setting forth theories of how and why racism is instituted and continues to exist, it can be said briefly that the Anglo-Saxon settlers of

This essay first appeared in *Art Journal* 49, no. 2 (Summer 1990): 167–73. Reprinted by permission of College Art Association, Inc.

the North American colonies brought racism with them from Europe; found it useful in the genocidal subjugation of the Indian peoples and the expropriation of their lands; used it as a rationalizing ideology for African slavery; and practiced it in the subjugation of the *mestizo* Mexicans in the nineteenth century. In the 1840s, when Anglos were anxious to seize Mexican territory, racial assertions bolstered that desire. Mexican soldiers, it was said, were "hungry, drawling, lazy half-breeds."[1] The occupation of Mexico was in order, since, as documented in the Illinois State Register, "the process which had been gone through at the north of driving back the Indians, or annihilating them as a race, has yet to be gone through at the south."[2] In the 1930s, one American schoolteacher claimed that the "inferiority of the Mexicans is both biological and class"[3]—a reference both to the Indian component of Mexican *mestizaje* and to the Spanish, who were considered among the "inferior" peoples of Europe because of their Moorish inheritance. Supposed racial inferiority eventually served to create in the United States a colonized cheap labor pool which not only worked for less at the dirtier, harder jobs but was used to threaten white workers demanding higher wages, shorter hours, and unions.

One of the first issues Chicano artists addressed in the 1960s was the question of their Indian heritage. The earliest expression was an embracing of pre-Columbian cultures in order to stress the non-European racial and cultural aspects of their background. Directly related to the question of racial identity, the 1969 Plan Espiritual de Aztlán, formulated at a national gathering in Denver, stated: "We are a Bronze People with a Bronze Culture."[4] Actually, the earliest colonists moving northward from New Spain or Mexico in the sixteenth century had mingled with the Pueblo Indians of New Mexico, and that process continued throughout the centuries. However, under the pressure of Anglo racism, this fact was hidden or denied as Mexicans designated themselves "Spaniards."

In 1968, in Del Rey, California, Antonio Bernal painted two murals on the outside walls of the Teatro Campesino headquarters that exemplify the iconography prevalent in the politicized murals of the 1970s. On one panel, pre-Columbian elites line up in flat horizontal bands, headed by a woman. There is little doubt that this scene was borrowed from the Maya murals of Room I in the temple at Bonampak, Chiapas, Mexico. Like the all male standing dignitaries at Bonampak, the Bernal figures wear headdresses with long feathers. On the second panel is a sequence of admired leaders from the period of the Mexican Revolution to the present, headed by the figure of a *soldadera* (woman soldier—perhaps the legendary La Adelita) wearing a bandolier and carrying a curved sword.[5] She is followed by revolutionaries Francisco "Pancho" Villa and Emiliano Zapata, the nineteenth-century outlaw-hero Joaquín Murieta, César Chávez of the United Farm Workers, Reis López Tijerina of the New Mexico

Fig. 72

land grant struggles, a Black Panther with the features of Malcolm X, and Martin Luther King, Jr. The figures in both murals are represented in appropriate garb with significant emblems and carrying objects related to their respective roles in the social process. All are organized processionally on a single ground line and are painted with unmodeled brilliant color against a plain background. Bernal applied the Maya style to modern as well as ancient personalities in order to establish a stylistic homogeneity. In what amounts to an affirmation of racial pride, the Spanish (presumably white) lineage is deemphasized while the dark-skinned indigenous heritage is stressed. The mural is unique in two respects: 1) for the prominence given activist women, which is unusually sensitive for this male-dominated period of Chicano art, and 2) for the suggested alliance between Mexicans and the African American civil rights movement, which seldom again comes up so directly.

Like Indianist culture in Latin America, Chicano indigenism was often of an archaizing and romantic character, setting up the values of Indian culture and civilization as an alternative to European values.[6] In the search for an affirmation of heritage in the extinguished past, the urge toward the creation of a heroic mythology was strong. Thus, in cultural terms, the concept of Aztlán—which defines the Southwest as the home of the original Aztecs and therefore their link to the present Chicano population—is itself a speculative bit of history not verified by archaeology.

A parallel notion, widely disseminated in visual and literary forms by Chicanos (who were 90 percent working class until the mid twentieth century or later), is that they were the descendants of the elite rulers of the Aztec, Maya, or Toltec states. The hundreds, perhaps thousands, of pyramids, warriors, and adaptations of pre-Columbian religious sculptures and paintings, as well as of Aztec and Maya princes and princesses, that permeate Chicano art are a testimony to this preoccupation.

One of the most ubiquitous of the latter images derives from the purportedly Aztec legend of the lovers Popocatépetl ("the smoking mountain") and Ixtaccíhuatl ("the white woman"), the names of two snow-capped volcanoes from the rim of mountains surrounding the Valley of Mexico. In the most popular version, a princess dies and her warrior lover builds two pyramids, on one of which he places her; on the other he stands holding a torch to illuminate her sleeping body.[7] Most versions of the story concur on the postures of the lovers: the peaked mountain represents the erect guardian, the flat-topped mountain is the sleeping woman. Almost invariably, however, Chicano images show the male figure carrying a voluptuous, often half-nude princess à la Tarzan and Jane. This melodramatic variation of the traditional iconography very probably derives from the popular chromolith calendars printed in Mexico and widely distributed with local advertising in Mexican communities of the

United States. The Texas sculptor Luis Jiménez modified the calendar-derived image in a color lithograph showing the scantily clad body of the princess draped across the warrior's knees in a manner reminiscent of Michelangelo's *Pietà*. The print includes also a blooming prickly pear cactus, an eagle, and a serpent—legendary symbols that led the nomadic Aztecs to their city of Tenochtitlán in the Valley of Mexico—as well as snow-clad volcanoes and a large maguey cactus.

Other scenes in Chicano art illustrate the fusing of pre-Columbian motifs with contemporary issues. One of the earliest such usages was the 1971 mural painted on two interior walls of a Las Vegas, New Mexico, high school by the Artes Guadalupanos de Aztlán.[8] Their naive representation is tempered by adaptations of the dramatic foreshortening and polyangular perspective characteristic of Siqueiros. On one wall, dominated by feather-adorned pre-Columbian Indians, a sacrifice scene takes place. The second wall, echoing the first, illustrates modern sacrifice: a symbol of the Vietnam War, followed by a crucified Christ beneath whose arms a mother with twin babies surmounts a flag-draped coffin with the slogan "15,000 Chicanos muertos en Vietnam. Ya basta!" ("15,000 Chicanos Dead in Vietnam. Enough!"). Functioning in a similar vein is a 1973 poster by Xavier Viramontes of San Francisco in which the slogan "Boycott Grapes" is flanked by red, white, and black thunderbird flags of the United Farm Workers Union. Above, a brilliantly colored feather-bonneted pre-Columbian warrior holds in his hands bunches of grapes from which blood drips over the words.[9]

Some indigenous motifs illustrate the recognition by Chicano artists that modern North American Indians have been similarly oppressed. For example, Victor Ochoa rendered a modern Native American on the exterior wall of the Centro Cultural de la Raza of San Diego: the Apache chief Geronimo, whose consistent defiance of the government in the late nineteenth century serves as a symbol for contemporary resistance.[10] Alliances between Chicanos and Native Americans appear also in a silkscreen poster produced in the mid-1970s by the Royal Chicano Air Force (RCAF) of Sacramento. A nineteenth-century Indian is shown with painted face and a feather in his hair; half of his face is covered by a U.S. flag from which blood drips. The slogan states "Centennial Means 500 years of Genocide! Free Russell Redner, and Kenneth Loudhawk."[11] No images of Chicanos appear in the poster; nevertheless, a Chicano presence and an endorsement of Native American struggles that paralleled the Chicanos' own are implied by the RCAF logo that appears on the poster.

More recently Chicano artists have reflected their empathy, brotherhood, and involvement with the Maya Indians of Central America, who are resisting genocidal decimation from dictatorial governments supported by U.S. military aid and advisers. Such artworks are Yreina Cervántez's 1983 silkscreen on Guatemala, *Victoria Océlotl*, and Roberto

Delgado's series of monotypes titled *Border Series* in which silhouetted pre-Columbian designs and shadowy Indian figures of today are interlaced with helicopters. As in Vietnam, the U.S.-supplied helicopters of Central American warfare against civilian populations have become the visual symbols of violent repression.

Ethnicity

Ethnicity is not an individual construct but the residue of societal processes that may have taken generations to evolve. Without embarking on a discussion of the nationalism to which ethnicity is obviously related, we can define it as a set of activities, traits, customs, rituals, relationships, and other emblems of signification that are rooted in group histories and shared to differing degrees by the members of a given national/ethnic group.

Perhaps the greatest difference between nationality and ethnicity is that the former is a given; that it exists by virtue of birth in a certain place and time, and that its manifestations are transparent enough not to be open to question. More concretely, a national group is considered such when it is politically independent (like a "sovereign state") no matter how loose or rudimentary its structure, no matter how dependent or infiltrated it may be by other states. Ethnicity, however, needs to be maintained, and is often in an embattled posture vis-à-vis a dominant national culture that surrounds and threatens to overwhelm (either acculturate or totally assimilate) an ethnic identity separated by years or generations from its original source. A multicultural and multiethnic political structure such as that of the United States is extremely likely to be large and complex enough to involve social stratification and the crosscutting of ethnicity with social inequality. Both these factors exacerbate ethnic consciousness, since the experience of discrimination is related to one's identity and thus to one's ethnicity, which is an important aspect of that identity.[12]

There is evidence to suggest that, beginning in the late 1970s, with the possibility and actualization of social mobility for a segment of educated Chicanos, ethnicity—severed from its socioeconomic aspirations for an entire group—has become an acceptable component of dominant ideology. Nevertheless, true to form, the multiethnic political structure has exerted its defining and structuring powers by conflating all "ethnics" of Latin American descent into a single group designated as "Hispanic." At the same time, the practice of milder and subtler stereotyping continues to be exercised as the occasion arises. Needless to say, the "acceptable ethnics" are those who can be assimilated into the middle class and accept the values of the "American Dream" as a realizable goal.

When Anglo-Americans first began to penetrate areas of the South-

west, then part of Mexico, many points of disagreement became apparent. The Anglos spoke English, were primarily Protestants, came from primarily southern states, and were proslavery; the Mexicans were Spanish-speaking, Catholic, tolerant of feudal peonage but opposed to slavery. Their diets were different, their family attitudes at variance, their racial stock was diverse. As conquerors, the Anglo-Americans attacked not only the political and economic power of the former Mexican territory but the culture of its inhabitants. "Colonialism," said Frantz Fanon, "is not satisfied merely with holding a people in its grip. . . . By a kind of perverted logic, it turns to the past of oppressed people, and distorts, disfigures, and destroys it."[13] As the dominant society and controller of power, the Anglos continued their attack upon Mexican culture from the time of penetration to the present—through stereotypes, the prohibition of spoken Spanish at schools, and the scorning of cultural manifestations. Chicano artists therefore attacked stereotypes, insisted not only on the use of Spanish but also on the validity of "interlingualism,"[14] and stressed the celebration of cultural symbols that identified their ethnicity.

The stereotype, critic Craig Owens writes, is "a form of symbolic violence exercised upon the body [or the body politic] in order to assign it to a place and to keep it in its place. [It] works primarily through intimidation; it poses a threat . . . [it] is a gesture performed with the express purpose of intimidating the enemy into submission." The insidious aspects of such gestures is that they "promote passivity, receptivity, inactivity—docile bodies. . . . To become effective, stereotypes must circulate endlessly, relentlessly throughout society" so that everyone may learn their significations.[15] It is abundantly clear that the dominant culture persistently considers cultural traits differing from its own to be *deficiencies*; the cultures being declared deficient (black, Chicano, Puerto Rican, Filipino, and hundreds of Native American groups) are considered so with respect to Anglo culture—a reflection of the ideologies that have served to justify the relationship of inequality between European and Third World peoples.[16]

As an image, the Virgin of Guadalupe has a long history in Mexico as the nation's patron saint. In the United States, that image has been carried on all farmworker demonstrations. It is a constantly repeated motif in artworks of all kinds, an affirmation of institutional and folk Catholicism. The institutional aspect of the Guadalupe began in 1531 as part of the evangelical process directed at the indigenous people by the Spanish Catholic Church. Evangelization was accomplished by means of a miraculous event: the apparition of a *morena* (dark-skinned) Indian Virgin to a humble peasant, Juan Diego, at Tepeyac, site of the shrine dedicated to the benevolent Aztec earth goddess Tonantzin—or "our mother."

A series of paintings and mixed-media works (1978–79) by the San Francisco artist Yolanda López takes the Virgin through a number of

Fig. 73 permutations. In one she addresses the syncretic nature of Mexican Catholicism, identifying the Guadalupe with Tonantzin by surrounding the latter with *guadalupana* symbols of mandorla, crown, star-covered cloak, crescent moon, angel wings, and four scenes from the Virgin's life. In others of the series, she places her grandmother, or her mother, or a modern Mexican Indian woman and child, or the artist herself as a runner, in various ensembles combined with the Virgin's symbols—a total secularization. When charged with sacrilege, López defended her images as those of "Our Mothers; the Mothers of us all."[17] The syncretic revival of Coatlicue/Tonantzin in conjunction with the Guadalupe pays tribute not only to the racial and religious affirmations of the Chicano movement but to the particular idols of feminist artists as well.

Among ethnic affirmations that appear in Chicano artworks in response to scornful denigration from the dominant culture are the inclusion of foods such as the humble tortilla, bean, chile pepper, and *nopal* (prickly pear cactus); the use of the Spanish language in texts; the rites of folk healing among rural Mexicans; the image of the *calavera* (skull or animated skeleton) as a death motif; and the celebration of the Día de los Muertos—an annual cemetery ritual in rural Mexican communities (which, ironically, is slowly disappearing with Mexican urbanization and has long been commercialized for the tourist trade).[18] Since the early 1970s, Día de los Muertos ceremonies have been celebrated increasingly in the Chicano barrios of large cities, sometimes with processions. Home altars associated with the Día de los Muertos were revived by Chicanos for gallery display, using the folk crafts and traditional format but also introducing contemporary variations. One example by San Francisco artist René Yáñez includes images of Diego Rivera, Frida Kahlo, skeletons, and a hologram within a domed form of El Santo—a mysterious and legendary Mexican wrestler of the 1940s whose trademark was a silver head mask slit only at the eyes, nose, and mouth, and who maintained his anonymity like Superman's Clark Kent.[19] On this cloth-covered altar, accompanied by two candlesticks made of twisted wire "flames," El Santo has truly become a "saint" as well as an icon of popular culture. Like López's Guadalupes, Yáñez's altar has been divested of any religious intent.

Although the Mexican presence in the United States predates the Anglo, it has constantly been increased and reinforced by Mexican immigration to provide rural and urban labor. The greatest movement of people north was during the years of the Mexican Revolution, roughly 1910 to 1920, and many of these immigrants headed to the big cities of Los Angeles and San Antonio, where a particularly urban ethnic expression arose by the 1940s: the Pachuco. The most famous (or infamous) attack against the Pachucos was that known as the "Zoot Suit Riots" fanned by the Hearst press in 1943 in which xenophobic U.S. servicemen invaded the

barrios and downtown areas of Los Angeles to strip and beat the zootsuiters in the name of "Americanism." (This was the same period in which Japanese in the U.S. were herded into concentration camps.)

Some Chicanos have glamorized the Pachuco into the status of a folk hero—as did Luis Valdez in the play *Zoot Suit*, where the proud defiant stance of the Pachuco character created by Edward James Olmos epitomizes the myth. El Pachuco, in the play, becomes the alter ego of Mexican American youth, the guardian angel who represents survival through "macho" and "cool hip" in the urban "jungle" filled with racist police, judges, and courts. In the 1940s, a policeman actually stated that "this Mexican element considers [fisticuffs in fighting] to be a sign of weakness. . . . All he knows and feels is the desire to use a knife . . . to kill, or at least let blood." This "inborn characteristic," said the policeman, makes it hard for Anglos to understand the psychology of the Indian or the Latin.[20] The "inborn characteristic" was a reference to pre-Columbian sacrifice, especially by the Aztecs, and the inference, of course, is that since the Aztecs were savages, so are their descendants.

The real Pachuco, drawn from family portraits of the time, is a less heroic personage, in his baggy pants, long coat, and chain borrowed from black entertainer Cab Calloway, and as he was immortalized in Mexican film by Tin Tan as an expression of border culture. This is how he is presented in paintings by César A. Martínez of San Antonio, which derive from old family photograph albums of the 1940s. Martínez's style is totally contemporary in its use of fields of thickly brushed paint and in its pop consciousness which allows the inclusion of an entire logo, with parrot and tree limb of La Parot Hi-Life Hair Dressing, above the image of a Pachuco combing back his thick hair in the characteristic "ducktail" style of the 1940s. Fig. 74

Class

Class divisions in the southwestern United States, which was once part of New Spain and Mexico, have existed since the first conquest in 1598. Juan de Oñate, a millionaire silver-mine owner from Zacatecas, Mexico, then led an expedition into New Mexico, colonizing the area and subjugating the Indians. In the semifeudal, semimercantile, preindustrial period that followed, Indians and lower-class mestizos formed the "working class." With the Anglo conquest in 1848, some Anglos married women from wealthy Mexican landowning families to form a bilingual upper class (in southern Texas and California, particularly), but by and large Mexicans in the Southwest were stripped of their land and proletarianized. As *vaqueros* (the original cowboys, to be distinguished from the elegantly dressed *charros* of the upper classes), as miners, as members of railroad section gangs, as agricultural laborers—and more recently as

industrial and service workers—Mexican Americans and Chicanos have been mostly of the working class.

Emigdio Vásquez of Orange, California, fills his murals and easel paintings with both well-known and anonymous heroes of the agricultural and industrial working class derived from historical and contemporary photographs, but without the impersonality of photorealism. His mural *Trib-* See fig. 44 *ute to the Chicano Working Class* introduces an Aztec eagle warrior, a Chicano, and a Mexican revolutionary, followed by a railroad boiler-maker, a rancher, a miner, and migrant crop pickers. The procession ends with portraits of César Chávez and a representative of the Filipino workers in the fields of Delano, California, who formed an alliance with the Mexican workers to set up what, in the 1960s, became the United Farm Workers Union.

Following on the heels of the black civil rights struggle in the United States, which influenced all the subsequent social-protest movements of the 1960s, farmworkers' activism provided a most important class encounter for Chicanos. It was an economic movement but also a cultural one, expressing itself with a flag (the black thunderbird on a red-and-white ground), the Virgin of Guadalupe banner in all processions, and the magazine *El Malcriado* with caricatures by Andy Zermeño and reproductions of Mexican graphics. During the course of the very effective grape boycott, the Nixon administration increased its purchase of grapes for the military forces. In one issue of *El Malcriado*, therefore, Zermeño shows Nixon himself being fed grapes by a fat grower, who emerges from his coat pocket, while his bare feet trample out the "juice" of farmworkers' bodies in a wooden vat. On the ground, in a pool of wine/blood, lies a dead body labeled "La Raza." The legend across the cartoon reads "Stop Nixon." Another cartoon addresses the dangers of pesticide crop spraying. In it, a gas-masked aviator sweeps low over fleeing farm workers while clouds of poison envelop them. Rows of graves line the background.[21]

Other figures of labor who have found their way into Chicano art include workers in the steel mills of Chicago, the garment industry sweatshops of Los Angeles, and the Mexican maids (often undocumented) in Anglo households whose vocabulary is limited to the household, and for whose employers little books of Spanish phrases for giving orders have been printed in the Southwest. In recent years, Chicano artists have become increasingly involved with the question of undocumented workers crossing into the United States to supplement their inadequate Mexican income. Although these workers are secretly recognized by U.S. employers as beneficial to the economy (and business profits), the flow is unregulated and, in times of depression or recession, the workers are scapegoated in the media to divert unemployed U.S. workers from recognizing the source of their own misery. In this ideological campaign, the

border patrol of the U.S. Immigration and Naturalization Service (INS) plays a brutal role by rounding up and harassing the Mexicans. The sculptor David Avalos of San Diego has made this theme a central part of his artistic production. In a mixed-media assemblage, Avalos combines an altar format with that of a donkey cart used for tourist photographs in the commercial zone of the border town of Tijuana, Mexico. His sardonic sense of humor is expressed in the sign painted before the untenanted shafts of the cart: "Bienvenidos amigos" ("Welcome Friends")—usually addressed to the U.S. tourist but not, of course, to the Mexican workers. The upper part of the cart, shaped like an altar with a cross above and *nopal* cactus on either side below two votive candles, has been painted as a flower-filled landscape with barbed wire within which an INS officer searches an undocumented worker whose raised arms echo a crucifixion scene.

Fig. 75

In poetically articulating the importance given the class struggle by Chicanos, the Plan Espiritual de Aztlán said the following: "Aztlán belongs to those who plant the seeds, water the fields, and gather the crops, and not to foreign Europeans." The Plan called for self-defense, community organizations, tackling economic problems, and the formation of a national political party. It called on writers, poets, musicians, and artists to produce literature and art "that is appealing to our people, and relates to our revolutionary culture."[22] The note of self-determination, however romantically phrased, is struck here, in 1969.

In conclusion, it can be said that Mexican American and Chicano culture in the United States has been characterized by three manifestations: cultural resistance (which started at the time of the first contact with Anglo-American penetration of the Southwest); cultural maintenance, which includes all aspects of ethnicity; and cultural affirmation, which celebrates race, ethnicity, and class and reached its strongest and most national expression, in my opinion, during the Chicano period.

Notes

1. R. H. Dana, Jr., "Two Years before the Mast," quoted in Jack D. Forbes (ed.), *Aztecas del Norte: The Chicanos of Aztlan* (Greenwich, Conn., Fawcett Publications, Inc., 1973, 153.

2. *The Illinois State Register*, December 27, 1844, in Forbes, *Aztecas del Norte*, 153.

3. Quoted in Forbes, *Aztecas del Norte*, 157.

4. Luis Valdez and Stan Steiner (eds.), *Aztlán: An Anthology of Mexican American Literature* (New York, Vintage Books, 1972), 402–6.

5. The Mexican revolutionary Emiliano Zapata appears in a famous photograph by Agustín V. Casasola with a rifle and a scabbarded sword. See *The World*

of Agustín Víctor Casasola, Mexico: 1900–1938 (Washington, D.C.: Fondo del Sol Visual Arts and Media Center, 1984), 49.

6. Jean Franco, *The Modern Culture of Latin America: Society and the Artist,* rev. ed. (Harmondsworth: Penguin Books, 1970), 120.

7. Frances Toor, *A Treasury of Mexican Folkways* [New York, Crown Publishers, 1979], 536] points out that for the ancient Aztecs, Popocatépetl and Ixtaccíhuatl were fertility gods worshiped with offerings and human sacrifices. The love story probably originated with the romantics and symbolists of the nineteenth century. For example, the Mexican artist Saturnino Herrán, carrying on *fin-de-siècle* themes with an indigenist orientation, painted several versions of the legend, one in 1911. See *La leyenda de los volcanes* in *Saturnino Herrán: Pintor mexicano, 1887–1987* (Mexico City: Instituto Nacional de Bellas Artes, 1987), 57.

8. See Alan W. Barnett, *Community Murals, the People's Art* (Philadelphia: The Art Alliance Press, 1984), 193.

9. See *A través de la frontera* (Mexico City: Centro de Estudios Económicos y Sociales del Tercer Mundo, 1983), 81.

10. See Philip Brookman and Guillermo Gómez-Peña (eds.), *Made in Aztlán* (San Diego, Calif.: Centro Cultural de la Raza, 1986), 47.

11. Redner and Loudhawk were indicted in about 1975 in Oregon on a charge of alleged arms possession. For an image of the poster, see *A través de la frontera,* 64.

12. E. L. Cerroni-Long, "Ideology and Ethnicity: An American-Soviet Comparison," *Journal of Ethnic Studies* 14, no. 3 (Fall 1986): 5.

13. Frantz Fanon, *The Wretched of the Earth,* trans. Constance Farrington (New York: Grove Press, 1963), 210.

14. Interlingualism is the term applied to the use of multiple languages in literature or speech. Chicano literature and poetry, for example, have employed as many as five idioms in one work: standard English, black English, Spanish, the Caló vernacular, and words from pre-Hispanic Indian languages.

15. Craig Owens, "The Medusa Effect or, The Spectacular Ruse," in *We Won't Play Nature to Your Culture: Barbara Kruger* (London: Institute of Contemporary Arts, 1983), 7.

16. For further information about cultural-deficiency theories and their evaluation, see Mario Barrera, *Race and Class in the Southwest: A Theory of Racial Inequality* (Notre Dame: University of Notre Dame Press, 1979), 176–82.

17. Interview with the artist, 1983.

18. See Néstor García Canclini, "¿Fiestas populares o espectáculos para turistas?" in *Plural,* no. 116 (March 1982): 48.

19. Yáñez himself assumed the identity of El Santo in a 1977 performance piece: covering his head with a Santo mask, he read a poem about human survival in Chile while a dagger floated above him.

20. See Carey McWilliams, *North from Mexico: The Spanish-Speaking People of the United States* (New York: Greenwood Press, 1968), 234.

21. The cartoons about Nixon and pesticide spraying appear in the issues of October 15, 1968, and February 15, 1969, respectively.

22. Valdez and Steiner, *Aztlán,* 403.

30

HOMOGENIZING HISPANIC ART

Homogenize: "to blend (diverse elements) into a uniform mixture; to make homogeneous."
 Webster's Dictionary

I think it's a very handsome, very attractive show. The one criticism I would level [is that] many Hispanics have been involved politically, and any social or political context has been edited out of the work. Fig. 76
 Luis Jiménez, Chicano artist

I am angry because a show such as this does not recognize the Hispanic experience which began as a "grassroots movement." Once again our resources are being appropriated and North American aesthetic tastes are determining what is Latin American art.
 Nilda Peraza, Puerto Rican, director of the Museum of Contemporary Hispanic Art, New York.

I heard from the artists that the curators were looking for specific imagery: something very ethnic, very exotic, expressionistic, representational, funky-looking.
 Inverna Lockpez, Cuban, director of INTAR Latin American Gallery, New York

Co-organized by Houston's Museum of Fine Arts (MFA) and the Corcoran Gallery of Art in Washington, D.C., the exhibition "Hispanic Art in the United States: Thirty Contemporary Painters and Sculptors" lays to rest

This essay first appeared in *New Art Examiner*, September 1987: 30–33.

409

whatever skepticism might surround the assertion that Latin American artists in the United States can match the work of any other group. Accompanied by an Octavio Paz lecture, a symposium with six speakers, and a panel discussion, the exhibit opened at the MFA the weekend of May 1, 1987, and will be at the Corcoran from October 10 to January 17, 1988. There is no question as to the excellence, the splendid outpouring of high energy, and the high quality of the artistic productions represented by this exhibition. However, the curatorial premise, with its focus on the identifying term "Hispanic," and its "primitivistic" emphasis, is problematic.

What's in a Name?

As recently as ten years ago there was no nationally recognized category known as "Hispanic art" unless one was referring to the art of Spain or Fig. 77 its Hispanic-American colonies in the New World. In the late 1970s, "Hispanic" became a term used for government and marketing purposes to "package" a heterogeneous population[1] composed of recently resident Latin Americans from many nations, as well as Mexicans (or Chicanos), Puerto Ricans (or Nuyoricans, in New York), and Cuban Americans. Lost in the "Hispanic" usage were national and racial/cultural signifiers (particularly Indian and African) employed as proud reaffirmations of identity during the 1960s and 1970s in face of prevailing and rampant racial, cultural, and political—not to mention economic—discrimination. "Hispanic," then, was the first signifier of homogenization; it is now defended as convenient, comprehensive, and universally acceptable. Many Latin Americans, however, admit that they use the term only for governmental and funding sources; among themselves they prefer their own designations.

Fig. 78 The curators Jane Livingston and John Beardsley of the Corcoran generally focused on large works, some of them commissioned for the show, with a fairly good balance of painting and sculpture, and the inclusion of a series of very interesting drawings by Mexican Martín Ramírez (1885–1960), a self-taught institutionalized schizophrenic, which formed a linchpin of their concept.

Under the rubric of sculpture were such varied works as Chicano Gilbert Luján's customized lowrider located in the lobby, Jesús Moroles's sophisticated architectonic stone carvings, Cuban Pedro Pérez's elaborately gold-leafed and cut glass structures with a satirical twist, figurative works in painted bronze and classical acrobatic bronze figures by California Chicanos Manuel Neri and Robert Graham, and beautifully carved and painted saints and an altar screen by New Mexican woodcarvers Félix Lopez and Luis Tapia. Two installations by Texas-born artists were also included: a finely crafted traditional altar dedicated to Frida Kahlo by Car-

men Lomas Garza; and Luis Jiménez's exciting celebration of southwestern working-class culture, *Honky Tonk*, featuring some fifteen life-size figures.

Paintings were also very varied. Particularly outstanding were Chilean Ismael Frigerio's huge epic canvases dealing with the Spanish Conquest, Cuban Paul Sierra's luminous dark impasto landscapes with figures, Puerto Rican Arnaldo Roche's large and obsessive figural images, and, among the Chicanos, Carlos Almaraz's car wrecks and coyotes, John Valadez's stunning realistic triptych, Gronk's explosive works from the Titanic series, Rolando Briseño's cutout paintings, and César Martínez's neighborhood personalities.

Fig. 79

The handsome catalogue contains essays by curators Livingston and Beardsley and by Mexican poet Octavio Paz. In it, the two curators make the following claim: "In reviewing the sum and substance of what is here, we think it will be apparent to all but the most prejudiced observer that the predominating values in this book and exhibition are artistic, not sociological. What we have cared about above all else is the strength of an artist's work, not conformity to some preconceived notion of what constitutes a Hispanic 'style' or 'school.'" Their concerns, they state, derive from "our observations of what is *good* about Hispanic art." Having said this, Livingston and Beardsley set about to establish precisely what is disclaimed: their own "sociology" of what constitutes Latin American art in the United States, and their own aesthetic standards. In the process, they jettison the history and resulting particularities of the heterogeneous populations they have undertaken not only to explain but to unify according to their own vision. In the process, the cultural manifestations that are part and parcel of that history are obscured.

According to the catalogue essays, "ethnicity"—as the glue that holds together artists of diverse populations and marks them out from the dominant society—is the major characteristic they wish to explore. However, the curators' view of ethnicity is shallow and even "primitivistic." It is composed of what is folkloric, naive, popular, exotic, religious, and traditional.

Fig. 80

Another characteristic pertaining to some of the artists is that of "style." This is a strange hybrid invented by Livingston called "Latino/Hispanic Modernism." This style comprises influences from "Joan Miro, Pablo Picasso, and the Mexicans, José Clemente Orozco, David Alfaro Siqueiros, Diego Rivera, and Rufino Tamayo" as well "latter day Latino/Hispanic Modernists Wifredo Lam, Roberto Matta, André Masson and Joaquín Torres-García," and even Henri Rousseau (apparently French surrealists and naives are also "Latino"). This combination results in "chromatic and compositional lushness" and "a kind of timeless, mythic, often primitive imagery" (page 106, catalogue). Thus, almost at one fell swoop, Livingston has explained the "style" of most Chicanos and Cubans in the

exhibit, one of the Puerto Ricans, and the single Uruguayan. I believe these categorizations are intended to account for surrealist, social realist, and constructivist influences on the artists. The rest of Livingston's essay is an attempt to either cram "Hispanics" into this procrustean bed or to qualify the numerous exceptions. The result is so murky that it defies analysis. The only antidote would be a good course in the history of Latin American art—a commodity unfortunately in short supply in most U.S. universities—or a meaningful working association with curators and art historians who are familiar with this history.

There *is* a common cement that binds Latin Americans together, and it is the cement of two conquests: that of Europe over the New World, in which Spain was a primary participant; and the later conquest by the United States, which, under the rubric of Manifest Destiny and the White Man's Burden, took over the remnants of Spanish empire in the late nineteenth century, absorbing the Philippines, Cuba, and Puerto Rico, to add to its earlier conquest of independent Mexican territory which now forms the U.S. Southwest. Latin American culture today is the result of a historical process of rich synthesis between the indigenous Indian cultures, those of imported labor forces (African and Asian), and of Euro-Americans. It is also marked by resistance, from both independent nations and national groups, to further economic colonization and cultural homogenization. Any consideration of Latin American culture in Latin America and in the U.S. must start from this base. Affirmation of ethnicity is only *one* aspect of a political and social whole, and is relevant primarily to populations of long-standing residence who have had to resist attacks against their national cultural attributes as part of a pattern of economic, political, and social domination.

A Numbers Game

Even within its own terms, the exhibit is not representative of work being done in Latino communities across the country, nor even of its own participants. Despite Beardsley's brief dip into Chicano *movimiento* history (he obviously did not investigate the Puerto Rican political movement, or the affinities of artists from Latin American nations), painters and sculptors who have consistently focused on community or political issues, or social criticism, were noticeably missing from the exhibit. Such important Chicano artists as Rupert García, Yolanda López, and Mel Casas; as Puerto Ricans Juan Sánchez (who was asked to collect slides of artists, but not invited despite his national reputation) and prize-winning Marina Gutiérrez; and as Chilean Alfredo Jaar—to mention only a tiny fraction of possibilities—were left out.

Even among the participating artists, the curators seemed to have

been motivated more by "sociological" rather than aesthetic principles. Luis Jiménez said he was puzzled by their choices, which by-passed the great number of his fiberglass sculptures containing his most trenchant social satire. In the case of Cuban Luis Cruz Azaceta, the emphasis is on his latest, more introverted and cool-hued paintings rather than on those disturbing and passionate autobiographical works which have been his responses to urban violence and alienation during the last decade. Ismael Frigerio commented on the fact that the curators were particularly interested in a huge serpent painted on untrimmed burlap. According to the artist, it was the "primitive" quality of the ground which excited interest. Word has it that well-known Puerto Rican artist Rafael Ferrer declined to participate in an exhibition focused on "folklore and ethnicity."

Numbers even enter into the discourse. It takes careful reading of the catalogue to identify exhibition participants by that important national background which often determines pictorial and sculptural ideas and forms. No argument is being made here for quotas; however, when an enterprise bills itself as "Hispanic Art in the United States" (the "Thirty Painters and Sculptors" was a very late addition to the title in response to considerable criticism from the Latin American arts communities), it is to be expected that given equal or higher quality, the choices would allow for gender considerations and a broad spectrum of nationalities as well as style and content. The numbers break down as follows: four Latin Americans from Chile, Colombia, and Uruguay; four Cubans; three Puerto Ricans; and nineteen Chicanos, including one who is half Puerto Rican. Of the thirty, three are women. Given that the largest Spanish-speaking groups in the United States within a total population of about twenty-five million are the Chicanos, Puerto Ricans, and Cubans; and that the Eastern seaboard, particularly New York, has one of the largest populations of Latin American artists in the Northern hemisphere, outside Mexico, the minimal representation of Puerto Ricans, Cubans, and other Latin Americans is surprising, to say the least.

The Ideology of Museography

The Houston show was marked at its entrance by a large colorful banner emblazoned with the word "Hispanic," which guaranteed the flow of traffic in a single direction. Walking through, the viewer becomes aware of an ideological disposition in the very arrangement of the rooms and how they are viewed. Work by a "primitive" such as Martín Ramírez, neither Chicano nor contemporary, is associated with the sophisticated abstract sculpture of Jesús Moroles, which echoes pre-Columbian art. If one starts with the mistaken notion—held by so many and so categorized in many

art history texts—that pre-Columbian art is "primitive," then the above equation can perhaps be justified by an appeal to "affinities" (a misused concept at the controversial Museum of Modern Art show "'Primitivism' in 20th Century Art" in 1984).[2]

The first several rooms develop this tendency, not as a historical progression but as an ahistorical fusing into one denominator of self-taught artists (including an elderly Puerto Rican toymaker and a New Mexican animal carver), traditional folk artists, and academy-trained contemporaries. All but one of the self-taught and traditional artists are of Mexican descent, yet they lay a primitivistic "floor" under the entire exhibit. Thus, for example, a secular altar by Carmen Lomas Garza and several neoexpressionistic paintings on Afro-Cuban themes by Paul Sierra link the opening rooms with the main portion of the exhibit, the naive and folkloric with "the primitivism in modern art," so to speak, as if Latino art in the United States (with the exception of those who entered the mainstream by avoiding "ethnicity") is automatically identified by its ethnic/primitive characteristics. Implicit in this equation is the inference that Latin Americans are emotive and visceral to the exclusion of more cerebral art forms such as geometric abstraction or conceptualism.

The second major theme is "Hispanic" neoexpressionism and new image painting. Livingston, who came to the Corcoran from the Los Angeles County Museum of Art (LACMA), claims in the catalogue that a 1974 LACMA show of "Los Four" (Luján, Almaraz, and Frank Romero of "Los Four" are in the present exhibit) was "so good, so open-ended, and so prescient of what was to come in mainstream art everywhere, that it seemed to call for resuscitation and elaboration." In other words, Latino artists who had been expressionists long before it became fashionable were now in vogue.

Spatially, the central core of the exhibit at Houston is devoted to figurative and semi-abstract neoexpressionism—not tragic neoexpressionists such as the international trans-avantgarde, but *ethnic* neoexpressionists. The last room and exit corridor feature the "mainstream" artists Neri and Graham. They represent "success" and acceptance by the art market, and what the curators promise is the same success to all the Latino artists in the exhibit. There is no question that most of them richly deserve it; and I for one wish them every success and access to major museums and galleries. For the artists, "Hispanic Art" is an important breakthrough: a merited recognition of their talent, persistence, and hard work, and the promise of recognition and some financial security.

What still remains is the big question: what is the nature and contribution of Latin American art in the United States? This question has not been answered by this well-funded (about a million dollars), well-publicized event.

Notes

1. According to historian Rodolfo F. Acuña, the Nixon administration consolidated Latin Americans into a national minority called "Hispanic" in order to manage them more easily. See Acuña, *A Community under Siege* (Los Angeles: Chicano Studies Research Center Publications, University of California, Los Angeles, 1984), 180. In 1978, José Gómez-Sicre, director of the Museum of Modern Art of Latin America (OAS), referred in a catalogue to Cubans billed as Latin Americans of the southeastern United States by the Lowe Art Museum of Miami as "Hispanic American artists."

2. See Thomas McEvilley, "Doctor, Lawyer, Indian Chief," *Artforum* (November 1984): 54–60, for a trenchant discussion on the relationship between modernity and "primitivism," a hotly debated issue.

31

UNDER THE SIGN OF THE PAVA:
PUERTO RICAN ART AND POPULISM
IN INTERNATIONAL CONTEXT

In 1949, Manuel Hernández Acevedo[1]—one of Puerto Rico's most important naive artists; in the mid-forties a man of the people with a large family who was looking for a job and had been drawn into the community education arts program as an apprentice—painted an enormous work, 4 × 12 feet, recording the inauguration proceedings for Puerto Rico's first elected governor, Luis Muñoz Marín. With a flair for composition and an eye for meticulous narrative detail that one finds among many self-taught artists with talent, Hernández portrays in one detail the tightly packed, racially mixed crowd, stacked row upon row along a road within a park-like setting of large trees in whose branches sit observers. A religious banner and small placards held by persons in the crowd identifying themselves catch the eye. A long blue banner proclaiming the presence of the company "Insular de Bomberos" faces us below olive-clad firemen, a red fire truck, a two-storied white structure, and a white ambulance. For the

This essay first appeared as "Bajo el emblema de la pava: Arte y populismo puertorriqueño dentro del contexto internacional" in *Plástica*, September 1988. I would like to extend my gratitude to four people: Myrna Báez, who provided many slides without which this paper would have been much harder to assemble; Mari Carmen Ramírez, for her advice; Annie Santiago de Curet, who directed me to resource materials; and Ruth Vassallo, who gave me a home in San Juan, Puerto Rico, while I was doing the research. In addition, I am indebted to Dr. Ida Caro and Executive Director Luis E. Agrait for access to, and assistance with, the archives of the Fundación Luis Muñoz Marín, Inc.

artist, this was a moment of jubilation involving the entire population and it merited a large-scale work rather than the smaller silkscreen prints and paintings for which he is known.

Exactly ten years later in 1959, Félix Rodríguez Báez, youngest of the self-designated "rebel artists" who organized the Centro de Arte Puertorriqueño in 1950—a short-lived but enormously important group which was the genesis of the first indigenous and nationalist modern art movement on the Island—painted *Status Quo?* in a social realist vein. This easel painting critically summarizes the results of a decade of Muñoz's "Operation Bootstrap"—renamed "Operation Bottletrap" on the white campaign booth from which the politician addresses the crowd in the lower left of the canvas. The careworn face and shoulders of an elderly woman dominate the composition, which is organized like a mural with a circle of narrative scenes. Around the woman are distributed the signs and symbols of the urban social ills that survive "under the sign of the *pava*": the rural straw hat, worn by the *jíbaro*, which hangs under the politician's double image (Muñoz Marín himself), on the building to the right. Since 1938, the *pava* symbolized for the Partido Popular Democrático its organizing slogan, "pan, tierra y libertad," borrowed from a Mexican revolutionary slogan demanding agrarian reform. Following the direction of the old woman's gaze we encounter a seated man reading a newspaper across which is written *serenidad*—a reference to "Operation Serenity," the ideological slogan which added the value of "spirituality" to those of material gains. It was coined by Muñoz Marín in 1953,[2] one year after the establishment of Puerto Rico as a Commonwealth attached to the United States. Known as the Estado Libre Asociado (ELA), the commonwealth was considered by many Puerto Rican intellectuals and artists as a betrayal of their aspirations for independence. Beyond is a working-class bar with a jukebox and a drinker. Above the woman's head a blond Anglo sailor walks with a Puerto Rican woman, possibly a prostitute. Above them a Puerto Rican flag is draped below a *vejigante* (the folk costume, with horned coconut mask, worn for an African-influenced festival which has been turned into a tourist attraction). On the tail of the costume appears a dollar sign, while a tourist in Old San Juan photographs the mask. Below is La Perla, the waterside slum that Rodríguez has painted numerous times over the last thirty years.

Fig. 81

La Perla appears again in a 1960 painting by Rodríguez called *Juvenile Delinquency* and based on the play *La Carreta* by René Marqués. The scene is set partially in La Perla, where pornography, knife fights, prostitution, and alcohol are symptoms of the economic and social problems of newly urbanized rural peoples, and partially in New York, where the migrant Puerto Rican community seeking a better life encounters similar slum conditions.

Nineteen-sixty was also the year that Fomento, the island's Industrial

Development Company, broke all records for the promotion of new plants in Puerto Rico. According to the San Juan Star of July 1, 1960, 158 U.S.-owned factories were signed by the agency (seventy of which were new to Puerto Rico), compared to sixty local firms. Considering this fact, it becomes of interest to note that, in 1969, twenty years after his celebratory "inauguration" painting, Hernández Acevedo took an unusually critical approach to the Muñoz regime in his work *Closed House* (*Casa clausurada*), in which he depicts Puerto Rico as a deserted, decaying home which has not benefited from the U.S. capital investment promoted under "Operation Bootstrap," and in which he invites the Yankees to "go home."

What, therefore, had occurred, from the artists' point of view, in the time between the triumphant popular election of Muñoz Marín—organizer in 1938 of the Partido Popular Democrático (PPD), and its standard bearer as legislator and four-term governor—and Muñoz's retirement in 1964? What were the successes and failures of his populist program? To answer these questions in terms of their impact on the modern art of Puerto Rico is what I propose to tackle in what follows. In particular, I hope to examine the influence of New Deal art from the United States and social realist Mexican art (which was crucial to New Deal muralism as well) on the artists of Puerto Rico during the height of *muñocista* populism.

Puerto Rico and the U.S. New Deal

Two key actors in the modern drama of Puerto Rican politics and culture are Luis Muñoz Marín himself and the last North American appointed governor of Puerto Rico (1941–46), Rexford Guy Tugwell. As governor, Tugwell emphasized U.S. responsibility for social reform in Puerto Rico, as well as the need for the Island to support the U.S. effort during World War II. Agrarian reforms begun during Tugwell's adminstration were negotiated into legal action by Muñoz Marín. Beyond any of the previous U.S. presidential appointees to this post, most of whom were military men who insulated themselves from a culture, language, and people they did not know or understand, Tugwell was "able to oversee changes in the economy and, to an extent, in the power structure, thanks to the conjuncture of events that made such change not only necessary but finally possible."[3] At the beginning of his term, he suggested that an elected governor might promote loyalty to the U.S. war effort; in any case, a colonial governor would become an embarrassment to the United States. Despite these "benign" attitudes, however, Tugwell himself was often paternalistic and condescending toward Puerto Rico and Puerto Ricans,[4] never learned Spanish, and vetoed a legislative law that provided for the

teaching of Spanish as the vernacular and English as a second language—a very sensitive area involving profound cultural values and feelings.[5]

Nevertheless, Tugwell's policies and programs served Puerto Rico very well in another arena. As a Roosevelt liberal, economist, and political scientist, Tugwell functioned as Assistant and Under Secretary of Agriculture in the U.S. between 1933 and 1937 (thus his interest in Puerto Rican agrarian reform), and was part of the Roosevelt "Brain Trust" that drew up New Deal solutions for the serious economic problems of the Depression years. It was under his administration that his Columbia University colleague Roy E. Stryker was appointed to head the Historical Section of the Resettlement Administration—later known as the photographic project of the Farm Security Administration (FSA). Tugwell advocated using visual means to disseminate information and advance political policy (in this case to push forward the New Deal farm program for resettling impoverished farmers), while Stryker had done picture research for a collaborative textbook with Tugwell in 1925. Thus he was the ideal person for the FSA program, which began in 1935 and lasted until 1941 (when it began to work for the war effort). It was finally red-baited and destroyed by Congressional action in 1943.

Stryker's aesthetic and sociological philosophies were quite clear, and doubtless served as guidelines when similar programs were set up in Puerto Rico. "The documentary photographer does not take snapshots," he said. "He [sic] speaks a language. . . . 'Documentary' is an approach, not a technic; an affirmation, not a negation. . . . In photography, as in the other arts, the documentary attitude is not a denial of the plastic elements which must remain essential criteria in any work. It merely gives these elements limitation and direction." To this he added, "The job is to know enough about the subject matter, to find its significance in itself and in relation to its surroundings, its time and its function."[6] Under Stryker, the FSA photographers were carefully briefed and intellectually equipped for their assignments. Thereafter, however, Stryker did not intervene, and their work shows the benefits of their own aesthetic acumen and dedication combined with their chief's intellectual and social concerns. Among the photographers in the FSA team were Dorothea Lange, Arthur Rothstein, John Vachon, Carl Mydens, Russell Lee, painter Ben Shahn, and—crucial for later Puerto Rican photography and film—Jack Delano, who, with his wife Irene (they were both trained artists), traveled for the photographic unit from 1940 until its demise. In 1941, the Farm Security Administration sent Delano to the Virgin Islands on assignment. While he was there, Pearl Harbor was attacked by the Japanese, and Delano went for three months to nearby Puerto Rico (which had its own FSA program), producing in that time three thousand photos, which are now stored in the Library of Congress. In 1945, the Delanos returned to Puerto

Rico, and in 1946 were offered jobs there by Edwin Rosskam, whom they knew from the FSA project.

Rosskam had been photo editor for the FSA, and in 1941 he became the cinematographer for black writer Richard Wright when the latter produced the film *Twelve Million Black Voices: A Folk History of the Negro in the United States* for the United States Film Service.[7] This was a New Deal agency, similar in intent to the FSA, begun by Pare Lorentz in 1935. Until abolished by Congress in 1941, it produced a series of documentary films under Lorentz, Joris Ivens, Raymond Evans, and Robert Flaherty that are considered as much the great classics of the genre as the FSA pictures are for photography. In 1937 Rosskam traveled to Puerto Rico to photograph the trial that followed the Ponce Massacre (which remains a cogent historical subject for Puerto Rican painters). During Rosskam's visit he came to know Muñoz Marín, who had just broken with the Liberal Party, and was to form the Partido Popular Democrático the following year. In 1945, Rosskam and his wife Louise returned to Puerto Rico, where he established a photographic archive for the Office of Information of La Fortaleza during Tugwell's last year in office. In 1946 he became the first director of the film and graphic units within a new program for adult education and betterment supported by the PPD, and modeled on the New Deal. He hired Jack Delano as a photographer, and Irene Delano as a designer of publications, for the Office of Information. Shortly thereafter, Irene became the founding director of the graphics workshop for the new program, where she set up offset and silkscreen programs, while Jack headed the film section. Until 1952, when they resigned, both trained Puerto Ricans in printing and filmmaking techniques.

Graphics were important to the Puerto Rican populist experiment of the mid-forties—particularly the inexpensive and completely hand-printed silkscreen technique. In the U.S. (where Irene learned silkscreen methods) adaptation of the formerly commercial silkscreen medium for posters was made under the jurisdiction of the Federal Art Project (FAP) of the Works Progress Administration initiated by the New Deal to give work to unemployed artists. A 1932 photo, republished in a recent book, *Posters of the WPA*,[8] shows the ten thousand unemployed who marched on Washington, D.C., during the Hoover presidency fruitlessly demanding jobs or aid. In the same book, a 1934 photo of an "Artists Committee of Action" demonstration in Union Square, New York, documents the militant attitude of Depression-era artists. Within this second photo, a poster held by one of the demonstrating artists saying "Today last year, May 9, 1933, Diego Rivera was kicked out of this city"—a reference to the Rockefeller Center mural dispute—evidences the confluence of U.S. and Mexican artistic interests.

Under the WPA, silkscreen posters were the inspiration of Anthony Velonis. His intention was to speed the process of the hand-painted, hand-

lettered posters then in use while losing nothing in quality. Frames and print-drying racks were constructed for silkscreen processing. In 1937, Velonis published a pamphlet called *Technical Problems of the Artist—Technique of the Silkscreen Process*, which explored silkscreening as a fine art process. Velonis felt that this was the print medium that came closer to painting than any other graphic form—an idea developed by Lorenzo Homar after 1952 when he took over Irene Delano's position as director of the graphic art workshop in Puerto Rico. As a result of Velonis's promotion of the silkscreen technique, artists were put to work producing posters and fine art prints—many on social realist themes—while classes in silkscreen began at various locations, including a high school. By 1940, an exhibition of fine art prints mounted at New York's Weyhe Gallery caused Velonis and Carl Zigrosser (the gallery director) to coin the name "serigraph" in order to dissipate the opprobrium connected with commercial silkscreening. Finally, FAP participant Elizabeth Olds opened the first school devoted to the art of silkscreen, definitely establishing the serigraph as a viable art medium. During the four years of its existence, from 1935 to 1943 (the latter years were dedicated to posters for the war effort), the FAP nationwide produced two million posters and thirty-five thousand designs, and opened one hundred community centers throughout the country for the dissemination and teaching of art.[9] Nevertheless, New York remained the fulcrum for New Deal graphics and public murals.

Among those who learned the silkscreen technique in this period was painter, muralist, and FSA photographer Ben Shahn, an artist of particular importance to the development of Puerto Rican graphics. Lorenzo Homar, working and studying in New York until 1950, very much admired Shahn, whom he briefly met and whose work could be seen at regular intervals from 1929 to 1959 at the Downtown Gallery in New York. Shahn's distinctive linear style with flat color appears in Homar's earliest silkscreens for community education in Puerto Rico. Also important for the younger artist was Shahn's fascination for, and stylistic development of, calligraphy in prints and paintings alike.

Both Shahn and Robert Gwathmey visited Puerto Rico in the late 1940s, and Gwathmey (a white social realist known for many paintings about rural black poverty and living conditions, rendered in flat line and color with a more geometric and angular style than Shahn's) made several silkscreens, now in Jack Delano's collection, which influenced Puerto Rican printmaker Juan Díaz.

Of additional consequence to Puerto Rican artists during the 1940s and 1950s were several important New York art schools and workshops staffed by former New Deal artists, European refugees, some Latin Americans, and several abstract expressionists. Among them were the Art School of the Brooklyn Museum and Pratt Institute (also in Brooklyn);

the Art Students League of Manhattan; and Stanley W. Hayter's Atelier 17, which had moved to New York from Paris between 1940 and 1950. Conceived of as serving a didactic need as a popular rather than an elite institution such as Manhattan's Metropolitan Museum of Art, the Brooklyn Museum was set in the middle of a working-class immigrant area, where it functioned as an integral part of a system of public education. Its purpose was to "americanize" the immigrants by focusing on ethnographic installations of New World indigenous populations, and on industrial design. It undertook to ensure a better educated, less radical, and more tractable community, and to provide skilled workers to the dominant society.[10]

From the decade of the 1940s (when both Lorenzo Homar and José Antonio Torres Martinó studied with Mexican painter/muralist Rufino Tamayo during the 1946 semester) until it closed in 1985, the Brooklyn Museum Art School hosted many prominent artists, among whom were Ben Shahn, Mexican-influenced Ecuadoran painter Camilo Egas (with whom Torres Martinó studied), and Max Beckmann. According to Homar, he was chagrined when he was not able to study with Beckmann in 1950. The German expressionist painter canceled his Art School semester to go to St. Louis and his place was filled by Ben Shahn.[11] In 1947 the Brooklyn Museum, responsive to the remarkable renaissance of printmaking that marked the post–World War II period, was one of the first to institute a Print Annual, which influenced institutions throughout the country. That same year, Shahn received recognition through a major retrospective at the Museum of Modern Art, and black WPA printmaker Robert Blackburn founded his Printmaking Workshop, today the oldest nonprofit lithography workshop in the U.S. and one which has provided scholarships for many needy students, including blacks and Puerto Ricans.

Homar and Torres Martinó also studied at the Pratt Institute, and Homar attended the student-controlled-and-managed Art Students League. So important has the latter institution been to Puerto Rican artists studying in New York over the years—including early-generation artists such as Carlos Raquel Rivera, Augusto Marín, Epifanio Irizarry, and Luisa Geigel—that its very name is reflected in San Juan's La Liga de Estudiantes de Arte, a nonprofit art school established in 1968. New Deal artists such as Reginald Marsh, Ivan Olinsky, muralists Jon Corbino and Harry Sternberg (who participated in Velonis's silkscreen workshop in the 1930s), all taught at the New York League. Hayter's very influential Atelier 17 was established for a time at the New School for Social Research, where students could see the impressive mural cycle painted in 1930–31 by José Clemente Orozco. The Atelier introduced Torres Martinó to new techniques in intaglio printing, and lent its name to Estudio 17 (though Torres Martinó claims that the address of the Estudio was also number 17), or-

ganized prior to 1950 in Puerto Rico by Torres Martinó and Félix Rodríguez Báez.

Operación Manos a la Obra/Operation Bootstrap

The ferment provoked by the utopian social program being advanced by the Partido Popular Democrático had its most important consequences among a generation of artists who had studied abroad by means of private fellowships and Puerto Rican government support, or via the funding extended to World War II veterans by the G.I. Bill of Rights of the United States. When they returned to Puerto Rico in the 1940s and 1950s, they participated in the government educational program of "Operation Bootstrap" on one hand, and on the other, sought artistic languages and practices that more closely conformed to their individual or collective visions.

Within the same period of time—from the mid-forties through 1952—these parallel processes continued. After 1952 (the date of the establishment of the Estado Libre Asociado, which ended hopes for an independent nation), ruptures appeared between governmental implementers of political and arts policy and those artists viewing themselves as *independentistas* (pro-independence for Puerto Rico) and/or pro-working class, exacerbated by the U.S. swing to the right under the Eisenhower administration and the McCarthy era witchhunts, which extended to Puerto Rico. Pioneer artist and historian Torres Martinó condemns the "opportunistic submission of the muñocista leadership." The United States has never ceded, he says, an iota of its sovereignty over Puerto Rico. . . . The power of decision over any substantive issue on the Island resides with the North American Congress."[12] While artists continued to work in government programs to sustain themselves and train younger artists, their private work was of a more critical nature. This is particularly true for artists such as Lorenzo Homar, Rafael Tufiño, Carlos Raquel Rivera, Félix Rodríguez Báez, Samuel Sánchez, Antonio Maldonado, and Torres Martinó. For these artists, the Mexican social realist model was felt to be the most meaningful. "Our path," says Torres Martinó, "had to be the social realism developed by the Mexicans. We turned our back on formal experimentation, on aesthetic experimentation for its own sake, on art of the markets."[13]

Operation Bootstrap was a multipronged program set up as a form of massive adult education and self-help. Its educational arm, first established in 1946 as the Cinema and Graphics Workshop under the Department of Recreation and Parks, gained its own official status as the Division of Community Education (DIVEDCO, or the Division) under House Bill No. 89 in May 1949. The first phase, under Edwin Rosskam, was characterized by him as "A Plan to Strengthen the People's Wisdom

Fig. 82

Fig. 83

Fig. 84

With Greater Knowledge; That They May Shape Their Own Path Into the Future Knowing What They Do," and was a pilot program to "produce films, posters, leaflets, booklets and books." Under DIVEDCO, radio and discussion groups that met in primarily rural areas were added. Pictorial records of these groups exist in documentary photographs, as well as in a 1974 Rafael Tufiño photographically derived silkscreen poster commemorating the twenty-fifth anniversary of the program. Discussion leaders were carefully chosen and trained to work directly with the people.[14] Four themes a year were developed, each theme complemented by films hand-carried into the countryside. The film unit had a fleet of twelve jeeps, screens, portable generators, and projectors. Silkscreen posters, with spaces to add location, date, and time of film showings, were printed. One designed in 1946 by Irene Delano announces a film about PPD pioneer Jesús T. Piñero. Another from 1950 by Lorenzo Homar (still influenced by Ben Shahn's style) concerns a baseball film, *Los peloteros,* directed by Jack Delano. Still another from 1955 by Carlos Raquel Rivera was for the film *Nenén de la Ruta Mora,* written and directed by Oscar Torres. Booklets such as *De cómo llegaron a Puerto Rico la caña, el café, el tabaco y muchas otras cosas* (*How Sugarcane, Coffee, Tobacco, and Many Other Products Arrived in Puerto Rico*), *Alimentos para su familia* (*Nutrition for Your Family*), *Cuentos de mujeres* (*Stories of Women*), *La ciencia contra la superstición* (*Science Combating Superstition*), and *El niño u su mundo* (*A Child's World*) sported covers in several colors and interior pages illustrated with photographs, in addition to covers by the most important artists of the country.[15] Each rural family was given one book. By 1952, 245,000 families had been served by DIVEDCO with 200,000 almanacs, 200,000 leaflets, 200,000 booklets—and 7000 silkscreen posters for each film. By 1971, almost eighty films had been produced.[16]

In addition to filmic announcements, didactic posters of simple design, limited color, and few artistic pretensions were printed in the workshops. Irene Delano's 1946–47 poster *Peligro,* which combines a gigantic fly with text explaining its dangers, and Wilfredo Cintrón's *Somos vecinos, trabajemos juntos,* depicting workers repairing a road together, are examples. Noncommercial silkscreen was a new technique for Puerto Rico in the 1940s. The earliest record of its use was in 1943 in the Education Section of the Health Department, headed by Dr. Tomás Blanco. A few years earlier, Blanco sent Francisco Palacios, who had earlier worked as a commercial artist, to the U.S. for training in serigraphy. Upon Palacios's return, he organized a modest workshop to produce silkscreen posters and signs on public health, an idea later expanded by the graphics workshop of Recreation and Parks under Irene Delano, where Palacios, Félix Bonilla Norat (who had run a commercial silkscreen workshop in New York), Aníbal Otero, and a group of apprentices were then employed.

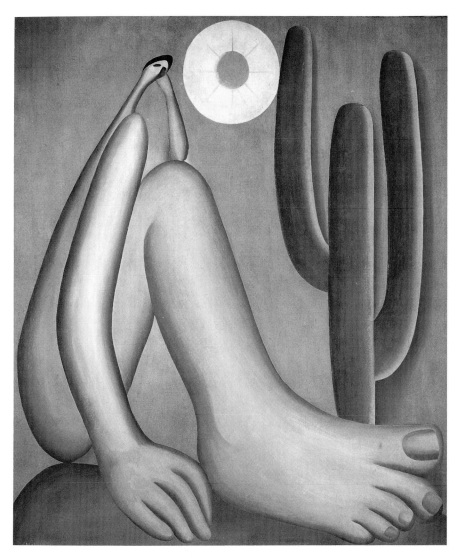

Fig. 55. Tarsila do Amaral, *Abaporu.* 1928. Oil on canvas, 34 in. x 29 in. Collection of Maria Anna and Raul de Souza Dantas Forbes. (Photo courtesy of Indianapolis Museum of Art.)

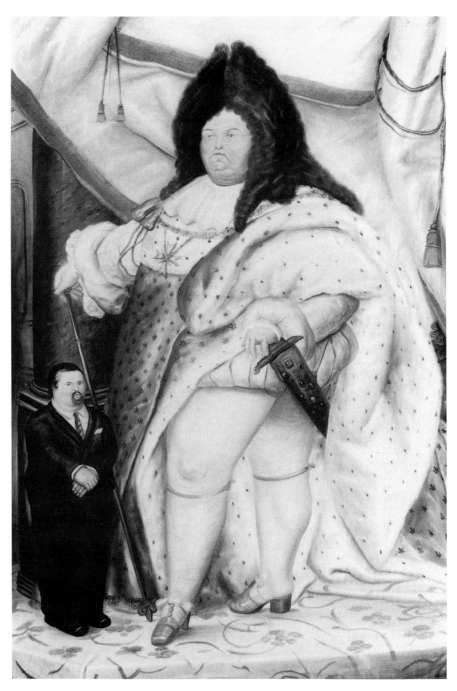

Fig. 56. Fernando Botero, *Self-Portrait with Louis XIV (after Rigaud)*. 1973. Oil on canvas, 114 in. x 78 in. Collection: Museo de Arte Contemporaneo de Caracas. (Photo courtesy of Indianapolis Museum of Art.)

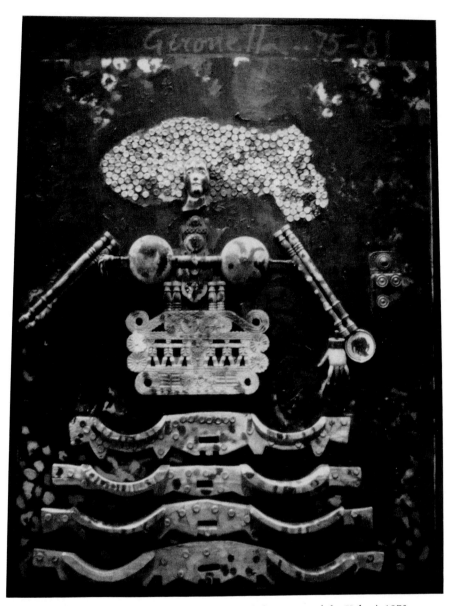

Fig. 57. Alberto Gironella, *La Reina de los yugos* (The Queen of the Yokes). 1973. Mixed media, 83 in. x 43 in. Collection of Luis Felipe del Valle. (Photo by author.)

Fig. 58. Siron Franco, *O Apicultor* (The Beekeeper). 1983. Oil on canvas, 71 in. x 67 in. Collection of Maria Anna and Raul de Souza Dantas Forbes. (Photo courtesy of Indianapolis Museum of Art.)

Fig. 59. Arnaldo Roche Rabell, *You Have to Dream in Blue.* 1986. Oil on canvas, 84 in. x 60 in. Courtesy of Frumkin/Adams Gallery, New York. (Photo courtesy of Indianapolis Museum of Art.)

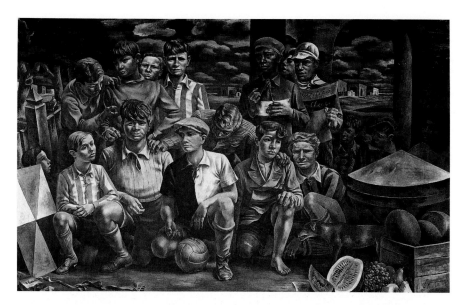

Fig. 60. Antonio Berni, *New Chicago Athletic Club*. 1937. Oil on canvas, 72-3/4 in. x 108-1/4 in. The Museum of Modern Art, New York. Inter-American Fund. (Photo courtesy of Museum of Modern Art.)

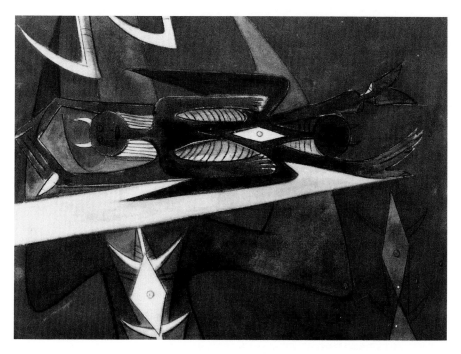

Fig. 61. Wifredo Lam, *Non-Combustible*. 1950. Oil on canvas, 35-1/2 in. x 42-1/2 in. Collection of Mr. Robert H. Bergman. (Photo courtesy of the Bronx Museum of the Arts.)

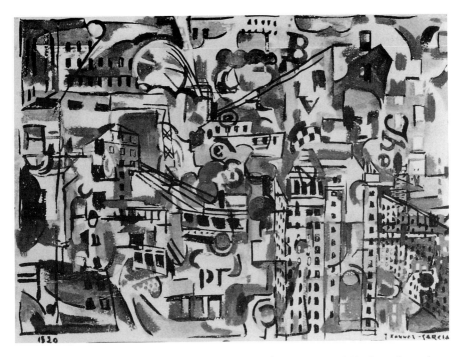

Fig. 62. Joaquín Torres García, *New York City: Bird's Eye View.* 1920. Gouache and watercolor on board, 13-1/4 in. x 19-1/8 in. Collection, Yale University Art Gallery. (Photo courtesy of the Bronx Museum of the Arts.)

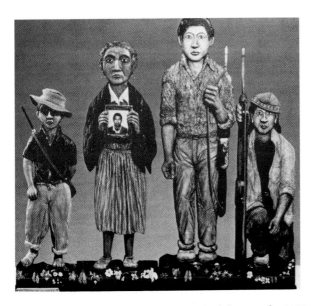

Fig. 63. Juan Edgar Aparicio, *La Familia/The Family.* 1985. Wood with mixed media, 25 in. x 25 in. x 3 in. Collection of the artist.

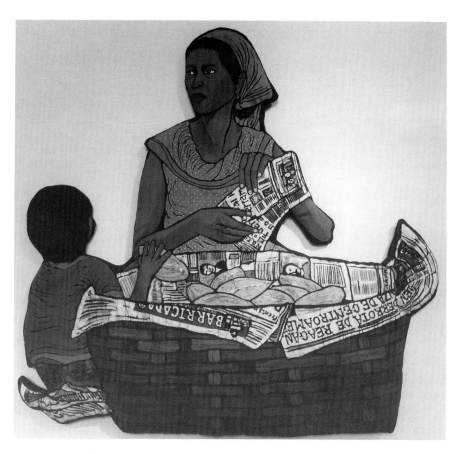

Fig. 64. Lisa Kokin, *Pan con dignidad/Bread with Dignity #1.* 1984. Stuffed and shaped batik, 30 in. x 32-1/2 in. x 1 in. (Photo courtesy of the artist.)

Fig. 65. Fernando Carballo, *Family Gallery* series. 1985. Oil on paper. (Photo by Adam Avila.)

Fig. 66. Fernando Castro, *Acerca del hombre/About Man* series, No. 1. 1985. Ink on paper. (Photo by Adam Avila.)

Fig. 67. Rolando Faba, *Endangered Species II.* 1985. Ink and collage on paper. (Photo by Adam Avila.)

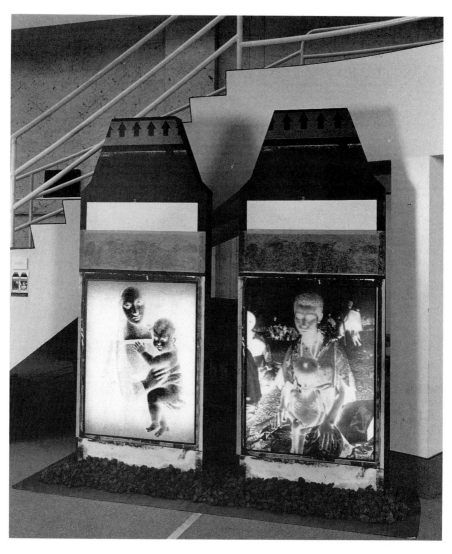

Fig. 68. Guillermo Bert, *Altar/Temple: Recycling Social Images. Madonna: Sacred and Secular.* 1990. Diptych, mixed media, 96 in. x 38 in. each. Collection of the artist. (Photo courtesy of the artist.)

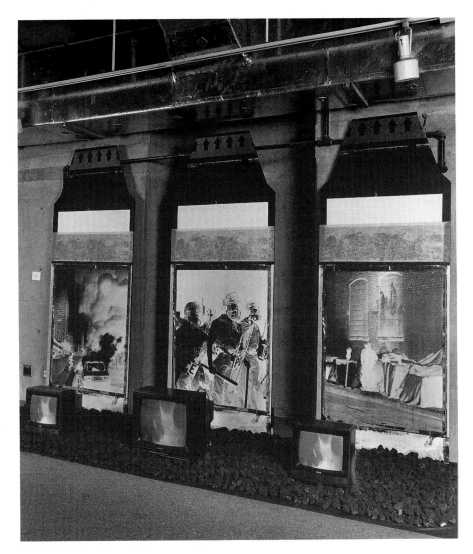

Fig. 69. Guillermo Bert, *Altar/Temple: Recycling Social Images. The Urban Trinity.* 1990. Triptych, mixed media with video monitors, 96 in. x 38 in. each. Collection of the artist. (Photo courtesy of the artist.)

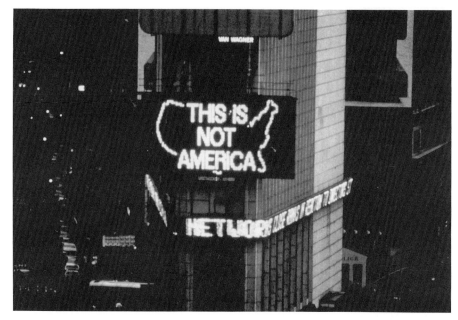

Fig. 70. Alfredo Jaar, *A Logo for America.* 1987. Computer animation sequence on spectacolor lightboard. Times Square, New York City. (Photo courtesy of the artist.)

Fig. 71. Leandro Katz, *Friday's Footprint.* 1982. Installation, slide projection, and sandbox, Whitney Museum of Art, 4 in. x 55 in. x 25 in. Collection of the artist. (Photo courtesy of the artist.)

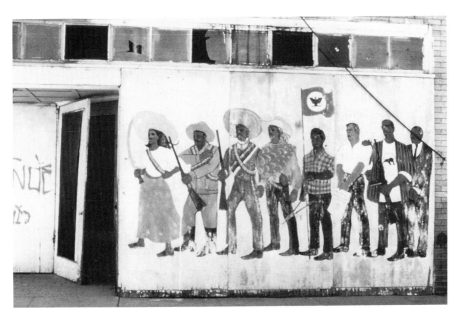

Fig. 72. Antonio Bernal, *Untitled.* 1968. Mural, enamel on wood, 108 in. x 240 in. At Teatro Campesino headquarters in Del Rey, California. (Photo by Robert Sommer.)

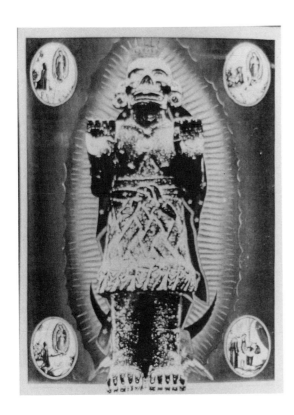

Fig. 73. Yolanda López, *Guadalupe-Tonantzin.* 1978. Collage, 8 in. x 6 in. (Photo by author.)

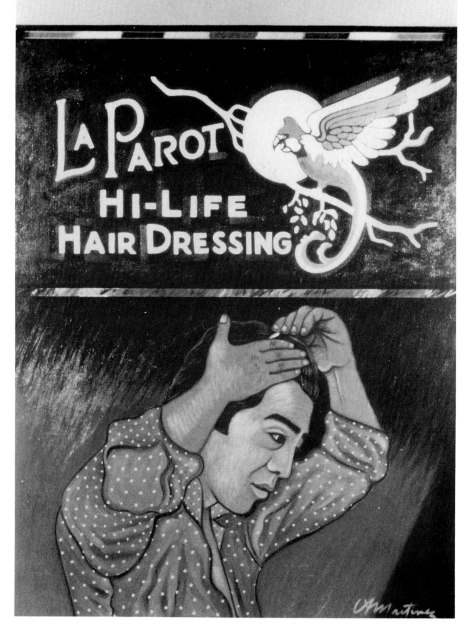

Fig. 74. César Martínez, *La Parot*. 1979. Acrylic on canvas, 70 in. x 50 in. (Photo courtesy of the artist.)

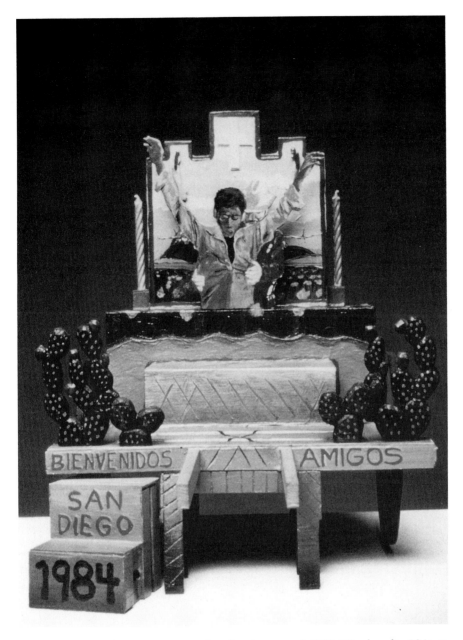

Fig. 75. David Avalos, *San Diego Donkey Cart* (maquette). 1984. Mixed media, 10 in. x 12 in. x 15 in. Collection of Gregory Marshall. (Photo courtesy of the artist.)

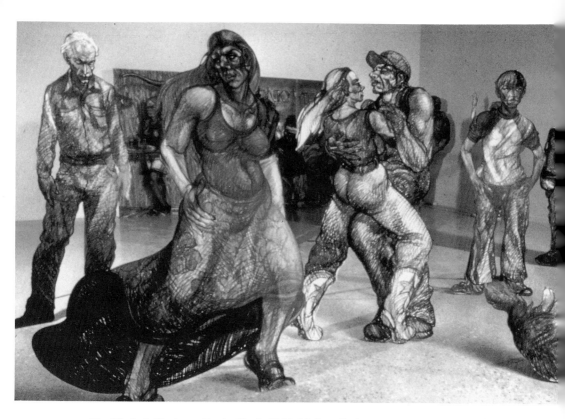

Fig. 76. Luis Jiménez, *Honky Tonk*. 1981–86. Installation, crayon paper mounted on foam core or plywood with neon element, 8 ft. x 16 ft. Collection of the artist. (Photo courtesy of the artist.)

Fig. 77. John Valadez, *Preacher.* 1983. Pastel on paper, 60 in. x 42 in. Collection of Hampar and Yvonne Mehterian. (Photo courtesy of Daniel Saxon Gallery, Los Angeles.)

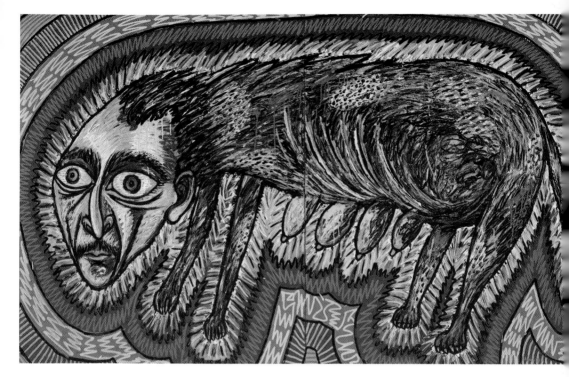

Fig. 78. Luis Cruz Azaceta, *Self-Portrait as a She Wolf.* 1985. Acrylic on canvas, 72 in. x 120 in.

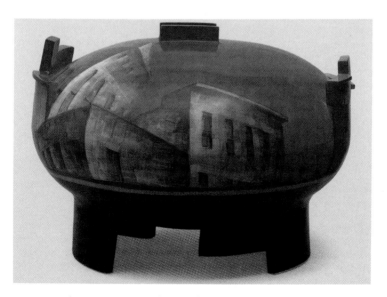

Fig. 79. Lidya Buzio, *Large Blue Roofscape.* 1986. Burnished earthenware, 11 in. high x 15 in. diameter. Collection of Katharine and Anthony Del Vecchio.

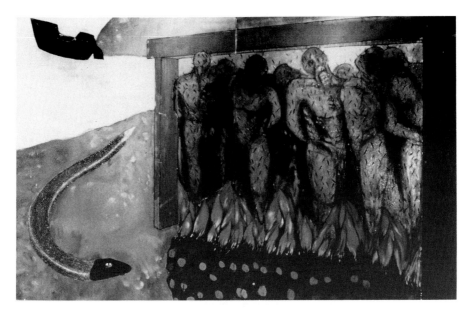

Fig. 80. Ismael Frigerio, *The Lust of Conquest.* 1985–86. Diptych, tempera and acrylic on canvas, 89 in. x 140 in. Collection of the artist. (Photo courtesy of the artist.)

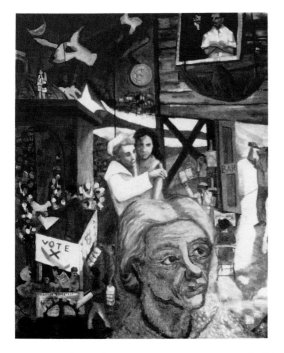

Fig. 81. Félix Rodríguez Báez, *Status Quo?* 1959. Oil on canvas and board. Present location unknown. (Photo by author.)

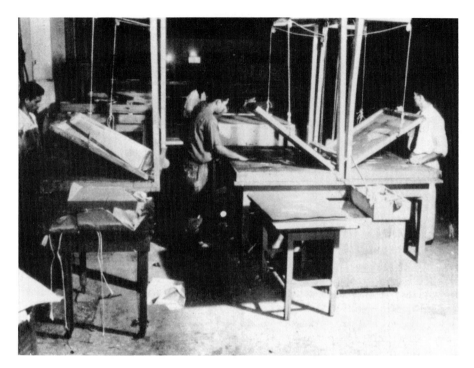

Fig. 82. Artists in the Graphics Workshop of the Division of Community Education, San Juan, Puerto Rico, 1950: Eduardo Vega, Manuel Hernández, Félix Bonilla Norat, José M. Figueroa. (Photo: Department of Public Instruction, San Juan.)

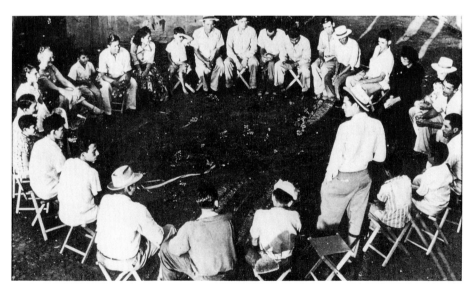

Fig. 83. Rural meeting, in Puerto Rico c. 1952. (Photo: Department of Public Instruction, San Juan.)

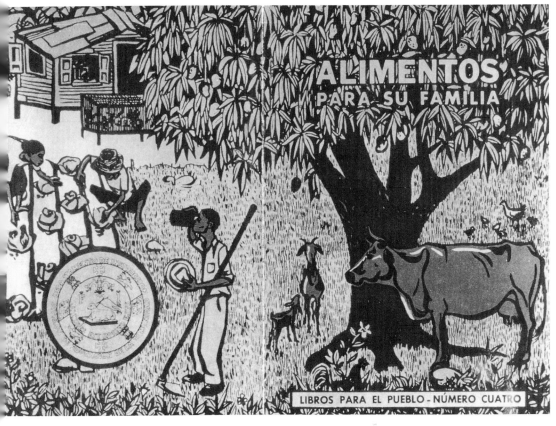

Fig. 84. Cover of *Alimentos para su familia* (Nutrition for Your Family), Books for the People, no. 4. 1952. (Photo: Department of Public Instruction, San Juan.)

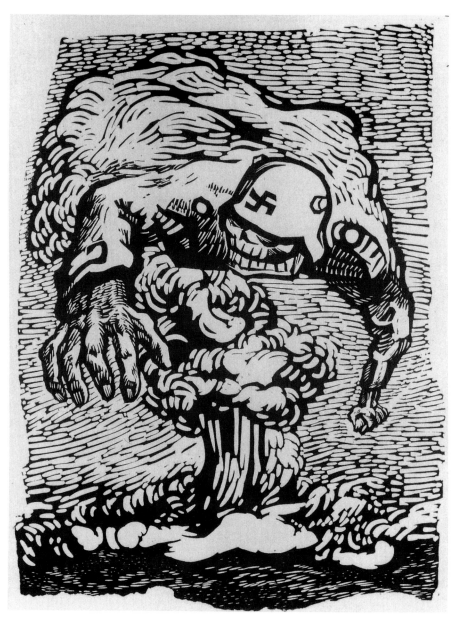

Fig. 85. Alfredo Zalce, *La Bomba atómica* (The Atomic Bomb). 1946. Linoleum cut, 16-1/4 in. x 12-1/2 in. Collection of the Grunwald Center for the Graphics Arts, University of California, Los Angeles. (Photo courtesy of the Grunwald Center.)

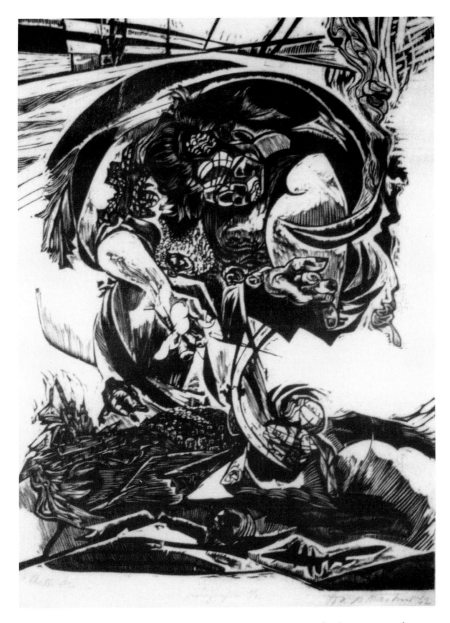

Fig. 86. José A. Torres Martinó, *Mater atómica* (Atomic Mother). 1962. Woodcut, 24-1/2 in. x 18-1/8 in. Collection of Museo de la Universidad de Puerto Rico, Río Piedras. (Photo by author.)

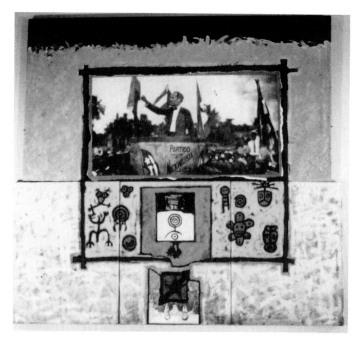

Fig. 87. Juan Sánchez, *Untitled.* 1985. Oil, photo, mixed media on canvas, 66 in. x 72 in. Collection Mauricio Fernández, Monterrey, Mexico. (Photo by author.)

Fig. 88. Juan Sánchez, *Para Julia de Burgos II.* 1985. Oil, Xeroxes, mixed media on canvas, 47 in. x 66 in. Collection Luis R. Irrizary, Puerto Rico. (Photo courtesy of Exit Art.)

Fig. 89. Juan Sánchez, *Isabel "Vieques" Rosado.* 1984. Oil, photo, mixed media on canvas, 64 in. x 46 in. Courtesy Guariquen, Inc., Bayamón, Puerto Rico. (Photo by author.)

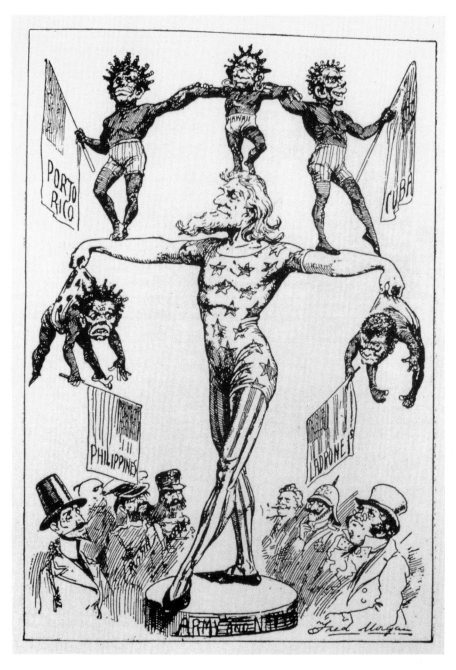

Fig. 90. Fred Morgan, "John Bull: It's really most extraordinary what training will do. Why only the other day I thought that man unable to support himself." *Philadelphia Inquirer*, 1898.

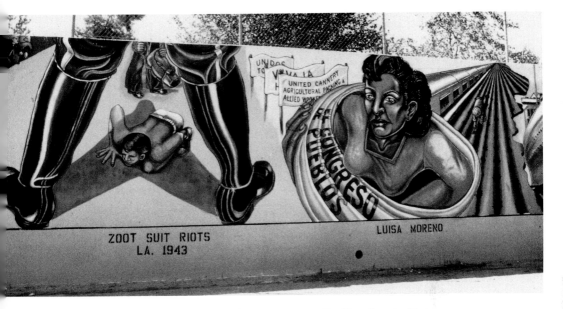

Fig. 91. Judith "Judy" Baca (Chicana) and team, *Great Wall of Los Angeles/Tujunga Wash*. 1981. Mural detail. Van Nuys, California. Courtesy of Social and Public Art Resource Center (SPARC), Venice, California. (Photo by author.)

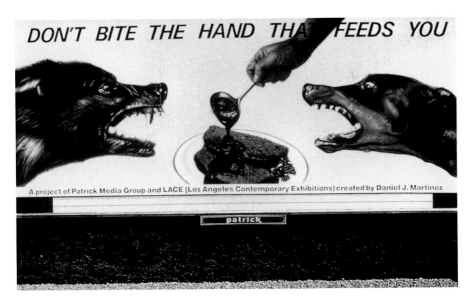

Fig. 92. Daniel Martínez (Chicano), *Don't Bite the Hand That Feeds You*. 1989–90. Billboard produced by L.A.C.E. and Patrick Media, 20 ft. x 48 ft. Los Angeles. (Photo courtesy of the artist.)

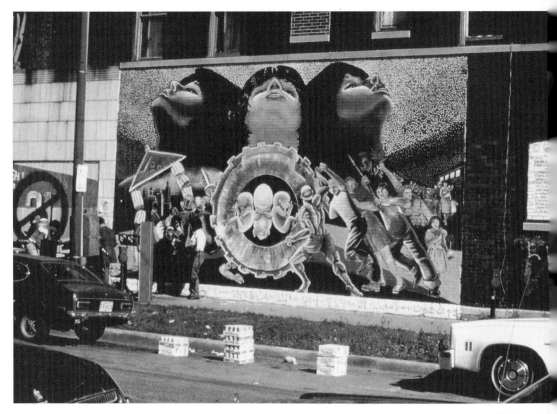

Fig. 93. Oscar Martínez (Puerto Rican) and José Guerrero (Chicano), *Stop Plan 21*. Circa 1979. Mural, acrylic. Chicago. (Photo courtesy of John Weber.)

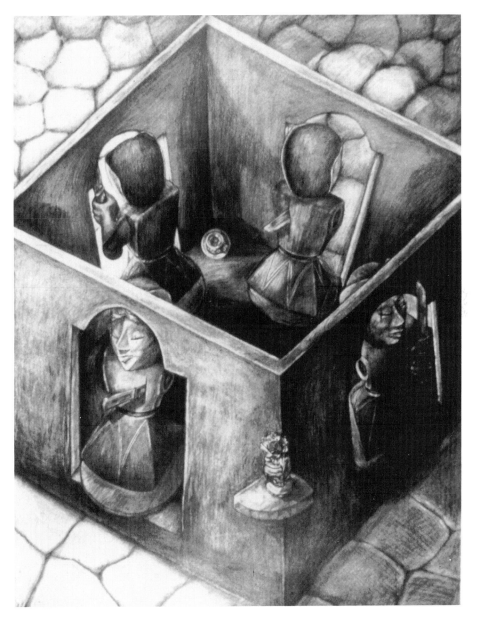

Fig. 94. Bibiana Suárez (Puerto Rican), *Temple of the Conflict of the Opposites.* 1984. Graphite on paper, 50 in. x 40 in. Collection of artist. (Photo courtesy of the artist.)

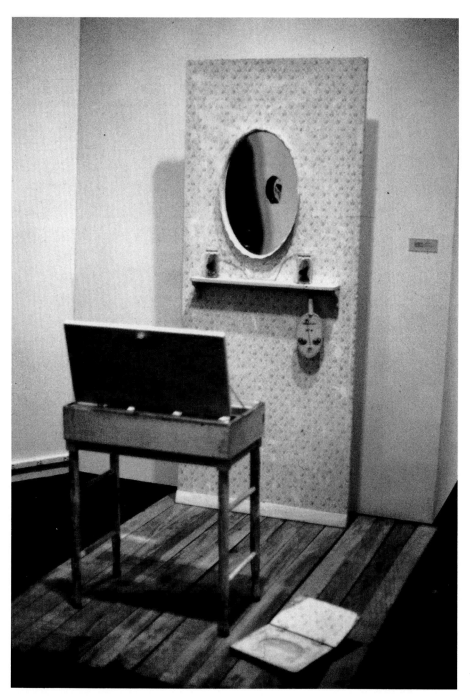

Fig. 95. María Brito (Cuban), *Woman before a Mirror*. 1983. Installation of mixed media, 78 in. x 51 in. x 70 in. Collection of artist. (Photo by author.)

Fig. 96. Jorge Pardo (Cuban), *Marielitos*. 1983. Oil pastel on black board, 28 in. x 34 in. Collection of artist. (Photo courtesy of the artist.)

Fig. 97. Hy Rosen, "It's Part of the Primitive Art That Still Exists." *Albany Times-Union*, 1969.

With the DIVEDCO workshop, cultural announcements of all kinds were also produced. Because of the enormous quantity of posters required, traditional drying racks were superseded by a construction of Jack Delano's: an 18-foot conveyor belt made of canvas on rollers under which the newly inked posters passed under infrared lights which dried them. Thus additional colors could be inked more rapidly. There was no attempt until 1952, when Lorenzo Homar took over the graphics workshop of DIVEDCO upon the retirement of Irene Delano, to seek "painterly" effects in silkscreen such as those developed by Anthony Velonis. Homar not only experimented with technique but explored the artistic and expressive possibilities of calligraphy integrated with images, or functioning as the design itself.

Puerto Rico and Mexican Social Realism

Celebrations of Puerto Rican culture were also part of the film and poster program. For example, in 1952 filmmaker Amílcar Tirado contracted with Rafael Tufiño to paint a mural for his film *La plena* treating popular Puerto Rican music. Finished in 1954, the 16' × 30' mural in casein on masonite panels has recently been rescued and installed in the Centro de Bellas Artes of Santurce. Images derive from different songs well known in the urban slums, the most spectacular of which is the giant horned flame-spitting horse of the *plena* "Santa María, líbranos de todo mal," before which the people ask mercy of the Virgin. Tufiño and Lorenzo Homar also undertook to print a linocut portfolio during the same year, designed by Irene Delano. In the graphic version, Tufiño chose to depict the people around the horse attacking the evil animal directly, rather than pleading with the Virgin for succor. In the fluid cutting and dramatic gestures of the horse, and in the personification of Hurricane San Felipe in another print, Tufiño's debt to the Mexican Taller de Gráfica Popular is evident, particularly the influence of Leopoldo Méndez, and of Alfredo Zalce, with whom Tufiño (and Antonio Maldonado, who went with him) studied from 1947 to 1949 at Mexico's San Carlos Academy. Tufiño brought back Zalce prints when he returned to Puerto Rico. One, of a sisal cutter from Yucatán, appears in newspaper photographs of his studio taken in 1950. Parenthetically, Zalce's 1946 linocut *The Atomic Bomb* obviously influenced Torres Martinó's 1962 woodcut *Mater atómica*, compositionally as well as thematically. Lorenzo Homar's linocut style from the *La plena* portfolio is very different than Tufiño's, much more crisp and precise—reflecting his years of training as a jewelry designer at Cartier's in New York—with a wicked edge of caricature when depicting the North American lawyer for the Sugar Trust swallowed by a shark, or the richly dressed clergy surrounded by upper-class sycophants, all of whom ignore the poor. Homar also admired the Mexican Taller, whose

Fig. 85

Fig. 86

1949 publication, *El Taller de Gráfica Popular: Doce años de obra artística colectiva,* he purchased before returning to Puerto Rico from New York in 1950. His love of caricature might be traced to knowledge of Mexico's José Guadalupe Posada, and of José Clemente Orozco, who not only worked as a caricaturist for newspapers but carried the mode into his murals and graphics. When the Centro de Arte Puertorriqueño (CAP) was opened in 1950, in an old building rented inexpensively to the group of "rebel artists" who were to transform Puerto Rican modern art by publisher Luis Muñoz Lee (son of the governor), there was no question that the collective work and criticism and the public educational principles of the Taller were incorporated into their thinking.

In addition to graphics, Mexican muralism (which impacted not only Latin America but the United States from the 1920s to the 1940s) was certainly familiar to Puerto Rican artists—especially those who studied in Mexico, or who visited New York, where examples of Rivera and Orozco murals could be seen. The artists who studied or worked in Mexico include Tufiño and Antonio Maldonado, Luis Borges, Spanish-refugee Carlos Marichal, who came to Puerto Rico from Mexico in 1949, Eduardo Vera, Fran Cervoni (who taught perspective classes in Mexico), Samuel Sánchez, René Irizarry Santos, and Francisco Rodón. (The influence of Marichal, who established a graphics workshop in Puerto Rico, is also important for the subsequent development of woodblock printing at which Puerto Rican artists have excelled from 1950 on.)

However, Mexican art was brought to the Island even earlier. In 1935—in accompaniment to an exhibition at the Universidad de Puerto Rico which included the art of Diego Rivera, José Clemente Orozco, David Alfaro Siqueiros, Fermín Revueltas, Carlos Mérida, Jean Charlot, Julio Castellanos, Miguel Covarrubias, and others—Concha Meléndez presented an historical overview of Mexican art at the Club de Español of the Escuela Baldorioty in which she traced the history of the Mexican movement from the 1923 formation of the Syndicate of Painters and Sculptors, which represented the social realist wing, to the Estridentistas and the Contemporáneos of the late 1920s and early 1930s, the latter of which were interested neither in politics nor nationalism, but in an internationalist "aesthetic revolution."[17]

Muralism never flourished in Puerto Rico despite the desires of many artists. When Tufiño returned from Mexico, he dreamed of covering the walls of public buildings in Puerto Rico with murals, but the necessary government support was not forthcoming.[18] By 1954, a proposal put forward to Muñoz Marín as part of a plan to encourage cultural programs in the school system suggested that murals be painted in public buildings, new schools, and factories created by "Fomento," the agency responsible for Puerto Rican industrialization. Murals were to be painted by national artists, but outsiders were not to be excluded if they chose Puerto Rican

or American themes. It was further proposed that such murals could be reproduced as color postcards.[19] There is testimony to the effect that murals were actually painted on Fomento buildings, but it has been very difficult to obtain information as to how many, where, when, and by whom; nor do reproductions appear to exist that could give a clue as to subject and style.

The Rebel Artists of CAP

The history of the Centro de Arte Puertorriqueño (known as CAP), formed in October 1950—precisely at the moment when the armed Nationalist Revolt by Pedro Albizu Campos forces took place—and inaugurated in December 1950, has been ably outlined in Torres Martinó's essay for the 1985 catalogue *Pintura y gráfica de los años 50*. It grew out of Torres Martinó's and Rodríguez Báez's Estudio 17, and at different stages included Tufiño, Homar, Julio Rosado del Valle, Carlos Raquel Rivera, Samuel Sánchez, Rubén Rivera Aponte, Carlos Marichal, and Irene Delano, among others. During its brief existence, it definitively changed the direction of Puerto Rican art, aesthetically and thematically. The new consciousness replaced "bucolic autumn landscapes, eternal Last Suppers, overflowing still lifes, and anchored boats" (to quote Antonio Martorell)[20] with images of the urban slums, the hard life of the rural *jíbaros*, revolutionary heroes, and a new valuation of folk culture.

In 1950, CAP held its first Exposición de Pinturas al Aire Libre in a local plaza. The exhibition included a juried vote to award prizes and honorable mentions, as well as a popular vote for the favorite picture. Another was held in 1951. That year, eight CAP artists (Torres Martinó, Rodríguez Báez, Tufiño, Homar, Rivera Aponte, Samuel Sánchez, Carlos Raquel Rivera, and Marichal) collaborated on *La estampa puertorriqueña*, a portfolio designed by Irene Delano composed of six linoleum cuts, a serigraph, and a wood engraving. A second portfolio of eight serigraphs, *Estampas de San Juan*, appeared in 1953 to which veteran silkscreen artists from the Division such as Eduardo Vera, Palacios, Hernández Acevedo, and José Figueroa along with several CAP founders contributed. These two portfolios set up a portfolio tradition that continued even after CAP went out of existence that same year: *La plena* of Homar and Tufiño; Tufiño's portfolio on coffee production; and the *Casos de Ignacio y Santiago* by Tufiño and José Meléndez Contreras, to say nothing of those by younger generations.

CAP also held one-person and group exhibitions in its space, offered classes for children and adults, maintained a workshop for painting and the graphic arts—woodcuts, engraving, etching, lithography, and silkscreen—and opened its facilities to all artists, particularly young ones. Its 1951 manifesto additionally proposed discussion on art in schools, the

use of radio and press to examine art topics, and the establishment of art centers throughout the Island. It thus offered an independent alternative vision with a participatory art production system. CAP felt that art in Puerto Rico could only develop through the identification of the artists with their people and their country; that only by working together and discussing the problems that arose from their work could they infuse a new vitality into Puerto Rican art. When CAP closed, its members carried their vision forward in DIVEDCO, and in other activities under the long-needed government-sponsored Instituto de Cultura Puertorriqueña, which opened in 1955.

Puerto Rican Populism and Modern Art

How does one respond to the questions posed earlier as to what had occurred in the time between the triumphant popular election of Muñoz Marín and his retirement in 1964? What were the successes and failures of his populist program? What was its impact on Puerto Rican modern art?

Populism, as defined by sociologist James D. Cockcroft, tends to prevail under certain historical conditions, and is composed of three overlapping areas: ideology, class alliances, and a social movement determined by the ideological and political practice of a class. It is distinguished by a policy action program advocating pro-people and relatively classless egalitarian demands. As such, it tends to limit demands to reform instead of revolution.[21]

In Puerto Rico of the 1940s, where many sectors of the population had suffered from four decades of unbridled capitalist expansion, the PPD's populist message, and Muñoz Marín's effort to gain the trust of the people (through political actions and ideological slogans such as "Operation Bootstrap" and "pan, tierra y libertad [bread, land, and liberty]"), offered the only hope. At the same time, the party's emergence and growth did not threaten U.S. colonial hegemony. The PPD's program and rhetoric were anti-imperialist and anti-expansionist; they were not, however, anti-U.S. or anti-capitalist. As a result of this program, Puerto Rico left its agrarian past behind by the 1950s (and, some people say, its essential *puertorriqueñidad* ["Puerto Rican-ness"]) and became an urban industrial nation.[22]

Operation Bootstrap and its corollary program of industrialization performed the necessary task of providing a reservoir of skilled workers for industry, primarily U.S. but also national. To quote a right-wing U.S. observer writing in 1954 who very accurately states the situation at the time:

> One of the greatest incentives to U.S. manufacturers [in addition to a ten-year tax holiday] has been the wage differential between

Puerto Rican and mainland workers. Many of those now employed in skilled trades [with a gradual rise in wage rates] were *jíbaros* who only a few years ago had never seen the inside of a factory. To teach them to run turret lathes and spinning machines, to operate intricate control panels, and to assemble electronic parts has required a far-reaching industrial training program. This has been accomplished through secondary vocational and trade schools set up in every part of the island.

The ideological posture of this article appears in its subheading: "Puerto Rico, rejecting socialism, builds a future in which private enterprise becomes the nation's prime goal, and the government its servant."[23]

The literacy and educational campaigns of Operation Bootstrap, implemented by DIVEDCO and its predecessor, set the stage for this transformation, which those who participated in could not have predicted. As one recent commentator noted:

> In practice, the Division's utopia was frequently contradicted by the Bootstrap utopia. While the Division made solid contributions to economic and social development [as well as to artistic development], it is clear that it was fighting against the main thrust of government policy, which was allied with forces largely indifferent to the concerns of the community education program. Certainly by the 1970s, the inability of the Puerto Rican model of colonial capitalism to continue generating jobs, reduce unemployment and sustain continual increases in real income became painfully evident, as did the spectre of the South Bronx. Ultimately, the imbricated contradictory utopian visions expressed . . . in the Bootstrap program are tragic, failed projects.[24]

In summary, it is clear that the impact on Puerto Rico of New Deal social policy on the one hand and the production of photography, film, and graphics on the other—via Tugwell, Rosskam, the Delanos, and others—was of great importance both to Puerto Rican history and art history. The films, books, posters, and wall newspapers are the residue of Puerto Rican social history in the 1940–65 period—and in their images can be found the expression of many contradictory processes conditioning Puerto Rican life and culture at that time.

The fact that these public art forms were to be used in ways similar to those employed during the Depression by the Roosevelt New Deal—but to quite another end—is also revealing. Characteristic of both, however, was the fact that the nature and content of the art production were geared to government programs that had at their core the essential purpose of rescuing an endangered capitalism, in the case of the United States; and in the case of Puerto Rico, of constructing a native capitalism in tangent

with U.S. investment that ultimately led to neocolonial control. Under the New Deal Federal Art Project, the representations of Project artists and their artworks were intended as cultural symbols of New Deal democracy, producing a national culture for a unified citizenry.[25] The same might be said for Operation Bootstrap to the degree that this notion is embedded in the concept of *serenidad*.

For those Puerto Ricans (as for those North Americans) who had other agendas—for example, an American socialism, or an independent and reformed Latin American nation with or without a socialist program—artistic inspiration was sought from alternate sources, among them the progressive artists of the New Deal period and of the Mexican School. At the same time, it must be asserted that the process of generating a truly Puerto Rican modern art, one that engaged and reflected the continuing realities and aspirations of the Puerto Rican people themselves, occurred only at that point at which Puerto Rican artists took control of their aesthetic and communicative powers in a process of artistic self-determination. This occurred with the formation of the Centro de Arte Puertorriqueño. What was learned or borrowed, in the constant and necessary usages of international intellectual interchange, had to be internalized, then transformed—"caribbeanized" if you will—into a new national culture that looked to its own artistic past (the Taíno Indian, the African, the creolized Spanish, popular arts and folklore, and the traditions of past painters such as José Campeche and Francisco Oller) as well as its own history of struggle against colonialism.

Furthermore, as has been incisively pointed out by José Luis González, what is understand by "national culture" is actually two cultures: that of the oppressors, and that of the oppressed—elite versus popular culture. In the case of a colonized nation such as Puerto Rico, a third and powerful tier is the institutionalized culture of the colonizer.[26] What was to be achieved by the modern Puerto Rican art movement that arose in the 1950s was not only a synthesis of foreign and Puerto Rican artistic forms but a class and nationalistically determined project. Social realism was chosen as a mode at a time when this mode was almost defunct in the modern world,[27] and social realism was made working class and tropical—that is to say, Puerto Rican.

Notes

1. Manuel Hernández Acevedo passed away just as this article was being published in Puerto Rico.

2. See "La personalidad puertorriqueña en el Estado Libre Asociado" by Luis Muñoz Marín. Speech to the General Assembly of the Teachers Association, 1953, page 8.

3. James L. Dietz, *Economic History of Puerto Rico: Institutional Change and Capitalist Development* (Princeton: Princeton University Press, 1986), 231.

4. Dietz, *Economic History of Puerto Rico*, 231.

5. Arturo Morales Carrión, *Puerto Rico: A Political and Cultural History* (New York: W.W. Norton & Co., 1983), 272.

6. Quoted in Willard D. Morgan (ed.), *The Complete Photographer* (no. 21, April 10, 1942), as cited in Grace M. Mayer's essay in Edward Steichen (ed.), *The Bitter Years: 1935–1941* (New York: Museum of Modern Art, 1962), at pp. iv–v.

7. See *12 Million Black Voices*, text by Richard Wright, photo direction by Edwin Rosskam (New York: Thunder's Mouth Press, 1988).

8. Christopher DeNoon, *Posters of the WPA* (Los Angeles: The Wheatley Press, 1987).

9. DeNoon, *Posters of the WPA*.

10. Aline Brandauer, "Going Native: Spinden in the Brooklyn Museum," unpublished manuscript, 1988. The parent body of the Brooklyn Museum was the Brooklyn Institute, established in 1843 (by 1890 the Brooklyn Institute of Arts and Sciences), to which a School of Design was added in 1851. This became the Art School in 1941, when it was moved to the Museum.

11. I am grateful to Leona Dicker and Kathy Johnson of the Brooklyn Museum for providing me with historical data about their institution.

12. Torres Martinó, "El Centro de Arte Puertorriqueño," in *Pintura y gráfica de los años 50*, catalogue, San Juan: First Federal Savings Bank, La Hermandad de Artistas Gráficos de Puerto Rico, Instituto de Cultura Puertorriqueña, 1985, 21. All translations are mine.

13. Torres Martinó, "El Centro de Arte Puertorriqueño," 22.

14. For a report on the DIVEDCO program, see Fred Wale and Carmen Isales, *El significado del desarrollo de la comunidad* (also published in English) (San Juan: Departamento de Instrucción Pública, 1967); the bilingual *Un programa de educación de la comunidad en Puerto Rico /Community Education Program in Puerto Rico* (New York: Radio Corporation of America, n.d. [c. 1960s]). On the film program see *Films with a Purpose: A Puerto Rican Experiment in Social Films* (New York: Exit Art and El Instituto de Cultura Puertorriqueña, 1987), and "Lista de películas," an unpublished document dated December 1971 from the archives of the Fundación Luis Muñoz Marín.

15. According to Jack Delano, booklets were illustrated with drawings done on a lead matrix that reproduced as linecuts. They were printed on the two available Multilith-Multigraph newspaper presses set with the illustrations or photography, and with linotype. Earlier booklets were made with silkscreen. For example, *Por qué la piña*, intended to introduce pineapple production to the island of Vieques, was designed by Irene Delano. The silkscreen cover was cut by Francisco Palacios, and Irene cut the stencils for the inside pages. Interview with Jack Delano in Puerto Rico, June 15, 1987.

When painter Antonio Maldonado joined the Division in 1957, he found artists José Meléndez Contreras, Rafael Tufiño, Carlos Raquel Rivera, Eduardo Vera, Epifanio Irizarry, José Manuel Figueroa, Isabel Bernal, Luis Germán Cajigas, and Manuel Hernández. In earlier years, artists Palacios, Lorenzo Homar, Juan Díaz, and Julio Rosado del Valle had been employed. See Diana Cuevas, "Diversas puntos de partida dan pie a las polémicas," *El Mundo* (San Juan), June 3, 1984.

16. In addition to Rosskam and Delano, the film crews included Benjamin

Doniger and Gabriel Tirado (from the U.S.), Amílcar Tirado, Luis Maisonet, Oscar Torres, Marcos Betancourt, and Angel Casiano.

17. Concha Meléndez, "Arte mágico," *Ateneo puertorriqueño* 1, no. 1 (1935): 107–19.

18. Juan Luis Márquez, "Rafael Tufiño: Ganador del primer premio en la exposición de pintura al aire libre," *El Mundo*, Aug. 5, 1950, Puerto Rico Ilustrado: 52.

19. Unpublished document signed by Muñoz Marín, June 2, 1954. Archives of the Fundación Luis Muñoz Marín.

20. Antonio Martorell, in *Pintura y gráfica de los años 50*, 8.

21. James D. Cockcroft, *Mexico: Class Formation, Capital Accumulation, and the State* (New York: Monthly Review Press, 1983), 140. Cockcroft examines the populist mode in Mexico, beginning with the presidency of Lázaro Cárdenas. It might be noted that Franklin D. Roosevelt in the U.S. also functioned with a populist ideology, as did Juan Perón in Argentina and Getúlio Vargas of Brazil—all within a short period of Muñoz Marín.

22. Dietz, *Economic History of Puerto Rico*, 179–81.

23. Robert E. Kingsley, "Operation Bootstrap," *The Freeman* 5, no. 1 (Orange, Conn.; July 1954): 18–19. Published by the Libertarians.

24. Antonio Lauria-Perricelli, "Images and Contradictions," in *Films with a Purpose*, n.p.

25. Jonathan Harris, "The Administrative Organization of the Federal Art Project: Power, Possession and State-Cultural Populism," unpublished manuscript, page 1.

26. José Luis González, *El país de cuatro pisos y otros ensayos* (Río Piedras: Ediciones Huracán, 1980), 19.

27. René Marqués, commenting on the Puerto Rican artists who were invited to the First Interamerican Biennial of Mexico in 1958, noted that the art of the hemisphere was involved in a struggle without quarter between the antagonistic tendencies of realism and abstraction. Judging by the quantity of works exhibited at the Biennial, he concluded that abstraction was winning the battle. However, "son quizás Méjico y Puerto Rico dos de los países en los cuales la tendencia realista logra mejor resistir la avalancha opuesto" ["Mexico and Puerto Rico are perhaps two countries in which the realist tendency has best resisted the opposing avalanche"]. Marqués, "Experiencia interamericana: Pintura puertorriqueña en la Bienal de México," *El Mundo*, June 27, 1958. For an overview of the Biennial, see *Artes de México* 4, no. 24 (July–August 1958).

32

LIVING ON THE FIFTH FLOOR
OF THE FOUR-FLOOR COUNTRY

José Luis González's poetic metaphor of Puerto Rican history and cul-
ture, "El país de cuatro pisos" ("the country of four floors"),[1] slices not
only through time but through politics, mythologies, and class interests,
bringing them all together in the present struggles for liberation. As such,
it offers a verbal analogy to Juan Sánchez's complex and layered pictorial
constructions and lends insight to their iconography. Speaking in the
present tense, González is careful to delineate the three-tiered structure
of contemporary Puerto Rico composed, top down, by the U.S. imperialist
presence, the dominated upper classes of Puerto Rico, and the lower
classes exploited by both. Toward this end, he separates culture into
"elite" and "popular," the latter of which has been studied by dominant
class intellectuals only as folklore, thus making invisible the true signi-
fication of popular culture in Puerto Rican history.

The "four floors" of the title begin with three historic groups: the ab-
original Taíno Indians whose resistance to Spanish enslavement caused
their extermination, the African slaves, and the Spanish conquerors. Con-
trary to common scholarship, González considers the most important
(for economic, social, and therefore cultural reasons) to be the Africans.
They survived and became carriers of aboriginal cultural elements owing
to interchanges between the two most oppressed groups of the social

This essay first appeared in Jeanette Ingberman, ed., *Juan Sánchez: Rican/Structured
Convictions*, catalogue (New York, Exit Art, 1989), 18–22.

pyramid. During the first two centuries of conquest, the Spanish population was in a state of flux, therefore the Africans (who could not leave) formed the most stable resident population and their (popular) culture is the first that is "American," that is to say, *puertorriqueña*. Metaphorically, then, the "first floor" of Puerto Rico is African/Taíno. It is revealing that Puerto Rico's first acknowledged artist of importance, José Campeche of the eighteenth century, was the son of a slave nourished by popular culture.

Except for its major areas of conquest, Spanish domination ignored colonial culture, particularly in Puerto Rico, which was considered nothing more than a strategic outpost.[2] Thus popular culture was the primary one until the nineteenth century. A truly nationalist art—for a country which entertained a scant few months of independence as a nation between the eviction of Spanish colonialism and the ingress of the United States in 1898—does not arise until the late 1940s.

The "second floor" was constructed and furnished by waves of nineteenth-century immigration, including revolutionary refugees from Latin America and numerous Europeans. If the first contingent brought ideas of independence to the Island, the second expropriated dominant status from the old landowners. The "third floor" was constituted by the U.S. conquest, which imposed its cultural paradigm on a population which had not had time to fuse its segments into a national synthesis.

The "fourth floor"—and my imaginary "fifth floor" imposed upon José Luis González's richly conceived housing structure without his permission or knowledge—were erected almost simultaneously. The former resulted in the spectacular and irreparably cracked structure of "late North American capitalism" in tandem with "Puerto Rican opportunistic populism," which weighted down Island society at the end of the 1940s. Organized by Luis Muñoz Marín, Popular Democratic Party leader who became the first elected Puerto Rican governor, the hopeful expansionist development of "Operation Bootstrap" (*manos a la obra*) resulted in the modernization-within-dependency mode that characterized the relations of many Latin American countries in the post–World War II epoch. Since 1917, poverty in the colony had already sent thousands of working-class immigrants to the U.S., where they had citizenship but little more access to its privileges than U.S.-born African Americans. (Those, like Juan's family, who were black or dark-skinned, suffered racial as well as economic and ethnic discrimination.) The eventually negative effects of "Bootstrap" economics can be found in statistics: from the 200,000 Puerto Ricans in New York City in 1948, the year of Muñoz's election, migration had increased to 612,000 in 1960. The 1990 census might record close to one million. This Puerto Rican population of economic exiles inhabits the "fifth floor" of the four-floor nation.

Born in Brooklyn in 1954 to a migrant working-class family, Juan Sán-
chez was politicized in high school by the Chicago-based Young Lords
Party (a Puerto Rican counterpart to the Black Panthers and the West
Coast–based Brown Berets of the Chicano movement), who formed their
New York organization in 1969 in Spanish Harlem. In the pages of the
Young Lords' newspaper, Pa'lante ("right on"), the teenage Sánchez found
the political arguments he used in his classes. It was the beginning of
consciousness about problems he intuitively sensed. Unlike many Latino
groups, women (after a sharp struggle against machismo) formed 40 per-
cent of the Young Lords' membership and served on the governing body,
a fact that probably sensitized Sánchez to the role of women in politics
and culture, as evidenced in many of his paintings.

Interested in art since childhood—and promoted by his teachers for
special art training—Sánchez found support and encouragement within
his family, including that of his father, who crafted religious altars from
wood which he would sell or give to local families. The altar format,
whether single or multiple panel or utilized simply as painted "frames"
around an image, remains an important element in the artist's composi-
tions. While enrolled by 1973 as an art student in Cooper Union, Sán-
chez—still influenced by Pa'lante—began producing posters on canvas
in 1974 which introduced into his later painting the possibility of the
incorporated texts he still uses. Having studied graphic design and pho-
tography, he entered painting classes where he absorbed the lessons of
then mainstream abstraction—including the use of shaped canvases that
reinforced his altar-influenced forms and strengthened his command of
composition. Nevertheless, he insisted on figurative and political im-
agery, which led him into a collision course with most of his teachers.

Reading widely in history and poetry, Sánchez was very aware of the
political currents of the time in which he and an older generation of
Puerto Rican activists lived. Occurring simultaneously was the Cuban
revolution of 1959 and the black civil rights movement with which black
Puerto Ricans strongly identified. Both "Ché" Guevara and Malcolm X
(as leaders and as martyrs) became symbols for separatist Puerto Rican
youth who then looked to their own history for a counterpart. They se-
lected Pedro Albizu Campos as their martyr and symbol for the cause of
Puerto Rican independence and, thereafter, fragments from his speeches
appeared on the murals and posters of the youth movement.[3]

Armed with a formulated political consciousness tempered by a great
faith and sensitivity toward his Puerto Rican community; equipped with
a good formal art education at Cooper Union and at Rutgers; endowed
with talent and a resilient spirit, Juan Sánchez emerged from the "mean
streets" of New York with a mission. His role was to open communica-
tion with his people by employing an artistic language and a variety of

symbols and images familiar enough to them so they would enter his space (the poster, the painting, the print, the photograph) with anticipation, and emerge with heightened understanding. Like the Mexican muralists (whose work he studied and who had earlier influenced the first generation of nationalist artists in Puerto Rico during the forties and the fifties), Sánchez employs an expressionist style, an abstract structural grid that unites his disparate images, a transformation of popular Catholic symbols and forms to convey new ideas, and an Indianist vocabulary which associates modern with historic resistance to the Spanish conquerors. The Mexican sources have been "puerto-ricanized" and, at the same time, commingled with influences such as those of Rauschenberg, minimalism, and the popular cultural forms of New York—the *botánica* (where herbs, amulets, and other objects for Afro-Caribbean *santería* can be purchased), the Spanish-language and religious calendars, the Puerto Rican Day parades with floats and fancy dress, the *bomba* and *plena* (popular songs and dances from Puerto Rico), the *santos* (carved saints), home altars, inexpensive religious chromoliths of folk Catholicism, and finally the Island love of brilliant color, tropical flowers and plants, and ocean-reflected light. The seamier side of the New York *barrio* environment—its cracked, crumbling, stained, and graffitied walls larded with the remains of generations of commercial and political posters—offered a prototype for Juan Sánchez's layered methods of painting, tearing, pasting, scratching, scumbling, and scribbling, and of graffiti-like text appearing and disappearing into the various layers. Total surfaces are activated in this manner; even prints may have as many as four layers. In this case, the medium itself provides a message situating the human and symbolic imageries within their New York context.

In placing Juan Sánchez on the "fifth floor" of the Puerto Rican house, it is my fancy to believe that for him the building is equipped with glass rather than wooden floors, through which he can see and transcribe all of Puerto Rican history from the beginning to the present simultaneously. Fig. 87 Thus an old photograph of Pedro Albizu Campos addressing a crowd of sugar workers from a platform draped with the flag of the Partido Nacionalista surmounts another photograph of New York activists covering the head of the Statue of Liberty with the Puerto Rican flag. This image, in its turn, surmounts and is flanked by painted representations of ancient Taíno petroglyphs which themselves surmount a reversed image of John F. Kennedy with Luis Muñoz Marín on a green ground crossed by a five-pointed red and black star on a brown bar. All these levels of time and resistance coexist in an untitled 1985 work and are framed within a diptych whose overpainted grounds of orange-on-blue and white-on-orange, flickering like flame into a black band, have all the rich calligraphic quality of a Mark Tobey surface.

Paintings dedicated to women include a series of homages to the art-

ist's mother, such as the poignant *A mi madre un año después y yo (A Self Portrait),* where pink and rose lace and flowers cover the surface on which appear photographs of his recently deceased and beloved mother and himself as a baby over a yellow amapola, national flower of Puerto Rico. *Para Julia de Burgos* celebrates a woman known for her romantic and erotic poetry symbolized by red and pink roses, lace, and Taíno petroglyphs in pink and blue. As a symbol of her less-known revolutionary poetry which inspired students during a 1979 strike, Sánchez includes barbed wire and shadows of two flags, along with text. *Cultural, Racial, Genocidal Policy* protests the sterilization of over one-third of Island women with Taíno and Catholic images, a flag, a rose, and the images and names of the unborn babies of the future. *Isabel "Vieques" Rosado* pays homage to an older woman of indomitable spirit who protested the occupation of the fishing island of Vieques by the U.S. Navy.

Fig. 88

Fig. 89

Negritude a la bomba y plena portorro invokes the popular African-derived music with an African face, the horned coconut-shell mask of the Loísa *vejigante* costume, the red, black, and green colors of African liberation, and palm trees. Barbed wire, a newspaper clipping, and the reversed photograph of Kennedy/Muñoz Marín link culture with political reality. *Flowers for Malcolm* quotes the assassinated leader and combines his image with a reversed U.S. eagle and the U.S. flag, a halo of barbed wire, and the joyful symbols of bright flowers and a rainbow. The large black "X" and a black Latin American saint, Martín de Porres, are symbols of the reverence in which Malcolm X is held. Martín de Porres appears again within an altar in *La lucha continua.* A young girl's confirmation dress, palm trees, and the West African gods and goddesses (called Orishas in the New World) Changó, Oshun, Obatalá, Yemayá, Ogun, Elegguá, and Oyá, who crossed the ocean to the Americas "with fire and spirit," share his space. "The struggle continues" says the text.

The plaint "Ay Bendito" across the color-framed collages of *Can't Go Back* is one of alienation. In Spanish and English the New York–based artist Papo Colo is quoted as saying "I can't return to my country. It is a victim of maracas and cement," a poignant lament for the loss of Puerto Rico to tourism and hotels.

It is the back-and-forthing, the free association of disparate historical and formal elements, the interweaving of personal and political attributes, the switching from Spanish to English texts, the references to widely known powerful personalities and unknown humble persons, which constitute the dialectical interactions occurring in the whole corpus of Juan Sánchez's work. His symbolic and formal usages are positioned to make most effective a complex and didactic view of Puerto Rican history, culture, sensibility, and politics. With time, his vision is broadening. He is attempting in his art, and in his activism, to synthesize the existing bifurcated view that separates Island from mainland reali-

ties.[4] Beyond that, he reaches out to the entire Third World, the macro-vision derived from his New York microcosm.

Notes

1. In *El país de cuatro pisos y otros ensayos* (Río Piedras, Puerto Rico: Ediciones Huracán, 1980), 9–90. I am indebted to Samuel A. Román Delgado for bringing this essay to my attention.

2. For example, both Mexico and Peru, which were viceregal and church seats of power and wealth, were encouraged in the development of art forms, from religious and secular architecture to easel painting and murals for state, Church, and the elite.

3. Harvard-educated lawyer Pedro Albizu Campos sustained an independence stance within his Nationalist Party after it was abandoned by Muñoz Marín's Popular Democratic Party when it came to political power. Repeatedly jailed for insurrection, he was released (1964) when almost on his deathbed. Albizu became the focus of a new search for identity among second-generation Puerto Ricans. Many, like Juan Sánchez, knew Puerto Rico directly only as small children or not at all. Photographs of Albizu as political orator and as he lay dying (in 1965) draped with the Puerto Rican flag appear repeatedly in Sánchez's works.

4. Examples of this direction outside the artworks themselves are demonstrated by the collaborative exhibition "Huellas: Avanzada estética por la liberación nacional" ("Signs: An Advanced Aesthetic for National Liberation"), coordinated and curated by a committee headed by Juan Sánchez, which brought together work by Puerto Rican artists from both locations supportive of national independence (whether or not engaged as an issue in their work).

33

THE MANIFESTED DESTINIES OF CHICANO, PUERTO RICAN, AND CUBAN ARTISTS IN THE UNITED STATES

North Americans suffer from historical amnesia—at least to the degree that recollecting history interferes with our national self-image, or our national self-interest. Thus, the political rhetoric of the United States has been persuasively blind when it comes to applying an imperialist label to our interventions in the national affairs of other countries or to the internal affairs of peoples in and outside our national boundaries. What I propose to do here is examine very briefly these interventions as they relate to United States relations with Mexico, Puerto Rico, and Cuba during the nineteenth and early twentieth centuries; the present consequences of such policies in terms of the cultural and social impact on conquered, immigrant, and exile populations from these three countries residing in the United States; and the artistic production for the last two decades of Chicanos/Mexican Americans, Puerto Ricans, and Cubans. For the Chicanos and Puerto Ricans, in particular, the artistic project has undertaken—among other things—to challenge and redetermine the impact of political and cultural colonization.

United States policy toward Latin America has been contained within two ideological formulations: Manifest Destiny (the older of the two), and the Monroe Doctrine of 1823, which gave it political leverage and proclaimed that the American continents were no longer to be considered a field for colonization by European powers. Manifest Destiny was invoked when the U.S. failed to buy Cuba from Spain, and California and New

Mexico from Mexico. What couldn't be purchased or won by diplomacy was taken by force during the Mexican American War of 1848, when Mexico lost almost half its national territory, and during the Spanish American War of 1898, when Cuba, Puerto Rico, and the Philippines passed into U.S. hands.

Two caricatures taken from the North American press of 1901 and 1896 respectively—borrowed from John Johnson's excellent book on the subject[1]—reflect the prevailing views given both visual and textual form. In one image, Uncle Sam stridently holds up the Monroe Doctrine while standing upon a large inverted kettle topped by the buildings of the 1901 Pan-American Exposition, which itself (as well as Sam) is supported by various Latin American peoples dressed almost identically and identifiable only by their labels. They kick up their heels, gleefully acknowledging their domination—an attitude not borne out by events of the time. Another caricature pictures Uncle Sam as a melodramatic hero telling the Spanish villain to stand back while he soothes and protects the revolutionary aspirations of a grateful female and *Caucasian* (!) Cuba.

In addition to the use of dependent white-skinned women as symbols for pliant Latin American countries, North American caricaturists turned to two other stereotypes: Latin Americans as children and Latin Americans as "pickaninny" blacks when they "misbehaved" (they were caucasianized only when they were "good"). In both, the patriarchal model remains. In a 1905 image, Cuba is shown as an angry, ragged, and barefoot black child who is in debt and is revolting against good Uncle Sam; the Puerto Rican child, on the other hand, is still Caucasian, well dressed, wearing shoes, and looking on in wonder as Uncle comments "And to think that bad boy came near being your brother." During the Mexican Revolution, the U.S. intervened again. Mexico appears in a 1916 cartoon as a small, dirty, obstreperous, dark-skinned hooligan who will be forced, nonetheless, to take the pill of pacification. By contrast, the "civilized" countries—Cuba, the Philippines, Nicaragua, and Panama— as clean and well-dressed children, set savage Mexico a good example. The United States as hemispheric policeman, lawgiver, standard of civilization, and father figure incorporates the ideologies of Manifest Destiny and Rudyard Kipling's racist "White Man's Burden" wherever the U.S. sought hegemony—as shown in a 1898 caricature in which Uncle Sam, with the approval of John Bull, his teacher, juggles a number of darkskinned "pygmies" representing New World countries. The use of pygmies is even more insidious than that of children; pygmies will never "grow up."

I have spent so much time on the view of Latin Americans from the United States because the three populations to be considered—Mexicans, Puerto Ricans, and Cubans—not only form the largest contingent of Spanish-language peoples in the United States, but trace their presence

Fig. 90

within these borders, and its consequent humiliations, to this manifested history—which space constraints force me to treat very schematically. Despite certain common denominators, it must be stressed, these are three separate histories which find their roots in conquest but their differences in the details of those histories, and in questions of changing cultural practices and in class, race, and gender realities, across three generations of artists.

The sustained and influential black civil rights protests of the late l950s and the 1960s inspired a whole generation of primarily working-class Mexican- and Puerto Rican–descent young people in the Southwest, the Midwest (where both groups met), and New York to emulate this struggle on their own behalf. In addition to economic and political issues, the two groups advanced demands for relevant education, respect for racial, cultural, and linguistic particularities, and the need for alternative spaces to disseminate cultural information. All were achieved with great difficulty. The Cuban exiles, on the other hand, did not begin to arrive until the 1960s and were the only immigrant group at the time receiving substantial financial aid from the U.S. government, a fact that aroused considerable bitterness among impoverished blacks, Chicanos, and Puerto Ricans. The earliest Cuban artistic manifestation in the U.S. was that of middle-class academy-trained artists from the Island who disassociated themselves from the postrevolutionary art beginning to evolve in Cuba in order to look back toward the Cuban avant-garde of the 1920s. Thus Cuban artistic development in the United States, for reasons of class, political posture, and chronology, has had a different character. In fact, the militant and political character of Chicanos and Puerto Rican artists was such that anti-Castro Cubans were excoriated and ostracized by both groups, while images of "Ché" Guevara appeared in East Los Angeles and on the headquarters of the Puerto Rican Young Lords' headquarters in Chicago.

Chicanos

The term "Chicano" began to be used in the 1960s as a special self-designation for young Mexican-Americans who wished to separate themselves from what they viewed as the assimilationist tendencies of their forebears. Sociopolitical and economic issues (national and international) formed one thematic nexus, while the reclamation of a societally suppressed identity formed the other—including their Indo-American roots. Both prongs of this program served as levers for the establishment of new power relations with the dominant society.

With both murals and graphics, Chicanos underlined their support for the embattled farmworkers of California and Texas. Portraits of Mexican and Chicano heroes appeared—such as those of imprisoned revolu- Fig. 91

tionary Ricardo Flores Magón and martyred newspaper reporter Rubén Salazar. Urban problems of landlord arson and drug use in one California mural borrow from a famous mural composition by Siqueiros. The Chicano engagement with Mexican art and its politics was selective: it was limited to pre-Columbian and contemporary Indians, to the popular (the skeletons of printmaker Posada, and folk Catholicism), and to the revolutionary muralists. Some artists painted police brutality and the self-destructiveness of gang warfare, while others illustrated the destruction of mind and culture by U.S. mass media, a process which was remediable through education in Mexican and Chicano history. Revival by Chicano artists of the zoot-suit Pachuco culture from the 1940s was updated by sympathetic portraits of their "children," the contemporary *cholo* and *chola* in the khakis and oversize T-shirts and the thrift shop chic of the post-fifties generation.

Women's images entered the arena with labor organizers Luisa Moreno and Emma Tenayuca presented in murals and posters. By the 1980s, women in particular looked to Frida Kahlo as a role model and prototype for their own lives. Some women reconsidered the Virgin of Guadalupe as a motif, and placed the Virgin in scandalous tandem with the Aztec goddess Coatlicue.

The ambivalence of identity for a Chicana caught between two cultures and for a lesbian threatened by homophobia has most poignantly been explored in the work of one Chicana photographer, while a number of gay men have pictorialized or designed performances about their status in our society. Border issues were addressed on the question of dehumanized Mexican workers in border towns, and by an indictment of the immigration authorities at the U.S./Mexico frontier who daily crucify the undocumented worker. By extension, these artists have questioned all such political/social boundaries. Finally, some artists have confronted contemporary problems of urban alienation, loneliness, competitiveness, and other issues that affect Chicanos and the whole society.

Fig. 92

Puerto Ricans

Under a nomenclature that includes Puerto Ricans, Ricans, Neo-Ricans, Nuevo Yorrícan (Spanish), Nuyorican (English), and Taíno Indian designations such as Borinquen (and Boricua as an adjective), Puerto Ricans—who began coming to United States in numbers as economic refugees in the 1940s, and in increasing quantity during the 1960s—form a large group in New York (whence the name Nuyorican), with smaller enclaves in Philadelphia and Chicago. The colonial status of Puerto Rico which allows the Afro-Hispanic Puerto Ricans to enter the U.S. mainland freely, be taxed, be subject to the draft, but not to have representation in Congress, has produced, on one hand, a terrible ambivalence about identity

and, on the other, a well-defined and militant platform for national independence which serves to strengthen that identity. Like Chicanos, Puerto Ricans also created murals during the 1970s in New York and Chicago celebrating national heroes such as Pedro Albizu Campos. In Chicago, a Puerto Rican and a Japanese artist collaborated on a history of Latin American and Japanese laborers in the United States, while another collaborative mural protested urban displacement as it affected two poor communities.

Fig. 93

In 1969, both the Museo del Barrio and the Taller Alma Boricua (Puerto Rican Workshop) were established in New York as cultural outposts for the Puerto Rican community.[2] Rafael Tufiño, a major printmaker and painter from the Island, designed the first Workshop silkscreen poster. Tufiño worked with Nuyorican and Island artists to translate to New York the collectivist and community service principles of San Juan's Centro de Arte Puertorriqueño (CAP), the 1950s organization that advanced the earliest nationalist artists' program of the Island. Located in Spanish Harlem and hosting outdoor exhibitions, classes for the community, and cultural activities of all sorts, the collaboration between Island and migrant artists, many born in New York, is unique for the three groups being considered. (While Chicanos also established cultural centers, galleries, and art classes across the Southwest in the 1970s, they were set up completely with local resources.)

The main themes of Puerto Rican art can be seen in works produced by Taller artists. Still lifes of tropical plants, the banana as the staff of life in Puerto Rico, and evocations of the aboriginal Taíno Indian set up important prototypes for Nuyoricans, while one artist's personal "spirit traps" laid claim to a lost indigenous heritage. West African deities (hybridized with Catholic saints in Puerto Rican and Cuban *santería*), or the ritual attending a child's burial among African-descent peoples, reactivate another cultural source.

Political themes remain cogent to the present; they are embodied in works advocating a free Puerto Rico and recreating Puerto Rico's history as a continuum from the Taíno Indians to the New York landscape and in works detailing abuses of the Island and the destructiveness of U.S. military exercises there. Alienation, loneliness, the split and fractured identity, and the search to recover a whole vision of self and existence are the themes of some works, while self-portraits portray interior states of mind.

Fig. 94

Cubans

While sharing many of the same problems as immigrants from elsewhere in the hemisphere, Cuban Americans have a particularly complex relationship with their adopted country owing to the intensity of U.S. involvement in Cuban affairs.[3] The Cubans came in two great waves: the

approximately 215,000 who left the Island between 1959 and 1962, included light-skinned ultraright landowners, business people, and members of the middle class—in other words, those who stood to lose the most within the more egalitarian society sought by the revolution; and the *marielitos* of 1980—with many trickling in between these dates.
Fig. 95 Today there are approximately a million Cubans dispersed between Florida, New York, New Jersey, Illinois, and California. The militarization of the first group's opposition to the Cuban revolution by the United States (which must be considered as yet another Manifest Destiny intervention in the internal affairs of Cuba) has consolidated the power of the most reactionary forces concentrated in Miami—and polarized the entire community, including artists. It has led to terrorism exercised against other Cubans who do not support the hard-line policies. Such was the case of the bomb that exploded, with considerable damage, outside the doors of Miami's Museum of Arts and Culture on June 14, 1990—the second in the museum's brief history. Furthermore, artists Ana Mendieta and Nereyda García had reportedly appeared on "hit lists" for repeatedly visiting Cuba.

The *marielitos* who came en masse via a boatlift from Mariel, Cuba, were not wealthy or all white or necessarily focused on a military anti-
Fig. 96 Castro crusade like the earlier exiles (though among their numbers were those who actively attacked the Cuban system). Their ranks also included a percentage of persecuted homosexuals. They were shunned by the established community[4] and encountered racism and homophobia in Miami and the country at large. Cuban American art, therefore, divides itself not only generationally, but by race, class, and sexual preference, and is polarized between those who are determined to exterminate the Castro regime and those who wish to establish a dialogue and modus vivendi with the Island after thirty years of isolation.[5]

Best known in this latter respect are the works of the now-deceased Ana Mendieta, wrenched from her family and sent to the United States, whose search for self-healing and a new identity employed a feminist language. Another artist has made "the victim" his principal theme—par-
See fig. 78 ticularly the political exile exposed to the brutalities of New York—using his own persona as the alpha and omega of a series of alienating and terrifying experiences. Metamorphoses of various kinds appear in Cuban art, and images emblematic of exile. The anguish of nostalgia for a lost homeland is particularly poignant among the Cubans, who are true exiles in that most cannot return even if they wished—which many claim they do not. Some refer back to childhood memories and mementos in Cuba, others portray the voyage of exile. The search for identity also invokes spiritual beliefs, drawing on rituals of *santería* and other Afro-Cuban religions as a major source of imagery and practice. (Ironically, their parallel generation in Cuba has focused on similar subjects, as well as making critical

statements about their society, and are receiving international attention for their originality and creativity—in the face of Cuban-exile claims that no art can exist in Castro's Cuba.) Another subject explored by Cuban exiles is that of dictators of the twentieth century. Others deal with the temptations of consumerism, or the unexpected sufferings of the *marielitos* in the United States.

If nostalgia and the search for a personal identity are keynotes of contemporary Cuban art (which has rarely engaged political issues of the United States as they affected so-called minorities), ethnicity and personal identity have also become major motifs for Chicanos and Puerto Ricans in the 1980s, replacing much—if not all—social protest themes of the 1970s. In the process, there has been an increasing tendency for all three groups to form limited artistic alliances against the second-class status tendered to most Latin American and Latino artists in the United States—even in the face of the "boom" of the 1980s.

In closing, I would like to revert to a caricature from the U.S. press illustrating the fact that the United States is far from abandoning the tragic workings of Manifest Destiny, which we can witness in the events transpiring since 1980 in Central America, Grenada, and Panama. In a Fig. 97 1969 cartoon, "primitive" art collector Nelson Rockefeller returns to report on his trip to Latin America to then President Nixon. The cartoonist more accurately gauges the situation than do the two politicians when he shows a "primitive sculpture" of a military dictator sitting on a prostrate peasant over the legend, "The Rich Get Richer and the Poor Have Children." In unbelievable contrast with this reality, the real Rockefeller report, when delivered, advised increased assistance to Latin America's military establishments as bulwarks against communism! Our newest population of victims to wrongheaded Manifest Destiny ideology—the millions of Central Americans—can be directly traced to this policy as U.S. history endlessly repeats itself.

Notes

1. John L. Johnson, *Latin America in Caricature* (Austin: University of Texas Press, 1980).

2. I am indebted to El Museo del Barrio and to Marcos Dimas of the Taller Boricua for research materials. The catalogue *Taller Alma Boricua: Reflecting on Twenty Years of the Puerto Rican Workshop*, produced by the Museo in 1990, and the documentary materials researched by artist Diógenes Ballester, who provided them to me in photocopy, have been enormously helpful. Artist Juan Sánchez has been a major source of information and insight over the years about U.S. Puerto Rican art and its relation to the Island, as has Nilda Peraza of the now defunct Museum of Contemporary Hispanic Art.

3. María del Los Angeles Torres, "Will Miami Fall Next?" *NACLA: Report on the Americas* 24, no. 3 (November 1990): 27.

4. Maria del Los Angeles Torres, "Will Miami Fall Next?": 27.

5. The Cuban exile situation is still in a state of flux. Not only are the younger artists more moderate in their attitudes toward the Island, but some are moving toward reconciliation with the eighties' generation of Island artists who have been forced to leave Cuba for economic reasons after the fall of the Soviet Union in 1991 and the tightening of the U.S. blockade in 1992. Most, though not all, have not broken their ties with Cuba and continue to exhibit there. In the face of right-wing condemnation, Miami and New York Cubans have exhibited with the colony of young artists residing in Mexico City and in Europe. See *15 artistas cubanos*, catalogue, Ninart Centro de Cultura, Mexico City, 1991; Elizabeth Hanly, "The Cuban Museum Crisis, or Fear and Loathing in Miami," *Art in America* 80, no. 2 (February 1992): 31–37; Peter Plagens, Paul Katel, and Tim Padgett, "The Next Wave from Havana," *Newsweek*, November 30, 1992: 76–78.

SELECTED GENERAL BIBLIOGRAPHY
ON LATIN AMERICAN ART

Continental in scope for the Spanish and Portuguese-speaking nations are the following publications:

Acha, Juan, *Arte y sociedad: Latinoamérica. Sistema de producción*, Mexico City: Fondo de Cultura Económica, 1979.

Ades, Dawn et al., *Art in Latin America: The Modern Era, 1820–1980*, catalogue, New Haven: Yale University Press, 1989.

Africa en América, catalogue, Mexico City: Centro de Estudios Económicos y Sociales del Tercer Mundo Mexico City, 1982.

Baddeley, Oriana and Valerie Fraser, *Drawing the Line: Art and Cultural Identity in Contemporary Latin America*, London: Verso, 1989.

Barnitz, Jacqueline, 1) *Latin American Artists in the U.S. before 1950*, catalogue, Flushing, New York: Godwin-Ternbach Museum, Queens College, 1981; 2) *Latin American Artists in the U.S., 1950–1970*, catalogue, Flushing, New York: Godwin-Ternbach Museum, Queens College, 1983; 3) et al., *Latin American Artists in New York since 1970*, catalogue, Austin: Archer M. Huntington Art Gallery, University of Texas, 1987.

Bayón, Damián 1) (ed.) *América Latina en sus artes*, Mexico City: Siglo Veintiuno Editores, 1974; 2) (ed.) *El artista latinoamericano y su identidad*, Caracas, Venezuela: Monte Avila Editores, 1977; 3) *Artistas contemporáneos de América Latina*, Paris: Ediciones del Serbal/UNESCO, 1981; 4) *Aventura plástica de Hispanoamérica: Pintura, cinetismo, artes de acción, 1940–1972*, Mexico City: Fondo de Cultura Económica, 1974; 5) *Historia del arte hispanoamericano: Siglos XIX y XX*, Madrid: Editorial Alhambra, 1988.

Bedoya, Jorge M., and Noemi Gil, *El arte en América Latina*, Buenos Aires: Centro Editor de América, 1973.

Bigname, Ariel, *Arte, ideología y sociedad*, Buenos Aires: Ediciones Silaba, 1973.

Cancel, Luis R., et al., *The Latin American Spirit: Art and Artists in the United States, 1920–1970*, catalogue, New York: Harry N. Abrams, 1988.

Castedo, Leopoldo, *A History of Latin American Art and Architecture from Pre-Columbian Times to the Present*, trans. Phyllis Freeman, New York: Praeger, 1969.

Catlin, Stanton Loomis, and Terence Grieder, *Art of Latin America since Independence*, catalogue, Yale University Press, 1966.

Cervantes, Miguel (ed.), *Mito y magia en América: Los ochenta*, catalogue, Monterrey, Nuevo León, Mexico: El Museo de Arte Contempóraneo de Monterrey, 1991.

Chase, Gilbert, *Contemporary Art in Latin America: Painting, Graphic Art, Sculpture, Architecture*, New York: Free Press, 1970.

Claves del arte de nuestra América: Documentos inaugurales 1, no. 1–16, Havana: Casa de la Américas, November 1986.

Damaz, Paul F., *Art in Latin American Architecture*, New York: Reinhold, 1963.

Day, Holliday T., and Hollister Sturges (eds.), *Art of the Fantastic: Latin America, 1920–1987*, catalogue, Indianapolis: Indianapolis Museum of Art, 1987.

Franco, Jean, *The Modern Culture of Latin America: Society and the Artist*, (rev. ed.), Harmondsworth: Penguin Books, 1970.

García Canclini, Néstor, 1) *Arte Popular y Sociedad en América Latina*, Mexico City: Editorial Grijalbo, 1977; 2) *Las culturas populares en el capitalismo*, Mexico City: Ed. Nueva Imagen, 1982; 3) *Culturas híbridas: Estrategias para entrar y salir de la modernidad*, Mexico City: Editorial Grijalbo, 1989.

Haight, Anna Lyon (ed.), *Retrato de la América Latina hecho por sus artistas gráficos/ Portrait of Latin America as Seen by Her Printmakers*, New York: Hastings House, 1946.

Hecho en latinoamérica: Primera muestra de la fotografía latinoamericana contemporánea, catalogue, Mexico City: Consejo Mexicano de Fotografía, 1978.

Hecho en latinoamérica: Memorias del primer coloquio latinoamericano de fotografía, Mexico City: Consejo Mexicano de Fotografía, 1978.

Hecho en Latino América: Segundo Coloquio latinoamericano de fotografía, Mexico City: Consejo Mexicano de Fotografía, 1981.

Juan, Adelaida de, *En la galería latinoamericana*, Havana: Casa de las Américas, 1977.

Kirstein, Lincoln, *The Latin American Collection of the Museum of Modern Art*, New York: Museum of Modern Art, 1943.

La Duke, Betty, *Compañeras: Women, Art, and Social Change in Latin America*, San Francisco: City Lights Books, 1985.

Lauer, Mirko, *La producción artesanal en América Latina*, Lima: Mosca Azul Ed., 1989.

Moraes Belluzzo, Ana Maria de (ed.), *Modernidade: Vanguardas artísticas na América Latina*, São Paulo: Fundação Memorial da América Latina, 1990.

Parra, Tomás (ed.), *Artes visuales e identidad en América Latina*, catalogue, Mexico City: Foro de Arte Contemporáneo, 1982.

Rodman, Selden, *Artists in Tune with Their World: Masters of Popular Art in the Americas and Their Relation to the Folk Tradition*, New York: Simon and Schuster, 1982.

Ramírez, Mari Carmen (ed.), *El Taller Torres-García: The School of the South and its Legacy*, catalogue, Austin: University of Texas Press, 1992.

Rowe, William, and Vivian Schelling, *Memory and Modernity: Popular Culture in Latin America*, London: Verso, 1991.

Sullivan, Edward, *Artistas latinoamericanos del siglo XX/Latin American Artists of the Twentieth Century*, catalogue, New York: Museum of Modern Art, 1992.

Traba, Marta, 1) *Arte latinoamericano actual*, Caracas: Editora San José, 1972; 2) *Dos décadas vulnerables en las artes plásticas latinoamericanas, 1950–1970*, Mexico City: Siglo Veintiuno, 1973.

Voces de ultramar. Arte en América Latina y Canarias: 1910–1960, catalogue, Madrid: Centro Atlántico de Arte Moderno, 1992.

Among the surveys and anthologies concerned exclusively with architecture and city planning are to be found:

Bullrich, Francisco, *New Directions in Latin American Architecture*, New York: George Braziller, 1969.

Hitchcock, Henry-Russell, *Latin American Architecture since 1945*, rpt., catalogue, New York: Museum of Modern Art, 1972.

López Rangel, Rafael, et al, *Las ciudades latinamericanas*, Mexico City: Instituto Nacional de Bellas Artes, 1989.

Segre, Roberto, et al., *Latin America in Its Architecture*, trans. Edith Grossman, New York: Holmes & Meier, 1981.

Bibliographies, dictionaries, and encyclopedias include the following:

Eder, Rita, and Mirko Lauer, et al., *Teoría social del arte: Bibliografía comentada*, Mexico City: Universidad Nacional Autónoma de México, 1986.

Findlay, James A., *Modern Latin American Art: A Bibliography:* Westport, Conn.: Greenwood Press, 1983.

Gesualdo, Vicente, (ed.), *Enciclopedia del arte en América*, 5 vols., Buenos Aires: Bibliográfica Omeba, 1968.

Nuñez, Benjamín, *Dictionary of Afro-Latin American Civilization*, Westport, Conn.: Greenwood Press, 1980.

Stephens, Thomas M., *Dictionary of Latin American Racial and Ethnic Terminology*, Gainesville: University of Florida Press, 1989.

By countries, we encounter the following titles:

Argentina

Brughette, Romualdo, *Historia del arte en Argentina*, Mexico City: Pormaca, 1965.

Gesualdo, Vicente (ed.), *Diccionario de artistas plásticos en la Argentina*, 2 vols., Buenos Aires: Editorial Inca, 1988.

Glusberg, Jorge, *Arte en la Argentina: Del pop-art a la nueva imagen*, Buenos Aires: Ediciones de Arte Gaglianone, 1985.

Iturburu, Córdoba, *La pintura argentina del siglo XX*, Buenos Aires: Atlántida, 1958.

Romero Brest, Jorge, *Arte el la Argentina: Ultimas decadas*, Buenos Aires: Paidos, 1969.

Bolivia

Querejazu, Pedro, *Pintura boliviana del siglo XX*, La Paz: Banco Hipotecario Nacional, 1989.

Villarroel Claure, Rigoberto, *Arte contemporáneo: pintores, escultores y grabadores bolivianos; desarrollo de las artes y la estética; de la caricatura*, La Paz: Academia Nacional, 1952.

Brazil

Amaral, Aracy, 1) (ed.), *Modernidade: Art brésilien du 20o siècle*, catalogue, Musée d'Art Moderne de la Ville de Paris, 1987; 2) (ed.), *Museu de Arte Contemporânea da Universidade de São Paulo: Perfil de un acervo*, São Paulo: Techint Engenharia, 1988.

Bardi, Pietro Maria, 1) *Pintura, escultura, arquitetura, outras artes*, São Paulo: Ediçoes Melhoramentos, 1975; 2) *O modernismo no Brasil*, São Paulo: Sudameris, 1978.

Cavalcanti, Carlos, et al., *Dicionário brasileiro de artistas plásticas*, 4 vols., Brasília: Instituto Nacional do Livro, 1973–.

Lemos, Carlos, et al., *The Art of Brazil*, trans. Jennifer Clay, New York: Harper and Row, 1983.

Mindlin, Henrique E., *Modern Architecture in Brazil*, New York: Reinhold, 1956.

Pontual, Roberto, 1) *Dicionário das artes plásticas no Brasil*, Rio de Janeiro: Editôra Civilização Brasileira, 1969; 2) (ed.), *Entre dois séculos: Arte brasileira do século XX na coleção Gilberto Chateaubriand*, Rio de Janeiro: Editôra JB, 1987.

Chile

Cruz de Amenábar, Isabel, *Arte: Historia de la pintura y escultura en Chile desde la colonia al siglo XX*, Santiago: Editorial Antártica, 1984.

Galaz, Gaspar, and Milan Ivelić, 1) *La pintura en Chile desde la colonia hasta 1981*, Valparaiso: Ediciones Universitarias de Valparaíso, 1981; 2) *Chile, arte actual*, Valparaiso: Ediciones Universitarias de Valparaíso, 1988.

Colombia

Arte colombiano del siglo XX, catalogue, Bogotá: Centro Colombo-Americano, n.d.[c. 1980].

Ortega Ricaurte, Carmen, *Diccionario de artistas en Colombia*, 2d ed. Bogotá: Plaza & Janes, 1979.

Serrano, Eduardo, *Cien años de arte colombiano, 1886–1986*, Bogotá: Museo de Arte Moderno, 1985.

Costa Rica

Echeverría, Carlos Francisco, *Historia crítica del arte costarricense*, San José, Euned, 1986.

Ferrero, Luis, *La escultura en Costa Rica*, San José: Editorial Costa Rica, 1973.

Rojas González, José Miguel, *Costa Rica en el arte: Colección de artes plásticas*,

Banco Central de Costa Rica, catalogue, San José: Museos Banco Central de Costa Rica, 1990.

Ulloa Barrenechea, Ricardo, *Pintores de Costa Rica*, San José: Editorial Costa Rica, 1975.

Cuba

Gómez Sicre, José, *Pintura cubana de hoy/Cuban Painting Today*, Havana: María Luisa Gómez Mena: 1944.

Juan, Adelaida de, *Pintura cubana: Temas y variaciones*, Mexico City: Universidad Nacional Autónoma de México, 1980.

Merino Acosta, Luz, and Pilar Fernández Prieto (eds.), *Arte Cuba República: Selección de lecturas*, 2 vols., Havana: Universidad de la Habana, 1987.

Museo de Arte Moderno, *Panorama del arte cubano de la colonia a nuestros días: pinturas, grabados y carteles*, catalogue, Mexico City, 1975.

Wood, Yolanda, *De la plástica cubana y caribeña*, Havana: Editorial Letras Cubanas, 1990.

Dominican Republic

Santos, Danilo de los, *La pintura en la sociedad dominicana*, Santiago: Universidad Católica Madre y Maestra, 1979.

Nader, Gary Nicholas, *Arte contemporáneo dominicano*, catalogue in Spanish, English, French, Santo Domingo: Amigo del Hogar, 1984.

Ecuador

Vargas, José María, *Historia del arte ecuatoriano*, Quito: Editorial Santo Domingo, 1964.

Moré, Humberto, *Actualidad pictórica ecuatoriana*, 2d ed., Guayaquil: Editorial Forma, n.d.[c. 1974].

El Salvador

Lindo, Ricardo, *La pintura en El Salvador*, catalogue, San Salvador: Ministerio de Cultura y Comunicaciones, 1986.

Guatemala

Mobil, José A., *Historia del arte guatemalteco*, 3d. ed., Guatemala City: Serviprensa Centroamericana, 1977.

Mexico

Cetto, Max, *Modern Architecture in Mexico*, New York: Praeger, 1961.

Fernández, Justino, 1) *A Guide to Mexican Art from Its Beginnings to the Present*, trans. Joshua Taylor, Chicago: University of Chicago Press, 1969; 2) *El arte moderno en México: breve historia, siglos XIX y XX*, Mexico City: Porrúa, 1937; 3) *La pintura moderna mexicana*, Mexico City: Pormaca, 1964.

Hurlburt, Laurance P., *The Mexican Muralists in the United States*, Albuquerque: University of New Mexico Press, 1989.

Myers, Bernard S., *Mexican Painting in Our Time*, New York: Oxford University Press, 1956.

O'Gorman, Edmundo, et al., *Cuarenta siglos de plástica mexicana: Arte moderno y contemporáneo*, Mexico City: Editorial Herrero, 1971.

Schmeckebier, Laurence E., *Modern Mexican Art*, Westport, Conn.: Greenwood Press, [1939], 1971.

Tibol, Raquel, *Historia general del arte mexicano; Epoca moderna y contemporánea*, Mexico City: Editorial Hermes, 1964.

Nicaragua

Arrellano, Jorge Eduardo, *Pintura y escultura en Nicaragua*, Managua: Banco Central, 1977.

Paraguay

Escobar, Ticio, *Una interpretación de las artes visuales en el Paraguay*, 2 vols., Asunción: Colección de las Américas, 1982.

Peru

Lauer, Mirko, 1) *Introducción a la pintura peruana del siglo XX*, Lima: Mosca Azul, 1976.

Lavall, José Antonio, and Werner Lang, *Arte y tesoros del Perú: Pintura contemporánea, 1820-1960*, 2 vols., Lima: Banco de Credito del Perú en la Cultura, 1976.

Ugarte Elespuru, Juan Manuel, *Pintura y escultura en el Perú contemporáneo*, Lima: Editorial Universitaria, 1970.

Puerto Rico

Delgado, Osiris, "Historia de la pintura en Puerto Rico," *La gran enciclopedia de Puerto Rico*, vol. 8, "Artes Plásticas," Madrid: Forma Gráfica, 1976.

Pérez-Lozano, Manuel, *Arte contempóraneo de Puerto Rico, 1950–1983*, Bayamón, Puerto Rico: Ediciones Cruz Ansata, 1985.

Ramírez, Mari Carmen, *Puerto Rican Painting: Between Past and Present*, catalogue, Princeton, New Jersey, The Squibb Gallery, 1987.

Somoza, María Emilia, *Graphic Arts in Puerto Rico from 1945 to 1970: A Historical Perspective and Artistic Analysis of Selected Prints*, New York University, unpublished dissertation, 1984.

United States

Beardsley, John, and Jane Livingston (eds.), *Hispanic Art in the United States: Thirty Contemporary Painters and Sculptors*, catalogue, New York: Abbeville Press, 1987.

Chicano Art: Resistance and Affirmation, 1965–1985, catalogue, Wight Art Gallery, University of California, Los Angeles, 1990.

Goldman, Shifra M., and Tomás Ybarra-Frausto, *Arte Chicano: A Comprehensive, Annotated Bibliography of Chicano Art, 1965–1981* (with essay), Berkeley: Chicano Studies Library Publication Unit, University of California, Berkeley, 1985.

Quirarte, Jacinto, *Mexican American Artists*, Austin: University of Texas Press, 1973.

Fuentes-Pérez, Ileana, Graciella Cruz-Taura, Ricardo Pau-Llosa (eds.), *Outside Cuba/Fuera de Cúba: Contemporary Cuban Visual Artists/Artistas cubanos contemporáneos*, catalogue, New Brunswich, New Jersey: Rutgers State University, 1989.

Gómez Sicre, José, *Art of Cuba in Exile*, Miami: Editora Munder, 1987.

Zuver, Marc (ed.), *Cuba-USA: The First Generation*, catalogue: Washington, D.C.: Fondo del Sol Visual Arts Center, 1991.

Uruguay

Argul, José Pedro, 1) *Proceso de las artes plásticas del Uruguay: desde la época indigina al momento contemporáneo*, 3d ed. Montevideo: Barreiro y Ramos, 1975; 2) *Pintura y escultura del Uruguay: Historia crítica*, Montevideo: Revista del Instituto Histórico y Geográfico del Uruguay, 1958.

García Esteban, Fernando, *Artes plásticas del Uruguay en el siglo veinte*, Monte: Universidad de la República, 1980.

Peluffo Linari, Gabriel, *De Blanes a Figari: Historia de la pintura uruguaya*, vol. 1, Montevideo: Ed. Banda Oriental, 1991.

Venezuela

Acevedo Mijares, José F., *Historia del arte en Venezuela*, Caracas: Ediciones TEC, 1951.

Boulton, Alfredo, *Historia de la pintura en Venezuela*, Caracas: Editorial Arte, 1964–72.

Calzadilla, Juan, 1) *El arte en Venezuela*, Caracas: Círculo Musical, 1976; 2) *Obras singulares del arte en Venezuela*, Bilboa, Spain: Editorial la Gran Enciclopedia Vasca, and Caracas: Euzuko Americana de Ediciones, 1979.

Montero Castro, Roberto, *De Venezuela: Treinta años de arte contemporáneo (1960–1990)/From Venezuela: Thirty Years of Contemporary Art (1960–1990)*, catalogue, Caracas: Fundación Galería de Arte Nacional, 1992.

SELECTED BIBLIOGRAPHY OF
WORKS CITED

Acuña, Rodolfo, *Occupied America: A History of Chicanos*, 2nd ed. New York: Harper & Row, 1981.

Ades, Dawn (ed.), *Art in Latin America: The Modern Era, 1820–1980.* New Haven: Yale University Press, 1989.

Africa Information Service, *Return to the Source: Selected Speeches of Amilcar Cabral*, New York: Monthly Review Press, 1973.

Agosín, Marjorie, *Scraps of Life: Chilean Arpilleras, Chilean Women and the Pinochet Dictatorship*, trans. Cola Franzen, Trenton: The Red Sea Press, 1987.

Aguila M., Osvaldo, *Propuestas neo-vangardistas en la plástica chilena: Antecedentes y contexto*, Santiago: CENECA, 1983.

Albert, Judith Calvir and Stewart Edward Albert, *The Sixties Papers: Documents of a Rebellious Decade*, New York: Praeger, 1984.

Alfaro Siqueiros, David. *See* Siqueiros, David Alfaro.

Alvarez Bravo, M., David R. Godine and the Corcoran Gallery of Art, Boston and Washington, D.C., 1978.

Amaral, Aracy, *Arte para quê? A preoçupacão na arte brasileira, 1930–1970*, 2nd ed., São Paulo: Livraria Nobel, 1987.

"A Market Solution for the Americas? The Rise of Wealth and Hunger," *NACLA Report on the Americas* 26, no. 4 (February 1993).

América en la mira: Muestra de gráfica internacional, Mexico City: Frente Mexicano de Trabajadores de la Cultura, 1978.

Angel, Félix, "The Latin American Presence. The Argentine New Figuration Painters: Ernesto Deira, Rómulo Macció, Luis Felipe Noé, and Jorge de la Vega," in Luis Cancel (ed.), *The Latin America Spirit: Art and Artists in the United States, 1920–1970*, 222–83, New York: Harry N. Abrams, 1988.

A nivel informativo: José Antonio, Victor Muñoz, Carlos Fink [sic], Sala Metropolitana, Palacio de Bellas Artes, Mexico City, 1973.

Aronowitz, Stanley, "Postmodernism and Politics," *Social Text*, no. 18 (Winter 1987–88): 99–115.

Arte Acá, "Grupos pictóricos en México," *La Semana de Bellas Artes* 16 (March 22, 1978).

A través de la frontera, Mexico City: Centro de Estudios Económicos y Sociales del Tercer Mundo, 1983.

Balfe, Judith Huggins, "Artworks as Symbols in International Politics," *International Journal of Politics, Culture and Society* 1, no. 2 (Winter 1987): 5[195]–27[217].

Barnett, Alan W., *Community Murals: The People's Art*, Philadelphia: The Art Alliance Press, 1984.

———, "The Resurgence of Political Art in Mexico," *San Jose Studies* 2, no. 2 (May 1976): 4–30.

Barrera, Mario, *Race and Class in the Southwest: A Theory of Racial Equality*, Notre Dame: University of Notre Dame Press, 1979.

Barrios de Chungara, Domitilia and Moema Viezzer, *Let Me Speak! Testimony of Domitilia, a Woman of the Bolivian Mines*, trans. Victoria Ortiz, New York: Monthly Review Press, 1978.

Bartra, Roger, "Mexican *oficio:* The Miseries and Splendors of Culture," *Third Text* (London), no. 14 (Spring 1991): 7–15.

Baxandall, Lee, *Marxism and Aesthetics: A Selective Annotated Bibliography. Books and Articles in the English Language*, New York: Humanities Press, 1973.

Bayón, Damián, *Aventura plástica de Hispanoamérica: Pintura, cinetismo, artes de acción (1940–1972)*, Mexico City: Fondo de Cultura Económica, 1974.

———, "La mejor plástica de una nueva cultura: El afichismo cubano," *Sin Nombre* (San Juan, Puerto Rico) 1, no. 2 (1970).

Beardsley, John, and Jane Livingston, *Hispanic Art in the United States: Thirty Contemporary Painters and Sculptors*, New York: Abbeville Press, 1987.

Beauvoir, Simone de, *The Second Sex*, trans. H. M. Parshley, New York: Alfred A. Knopf, 1952.

Bello, Walden, "South Gets 'Discipline,' Not Development," *Guardian* (June 17, 1992): 12.

Beltrán, Félix, "The Poster and National Consciousness," *Art and Artists* (February 1983): 10–11.

Berger, John, *Art and Revolution: Ernst Neizvestny and the Role of the Artist in the U.S.S.R.*, New York: Pantheon Books, 1969.

———, *The Success and Failure of Picasso*, Hammondsworth: Penguin Books, 1965.

———, *Ways of Seeing*, New York: Viking Press, 1973.

Berman, Greta, *The Lost Years: Mural Painting in N.Y. City under the WPA Federal Art Project, 1935–1943*, New York: Garland Publishing, Inc. 1978.

Bianchi, Soledad, "El movimiento artístico en el conflicto político actual," *Casa de las Américas* (Havana), no. 130 (February 1982): 146–54.

Billeter, Erika (ed.), *Images of Mexico: The Contribution of Mexico to 20th Century Art*, Dallas: Dallas Museum of Art, 1987.

Birmingham, Peter, *The New Deal in the Southwest: Arizona and New Mexico*, Tucson: University of Arizona Museum of Art, n.d. [1980].

Bloch, Lucienne, "On Location with Diego Rivera," *Art in America* 74, no. 2 (February 1986): 102–23.

Bloch, Peter, *Painting and Sculpture of the Puerto Ricans*, New York: Plus Ultra Educational Publishers, 1978.

Bloom, Allan, *The Closing of the American Mind*, New York: Simon and Schuster, 1987.

Boime, Albert, *Art in an Age of Bonapartism, 1800–1815*, Chicago: University of Chicago Press, 1990.

———, *Art in an Age of Revolution, 1750–1800*, Chicago: University of Chicago Press, 1987.

Bonfil Batalla, Guillermo (ed.), *Utopia y revolución: El pensamiento político contemporáneo de los indios en América Latina*, Mexico City: Editorial Nueva Imagen, 1981.

Boyd, E., *Popular Arts of Spanish New Mexico*, Santa Fe: Museum of New Mexico, 1974.

Brenner, Anita, *Idols behind Altars*, Boston: Beacon Press, [1929], 1970.

Brett, Guy, "Hélio Oiticica: Reverie and Revolt," *Art in America* 77, no. 1 (January 1989): 110–20, 163–65.

———, "A Radical Leap," in Dawn Ades (ed.), *Art in Latin America: The Modern Era, 1820–1980*, 253–83. New Haven: Yale University Press, 1989.

———, *Transcontinental: An Investigation of Reality. Nine Latin American Artists*, London: Verso, 1990.

Briggs, Charles L., *The Wood Carvers of Córdoba, New Mexico: Social Dimensions of an Artistic "Revival,"* Knoxville: University of Tennessee Press, 1980.

Bullrich, Francisco, *New Directions in Latin American Architecture*, New York: George Braziller, 1969.

Burgos-Debray, Elizabeth (ed.), *I, Rigoberta Menchú: An Indian Woman in Guatemala*, trans. Ann Wright, London: Verso, 1964.

Burton, Julianne, (ed.), *Cinema and Social Change in Latin America: Conversations with Filmmakers*, Austin: University of Texas Press, 1986.

Cancel, Luis (ed.), *The Latin American Spirit: Art and Artists in the United States, 1920–1970*, New York: Harry N. Abrams, 1988.

Camnitzer, Luis, "Carlos Capelán," in *Carlos Capelán: Kartor och landskap*, Lund, Sweden: Lunds Konsthall, 1992–93.

Campa, Arthur L., *Hispanic Culture in the Southwest*, Norman: University of Oklahoma Press, 1979.

Carpentier, Alejo, "De lo real maravilloso americano," (1966), rpt. in *Revolución, letras, arte*, 188–200, Havana: Editorial Letras Cubanas, 1980.

Catlin, Stanton, and Terence Grieder, *Art of Latin America since Independence*, New Haven: Yale University Press, 1966.

Cato, Susana, "'Confidencial,' la lista completa de la colección de arte Banamex; su monto 200 milliones de pesos," *Proceso* (Mexico) no. 308 (September 27, 1982): 56–59.

Cerroni-Long, E. L., "Ideology and Ethnicity: An American-Soviet Comparison," *Journal of Ethnic Studies* 14, no. 3, Fall 1986.

Charlot, Jean, *The Mexican Mural Renaissance: 1920–1925*, New Haven: Yale University Press, 1967.

Chase, Gilbert, *Contemporary Art in Latin America*, New York: The Free Press, 1970.

Christ, Ronald, "Catalina Parra and the Meaning of Materials," *Artscanada* 38, no. 1 (March–April 1981): 3–7.

Clark, T. J., *Image of the People: Gustave Courbet and the Second French Republic, 1848–1851*, Greenwich: New York Graphic Society, Ltd., 1973.

Cockcroft, Eva, "Abstract Expressionism: Weapon of the Cold War," *Artforum* 12, no. 10 (June 1974): 39–41.

——, "Notes on Muralism in Mexico," *Community Murals Magazine* (Fall 1981): 17–20.

Cockcroft, Eva, and David Kunzle, "Report from Nicaragua," *Art in America* 70 (May 1982): 51–59.

Cockcroft,Eva, et al., *Toward a People's Art: The Contemporary Mural Movement*, New York: E. P. Dutton & Co., 1977.

Cockcroft, James D., *Mexico: Class Formation, Capital Accumulation and the State*, New York: Monthly Review Press, 1983.

Cook, Geoffrey, "The Padín/Caraballo Project," in Michael Crane and Mary Stofflet, eds., *Correspondence Art: Source Book for the Network of International Postal Art Activity*, 369–74, San Francisco: Contemporary Arts Press, 1984.

Cortina, Leonor, "Artes visuales: Las místicas, las dóciles, las rebeldes," in *La mujer mexicana en el arte*, 134–79, Mexico City: Bancreser, S.N.C., 1987.

Cotera, Martha P., *The Chicana Feminist*, Austin: Information Systems Development, 1977.

Crane, Michael, "The Spread of Correspondence Art," in Michael Crane and Mary Stofflet (eds.), *Correspondence Art: Source Book for the Network of International Postal Art Activity*, 133–98, San Francisco: Contemporary Arts Press, 1984.

Craven, David, *The New Concept of Art and Popular Culture in Nicaragua since the Revolution in 1979*, Lewiston, N.Y.: The Edwin Mellen Press, 1989.

Craven, David, and John Ryder, *Art of the New Nicaragua*, privately printed, 1983.

Croix, Horst de la, and Richard G. Tansey, *Gardner's Art through the Ages*, 6th ed., New York: Harcourt Brace Jovanovich, 1975.

Crow, Thomas, "Art History as Tertiary Text," *Art in America* 78, no. 4 (April 1990): 43–45.

Cryer, Patricia L. Wilson, *Puerto Rican Art in New York: The Aesthetic Analysis of Eleven Painters and Their Work*, unpublished Ph.D. dissertation, New York University, 1984.

Day, Holliday T., and Hollister Sturges (eds.), *Art of the Fantastic: Latin America, 1920–1987*, Indianapolis Museum of Art, 1987.

DeNoon, Christopher, *Posters of the WPA*, Los Angeles: The Wheatley Press, 1987.

Dietz, James L., *Economic History of Puerto Rico: Institutional Change and Capitalist Development*, Princeton: Princeton University Press, 1986.

Dorfman, Ariel, and Armand Mattelart, *How to Read Donald Duck: Imperialist Ideology in the Disney Comic*, trans. by David Kunzle, New York: International General, 1975.

———, "The Invisible Chile: Three Years of Cultural Resistance," *Praxis* 2 (Goleta, Calif.), no. 4 (1978).

Drescher, Tim, *Community Murals Magazine*, Chicago/San Francisco: 1978–87.

Durham, Jimmie, "Legal Aliens," in *The Hybrid State*, 74–78, New York: Exit Art (1992).

Eels, Richard, *The Corporation and the Arts*, New York: MacMillan Co., 1967.

Egbert, Donald Drew, *Socialism and American Art in the Light of European Utopianism, Marxism and Anarchism*, Princeton: Princeton University Press, 1967.

———, *Social Radicalism and the Arts: Western Europe. A Cultural History from the French Revolution to 1968*, New York: Alfred A. Knopf, 1970.

El pan nuestro de cada día, Santiago de Chile: Terranova Editores S.A., 1986.

Escobar, Ticio, "Identity and Myth Today/Identidad, mito: Hoy." *Third Text* (London) 20 (Autumn 1992): 23–32.

Espinoza, César H., "Arte y praxis política: Frente de Trabajadores Culturales," *El Universal* (Mexico; February 8, 1978): 1–3.

Expediente Bienal X, Mexico City: Editorial Acción Libre [Beau Geste Press], 1980.

Exposición: Arte, luchas populares en México, Museo Universitario de Ciencias y Artes, Mexico City, February [1979].

Exposición de obras plásticas con motivo del Primer Simposio Mexicano Centroamericano de Investigación Sobre La Mujer, Museo de Arte Alvar y Carmen T. de Carrillo Gil, Mexico City, 1977.

Fann, K. T., and Donald C. Hodges, *Readings in U.S. Imperialism*, Boston: Sargent, 1971.

Fanon, Frantz, *The Wretched of the Earth*, trans. Constance Farrington, New York: Grove Press, 1968.

Favela, Ramón, *The Art of Rupert García: A Survey Exhibition*, San Francisco: Chronicle Books, 1986.

Ferguson, Russell (ed.), *Out There: Marginalization and Contemporary Culture*, New York: New Museum of Contemporary Art, 1990.

Ferguson, Russell, et al. (eds.), *Discourses: Conversations in Postmodern Art and Culture*, New York: New Museum of Contemporary Art, 1990.

Fernández Retamar, Roberto, "Calibán y otros ensayos." *Casa de las Américas*, no. 68 (1971), rpt. as "Calibán" in *Revolución, letras, arte*, 221–76, Havana: Editorial Letras Cubanas, 1980.

———, *Caliban and Other Essays*, trans. Edward Baker, Minneapolis: University of Minnesota, 1989.

Films with a Purpose: A Puerto Rican Experiment in Social Films, New York: Exit Art and El Instituto de Cultura Puertorriqueña, 1987.

Fine, Elsa Honig, *The Afro-American Artist: A Search for Identity*, New York: Holt, Rinehart and Winston, 1973.

Finkelstein, Sidney, *Existentialism and Alienation in American Literature*, New York: International Publishers, 1965.

Fischer, Ernst, *The Necessity of Art: A Marxist Approach*, trans. Anna Bostock, Harmondsworth: Penguin Books, 1963.

Fitzgerald, Frank, and Ana Rodríguez, "Guayasamín: Artless Power vs. Powerful Art," *NACLA Report on the Americas* 23, no. 2 (July 1989): 4–6.

Flora, Cornelia Butler, "The Fotonovela in Latin America," *Studies in Latin American Popular Culture* 1 (1982): 15–26.

Foner, Philip S., *History of the Labor Movement in the United States*, vol. 3, *The Policies and Practices of the American Federation of Labor, 1900–1909*, New York: International Publishers, 1964.

Foster, James C., *American Labor in the Southwest: The First One Hundred Years*, Tucson: The University of Arizona Press, 1982.

Franco, Jean, "Dependency Theory and Literary History: The Case of Latin America," *Minnesota Review*, no. 5 (Fall 1975): 65–79.

———, *The Modern Culture of Latin America: Society and the Artist*, rev. ed., Harmondsworth: Penguin Books, 1970.

———, *Plotting Women: Gender and Representation in Mexico*. New York: Columbia University, 1989.

Freire, Paulo, *Pedagogy of the Oppressed*, trans. Myra Bergman Ramos, New York: Herder and Herder, 1970.

Friedan, Betty, *The Feminine Mystique*, New York: W. W. Norton, 1963.

Fuentes, Annette, "New York: Elusive Unity in La Gran Manzana," *NACLA Report on the Americas* 26, no. 2 (September 1992): 27–33.

Galaz, Gaspar, and Milan Ivelic', *Chile: arte actual*, Valparaíso: Ediciones Universitarias de Valparaíso, 1988.

———, *La pintura en Chile desde la colonia hasta 1981*, Valparaíso: Ediciones Universitarias de Valparaíso, 1981.

Galeano, Eduardo, *Open Veins of Latin America: Five Centuries of the Pillage of a Continent*, trans. Cedric Belfrage, New York: Monthly Review Press, 1973.

García Canclini, Néstor, *Arte popular y sociedad en América Latina*, Mexico City: Editorial Grijalbo, 1977.

———, *Culturas híbridas: Estrategias para entrar y salir de la modernidad*, Mexico City: Editorial Grijalbo, 1989.

———, "Cultura y nación: Para qué no nos sirve ya Gramsci," *Nueva Sociedad* (Caracas), no. 115 (September–October 1991): 98–103.

———, "Culture and Power: The State of Research," *Media, Culture and Society* 10 (1988): 467–96.

———, "Fiestas populares o espectáculos para turistas," *Plural*, 2ª epoca, no. 126, Mexico City, March 1982: 40–52.

———, *La producción simbólica: Teoría y método en sociología del arte*, Mexico City: Siglo XXI Editores, 1979.

———, *Las culturas populares en el capitalismo*, Mexico City: Ed. Nueva Imagen, 1982.

Garrigan, John, et al., "Introduction," in *Images of an Era: The American Poster, 1945–75*, 10, Washington, D.C.: Smithsonian Institute, 1975.

Gever, Martha, "Art Is an Excuse: An Interview with Felipe Ehrenberg," *Afterimage* (April 1983): 12–18.

Giroux, Henry A., *Border Crossings: Cultural Workers and the Politics of Education*, New York: Routledge, 1992.

Glade, William (ed.), *Privatization of Public Enterprises in Latin America*, San Francisco: ICS Press, 1991.

Goldman, Shifra M., *Border Issues/La Frontera*, El Paso: Bridge Center for Contemporary Art, 1991–92.

———, *Contemporary Mexican Painting in a Time of Change*, Austin: University of Texas Press, 1981.

———, "Identifying Latin American Art: Are the Lines Accurately Drawn?" *Art History* 13, no. 4 (December 1990): 590–94.

———, "La década crítica de la vanguardia cubana/The Critical Decade of the Cuban Avant-Garde," *Art Nexus/Arte en Colombia*, no. 53 (January–March 1993): 52–57/201–4.

———, "La nueva estética del arte mexicano/Estheticizing Mexican Art," *Arte en Columbia*, no. 4 (May 1989): 39–47.

———, "Latin Americans Aquí/Here," *Artweek* (December 1, 1984): 3–4.

———, "Mexican Splendor: The Official and Unofficial Stories," *Visions Art Quarterly* 6, no. 2 (Spring 1992): 8–13.

———, "Tropical Paradise: Siqueiros's LA Mural, A Victim of Double Censorship," *Artweek* (July 5, 1990): 20–21.

———, "Updating Chicano Art: The 'CARA' Show in Retrospect," *New Art Examiner* 20, no. 2 (October 1992): 17–20.

Goldman, Shifra, and Tómas Ybarra-Frausto, *Arte Chicano: A Comprehensive Annotated Bibliography of Chicano Art, 1965–1981*, Berkeley: Chicano Studies Library Publications Unit, University of California, 1985.

Goldman, Shifra, and Luis Camnitzer, "Recent Latin American Art," *Art Journal* 51, no. 4 (Winter 1992).

Gómez-Peña, Guillermo. "A New Artistic Continent," in Philip Brookman and Guillermo Gómez-Peña (eds.), *Made in Aztlan*, 86–97, San Diego: Centro Cultural de la Raza, 1986.

———, "Documentado/Indocumentado," *Multicultural Literacy, The Greyhound Annual* 5 (1988).

———, "The Multicultural Paradigm: An Open Letter to the National Arts Community," *HIgh Performance* 12, no. 3 (Fall 1989): 18–27.

Gómez-Quinoñes, Juan, *Development of the Mexican Working Class North of the Rio Bravo: Work and Culture among Laborers and Artisans, 1600–1900*, Los Angeles: University of California, Chicano Studies Research Center Publications, Popular Series, no. 2, 1982.

González, José Luis, *El país de cuatro pisos y otros ensayos*, Río Piedras, Puerto Rico: Ediciones Huracán, 1980.

Gradburn, Nelson H. H. (ed.), *Ethnic and Tourist Arts: Cultural Expressions from the Fourth World*, Berkeley: University of California Press, 1976.

Gramsci, Antonio, *Selections from the Prison Notebooks of Antonio Gramsci*,

trans. and ed. Quintin Hoare and Geoffrey Nowell Smith, New York: International Publishers, 1971.

Griswold del Castillo, Richard, et al., *Chicano Art: Resistance and Affirmation, 1965–1985,* Los Angeles: Wight Art Gallery, University of California, 1991.

Grobet, Lourdes, "Sobre mi labor fotográfica," *Los Universitarios* (Mexico), no. 111–12 (January 1978): 18–19.

Grupo Suma: La Calle, Salón Nacional de Artes Plásticas, Sección Anual de Experimentación en México, Auditorio Nacional, Mexico City, 1979.

Grynsztejn, Madeleine, *Alfredo Jaar,* La Jolla, Calif.: La Jolla Museum of Contemporary Art, 1990.

Gual, Enrique F., *La pintura de Fanny Rabel,* Mexico City: Anáhuac Cia. Editorial, S.A., 1968.

Guilbaut, Serge, *How New York Stole the Idea of Modern Art: Abstract Expressionism, Freedom and the Cold War,* trans. Arthur Goldhammer, Chicago: University of Chicago Press, 1983.

Hadjinicolaou, Nicos, *Art History and Class Struggle,* trans. Louise Asmal, London: Pluto Press, [1973] 1978.

———, "On the Ideology of Avant-Gardism," *Praxis,* no. 6 (1982): 39–70.

Hancock de Sandoval, Judith, "Latin American Artists in New York, USA," *Artes Visuales* (Mexico) no. 15 (Fall 1977): 30–32.

Hanly, Elizabeth, "The Cuban Museum Crisis, or Fear and Loathing in Miami," *Art in America* 80, no. 2 (February 1992): 31–37.

Harris, Jonathan, "The Administrative Organization of the Federal Art Project: Power, Possession and State-Cultural Populism," unpublished manuscript (c. 1987).

Hauptman, William, "The Suppression of Art in the McCarthy Decade," *Artforum* 12, no. 2 (October 1973): 48–52.

Hauser, Arnold, *The Philosophy of Art History,* Cleveland: Meridian Books, [1958] 1961.

———, *The Social History of Art,* trans. Stanley Godman, New York: Vintage Books, [1957] 1985.

Herner de Larrea, Irene, et al., *Diego Rivera: Paraíso perdido en Rockefeller Center,* Mexico City: Edicupes, S.A., 1986.

Herrera, Hayden, *Frida: A Biography of Frida Kahlo,* New York: Harper and Row, 1983.

———, "Frida Kahlo: Her Life, Her Art," *Artforum* (May 1976): 38–44.

———, "Portrait of Frida Kahlo as a Tehuana," *Heresies* (Winter 1977–78): 57–58.

Herring, Hubert, *History of Latin America from the Beginnings to the Present,* 3rd ed., New York: Alfred Knopf, 1972.

Híjar, Alberto, "Cuatro grupos a Paris," *Plural,* 2ª época, 73 (October 1977): 51–58.

Hillinger, Charles, "The Royal Chicano Airforce: Activists in Sacramento Use Humor to Instill Pride," *Los Angeles Times* (July 22, 1979): I-3.

Hills, Patricia, *The Working American,* National Union of Hospital and Health Care Employees District 1199 and Smithsonian Institution Traveling Exhibition Service, 1979.

Home, Stewart, "Gustav Metzger and Auto-Destructive Art," in Home, *The Assault on Culture: Utopian Currents from Lettrisme to Class War*, Stirling, Scotland: AK Press, 1991.

Hugo, Joan, "Communication Alternatives," *Artweek* 10, no. 31 (September 29, 1979): 5.

Hurlburt, Laurance P., *The Mexican Muralists in the United States*, Albuquerque: University of New Mexico Press, 1989.

———, "The Siqueiros Experimental Workshop: New York, 1936," *Art Journal* 35, no. 3 (Spring 1976): 237–46.

Hurley, Jack, *Portrait of a Decade: Roy Stryker and the Development of Documentary Photography in the Thirties*, New York: De Capo Press, Inc., 1977.

Images of Mexico: An Artistic Perspective from the Pre-Columbian Era to Modernism, Mandeville Arts Gallery, University of California, San Diego, 1980.

Janson, H. W., *History of Art: A Survey of the Major Visual Arts from the Dawn of History to the Present Day*, 4th ed. (revised and expanded by Anthony F. Janson), New York: Harry N. Abrams, 1991.

Jensen, Robert, "The Avant-Garde and the Trade in Art," *Art Journal* 47, no. 4 (Winter 1988): 360–67.

Jewett, Masha Zakheim, *Coit Tower, San Francisco: Its History and Art*, San Francisco: Volcano Press, 1983.

Johnson, John L., *Latin America in Caricature*, Austin: University of Texas Press, 1980.

Johnson, Robert Flynn, and Lucy Lippard, *Rupert García: Prints and Posters/Grabados y afiches, 1967–1990*, San Francisco: Fine Arts Museums, 1991.

Juan, Adelaida de, "Actitudes y reacciones," in Damián Boyón, ed., *América Latina en sus artes*, 34–40, Mexico City: Siglo Veintiuno Editores, 1974.

———, *Pintura cubana: Temas y variaciones*, Mexico City: Universidad Nacional Autónoma de México, 1980.

Kaplan, Janet, "Remedios Varo: Voyages and Visions," *Woman's Art Journal* (Fall 1980/Winter 1981): 13–18.

———, *Unexpected Journeys: The Art and Life of Remedios Varo*, New York: Abbeville Press, 1988.

Kerr, Patricia, "Las Mujeres Muralistas," in Moira Roth, ed., *Connecting Conversations: Interviews with 28 Bay Area Women Artists*, 131–36, Oakland, Calif.: Eucalyptus Press, Mills College, 1988.

Kosiba-Vargas, S. Zaneta, *Harry Gamboa and ASCO: The Emergence and Development of a Chicano Art Group, 1971–1987*, unpublished Ph.D. dissertation, 1988.

Kozloff, Max. "American Painting during the Cold War," *Artforum* 11, no. 9 (May 1973): 48–52.

———, "The Rivera Frescoes of Modern Industry at the Detroit Institute of Arts: Proletarian Art under Capitalist Patronage," *Artforum* 12, no. 3 (November 1973): 58–63.

Kroll, Eric, "Folk Art in the Barrios," *Natural History* (May 1973): 56–65.

Kunkel, Gladys M., *The Mural Paintings of Anton Refregier in the Rincon Annex*

of the San Francisco Post Office, San Francisco, Calif., unpublished Master's thesis, Arizona State University, Tempe, 1969.

Kunzle, David, "Art in Chile's Revolutionary Process: Guerilla Muralist Brigades," *New World Review* 61, no. 3 (1973): 7–8.

——, "Art of the New Chile: Mural, Poster and Comic Book in the 'Revolutionary Process,'" in Henry A. Millon and Linda Nochlin (eds.), *Art and Architecture in the Service of Politics*, 356–81, Cambridge: MIT Press, 1978.

——, "El mural chileno: Arte de una revolución. La arpillera chilena: Arte de protesta y resistencia," in *Chile vive*, 81–88, Mexico City: Centro de Estudios Económicos y Sociales del Tercer Mundo, A.C. y El Instituto de Investigaciones Estéticas, Universidad Nacional Autónoma de México, 1982.

——, *Murals of Revolutionary Nicaragua, 1979–1991/92*, Berkeley: University of California, forthcoming.

——, "Nationalist, Internationalist and Anti-Imperialist Themes in the Public Revolutionary Art of Cuba, Chile and Nicaragua," *Studies in Latin American Popular Culture* 2 (1983): 141–57.

——, "Public Graphics in Cuba: A Very Cuban Form of International Art," *Latin American Perspectives* 2, no. 4, issue 7 (Supplement 1975).

——, "Uses of the Portrait: The Che Poster," *Art in America* 63, no. 5 (September–October 1975): 66–73.

La gráfica del 68—Homenaje al movimiento estudiantil, compiled by Grupo Mira, Mexico City: Talleres de la ENAP-UNAM, 1982.

La Raza Silkscreen Center, *"Images of a Community": An Exhibit of Silkscreen Posters and Graphic Works from 1971 to 1979*, San Francisco: Galería de la Raza, 1979.

Larkin, Oliver W., *Art and Life in America*, rev. ed. New York: Holt, Rinehart and Winston, 1964.

Latorre, Teresa, "Arte oficial y arte disidente en Chile," in *Chile vive*, 63–75, Mexico City: Centro de Estudios Económicos y Sociales del Tercer Mundo, A.C. y El Instituto de Investigaciones Estéticas, Universidad Nacional Autónoma de México, 1982.

Lauer, Mirko, "Artesanía y capitalismo en Perú," *Análisis* (Lima), no. 5 (1979): 26–48.

——, *Introducción a la pintura peruana del siglo XX*, Lima: Mosca Azul Editores, 1976.

——, *La producción artesanal en América Latina*, Lima: Mosca Azul Editores, 1989.

Lawson, John Howard, *Film: The Creative Process. The Search for an Audio Visual Language and Structure*, New York: Hill and Wang, 1964.

Linares, Laura, and Keneth Kemble, "El movimiento artístico que maró una época: Otra Figuración 20 años después," *La Nación* (Buenos Aires; March 1, 1981).

Lippard, Lucy, *Get the Message! A Decade of Art for Social Change*, New York: E. P. Dutton, 1984.

——, "Headlines, Heartlines, Hardlines: Advocacy Criticism as Activism," Douglas Kahn and Diane Neumaier, eds., *Cultures in Contention*. Seattle: The Real Comet Press, 1985.

————, *Mixed Blessings: New Art in a Multicultural America*, New York: Pantheon Books, 1990.

Littlefield, Alice, "Of Devils and Domination, Capitalism and Culture," *Studies in Latin American Popular Culture* 3 (1984): 174–78.

López Anaya, Jorge, "Teoría y práctica de la neofiguración," *Revista de Estética* (CAYC, Buenos Aires) 3 (1984): 51–60.

Lowe, Sarah M., *Frida Kahlo*, New York: Universe Publishing, 1991.

Malvido, Adriana, "A raíz de la nacionalización de la banca, la colección del arte Banamex, una de las más importantes del país, pasó al estado," *Uno más uno* (September 8, 1982), 19.

Manrique, Alberto, et al., *El geometrismo mexicano*, Mexico City: Universidad Nacional Autónoma de México, 1977.

Marcuse, Herbert, *The Aesthetic Dimension: Toward a Critique of Marxist Aesthetics*, Boston: Beacon Press, 1978.

————, "Art as a Form of Reality," in Edward F. Fry (ed.), *On the Future of Art*, 121–34, New York: The Viking Press, 1970.

————, *Eros and Civilization: A Philosophical Inquiry into Freud*, Boston: Beacon Press, 1955.

Martínez, Elizabeth (ed.), *450 Años del pueblo chicano/450 Years of Chicano History in Pictures*, Albuquerque: Chicano Communications Center, 1976.

———— (ed.), *500 Años del pueblo chicano/500 Years of Chicano History in Pictures*, 2nd ed., Albuquerque: Southwest Organizing Project, 1991.

Mathews, Jane de Hart, "Art and Politics in Cold War America," *American Historical Review* 81, no. 4 (October 1976): 762–87.

Mattelart, Armand, et al., *International Image Markets: In Search of an Alternative Perspective*, trans. David Buxton, London: Comedia Publishing Group, 1984.

————, *Transnationals and the Third World: The Struggle for Culture*, trans. David Buxton, South Hadley, Mass.: Bergin and Garvey, 1983.

May, Lary (ed.), *Recasting America: Culture and Politics in the Age of the Cold War*, Chicago: University of Chicago Press, 1989.

McBane, Margo, *The History of California Agriculture: Focus on Women Farmworkers*, San Francisco: The Coalition of Labor Union Women of Santa Clara County, Retail Store Employees Local 248, The Youth Project, 1975.

McEvilley, Thomas, "Doctor, Lawyer, Indian Chief," *Artforum* (November 1984): 54–60.

McKenzie, Richard D., *The New Deal for Artists*, Princeton: Princeton University Press, 1973.

McWilliams, Carey, *North from Mexico: The Spanish-Speaking People of the United States*, New York: Greenwood Press, 1968.

Merkx, Gilbert W., "Editors Foreword," *Latin American Research Review* 27 no. 3 (1992): 3–6.

Mexico: Splendors of Thirty Centuries, Boston: Little, Brown and Company and the Metropolitan Museum of Art, 1990.

México Sociedad Anónima (Imágenes crónicas de una ciudad), Escuela Nacional de Artes Plásticas, Mexico City, 1977.

Meyer, Hannes et al., *El Taller de Gráfica Popular: Doce años de obra artística colectiva*, Mexico City: La Estampa Mexicana, 1949.

Meyer, Karl E., *The Art Museum: Power, Money, Ethics*, New York: William Morrow and Company, 1979.

Michelson, Annette, et al. (eds.), *October: The First Decade, 1976–1986*, Cambridge: MIT Press, 1987.

Millier, Arthur, "The Pictorial Ferment of Mexico Agitates Present Day Los Angeles," *La Opinion* (June 30, 1932).

———, "Von Sternberg Dotes on Portraits of Himself," *Los Angeles Times* (June 12, 1932): 13, 19.

Millon, Henry A., and Linda Nochlin (eds.), *Art and Architecture in the Service of Politics*, Cambridge: MIT Press, 1978.

Mirandé, Alfredo, and Evangelina Enríquez, *La Chicana: The Mexican American Woman*, Chicago: University of Chicago Press, 1979.

Monsiváis, Carlos, *María Izquierdo*, Mexico City: Casa de la Bolsa Cremi, 1986.

Montecino, Marcelo, *Con sangre en el ojo*, Mexico City: Editorial Nueva Imagen, 1981.

Montoya, Malaquías, and Lezlie Salkowitz-Montoya, "A Critical Perspective on the State of Chicano Art," *Metamorfosis* (University of Washington, Seattle) 3, no. 1 (Spring/Summer 1980): 3–7.

Moquin, Wayne, et al., *A Documentary History of the Mexican Americans*, New York: Bantam Books, 1972.

Morais, Frederico, *Artes plásticas: A crise da hora atual*, Rio de Janeiro: Editora Paz e Terra, 1975.

———, *Artes plásticas na América Latina: Do transe au transitório*, Rio de Janeiro: Editora Civilização Brasileira, 1979.

Morales Carrión, Arturo, *Puerto Rico: A Political and Cultural History*, New York: W. W. Norton & Co., 1983.

Moreno Capdevila, Francisco, *Exposición de Susana Campos: Ritmos obsesivos*, Mexico City: Salón de la Plástica Mexicana, 1975.

Mosquera, Gerardo, "The Marco-Polo Syndrome: Some Problems around Art and Eurocentrism," trans. Jaime Flórez, *Third Text*, no. 21 (Winter 1992–93): 35–41.

Muros frente a muros. Casa de la Cultura de Michoacán, Morelia, Michoacan, May 1978.

Myers, Bernard S., *Mexican Painting in Our Time*, New York: Oxford University Press, 1956.

Nochlin, Linda, and Edward J. Sullivan, *La mujer en México/Women in Mexico*, Mexico City: Fundación Cultural Televisa, 1990.

———, *Realism*, Hammondsworth: Penguin Books, 1972.

Nómez, Naín, "On Culture as Democratic Culture in Latin America," *Studies in Latin American Popular Culture*, no. 2 (1983): 171–81.

Novelo, Victoria, *Artesanías y capitalismo en México*, Tlalpan, Mexico D.F.: Centro de Investigaciones Superiores, Instituto Nacional de Antropología e Historia, 1976.

Obler, Geraldine, *Aspects of Social Protest in American Art: 1963–1973*, unpublished Ph.D. dissertation, 1974.

O'Connor, Francis V. (ed.), *Art for the Millions: Essays from the 1930s by Artists and Administrators of the WPA Federal Art Project*. Boston: New York Graphic Society, [1973] 1975.

———, *Federal Support for the Visual Arts: The New Deal and Now*, 2nd ed. Greenwich, Conn.: New York Graphic Society, 1971.

———, "The Genesis of Jackson Pollock: 1912 to 1943, *Artforum* (May 1967).

——— (ed.), *The New Deal Projects: An Anthology of Memoirs*, Washington, D.C.: Smithsonian Institution Press, 1972.

Olalquiaga, Celeste, *Megalopolis: Contemporary Cultural Sensibilities*, Minneapolis: University of Minnesota Press, 1992.

Orenstein, Gloria, "Frida Kahlo: Painting for Miracles," *The Feminist Art Journal* (Fall 1973): 7–9.

"Orozco Show Banned in L.A.," *Art Digest* (August 1953).

"Orozco Unveiled," *Art in America* 76, no. 11 (November 1988): 216.

Ortiz, Renato, "Lo actual y la modernidad," *Nueva Sociedad* (Caracas), no. 116 (November–December 1991): 94–101.

Ortiz Pinchetti, Francisco, "Del echeverrismo surgió todopoderoso el Grupo Monterrey," *Proceso* (Mexico), no. 78 (May 1, 1978): 16–19.

Ortúzar, Ximena, "Rescatan 'Ejercicio Plástico', el mural de Siqueiros perdido en un sótano de Buenos Aires," *Proceso* (October 21, 1991): 48–51.

Owens, Craig, "Representation, Appropriation & Power," *Art in America* 70, no. 5 (May 1982): 9–21.

———, "The Medusa Effect or The Spectacular Ruse," in *We Won't Play Nature to Your Culture: Barbara Kruger* 7–11, London: Institute of Contemporary Arts, 1983.

Park, Marlene, "City and Country in the 1930s: A Study of New Deal Murals in New York," *Art Journal* 39, no. 1 (Fall 1979): 37–47.

Parra, Isabel, *El libro mayor de Violeta Parra*, Madrid: Ediciones Michay, S.A., 1985.

Pass-Zeidler, Sigrun, and Georges Raillard, *Chilenisches Tagebuch*, Wilhelm-Hack-Museum, Ludwigshafen am Rhein, 1981.

Paz, Octavio, *The Other Mexico: Critique of the Pyramid*, trans. Lysander Kemp, New York: Grove Press, 1972.

Peccinini de Alvarado, Daisy Valle Machado, *Novas figuracôes, novo realismo e nova o objetividade. Brasil anos '60*, unpublished Ph.D. dissertation, São Paulo, 1987.

Peluffo, Gabriel, "Crisis de un inventario," in Hugo Achugar and Gerardo Caetano (eds.), *Identidad uruguayo: ¡Mito, crisis o afirmación!* 1–11, Montevideo: Ediciones Trilce, 1992.

Peraza, Nilda, Marcia Tucker, and Kinshasha Conwill (eds.), *The Decade Show: Frameworks of Identity in the 1980s*. New York: Museum of Contemporary Hispanic Art, The New Museum of Contemporary Art, The Studio Museum of Harlem, 1990.

Phillips Collection, The, Washington, D.C., *Rufino Tamayo: Fifty Years of His Painting*, 1978.

Pinkel, Sheila, *Multicultural Focus: A Photography Exhibition for the Los Angeles Bicentennial*, Los Angeles: Los Angeles Municipal Art Gallery, 1981.

Pintura y gráfica de los años 50, San Juan: First Federal Savings Bank, La Herman-

dad de Artistas Gráficos de Puerto Rico, Instituto de Cultura Puertorriqueña, 1985.

Pitt, Leonard, *The Decline of the Californios: A Social History of the Spanish-Speaking Californians, 1846–1890,* Berkeley: University of California Press, 1966.

Plagens, Peter, *Sunshine Muse: Contemporary Art on the West Coast,* New York: Praeger Publishers, 1974.

Pohl, Frances, "An American in Venice: Ben Shahn and United States Foreign Policy at the 1954 Venice Biennale, or Portrait of the Artist as an American Liberal," *Art History* 4, no. 1 (March 1981): 80–113.

———, *Ben Shahn: New Deal Artist in a Cold War Climate, 1947–1954,* Austin: University of Texas Press, 1989.

Poniatowska, Elena, *La noche de Tlatelolco: Testimonios de historia oral,* Mexico City: Biblioteca Era, 1983.

Powell, Philip Wayne, *Soldiers, Indians & Silver: North America's First Frontier War,* Tempe: Arizona State University, 1975.

"Power Unadorned Marks Olvera Street Mural," *Los Angeles Times,* October 16, 1932.

Presencia de México en la X Bienal de Paris, Instituto Nacional de Bellas Artes and Museo Universitario de Ciencas y Arte, Mexico City, 1977.

Preziosi, Donald, *Rethinking Art History: Meditations on a Coy Science,* New Haven: Yale University Press, 1989.

Programa de educación de la comunidad en Puerto Rico/Community Education Program in Puerto Rico, Un, New York: Radio Corporation of America, n.d. [c. 1960s].

Quirarte, Jacinto, *Mexican American Artists,* Austin: University of Texas Press, 1973.

Ramírez, Mari Carmen, "Between Two Waters: Image and Identity in Latino-American Art," Symposium: Arte e identidad en América Latina, São Paulo, Brazil, September 1991.

———, "Re-Installing the Echo Chamber of the Past," *Encounters/Displacements: Luis Camnitzer, Alfredo Jaar, Cildo Meireles,* Archer M. Huntington Art Gallery, University of Texas, Austin, 1992.

———, *The Ideology and Politics of the Mexican Mural Movement: 1920–1925,* unpublished Ph.D. dissertation, 1989.

Richard, Nelly, "Margins and Institutions: Art in Chile since 1973," *Art & Text* 21 (n.d. [1986]).

———, "Postmodern Disalignments and Realignments of the Centre/Periphery," in Shifra M. Goldman and Luis Camnitzer, eds., "Recent Latin American Art," *Art Journal* 51, no. 4 (Winter 1992): 57–59.

Rivera, Anny, *Notas sobre el movimiento social y arte en el regimen autoritario 1973–83,* Santiago: CENECA, 1983.

Rodríguez Prampolini, Ida, "Arte o justicia? El Taller de Investigación Plástica de Morelos," *Plural,* 2ª época, no. 101 (February 1980): 31–37.

———, *El surrealismo y el arte fantástico en México,* Mexico City: Instituto de Investigaciones Estéticas, Universidad Nacional Autónoma de México, 1969.

Rogovin, Mark, et al., *Mural Manual*, Boston: Beacon Press, [1973] 1975.

Roman, Melvin, "Art and Social Change," *Américas* (February 1970): 13–20.

Romero Brest, Jorge, *El arte en la Argentina: Ultimas décadas*, Buenos Aires: Paidós, S.A., 1969.

Rosaldo, Renato, *Culture and Truth: The Remaking of Social Analysis*, Boston: Beacon Press, 1989.

Rowe, William, and Vivian Schelling, *Memory and Modernity: Popular Culture in Latin America*, London: Verso, 1991.

Ryan, Michael, "On/Against Mass Culture, III: Opening Up the Debate," *Tabloid: A Review of Mass Culture and Everyday Life*, no. 5 (Winter 1982): 2–12.

Sánchez, Rita, "Imágenes de la Chicana," in *Imágenes de la Chicana*, Menlo Park, Calif.: Nowels Publications, 1974.

Sánchez, Rosaura, and Rosa Martinez Cruz (eds.), *Essays on la mujer*, Los Angeles: Chicano Studies Center Publications, University of California, Los Angeles, 1977.

Schapiro, Meyer, "The Social Bases of Art," in David Schapiro (ed.), *Social Realism: Art as a Weapon*, 118–27, New York: Frederick Ungar Publishing Co., 1973.

Schiller, Herbert I., *Mass Communications and American Empire*, Boston: Beacon Press, 1971.

——, *The Mind Managers*, Boston: Beacon Press, 1973.

Schwartz, Barry, *The New Humanism: Art in a Time of Change*, New York: Praeger Publishers, 1974.

Schwartz, Theresa, "The Politicalization of the Avant-Garde," *Art in America* 59, no. 6 (November/December 1971): 96–105.

Segre, Roberto (ed.), *Latin America in Its Architecture*, trans. Edith Grossman, New York: Holmes and Meier, 1981.

Selz, Peter (ed.), *New Images of Man*, New York: Museum of Modern Art, 1959.

Shikes, Ralph E., *The Indignant Eye: The Artist as Social Critic in Prints and Drawings from the Fifteenth Century*, Boston: Beacon Press, 1969.

Siqueiros, David Alfaro, *Cómo se pinta un mural*, 2nd ed., Mexico City: Ediciones Taller Siqueiros, 1977.

——, *La historia de una insidia. ¿Quiénes son las traidores a la patria? Mi respuesta*, Mexico City: Ediciones de "Arte Público," 1960.

Smith, James F., "The Painter and the Yanquis," *Los Angeles Times*, November 29, 1989, Calendar Section, 1 +.

Solomon R. Guggenheim Foundation, *Rufino Tamayo: Myth and Magic*, New York, 1978.

Steichen, Edward (ed.), *The Bitter Years: 1935–1941*, New York: Museum of Modern Art, 1962.

Stellweg, Carla, "'Magnet—New York': Conceptual, Performance, Environmental, and Installation Art by Latin American Artists in New York," in Luis Cancel (ed.), *The Latin American Spirit: Art and Artists in the United States, 1920–1970*, 184–221, New York: Harry N. Abrams, (1988): 184–221.

Stermer, Dugald, and Susan Sontag, *The Art of Revolution: Castro's Cuba: 1959–1970*, New York: McGraw-Hill Book Co., 1970.

Stiles, Kristine, *Rafael Montañez Ortiz: Years of the Warrior 1960; Years of the Psyche 1988*, New York: El Museo del Barrio, 1988.

Stoddard, Veronica Gould, "Mexico Today: Art as Ambassador," *Américas* 31, no. 2 (February 1979).

Suárez, Orlando S., *Inventario del muralismo mexicano (Siglo VII a. de C.*, Mexico City: Universidad Autónoma de México, 1972.

Taller Alma Boricua: Reflecting on Twenty Years of the Puerto Rican Workshop, New York: El Museo del Barrio, 1990.

"Testimonios de Latinoamérica: Comunicaciones visuales alternativas," in *La Semana de Bellas Artes*, Mexico City: Instituto Nacional de Bellas Artes, nos. 42 and 43 (September 20 and September 27, 1978).

Tibol, Raquel, *David Alfaro Siqueiros: Der neue mexikanische Realismus. Reden und Schriften zur Kunst*, Dresden: VEB Verlag der Kunst, 1975.

———, *Diego Rivera: Arte y política*, Mexico City: Editorial Grijalbo, 1979.

———, *Frida Kahlo: An Open Life*, trans. Elinor Randall, Albuquerque: University of New Mexico Press, 1993.

———, *Frida Kahlo: Una vida abierta*, Mexico City: Editorial Oasis, 1983.

———, *Gráficas y neográficas en México*, SEP and Universidad Nacional Autónoma de México, 1987.

———, *Hermenegildo Bustos: Pintor de pueblo*, Guanajuato: Gobierno del Estado de Guanajuato, 1981.

———, *Historia general del arte mexicano: Epoca moderna y contemporánea*, Mexico City: Editorial Hermes, S.A., 1964.

———, *José Clemente Orozco: Cuadernos*, Mexico: Secretaría de Educación Pública, 1983.

———, "La calle del Grupo Suma," *Proceso* (Mexico; February 12, 1977), 78–79.

———, "Otra vez, muralismo en el E.U.," *Excelsior* (Mexico), Diorama de la Cultura, 3.

———, *Pedro Cervantes*, Mexico City: Secretaría de Educación Pública, 1974.

———, "Pilar Castañeda," Puebla, Mexico: Casa de la Cultura, 1974.

———, "Se inauguró el museo: Con Tamayo, la iniciativa privada al poder cultural," *Proceso* (Mexico), no. 239 (June 1, 1981): 44–47.

———, *Siqueiros: Introductor de realidades*, Mexico City: Empresas Editoriales, 1969.

Toor, Francis, *A Treasury of Mexican Folkways*, New York: Crown Publishers, 1979.

Torres, María de Los Angeles, "Will Miami Fall Next?" *NACLA: Report on the Americas* 24, no. 3 (November 1990): 27–29.

Traba, Marta, *Dos décadas vulnerables en las artes plásticas latinoamericanas, 1950–1970*, Mexico City: Siglo Veintiuno Editores, 1973.

Turner, Kay, "Mexican American Home Altars: Towards Their Interpretation," *Aztlán: International Journal of Chicano Studies Research* (University of California, Los Angeles) 13 (Spring and Fall 1982): 309–26.

Valdez, Luis, and Stan Steiner, *Aztlan: An Anthology of Mexican American Literature*, New York: Vintage Books, 1972.

Venegas, Sybil, "The Artists and Their Work—The Role of the Chicana Artist," *ChismeArte* 1, no. 4 (Fall/Winter), c. 1978.

Vigo, Edgardo-Antonio, "The State of Mail Art in South America," Michael Crane and Mary Stofflet (eds.), *Correspondence Art: Source Book for the Network of International Postal Art Activity*, 349–68, San Francisco: Contemporary Arts Press, 1984.

Villa, Carlos (ed.), *Other Sources: An American Essay*, San Francisco: San Francisco Art Institute, 1976.

Wallis, Brian (ed.), *Art after Modernism: Rethinking Representation*, New York: New Museum of Contemporary Art, 1984.

———, "Institutions Trust Institutions," Brian Wallis (ed.), *Hans Haacke: Unfinished Business*, 51–59, New York: New Museum of Contemporary Art, 1986.

Wells, Harry K., *Pragmatism: Philosophy of Imperialism*, New York: International Publishers, 1954.

West, Cornel, *Race Matters*, Boston: Beacon Press, 1993.

Wilson, Michael, and Deborah Silverton Rosenfelt, *Salt of the Earth*, Old Westbury, N.Y.: The Feminist Press, 1978.

Wolf, Eric R., *Europe and the People without History*, Berkeley: University of California Press, 1982.

Wolfe, Bertram D., *The Fabulous Life of Diego Rivera*, New York: Stein and Day, 1963.

Wolff, Janet, *The Social Production of Art*, New York: New York University, [1981] 1984.

World of Agustín Víctor Casasola, Mexico: 1900–1938, The, Washington, D.C.: Fondo del Sol Visual Arts and Media Center, 1984.

Wright, Richard, *Twelve Million Black Voices*, New York: Thunder's Mouth Press, [1941] 1988.

Wroth, William (ed.), *Hispanic Crafts of the Southwest*, The Taylor Museum of the Colorado Springs Fine Arts Center, 1977.

Wye, Deborah, *Committed to Print: Social and Political Themes in Recent American Printed Art*, New York: Museum of Modern Art, 1988.

Yúdice, George, Jean Franco, and Juan Flores (eds.), *On Edge: The Crisis of Contemporary Latin American Culture*, Minneapolis: University of Minnesota Press, 1992.

———, "We Are *Not* the World," *Social Text* 10, nos. 2 and 3 (1992): 202–16.

Zarotsky, Eli, *Capitalism, the Family, and Personal Life*, Santa Cruz, Calif.: Loaded Press, n.d. [1970s].

Zimmerman, Marc, "Françoise Perus and Latin American Modernism: The Interventions of Althusser," *Praxis: Art and Ideology*, no. 6 (1982): 157–76.

GLOSSARY

Altiplano	High plateau.
Apertura	A temporary political relaxation during a period of repression or dictatorship.
Arpillera	Sackcloth; in Chile, refers to stitched and appliqued political narratives by women from families of prisoners or the "disappeared."
Arrieros	Mule drivers.
Artesanía	Arts and crafts.
Avanzada	Avant-garde of Chile during the Pinochet dictatorship.
Aztlán	Applied by Chicanos to the Southwest United States as the mythohistorical location of origin of the Aztecs.
Barrio	A working-class neighborhood.
Bomba	An Afro-Antilles dance, accompanied by the *bomba* drum, popular in Puerto Rico.
Botánica	A sales outlet for curative herbs, animal and aquatic products, charms, and religious objects used in Afro-Caribbean rituals like *santería* and Spiritualism.
Brujería	Witchcraft.
Brujo/a	A male or female sorceror. See curandero/a for a more benign kind of magic.
Caballero	A horseman; also means a gentleman in Spanish usage.
Calavera	A skull, or an animated skeleton used in Día de los Muertos celebrations in Mexico and by several nineteenth-century caricaturists.
Causa, La	The "Cause" or the program that animates a political or social movement.
Charro	Horseman, usually in fancy dress for display.
Chicano	Self-designation of Mexican American youth in the 1960s to differentiate themselves from what many considered assimi-

	lationist parents and families who denied their Indian heritage.
Cholo/a	Younger generations of postwar Mexican Americans who, like the Pachucos before them, distinguished themselves by their dress (khakis, oversize T-shirts, headbands, tattoos), low-rider cars, and neighborhood-identifying graffiti. Women, like the Pachucas, dressed in short skirts, used heavy makeup, tattoos, and elaborate earrings.
Científico	A high administrator in the government of Porfirio Díaz of Mexico, infused with Positivist ideas, who believed problems could be solved by scientific solutions.
Compañero/a	A comrade, someone sharing a "cause."
Conquistadores	Spanish conquerors of the New World.
Criollo	Creole; A white European born in the Spanish American empire.
Curandero/a	A folk healer.
Desaparacidos	The "disappeared"; individuals during the Latin American dictatorships from the 1960s to the 1990s who vanished from sight, either assassinated or put in prison. State, military, and paramilitary groupings denied knowledge of their whereabouts. Most have never been found, dead or alive.
Desarrollismo	Developmentalism: an economic theory exercised in Latin America (and other Third World areas) during the 1960s and 1970s. It proposed growth through state leadership, domestic market protection, and strong controls on western investment to bring about a global redistribution of wealth.
Día de los Muertos	Day of the Dead; rituals practiced in Mexico every November to honor the deceased with altars, candles, and special foods. Adopted in the 1960s by Chicano artistic communities.
Enjarrando	Plastering an adobe building; in the Southwest usually carried out by indigenous women.
Estampa	To print, or publish. In the arts, refers to prints like woodcuts, linoleum cuts, lithographs, etc., or to the plates in a book or portfolio.
Estudiantil	The term "student" used as an adjective.
Favelas	Working-class slums in Brazil.
Fotonovelas	"Comic strips" produced with photographs rather than drawings.
Frontera	The border.
Gráfica	Graphic or graphics.
Guadalupana	Adherent of the group devoted to the worship of the Virgin of Guadalupe.
Hembrismo	From the word *hembra*, or female. An exaggerated belief in femininity; the opposite of *machismo*.
Homenaje	Homage.
Huelga	Strike, as in a labor dispute.
Imbunche	Legend from Chilean Indian lore about an infant whose ori-

fices were sewn shut to prevent the egress of evil. Artistic reference: Catalina Parra; literary reference: José Donoso's novel *The Obscene Bird of Night*.

Indigenista	An individual who is pro-indigenous. Alternative to a *hispanista*, who is pro-Spanish.
Jefe	Chief, boss, leader, masculine head of a family. In Pachuco and Chicano vernacular, *jefa* or *jefita* also used as reference to the mother as leader. Also refers to a labor contractor (see Papacito, Patroncito).
Jíbaro	Peasant, in the Caribbean.
Jícara	Gourd.
Jinete	Horseman.
Ladino/a	Spanish-speaking Indian, assimilated into Spanish culture. Used in Central and South America.
Latino/a	U.S. term referring to a spectrum of long-term Spanish-speaking residents of Latin American descent; self-designation often preferred to the institutional term "Hispanic."
Machismo	From *macho*, meaning male; virility or masculinity cult.
Malinche, La	Malintzin, Doña Marina; names of the Nahuatl- and Maya-speaking Indian woman given to Hernán Cortés. She functioned as his guide, interpreter, and mistress. *Malinchismo* in Mexican traditional vernacular equated with traitorous behavior, although recently challenged by feminist writers.
Marielitos	Cuban exiles who came to the United States in 1980, taking their name from the boatlift that originated in Mariel, Cuba.
Mestizo, mestizaje	A person of mixed parentage. Usually refers to a European-Indian mixture. Mestizaje is the process of mixing.
Mujer	Woman.
Muñocista	Adjective referring to a follower of Puerto Rican governor Luis Muñoz Marín.
Nopal	Prickly-pear cactus.
Nuyorican	One of a number of self-designations adopted by Puerto Ricans living in New York. Others include Neo-Ricans, Nuevo Yorrícan.
Orishas	Yoruba-derived pantheon of male and female gods translated to the Americas as part of African-derived culture and serving as deities for *santería (Regla de Ocha)*. Related to divination and forces of nature. Term used in Cuba, Brazil (Orixa), and other locations.
Pachuco/a	Mexican youth of the Southwest during the 1940s who adopted a distinctive dress code (the zoot suit for males), a vernacular language known as Caló, customized cars (hot rods, low-riders), and other cultural traits distinguishing them from their traditional Mexican parents and from U.S. Anglo society.
Pan, tierra y libertad	"Bread, Land and Liberty"; a slogan of the Mexican Revolution.

Papacito	Literally "little father"; refers to the Mexican American labor contractor who recruits and manages cheap Mexican labor to work in the United States. (See Jefe, Patroncito).
Papel picado	Thin-cut paper; specifically, that folded many times and cut in complex patterns, sometimes with figures and text.
Parentela	The relatives of one's family.
Patroncito	In Spanish-speaking America, the owner or boss. Use of the diminutive "ito" seems to be affectionate or trusting, but doubtless is a hidden irony.
Pava	In Puerto Rico, the typical straw hat of the farm laborer.
Plena	Popular Puerto Rican narrative songs that relate notable events and scandals.
Poblaciones	Poor working-class neighborhoods; term used in Santiago, Chile.
Porfiriato	The period of the Mexican dictator, Porfirio Díaz (1876–1911).
Puertorriqueño/a	Puerto Rican, used as an adjective.
Raza, La	Literally "the race," figuratively "the people" of Latin America and Latin American descent.
Rurales	Mexican federal troops used in the rural areas.
Santería	Afro-Caribbean religion centered in the worship of Christian saints and African deities, predominantly Yoruba.
Santos	Images of saints.
Soldadera	During the Mexican Revolution, a woman—attached to a soldier—who cooked, tended the ill and wounded, and fought.
Taller	A workshop.
Tejido	A weaving.
Tres Grandes	A term designating the "Big Three" of Mexican muralism: Orozco, Rivera, Siqueiros.
Vaquero	A Mexican cowboy. A term used in the borderlands of northern Mexico.
Vejigante	Costume for the Puerto Rican festival celebrating Santiago Matamoros (St. James—the Moor Killer). The *vejigante* outfit consists of a painted and horned coconut or papier-mâché mask with a brilliantly colored costume.
Velorio	A wake for the dead.
Viviendas	Mexican lower-class apartments, usually single-story, surrounding a courtyard where water, washbasins, and room for clotheslines are provided. Transition between rural and totally urban housing.
Xilografía	Woodcut technique of printmaking.

INDEX